ART AS POLITICS
IN THE THIRD REICH

ART
AS POLITICS
IN THE THIRD
REICH

Jonathan Petropoulos

THE UNIVERSITY OF NORTH CAROLINA PRESS

Chapel Hill & London

Library of Congress
Cataloging-in-Publication Data

Petropoulos, Jonathan
Art as politics in the Third Reich / by
 Jonathan Petropoulos.
p. cm.
Originally presented as the author's
thesis (doctoral) — Harvard University.
Includes bibliographical references and
 index.
ISBN-13: 978-0-8078-2240-1 (cloth: alk.
paper)
ISBN-13: 978-0-8078-4809-8 (pbk.: alk.
paper)
 1. National socialism and art.
2. Art and state — Germany — History —
20th century. 3. Art, German.
4. Art, Modern — 20th century —
Germany. 5. Germany-Cultural
policy — History — 20th century.
6. National socialists — Germany — Art
collections.
I. Title.
N6868.5.N37P48 1996
701'.03 — dc20 95-11738
 CIP

11 10 09 08 07 8 7 6 5 4

TO RICHARD M. HUNT

CONTENTS

ILLUSTRATIONS

ACKNOWLEDGMENTS

This book originated as a doctoral dissertation in the Department of History at Harvard University. From its inception Professor Charles Maier has been a wise and supportive supervisor. I thank him for all of his assistance. I owe special gratitude to Dr. Richard M. Hunt, whose friendship and knowledge of German history have helped me more than words can express. I have also learned a great deal from Professor Franklin Ford and have benefited tremendously from working with Stephanie Barron at the Los Angeles County Museum of Art, as I assisted her in organizing an exhibition chronicling the "degenerate" art campaign in Nazi Germany.

A number of colleagues deserve my special thanks for having commented on drafts of the manuscript. Chris Jackson in San Francisco and Stephan Lindner in Munich as well as Margaret Menninger and Jerry Sweeney in Cambridge have performed a service above and beyond the call of friendship by helping me with close readings. I, of course, take responsibility for all the shortcomings in this study. There would be many more, however, but for the help of these special friends.

The research for this project was made possible by grants from Harvard University's Minda de Gunzburg Center for European Studies and the Deutscher Akademischer Austauschdienst. They allowed me to make several trips to Europe, including eighteen months in Germany. The majority of that time was spent in Koblenz at the Bundesarchiv. The staff there made me feel particularly welcome: I owe special thanks to Werner Scharmann, Alois Röser, Marcus Geissler, and Frau Jacobi for helping me procure documents, and to Annegret Schöttler and Annette Meiburg for their advice and friendship. Daniel Simon, David Marwell, Heinz Fehlauer, and their staff at the Berlin Document Center accommodated my visits on three occasions; the materials I found there proved very valuable to this study. Frau Barwitz and her colleagues at the Oberfinanzdirektion in Munich were extraordinarily kind to this rare visitor; their tour of the Nazi art stored there was fascinating, and their assortment of documents proved extremely useful. The staff at the Institut für Zeitgeschichte in Munich, like that at the Institut für Zeitgeschichte in Vienna and the Preußisches Geheim Staatsarchiv in Berlin proved exceedingly helpful. In Paris, I owe special thanks to Monsieur Jacobson and Madame Halperyn at the Centre Documentation Juive Contemporaine. As masters of this valuable archive, they put their expertise at my disposal. The staff at the Österreiches Staatsarchiv in Vienna also helped me immensely during the two summers I spent there conduct-

ing research; special thanks to Rudolf Jerabek and also to a valued friend, Andrea Hackel.

Closer to home, Tom Noonan and Clark Evans at the Library of Congress assisted me with materials in the Third Reich Collection. Stephan Nonack, Brent Sverdloff, and Kirsten Hammer at the Getty Center for the History of Art and the Humanities helped me find pertinent documents and photographs. Thanks also for the kind assistance provided by Victoria Steele, the head of the Department of Special Collections at the Doheny Library at the University of Southern California. I also appreciate the collegiality of Tim Benson, Susan Trauger, Vicki Gambel, and Chris Vigeletti at the Rifkind Center for the Study of Expressionism in Los Angeles. They made two summers appreciably more productive and enjoyable. The staffs at Harvard's Widener, Fine Arts, and Houghton libraries have also been unfailingly supportive. From the latter, I appreciate the special assistance proffered by Roger Stoddard.

I owe a great thanks to a number of people who were not only good colleagues but invaluable friends. In particular, I would like to recognize Robert Aguire, Peter Baldwin, Günter Bischof, Josh Blatt, Glenn Cuomo, John Czaplicka, Patrice Dabrowski, Lee Davison, Scott Denham, Catherine Epstein, Robert Fisher, Norbert Frei, Rachelle Friedman, John Gibert, Daniel Goldhagen, Fiona Grigg, Karl Guthke, Sally Hadden, Irene Kacandes, Jean and Fred Leventhal, David Leviatan, Ina Lipkowitz, Lisbet and Joseph Koerner, Francis MacDonnell, Timothy Naftali, Peter Nisbet, Mark Peterson, Jeff Richter, Oliver Rathkolb, Timothy Ryback, Nigel Rothfels, Alex Sagan, Annette Schlagenhauff, Eleanor Sparagana, Alan Steinweis, Nathan Stolzfuss, Robert Mark Spaulding, Margaret Talbot, and John Trumpbour. My associates at Lowell House, and Masters Bill and Mary Lee Bossert in particular, as well as my colleagues at the Minda de Gunzburg Center for European Studies deserve special mention for providing such a stimulating environment.

My new associates at Loyola College in Maryland have been warm in their welcome, making a transition so much more painless than it might otherwise have been. Dean David Roswell and my associates in the history department have been particularly supportive. I look forward to many years of mutual inspiration.

Lewis Bateman and the staff at the University of North Carolina Press have been extremely thoughtful in moving me along with this project. I appreciate all of their support. As a final word of gratitude, I would like to thank my wife, Kimberly. Her assistance with the charts in this book, while important, cannot compare to the other ways in which she has aided me.

A NOTE ON NAMES, TITLES, AND ABBREVIATIONS

Because this study concerns political and cultural organizations, a great number of titles and offices are mentioned. Every effort has been made to render these terms so that the reader will readily understand them. Thus, a combination of German and English terms has been employed. Using exclusively German titles would obscure the significance of some names for readers unacquainted with German, and using only English titles would impart the sterilizing effects of translation. Thus the intermixing of German and English titles will hopefully enhance the reader's understanding of the subject. The list of abbreviations and the organizational charts and glossary in the Appendix are intended to provide clarification. With respect to artworks, all titles have been translated into English for the sake of consistency and comprehensibility. The aristocratic prefixes of the Germans have been left in the original language. Those of other nationalities have been translated into English. The names of cities and other geographic entities have also been rendered into English. The German name is invoked in a few cases, such as when reconstructing the thoughts of a historic figure. Hopefully this system of translation will provide clarity without sacrificing the nuances of the original language.

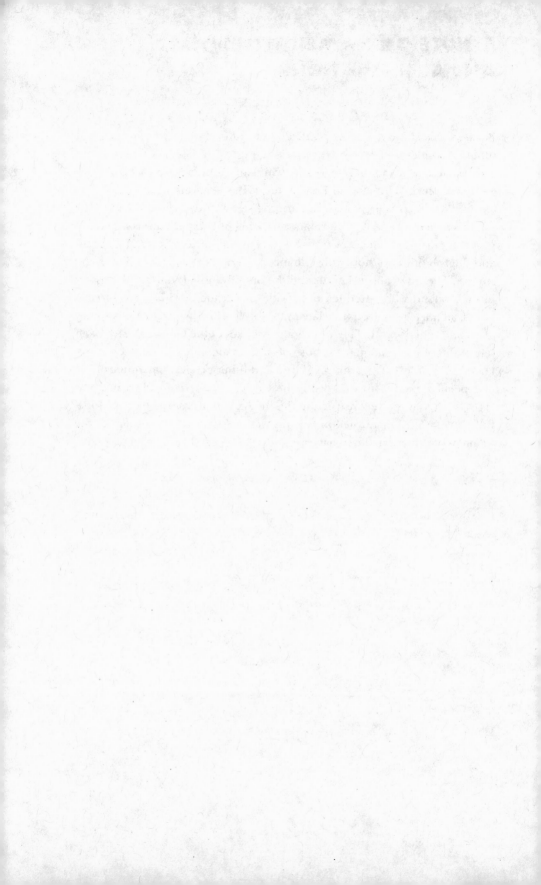

ABBREVIATIONS AND ACRONYMS

DAF	Deutsche Arbeitsfront (German Labor Front)
DBFU	Der Beauftragte des Führers für Überwachung (Commissar for Supervision—Alfred Rosenberg)
ERR	Einsatzstab Reichsleiter Rosenberg (Special Staff of Reichsleiter Rosenberg)
ffr	francs français
GBI	Generalbauinspektor der Reichshauptstadt, Berlin (General Building Inspector, Berlin—Albert Speer)
GDK	*Große Deutsche Kunstausstellung* (*Great German Art Exhibition*)
Gestapo	Geheime Staatspolizei (Secret State Police)
GTO	Generaltreuhänder Ost (General Trustee East, or General Overseer for the Securing of German Cultural Goods in the Annexed Eastern Territories)
HTO	Haupttreuhandstelle Ost (Main Trustee Agency East)
KdF	Kraft durch Freude (Strength through Joy)
KfdK	Kampfbund für deutsche Kultur (Combat League for German Culture)
MFA and A	Monuments, Fine Arts, and Archives, U.S. Army
NS	National Socialist
NSDAP	Nationalsozialistische Deutsche Arbeiter-Partei (NS German Workers' Party)
NS-KG	NS-Kulturgemeinde (NS Cultural Community)
OKH	Oberkommando des Heeres (Army High Command)
OKW	Oberkommando der Wehrmacht (Military High Command)
OSS	Office of Strategic Services
RkdbK	Reichskammer der bildenden Künste (Reich Chamber for the Visual Arts)
RKFdV	Reichskommissar für die Festigung deutschen Volkstums (Reich Commissar for the Strengthening of the German Race)
RKK	Reichskulturkammer (Reich Chamber of Culture)
RKS	Reichskultur Senat (Reich Cultural Senate)
RM	Reichsmarks
RMBO	Reichsministerium für die besetzten Ostgebiete (Reich Ministry for the Occupied Eastern Territories)
RMdI	Reichsministerium des Innern (Reich Ministry of the Interior)

RMVP	Reichsministerium für Volksaufklärung und Propaganda (Reich Ministry for Public Enlightenment and Propaganda)
RMWEV	Reichsministerium für Wissenschaft, Erziehung und Volksbildung (Reich Ministry for Science, Education, and Public Instruction)
RPL	Reichspropaganda Leitung (Reich Propaganda Leadership of the Nazi Party)
RSHA	Reichssicherheitshauptamt (Reich Security Main Office)
RuSHA	Rasse und Siedlungs Hauptamt (Race and Settlement Main Office)
SA	Sturmabteilung (Storm Division)
SD	Sicherheitsdienst (Security Service)
Sf	Swiss francs
SS	Schutzstaffel (Protection Staff)
VoMI	Volksdeutsche Mittelstelle (Ethnic German Transit Agency)
Vugesta	Vermögens Umzugsgut von der Gestapo (Property Removed by the Gestapo)

ART AS POLITICS
IN THE THIRD REICH

The whole principle of cultural policy or *Kulturpolitik* . . . comes from an acceptance of the somewhat un-English notion that arts have a social and political role and can make an impact on the world.

–John Willett, *Brecht in Context*

"I understand," said Max turning to the countess, "that he has asked the Führer to revive in his favour the title that Landgrave Wilhelm III of Hesse gave to his adviser on art–Director-General of the Delights of My Eye."

–Robertson Davies, *What's Bred in the Bone*

INTRODUCTION

Certain scenes in history resonate with meaning, as if they possess special symbolic or metaphoric import. These events, when depicted visually (as in photographs) or with words, seem connected to other developments or to larger issues and themes. If one were to search for such scenes in this study, there would be an extraordinary array from which to choose. One might look to an incident early in the Nazis' rule, when Hitler laid the cornerstone for his "temple of German art" on 15 October 1933. With a sense of ominous foreshadowing, the hammer with which he struck the specially selected slab of "National Socialist" granite exploded into a thousand pieces (the newsreels edited out the scene).[1] There is also something poetic about selecting an image from the last days of the war, the denouement of the Third Reich when Germany's cities were bombed out and Allied troops were advancing on both fronts. Hans Frank, who had ruled the General Government in Poland with devastating arrogance and greed, returned to his chalet in Bavaria in February 1945. In his possession were rolled-up canvases by Leonardo da Vinci and Rembrandt, among others, which he had commandeered earlier and placed in his residences. Frank attempted to give the works to the Bavarian museum directorate, but they would not touch the plunder. Instead Frank took them to his home, where he sat among these masterpieces and awaited the arrival of American troops— who would later help try, convict, and execute him.[2]

The most apt "snapshot" from this study, however, would feature a scene from the early years of the war, when the Germans stood at the height of their military fortunes and when they amassed the bulk of their largest art collections. The following diary entry by Joseph Goebbels from 19 October 1940 is particularly suggestive: "To Paris. The ancient magic of this wonderful city, which is pulsating with life once more. Big military presence. I stroll through the street with [Hermann] Göring. A huge sensation, then I do a little shopping. Eat at Maxim's with Göring, who is very good to me. There is no sign of war here. The pilots sit and drink. They have earned it. . . . Göring is fantastic. He really is a good fellow. Fall into bed, late and dead-tired."[3] Does this scene of their jovial excursion simply represent the winners enjoying the spoils of victory, or is there a larger significance to be deduced?

As a starting point, the presence of Göring and Goebbels in Paris at this particular time has myriad historic connotations. The Battle of France was sufficiently far in the past for the two Nazi chieftains to move about the city in security and comfort. Yet their presence in the West, as well as the large

number of troops in the French capital, indicates that there was still military business at hand. Göring, the chief of the Luftwaffe, had established a mobile headquarters to oversee the Battle of Britain, which was still at a critical stage. Goebbels went to France on a reconnaissance trip, with an eye toward taking charge of foreign propaganda and increasing the Germans' share of the European film market.[4] Both men found themselves in Paris with one other mission: to control the flow of plunder from this artistically rich country. This booty precipitated a contest that eventually engaged a number of the Nazi elite.

Amid this bureaucratic rivalry these two leaders chose to interact while out on the town shopping, in part, because Nazi leaders engaged in a brand of theater-politics. In addition, on this day Göring and Goebbels were attempting to communicate with each other, as well as with the subordinates present, by way of gesture and performance. Göring played the role of worldly host, first inviting Goebbels to inspect his field headquarters, then providing the car (and hence determining much of the agenda for their day together).[5] His position of power as Reichsmarschall was underscored by other means, such as staying in the *Fürstenzimmer* (Princes' Suite) at the Ritz Hotel, and having his adjutant Karl Bodenschatz (a general no less) travel in his wake with a supply of money, dispensing cash for the Reichsmarschall's extravagant acquisitions.[6] Goebbels asserted himself by making his share of purchases (in all likelihood charging the goods, with the bills sent to his ministry) but also by arranging for a visit to a burlesque show – a sampling of the popular culture.[7] As he noted in his journal, and as he undoubtedly made clear to his companion, the variety show in the Casino de Paris "was not as good as in Berlin."[8] In short, their itinerary allowed them to engage in this exercise in self-definition: they both viewed and portrayed themselves not only as powerful and charismatic but also as tasteful and sophisticated.

The Nazis, like many other people, associated the city of Paris with culture (although perhaps not with the more meritorious *Kultur*). Even Hitler, in his early morning visit on 28 June 1940, ordered his artistic coterie to escort him. The group included architects Albert Speer and Hermann Giesler and sculptor Arno Breker. In Speer's memoirs he noted that Hitler's trip at the end of the French campaign "was not to be an official visit . . . but a kind of 'art tour' by Hitler."[9] The Nazi leaders' perceptions of French culture were tinged with both antipathy and a sense of superiority, but there was nonetheless much that elicited their interest and praise. Their appreciation of classical architecture, museums, galleries, and the opera and theater, as well as fine restaurants and hotels of the French, represented an effort to model themselves as men of culture. It is not entirely clear if they

were conscious that much of their behavior contradicted their stated ideology—this was not what one would expect from cultural nationalists and members of the *Volksgemeinschaft* (peoples' community). Goebbels indeed railed against the plutocrats and then indulged himself at Maxim's. Their political and military successes contributed to an unbounded egotism. By 1940, as indicated in the journal excerpt above, they thought of themselves as the ones to reinvigorate the flagging cultural life of Paris. This generous assessment of their own abilities proves critical to an understanding of their engagement with cultural issues. On the other hand, their attitudes toward art became central to their self-conceptions.

Conventional wisdom maintains that the arts exert a humanizing and ennobling influence. Conversely, the absence of culture in a person's life is taken to be a sign of intellectual and spiritual poverty. "A house that does not have a picture on the wall," a museum director noted recently, "is the house of a sick person."[10] Acknowledging that the obverse of this formulation does not always hold true—paintings on one's walls do not invariably denote healthiness—the NS elite offer a case in point. They represent the union of barbarism and culture, a combination much commented on by post—World War II intellectuals.[11] The Nazi leaders, while undeniably malevolent men, took a great interest in the arts. Indeed, "never before National Socialism had comparable financial means and political power been at the service of aesthetic activity."[12] In following Hitler, the subleaders of the Third Reich dedicated an inordinate amount of time and energy to the visual arts. They perceived themselves not only as cultured men but as experts qualified to determine and administer the nation's aesthetic policies. Their interest in the visual arts encompassed both the official and the private spheres of their lives; hence the organization of this study.

Part I analyzes how the Nazi leaders in the government engaged in a never-ending battle to control the Reich's artistic policies, defined broadly to include the supervision of practicing artists, the overseeing of museums and academies, the publication of magazines concerning the arts, the organization of exhibitions, the arranging of cultural exchanges with other nations, the expropriation of artistic property belonging to declared enemies, the claims on cultural goods belonging to those ethnic Germans resettled from neighboring lands into the Reich, the plundering campaigns launched during the war, and the closing of offices and institutions as part of the "total war" measures. Part II discusses the efforts of the Nazi leaders to collect art, a much more private activity not only because it involved personal property but also because it helped them define their personalities, shape their domestic lives, and develop a sense of their class identity. Al-

though the official realm has been treated first, the two components might easily have been reversed. The rationale for first explaining the history of the visual arts bureaucracy is twofold. First, it allows for a chronologically based narrative, and hence an overview of the evolution (or radicalization) of the leaders' policies. Second, the history of the NS visual arts administration displays a fundamental characteristic of the regime: nearly all the top-ranking leaders engaged in the formulation of aesthetic policy.

The number of Nazi leaders who exhibited an interest in art is one of the most striking aspects of this history. Owing to limitations of space, and in consideration of the extant documentation, this study focuses on Adolf Hitler, Hermann Göring, Joseph Goebbels, Heinrich Himmler, Joachim von Ribbentrop, Baldur von Schirach, Albert Speer, Robert Ley, Hans Frank, Alfred Rosenberg, Josef Bürckel, and Arthur Seyss-Inquart. In comparing this group to that examined by Joachim Fest in his well-known work on the Nazi leaders, *The Face of the Third Reich,* only Reinhard Heydrich, Franz von Papen, Ernst Röhm, and Rudolf Hess are excluded.[13] Even among these latter, Heydrich was a skilled violinist who, as deputy Reich protector of Bohemia and Moravia, eventually lived amidst artworks in the Brezany castle outside Prague (and he was also a complicitous member of the plundering bureaucracy), while Papen decorated his ambassadorial residences with art.[14] Röhm perished early in the Third Reich, and Hess, Hitler's sycophantic and mentally unstable deputy, patronized artists prior to his flight to Scotland in 1941.[15]

This study then, focuses on a narrow circle of leaders and is not an examination of the broader Nazi elite.[16] Still, it can be seen, as Dietrich Orlow has suggested, that the Third Reich "must at times read as a series of interwoven political biographies," which is a testament to the extraordinarily personal nature of the NS political system.[17] These rulers not only attempted personally to shape artistic policy; they also maintained a hands-on management of the art collections they amassed. Hitler ordered that the documents concerning Sonderauftrag Linz, the mammoth Führermuseum that he envisioned, be typed triple-spaced so that he could read them even with his poor eyesight. Hitler also specified that all pieces in the museum receive his express approval; after the war, MFA and A officers found artworks stored in salt mines with the attached inscription, "not yet decided upon by the Führer."[18] Göring, too, kept a close watch over his collection, carefully monitoring almost every transaction.[19] Goebbels and Himmler, like many other leaders, engaged art dealers, and they, too, specified that no purchases were to take place without their prior consent.[20] In short, art and its assemblage in collections attracted the close attention of the Nazi leadership corps.

In searching for an explanation for this preoccupation, one must recognize that art provided a means to a larger and more important set of goals. For this reason, the Nazi leaders used art instrumentally, that is, to serve as a means or intermediary to a particular result. Although the larger objectives of the NS elite proved multifaceted and complex (as is revealed in Part II of this study), in general, the leaders manipulated art policy and the collecting of works in order to articulate fundamental (or even definitional) tenets of their ideology. These included the premise that the Aryan race was the preeminent promoter of culture, that German culture stood above that of other nations or racial groups, and that the possession of an artistic patrimony reflected military strength and biological vitality. Beyond ideology, the leaders used artworks instrumentally in order to further their own political careers and as a means of self-definition. Art offered a means to achieve legitimacy and social recognition, as the works themselves suggested power and taste due to the perceived link to the preexisting ruling classes and their aesthetic values.[21]

Hitler's decoration of his office in the Reich Chancellery, which was executed by Albert Speer and completed in 1939, is an example of the instrumental approach to art.[22] Hitler played an active role in the conception of both the Chancellery and the office. His goal was to impress and to intimidate. As he told Speer in 1941, "Whoever visits the Reich Chancellor must have the feeling that he is before the master of the world."[23] This message was conveyed most effectively by the scale of the room and the furniture contained therein. Stretching some 88.5 feet long, 47.5 feet wide, and featuring ceilings almost 33 feet high, it sported tables, chairs, and sofas that were similarly monumental.[24] The artworks that adorned the office communicated more specific messages. The portrait of Bismarck by Franz Lenbach that hung in a prominent place over the fireplace and a statuette of Frederick the Great that was placed on a centrally located table were attempts to link Hitler with previous great leaders in German history. A bust of President von Hindenburg, whom Hitler in certain respects viewed as his predecessor, symbolized the supposed legitimacy of his rule.[25] Angelika Kauffmann's *Hermann's Return from the Battle of the Teutoburger Forest*, depicting the Germanic tribes' great victory over the Romans, and a work by the school of Rubens called *Hercules and Omphale*, portraying not only strength but also the classical Hellenes, offer two further allegories.[26] The inclusion of tapestries – viewed by many as a royal form of art because of the value of the weavings and the association with European nobility – also reflected an attempt to exude power and convey status. Hitler placed plants on his desks and flowers around the room in an effort to soften the image and suggest a more simple and human side. The monogrammed ornaments above the

doors, the decorative motifs on his desk, and the placement of the furniture were used as a means of communicating other messages. Photographs of the office were widely published at the time, making it both a propaganda tool and a means of self-definition.[27] For Hitler, this project constituted the visual representation of his rule.[28] Hitler was not alone in adopting this perspective. Rudolf Hess, who suffered a perceptible decline in status in the late 1930s, hurt his cause with his inferior skills as an interior decorator as "an official's personal tastes in home furnishings might well have a decisive influence on his position within the hierarchy."[29]

The sphere of visual arts management provided a microcosm for the NS state as a whole. Competing ministers, in advancing their own causes, constituted a bewildering but dynamic force. Their independent initiatives served to radicalize policy as they contributed to the introduction of increasingly repressive measures.[30] This proved central to the nature of the political system in the Third Reich: "The institutional confusion of the Nazi state became its essential identity."[31] In the realm of aesthetic policy making, Martin Broszat's "triangular absolutism"–namely, three main spheres of authority resting with the Party agencies, the Reich or state apparatus, and the Führer himself–manifested itself as Hitler invested authority in both Party and state offices, with the demarcations of jurisdiction being typically blurred.[32]

Hitler's preeminence in this sphere was never questioned. He was a strong leader with respect to issues concerning art and architecture largely because they were subjects of tremendous interest. As Albert Speer reported: "He took Breker with him to Paris, he spent hours in Troost's studio; each year he opened the Grand Art Exhibition."[33] Hitler had long fashioned himself as a "frustrated artist," an image that Speer and others later sustained.[34] Even though Hitler's views did not evolve to any significant extent after he reached age thirty, the visual arts–and architecture above all–were of central importance to him.[35] Much has been written about Hitler's views on architecture, painting, and sculpture: his love of the Baroque and Romantic periods, his insistence on *Naturtreue* painting, and above all, his fixation with the monumental.[36] Yet what is crucial for this study is the manner in which he inspired his subordinates to adopt similar views and concerns, and the way in which he interceded in the determination of the government's cultural policies.

In addition to Hitler, three ministers clearly had legitimate claims to the supervision of culture: Joseph Goebbels, in his capacity as Reich minister for propaganda and public enlightenment; Bernhard Rust, the Reich minister for science, education, and public instruction, who occupied the position that traditionally oversaw museums, art schools, and other cultural in-

stitutions; and Alfred Rosenberg, who held the Party post supervising ideology, the Führer's delegate for the entire intellectual and philosophical education and instruction of the National Socialist Party. These leaders not only battled one another for jurisdiction over the administration of the arts, but they were forced to contend with a variety of other ministers: Himmler and Göring, for example, who used their respective positions atop the police and economic bureaucracies as a means of encroachment. The regional leaders, most notably the Gauleiters and later the Reichskommissars (rulers of the territories occupied during the war), also constituted a source of competition.

The gradual radicalization of the Nazi government found expression not only in the realm of foreign policy and in the treatment of Jews but also in the administration of the visual arts. By 1936 the government no longer tolerated modern art or any expression which deviated from that sanctioned by the state, and in 1937 the "degenerate art" exhibition, which traveled throughout the Reich, signaled a more activist posture on the part of the government.[37] Yet 1938 was pivotal due to a more aggressive foreign policy and the increasing repression within Germany.[38] The confiscation of privately owned art began in this year, first in Austria, where many Jews lost their property, and then in November, in the wake of the *Kristallnacht* pogroms, within the *Altreich*. The burgeoning totalitarianism of the Nazi state was manifested in its leaders' decreasing respect for law and private property and in the discernibly escalating persecution of the Jews. Artworks figured into this process, most clearly in the confiscation programs.

In the wake of the Austrian *Anschluß*, the Nazi leaders exported these confiscation campaigns abroad. The succession of victimized neighboring states proceeded with Czecho-Slovakia and Poland, followed by the Baltic lands and the South Tyrol. Himmler proved the master of these early plundering forays, using his position not only as Reichsführer-SS but also as RKFdV as the bureaucratic basis for his activities. The invasion of the western European countries and, later, the Soviet Union continued this process of radicalization, moving from limited military campaigns to an unrestricted ideological crusade. Indicative of the Nazi plunder is the figure for artworks amassed at the Allies' Central Collecting Point in Munich after the war: 249,683 objects were counted there prior to March 1949, with their disposition determined by an international commission of experts and diplomats.[39] The Nazis valued and cared for these treasures – the booty of war – by placing them in salt mines and castles, which resulted in a remarkably low incidence of damage and destruction.[40] In principle, these works were to be the property of the German nation. But given Hitler's disdain for legality, and given his penchant for identifying himself with the Third

Reich, it is not particularly surprising that he utilized this loot to undertake the Führermuseum in Linz.[41] The other subleaders used government funds, ministerial personnel, and their political influence to add to their own collections.

The Nazi leaders' interest in art collecting developed in the mid-1930s, the impetus coming largely from the regime's attention to the fine arts (for propagandistic reasons) and from their increasingly luxurious lifestyles. Attending the opening ceremonies of the *Große Deutsche Kunstausstellung* in Munich – an annual event beginning in 1937 that was marked by a speech by Hitler and a festival known as the Day of German Art – was but one way in which the subleaders became more aware of the visual arts. Numerous other events, from Hitler's annual cultural speeches at the Nuremberg Party congresses to factory exhibitions, heightened this consciousness. Living among objects of luxury and having the means to buy artworks also induced the elite to collect. Upon coming to power in 1933, the Nazi elite followed Hitler's lead by inhabiting grandiose dwellings and by using official funds to redecorate. While the Nazi leaders were on occasion motivated by aesthetic appreciation to collect art, the predominant impulse stemmed from an individual or a group narcissism, that is, the advancement of their own careers or the NS movement in general.

The taste of the Nazi leaders underwent a gradual transformation during their twelve years in power. Early in their tenure a more modest, folksy style was in vogue. Inspired, perhaps, by the populist element in their program, they turned to petit bourgeois, *Biedermeier*, and rural idioms to decorate their homes. Hitler's Berghof on the Obersalzberg, with its modest wooden furniture, old-fashioned tile ovens, lace curtains, and kitschy mementos, offers a striking example of this style.[42] Even Göring's estate Carinhall originally had the look of a hunting lodge. But the Nazi leaders' early predilection for rustic simplicity soon gave way to a desire to possess the elaborate trappings of power. Almost without fail, they built huge homes and filled them with expensive and imposing objects. Paintings – in particular, works by old masters – became an integral part of this aesthetic. The Berghof chalet was transformed midway through the decade into a roomy, elegant abode with works by Bordone, Pannini, Spitzweg, and others.[43] By 1937 modern art had been proscribed, and even Impressionist landscapes were no longer viable alternatives for the Nazi leaders in the decoration of their homes and offices (although exceptions occurred in a few cases). This left them with a choice between Nazi art and traditional works. While the Nazi leadership corps patronized contemporary artists on a grand scale and used such works for decoration, they did not sustain

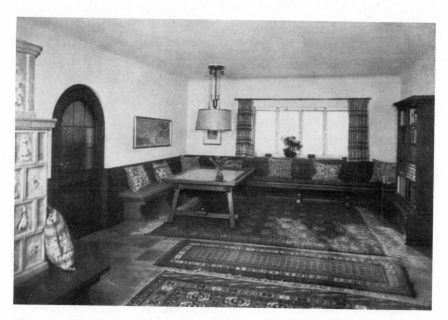

The Berghof before transformation as a comfortable chalet (BHSA)

themselves entirely on this fare. The exclusive possession of Nazi art made them feel too provincial and too limited. In aspiring to the top echelon of European society, they pursued those artworks traditionally prized in western culture, namely, the works of old masters. In seeking to drape themselves in the mantle of the aristocracy, they have subsequently been followed by despots like Nicolae and Elena Ceauçsescu, Ferdinand and Isabella Marcos, and Manuel Noriega, who also amassed substantial art collections in an attempt to enhance their social prestige and political position.

The ideological foundation of the Nazi elite's art collecting is considerably more complex than this formulation would suggest. Clearly evident is their national chauvinism. Following Hitler's lead, they sought a revaluation of Europe's artistic legacy, whereby Austro-Bavarian landscape and genre painting of the nineteenth century and the work of German old masters such as the Cranachs and Dürer were recognized as the pinnacle of artistic accomplishment.[44] Beyond advancing a new hierarchy of art history, the Nazi leaders wanted to control materially their nation's cultural legacy. What started as a kind of artistic irredentism – the quest to possess all artworks created by Germans or once owned by Germans – evolved into a megalomaniacal quest to command nearly all artifacts of European culture. In 1939 Goebbels commissioned the director of the state museums in Berlin to compile a list of artworks of German origin that had been taken

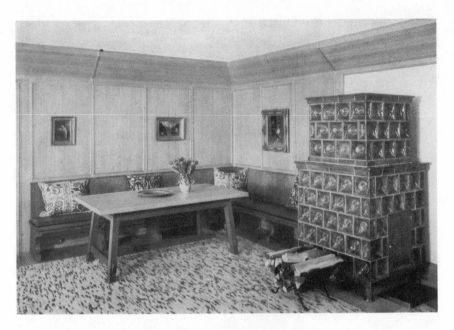

A tile oven and paintings in the pre-transformation Berghof (BHSA)

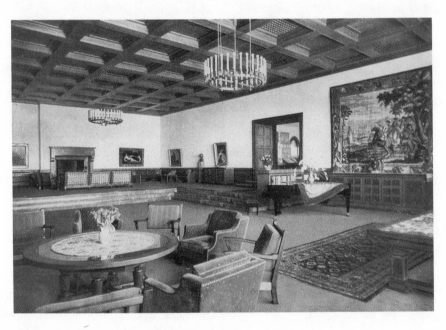

The Berghof after renovations in mid-1930s (BHSA)

A tapestry with aristocratic connotations in Hitler's remodeled retreat (BHSA)

A series of paintings and plush furniture in the post-transformation Berghof (BHSA)

abroad since 1500. These works were to be brought back to the Reich once a favorable geopolitical constellation had been achieved. The radicalization of their goals is reflected by Himmler's attempt in 1944 to acquire the Bayeux tapestry from the French. The sole basis of his claim was that the medieval treasure was a product of the Aryan race. In conversations with his confidants, Hitler settled upon the idea of forcing the French to relinquish the pieces from the Louvre and other national museums as part of an eventual peace treaty (although during the war the Nazis for the most part left the French state collections alone).[45] Besides expressing the Nazis' dreams of European hegemony, their art collecting reflected their other fundamental ideological goal: the war against the Jews. By expropriating the artworks of the Rothschilds, the Seligmans, the Kanns, and the other prosperous Jewish families, the Nazis expressed their genocidal program in their collecting practices.

The NS leaders also used art in an instrumental manner to define their relationship to one another. In developing a tradition of gift-giving, they affirmed their sense of an elite caste by bestowing artworks. Reciprocal gestures bound the subleaders to one another, despite the feuding that pervaded the group as a whole. The art given to Hitler as tribute confirmed the hierarchical organization of the leadership corps. Similarly, the size of the leaders' respective collections conveyed a sense of their relative power.

Hitler, by way of his Führermuseum, had the greatest assemblage of art (6,755 paintings, of which 5,350 were by old masters).[46] Göring, recognized as the second man in the Reich, had the next most prodigious collection (with estimates ranging from 1,700 to 2,000 artworks). Himmler, Goebbels, Ribbentrop, and the other important ministers possessed collections roughly indicative of their rank (see Chapter 7). From the Gauleiters controlling pieces that fell within their territorial spheres to their relatively anonymous subordinates who implemented the perfidious policies, art offered a common currency laden with symbolic meaning. The pervasiveness of art collecting is suggested further by a 1969 report issued by the treasury (Bundesschatzmeister) of the Federal Republic that noted that 20,083 artworks once in the hands of the Nazi leaders had been determined legal acquisitions and were now state property, located in museums, embassies, and government offices.[47]

The collecting of art also revealed the leaders' social aspirations. Stemming, for the most part, from milieus where they had learned to appreciate traditional European culture–and this included not only museum-quality art but also opera and classical music–yet still having the air of parvenus when they came to power in 1933, the Nazi leaders perceived art as a means of assimilation into the traditional elite. Later, as their collections surpassed those of the customary ruling groups and as they used aristocrats to assist them in the pursuit of desired works, this enterprise served to express their gradual dominance over German society. Berthold Hinz described the move away from their popular roots: "As the National Socialist elites drew away from the people and entrusted control of the people more to their anonymous henchmen than to displays of their own persons in plebiscitary spectaculars, they gave themselves up to luxury and pleasure on a feudal scale."[48] The leaders of the Third Reich sought the material expression of their status; the collection of artworks provided a suitable means of doing so.

The Nazi elite were more skilled at purchasing and seizing existing cultural artifacts than they were in promoting or furthering creativity. Joachim Fest noted that "rarely was a government's cultural ambition higher; never was the result more provincial and insignificant."[49] The art collections of the Nazi elite were in fact significant–among the largest that the world has ever known. But this does not mean that these men had a profound understanding of these works or had the ability to shape a governmental aesthetic policy that produced great achievements. Art nevertheless occupied their time in both the official and private spheres, and it played an important role in their efforts to fabricate personae. Heinrich Himmler

visited the Haus der Deutschen Kunst more often than he did Auschwitz, and Julius Streicher, the most primitive racist ideologue in the movement, was captured by American troops in 1945 at a farmhouse in Bavaria while posing as a landscape painter.[50] Such unsettling images convey a central paradox of the Third Reich: these venomous individuals were engrossed with art.

I

ADMINISTERING ART

THE
COMPETITION
FOR
CULTURAL
CONTROL

1

THE ESTABLISHMENT OF THE NATIONAL SOCIALIST CULTURAL BUREAUCRACY, 1933–1936

The supervision of visual arts in the Third Reich received scant notice during the period that directly followed the "seizure of power" and only gradually emerged as a point of contention among the NS elite. Indeed, the behind-the-scenes agreement hammered out by Hitler, Papen, Hindenburg, and others in late January 1933, which placed the chancellorship and various cabinet posts in the Nazis' hands, said nothing about ministries for culture or propaganda. Even upon the creation of the RMVP on 13 March 1933, Joseph Goebbels thought a special department for visual arts to be unnecessary; the RMVP's department for *bildende Kunst* was not created until October 1934.[1] It was the divisive debate over the place of modernism in the National Socialists *Kulturpolitik* and government officials' daunting experience carving out spheres of authority, as well as the more general quest for totalitarian control, that induced the leaders to turn their attention to the management of the nation's cultural policy.

The cultural bureaucracy that took shape between 1933 and 1935 manifested the character and administrative styles of the key Nazi ministers.

Goebbels emerged as the most influential of the subleaders, while Alfred Rosenberg persisted in his efforts and salvaged what he could from what seemed to be a perpetual cycle of setbacks. Hermann Göring and Robert Ley used their powerful positions elsewhere in the NS state as bases for incursions into the cultural sphere. Other leaders, such as Education Minister Bernhard Rust and Interior Minister Wilhelm Frick, acted defensively as they attempted to maintain the power that they had inherited at the start of their tenure in office. The backdrop to this bureaucratic infighting came in the form of the debate over the place of modern art in the "new" Germany. Alliances formed and dissolved around this issue, and Hitler's all-important edicts–although inconclusive on this point between 1933 and 1935–were interpreted by government officials and interested observers in light of this foremost aesthetic controversy.

As Goebbels initially displayed some restraint toward the visual arts bureaucracy, and as most NS leaders focused their attention on other spheres of government after the *Machtergreifung*, the supervision of *bildende Kunst* remained under the auspices of the traditional authorities for the first nine months of the Third Reich. The RMdI, the RMWEV, and the *Länder* (provincial governments) retained their jurisdiction. The Nazis' influence over the arts often came as a result of controlling posts that were not explicitly cultural in nature. For example, Minister of the Interior Frick, who oversaw the nation's police forces, was therefore able to implement measures that had import for the embryonic *Kulturpolitik*. Additionally, Hermann Göring, as the Prussian minister of the interior, set the police against a number of Communist artists who had not had the foresight to emigrate. On 11 April 1933 Göring ordered a search of the Bauhaus in Berlin on the grounds that it was a bastion for subversives; on 20 July it was formally closed.[2]

The National Socialists' *Kunstpolitik* remained unresolved not only because of the network of conflicting offices but also because individual Nazi leaders failed to make up their own minds about the subject. Adolf Hitler's active opposition to modern art emerged only gradually. During the first years of the Third Reich, despite his personal antipathy toward abstraction, Hitler reportedly expressed regret about the Nazis' harsh attacks against the Expressionist artist Ernst Barlach, and he went so far as to suggest some sort of reconciliation.[3] Bernhard Rust, the Prussian education minister beginning on 9 February 1933, had even more conflicted views. Although he praised the Expressionist painter Emil Nolde in private, he prohibited the director of the Berlin Nationalgalerie, Alois Schardt, from printing a controversial 1934 speech that endorsed modern art. Later, upon inspecting the modern section of the gallery in October of that year, he ordered Schardt's resignation.[4] Just as Reichsminister Frick closed and then re-

opened *30 German Artists*, an exhibition of modern works at the Ferdinand Möller Gallery in Berlin, and therefore conveyed an absence of firm resolve, many other officials also lacked confidence in their own views.[5] As Hitler himself had yet to articulate a coherent position regarding a new *Kunstpolitik*, it was not surprising to find the subordinate cultural bureaucrats in a similar position.

GOEBBELS AND THE RMVP

Joseph Goebbels, who quickly became "the Czar of Nazi culture," had long harbored designs for an agency that would supervise the arts, as revealed by a diary entry fifteen months prior to the seizure of power, where he mapped out the aspirations he held for a cultural ministry.[6] Yet Goebbels, the head of the Nazi Party Propaganda Leadership, or RPL, since 1928, decided that in duplicating this agency on a national level he would do best initially to limit the scope of his ministry.[7] As it was, Goebbels appropriated the responsibilities of a wide range of other Reich ministries in forming the RMVP. He took over the press office from the Reich Chancellery, broadcasting from the Postal Ministry, censorship powers from the RMdI, and the supervision of advertising from the Economics Ministry.[8] Still, Goebbels had a sense of his limitations. He was conscious of the low regard in which he was held by President Hindenburg, who disliked the young agitator so intensely that he balked at any appointment higher than *Ministerialrat*.[9] This was also the first governmental post for the thirty-six-year-old man. Goebbels therefore proceeded carefully as he set up his bailiwick.

Amid the increasingly strident and prominent debate over the place of modern art in the Third Reich, and within the context of the invariably brutal jurisdictional battles in the government bureaucracy, Joseph Goebbels moved quickly to expand his RMVP. First, he secured a steady source of funding that allowed his ministry to expand the number of employees from the initial 350. Goebbels convinced Hitler and the cabinet to direct revenues derived from radio licenses to the RMVP, and this income came to comprise 88.5 percent of the ministry's operating budget.[10] In addition to achieving considerable financial independence (from the Finance and Economic Ministries, as well as from the Reich Chancellery), Goebbels proved a shrewd administrator. He brought in young, ambitious, and comparatively well-educated men, and not Party hacks. The RMVP's employees averaged 38.9 years of age, ten years younger than the figures for the governing elite as a whole, and it was known that "Goebbels preferred men

with Ph.Ds. as his close collaborators."[11] Goebbels, as compared with many other Nazi ministers, also employed a hands-on management style. Usually well briefed, he assumed an active role in most facets of the ministry. Among the measures he implemented to improve efficiency was a five-page limit on all intraministry communications.[12]

Despite the competitive edge of the RMVP, Goebbels and his subordinates still encountered difficulties. Because of his sharp tongue, vanity, and unscrupulousness, the Reichsminister was not widely liked – even by most of his own staff.[13] Goebbels also frequently clashed with other Nazi leaders, including Göring, Ribbentrop, and Himmler. They "and many of the Gauleiter were not prepared to trust him with the responsibility of publicizing their activities."[14] Even so, Goebbels could still charm or secure alliances when necessary. On balance, his gigantic ego and blunt manner, when combined with his high expectations, created a sword that cut two ways: while promoting efficiency and hard work, it could also demoralize both underlings and potential allies.

Goebbels's trump card in the bureaucratic game that lasted twelve years was his close relationship with Adolf Hitler. In the early years of the Third Reich, he had access to the Führer to an extent that no other minister could rival, and he manipulated this advantage with great skill. For example, in the spring of 1933 Goebbels attempted to make inroads into Robert Ley's workers' organization, the DAF. He helped Ley develop the cultural programs within the German Labor Front, conceived their famous slogan *Kraft durch Freude* (Strength through Joy), and placed a number of his protégés in key positions.[15] This collegial assistance afforded Goebbels increased authority in the cultural realm, and he protected his step-by-step gains with great tenacity. When Ley later sought to assume personal control over the KdF leisure organization, Goebbels complained to Hitler (in July 1933) that "Ley was thinking in outdated terms of class antagonism."[16] Hitler tried to give the impression of a compromise decision as he preached the need for reconciliation, but Goebbels nonetheless managed to meddle in Ley's ministry. A Führer decree of 30 June 1933 further strengthened Goebbels's position: Hitler declared that "the Reichsminister of Public Enlightenment and Propaganda has jurisdiction over the whole field of spiritual indoctrination of the nation, of propagandizing the state, of cultural and economic propaganda, of enlightenment of the public at home and abroad; furthermore, he is in charge of the administration of all institutions serving this purpose."[17] With a consolidated position with respect to the KdF program, and the generous, if somewhat ambiguous, Führer decree, Goebbels's confidence increased steadily during the early stages of the Third Reich.

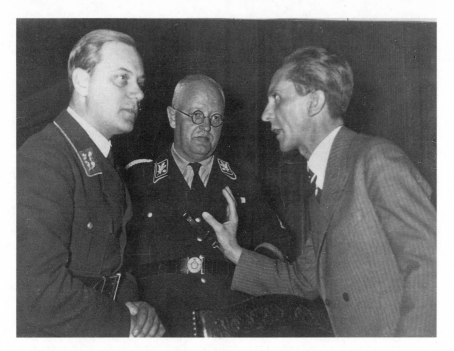

Alfred Rosenberg, Franz Xaver Schwarz, and Joseph Goebbels during negotiations, 1934
(BAK)

As already mentioned, it was not solely the rigors of these bureaucratic battles that induced Goebbels to wrest the supervision of *bildende Kunst* from the traditional authorities. The aesthetic debate over abstract art, which intensified in early 1933, drew Goebbels into the fracas as he gradually emerged as the key proponent of the promodernist line. The early phase of this struggle featured Goebbels and Alfred Rosenberg, the self-proclaimed "Party philosopher," leading the diametrically opposed camps.[18] This controversy was not resolved in the autumn of 1934, when Hitler in his Nuremberg Party congress cultural speech (given annually) spoke out against modern art, as the fight extended considerably longer into late 1936. At Nuremberg in 1934 Hitler also criticized and even mocked the ideas of the *völkisch* faction, calling their program "Teutonic non-sense."[19] The absence of a victor in what came down to a battle between Goebbels and Rosenberg prolonged the debate over the place of modern art in the Third Reich.

The propaganda minister employed a variety of tactics to bolster support for German Expressionism. First, he backed the NSD-Studentenbund in Berlin, which actively opposed the *völkisch* movement.[20] Polemical articles by the students in periodicals and newspapers such as the liberal-

leaning *Deutsche Allgemeine Zeitung* as well as highly publicized rallies on behalf of a more liberal *Kunstpolitik* made the NSD-Studentenbund a valuable resource for Goebbels. The propaganda minister also endorsed other promodernist groups during the period stretching to the autumn of 1935. An exhibition society called Der Norden, which frequently organized shows at the Ferdinand Möller Gallery in Berlin, and the art journal *Kunst der Nation*, which openly advocated Expressionism, were two such groups.[21] Even the RkdbK published a monthly journal called *Die Kunstkammer*, which included illustrations of abstract works.[22] Goebbels also consented to serve on the Honor Committee for the March 1934 show of Italian Futurist art, *Italienische Futuristische Flugmalerei* (Italian Futurist Paintings of Airplanes). The controversial exhibition opened with speeches by the Expressionist poet Gottfried Benn and the leader of the Futurist movement, Filippo Marinetti.[23] While Goebbels refrained from formal remarks at the opening, he frequently spoke out in praise of modernism and experimentation in art. In a speech on 8 May 1933 he called the New Objectivity (*Neue Sachlichkeit*) style, which had arisen during the Weimar Republic, "'the German art of the next decade.'"[24] As Goebbels carried out his program of Gleichschaltung (coordination), he also hoped to sustain a high degree of artistic creativity—if only for propagandistic reasons. He repeatedly uttered the phrase "We guarantee the freedom in art," employing it, for example, in a famous speech before a conference of the RKK on 7 February 1934.[25] As the speech was published in the promodernist journal *Kunst der Nation*, there initially appeared to be little doubt about Goebbels's aesthetic inclinations.

Goebbels is often portrayed as highly unprincipled with respect to culture—as subordinating it to political and ideological goals.[26] This is partly true, as Goebbels shared with Hitler the notion that art is the most accurate reflection of racial groups and their political institutions. But two points need to be made about Goebbels's views toward art. First and foremost, he was an ultranationalist and supported any art form that brought acclaim to Germany. His main concern lay in encouraging the production of the highest quality art possible, and he therefore opposed any doctrinaire *Kunstpolitik* on the grounds that it would hinder creativity. Second, Goebbels genuinely admired modern art, at least in the early years of the Third Reich. It is inaccurate to portray him as purely nihilistic or as a cynical *Realpolitiker*, when his behavior in private reveals that his promodernist views were quite sincere. One famous incident recounted by Albert Speer concerns Goebbels giving the young architect a commission to redecorate his private residence in 1933. Speer hung "a few watercolors" by the Expressionist painter Emil Nolde on the propaganda minister's walls and reported that "Goebbels and his wife were delighted with the paintings."[27] Other visitors to his

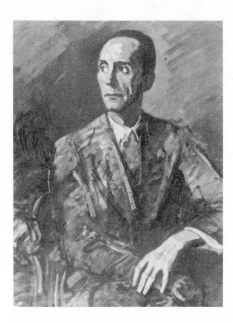

Portrait of Goebbels by the Impressionist painter Leo von König, 1935 (Rembrandt Verlag)

private residence in the mid-1930s report having seen works by Käthe Koll-witz, which is perhaps shocking considering her left-wing proclivities.[28] Goebbels also appreciated Ernst Barlach's work. The photographer Hein-rich Hoffmann claimed that Barlach's small Expressionist sculpture *Man in the Storm* was in the minister's office until at least mid-1935.[29] Another of Goebbels's offices, that in the Berlin Gauleitung, also featured modern art.[30] The Reichsminister's regard for Leo von König – an Impressionist painter who first made his mark as part of the fin de siècle Berlin Secession – compelled him to commission a portrait that hung first in the RMVP's Wilhelmstraße building and then later (when Hitler outlawed modernist art) in his Schwanenwerder home.[31]

Goebbels not only admired many types of modern art (he was of course critical of some styles), but he also felt considerable antipathy toward the *völkisch* artistic principles as articulated by Rosenberg and his allies. The physically disabled Goebbels (he had a club foot) had little inclination for theories about the "master race."[32] This, of course, did not preclude him from being a rabid anti-Semite. Furthermore, the educated doctor, who had spent his university years in cosmopolitan cities such as Berlin and Munich (and by 1933 he had been Gauleiter of Berlin for nearly seven years), had little to do with the *völkisch* circles who drew the bulk of their support from the provinces. Goebbels never subscribed to the Nordic-pagan religion (the Deutsche Glaubensbewegung or German Faith Move-ment) advocated by Rosenberg, Bormann, and others. A Catholic Rhine-lander, he even had his children baptized.[33]

Goebbels's resistance to *völkisch* ideas might also be explained by his roots in the socialist wing of the Nazi Party (the Strasser faction). There was indeed a link between the revolutionary branch of the NSDAP and those with promodernist sympathies. Until the Röhm purge in June 1934, there still existed hope for a "a connection between social revolution and the avant-garde."[34] In the parallel debate over architecture, an admiration for streamlined urban forms and low-cost housing projects provided more common ground for the left-wing branch of the NSDAP and those with promodernist sympathies.[35] Goebbels's position within the promodernist camp was therefore based on sincere beliefs and consistent with his life experience.

With the formation of the RKK, the government organization for all practicing artists (in the broad sense of the word), Goebbels appeared to have the cultural realm firmly in hand. On 22 September 1933 he publicly announced the formation of this corporatist organization for *Künstler*, and he himself held the position of president.[36] In controlling the central administrative body that oversaw the seven discipline-specific chambers (for art, music, literature, film, the press, radio, and theater), Goebbels and his more tolerant cultural policy had seemingly prevailed. He stressed in his speech to open the RKK that the NS government would adopt a flexible aesthetic policy: the new culture would have no "scent of a characteristic way of thinking," as art should not be determined by party politics.[37] That Goebbels tried to recruit a number of non-*völkisch* artists to head the individual chambers – including the modernist poet Stefan George for the Literature Chamber, the innovative director Fritz Lang for the Film Chamber, and the once-groundbreaking composer Richard Strauss (who had experimented with atonality) for the Music Chamber – attests to the propaganda minister's relative flexibility and to his desire that high-quality artists continue productive lives within the Reich.[38]

Goebbels himself believed in the fall of 1933 that he had won the aesthetic and bureaucratic battle for art, as he then headed the RMVP, the RPL, and the RKK. He therefore sought to heal the wounds caused by the debate over modernism by making peace with the *völkisch* camp. The battle between Rosenberg and Goebbels had been a source of concern and irritation for many government and Party leaders in the previous months. During the summer of 1933 Bernhard Rust, for example, had unsuccessfully tried to stop the quarrel by threatening "disciplinary action against all those who twist the words of sincere National Socialists and so attempt to bring division into the front of the true new German art."[39] Hitler at the Nuremberg Party congress reiterated a similar message of conciliation as he discouraged the "slippery dialecticians" from engaging in this divisive

debate.[40] Goebbels now thought that he could afford to treat his vanquished opponents more generously. "After his victory over the Kampfbund [KfdK], Goebbels's artistic policy developed along the lines of the compromise suggested in Hitler's speeches," as he did not "completely repudiate the ideals of the Kampfbund, but rather pursued a middle course."[41] Goebbels actually proved amenable to such conciliatory behavior in late 1933 while he attempted to construct his all-encompassing artists' organization.

One of Goebbels's concessions to the *völkisch* faction was to appoint Eugen Hönig as president of the RkdbK. A professor of architectural history at the Art Academy of Munich, Hönig had previously been the head of the KfdK's Munich chapter as well as the leader of the *völkisch* group Verein für künstlerische Interessen (Association for Artistic Interests).[42] Hönig's conservative aesthetic views and his ties with Rosenberg made his appointment acceptable to the *völkisch* camp. Goebbels chose Hönig to head the RkdbK not only to placate the conservative camp but also because he knew the professor to be a pliable man whom he could dominate. The promodernists within Germany therefore had relatively little to fear by his selection. Modernist art exhibitions and publications continued within the Reich after Hönig's appointment, even though he, as chamber president, possessed the power to imprison or fine (up to RM 100,000) those artists whom he thought subversive.[43] Hönig was well aware of Goebbels's support for liberal exhibition societies (such as Der Norden) and journals (such as *Kunst der Nation*). He must also have been aware of Goebbels's sympathy for certain modern artists. The propaganda minister, for example, sent the Norwegian Expressionist painter Edvard Munch a telegram on his seventieth birthday in December 1933 which verged on a panegyric: "Munch's work, which stems from the Nordic-Germanic earth, speaks to me of the deepest solemnity of life. . . . A powerful and independent spirit-heir to the Nordic nature, he has freed himself from any naturalism and has reclaimed the eternal foundations of the *völkisch* creators of art."[44] Hönig possessed neither the courage nor the stupidity to try to countermand Goebbels's wishes and impose his own *völkische Kunstpolitik*.

Goebbels's ability to organize and to manipulate the bureaucracy to his own ends became increasingly evident during the expansion of his cultural empire in autumn 1933. He strengthened the position of the RKK by creating considerable overlap with the more established RMVP. He made RMVP Staatssekretär (state secretary) Walther Funk (later economics minister) the first vice-president of the RKK; the second Staatssekretär of the RMVP, Leopold Gutterer, became a vice-president in the RKK; and he appointed Hans Hinkel to high-ranking posts within both the RMVP and the RKK

(serving as secretary general of the latter).[45] The RMVP and the RKK also often overlapped at the local level, as they often employed the same local representatives.[46] As each RKK chamber had the authority to determine the admission of its members (a requirement for all practicing artists), to regulate the work conditions for the relevant employees, and to open and close businesses under its jurisdiction, Goebbels advanced his cause not only in the administrative realm but also with respect to legal statutes.[47]

The jurisdiction of the RkdbK extended to a wide range of activities. In order to carry out its supervisory functions, President Hönig created various sections within the chamber: visual arts, architecture, arts and crafts, graphic arts (including advertising), art and antique dealing, art publishing, interior decorating, and landscape design.[48] By limiting membership, issuing fines, and conducting investigations, they regulated the production and commerce of many kinds of art. By December 1936 the RkdbK possessed 42,000 members, including 14,300 painters, 2,900 sculptors, 2,300 arts and crafts workers, and 4,200 graphic artists.[49] The RkdbK, like its parent organization, the RKK, quickly emerged as a mass organization critical to the nation's cultural life.[50]

ROSENBERG AND THE *VÖLKISCH* MOVEMENT

While Goebbels supported the promodernist forces within the Party and did much to enhance their cause, he never assumed a position of prominence comparable to Alfred Rosenberg's place within the *völkisch* movement. Through his KfdK and by means of his position as editor of the Party newspaper, the *Völkischer Beobachter*, Rosenberg moved to the forefront of the conservative cause. The KfdK was but one of many groups advocating *völkisch* culture. One estimate places twenty such groups in Saxony, Bavaria, and Baden alone in 1930.[51] These diverse organizations managed to attain an impressive degree of contact and cooperation, with one effective way stemming from the Deutsche Kunstkorrespondenz, a service headed by Bettina Feistel-Rohmeder which provided ideologically suitable (that is, *völkisch*) articles on art to the press.[52]

The *völkisch* groups originated as a phenomenon in Germany around the turn of the century (the most prominent were the *Dürerbund*, the *Werdandibund*, and later, the Bayreuth Circle) and are aptly characterized by the term "radical traditionalists."[53] Key elements of the *völkisch* cultural program included the idealization of the German peasant, the rejection of all nontraditional aesthetic styles (often referred to by the catch-all epithet "cultural bolshevism"), and a propensity toward racism based on the sup-

position that artistic expression and "blood" are inextricably linked. These *völkisch* groups also exhibited another common quality: a dogmatic and even militant advocacy of their views.

Alfred Rosenberg, a "doctrinaire theorist," advanced his intolerant views most effectively through his KfdK. The organization's roots stretch back to 4 January 1928, when he and other "radical traditionalists," including Franz Xaver Schwarz (the NSDAP treasurer), Philipp Bouhler (later head of the Führer's Chancellery), and Franz Ritter von Epp (a retired general and NSDAP Reichstag deputy), joined the directorate of an organization called the National Socialist Society for German Culture.[54] Their declared purpose was to "demonstrate the interdependence between race, culture, science, morals, and soldierly virtues."[55] The group coalesced at an inauspicious time, for the Nazi Party had just suffered a disastrous election in May 1928, garnering only twelve seats in the Reichstag (810,000 votes nationally, or 2.6 percent of the popular vote).[56] Rosenberg gradually arrived at the decision that his cultural organization could be more effective if it was administratively and financially independent from the Party. In February 1929 he founded the KfdK, the successor to the NS Society for German Culture.[57] Despite the nonaffiliated status of the KfdK, prominent members of the NSDAP, including Heinrich Himmler and Richard-Walther Darré (later the Reich farmers' leader and food minister), soon signed on and, in effect, strengthened the organization's links to the Party—albeit while maintaining the legal separation.[58]

The KfdK's promotion of *völkisch* culture, and the concomitant offensive against "cultural bolshevism," took multifaceted forms. Rosenberg managed to enlist the support of an array of prominent non-Nazi intellectuals, including the Viennese sociologist Othmar Spann and the anti-Semitic literary scholar Adolf Bartels. Such "support [from prominent intellectuals] enabled the Kampfbund to extend its membership very rapidly, particularly in academic circles, and to absorb its rivals among local organizations with similar aims."[59] Representative events included Nazi art historian Paul Schultze-Naumburg speaking on architecture and race, and the writer Hanns Johst reading his poetry and fiction (for example, from his novel *Schlageter*, which glorified the German resistance to the French occupation of the Ruhr after World War I). The KfdK's illustrated journal, *Deutsche Kulturwacht* (German Culture Watch), which was established in 1932, supplemented a newsletter, the *Mitteilung des Kampfbunds für deutsche Kultur* (Communication of the KfdK). Both publications went to all members of the society. These periodicals featured reviews of exhibitions, plays, literature, and other cultural events and therefore afforded the KfdK a forum for attacking its enemies. The favorite targets at this early point were the

Jewish theater impressario Max Reinhardt and the left-wing writer Heinrich Mann.[60] In terms of "positive" activities, a variety of awards were given by the society to artists whom they approved. The Dresden chapter, for example, issued an annual literary prize.

Alfred Rosenberg, while nominally the figurehead of the KfdK, did little in the way of hands-on administrative work. Delegating authority to subordinates, such as the loyal Dr. Walter Stang (who worked for Rosenberg until 1945), diminished the effectiveness of the organization. Other NS leaders knew that the KfdK was but one of Rosenberg's many pet projects, and this suggested that the Reichsleiter's heart was not in the enterprise. Still, Rosenberg managed to use the league to improve his relations with other high-ranking Party members. For example, a KfdK congress held in Weimar in June 1930 brought Wilhelm Frick (then the minister of interior and culture in Thuringia), Richard-Walther Darré, and Eugen Hönig, among others.[61] This sort of networking within the cultural sphere of the Party helped improve Rosenberg's reputation, even though he was widely disliked because of his haughty and combative personality.

While the KfdK allowed Rosenberg to reach a limited audience – intellectuals were the organization's primary constituency – his position as editor of the *Völkischer Beobachter* provided him with his best means for reaching the masses. The Party newspaper began running reviews of art exhibitions in 1928, though substantive and regular attacks on modern art did not appear until 1930.[62] Gottfried Feder's article of 6 April 1930, entitled "Against Negro Culture," while an important landmark because it spurred much debate, paled in comparison to the salvos fired by Rosenberg and his allies during the period of the heated controversy over modern art (1933–35).[63] Rosenberg's four-column article of 21 June 1933, which he followed with pieces on 6 July and 14 July, constituted the *völkisch* faction's frontal assault on the promodernist camp (and specifically the leaders of the NSD-Studentenbund).[64] These articles by Rosenberg in the *Völkischer Beobachter* differed from the unintelligible philosophy that he usually expounded – the "clumsy, obscurantist mysticism" of the *Myth of the Twentieth Century* – in that they entailed specific attacks and allegations.[65] In one article he called Otto Andreas Schreiber of the NSD-Studentenbund "a cultural Otto Strasser," referring to the "left-wing" Nazi who had been expelled from the Party in 1930.[66] In coordinating the campaign against the promodernist faction, Rosenberg not only penned his side's attacks but also bolstered the Nazi paper's stable of *völkisch* art critics, with fellow KfdK member Robert Scholz becoming the most prominent of the group.[67] The bitter aesthetic and political controversy therefore entailed the mobilization of cultural groups as well as a range of press organs.

Rosenberg (center) and colleagues from the NS-KG with the mayor of Munich, Karl Fiehler (right), 1935 (IfZG)

The other noteworthy tactic employed by the competing factions during the period of the as-yet-unresolved NS *Kunstpolitik* came in the form of propagandistic exhibitions. The Nazis relied on two basic types of shows: those that highlighted positive examples of the "new" German art, and those that featured the negative elements to be attacked and purged. The negative variety, notably the *Schandausstellung* (shame exhibition), proved the most sensational, as it attempted to place modern art in an unfavorable and even grotesque light. The artworks in these shows came primarily from private collections, although certain sympathetic museum directors also

loaned artworks and offered assistance to these antimodernist productions. Among the directors who supported these early "anti-exhibitions" were the replacements for those officials who had been purged by the Nazi government in the wake of the 7 April 1933 Law for the Restoration of the Professional Civil Service.[68] Prussian Kultusminister Rust and other Nazi cultural bureaucrats had engineered the dismissal of five established directors in the spring of 1933 on the grounds that they were either Jewish or politically "unreliable." Promodernist sympathies initially did not necessitate forced retirement, but the replacements tended toward antimodernist views.

A quick survey of the *Schandausstellungen*–which began in 1933 and appeared in various forms throughout the decade–gives some insight into the phenomenon and clearly shows that the infamous *Entartete Kunst* (degenerate art) exhibition of 1937 had its roots in the first year of the Third Reich.[69] One can draw distinctions between the 1933 *Schandausstellungen* and the 1937 *Entartete Kunst* show; yet the differences lay more in the realm of organization and scale than in content or tone. Basically the 1933 *Schandausstellungen* were smaller and involved more private (as compared with official) initiative. The 1937 show also entailed much greater publicity, as the opening speeches by the leading cultural bureaucrats were broadcast nationally on the radio, included in newsreels, and widely discussed in the press. The early *Schandausstellungen* tended to be local events, as compared with the traveling circus that toured the Reich four years later. Hitler himself played a role only in the 1937 campaign.

The various independent *Schandausstellungen* in service of the *völkisch* cause were strident, sensational attacks, and they pioneered different "low blow" techniques that would later be employed. In Karlsruhe the exhibition *Regierungskunst 1918–33* (Government Art, 1918–33) included the work of Max Liebermann, Edvard Munch, and various painters from the Expressionist group *Die Brücke*. In order to draw attention and to create excitement, the organizers forbade entry to those under eighteen years of age. The prices of the pieces, often at the inflationary levels of 1923 (a trick used again in the 1937 show), were listed adjacent to the paintings. The Karlsruhe organizers also exhibited photographs of traditional artworks that had been either kept in storage or deacquisitioned to raise money for modern art, thus presenting these works as slighted or unjustly disregarded.[70] In short, the exhibitions collectively constituted a brief against modern art. The titles of the *Schandausstellungen* convey many of the points advanced by the projects' directors. In Stuttgart, for example, the exhibition *Novembergeist–Kunst im Dienste der Zersetzung* (November Spirit–Art in the Service of Decay), drew the connection between modern art, the Weimar Republic,

and cultural decline. The Chemnitz show, *Kunst, die nicht aus unserer Seele kam* (Art Which Has Not Come from Our Soul), concerned the linkage between art and native spirituality. Mannheim hosted one called *Kulturbolschewismus*, which suggested the political implications the Nazis perceived in modern art. The show *Schreckenskammern der Kunst* (Horror Chambers of Art), which appeared in both Dessau and Nuremberg, had a sensational and even carnival element to it. The Dresden public had the opportunity to see *Spiegelbilder des Verfalls in der Kunst* (Reflections of Degeneration in Art), which expressed the cultural pessimism so common in the early years of the depression.

The "positive" exhibitions displayed the type of art that the *völkisch* faction admired. These shows naturally implied that modern art was unacceptable in the Third Reich. The traveling exhibition *Reine Deutsche Kunst* (Pure German Art), which opened in Brunswick on 30 April 1933, suggested that its obverse – impure German art – also existed. The Brunswick show featured figurative art (that is, no abstraction), works with verisimilitudinous colors, and idealized subjects – features that would later characterize the Nazis' officially sanctioned art. Rosenberg preferred, somewhat surprisingly, that the KfdK refrain from organizing either "positive" or "negative" exhibitions, although individual members, such as Hans Severus Ziegler, assisted with the production of certain exhibitions – although this usually came about as a result of other positions.

Rosenberg and the KfdK believed that allied groups in the *völkisch* movement could take care of the propagandistic exhibitions. As noted earlier, *völkisch* groups managed significant cooperation with one another. Hence, KfdK rallies, such as those held during the summer of 1933 at the height of the modernism debate, served as rallying points for members of different organizations.[71] Someone like Hans Adolf Bühler, the director of the Karlsruhe Academy and the Karlsruhe Gallery, who was sympathetic to Rosenberg's league, possessed better resources for organizing art exhibitions. Bühler in fact put together the "shame exhibition" *Regierungskunst von 1918 bis 1933* as well as the "positive" show *Reine Deutsche Kunst*.[72] Rosenberg stood in the forefront of the *völkisch* movement, but he had no monopoly on the faction's initiatives.

The *völkisch* movement's campaign, despite much frenzied action, suffered from poor administration, and much of the responsibility for this lies with Alfred Rosenberg. As editor of the *Völkischer Beobachter*, head of the KfdK, a Reichstag delegate, and a Reichsleiter (he was one of the seventeen named to the Party's highest echelon in the summer of 1933), he alone in the *völkisch* faction could coordinate an effective promotional drive. Yet there were glaring organizational mistakes: failing, for example, to provide

advance notices or news coverage of the KfdK's programs in the *Völkischer Beobachter*. Only one-fourth of the league-sponsored events received prior publicity in the Party paper.[73] Rosenberg did not become aware of this until February 1934. Two factors stand out as key to these administrative shortcomings: Rosenberg's inability to focus his attention on any one project or sphere, and his repugnant personality. In the spring of 1933 Rosenberg not only sought to control the cultural policy of the Third Reich but also had ambitions in the field of foreign affairs. His Aussenpolitisches Amt der NSDAP (Party Foreign Affairs Department), which Hitler allowed him to create in order to counterbalance the Reich Foreign Ministry, when added to his other responsibilities, prevented him from concentrating on or excelling in any one area. Goebbels maliciously referred to him as "almost Rosenberg" because he was almost a scholar, almost a journalist, and almost a politician – "but not quite."[74] Rosenberg's disastrous trip to London in May 1933, when he greeted the king with a grossly inappropriate *Heil Hitler* and placed a swastika wreath before the Cenotaph, elicited many reactions similar to Sir Robert Vansittart's, who described him as "a Balt who looked like a cold cod."[75] Indeed, Rosenberg's failed London trip "resulted in a sharp decline in his prestige within the Party."[76]

By late 1933 the prospects for his *völkisch* wing, after some early successes, looked increasingly unfavorable. Goebbels controlled the RKK and the RMVP, while Rosenberg had failed to garner either a state or Party position in the cultural realm. Despite repeated attempts, Rosenberg met with no success in his efforts to secure an official place for the KfdK within either the Party or state apparatuses.[77] The league therefore remained financially weak since it relied on membership dues (RM 3 per year) as its primary source of income. Limited funding did come from the Party, but the amount was insignificant.[78] Despite the distinction of being the largest nongovernmental organization in Germany, there were "rumours of the Kampfbund's imminent collapse at the end of 1933."[79] Some speculated that the Kampfbund would be subsumed by the DAF.[80] At this desperate point, Rosenberg realized that some creative *Organisationskunst* (literally, organization-art) or a fortuitous turn of events would be necessary if he wished to salvage his position in the cultural bureaucracy.

Rosenberg rebounded from this nadir of power in the cultural sphere when Hitler appointed him Beauftragter des Führers für die Überwachung der gesamten geistigen und weltanschaulichen Schulung und Erziehung der Partei und gleichgeschalteten Verbände (DBFU) on 24 January 1934. A comparison of this appointment with the decree Hitler made with respect to Goebbels in June 1933 makes it quite clear that Hitler wished to create a duplicate Party organization to rival Goebbels's largely state authority.[81]

Rosenberg, in finally gaining a bureaucratic base from which to challenge Goebbels, interpreted his new commission in an extremely broad fashion. In acting as the Party's ideological watchdog, he understood his jurisdiction to extend to all cultural fields, including the visual arts.

Hitler's motives for creating an organization to rival those under Goebbels's control were twofold. The first centers on the nature and distribution of power in the Third Reich. Gordon Craig, among others, has referred to Hitler's administrative philosophy as the classic *divide et impera,* observing that "this duplication of function cannot be ascribed solely to Hitler's administrative carelessness and the ambition of his party comrades, for there was an element of design at work as well."[82] Throughout the Third Reich, Hitler behaved in a manner that ensured he would remain the arbiter of all disputes – what Martin Broszat has called "Führer absolutism."[83] By creating rivalries, he made his underlings dependent on him. Goebbels began to appear too powerful in the cultural sphere by early 1934. Rosenberg's appointment thus humbled the propaganda minister and confirmed the latter's reliance on the Führer.

A second reason for Hitler's decision to undermine Goebbels's position stemmed from his dissatisfaction with the Reich's aesthetic policies. Goebbels, despite his lip service to the *völkisch* camp, promoted a *Kunstpolitik* that Hitler found too liberal. Hitler's antipathy to modern art, like his anti-Semitism and many of his other views, originated in his youth. His own work as a painter prior to World War I exhibited these conservative tendencies, and his hatred of the Weimar Republic extended to the modern art it had fostered. In the early stages of the Third Reich, Hitler largely concealed his ideas about art, or at least refrained from forcefully advancing them. Still, there can be little doubt about his antipathy toward modernism.[84]

Rosenberg's appointment and the fashioning of the agency that came to employ hundreds cannot be viewed entirely in terms of *bildende Kunst* or the modernism debate. The primary task of Rosenberg's DBFU concerned ideological oversight. The Nazi Party had increased in size at a tremendous rate prior to the 1 May 1933 cutoff date for membership (1.6 million people joined the Party between 30 January and 1 May).[85] Many of the "March violets," as they were pejoratively referred to by the *alte Kämpfer* (old fighters), were ideologically suspect. Hitler therefore brought in Rosenberg – the Party philosopher – to supervise school policy, youth programs, church affairs, and a number of other areas where ideological issues came into play.[86] Rosenberg's ambitions extended to almost every facet of the nation's cultural life. Regarding his claim to manage art policy, the headline from one of the periodicals put out by his office, the *Deutsche Bühnenkorrespondenz*

(German Stage Correspondence), summed up his rationale: "*Kunst und Schrifttumspflege ist eine Angelegenheit der Seele* (the cultivation of art and literature is an affair of the soul)."[87] As Rosenberg's commission from Hitler charged him with the task of *geistige überwachung* (spiritual supervision), he felt his involvement with all artistic expression to be within his jurisdiction.

Rosenberg implemented a number of bureaucratic reforms in 1934 in an effort to enhance his power in the cultural sphere. One of these was to do away with the KfdK. Although Rosenberg tried to rid himself of the ailing organization in February 1934 by making an agreement with Goebbels – they were to streamline the cultural bureaucracy as the league would be eliminated in exchange for Goebbels's promise to cut back the number of local representatives of the RMVP (called *Kulturwarte* or cultural wardens) – the propaganda minister eventually balked at the deal.[88] Rosenberg then turned to Robert Ley and the DAF. In June 1934 the KfdK merged with a theater association under Ley's control, the Reichsverband für deutsche Bühne (Reich Association for German Theater), and together they formed the NS-KG. The NS-KG was "bodily incorporated into the German Labor Front" with the idea that it would evolve into "a mammoth cultural organization" that would rival the RKK.[89] The NS-KG, while never living up to either Rosenberg's or Ley's expectations, did exert considerable influence on the culture of the Third Reich. Regarding the visual arts, the NS-KG published a magazine from 1934 to 1938 entitled *Kunst und Volk*, they organized exhibitions, and they monitored artists working within Germany.

Within the DBFU, Rosenberg created by "executive order" four *ämter* (offices), of which one, the Amt Kunstpflege, concerned itself with the visual arts. Dr. Walter Stang, a prominent KfdK official, headed not only the DBFU's Amt Kunstpflege but also the NS-KG. The overlapping of personnel between these two organizations occurred in a number of instances, just as Goebbels allowed his employees to hold simultaneous positions in both the RMVP and the RKK. Robert Scholz, the *völkisch* art critic who became a central figure in the Nazi visual arts bureaucracy, offers another striking example of someone with multiple appointments within Rosenberg's offices. Besides organizing exhibitions for the NS-KG, Scholz headed one of the four departments that made up the Amt Kunstpflege: his Visual Arts Department complemented the Music Division, the Writing Division, and the Kulturpolitisches Archiv (an archive that developed into a sort of cultural police). The energetic and influential Scholz later also found time to act as the director of the museum in Halle (the Galerie Moritzburg) and serve on a committee outside Rosenberg's jurisdiction that made recommendations on the fate of those artworks deemed degenerate and purged from state collections.[90]

The primary problem faced by the DBFU concerned its source of funding. One of the limitations that Hitler had imposed on Rosenberg when he granted him his appointment was to make him financially dependent on other leaders and organizations, thus curtailing his freedom of action. Rosenberg had tried early to address this concern as he sent out a general appeal for funds to his fellow Reichsleiters at a conference held in Munich on 12 April 1934. Those present voiced their approval for the DBFU's mission, but no tangible offers were forthcoming.[91] Rosenberg directed a specific request for money to Bernhard Rust, but the Prussian minister of science, education, and art also failed to provide the needed assistance.[92] Rosenberg also approached the Party treasurer, F. X. Schwarz – the logical source of funding for the DBFU considering that it was a Party agency – and requested RM 12,000 to RM 14,000 per month to cover operating expenses.[93] Although Schwarz later arranged for the DBFU to receive a financial contribution from the NSDAP, he turned Rosenberg down in the spring of 1934.[94]

Despite Rosenberg's ability to forge alliances with other NS leaders, he continued to display ineptitude as an administrator. Examples of poor management skills began with the failure to house the DBFU's offices in one building in Berlin. Additionally, "Rosenberg chose his close associates on the basis of ideological compatibility, not on the basis of their administrative or organizational talents."[95] The appointment of the insurance businessman Otto Schneider to head the Amt Ausstellung (exhibition office) within the Amt Kunstpflege in August 1938 offers a case in point, as Schneider's prior experience in public service consisted of a position in the Reichsamt für die Berufserziehung des Kaufmanns (Reich office for the professional education of the merchant). Schneider had no training in the visual arts and no experience organizing exhibitions.[96] His lack of qualifications for the post was, in Rosenberg's mind, mitigated by his fanatical devotion to National Socialism. He fit in quite well among these ideologues.

Rosenberg, to be sure, had a number of competent administrators in his service. The most important of his cultural bureaucrats – the men who will figure most prominently in this history – were characterized by certain common traits: foremost was a fanatical commitment to National Socialism and a sense of personal loyalty to Rosenberg (service within the DBFU until 1945 being quite common). The key members of Rosenberg's corps were Robert Scholz, who served as Rosenberg's expert on the visual arts and therefore held a variety of positions; Gotthard Urban, who had once been the business manager of the KfdK and continued in Rosenberg's employ as the DBFU's staff leader until he was killed on the Eastern Front in 1941; Dr. Werner Koeppen, Rosenberg's right-hand man and adjutant; and

Dr. Walter Stang, the head of the NS-KG and chief of the Amt Kunstpflege. Throughout the course of the Third Reich, these men proved ruthless and committed executors of Rosenberg's warped vision. In zealously trying to play the role of ideological watchdogs of the Third Reich, Rosenberg's staff developed a certain esprit de corps. Other Nazi ministers of course also encouraged their underlings to act "loyally." Goebbels went so far as to issue an order that forbade his employees from taking problems outside his ministry.[97] Rosenberg's staff, despite failure and mismanagement, nonetheless endured many bureaucratic battles together and sustained a certain camaraderie.

LEY AND HIS EFFORTS TOWARD BUREAUCRATIC ALLIANCES

Robert Ley also played a key role in the creation of the DBFU. Ley, who had grand ambitions for his huge organization ("an organization surpassing in size and scope anything in Western history"), had been rapidly expanding the DAF in late 1933.[98] The most significant area of growth at this time occurred in the cultural realm, as the KdF office for workers' leisure time was announced by Ley on 27 November 1933.[99] Ley also wished to establish an agency for education and ideological guidance (to "organize all German Workers of the fist and brain"), and he met with Rosenberg on several occasions in November and December 1933 to discuss the subject.[100] It mattered little that Ley, "one of the most ideologically indifferent men at the top of the Nazi Party," was not inclined toward theoretical or spiritual matters.[101] Similarly, Ley did not allow his personal dislike for Rosenberg to interfere with his ambitions.[102] Like a vulture, he saw Rosenberg struggling in late 1933, and he himself hoped to carry off the carcass (which included Rosenberg's numerous agencies and titles) by coopting the overextended Reichsleiter.

Ley proved unable to transform Rosenberg's bureaucratic setbacks of 1933 into any tangible gains. Rosenberg, an able negotiator, insisted that he be given control not only of the DAF's ideological training but also of the cultural programs. Rosenberg also demanded that his own independent organizations, including the KfdK, be kept separate from Ley's. As was typical of the agreements between Reichsleiters, the pact they arrived at, which linked the KdF and the NS-KG, was characterized by much ambiguity. Most importantly, it failed to determine spheres of jurisdiction or resolve the issue of funding.[103] Yet Ley wanted some sort of pact binding him to the floundering ideologue—hoping that he could bully him once the working relationship had progressed. Rosenberg, who had yet to receive his DBFU

commission, felt a tremendous need for some sort of official confirmation. Hitler approved the Ley-Rosenberg pact on 24 January 1934.

Robert Ley's proposals for the above-mentioned partnership, while providing the impetus for the creation of the DBFU, were largely self-interested.[104] Ley's strategy consisted of playing Rosenberg and Goebbels off one another, with the hope that his own influence in the cultural sphere would eventually be expanded. In February 1934 Ley and Goebbels signed an agreement that made the RKK "a corporate member of the DAF"–although this arrangement, like many others, did not prove binding or significant.[105] Previously Ley had consulted the propaganda minister when he formed the DAF's Kulturamt (Cultural Office). Goebbels had successfully recommended one of his own to head the office: the promodernist painter Hans Weidemann, who had previously worked in the RPL. Weidemann, in fact, turned the KdF's Cultural Office into a bastion of promodernist sentiment, organizing workers' exhibitions that featured the art of Nolde, Pechstein, and others who created in nontraditional styles.[106] Ley's behavior in this period with respect to Goebbels and Rosenberg attested to his ideological flexibility.

Ley had expected that he would be the chief of the NS-KG and Rosenberg the adviser, a fair trade in his mind for the financial support that he was providing. Yet Rosenberg continued to resist all incursions into his offices and any restrictions on his independence. A frustrated Ley tried to

resolve the matter in December 1934, when he attempted to subsume completely the NS-KG under the KdF organization. He issued an ultimatum to Walter Stang that the NS-KG must "cease its operations and merge with the KdF."[107] One week prior to Ley's letter, Rosenberg had brought suit against Horst Dressler-Andress, the Ley-backed head of the KdF who had refused to cooperate with Rosenberg. This nasty dispute went all the way to the Party's supreme court.[108] Ley and Rosenberg did finally manage to make peace. On 19 January 1935 they signed a renegotiated agreement that affirmed the independence of both the NS-KG and the KdF and provided the NS-KG with RM 4.3 million annually for services rendered to the KdF.[109] The new pact again proved impermanent. Rosenberg, despite much haggling, never managed to secure the full contribution promised to him by Ley.[110] Ley's organization nonetheless continued to provide the NS-KG with enough funding to enable its existence until mid-1936. Rosenberg thus always faced budgetary difficulties, but the existence of his bureaucratic fiefdom was never seriously threatened.

RUST AND THE ART OF ADMINISTERIAL ENTRENCHMENT

The administrative creativity and dynamism of the Nazi leaders varied tremendously, with Rosenberg and Goebbels located on one end of the spectrum and the rather pathetic Bernhard Rust occupying a position at the opposite extreme. Rust received his promotion to Reichsminister on 30 April 1934 when Hitler extended his position as Prussian minister of science, education, and art to a national level. Although Rust was the Gauleiter of the South Hanover–Brunswick district from 1925 to 1940, he had no post within the National Socialist Party in the cultural sphere. His inability to augment his state authority has been viewed by many observers as a key factor in explaining the difficulties he faced.[111] "The Reich Education Ministry, then, was under siege almost from its inception, with various Party agencies seeking to trespass on its territory. Yet the lame-duck reputation that the Minister deservedly acquired obscures the frequent successes of his higher education staff in protecting their bailiwick."[112] Indeed, a somewhat paradoxical situation existed within the Education Ministry, where Rust's subordinates considered him inept and politically impotent, yet for self-interested reasons tenaciously defended the traditional authority of the ministry.[113]

While Rust fought battles for jurisdiction with a number of leaders—for example, Baldur von Schirach in the field of youth supervision, Rosenberg over education policy, Fritz Wächtler regarding the overseeing of teachers,

Bernhard Rust (front) and August Wilhelm Prinz von Preußen (left) at rally (BAK)

Himmler concerning the research institutes dealing with early German history, and Robert Ley with respect to the Order Fortresses – the most interesting and enduring *Kompetenzstreit* (jurisdictional fight) involved Goebbels and his quest for complete dominance over visual arts policy.[114] Specifically, the two ministers fought over the control of state museums and galleries (especially their financial management) and for control of the art and music academies and *Hochschulen.* The two leaders' dispute began in spring 1934, and they continued to wrangle over these two spheres until 1945. Toward the end of the Third Reich, when total war measures were put into effect, the issue changed from that of supervising the institutions in question to overseeing the closing of the schools and museums.

The first serious discussions concerning the administration of museums took place on 15 May 1934 in the Prussian Finance Ministry. The RMVP/RKK was represented by Walther Funk, who tried to arrange for the transfer of authority over "state owned artworks" from Rust's RMWEV and the *Länder* to the RMVP. Funk argued that "according to the opinion of the Reichskanzler . . . the German museums and monuments should together be managed by the Reichskulturministerium [the RMVP]."[115] The most eloquent and effective defender of the status quo (hence being pro-Rust) was the Prussian finance minister Johannes Popitz. He rejected Funk's proposals, even the conciliatory *Verwaltungsgemeinschaft* (joint administration) that would have kept the Prussian state involved in the administration of

museums in that province. In this meeting Popitz also advanced the argument that would become the key principle in regulating the boundaries between the RMVP/RKK and the RMWEV: *lebende Kunst* (living art) – which took some time to define, but basically came to mean the products of living artists – would be Goebbels's responsibility, while "the protection of museums and the caring for monuments" would remain within the jurisdiction of the Education Ministry and the various provinces.[116] Funk and the RMVP rejected this formulation, however, saying that it ran counter to the intentions of the Führer and that no distinction between "old" and "new" art could be made.[117] Hitler was eventually compelled to attend a meeting to resolve the dispute. On 19 June 1934 a *Chefbesprechung* (executive discussion) took place in the Reich Chancellery, where Goebbels, Rust, Frick, Popitz, and others made their cases. Hitler approved the motion to leave Rust with the supervision of scientific matters but to allow Goebbels to manage all of the arts (the RMVP was to "embody the artistic impulse of the nation").[118] The meeting also produced a protocol that provided Goebbels with what he wanted: the RMVP, according to the document, would oversee art education (that is, the *Kunst/Musik Hochschulen*) and the "cultivation" of art.

Despite Hitler's intervention, the conference, and the protocol, Goebbels and Rust remained far from resolving the dispute. The protocol that the RMVP had drafted after the meeting proved unsatisfactory to Rust. A 29 November 1934 memorandum in the Reich Finance Ministry noted that Rust had refused to sign the document because of certain unspecified objections.[119] While the protocol was initially supposed to form the basis for a law (referred to as the *Künstlergesetz*), these hopes were dashed by the late autumn of 1934. Instead, many leaders, such as Popitz and Krosigk, now sought to salvage a more limited agreement between the concerned ministries as well as the provincial governments, who were also interested in the matter as the dispute related to *Reichsreform* and the question of provinces' relation to the central government.[120] All parties involved realized that such agreement would require further negotiations and would occur only at some future point.

Bernhard Rust's behavior during this incident illustrates the manner in which he defended his ministry's traditional sphere of authority. In face-to-face discussions his unimpressive performances seemed to leave him with diminished power, as for example, in the June 1934 conference where Goebbels appeared to have vanquished the education minister. By dragging his feet and refusing to come to agreement with other ministers, however, he salvaged a remarkable degree of his 30 April 1934 inheritance.

His subordinates also learned how to use indecisiveness and obstinacy to further the Education Ministry's interests. Rust's Staatssekretär, Werner Zschintzsch, who represented the ministry in many of the subsequent discussions with the RMVP, haggled with Funk and other Goebbels representatives about the distinction between *lebende* (living) and *tote* (dead) art until well into 1936.[121] The stalemate between the two ministries allowed Rust to retain control over museum administration in the Third Reich. He oversaw budgets, the appointment of directors and staff, and the safeguarding of the artworks themselves during the war.

Rust and his associates at the Education Ministry also avoided a checkmate by Goebbels in the chess-game-like struggle for control of art education, and the responsibility for art academies was never turned over to the RMVP.[122] Confusion on this point is understandable as it appeared that Goebbels had, on a number of occasions, secured control of art education. The Supplementary Law of the Reichskulturkammer of 15 May 1934 even had this transfer as a provision, but Rust never recognized this specific point and never relinquished control of the academies and schools. The exchanges between the two ministers in the years after the Supplementary Law demonstrate Rust's successful defense of this prerogative. Later Goebbels and Rust met in Heidelberg in June 1936 for the celebration of the university's 550th anniversary, and again they discussed the issue at length.[123] This inconclusive meeting was followed by another in February 1937, where Goebbels voiced his opposition to Rust's Reich School Law and, specifically, the clause that kept "the training of artists" within the RMWEV's domain.[124]

Goebbels's competition with Rust stemmed from reasons that were more bureaucratic than ideological. Rust's cultural agenda was generally National Socialist (that is, anti-Semitic, nationalist, and inclined toward traditionalism) and did not provoke much opposition from within the Party. Goebbels even appeared to be one of Rust's early supporters, as his 9 February 1933 journal entry reveals: "And Rust is the [Prussian] Education Minister. Which is as it should be."[125] Rust's cultural views were actually rather enigmatic at the time. While he had been active in the *völkisch* movement since 1922 – and was even a leader of the KfdK chapter in Hanover – he was not a crusader in the cultural realm like Rosenberg.[126] Rust was in fact known for appointing liberal department chiefs, such as Dr. Wolf Meinard von Staa and Dr. Hans von Oppen, both of whom proved tolerant of promodernist exhibitions.[127] If there was a personal element to the Rust-Goebbels rivalry, it was not based on divergent cultural views but on an increasing mutual contempt for each other's abilities and demeanor.

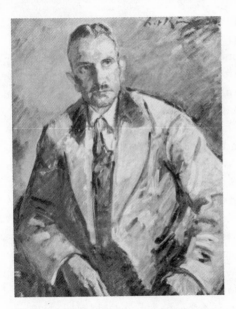

Reichsminister Bernhart Rust's portrait by the Berlin Secessionist Leo von König, 1934 (Rembrandt Verlag)

THE VISUAL ARTS ADMINISTRATION IN
THE FIRST YEARS OF THE THIRD REICH:
THE TEMPORARY RESOLUTION

The machinations of Goebbels, Rosenberg, Ley, and Rust in late 1933 and early 1934 suggest that Hitler was not the sole designer of the cultural administration within the Nazi state. While Hitler cannot be classified as a weak dictator in this case, or in most matters concerning the visual arts, much of the initiative for these new offices in the cultural bureaucracy came from the Reichsleiters. Throughout the Third Reich a type of dialectic existed between "Führer absolutism" and ministerial initiative: neither in itself determined the evolution of the NS state, but their interplay shaped the growth of the government. All efforts at *Organisationskunst* required the approbation of Hitler, but interministerial alliances were also viewed as a key to bureaucratic expansion. Leaders like Goebbels and Rosenberg tried to build these bridges despite their egotistic and dominating personalities. As a result of these qualities few of the partnerships among the Nazi leaders endured, but the men nonetheless tried to forge them. Goebbels, for example, found much sympathy from the Reichsjugendführer Baldur von Schirach because they had much in common in terms of taste and governing style.[128] While Schirach's own poetry cannot be considered modernist by any stretch of the imagination, his support for pro-Expressionist student groups (for example, the NSD-Studentenbund) and his encouragement of younger artists who often worked in nontradi-

tional forms made him a proponent of a more liberal cultural policy. Rosenberg's search for support included extensive cooperation with Himmler and his police force. The DBFU's Kulturpolitisches Archiv shared information on artists with the Gestapo. Rosenberg even tried to induce Himmler to have his agents confiscate the promodernist magazine *Kunst der Nation* in late 1934, but Himmler, being aware of Goebbels's patronage, wrote back that he did not possess the authority to do so.[129] While the Goebbels-Rosenberg rivalry was very much a two-man struggle, they managed to involve others, thus magnifying the political significance of this debate over culture.

The bureaucratic competition in the realm of visual arts policy ran parallel to the debate over modernism in that both defied resolution until well into 1936. As noted above, Hitler was primarily responsible for this lack of clarification. His cultural speeches, such as the one delivered at Nuremberg on 4 September 1934, where he warned of "stuttering Cubists, Futurists, and Dadaists," while deploring "the sudden emergence of backward lookers," left both the leaders and the public uncertain about the official aesthetic policy.[130] Hitler at this time – in the wake of the Röhm purge – was preaching Party unity, and he perhaps wished to avoid an unnecessarily exclusionist cultural policy. His pronouncements did serve as a warning to the supporters of modernism, but there was still a sense of toleration – or at least the perception of a gray area. The Expressionist artist Ernst Ludwig Kirchner, for example, "for years had no idea that the days of the avantgarde were numbered, and he believed until 1935 that the Nazis viciously attacked him out of error."[131] Goebbels also resisted abandoning his sympathies for modern art.[132] He continued to further modernist art, as shown by his support for the Munich exhibition *Berliner Kunst 1935*, a show organized "with the cooperation of [Goebbels's] ministry," which featured works by Ernst Barlach and others.[133] Goebbels not only visited the exhibition but had the audacity to purchase pieces with RMVP funds.[134] The propaganda minister simply learned to act more discreetly and cautiously in 1934 and 1935. He would sometimes even deny supporting modern artists when he sensed an attack from the conservative camp. For example, he answered one of Rosenberg's accusatory letters by protesting, "It is untrue that the men employed in the Visual Arts Chamber have the closest relations with the Barlach-Nolde circle."[135] Goebbels knew that it was pointless to try to alter Rosenberg's views or convince him of the virtues of a more liberal *Kunstpolitik.* He therefore endeavored to placate the Party philosopher by avoiding confrontation, knowing that he himself still possessed the most important means to shape the Reich's cultural policies.

Despite treading more carefully in his advocacy of a liberal *Kunstpolitik,*

Goebbels and assistant Hans Schweitzer ("Mjölnir") visit exhibition Berliner Kunst *in Munich, 1935. Goebbels patronized this show, which featured many modernist artworks.* (BAK)

Goebbels encountered a series of setbacks in the summer of 1935 that endangered his position atop the cultural bureaucracy of the Third Reich. Rosenberg, of course, contributed to these difficulties. As mentioned earlier, the competition between the various Reichsministers in the cultural field was not confined solely to the realm of *bildende Kunst.* The visual arts were but one of a number of cultural spheres, albeit one of exceptional importance to the Nazi elite. Still, problems in other areas jeopardized Goebbels's control over art. For example, Richard Strauss, the illustrious composer and president of the Music Chamber, had his letters to the Jewish librettist Stefan Zweig intercepted by the SD.[136] Strauss's letters to his collaborator-in-exile not only revealed that he had ignored orders to sever relations but proved that he was very critical of the Nazi regime. To avoid a public scandal, Strauss was allowed to retire gracefully from the presidency of the Music Chamber in August.[137] Still his patron and superior, Goebbels, came under fire. A host of other difficulties added to the propaganda minister's problems: the president of the Literature Chamber, Hans Friedrich Blunck, resigned that summer due to political pressure; a vice-president in the chamber, Heinz Wismann, who was married at one time to a *Halbjüdin* was under fire for supposedly helping his former in-laws; the president of

the Film Chamber, Fritz Scheuermann, was accused of Jewish ancestry and forced from his post; the president of the Theater Chamber died; and Eugen Hönig, president of the RkdbK, also threatened to quit (but stayed on until the fall of 1936).[138]

Rosenberg did his utmost to contribute to Goebbels's difficulties while trying to develop his own offices into a viable alternative as the official overseer of culture. By mid-1935 "Rosenberg dreamt of substituting his organization, renamed in 1934 the NS-Cultural Community, for the Chamber of Culture, if not for the whole cultural side of the RMVP, and even getting himself appointed Reichsminister for World Outlook and Culture."[139] Rosenberg, in yearning for a state position (and not just his Party post), tried to give the impression that he was a dynamic and capable manager of the arts. He therefore attempted to act as both theorist and organizer. For example, on 4 March 1935 he opened the second exhibition sponsored by the NS-KG, a highly publicized show that featured the work of the sculptor Josef Thorak and the painter of Tyrolean landscapes Ferdinand Spiegel. Rosenberg himself gave the opening address, which, like the exhibition, took place in the DBFU's own Berlin gallery (Tiergartenstraße 21a). A photo of him giving the address appeared in the *Völkischer Beobachter*, with the summation, "The speech reiterated the wish·for a unified, simple but monumental art."[140] Rosenberg and his colleagues later organized exhibitions of well-known contemporary artists such as Fritz Klimsch, Albin Egger-Lienz, and Wilhelm Peterson.[141] In short, he attempted to use his position and reputation in the cultural realm to maximum advantage – as a means of incursion into Goebbels's empire.[142]

Joseph Goebbels responded to these setbacks and Rosenberg's challenge by adopting a more conservative and intolerant cultural program. Given a choice between his promodernist aesthetic inclinations and his powerful position atop the cultural bureaucracy, he chose the latter. The difficulties that Goebbels encountered in mid-1935 therefore proved crucial in motivating him to abandon his liberal *Kunstpolitik*. To be sure, Hitler continued to push him away from his formerly moderate position. The scathing indictment of modern art in Hitler's cultural address at the Nuremberg Party congress in September 1935 was not lost upon the propaganda minister.[143] Goebbels's shift toward more conservative policies can therefore be dated to this year. For a start, he began by making personnel appointments to the RKK and to the RMVP that were invariably secure. "In all cases, the replacement was someone who took NS theories more seriously."[144] Goebbels also ordered Hans Hinkel, the general manager of the RKK, to step up the purging of Jews (*die Entjudung*) from the various chambers.[145] Goebbels, who was one of the leaders of the book-burning

campaign of 10 May 1933 and who later played a key role in the *Kristallnacht* pogrom of November 1938, could adopt a radical posture when he felt so inclined. The results were usually quite destructive.

Goebbels's response to the difficulties that began in mid-1935 cannot be considered a mere pose. The transformation in his views and behavior were not temporary or chameleonlike, but permanent and immutable. By late 1935 Goebbels exhibited decidedly antimodernist tendencies. One early example of this new outlook was his applauding the purging of modern art from Germany's museums, as his journal entry of 15 December 1935 reveals: "With the Führer at midday. Göring also there. Questions about building. Questions about painting. It is still very upsetting. The crap must be cleaned from the Kronprinzenpalais."[146] Perhaps this transformation expressed the nihilistic *Realpolitiker* in his character.[147] Historian E. K. Bramsted argues convincingly that Goebbels was part opportunist and part ideologue, the two constants in his thinking being his anti-Semitism and his feudal loyalty to Adolf Hitler.[148] Irrespective of this psychological portrait, it is undeniable that in late 1935 Goebbels experienced a stunning reversal in his views about modern art.

In explaining Goebbels's metamorphosis into an antimodernist, the influence exerted by Hitler needs to be stressed. While Goebbels did worry about the challenge of Rosenberg and like-minded allies – Reichsführer-SS Himmler and Richard-Walther Darré, for example – he believed that he could indefinitely withstand their opposition.[149] What was decisive was Goebbels's realization that Hitler had arrived at a steadfast decision in the debate over modernism. Significantly, the Führer's 1935 Nuremberg Party congress speech attacked modern art in terms stronger than ever before. Additionally, personal relations between Hitler and Goebbels were especially close at this point, as compared with a later date when a falling-out occurred. Hitler seemed to be able to exercise even greater influence than usual over the propaganda minister. Goebbels's journal entry on his birthday, 30 October 1935, suggests one way in which their warm relations might have shaped his cultural views: "My birthday. . . . The Führer comes at midday. He gives me a wonderful Spitzweg. I am deeply blessed. He is so good to me."[150] That Hitler would give Goebbels a valuable artwork by his favorite painter, a representative of the nineteenth-century Austro-Bavarian realist genre, suggests a subtle form of manipulation on the part of the Führer. This stratagem evidently worked, as Goebbels's rapturous response to Hitler and his respect for the latter's ideas about art reveal something beyond mere intellectual agreement. On 25 November 1935 Goebbels wrote in his journal, "The Führer speaks about art and the structure of the state. As always, totally great and fundamental. He is always looking toward the

future. He gives assignments; then art will soon bloom."[151] That Goebbels, the Nazi leader responsible for coordinating public opinion was himself now *gleichgeschaltet* in his views concerning art, reflects, above all, his desire to be in total agreement with his idol.

By subordinating his views to Hitler's, Goebbels again found it possible to strengthen his bureaucratic position. His renewed good fortunes in late 1935 and 1936 were largely based on his intimacy with Hitler. For example, a rather conspiratorial tone emerged in his journal entry of 13 October 1935: "Discussion with the Führer. . . . Sharp against Rosenberg. He will prohibit Rosenberg's cultural program. He approves all of my suggestions. He is very pleased."[152] Goebbels was to outdistance Rosenberg in autumn 1935, but the price he paid was a curtailed independence of his views. The propaganda minister even went so far as to have Hitler screen many of his cultural speeches, as he acknowledged in his diaries.[153]

The obedient Goebbels thus fought off Rosenberg's challenge to replace him, with the crucial victory coming in November 1935, when Hitler issued a decision on their rival plans to form a Reich cultural senate (RKS). It is fitting that their conflict should achieve clarification in this specific case; the RKS was to exist almost exclusively as a symbolic entity. This was so much the case that some historians have erroneously claimed that the body never convened.[154] Goebbels's assemblage of cultural (and political) luminaries did in fact meet, but nothing of significance was ever decided.[155] The importance of the RKS lies not in what the body accomplished but in what it represented: Goebbels's bureaucratic triumph over Rosenberg.

Rosenberg's defeat in the RKS affair proved all the more damaging because of the publicity involved in this bureaucratic battle. In the late summer and early autumn of 1935, the period when Goebbels suffered through the above-noted mishaps, Rosenberg, encouraged by promising signals from Hitler, sent the other Nazi leaders a letter that read, "On 11 September 1935 . . . the Führer commissioned me to form a Cultural Senate, with the goal of selecting and promoting all art and science that is taking place in Germany in the creative, National Socialist sense."[156] Rosenberg thus announced to the leadership corps his intent on challenging Goebbels for control of this body. The propaganda minister responded with a proposal of his own: citing the 1 November 1933 RKK law as a legal basis, the shrewd bureaucratic warrior argued that it was his prerogative to organize and head the cultural senate.[157] Hitler adjudicated the bitter dispute in early November 1935. From Goebbels's journal it is clear that Hitler issued the verdict verbally and then let the victor inform his foe of the disappointing news: "Letter to Rosenberg. On orders of the Führer, he may not bring his Cultural Senate into existence."[158]

One week later, on 16 November 1935, Goebbels cashed in on his triumph, as he convened the RKS for its first meeting. Himmler, Schirach, and many other Reichsministers had agreed to join Goebbels's senate. This largely useless body therefore played an important role in securing Goebbels's preeminence atop his cultural empire. The importance of the other Nazi ministers agreeing to participate in the cultural senate "probably helped to save the whole complex of [Reich Cultural] Chambers from dissolution."[159] One should recognize that despite its ineffectiveness, the organization captivated the imagination of many of the Nazi elite. A number of the subleaders clamored to gain admission, as Goebbels recorded in his journal on 17 November 1935: "Ley und Bouhler also want into the Cultural Senate."[160] Even Rosenberg attended the first meeting, although he was later to lead a boycott against the hapless institution.

Goebbels wrote an especially long description of his night of triumph in his journal the following day, 17 November 1935: "First meeting of the Reich Cultural Senate. A board of great minds. An almost festive atmosphere for all concerned. Johst [the new president of the Reich Chamber for Literature] laments Rosenberg. And rightly so!"[161] The evening continued as Goebbels and his wife, Magda, joined Hermann and Emmy Göring in their box at the theater to see a performance of Hanns Johst's play *Thomas Paine*. Later Goebbels proceeded alone to the Künstlerklub (artists' club), a private establishment run by one of Goebbels's RMVP employees, Benno von Arent, where the elite of the Third Reich mingled with "artists" (a term used loosely here to include the glamorous element in Berlin). Goebbels wrote of his last public appearance of the evening: "A multitude of artists and politicians. Nice and entertaining company. It makes me feel especially good. . . . With the great success in my pocket, it makes one so happy."[162] Goebbels had good reason to feel contented that evening. He had met Rosenberg's challenge and maintained his position atop the NS cultural bureaucracy.

2

DEGENERATE ART AND STATE INTERVENTIONISM, 1936–1938

So far as the visual arts were concerned, 1936 was in many respects a pivotal year, as Goebbels intervened energetically to lead the opposition to modern art.[1] Moreover, the cultural bureaucracy, which like most branches of the NS state had expanded, now featured more officials to organize art programs and propaganda. However, a more profound break occurred in 1938, when the authorities adopted a more violent and lawless cultural policy. In that year the Nazi elite began to engage in widespread if clandestine corruption for their personal gain. Outside the cultural realm, state terror increased, foreign policy became more aggressive, and the government and military experienced the reorganization of personnel. In brief, 1938 marked "a break in the constitutional development of the Hitler state."[2]

The more drastic transformations of the post-1938 period could not have occurred without the gradual radicalization of policy that began in 1936. The crucial cultural event in this process was the *Entartete Kunst Ausstellung* (Degenerate Art Exhibition), which opened in Munich on 19 July 1937. In

conjunction with this Goebbels-sponsored show over 16,000 modernist artworks were purged from Germany's state museums and galleries.[3] The *entartete Kunst Aktion*, the term used to denote both the purge and the exhibition, publicly and unequivocally established Goebbels's new position and signaled the start of the state's more decisive intervention.

The buildup to the *entartete Kunst Aktion* entailed a gradual process. Despite Goebbels's conversion to the antimodernist outlook in the autumn of 1935, he was not quick to confirm this transformation by deeds, because "whenever possible, Goebbels avoided a sudden and complete reversal of a line of propaganda."[4] Goebbels's reluctance to act against modern art in late 1935 and the first half of 1936 also stemmed from Germany's position as host to the Olympics of 1936, when foreign visitors experienced a more tolerant and less explicitly anti-Semitic atmosphere than that which existed before and after the games. Goebbels believed that this was not the time for an aggressive cultural policy. With rare exceptions, such as the *Antikominternausstellung* (Anti-Comintern Exhibition) in Munich in March 1936, and a small *Schandausstellung* that was organized in Dortmund and traveled to various cities in 1936, the Nazis adopted a more positive tenor in their cultural programs.[5] The art exhibitions in Germany during this period, including the special ones organized for the Olympics, were nationalistic and even National Socialistic (presenting artworks with traditional aesthetic styles and themes such as those that glorified the German *Volk* and their leaders), but explicitly negative productions were pushed to the side until the foreigners had departed.[6]

GOEBBELS AND THE SHARPER TONE

The radicalization of the NS *Kunstpolitik* began in earnest in late 1936. On 26 November Goebbels issued a proclamation in which he banned art criticism. On 1 December he replaced the pliable President of the Chamber for Visual Arts Eugen Hönig with the more conservative and militant Adolf Ziegler. A painter who specialized in stiff, idealized nudes (he was mocked by many contemporaries as the master of the German pubic hair), Ziegler nonetheless possessed the respect of the aesthetic conservatives in the Nazi Party. An extensive correspondence with the Reich farmer leader Darré, a leading *Blubo* (*Blut und Boden* or "blood and soil") enthusiast, is but one telling example of his connections.[7] Ziegler also enjoyed Hitler's confidence, having served as a consultant on artistic matters since 1925 and having been honored in 1935 with a well-paying commission to paint a portrait in memoriam of the Führer's beloved niece, Geli Raubal, who com-

Goebbels, Ziegler, Troost, and Hitler (right to left) at the first GDK, 1937 (BAK)

mitted suicide in 1931.[8] Ziegler's appointment boosted the antimodernist drive. His arrival and subsequent seven-year tenure as president of the RkdbK spelled hard times for modern art and its practitioners.

The ban Goebbels placed on art criticism constituted an even more explicit and public sign of the government's sharper tone than the Ziegler appointment. The message of the new journalistic regulations was clear as the leaders sought to assume control over all public forums and hence inhibit the development of new or contrary ideas. Goebbels's earlier support for modernism had often come by way of calls for freedom of expression. But he now implemented language restrictions (*Sprachregelungen*) by stipulating that writers may only describe their subjects and not employ judgmental or critical rhetoric. The November 1936 decree also restricted the number of people allowed to write about art, providing that "only art editors may discuss artistic accomplishments."[9] By circumscribing the discourse about art, Goebbels both enhanced the government's ability to monitor critics (as there were fewer active writers to watch over) and helped monopolize the commerce of ideas.

Thus, the banning of art criticism also constituted a broadside against modern art. The Nazis had long believed that the press was responsible for the popular success of nontraditional artforms. As Hitler stated in a Bürgerbräukeller (Munich) speech of 9 April 1929, "All of this so-called modern

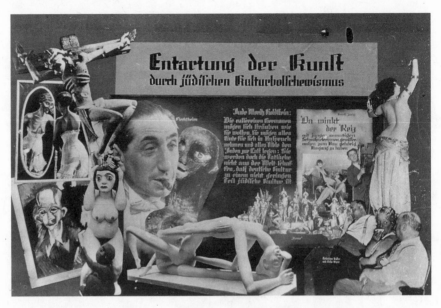

An anti-Semitic and antimodernist exhibit from The Eternal Jew *(Österreichisches Institut für Zeitgeschichte, Vienna)*

art of today would not be thinkable without its propagation through the work of the press. The press first makes something out of this crap."[10] In the Nazi Weltanschauung the connection between modern art and the press also tied in with their anti-Semitism, as they believed that Jews controlled the media prior to the Third Reich and that Jews had intentionally duped the German people into embracing nontraditional aesthetic styles. With the premise that Jews controlled a large portion of the art market, the Nazis argued that they had promoted modern art as a ploy to reap huge profits. Goebbels's official decree restricting art criticism echoed this belief. One passage referred to the abuses perpetrated by the art critics during "the time of the Jews' alien take-over of art."[11]

Antimodernism in the Third Reich had racial anti-Semitism as a key component, which found expression in a variety of ways: the purging of artworks of all Jewish artists from the German museums (for example, Otto Freundlich, Marc Chagall, and Ludwig Meidner), and the devotion of one of the nine rooms in the *Entartete Kunst Ausstellung* to works that depicted Jewish subjects (for example, Otto Pankok's *Passion*).[12] Walter Hansen, one of the RMVP officials most responsible for the *entartete Kunst Aktion*, later published a pamphlet, *Judenkunst in Deutschland*, which explored the purported connection between Jews and modern art.[13] Anti-Semitism and antimodernism increased in Germany in the mid-1930s, and as a result of the Nazis' sophistry, the two ideas reinforced each other.

Goebbels's gradually escalating attacks on modern art–where he moved from a burgeoning private or semiprivate antipathy in late 1935 and early 1936 (comments to Hitler, remarks in his diary) to a more public opposition (the appointment of hard-liners such as Ziegler, the restrictions on art criticism) culminated with the *entartete Kunst Aktion*.[14] Despite this progression, a precise chronology of the degenerate-art project proves elusive. Goebbels issued a decree on 30 June 1937 that set Ziegler and his commission loose on German state museums, and shortly thereafter he entrusted the Institut für Deutsche Kultur- und Wirtschaftspropaganda with organizing the large and elaborate exhibition.[15] Still, it is a wonder that the show, which included 730 artworks by 112 artists, opened in Munich on 19 July 1937. As the Hofgarten Arcade venue had to be transformed from an archaeological museum into a propagandistic installation–with elaborate embellishments such as insulting illustrations and vulgar captions–the *Entartete Kunst Ausstellung* was an organizational marvel. There are indications that there were clandestine preparations prior to the official 30 June startup date. In his diaries Goebbels refers to measures being taken on 5 June 1937, as he noted, "Pitiful examples of cultural Bolshevism have been submitted to me. But I shall now intervene. . . . And in Berlin I intend to organize an exhibition of decadent art."[16] Yet the Ziegler commission's confiscations between 2 and 14 July formed the bulk of the Munich show, and the paint in the Hofgarten gallery was indeed still wet when Hitler trooped through the doors on 19 July.[17]

The preparations for the Berlin-based exhibition *Gebt mir vier Jahre Zeit* (Give Me Four Years' Time) might also be seen as part of the early stages of the *entartete Kunst Aktion*. The show, held in the spring of 1937, was organized by Wolfgang Willrich, a hateful *völkisch* art critic and painter, and by Walter Hansen, the aforementioned racist polemicist in the RMVP.[18] As part of their commission, which came from Goebbels, Willrich and Hansen were empowered to requisition modern pieces from state collections. They did not need a large number of works, however. *Gebt mir vier Jahre Zeit*—the phrase stemmed from Hitler's slogan of 1933 when he assumed control of the country–entailed a broad comparison of how life had changed between 1933 and 1937: the visual arts comprised only one relatively minor section of the exhibition. Goebbels's agents sought to commandeer a limited number of artworks they deemed representative of the Weimar Republic. However, they attempted to do so before they had a sufficient legal dispensation. In April 1937, possessing only a ministerial directive signed by Goebbels, they started to remove modern artworks from the Berlin National-

galerie and galleries in Dresden.[19] Without public authorization, Willrich and Hansen encountered a number of obstacles.[20] Most notably, the director of the Nationalgalerie, Eberhard Hanfstaengl, before he was sent on "indefinite leave" on 27 July 1937, vigorously opposed any confiscations from the state collections – especially the one in his care – and blocked every move made by Willrich and Hansen.[21]

Goebbels was undaunted by the resistance to the antimodernist program. He helped to remove the uncooperative Hanfstaengl – although museum administration fell within Rust's jurisdiction – and was not reluctant about issuing strongly worded directives, as one finds repeatedly during this campaign. Yet Goebbels also used finesse in pursuing his goals. One tactic entailed broadening political support for the program. To do this, he directed Adolf Ziegler to include representatives from different branches of the bureaucracy on the purging commission. Ziegler selected five other members to the commission: Wolfgang Willrich; Hans Schweitzer, a well-known artist who, under the name "Mjölnir," drew steel-jawed Nazis during the *Kampfzeit* and now had a sinecure under Goebbels's purview called the Reich deputy for artistic conception (*Künstlerische Formgebung*); Klaus Graf von Baudissin, an SS officer who had replaced the purged Ernst Gosebruch as director of the Folkwang Museum in Essen; Otto Kummer, a bureaucrat representing Rust's RMWEV; and Robert Scholz, already mentioned as Rosenberg's art expert.[22] Ziegler and his colleagues managed to "cleanse" the Nationalgalerie (although they too had a run-in with Hanfstaengl, as he refused to receive the commission) on 7 July, and they eventually worked their way through virtually all of the state's collections.[23]

The *entartete Kunst* confiscations continued until October 1937. In the Ziegler commission's six months of activity, they seized approximately 5,000 paintings and 12,000 graphic artworks from 101 museums.[24] The Ziegler commission maintained a rather steady pace of approximately 2,000 works per month throughout its existence. Records reveal that they collected 5,328 of the total 17,000 artworks before (and hence about 11,500 after) the premiere of the *Entartete Kunst Ausstellung* in July 1937.[25] In the period after the opening of the Munich exhibition commission members exhibited a more zealous approach to modern art.[26] Ziegler had given a vitriolic keynote address at the opening ceremonies – a nationally broadcast event from the Haus der Deutschen Kunst – and by this point certainly felt passionately about the project.[27] Still, he did not accede to the suggestion of Baudissin and other extremists to confiscate private collections of modern art, and the commission limited its purges to the state's holdings.[28]

The Ziegler commission's hard-line policy of impounding the art deemed modern (which usually meant works with abstract images or unrealistic

color) provoked a number of controversies during the confiscation process. Yet pieces that some contemporary observers thought might slip through rarely did so. The pro-Nazi painter Emil Nolde had 1,052 works seized; the largely representational artist Max Beckmann lost 508 because his works had a modern sensibility; and a number of painters who continued to live in the Reich and who were not (yet) forbidden to ply their trade, such as Otto Dix and Karl Schmidt-Rottluff, came under attack (losing 260 and 608 works, respectively).[29] Perhaps the most difficult decisions made by the commission concerned the art of Auguste Macke and Franz Marc. While inspecting the room featuring their paintings in the Berlin Kronprinzenpalais (within the Nationalgalerie), certain members of the commission suggested that these two "Aryan" artists who had died while fighting for Germany in the First World War deserved a less ignominious fate. Ziegler, as chairman, asserted his authority and announced that aesthetic criteria would be the sole consideration in determining which pieces were to be confiscated. Hence the work of Marc and Macke as well as Nazi sympathizer Nolde fell victim to the purgers.[30] It is interesting, if not yet entirely explainable, that works by Franz Marc that appeared in the Munich venue of the *Entartete Kunst Ausstellung* (for example, the famed *Tower of the Blue Horses*) were pulled from the show before it traveled to Berlin. It seems that the Nazis recognized the public sympathy for the artist and did not want to undermine the propagandistic punch of the event by including works that elicited mixed emotions.[31]

The exhibition *Entartete Kunst* opened in Munich the day after the inauguration of the Haus der Deutschen Kunst – the Munich museum built by the Nazis for state-approved art and which featured the first annual *GDK*. The negative show clearly overshadowed its purportedly more edifying counterpart. Indeed, it broke all existing attendance records for an art exhibition in Germany, as 2,009,899 people saw the show (an average of over 20,000 per day) in Munich, and over 3,000,000 visitors in total were counted after the long run in other cities in the Reich, including Berlin, Leipzig, Düsseldorf, Salzburg, Weimar, Vienna, and Halle.[32] By comparison, the supposedly inspiring NS culture in the *GDK* attracted just over 400,000 visitors in its four-month run, or approximately 3,200 per day.[33] Goebbels tried to shed positive light on the public's interest in the defamed modern art: he wrote in his diary on 1 September 1937, "In the *Entartete Kunst* exhibition, one million [visitors]. A great success."[34] He never considered whether some visited the show in order to bid a sad farewell to modern art in Germany,[35] nor did he dwell on the larger and more important goal of creating a new and significant culture for the Third Reich – one that went beyond a mere rejection of the recent past. The second-place

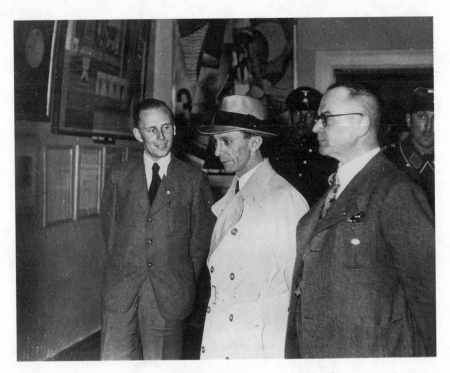

Goebbels (center), accompanied by organizer Hartmut Pistauer (left), visits the Degenerate Art Exhibition *at the Berlin venue, 1938* (BAK)

finish of the officially approved art suggested that it had not yet captivated the public's imagination.[36] Although Goebbels treated the *Entartete Kunst Ausstellung* as a triumph, the victory could not have been as sweet as Goebbels pretended it to be.

THE *GDK* AND THE SEARCH FOR
A POSITIVE CULTURAL PROGRAM

The panicky preparations for the first annual *GDK* reveal further the NS leaders' dissatisfaction with art being produced in the Third Reich. Heinrich Hoffmann, who made a name and fortune for himself as Hitler's photographer, was appointed commissioner of the annual show by a desperate Hitler, who feared that the exhibition would humiliate the regime. Hoffmann's own account proves quite revealing:

The first exhibition in the Haus der Deutschen Kunst was to be opened on 18 July 1937, and a jury of twelve Professors had been appointed to

Model of the Haus der Deutschen Kunst carried in parade through Munich on Day of German Art, 1937 (BHSA)

make selections from the eight thousand works submitted. A few days before the exhibition was due to open, Hitler asked me to accompany him on a tour of the various galleries. It was not a very pleasant spectacle that presented itself to our eyes. . . . Hitler went through the various rooms, and I could see that he was not particularly edified by what he saw. . . . Disappointed and angry, he suddenly declared: "There will be no exhibition this year! These works which have been sent in show clearly that we still have in Germany no artists whose work is worthy of a place in this magnificent building. I hereby dissolve the Jury of Selectors!"[37]

Hoffmann, with Hitler's direct guidance, arrived at a selection of 884 works that were exhibited and duly praised. Yet the positive element in the NS *Kunstpolitik* did not unfold as smoothly as had the negative.

The Nazi leaders certainly cannot be accused of not trying to foster a unique, representative artistic style; the sums they spent serve as a testament to this effort. Nearly all the leaders had official funds at their disposal with which to purchase art. Hitler had the greatest amount at his disposal, and between postage stamp and book royalties, he generated supplementary funds for artworks that were quite substantial. Goebbels developed the Stiftung Künstlerdank in 1936, which in the first year alone arranged for the disposal of RM 2 million to "older artists who suffered during the bolshev-

ist time"; the fund awarded approximately RM 5 million over the next four years.[38] Himmler, Schirach, Ley, and Ribbentrop, among others, also controlled sizable accounts earmarked for the purchase of art. The *GDK* quickly became one of the favored markets for the Nazi leaders. As nearly every work in the exhibition was for sale and as the NS leaders frequently exercised their prerogative to purchase works prior to the show's public opening, a significant portion of the ministers' artistic budgets went to this annual event. The figures discussed more specifically in Chapter 7 detail the leaders' behavior, but Hitler would typically buy 250 artworks per exhibition, with Goebbels averaging 40 to 50, and the others 5 to 25. The positive element of the Nazis' *Kunstpolitik* was well funded if nothing else.

THE NAZI LEADERS' RESPONSES TO THE
ENTARTETE KUNST CAMPAIGN

The Nazi authorities who organized the display of the purged art had done much of their work in a clandestine fashion, but the popularity of the exhibition induced them to take greater public responsibility for the *Aktion*. Therefore, on 4 August 1937, three weeks after the show's opening in Munich, Hitler personally issued another *Vollmacht* (decree of empowerment) to Ziegler that again spelled out the commission's assignment. This decree complemented and superseded that of 30 June from Goebbels (which carried less weight) and the 14 July directive from Hitler (which was of a more general nature).[39] The issuing of post-facto decrees and laws became standard procedure in the *entartete Kunst Aktion*. Not only would Ziegler receive his full authorization to form a commission in August, long after the start of the purging process, but Goebbels would pass a law the following year, dated 31 May 1938, and publish it in the *Reichsgesetzblatt*, making the confiscation of degenerate art from state collections a legal act. This tardy issuance of decrees and laws reveals how the leaders often first waited for public reaction before taking public responsibility.

The success of the *entartete Kunst* campaign brought increased interest from the various figures within the cultural bureaucracy, and this desire to participate in the defamation spawned further competition, disputes, and alliances. The main conflict arose between Goebbels on one side and Rust and Göring on the other, and it came to a head in late July and early August 1937. Rust challenged Goebbels for leadership of the *Aktion*, claiming that because he was responsible for overseeing the administration of Germany's state museums, he had the right to determine the fate of the purged artworks. As a precedent, Rust cited his closure of the modern section of the

Kronprinzenpalais (Nationalgalerie) on 30 October 1936—an action that took place under the Kultusminister's aegis. Rust made his move by obtaining an order from Göring (acting as minister president of Prussia) on 28 July 1937 that empowered him to "cleanse the property in all of the public art collections in Prussia."[40] This order emboldened Rust to directly challenge the propaganda minister for control of the project. Rust called the directors of the state museums to Berlin for a meeting on 2 August 1937 and issued his own guidelines for the purging of modern art.[41] This meeting constituted an affront to Goebbels and Ziegler, and the fight that ensued is emblematic of the cultural politics of the Nazi state.

Göring and Rust had a long history of cooperation. Rust had been Prussian minister for science, art, and education since February 1933, and two months later, upon the demise of Papen's commissarial government in Prussia, Göring became the province's Ministerpräsident. The two worked together on many occasions, and they often developed mutually beneficial arrangements. On 15 July 1937, for example, Rust induced Göring to accept the position Protektor der Preußischen Akademie der Künste.[42] Around the same time, Göring sponsored Rust in the latter's challenge to Goebbels's leadership of the degenerate-art action. As was most often the case, Göring got the better of the deal. In the 28 July 1937 decree that empowered Rust to oversee the purging process, one clause stated, "Concerning the dispensation of all of the expurgated objects, so far as they belong to the state, a list will be placed before me, and I will make the decision."[43] Göring appended a personal letter to Rust with the decree, specifically requesting a precise catalog of all of the *sogenannte Kunstwerke* (so-called artworks) and any available information pertaining to the objects' creators, previous owners, and appraised price.[44] Göring's derogatory tone toward the purged art was mostly theatrics, for he admired Impressionist art and had ambitions to use the other "so-called artworks" for trade abroad and hence personal gain.

Joseph Goebbels did not approach this jurisdictional threat posed by Göring and Rust in a defensive posture. The propaganda minister fought energetically, partly out of instinct but also consciously believing that a successful execution of the *entartete Kunst Aktion* would reflect positively upon him and allow him to expand his authority. Goebbels recorded in his diary on 27 July 1937 that after the *entartete Kunst* campaign he would "give a general report to the Führer and then [Hitler] shall transfer over to me all of the academies."[45] Goebbels's long-standing desire to take over the supervision of art education from Rust therefore again came into play. Rust was undoubtedly aware of this challenge, and his appointment of Göring to the honorary position of *Protektor* of the Prussian Academy of the Arts two

weeks earlier stemmed from his efforts to bolster his bureaucratic defenses. The conflict was not exclusively between Goebbels and Rust, however, as Göring also felt anxiety about Goebbels growing too powerful in the cultural administration. By cooperating with Rust, he could check the propaganda minister's influence and enhance his own.

A conflict like this one, which involved figures at the apex of the NS regime, required a resolution from Hitler. As was customary, the settlement involved balancing power, as both sides were thwarted in their efforts to usurp responsibilities from each other. Hitler left the *entartete Kunst* campaign with Goebbels's forces in the RMVP and RkdbK, while he kept art education–or the academies noted by Goebbels in his journal–in the hands of Rust and the RMWEV. As Goebbels recounted, Hitler castigated both Rust and Göring for seeking to control the *entartete Kunst Aktion*.[46] Goebbels's dire predictions that Hitler would remove Rust did not come true, but Rust had provoked the Führer's wrath. The Kultusminister wisely made a special trip to see Hitler at the Berghof in late August 1937, accompanied by the radically antimodernist museum director Klaus Graf von Baudissin, whom he had recently appointed to his staff.[47] Hitler remarked that Rust should support Ziegler and the commission's work to the utmost and avoid such challenges and disputes in the future.[48] Hitler's reprimand induced not just Rust but the other Nazi ministers to act more cooperatively with respect to the degenerate-art campaign. After September 1937 the *Aktion* proceeded with less ministerial conflict, as members of the regime undertook the disposal of the confiscated art.

THE BALANCE OF POWER IN THE VISUAL ARTS ADMINISTRATION

Despite a more aggressive and cohesive *Kunstpolitik* in the period after November 1936, where government and Party officials almost invariably supported the measures taken against modern artworks and the proponents of nontraditional aesthetic forms, the Nazi cultural bureaucracy's unique system of checks and balances continued as before. As demonstrated above, Hitler tried to maintain a sense of parity as he split his decisions between Goebbels, Rust, and Rosenberg. The Reichsministers also sought to maintain a balance of power. In an arrangement analogous to the Great Powers after the Congress of Vienna, they would make and break alliances in a manner that always prevented any one from gaining a decisive advantage.

The greatest threat to the precarious balance in the cultural administration came from Goebbels. The cunning bureaucrat constantly attempted to

expand his authority. Despite numerous setbacks, he managed to do so between 1936 and 1938. The RMVP's operating budget, based on radio license revenues, Reich Finance Ministry allocations, and *Wochenschau* (newsreel) income, more than tripled between 1933 and 1939, increasing from RM 23.4 million in 1933 to RM 55 million in 1936 to RM 87.4 million in 1939.[49] Goebbels also enhanced his personal power within his own bureaucracy. He had a knack for administrative reform, and he ingeniously did so to his own advantage. For example, on 31 May 1938 he issued a decree that "clarified" the relationship between the RMVP and the RKK. Whereas before, a central office had mediated between the two organizations, the Reichsminister now ordered RKK employees to report directly to him, thereby eliminating the liaison staff.[50] Goebbels's relentless efforts to reshape his existing offices enabled him to expand outwardly into the state bureaucracy.

However, Goebbels was not always successful in advancing his power. His initiatives were often checked, as for example, when he attempted to reform the art export laws of the Reich. On 21 December 1938 Goebbels released a *Rundschreiben* (circular letter) to a number of the Reich ministries where he called for harsher penalties for those caught exporting artworks from the Reich without prior governmental approval. This entailed imprisonment for certain violators and fines that could equal three times the value of the object in question.[51] Goebbels's draft law, which he circulated with the *Rundschreiben*, extended the 11 December 1919 law to protect national treasures. His draft, however, enhanced the power of the customs authorities by making them more active as decision makers, and it placed the whole issue of art export policy under the jurisdiction of the RMVP. The rationale behind Goebbels's move to strengthen the government's export controls were to increase his own power and to prevent emigrating Jews and anti-Nazis from taking artworks abroad with them.

His draft law elicited strong objections from both the Education Ministry and the RMdI. Rust and Frick responded in early January 1939 with sharply worded *Rundschreiben* of their own.[52] Rust and his associates at the Education Ministry invoked the old distinction between *lebende* and *tote* art in opposing the RMVP proposal. Furthermore, the Education Ministry's *Rundschreiben* noted that Frick and Rust were presently working together to compose a law for the protection of cultural monuments (*Kulturdenkmäler*), which would include a section pertaining to export measures. Frick also articulated "serious objections" to Goebbels's proposal, most pointedly to investing so much power in untrained customs officials who had little understanding of what constituted a national treasure. Frick also noted that another law, the 3 December 1938 *Verordnung* concerning "the emigration

of the Jews, [offered] essential help in the attachment of Jewish art posses-
sions."[53] Goebbels invited Rust, Frick, and the other concerned ministers
to a meeting on 10 January 1939 to discuss his draft law, but most refused to
attend – a tactic designed to stall reform.[54] The following month Goebbels
arranged a meeting of subordinates in the hopes of starting the negotia-
tions and laying the groundwork. But these representatives were in no po-
sition to demarcate new spheres of influence and, accordingly, concluded
the meeting by affirming the old principle of *lebende* art versus the *tote* vari-
ety. The national treasures were deemed *tote Kunst* and hence beyond the
RMVP's authority.[55] Goebbels was thwarted again in his efforts to usurp
power from Rust and Frick, as the two second-rank ministers banded to-
gether to maintain the status quo.

The Nazi ministers repeatedly did the obverse of the incident noted
above, as they maintained the balance of power by sustaining or assisting a
colleague plagued by difficulties. Perhaps those leaders who suffered re-
peated setbacks, such as Alfred Rosenberg, were periodically written off as
threats by the other ministers and therefore were given greater freedom of
action (as compared with the vigilant watch kept on Goebbels). As with
Göring's patronage of Rust, where the Reichsmarschall provided the flag-
ging Kultusminister with orders that worked toward expanding Rust's in-
fluence, there was a tendency among the more powerful leaders to create
alliances that bolstered the position of the lesser ministers. Alfred Rosen-
berg's ability to remain active in the cultural bureaucracy, despite repeated
failures and administrative defeats, demonstrates the applicability here of
another axiom of the "classical balance of power": the continued existence
of the individual powers was never to be jeopardized.[56]

ROSENBERG AND BUREAUCRATIC ENDURANCE

Alfred Rosenberg's misfortunes multiplied in the wake of his failure to
gain the commission to form the RKS in November 1935. He initially tried
to save face by refusing Goebbels's offers to join the existing organization,
as he played the role of prima donna. He rejected one invitation by
Goebbels on 31 March 1936, responding that "the Reich Cultural Senate has
been convened without me having been informed in the slightest about its
composition," and he added that he would not join unless he was given
specific supervisory duties.[57] Rosenberg then tried to arrange a boycott of
the senate, but he lacked the influence or savvy to rally other ministers
against his rival. Himmler, for example, wrote to Rosenberg that he had al-
ready sent an affirmative reply to Goebbels's invitation to participate in the

senate.[58] For Rosenberg, losing the bid to form the senate had been a serious blow; to suffer further defeats as a result of an inept effort at opposition added to his humiliation.

Rosenberg's failure to maintain a viable relationship with Robert Ley proved an even more significant setback for the Party philosopher, and the denouement of this conflict occurred concurrently with the final stages of the RKS affair. Rosenberg and Ley had renegotiated their NS-KG/KdF pact at a meeting of Reichsleiters in February 1936. Ley agreed to provide the NS-KG with RM 3 million per year, though of course the entirety of this sum never made it to Rosenberg's offices.[59] In April 1936 Ley, tired of arguing with Rosenberg–they had clashed in March over the creation of an Amt Feierabend (festival office) in Ley's KdF–canceled their February agreement. Ley refused to make any further financial contributions to the NS-KG. Rosenberg took Ley to the Party supreme court and sued him for breach of contract, while also stressing that numerous jobs belonging to Party members were at stake.[60] Hitler intervened and ordered Ley to meet his previously contracted financial obligations–a decision made in order to avoid "breadless Party comrades."[61] Ley was assured, however, that this financial commitment would not be permanent and that he would not be forced to ally himself indefinitely with Rosenberg.

Rosenberg's response to the numerous setbacks in 1936 and 1937–the RKS affair and the broken pact with Ley were but two examples–came in the form of bureaucratic consolidation. The NS-KG, on shaky ground without Ley's money, was therefore dismantled in June 1937. The master of *Organisationskunst* transferred a number of the offices into the restructured DBFU.[62] The elimination of the NS-KG as an independent entity–that is, the failure of this organization that Rosenberg had once hoped would rival and eventually supplant Goebbels's RKK–marked the end of Rosenberg's chances to replace the propaganda minister as the true overseer of NS culture.[63] In 1939 Rosenberg made one last futile push to unseat Goebbels.[64] It is axiomatic that all of the NS elite continued to battle for advancement within the administration until 1945.[65] However, Rosenberg later had neither the means nor the reputation to hold a post as important as minister of culture.

In falling out of contention for Goebbels's position, Rosenberg helped himself in other respects. He was not viewed as a threat by the other leaders, and they treated him more sympathetically. Hitler recognized Rosenberg with the first National Prize for Culture in 1937. At the ceremony in Nuremberg Rosenberg enjoyed not only Hitler's laudatory speech but also reveled in the bestowal of the award by Goebbels. Later, in February 1938, Rosenberg received a commission from Hitler to oversee the art journal

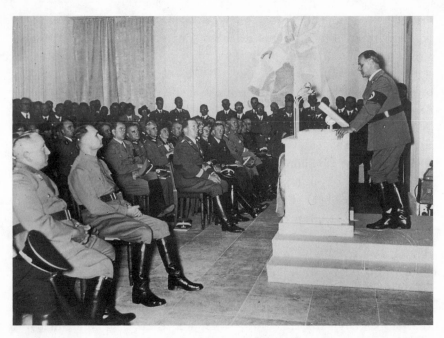

Rosenberg delivers speech to open exhibition Europas Schicksalskampf *at Nuremberg Party congress, 1938. Audience members include Ley, Hess, Speer, and Seyss-Inquart.* (BHSA)

Kunst im Dritten Reich. This assignment bolstered his struggling fortunes, as the magazine presented the government-approved art and therefore involved him more closely in the articulation and promotion of the official *Kunstpolitik.*[66] Rosenberg deserved consideration for the editorship of this important journal because of his experience with the *Völkischer Beobachter* (he had quit the post in January 1938) and the NS-KG's successful art magazine, *Kunst und Volk,* which was published from 1934 until the NS-KG's demise in 1937.[67] *Kunst im Dritten Reich* (the name was changed in 1939 upon Hitler's instructions to *Kunst im Deutschen Reich*) had an impressive circulation of 25,000 issues per month and remained a high priority project for the regime until bomb damage to the printing facilities prohibited further production late in the war. To launch the magazine in 1938 Hitler provided Rosenberg with additional funding to send 5,000 complimentary copies to the nation's elite.[68] This perquisite given to Rosenberg by Hitler was much like the Party philosopher being allowed to shine at the Nuremberg Party congress. Both were concessions intended to help Rosenberg maintain his stature among his peers.[69] The tactic seemed to work as Rosenberg finally secured a firm, if reduced, commitment from the Party treasurer F. X. Schwarz to fund the DBFU.[70]

Rosenberg excelled, or was allowed to excel, in the realm of visual arts

administration because of his highly competent expert on art, Robert Scholz. Although a virulent racist and an unwavering opponent of modernism, Scholz had some understanding of art. He had spent three years studying art at the Hochschule für Bildende Kunst in Berlin with Professor Ferdinand Spiegel in the early 1920s and two further years at the Prussian Academy of the Arts in the *Meisterklasse* of Professor Arthur Kampf (both professors becoming favorites of the Nazis), and he had considerable experience as an art critic.[71] Because Scholz occupied the key position for visual arts policy in the DBFU – he was head of the Hauptamt Bildende Kunst – it was not surprising that he was appointed by Rosenberg to the post of managing editor of *Kunst im Dritten Reich*. In addition to the day-to-day management of the prestigious journal, Scholz continued to serve as an art editor for the *Völkischer Beobachter* (and he later worked as a plunderer and held a post within the NSDAP called the overseer of the artistic portrayal of the Führer). Robert Scholz's talents as a cultural bureaucrat were widely recognized. In the spring of 1939 Albert Speer and Gerdy Troost (the widow of Hitler's favorite architect and an important adviser on art and interior design) both sent recommendations to Goebbels in support of Scholz's appointment as head the RMVP's Visual Arts Department.[72] Goebbels agreed with their suggestion but could not lure away Rosenberg's aide before the war broke out, and the matter was shelved.[73] Scholz's importance to Rosenberg should not be underestimated. Although it is likely that Hitler gave Rosenberg the important commission to launch *Kunst im Dritten Reich* because of Scholz's expertise, this cultural bureaucrat's other initiatives also proved invaluable to his chief.

The art exhibitions that Scholz organized on Rosenberg's behalf were also extremely important in helping the Reichsleiter play a larger role in the shaping of the Reich's cultural policy. The exhibitions and the accompanying opening ceremonies provided a venue for articulating aesthetic and political ideas, for promoting favorite artists and genres, and for networking within the governing corps. Even the opening of an event as uncelebrated as the NS-KG-sponsored exhibition *Seefahrt und Kunst* (Sea Travel and Art) in October 1935 drew among its *Ehrengäste* (guests of honor) Admiral Erich Raeder, Bernhard Rust, Hjalmar Schacht, and Hermann Göring.[74] Beyond enabling Rosenberg to maintain contact with other leaders, the exhibitions allowed him to engage them in a sphere where he was deemed qualified to comment.[75] Rosenberg had a number of successes in this arena. In particular the Josef Thorak exhibition of 1935, which launched the sculptor's meteoric rise to stardom in Nazi Germany, reflected well upon the DBFU.

Rosenberg, more than any other Nazi leader, utilized conferences and

Robert Scholz of the DBFU and the ERR
(BAK)

meetings to promote his career. His forte lay in proselytizing the converted, but he did not possess the skills of Goebbels, who could communicate with the masses.[76] The conferences organized by Rosenberg and his subordinates were sometimes official and sometimes private. In the official realm, at the NS-KG's annual meeting the guest list included a host of Nazi leaders. The 1936 conference took place in Munich, lasted five days, and featured, among numerous events, an art exhibition at the Lenbach Haus (entitled *Heroische Kunst*), concerts by groups ranging from the Munich Philharmonic to the SS choir, film and stage performances, and a lecture series (including Robert Scholz on *Kunst und Rasse*).[77]

Distinct from the official sphere (meaning Party or state), Rosenberg nurtured private or semiprivate organizations as a means of increasing his influence. The Nordische Gesellschaft, which was formed to promote German-Scandinavian relations, became the most important of those with nonofficial status. Rosenberg described the organization to Himmler as "the largest semi-official (*zwischen-staatliche*) organization in Germany."[78] Among its members the Nordische Gesellschaft counted Heinrich Himmler, Richard-Walther Darré, Baldur von Schirach, Viktor Lutze (the SA chief of staff who succeeded Röhm in 1934), and Hinrich Lohse (the Gauleiter of Schleswig-Holstein and later a notorious wartime administrator in the Occupied Eastern Territories).[79] The Nordische Gesellschaft also held annual conferences, organized art exhibitions (such as an exchange of Finnish and German art of the preceding 100 years, which had both Berlin and Helsinki venues), and sponsored "cultural evenings."[80] Although the elite at-

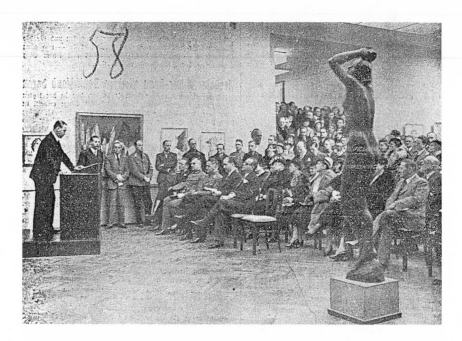

Rosenberg delivers address to open the NS-KG's exhibition of Thorak's sculpture, 1935 (BAK)

tended primarily to intermingle with others besides the host, Rosenberg's ability to organize these cultural events helped prevent a complete collapse of his authority. The initiative he displayed with these projects helped induce Hitler and the other Nazi ministers to uphold his position within the cultural bureaucracy.

Alfred Rosenberg thus continued to occupy a place in the cultural administration of the Third Reich during the late 1930s, albeit with diminished power and status in the years 1936 to 1939. He played a minimal role in many of the regime's important projects of this period, such as the *entartete Kunst Aktion* and the festivities surrounding the annual Day of German Art in Munich. Within the cultural sphere, he remained subordinate to Goebbels in many respects. For example, the DBFU's Division of Visual Arts needed the approval of the RMVP in order to undertake exhibitions. In December 1938 the RMVP rejected plans for the show *Ein Volk, Ein Reich, Ein Führer* on the grounds that Hitler reportedly opposed the project. Goebbels and his staff were not inclined to adopt a rubber-stamp approach, and they not infrequently exercised their power against Rosenberg.[81] As Michael Balfour observes, "Rosenberg's chances for replacing Goebbels were never great. Hitler realized his inadequacies, showed great reluctance to receive him, and referred to him as a narrow-minded Balt who thinks in a fearfully complicated way. But he was not prepared to disown publicly so

Rosenberg escorts Hitler through the Finnish art exhibition that his NS-KG organized in 1936
(BHSA)

old and faithful a colleague."[82] This negative assessment of Rosenberg should be qualified to take into account the career revival he staged in the years 1940–42. In short, Rosenberg's roller-coaster career did not hit bottom until the late stages of the war.

NEW BLOOD IN THE CULTURAL BUREAUCRACY: ALBERT SPEER

While the *alte Kämpfer* of the Party continued their bureaucratic struggles until the demise of Third Reich, the regime in general, and the cultural bureaucracy in particular, occasionally experienced infusions of new blood. The most extraordinary newcomer to the Nazi administration was Albert Speer. His rapid rise to power, based on his activities as both an artist and an administrator, made for a remarkable career.[83] Two factors contributed to Speer's ascent within the Nazi state: first, he demonstrated an ability to work effectively with other, established leaders; second, and ultimately more important, Speer became a, if not *the*, favorite of Hitler. Although Speer gained his entrée into the higher echelons of the Third Reich by way of the subleaders–Goebbels had hired him to remodel a Berlin Party office in 1932–his rise to Reichsminister depended on Hitler's patronage.[84] These two pillars of support did, of course, bear some relation

to each other. Speer worked more effectively with most of his colleagues as a result of his special relationship with the Führer. Funding and other resources proved more readily accessible, and capturing Hitler's attention, a goal in itself for most ministers, seemed easier to accomplish.

While the importance of Hitler to Speer's career is well-documented, Goebbels's regular and long-term patronage was also invaluable. Speer moved from doing interior designing for the propaganda minister to the post of chief of artistic production of mass demonstrations in the RPL (the "cathedral of lights" that Speer created for the Nuremberg Party rallies, as well as the festivals celebrating 1 May at the Tempelhof airport and the autumnal harvest in Bückeberg were done in this capacity).[85] While Speer branched out by assuming a post within the DAF as head of the Amt der Schönheit der Arbeit (Office for the Beauty of Work), he advanced his career most rapidly by way of architectural commissions.[86] A crucial step came in 1937 when Goebbels selected him to design and oversee the imposing German pavilion at the World's Exposition in Paris. Speer distinguished himself here with a spectacular stone structure as the Germans outspent all other participants by a wide margin.[87]

Goebbels's patronage of Speer extended to the nonofficial sphere as well, as the propaganda minister commissioned the Reich's most fashionable architect to design his private home. Their collaboration was a close one. Goebbels noted in his journal that both he and his wife, Magda, were working "with Speer on the building plans for a new house."[88] Speer, it seems, did what Goebbels asked of him. Like Goebbels, he possessed a flexibility and a sense of practicality that aided him in his rise. The designer who once hung Nolde watercolors in Goebbels's first official residence later joined the propaganda minister in battling degenerate art. Six weeks prior to the opening of the *Entartete Kunst Ausstellung* in 1937, Goebbels wrote that he had "discussed [his] measures against cultural bolshevism with Speer. He will help me with them."[89]

While Albert Speer held positions subservient to other ministers prior to 1937, his greatest increase in stature within the cultural bureaucracy came in January of that year, when Hitler named him GBI. Speer was now "subordinate to neither the Party nor any government agency, [but] was responsible to the Führer alone."[90] Charged with overseeing the remodeling of Berlin, Speer controlled tremendous resources. With respect to the arts, he used the funds at his disposal to become one of the key patrons in Nazi Germany—a development that boosted the careers of many artists, including his good friends sculptors Arno Breker and Josef Thorak.[91] That Speer used building funds to patronize artists was no state secret. The Nazis had even passed a law on 22 May 1934 that required at least 2 percent of all bud-

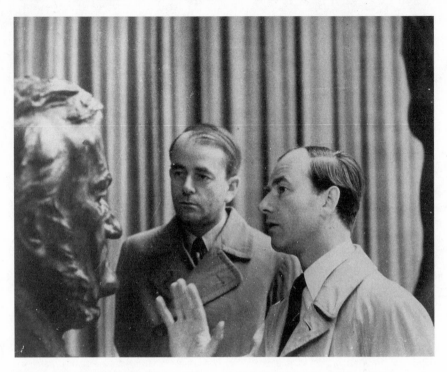

Speer and Breker with bust of Richard Wagner, which Speer later presented to Göring as a gift (BAK)

gets for new buildings to go toward artistic embellishment (a measure to alleviate the financial distress that many artists were suffering during the depression).[92] Although this ordinance was abandoned in 1938 because the number of artists was inadequate to meet the demand generated by the new construction projects – hence a condition that slowed the production of buildings – Speer continued to do more than his share to keep the Reich's artists busy.[93]

The cultural endeavors undertaken by the GBI extended beyond the commissioning of sculptures and murals for the new buildings. The GBI directed a small army of artists to craft models and make etchings of the new designs. They organized and constructed exhibitions that traveled not only within the Reich but throughout Europe. These shows often had significant political import, as demonstrated, for example, in the Madrid opening of *Neue Deutsche Baukunst* in 1942, where Speer was feted by General Franco and other Spanish dignitaries.[94] Speer served on numerous panels that decided awards, including one, for example, entitled the Prize for Visual Arts in the Reich Capital Berlin.[95] He also frequently nominated favorites for professorships as well as the National Prize (the award created by Hitler in

Speer at opening of his designs in exhibition Neue Deutsche Baukunst, *Lisbon, 1942* (BAK)

1937 to replace the Nobel Prize) and the Goethe Medal (for older, distinguished artists).[96] As editor of the architectural supplement to *Kunst im Dritten/Deutschen Reich*–Rosenberg thought it an asset to have Speer as a collaborator–he decided what structures and plans were to be shown in the country's most important art journal.[97] Goebbels, as mentioned earlier, consulted him while seeking a department chief of the RMVP's Division of Visual Arts. In short, Speer was tremendously influential in cultural affairs.

Speer's importance in the administration of the visual arts received a sort of symbolic confirmation with the determination of the physical site of the GBI's offices. On 10 February 1937 Bernhard Rust wrote to the president of the Preußische Akademie der Künste and told him to make space in the Akademie's Pariser Platz building for Speer's new office.[98] Speer received numerous rooms in the famous old building, including "the official residence of the Akademie's Chief Inspector on the third floor."[99] When he designed the New Reich Chancellery the following year, he arranged for a special tunnel that linked his and Hitler's offices.[100] The venerable Prussian academy was forced to relocate to another part of the capital.

Speer's quietly imperialistic behavior in this relatively minor incident is consistent with both his personality and his milieu. Regarding the former, Speer elicited great praise from his peers, and he became all the more

confident and egotistical as a result.[101] He understood that he occupied a special position in the regime. "For the official political staffers . . . Speer was the Führer's friend and artistic colleague – a position that made him sacrosanct."[102] Thus he would not refrain from stepping on those in his way. Speer's domineering side was displayed perhaps most vividly by his later machinations to force the resignation of Berlin's Mayor Julius Lippert, who had not proven sufficiently pliant for the GBI.[103] The GBI also administered a number of residences confiscated from Jews in Berlin, and Speer showed no compassion in this enterprise either.[104]

Speer rose to a position of influence during a period of increasing brutality and lawlessness. The "decent Nazi" was, if anything, ambitious and opportunistic. He was not especially cruel by the standards of his epoch, but he was also not above turning a blind eye to suffering when in pursuit of a goal. During the period in which he focused on cultural activities (through 1942), Speer did what he thought was asked of him. He did not seem troubled, for example, by the source of the granite for his buildings, even though much of it was mined by concentration camp inmates.[105] When Alfred Rosenberg sought his advice in 1940 about a new ethnographic (*Völkerkunde*) museum, Speer did not object to its racist organizational principles.[106] As a radicalized *Kunstpolitik* prevailed after 1937, Speer's cultural activities, like those of his associates, came to involve the oppressive and the illegal.

3

FROM CONFISCATION TO ARYANIZATION

THE RADICALIZATION OF CULTURAL POLICY, 1938–1939

While 1936 can be viewed as a turning point in the Nazi *Kunstpolitik* because of the decision to pursue an unambiguous antimodernist policy, 1938 marked the emergence of a more lawless and destructive campaign against the art deemed unacceptable. After 1936 the lack of toleration subsequently evolved into a more violent and unbridled radicalism, and cultural bureaucrats exhibited little regard for domestic law or world opinion. The Nazis' radical and often illegal behavior served two purposes: (1) the pursuit of their ideological goals, which included the elimination of all art in the Reich that conflicted with their conception of German art, and (2) the leaders' personal gain. This mixture of misguided idealism and self-enrichment – with the latter becoming an increasingly discernible source of motivation – characterized the behavior of the Nazi leaders after 1938. The purge of the prestigious Preußische Akademie der bildenden Künste that entailed the forced resignations of well-known modern artists, including Ernst Barlach, Ernst Ludwig Kirchner, Mies van der Rohe, and Oskar Kokoschka; the disposal of modern art from state collec-

tions, where the leaders both sold and destroyed the unwanted works; and the expropriation of artworks owned by Jews formed the core of this shift to a more radical policy.[1]

THE DISPOSAL OF THE CONFISCATED MODERN ART

The Nazis' incontestably illegal actions involving art began with the purged *entartete Kunst*. The program of confiscation from public galleries undertaken by Ziegler's commission in 1937 already constituted an act of dubious legality.[2] The NS elite's disposal of the seized art—initially selling pieces secretly and privately, then publicly through an international auction in Switzerland, and finally destroying them in a tragic immolation at Berlin's central fire station—marked a conspicuous departure from the relative restraint of the preceding years. The purging of the Reich's museums was carried out through the collusion of a number of ministers, principally Goebbels, Göring, and Rust. The liquidation of the works also involved a joint effort on the part of these same three leaders. In the initial phase of the disposal action—the year that followed Hitler's settling of the jurisdictional dispute regarding the purge in the summer of 1937—the Nazi leaders cooperated with one another to a remarkable extent.

All the *entartete Kunst*, save those pieces that comprised the traveling exhibition, was placed in storage depots—first in a warehouse located at Köpenickerstraße 24a in the Kreuzberg section of Berlin, and then in August 1938 in *Schloß* Niederschönhausen outside the capital.[3] Ziegler and the general secretary of the RkdbK, Walter Hoffmann, initially had responsibility for the administration of the warehouse that first housed the confiscated artworks. But Goebbels, the primary force behind the *entartete Kunst Aktion* (and Ziegler's superior), arranged in late 1937 for the administration of the storage facilities to be transferred from the RkdbK to the RMVP, a move that gave him more control over the artworks.[4] Goebbels later arranged for Ziegler's commission to be reformed in May 1938 into a disposal commission (Verwertungs Kommission), with Franz Hofmann (the head of the Visual Arts Department in the RMVP) chairing the newly constituted eight-man group. This Disposal Commission not only afforded Goebbels continued control of the action but also, by including the private art dealers Karl Haberstock, Karl Meder, and Max Taeuber, provided the needed expertise for selling the works.[5] Goebbels had harbored plans to assume control of the works for some time. In October 1937 he had written to the Reichsfinanzministerium asking them to provide the RMVP with RM 70,000 to cover the costs of storage, security, and the creation of an inventory list.[6]

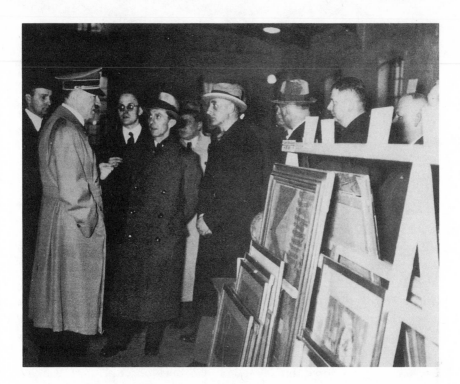

Hitler, Goebbels, and Ziegler inspecting confiscated "degenerate" art at the Köpenickerstraße warehouse in Berlin, January 1938 (NAW)

Goebbels visited the warehouse in November to inspect the impounded art and then returned with Hitler in early January. In his journal entries he displayed great pride in being able to guide Hitler on a tour of the defamed artworks and even noted that he had conceived plans to send the works abroad for "decent masters."[7]

At the same time that he secured control over the storage of the *entartete Kunst* and reformed the expert commission, Goebbels began to develop strategies for disposal of the artworks. Plans for action arose in January 1938, approximately five months before any substantive measures were enacted.[8] As Goebbels's journal reveals, Göring also contributed suggestions for the disposal of the works, proffering the idea that opportunities for selling the art be explored.[9] Goebbels proved very receptive to the idea and, accordingly, decided to appoint the three dealers to the Disposal Commission. Robert Scholz, who also sat on the commission, wrote in 1979 that art dealers in Germany bore responsibility for not only the *entartete Kunst* sales and trades but the entire *Aktion*.[10] Scholz, who wrote his book with continued sympathy for both NS art and the government's cultural policies, overlooked the galvanizing role played by Goebbels in the disposal scheme. Art

dealers did not exploit the Nazi government, but rather, Goebbels em-
ployed the dealers.

The dealers who acquired the commission to sell the degenerate works
abroad had a huge and seemingly valuable stock at their ready disposal –
German state museums having been great patrons of modern art (espe-
cially during the Weimar Republic). The lure of substantial profits, and in
some cases a humanitarian concern for the artworks, induced a significant
number of professional traders, both within Germany and abroad, to ap-
proach the RMVP and the Reich Chancellery for the opportunity to partici-
pate in this commerce. Thus, representatives from the Paris-based firms
Wildenstein & Co. and Seligmann & Co. negotiated with Nazi officials
about buying the art, and the Colnaghi Gallery in London and the Fides
agency in Zurich inquired about purchasing the entire stock.[11] The num-
ber of dealers involved in selling the art increased with time, as established
vendors like Ferdinand Möller, Karl Buchholz, Bernhard Boehmer, and
Hildebrand Gurlitt were granted the special dispensation by the govern-
ment. The dealers were always a small group, however, dependent on the
Nazi officials in this undertaking.[12] Karl Haberstock, for example, who later
made a fortune by selling art to Hitler, Göring, and other members of
the Nazi elite, answered directly to both Goebbels and to Hitler. At times
Haberstock could indeed act as an adviser and lobby for specific causes. In
letters on 26 April and 20 May 1938 to Hitler, he expressed concern about
the still unannounced *entartete Kunst* law and urged immediate attention to
the matter, as he felt that a legal provision was needed before the sales
could proceed.[13] Despite occasional efforts to lobby the leaders, Haber-
stock and the other dealers played an indisputably subordinate role. Goeb-
bels, under Hitler's supervision, dictated the government's policy. This in-
cluded taking public responsibility for the *entartete Kunst* law of 31 May 1938
and deciding who would dispose of the art and in what manner.[14]

Bernhard Rust, who as Reichsminister for science and education had
jurisdiction over the state museums and the artworks they housed, also
played an active, if secondary role in the disposal of the seized art objects.
Despite his inability to wrestle control of the *entartete Kunst Aktion* away
from Goebbels, Rust continued to assert himself during the campaign. In
March 1938 he issued a circular memorandum that went to the RMVP, the
Reich Chancellery, and various other government offices, in which he de-
manded that any profits derived from the sale of degenerate art be di-
rected toward his ministry in order that the museums could be compen-
sated properly for their losses.[15] Previously Rust had written Goebbels to
tell him that he expected the RMVP to pay the costs of any damage sus-
tained by the *Verfallkunst* (art of decay). He noted that the government, as

a general policy, did not take out insurance for objects in their care because it was too expensive.[16] He therefore considered Goebbels and the RMVP to be responsible for the safekeeping of the works. Rust continued to badger Goebbels and the other ministers about his rights and authority. This tactic worked, as his ministry eventually obtained a portion of the proceeds from the sale of the seized art to compensate the affected state museums.[17]

In contrast to Rust's incessant complaining, Hermann Göring chose to pursue his goals by cooperating and conspiring with Goebbels. Göring, of course, exploited his position as the number two man in the Reich; he knew very well that Goebbels, attuned to hierarchies as he was, would inherently respect his rank. His lofty position, combined with his ability to charm and his extensive business connections (with art dealers in particular), induced the propaganda minister to collaborate with him in the disposal of the confiscated art. Thanks to Goebbels's assistance, Göring arranged for thirteen valuable post-Impressionist paintings, including works by Van Gogh and Cezanne, to be removed from the Köpenickerstraße warehouse in the spring of 1938 and placed under his care.[18] They were then bartered or sold abroad for more traditional artworks.[19]

The thirteen paintings that Göring had obtained from Goebbels were sent abroad in a complex series of business agreements.[20] The Reichsmarschall employed rug merchant and sometime art dealer Sepp Angerer to represent him. Angerer had international business contacts, and the initial negotiations with foreign art dealers for the *entartete Kunst* took place in Paris on 21 May 1938, before the *entartete Kunst* law took effect.[21] Angerer met with, among others, Amsterdam banker Franz Koenigs, who arranged to buy Van Gogh's *Dr. Gachet* and his *Garden of Daubigny* as well as Cezanne's *The Quarry* for the considerable sum of 12,000 English pounds and RM 800,000 worth of *Sperrmarks* (blocked marks).[22] Angerer sold the ten remaining pictures that he had at his disposal, and they were dispersed to a variety of places. He traveled to Sweden, where he sold works by Munch and Signac, and to London, where he exchanged two other pieces by Munch for more foreign currency.[23] For his efforts, Angerer received RM 15,000.[24]

Sepp Angerer was not the only one to profit from these clandestine deals. Göring used some of the money earned from the sales to purchase tapestries, which found their way to Carinhall. Angerer bought six tapestries for the Reichsmarschall in Italy for 400,000 lire, and the art dealer Karl Haberstock, who had a London branch of his business until the outbreak of the war, procured for Göring Lucas Cranach's *Nymph at the Spring*.[25] Göring also reportedly attempted to sell works in his care to foreigners.

The American correspondent William Shirer told of being offered a painting by Oskar Kokoschka in exchange for dollars during an interview with Göring in the latter's office in the Aviation Ministry.[26] Although Göring used the profits from such entrepreneurial efforts to bolster his own collection, he attempted to conceal, or at least obscure, any illegality. One effective maneuver was simultaneously to buy and trade art for the benefit of Hitler. As part of the Angerer-arranged exchanges, Göring procured "eight tapestries after Albert Auwerx's Gothic myths for the Führer."[27] This not only allowed Göring to appear loyal to Hitler but also provided a suitably complex business deal with which to camouflage his own machinations.

Göring concealed the personal benefit he derived from the sale of the paintings entrusted to him by giving the illusion that he was disposing of art in a proper and unselfish manner. Previously he had assured Goebbels that he would indemnify the relevant museums once the sales and exchanges were completed.[28] Indeed, he made token gestures along these lines so that he could claim to have acted with propriety. At the same time, he avoided paying the full reimbursement, thus ensuring his own profit. The exact details regarding Göring's dealings in this affair may never be known completely. His files and correspondence as Ministerpräsident of Prussia, for example, indicate that he made compensation payments in a number of cases: RM 100,000 was paid to the Folkwang Museum in Essen as a result of their having lost Cezanne's *The Quarry*; RM 150,000 went to the Frankfurt Städtische Galerie for Van Gogh's *Dr. Gachet*; and RM 150,000 and RM 15,000, respectively, went to the Berlin Nationalgalerie for Van Gogh's *Garden of Daubigny* and for four pictures by Paul Signac and Edvard Munch.[29] The records of payments to the Prussian state museums and the letters of thanks sent to Göring by various officials – including Paul Rave of the Berlin Nationalgalerie and the Bürgermeister of Essen – only underscore the effectiveness of Göring's obscurantist tactics.[30] The Reichsmarschall, who acted the part of both barbarian and aristocrat, generally sought the veneer of legality in his art collecting, but his perfidy becomes evident upon closer scrutiny of his transactions.

The selling of the degenerate art on behalf of the Reich lasted until 1942.[31] Most of the revenue derived from the sales went into a special account at the Reichsbank – the *Sonderkonto Entartete Kunst* (Special Account for Degenerate Art) – which was overseen by the RMVP.[32] All told, the disposal action raised slightly in excess of RM 1 million; of that, 570,940 Sf, the largest single source, came from the sale at the June 1939 Galerie Fischer auction in Lucerne.[33] Although there was much talk that the funds raised by selling the degenerate art would go to fuel the German war machine,

the reality was quite different. Certain museums obtained partial compensation for their losses. The Nationalgalerie in Berlin, for example, received approximately a sixth of its total loss, which was over RM 1 million; the rest was converted to sterling and placed in a London account that was used to acquire traditional art desired by Hitler.[34]

Hitler was interested in many aspects of the disposal action, although he often used his adjutants or Martin Bormann (at that time the chief of the cabinet in the office of Deputy Führer Rudolf Hess) as intermediaries. Bormann, for example, would receive reports about the ongoing negotiations for artworks. In one case a Norwegian envoy tried to arrange for an Oslo art dealer to buy fourteen pictures by Edvard Munch, and Bormann was kept abreast of the situation by the RMVP.[35] Bormann also approached Hitler with the suggestion for the Lucerne auction. He reported on Theodor Fischer, an "Aryan" art dealer in Lucerne who had visited the Köpenickerstraße and Niederschönhausen storage facilities in the fall of 1938, and who had discussed the potential sale with Karl Haberstock and other members of the Disposal Commission.[36] The results of this meeting had been presented to Bormann, who in turn took the plan to Hitler for approval. It was suggested that the finest works seized in the *entartete Kunst Aktion* be placed on the auction block. The report estimated that "about thirty thousand English pounds" would be raised by the sale.[37] Hitler therefore had considerable knowledge of the disposal measures, and he bore ultimate responsibility for the decision to put the despised art up for sale.

The public auction at the Hotel National in Lucerne on 30 June 1939 proved something of a disappointment to the Nazi government. There had been great fanfare prior to the sale, with the 125 pieces put on display in Zurich from 17 to 27 May, before they were moved to Lucerne.[38] Indeed, the auction was well attended, as reported by the London *Times*, which noted that "directors of art galleries from all parts of the world, international art dealers and numerous private purchasers" made their way to the unique event.[39] Certain pieces fetched more than had been expected. The Munich Van Gogh *Self-Portrait* offered at 145,000 Sf brought 175,000 Sf ($40,000), and Picasso's *Two Harlequins* sold at 80,000 Sf, instead of the list price of 52,000 Sf.[40] Most of the works, however, did not elicit the bids that had been anticipated. Thirty-eight lots even remained unsold, including two works by Picasso, *Head of Woman* and *The Absinth Drinker*.[41] As noted above, the revenue from the Fischer auction came to 570,904 Sf–a rather disappointing sum.[42] Another, smaller Swiss auction took place at the Galerie Fischer in Lucerne at the end of August 1939. The thirty unsold works from the June auction and eleven new pictures were offered just prior to the outbreak of

war; but there was evidently little interest, as few of the works sold.[43] The reasons for these substandard sales are not clear. Perhaps some buyers held back because they knew who was to benefit from the proceeds. Fischer himself believed that a cabal of art dealers conspired to keep the prices low.[44] Still, this does not accord with the high turnout of professional dealers and collectors among the approximately 350 people present for the Lucerne auction.[45]

Lovers of modern art should have, according to logic, made sure that all the pieces put up for auction found buyers. Four months earlier Joseph Goebbels had approved a proposal by Franz Hofmann to burn those modernist artworks deemed impossible to sell.[46] Hofmann had previously made similar requests to Goebbels on 12 December 1938 and 19 January 1939.[47] However, other staff members in the RMVP as well as members of the Disposal Commission such as Haberstock, Scholz, and Taeuber opposed such radical measures.[48] One employee, Rolf Hetsch, apparently managed to save a substantial portion of the stock. Hofmann envisioned burning all 12,167 works left in the storage facilities in February 1939 (in one memo he noted that the space was needed to store grain), but ultimately 4,829 (1,004 paintings and 3,825 drawings) were classified as worthless and made eligible for destruction.[49] This was done on 20 March 1939 in a secret bonfire – quite unlike the public book burnings of 1933 – in the courtyard of Berlin's main firehouse.[50] The surviving works remained in storage, out of public view, until the end of the war.

Neither the incineration nor the auction marked the culmination of the *entartete Kunst Aktion*. The dealers Ferdinand Möller, Hildebrand Gurlitt, Bernhard Boehmer, and Karl Buchholz continued to sell modern works for convertible foreign currencies. In an internal RMVP memorandum written in January 1940 by Franz Hofmann shortly before he was dismissed from his position as head of the Visual Arts Department, he recommended that the "liquidation measures" be concluded by that summer because the war had made sales difficult, especially to buyers in America.[51] Goebbels filed a "closing report" with Hitler on 4 July 1941, somewhat prematurely, as a few sales took place in 1942. He calculated that 300 paintings and 3,000 works of graphic art were sent abroad and that these pieces had brought in English, American, French, and Swiss currency as well as much "valuable" art in exchange.[52] On balance, the Nazis cannot be described as shrewd businessmen in their selling of the unwanted art. Although the auction was not a complete failure, the individual sales engineered by the complicitous art dealers were often shameful, as they generated paltry sums for the government, such as $20 for Beckmann's *Southern Coast* and $10 for Lehmbruck's

Kneeling Woman.[53] The one-sided trades orchestrated by the dealers were often equally outlandish. For example, twenty-five of Kirchner's oil paintings were exchanged for a Romantic landscape by a student of Caspar David Friedrich.[54] Goebbels and those in charge of the *entartete Kunst* action settled for very modest results, especially after the outbreak of the war, when the value of the modern works plummeted. Disposal, not income, became their primary concern.

The Nazis' disposal of the purged art is remarkable not only because it marked an escalation in the illegality of their behavior but also because it entailed relatively cooperative and *kameradschaftlich* conduct. Aside from Bernhard Rust's periodic demands on behalf of the state museums, there were few disagreement or arguments among the governing elite. Goebbels played the key role among the ministers. Yet he not only allowed Göring a free hand with some of the artworks under his control but also involved other leaders in the liquidation measures. Both Deputy Führer Rudolf Hess and Minister of the Interior Wilhelm Frick, for example, were consulted in the drafting of the *entartete Kunst* law of 31 May 1938, and Bernhard Rust was kept abreast of the entire action.[55]

Goebbels's decision to yield to Rust's demands and to provide partial compensation to the museums took the guise of generosity. An RMVP internal memorandum noted that "this compensation is not founded on legal obligation, but comes exclusively from reasons of fairness."[56] Shortly thereafter, Dr. Lucerna, a bureaucrat in the RMVP, wrote Rust that the money being given to the museums was not *Entschädigung* (compensation), but a *Zuschuß* (grant).[57] The propaganda minister probably adopted such a cooperative approach during the disposal action because of his career difficulties at this time and Hitler's close supervision. The Führer had personally assured the director of the Bayerische Staatsgemäldesammlungen, Ernst Buchner, that profits from the *entartete Kunst* sales would be directed to the concerned galleries, and Goebbels's reputation suffered damage due to the scandal that arose from his affair with actress Lida Baarova.[58]

ATTACHING ARTWORKS IN AUSTRIA

The NS leaders' increasingly bold course of action in 1938 manifested itself not only in regard to their treatment of artworks belonging to the state but also in their policies toward Jewish-owned art. After the *Anschluß* of March 1938, Austria, or more specifically Vienna, served as the crucial testing ground for NS policies with respect to artworks possessed by those

deemed *Volks-* or *Staatsfeinde* (people's or state's enemies).[59] While the *entartete Kunst* disposal process featured personal corruption (especially by Göring) and tragedy (the auto-da-fé in March 1939), the Nazis' behavior with respect to the Jews constituted a different type of illegality. This was plundering, or *Kunstraub*, and the targets were not only artworks and institutions but human beings.

The experience of Baron Louis de Rothschild, despite his extraordinary wealth, is perhaps most emblematic of the Nazis' confiscation program in Austria. Immediately upon the German *Einmarsch* on 13 March 1938, the Nazi authorities, led by SS chiefs Reinhard Heydrich and Karl Wolff, organized a search for the various members of the illustrious family. While some, like Alphonse and Eugénie, managed to flee the country, Louis de Rothschild ("the richest Viennese during the 1930s") was denied exit from the country at the Aspern airport and then arrested the following day at his palace.[60] Imprisoned at Gestapo headquarters in the Hotel Metropol—the fifteenth floor also serving as a prison for Chancellor Kurt von Schuschnigg— Rothschild remained in custody for nearly nine months, until he, in effect, ransomed his property for his freedom. As Louis de Rothschild reportedly possessed more than a thousand paintings, including Rembrandts, Bouchers, and other old masters, the price was very high indeed.[61] The Nazis wanted the collection so desperately that Himmler, Kaltenbrunner, and Wolff—three of the highest-ranking members of the SS— visited the baron on 12 December 1938 in order to negotiate the deal that led to his release.[62]

The Gestapo clearly jumped the gun in pursuing these declared enemies and their property; the order that authorized confiscations of Jewish art was not drafted until the following month.[63] The 26 April 1938 Ordinance for the Registration of Jewish Property required Jews to submit lists of all possessions (except household goods and personal objects) with the state by 30 June and provided for "these objects to be secured in accordance with the dictates of the German economy."[64] A series of further measures to facilitate confiscations followed later in 1938. Most important were the 20 November 1938 Ordinance for the Attachment of the Property of the People's and State's Enemies (which applied to non-Jewish enemies of the regime) and the more stringent 3 December 1938 Ordinance for the Employment of Jewish Property.[65] While always confusing and often redundant—over 400 anti-Jewish measures were passed during the Third Reich— these ordinances aimed at Jewish property provided an almost inescapable legal net which the Nazis used to snare their victims.[66]

Although these ordinances applied to the entire Reich, the Nazis—or

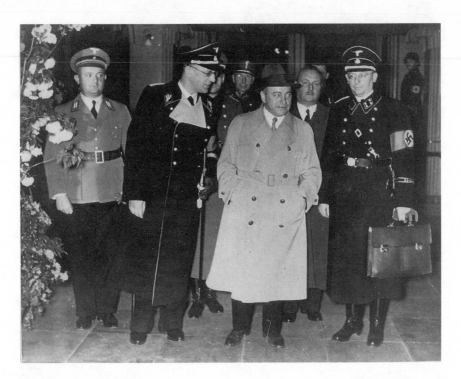

Seyss-Inquart (middle left) and Bürckel (middle right) before a Reichstag session, March 1938
(BAK)

specifically the Gestapo and the SD – first concerned themselves with Jewish artistic possessions in Vienna. Along with Reichsführer-SS Heinrich Himmler and SD-Chief Reinhard Heydrich the other important actors in the Viennese confiscation campaign were Josef Bürckel, who carried the weighty titles Gauleiter of Vienna and Reich commissioner for the political, economic and cultural incorporation of Austria into the Reich; Arthur Seyss-Inquart, the Reich governor of "the Ostmark" (Eastern Marches), as Austria was temporarily renamed; and his assistant, Kajetan Mühlmann, who held the post leader of the Art and Culture Department in the Ministry for Inner and Cultural Affairs, and the head of Department III in the office of the Reichsstatthalter, which oversaw the administration and attachment of "*volksfeindliche*" property.[67] All of these figures were officers in the SS. For this reason perhaps, order prevailed at the beginning of the collection action. The Gestapo and SD carried out most of the confiscations, and they worked quickly. By January 1939 Himmler reported to the Reich Chancellery that RM 60 to 70 million worth of art had been seized and put in storage in the Rothschilds' hunting retreat at Waidhofen an der Ybbs and in the Neue Hofburg palace in the heart of Vienna.[68]

Seyss-Inquart, Mühlmann, and Goebbels in Vienna, greeting Nazi alte Kämpfer, *1938* (BAK)

As early as June 1938 Hitler directed his attention to the fate of this growing stockpile of treasure. The Führer instructed Lammers to write to Himmler on 18 June 1938, with explicit orders that the art should not end up in the hands of the leading personalities of the state or the Party; copies of the letter were specifically directed to Goebbels, Frick, Rust, and Seyss-Inquart.[69] On 13 August 1938 Hitler rejected Himmler's suggestion to remove the "secured" art objects to Berlin and/or Munich, explaining that he did not want the objects to leave Austria.[70] In June 1939 Hitler traveled to Vienna, and escorted by Mühlmann he toured the repositories.[71] He formulated specific plans for the confiscated artworks and therefore zealously guarded his right to determine their fate.

The disposal of the *entartete Kunst* proved important to the plundering in Austria in ways other than being a part of the Nazis' increased criminality: the sale of the unwanted art established the Führer's prerogative over pieces impounded by the government. The 31 May 1938 *entartete Kunst* law read, "The Führer and Reich Chancellor orders the taking in [of all degenerate art]. He has authority over those objects which are given over to become property of the Reich."[72] With the radicalization of the government's policy, where the confiscation of state property escalated into the seizure of private property, Hitler maintained his predominance. Indeed, his abil-

ity to decide the fate of the artworks constituted an expression of the *Führerprinzip.*

During the Austrian episode Hitler articulated a policy that came to be referred to as the *Führer Vorbehalt* (reservation for the Führer). This term first came into use in June 1938, and it served as the foundation for his subsequent claims on the Nazis' plunder. Hence, for example, a November 1942 *Vermerk* by Lammers, which listed the orders stemming from the Führer concerning the seized art, detailed the progression: Hitler first gained authority over art confiscated in Austria, then in the entire Reich, followed by Bohemia and Moravia, Poland, and eventually all of the occupied territories.[73] This series of decrees reflected the Nazis' propensity for issuing redundant orders and illustrated the importance Hitler attached to art, as he singled out this category of *Vermögen* (property) above all others as meriting distinct and explicit measures.

The primary articulators and proponents of the *Führer Vorbehalt* were Reichsminister Hans Heinrich Lammers, chief of the Reich Chancellery, and Reichsleiter (later Reichsminister) Martin Bormann, who served under Hess until the latter's flight to Scotland in May 1941 and thereafter headed the newly created Party Chancellery. These two men made their careers by controlling access to Hitler. Lammers had arranged by 1943 to have all of Hitler's decrees (*Erlaße*), save those applying to Albert Speer, come through his office. Bormann, the "*èminence Grise* of the Third Reich" (to use Heinz Guderian's description), constantly looked after what he thought to be the Führer's interests.[74] These two men fought Hitler's *Papierkrieg* – one from the state side, the other from within the Party. Despite Lammers's and Bormann's skillful handling of the *Papierkrieg*, other Nazi leaders still managed to commandeer artworks. "Hitler's order that he alone maintained the power of determination over the artworks in Vienna at this time was evidently not taken very seriously."[75] The two masters of Hitler's antechamber therefore resorted to means other than decrees and *Rundschreiben* in venturing after art for the Führer.

Their most effective method of controlling the seized artworks was to employ agents to do the Führer's bidding. In Vienna they enlisted the services of Karl Haberstock, the Berlin art dealer who was participating simultaneously in the disposal of the *entartete Kunst.* In late 1938 Haberstock formally agreed to serve as Hitler's adviser on the art taken from Austrian Jews, as he was to appraise the objects stored in the Neue Hofburg and the Rothschild hunting lodge and then make recommendations concerning their fate.[76] The SD, as Heydrich wrote Lammers in April 1939, was at that time charged with the inventory and administration of the confiscated art in Vienna.[77] They opposed the intrusion of Haberstock, whom they per-

ceived as an outsider. Only Bormann's and Lammers's active intervention enabled Haberstock to make any progress toward carrying out his appointed task. This intervention took multiple forms: they wrote strongly worded letters of support (not only to Heydrich and Himmler but also to Bürckel and Seyss-Inquart) and gave practical assistance, such as help in procuring catalogs and albums from art dealers.[78]

Karl Haberstock encountered opposition not simply because he was an outsider and a latecomer to the Austrian confiscation action but also because he was charged with implementing in Vienna a controversial policy conceived in Berlin. Hitler decided that the seized art would be divided among the museums of the entire Ostmark. This entailed sending much of the art to provincial museums, most notably those in Innsbruck, Graz, Salzburg, and Klagenfurt. As most of the confiscated works had come from Vienna, the cultural center of the nation and home to most of Austria's Jews, the distribution plan meant that Vienna would lose some of its luster.[79] Hitler had developed ambivalent feelings about the Austrian capital in his youth after having spent a number of frustrating and unsuccessful years there (he was twice denied entry to the Akademie der bildenden Künste). The Nazi *Bonzen* (bigwigs) in Vienna – not only Bürckel and Seyss-Inquart but also the directors of the city's cultural institutions, such as Fritz Dworschak, the director of the famed Kunsthistorisches Museum – quite understandably resisted both Hitler's specific redistribution plan and his more general efforts to humble the city, a rival of Berlin as the jewel of *Mitteleuropa*. The plan therefore exacerbated the already existing tensions between the *Reichsdeutsche* and the Austrians.[80]

The efficient and relatively frictionless confiscation action led by Himmler and Heydrich gradually gave way to the more typical infighting and confusion when the Nazis moved on to the next phase and attempted to determine the fate of the art that they had secured. High stakes were involved. Haberstock, in one of his preliminary reports to Hitler, counted among the treasures thirty-six works by Rubens, eighteen by Titian, and twenty by Lucas Cranach.[81] As few officials really understood how the jurisdiction over the art had been demarcated, it became the norm to proceed with as much bluster and confidence as possible. Dworschak of the Kunsthistorisches Museum told Haberstock in May 1939 that Seyss-Inquart had been given exclusive control over the confiscated art and that only the Führer's explicit orders could override the Reich governor's authority and allow for the removal of the pieces from the Neue Hofburg.[82] While archival records offer no documents supporting Dworschak's claim, Seyss-Inquart and other like-minded leaders nonetheless temporarily blocked

Hans Posse, Direktor of the Führermuseum and Dresden Gemäldegalerie (BAK)

Haberstock from implementing the redistribution plan. A variety of techniques were used to keep the artworks in Vienna, including seemingly trivial obstructions, such as preventing Haberstock from obtaining the lists and photographic materials that he needed.[83] The Berlin art dealer's imperious attitude contributed to a rift with other Viennese authorities. As Bürckel wrote to Bormann, "the arrogant demeanor of Haberstock is gradually wearing upon the nerves."[84]

Haberstock, despite a history of close cooperation with Nazi leaders and considerable experience with underhanded business deals, proved incapable of overcoming the infighting of Vienna. He accomplished very little in his tenure there, although he avoided major entanglements. In certain respects he acted cautiously–for example, advising against selling off the unwanted, modern Jewish-owned artworks because he feared that legal difficulties would arise once the works left the Reich.[85] Haberstock recognized his ineffectiveness and bowed out of the Austrian operation after only a few months. His replacement was a man whose career he had helped rehabilitate: Dr. Hans Posse, the director of the Dresden Gemäldegalerie from 1913 until the mid-1930s. Posse had lost his position after a dispute with a local Party official.[86] Haberstock talked to Hitler about Posse in the summer of 1938 and helped restore the director's reputation by providing

assurances that Posse was not soft on modern art. Hitler in turn brought up Posse's case with the Gauleiter of Saxony, Martin Mutschmann, and Posse regained the directorship of the renowned Dresden museum.[87]

Posse succeeded Haberstock as Hitler's chief adviser on art collecting in June 1939, when the Führer commissioned him to create an art collection for Sonderauftrag Linz (Special Project Linz), the plan to transform Hitler's childhood hometown into Europe's cultural mecca. The Führermuseum itself, a project awarded to Albert Speer, was to be the focal point of the cultural complex, standing out from the symphony, opera, theaters, library, and cinemas.[88] Although Posse learned of his role in the enterprise in late 1938, he did not receive his official commission as director of the Führermuseum until 26 June 1939.[89] Posse was instructed to refrain from publicizing the project—the quest to assemble the greatest art collection of all time–a policy that he generally followed.

In the early autumn of 1939, four months after his Sonderauftrag Linz appointment, Posse replaced Haberstock in Vienna.[90] Further discussions with Bürckel and Seyss-Inquart were necessary before he was to gain access to the confiscated art. The Reich Chancellery supported him with unambiguous orders, however, which made it impossible for the governing elite of the city not to recognize Posse as Hitler's agent–and hence the arbiter of the fate of the artworks. When Posse arrived in Vienna, he met with local officials and negotiated a compromise solution to the dispute over administering the confiscated treasure. Posse could select those artworks of outstanding quality that he deemed worthy of the Führermuseum (122 were immediately shipped to the Führerbau in Munich); the remaining portion of the art was to be administered by a state-sponsored institution, the Central Authority for the Protection of Monuments (Denkmalschutz).[91] Posse drafted a plan for Hitler, recommending how the confiscated artworks would be divided among the Austrian museums; but this plan was only provisional, and the art remained in the care of the Denkmalschutz office.[92]

The Denkmalschutz agency, led by Dr. Herbert Seiberl, was in principle responsible to the Reich government and therefore worked toward implementing Posse's plans for redistribution.[93] Because the agency also fell under the jurisdiction of the Ministry for Inner and Cultural Affairs, however, it afforded local officials in Vienna a means of retaining some control over the art in their domain. A joint administration of the plunder evolved that proved acceptable to all parties. As early as November 1939 Gauleiter Bürckel sounded enthusiastic about participating in this arrangement, as he wrote the Reich Chancellery that he was prepared to help cover any unanticipated expenses incurred by Posse.[94] The SS and the SD also

continued to play a role in administering the plunder, in part because they did not cease confiscating Jewish property until 1942, and in part because they wielded tremendous power in Vienna.

The exercising of arbitrary power remained a feature of the Nazi leaders' rule, and the administration of the secured art in Austria proved no exception. Despite having agreed to a compromise solution to the supervision of the Jews' cultural goods, which included tacit recognition of the *Führer Vorbehalt*, the Viennese officials still found ways to circumvent guidelines and act autonomously. For example, Seyss-Inquart and Bürckel used plunder as a source of presents. Both sent Hitler tapestries as personal gifts, apart from Posse and the Sonderauftrag Linz bureaucracy, and Seyss-Inquart corresponded with Gauleiter of East Prussia Erich Koch about the possibility of sending the latter a secured Gobelin tapestry for his official residence.[95] Decorating offices with confiscated Jewish property was also not uncommon. Bürckel decorated his Vienna residence and a *Klubhaus* outside the city with furniture and art from the depots (many of the pieces came from the Rothschild collection), and the RMVP office in Vienna took an assortment of rugs and furniture that had once belonged to Austrian Jews.[96] The Führer's edicts prohibiting government officials from expropriating *bildende Kunst* for personal use made the Nazi leaders more circumspect when talking about their conduct with respect to paintings and objets d'art, but because rugs and furniture were not explicitly covered by the *Führer Vorbehalt*, the Nazi leaders were more brazen in commandeering these objects. The leaders typically used discretion when discussing the acquisition of artworks. However, during the war a Gestapo agency called the Vugesta openly sold confiscated artworks in their possession to Nazi officials – including Bürckel's successor as Gauleiter of Vienna, Baldur von Schirach.[97] Regarding the sale of the property belonging to the dispossessed and deported, one 1941 document noted about the 60,000 Jews from the Reichsgau Vienna, "The sale . . . to old Party members and also to offices of the NSDAP will be carried out at this time by the 'Vugestap' at extraordinarily favorable prices."[98] The veneer afforded by a sales agreement was more than sufficient to cover the appearance of any impropriety.

Posse's job in Vienna became easier when the alliance between local leaders broke down. Seyss-Inquart and Bürckel, who had rarely worked without friction, had a decisive falling-out during the summer of 1939 when Bürckel dismissed one of Seyss-Inquart's favorites, Kajetan Mühlmann, from his post in the Ministry for Inner and Cultural Affairs. Mühlmann, according to Bürckel, had mishandled a theater group, the Wiener Werkel, whose productions included political satire.[99] The reason underlying the firing and the rift, however, went back to the tensions between *Reichsdeutsche*

and Austrians. Mühlmann and Seyss-Inquart were both Austrians who wished to keep the art in Vienna, and Bürckel (a *Reichsdeutscher*) was coming around to favor Hitler's and Posse's redistribution plans.[100] Mühlmann and Seyss-Inquart were also old friends, and the latter became enraged by Bürckel's unilateral decision to dismiss Mühlmann, who had by this point risen within the government to the position of Staatssekretär.[101] The ensuing battle came to involve Himmler and Göring, who both tried to restore calm.[102] The resolution of this conflict came only in the fall of 1939, when Seyss-Inquart and Mühlmann both assumed positions in the occupation of Poland: Seyss-Inquart as the deputy to the Nazi Generalgouverneur, Hans Frank, and Mühlmann as a special agent heading an art plundering unit.[103]

THE CONFISCATION OF JEWISH PROPERTY IN THE ALTREICH

The practice of seizing the art and property of Jews, which first proved so manageable and lucrative in Vienna, also occurred in the *Altreich* during the course of 1938. The regime-sponsored violence of *Kristallnacht* in November ushered in a period where the Nazis actively sought to attach Jewish property. Previously the government had adhered to the policy of pursuing only that property that belonged to Jews who had emigrated. Amid a more aggressive program to "Aryanize" Jewish businesses, and as a result of the more violent tenor of anti-Jewish agitation, a number of cases arose where Jews still living in the Reich lost their property.[104] These harsher legal measures also dovetailed with greater corruption among Nazi officials; in aggregate, this led to a marked increase in the severity of the persecution.

In this radicalization process a number of events emerged as crucial to the gradual exclusion of Jews from the nation's cultural life (and then, of course, far worse): the Nuremberg Decrees of September 1935, which attempted to define who was a Jew and which deprived such individuals of German citizenship and certain civil rights; Goebbels's ordinance of February 1936, which forbade Jewish art dealers or purveyors of culture (such as book dealers) from being members of the RKK; and the aforementioned Ordinance for the Registration of Jewish Property of 26 April 1938, which required Jews to register property valued at more than RM 5,000 with the state.[105] On 12 November 1938, in the wake of the *Kristallnacht* disturbances, the First Ordinance on the Exclusion of Jews from German Economic Life was passed. On that same day Goebbels issued another important decree that prohibited Jews from entering theaters and museums or attending

"cultural events."[106] The 20 November 1938 Ordinance for the Attachment of the Property of the People's and State's Enemies was followed the next day by the levying of an "atonement tax" (*Sühneleistung*) – by order of the economics minister – which required Jews to pay 20 percent of the assets they had declared as per the April decree.[107] The intent of this last measure was to raise RM 1 billion, the penalty for their having supposedly incited the *Kristallnacht* violence.

The confiscation of artworks belonging to Jews in the *Altreich*, a process that occurred between 1938 and 1941, is comparable to the events in Austria in terms of corruption and competition. Jews throughout Germany suffered as a result of the government's expropriation policies, and the example of the city of Munich conveys the nature of the program as well as its organizational dynamic. While Munich's Jewish residents did not possess collections of the same size or quality as Vienna's Rothschilds, Lanckoronskis, and Bondys, there existed more than enough riches for a fight among the Nazi authorities.[108] One report from 1942 noted that the confiscations began "in the course of the *Judenaktion* of November 1938" and that the Gestapo seized over 950 objects from fifty-eight individuals and one art dealership, the Bernheimer Galerie.[109] As in Vienna, the local museum directors proved not only compliant but also complicitous. The Bayerische Staatsgemäldesammlungen director Ernst Buchner and his colleagues assisted the Gestapo in various ways, including providing storage space for the seized artworks (most went to the Bayerisches Nationalmuseum).[110] The Gestapo agents again showed themselves to be voracious thieves. Even Munich Oberfinanzpräsident Wiesensee noted in a 1942 letter that Himmler's forces were overly zealous. Twenty-two of the fifty-nine collections they had seized belonged to Jews who had not emigrated at the time of confiscation.[111] According to the legal statutes, Jews should have registered their valuable artworks with the government, but unless they had left the country or owed taxes to the Reich (including the atonement tax), they should not have been subjected to a loss of property. Wiesensee was aware of this discrepancy between law and deed, but he still endorsed the confiscation of the 192 pieces from the twenty-two collections.[112]

Oberfinanzpräsident Wiesensee, one of the government officials who determined the fate of the art confiscated in Munich, seemingly had little choice in 1942 but to adopt the above-noted position. Many of the pieces had already been distributed by this point. Hans Posse, wielding orders from Martin Bormann (and hence Hitler), had arrived on the scene in the summer of 1939 to take those pictures he thought suitable for Sonderauftrag Linz. Posse removed only five paintings from the Gestapo-managed

warehouses in Munich, but he reserved the right to acquire more on a future visit.[113] The city's museums, according to Hitler's explicit order of 7 November 1940, had also been allowed to enhance their collections with this confiscated art. The Nationalmuseum, the Städtische Galerie, the Kunsthistorisches Museum, and the Pinakothek obtained works from the Munich depots, with payments to the Gestapo by way of the Bank der Deutschen Arbeit.[114] The municipal museums purchased this confiscated art in sizable quantities, with the Nationalmuseum, for example, allocating RM 253,610 for these favorable deals.[115]

The museum directors had no illusions about the origins of this art. For one, the price lists they used, now in the Bundesarchiv in Koblenz, noted the former Jewish owners.[116] The Generaldirektor of the Staatsgemälde-sammlungen and later professor at the University of Munich, Dr. Ernst Buchner, was involved in a variety of sordid affairs, from helping Munich's Gauleiter Adolf Wagner select from the seized stockpile "representative decorative pieces (*Wandschmucke*) for the various state and Party buildings," to leading an expedition during the war, where he hunted down the Van Eyck brothers' famous *Mystic Lamb* altarpiece in a journey stretching from Brughes to Pau (in unoccupied France).[117] With the support of museum officials such as Buchner, the Gestapo liquidated the art. The prices were again very reasonable. For example, the Gestapo sold a small Lenbach painting to the Städtische Galerie for RM 800, and an important landscape by Hans Thoma to the Neue Pinakothek for only RM 7,000.[118] With these bargain prices, Munich's museum officials did not resist the opportunity to expand their collections.

The confiscation actions in Vienna and Munich illustrate a phenomenon common in cities throughout the Reich. In all cases Himmler's and Heydrich's forces were the first to be let loose on the vulnerable, stateless Jews. They controlled both the forces carrying out the raids and the concentration camps that came to house many of the victims. The deportation actions undertaken during the war only increased the scope of their activities. With the gradually escalating oppressiveness of the regime in the course of the late 1930s (perhaps better described as the transition from authoritarianism to totalitarianism), and the concomitant radicalization of the government's *Kunstpolitik*, so grew Himmler's influence over the cultural life of the country. The consolidation of power effected by Himmler within his own bureaucratic empire – by June 1936, he had control of both the political and criminal police in the Reich as well as a growing SS empire – provided him with tremendous resources. Himmler proved eager to utilize these resources, frequently cooperating with other NS leaders to extend the state's control over the population.

The inroads into the cultural realm made by the Reichsführer-SS initially came by way of collaboration with other Nazi leaders. Himmler, for example, put his forces at Goebbels's disposal, as the latter attempted to enforce measures issued by both the RMVP and the RKK. More specifically, the RkdbK imposed numerous restrictions on artists, most commonly imposing either a *Malverbot* (ban on painting) or an *Ausstellungsverbot* (prohibition of the exhibition of works). Emil Nolde, whose Expressionist art elicited a *Malverbot* in 1941, recalled after the war that Gestapo agents would visit his home and inspect his brushes to see if the remnants of fresh paint were discernible (he thus worked only with watercolors because, unlike oils, they were odorless).[119] Himmler's agents also confiscated the books that had been proscribed. Amidst the modernist debate in late 1935, volumes featuring the art of Franz Marc, Ernst Barlach, and Wilhelm Lehmbruck, among others, were seized by the Gestapo.[120] Himmler's police forces cooperated with Alfred Rosenberg's Kulturpolitisches Archiv (a division of the DBFU), as they shared information about individuals who they suspected might be culturally or politically subversive.[121] During the first years of the Third Reich, Himmler proved more an executor than a formulator of cultural policy. Yet he and his agents played an undeniably important role in implementing the regime's opprobrious measures.

Heinrich Himmler did, however, affect the course of the regime's administration of culture. First, he and his forces provided the government with the means and resources to oppress and terrorize, therefore contributing to the radicalization process. Adolf Ziegler would have been less inclined to issue a *Malverbot* if he thought it was unenforceable, and confiscations would have appeared a less attractive option if they had not been carried out so efficiently. Second, Himmler had specific ideas of his own about art and culture, which he advanced with great conviction. Always considered by other Nazi leaders to be somewhat eccentric in his cultural views, Himmler developed interests centered around the "exploration of the Northern Indo-Germanic race and its achievements."[122] His highly racialist worldview, his passion for Teutonic myth and imagery, and his idiosyncratic understanding of history all contributed to his bizarre conception of German culture. Himmler's Nordic-pagan obsession, while not entirely within the mainstream of NS thought, nonetheless found supporters, and they, as a whole, exerted considerable influence on the cultural life of the nation.

Himmler's importance within the cultural bureaucracy stemmed not

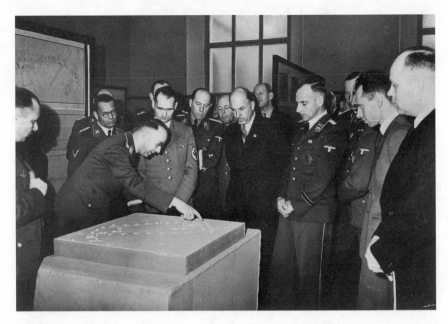

Himmler, Bouhler, Hess, Todt, and Heydrich, among others, at exhibition Aufbau und Plannung im Osten, *1941* (BHSA)

merely from his control of the police and the paramilitary SS troops but from organizations over which he presided that were dedicated to cultural and scientific matters. Foremost were the Ahnenerbe (literally, "legacy of ancestors"), the Society for the Care of German Cultural Monuments, and a publishing house, the Nordland Verlag. The Ahnenerbe was the most important of these institutions. Himmler assumed the presidency of this so-called *Forschungs-und-Lehrgemeinschaft* (Research and Teaching Community) at a relatively late date in 1939; yet the organization was an official organ of the SS as of 9 August 1937 and had ties to the personal staff of the Reichsführer-SS – including receiving funding – which extended back to 1936.[123] Himmler's financial assistance to the Ahnenerbe often came by way of diverting contributions made to him by a society called the Circle of Friends of the Reichsführer-SS.[124] Annual contributions from industrialists and others who shared Himmler's vision were kept in a discretionary fund, which increased from about RM 600,000 in 1936 to RM 8 million in 1944.[125] Himmler's enormous and ever-expanding SS empire provided him with even greater sources of revenue, which he invested in a range of undertakings. The Ahnenerbe undertook a number of expensive projects, including extensive archaeological excavations in northern, central, and eastern Europe and expeditions to Tibet.[126] The researchers within the Ahnenerbe addressed Himmler's cultural concerns, exploring the history and civiliza-

tion of the Germanic peoples. Their studies, while "dedicated to the service of [Himmler's] fixed ideological goals," were undeniably interdisciplinary, as they embodied a mixture of archaeology, anthropology, biology, history, and art history.[127]

The Ahnenerbe organization's involvement with art usually occurred in an indirect manner – as an outgrowth of other projects. For example, they operated a publishing house, the Ahnenerbe-Stiftung Verlag, and among the titles they distributed were a number dealing with art. A Dr. Lehrmann wrote a book, *Deutsche Volkskunst,* and a tract, *Die einzige Wahre Quelle der Kunst ist unser Herz* (The only true source of art is our heart), both titles suggesting the ideological inclinations of the publishing house.[128] The Ahnenerbe researchers also organized exhibitions that included artworks. For example, one characteristic show held in Innsbruck in 1943 was entitled *Der Nordische Bauernhof an der Südgrenze des germanischen Lebensraum* (The Nordic peasant farm on the southern border of the Germanic living area); paintings and folk art, along with photographs, formed the core of the exhibition.[129]

In attempting to act as a research center, the Ahnenerbe also administered scholarships. One, for example, called Stipend: Forest and Tree in the Aryan-Germanic Spiritual and Cultural History, included on the committee of selectors Hermann Göring, who was both Reich forest and hunting master; Reich Peasant (*Bauern*) Leader Richard-Walther Darré; and Himmler. Art historians, among others, applied for the scholarship. Dr. Hermann Bunjes of the Friedrich-Wilhelm University in Bonn, for example, who was later to work for the *Kunstschutz* (art protection) unit and the ERR in France and head the SS-sponsored Deutsches Kunsthistorisches Institut, proposed a research topic entitled "Forest and Tree in German Art."[130]

The members of the Ahnenerbe did not, however, confine themselves to innocuous projects. Later involved in gruesome medical experiments that relied on concentration camp inmates, they first helped with the plundering of art in Poland, the Baltic states, the South Tyrol, and parts of southeastern Europe. On Himmler's birthday, 7 October 1939, Hitler added one more title to the Reichsführer-SS's already substantial résumé: the post of RKFdV.[131] In attempting to aid those Germans outside the Reich, Himmler marshaled all of the resources under his control. Hence the Ahnenerbe, and specifically its business manager, Wolfram Sievers, became concerned with the cultural property of Germanic people outside the Reich. The Nazis effected massive population shifts in central and southern Europe just prior to and during the war; remarkable quantities of art became dislodged during these engineered migrations. Himmler, the great confisca-

Himmler and Hans Knappertsbusch at a concert in the SS concert hall (Tonhalle), *1934*
(BHSA)

tor of the Jewish treasures within the Reich, also proved very adroit at se-
curing art in foreign lands.

Himmler's interest in the visual arts should not be underestimated.[132]
Although much of his involvement with art arose due to police or military
matters, he believed that all true Aryans were men of culture and therefore
cultivated himself accordingly. He would invariably attend the annual Day
of German Art festivities in Munich as well as participate in exhibition
openings and conferences with art-related agendas. Himmler also main-
tained a vigorous correspondence with a number of art dealers.[133] This en-
abled him to amass a sizable collection (both personally and on behalf of
the SS). Perceiving himself as sensitive to culture, he welcomed contact
with Nazi writers and artists as well as scientists (hence the Ahnenerbe). In
the mid-1930s, for example, he corresponded with Wolfgang Willrich, the
aforementioned crusader against *entartete Kunst*.[134] Himmler's cultural pre-
tenses grew with his megalomania such that he confided to his masseuse
Felix Kersten in 1943 that he would seek the post of Kultusminister after the
Endsieg (final victory).[135] Along these lines, a hand-signed letter written on
26 February 1944 by Himmler to Oswald Pohl, the chief of the economics di-
vision of the SS, requested that *Schloß* Grünewald near Munich be bought
so that *irgend eine weltanschauliche Schule* (some kind of ideological school)

could be established.[136] Himmler indeed saw himself as capable of replacing either Bernhard Rust or Alfred Rosenberg. With an inflated self-image and boundless ambition, he played an important, albeit somewhat unlikely role within the NS cultural bureaucracy. As the master of the terror apparatuses in the Nazi state, Himmler's influence grew as the regime's policies took a more radical course.

4

ART AND AVARICE ABROAD
THE ADVENT OF NAZI PLUNDERING IN POLAND, THE BALTIC STATES, AND THE SOUTH TYROL, 1939–1940

The first organized *Kunstraub* on foreign soil occurred with the German invasion of Poland in the autumn of 1939. While there were indeed Gestapo and SD *Kunstkommandos* in the front lines of the *Einmarsch* into "rump-state" Czecho-Slovakia in spring 1939, these agents were relatively restrained in their behavior.[1] The state collections were not attached, largely as a result of the Nazi leaders' more grandiose plans for annexation and because most of the Jews who formerly lived there had fled, the Austrian precedent having sent a clear warning.[2] There were, of course, flagrant cases of expropriation. Hitler was known to have taken valuable tapestries from the Hradcany castle in Prague after his visit in mid-March 1939.[3] But such events were not part of an elaborate action. They were spontaneous expressions of the Germans' triumph, and more the exception than the rule.

In Poland – namely, the territories incorporated into the Reich (the four Gaue, which included Danzig, West Prussia, and the Wartheland) and the remainder of the country called the General Government – Göring, Himmler, and Hans Frank jointly oversaw an elaborate plundering bureaucracy.[4] These three crafted a network of overlapping offices and spheres of authority where redundant orders and personnel with multiple positions were the norm. Their looting program must be viewed as part of the more general occupation policies. "Poland too, was covered by this *Ostpolitik* – indeed, she served as its preliminary proving ground. This is where the techniques of Germanization, including systematic economic exploitation and the 'biological enfeeblement' of the native population, were first evolved and put into practice: forced labor, measures to curb the birthrate, 'removal' of the Jews, abolition of all centers of higher education and academic facilities open to Poles, and elimination of the Polish intelligentsia."[5] Hitler had personally ordered that the "Polish upper crust" must be liquidated so far as possible and that the national culture must be undermined to as great an extent as was feasible.[6] The plundering agencies worked toward these ends.

In comparison with the physical suffering inflicted on the Polish population, the confiscation of artworks seems almost insignificant. These seizures, however, beyond being a part of the broader occupation policies, had undeniable symbolic value. It was one thing for Himmler to write policy papers on plans to eradicate Polish culture, which he did.[7] It was a more vivid, and arguably more significant, act when Göring delivered thirty-one drawings by Albrecht Dürer to Hitler – works removed from the Bawarowski Museum in Lvov.[8] That these drawings, which Göring presented to Hitler in July 1941, were still known to be in the Führerhauptquartier in mid-1943 suggests that the deeper meaning may not have been lost on the recipient.[9]

The bureaucratic fortunes of Göring, Himmler, and Frank in Poland are difficult to assess, as each had successes and failures during the wartime occupation. Himmler prevailed in the initial stages (September – October 1939), when his SS and SD troops accompanied the invading German armies in the conquest of Poland. Members of the Ahnenerbe were also among the first to secure art in this region. Göring responded quickly with arrangements of his own, appointing Kajetan Mühlmann to head a task force that grew rapidly in importance. Ultimately Göring joined forces with Hans Frank, whom Hitler selected as his plenipotentiary in the General Government on 12 September 1939. Together they managed to assert themselves in the region, especially in late 1939 and early 1940 when much of the

booty was seized. Himmler remained a significant actor because of his SS empire. He responded to the challenge of Frank and Göring in December 1939 by issuing a new round of orders. A stalemate ensued, although the real losers were the Poles. Himmler emerged as the predominant figure in the parts of Poland incorporated into the Reich, with the other two having the upper hand in the General Government.

Explicit plans for confiscating art objects crystallized in the midst of the Polish campaign. As the army slowly began to engage their art protection (*Kunstschutz*) units–military personnel with the more honorable mission of preserving objects with cultural significance–they were promptly overwhelmed by Himmler's and later Göring's agents, who were more energetic and better organized.[10] As was often the case in the Nazi cultural bureaucracy, the functionaries in the service of the Reichsministers played a pivotal role. Wolfram Sievers, who answered to Himmler, was the first of these lower-ranking instigators, as he approached his chief with the idea of the Ahnenerbe taking over the "protection measures of prehistorical monuments in occupied Poland."[11] Himmler approved the suggestion, arranging for Sievers and Heinrich Harmjanz–an academic with ties to the Ahnenerbe–to head the GTO, the first unit organized expressly for expropriating property in Poland.[12] Sievers and Harmjanz employed two professors of ancient history (*Prähistoriker*), Peter Paulsen and Ernst Peterson, to draft a list of museums, noteworthy prehistoric material, and valuable art collections in the soon-to-be conquered land.[13] Many postwar scholars believe that the Nazi leaders employed art historians as spies prior to the outbreak of hostilities in order to glean information about the works possessed by the Poles. The trip of Breslau professor Dagobert Frey in December 1938, where the well-regarded Michelangelo scholar was shown collections and presented with art catalogs by his Polish colleagues, stands out as an especially suspicious episode.[14] The research conducted by Frey and other art historians was evidently put at the disposal of Himmler's forces (the SD, the GTO, and more specifically, the Sonderkommando Paulsen [Battalion Paulsen]). However, as the Poles had packed up and evacuated most of their cultural treasures to safer quarters, Himmler's agents initially made only limited progress in seizing the desired objects.[15]

The SD and the Sonderkommando Paulsen began their "securing" campaign in Poland in early October 1939, just after the capitulation of the Warsaw government on 27 September. Peter Paulsen, the leader of the Special Commando, was a Gestapo Untersturmführer (lieutenant), as was Peterson, which provided them with contacts to the SD and helped in the gathering of further intelligence and in the creation of their confiscation squad. Paulsen's commando was quite modest in size and required only two

Peter Paulsen, academic and SS plunderer responsible for Veit Stoß altar in Cracow (BDC)

trucks and a couple of nonmilitary automobiles for transportation.[16] The Sonderkommando's most significant seizure prior to its official dissolution the following summer was the altarpiece in the Church of Maria in Cracow.[17] Despite having been carved within the church in the fifteenth century, the elaborate wood sculpture was crafted by the great German-born artist Veit Stoß, and the Nazis therefore viewed it as a piece of their heritage.[18] At the outbreak of war, the Poles had dismantled and packed the massive altar and disbursed the crates to different locales in Poland, including the quiet town of Sandomierz on the Vistula. The Sonderkommando nonetheless located the pieces in early October and prepared them for transport to the Reich. Certain sections of the altar—most notably the twelve-foot-high apostolic figures that adjoined the panels—arrived in Berlin by mid-month, and the other pieces followed shortly thereafter. According to Hitler's orders they were placed in the vault of the Reichsbank in Berlin.[19] Aside from the one trophy described above, however, the damage wreaked by the Sonderkommando Paulsen was limited, especially in comparison with the agencies of Himmler and Göring.[20]

Göring and Frank made their move onto the plundering scene shortly after the first success of the Sonderkommando Paulsen. The Reichsmarschall met with Kajetan Mühlmann on 6 October 1939 and issued a wide-ranging commission to him three days later. The Austrian SS officer, who

Kajetan Mühlmann and Generalgouverneur Hans Frank in Cracow, 1940 (Rijksinstituut voor Oorlogsdocumentatie)

had been active in the confiscation of the artworks of Viennese Jews, was named by Göring as the special commissar (*Sonderbeauftragter*) for the securing of art and cultural treasures in the General Government.[21] Göring engaged Mühlmann in his capacity as chair of the Reich Defense Council, head of the Four-Year Plan, and chief of the HTO – the latter agency charged with extracting industrial and material wealth from Poland. Göring provided the funding for Mühlmann's staff by using the coffers of these various organizations (primarily the Four-Year Plan office).[22] Because Mühlmann worked in the General Government he also answered to Frank. Accordingly, on 15 November 1939, Frank issued the Order for the Confiscation of the Property of the Former Polish State Inside the General Government, which sanctioned Mühlmann's plundering in a more public fashion. A month later Frank signed a more far-reaching decree, the Order of the General Government for the Confiscation of the Entire Public Art Patrimony.[23] Mühlmann therefore answered to two masters at this point, although the number was to increase as he later plied his trade in other occupied lands.

Kajetan Mühlmann's task was to coordinate the plundering squads that descended on Poland. His closest associates, called his work staff, consisted of nine experts, eight of whom were trained Ph.D.'s. The participation of respected professionals – above all, academics and museum directors – stands out as one of the remarkable features of the *Kunstraub* in the Third Reich.[24] While hiding behind the euphemistic language of their orders – Mühlmann was to provide *einheitliche wissenschaftliche Leitung* (coordinated scientific leadership) and the artworks were to be *sichergestellt* (secured) – they all understood the nature of their project.[25] Mühlmann later admitted at Nuremberg that "in case of a German victory [the artworks] would not have remained in Poland, but would have been used for the completion of German art holdings."[26] During the war, he and his colleagues frequently referred to themselves as a scientific staff and trumpeted the claim that restoration work was performed on certain pieces, but they could never escape the transparency of these attempts at deception.[27]

Mühlmann himself had a notorious reputation, as revealed by a letter from the Gauleiter of his native region, Gustav Scheel, to Martin Bormann: "In terms of politics and character, the named enjoys no good reputation amongst the National Socialists of Salzburg. . . . He is recognized for his capability in the sphere of art scholarship, although earlier he expressly supported expressionist art. Mühlmann has a special talent for ferreting out art treasures."[28] Mühlmann can be characterized as an opportunist (the above quotation shows that he even lacked artistic principles) and as an uncouth rowdy. He was imprisoned four times in the 1930s for offenses in-

cluding pro-Nazi agitation, reckless driving, and "insulting a public official."[29] As argued above, the experts he employed had few doubts about the intentions of their leader. The fiction of being protectors of culture could not have withstood the reality that they were roaming the Polish countryside alongside the murdering squads of the SS.[30] Mühlmann and his band of experts quickly earned a reputation for unscholarly behavior. Word of their deeds got out to Polish émigré circles, as exhibited by a contemporary source who publicized this information, describing the commandos as "marked by particular and systematic brutality towards collections, museum staffs, and private owners."[31]

Mühlmann divided his staff into two work groups. One based in Warsaw and led by his half-brother Josef Mühlmann (a Gestapo agent) covered the northern part of Poland above the fifty-first parallel, and the other, the Südgruppe, worked out of Cracow and canvassed the south.[32] Their targets included state collections, universities, churches, and valuable private estates. Notable examples included the Royal Castle in Warsaw, the Cracow cathedral, the National Museum in Cracow, and the private collections of Prince Czartoryski, Count Branicki, and Count Adam Potocki.[33] Between the two work groups scarcely a city, town, or significant collection was left untouched. The commandos began in the cities and worked their way to the provinces. They proceeded very quickly, attaching 95 percent of Poland's artworks within the first six months.[34]

Mühlmann's agents in Poland were scientific to the extent that they employed a rational system to classify the secured artworks. The "scientific staff" was instructed to identify the most valuable pieces, which were referred to in the official correspondence as *wichtige Reichsinteressen* (important interests of the Reich), and then to list them in a catalog, called *Wahl I* (first selection). The 521 pieces that came to constitute *Wahl I* were photographed by the agency's picture archive, and a copy of this five-volume catalog, which depicted Poland's finest artworks, was presented to Hitler, who kept it in the Reich Chancellery and reportedly studied it carefully.[35] The pieces on the *Wahl I* list were reserved for the Reich, whether state museums or the Führermuseum, and were kept in storage either in the agency's facilities in Poland (the main depot being the Jagellonian Library in Cracow) or in a vault of the Deutsche Bank in Berlin.[36] *Wahl II* consisted of art that Mühlmann's experts deemed "not necessarily worthy of the Reich, but of good quality." This art was not photographed, and the inventory lacked the precision of the first group. *Wahl III*, the least valuable plundered art, usually ended up in the hands of General Government or SS officials as it was used "for representational purposes," a euphemism that meant that the occupying forces took the pieces to decorate their homes

and offices.[37] Examples of such expropriations include the Cracow Luftwaffe commander Major General Unger taking over twenty-one works (six from the seventeenth and eighteenth centuries), and an SS headquarters near Cracow commandeering ninety-seven pieces.[38] In addition to approved diversions of plunder, personal enrichment also took place. Odilo Globocnik, the former Viennese Gauleiter who oversaw the killing of Jews in the General Government (Operation Reinhard) was transferred to the Adriatic late in the war because of this improper allocation of confiscated property.[39] Yet the distinction between public and private was very difficult to ascertain amid the chaos in the east.

Heinrich Himmler attempted to impose order in this region by way of his expanding SS empire. Many of the actors in the plundering agencies were members of his SS. Mühlmann held the rank of an SS-Oberführer (colonel), and other key members of the occupation administration, such as Deputy-Governor Seyss-Inquart (an Obergruppenführer, or lieutenant general) had honorary SS affiliations. Himmler also used SS connections to infiltrate Göring's GTO. Because the GTO was headed by two of Himmler's close associates, Wolfram Sievers and Heinrich Harmjanz, it provided him with a means of encroachment. The GTO had branch offices throughout Poland, including in Poznan, Lodz, Kattowitz, and Gdansk, and they proved very effective in shipping artworks back to Germany.[40] Himmler's success in making these inroads emboldened him to issue orders, which, while often redundant, nonetheless confirmed his position as a ranking leader. For example, on 16 December 1939, the same day that Frank issued his far-reaching decree to seize nearly all art collections, Himmler circulated his own *Runderlaß* that ordered "the confiscation of objects from Polish and Jewish possessions that are of cultural, artistic or historic value."[41]

The reaction of Göring and Frank to Himmler's machinations was mixed. Generalgouverneur Frank vigorously resisted the initiatives of the Reichsführer-SS, as exemplified by his remarks in his journal concerning the rival 16 December order: "I am the representative of the Führer . . . and I can say that upon my protest, the decree of the Reichsführer-SS will be effectively withdrawn."[42] In contrast, Göring was more tolerant of Himmler's incursions, largely because he sought the use of SS forces as well as the scholars affiliated with the Ahnenerbe.[43] Himmler contributed further to the plundering campaign by creating four additional Erfassungskommandos (seizure commandos), which he placed in the service of the GTO.[44] These Erfassungskommandos operated primarily from the four GTO offices in Poland mentioned above. Like the SD-backed Sonderkommando Paulsen that preceded them, the units swept into designated areas and confiscated those artworks deemed valuable. A March 1941 report

of one squad's activities listed the seizure of 1,100 paintings and 25 sculptures as well as coins, Egyptian artifacts, porcelain, and weapons.[45] The targets of this Erfassungskommando included seventy-four castles, fifteen museums, and three picture galleries.[46] The commandos continued their confiscation activities until well into the war, though one of the four groups ceased operations in February 1941 when its two leaders (including the well-known professor Dr. K. H. Clasen) assumed posts at the reopened university in Poznan.[47]

The Nazi leaders themselves generally perceived this project of denuding Poland of its artistic treasures to be manageable and of limited duration. As they had little respect for the cultural accomplishments of the Poles, they expected a paucity of desirable art. Hitler explicitly stated that he anticipated finding few objects for his Linz Project in this land. For the most part, he hoped to "repatriate" the Germanic art that had found its way to Poland over the centuries.[48] Hans Posse, who visited Poland and met with Mühlmann and other plunderers in late 1939, confirmed this expectation, as expressed in a report to Bormann, where he noted, "Except for those artworks of top quality already known to us in Germany (e.g., the Veit Stoß altar, panels by Hans von Kulmbach from the Maria Church in Cracow, the Raphael, Leonardo, and Rembrandt in the Czartoryski collection) and a few works from the National Museum in Warsaw, there is not very much here for an enrichment of German possessions in the high arts (painting and sculpture)."[49] The primary objective of the Nazis, then, was to return Germanic art *heim ins Reich*–a theme that recurred throughout the war in their explanations as to why they secured art in foreign lands.

The Nazi elite's brash attitude toward Germanic art in conquered Poland had first been demonstrated by their treatment of the Veit Stoß altar. The altarpiece, although carved by a Nuremberg artist, had been commissioned by the regent of Poland 400 years earlier. The Poles had taken great expense to restore it in 1933.[50] Still, there was no question in the Nazis' minds that this masterpiece would be removed to the Reich, as Veit Stoß was "the darling of the Poland-is-really Germany school."[51] While the Sonderkommando Paulsen had first seized the altar and shipped the apostolic figures back to Berlin in October 1939, a dispute arose over which leader was to have control over the main panels.[52] Hitler personally determined their fate, and he charged Albert Speer with overseeing their transportation from Cracow. So sure were the Nazis of their right to reclaim their cultural heritage that even the *anständig* (respectable) one, Speer, allowed himself to be openly involved, as Speer's name appears frequently in the administrative documentation of the project.[53] The mayor of Nuremberg, Willy Liebel, made the most convincing appeal to Hitler, arguing that

the city's ties to the artist and its famed Germanisches Museum warranted a decision in his favor.[54] Nuremberg eventually obtained the altar after Speer, using his *Vollmacht* from Hitler, energetically collected the altar's panels that had been dispersed (one had gone to Himmler in Berlin and another had remained in Cracow). Other issues, such as Goebbels's desire to create a touring exhibition of the altar – to celebrate both its return to the Reich and the 500th anniversary of the artist's birthday – also had to be decided.[55] The Veit Stoß altar spent the war sitting unseen in vaults below the main square in Nuremberg, not far from the jewels of the Holy Roman Empire that had been removed from Vienna.[56] The Nazi elite, while not overly eager to flaunt their plunder, nonetheless publicly justified the actions. "Reclaiming" the German cultural legacy fit in well with their broader ideological precepts of creating a unified and more dominant *Volk*, and was thus official policy.

The Nazis' measures to locate and confiscate Polish art were acts of purposeful destructiveness only to a limited degree. Granted, the invaders remorselessly bombed the beautiful city of Warsaw into rubble, and the atrocity stories about Polish cultural treasures merit great credence.[57] But the Nazis proved more pragmatic with respect to the cultural treasures that survived combat. In forming an elaborate network of offices concerned with the preservation of artworks, they demonstrated that amid their program for destruction they still maintained some regard for property.[58] The members of the SS commandos who concerned themselves with cultural artifacts (the Sonderkommandos and Erfassungskommandos) were less savage and destructive than most of the other 18,000 SS troops who participated in the invasion of Poland.[59] This is suggested by the reports written by the agents of the Erfassungskommandos to Himmler. They chronicle their work and reflect greater concern for inventories than for the liquidation of the owners of the artworks (accounts of armed engagements or deportation measures are rare). The favorite topic in the commandos' reports was the remarkable discovery. Johannes Dettenberg, for example, an artist who worked for the Gestapo before being joining an Erfassungskommando, wrote of finding a painting he recognized as a Cranach in a "shot-up building" near the Soviet border in eastern Poland.[60] These reports made the plundering out to be a game or competition, and hence the commandos collected eagerly to earn favor with their SS superiors.

Despite these units' being more concerned with conservation than destruction, they were, not surprisingly, despised by the local inhabitants. Johannes Dettenberg was killed in July 1942 in a roadside ambush while working in the Balkans (*slowenische Banden* were blamed).[61] While this military confrontation stands out amid the Erfassungskommandos' reports, the

point remains, as made above, that organized plunderers worked alongside the perpetrators of the real terror. They were part of the same project, and they served the same masters. Art historians were even assigned to certain SS divisions, as illustrated by the appeal of the head of the Prinz Eugen division for experts to help identify the booty found while pushing into southeastern Europe.[62] With reason, the International Military Tribunal at Nuremberg declared the entirety of the SS to be a criminal organization.

THE EXTRACTION OF CULTURAL ARTIFACTS FROM THE BALTIC STATES

While Poland suffered a deliberate attack on its people and culture – 4 to 6 million people, or 15 to 22 percent, of its population died during World War II – the Germans approached the Baltic states with less malignant intentions.[63] Granted, their long-term goals were largely the same as in Poland: the removal of the Jews and other "undesirables" and the Germanization of the remaining populations.[64] Yet the Nazis' behavior with respect to the Baltic states reflected greater pragmatism and moderation. In August and September 1939 they ceded most of the Baltic lands to the Soviets in exchange for an orderly migration of Baltic Germans into the recently expanded Reich.[65] In October 1939 they concluded essentially nonbinding agreements with the Estonians and the Latvians concerning the emigration of ethnic Germans and their cultural property.[66] That the Nazis pursued their policies via negotiations, first with the independent Baltic governments and then, beginning in June 1940 after the Soviet occupation of the region, with Moscow and the puppet governments, as well as the fact that they never directly went to war with the Baltic states, perhaps accounts for the less brutal occupation policies in this region: 8 to 9 percent of the Baltic states' native populations perished during World War II.[67]

Heinrich Himmler, in his capacity as RKFdV, coordinated the efforts to rearrange the ethnic composition of the region. For this purpose he also utilized SS agencies such as the RuSHA and the VoMI.[68] His plans to redraw the ethnic map of Europe took shape after the military conquest of Poland, as he implemented a program of settling Baltic Germans in newly annexed sections of western Poland. The forced migration – moving the ethnic Germans out of the Baltic region – has been described as "bringing to an end 700 years of Baltic German history."[69] The NS leaders' main concerns seemed to be consolidating the ethnic German population of Europe, reclaiming their cultural heritage, enlarging the Reich's labor force, and colonizing the annexed part of Poland west of the Baltic states. The 23 August and 28 September 1939 agreements between the Germans and the So-

viets specified special emigration rights for 134,000 Volhynian Germans and 100,000 Baltic Germans.[70] By 1941 this program to rearrange the various ethnic populations had resulted in 497,000 "racial Germans" from this region having moved westward into the Reich.[71] More were to follow during the course of the war.

The German experts charged with arranging the transfer of artworks and cultural goods deemed to be German were largely the same individuals who made names for themselves as wartime plunderers. Dr. Heinrich Harmjanz, for example, who held a leading plundering post in the GTO in Poland, served as one of the chief negotiators on a commission that met with the Soviets, who by mid-1940 were then the true masters of the region, to conclude the transfer agreement.[72] The individual who bears primary responsibility for the removal of Baltic German artworks to the Reich, however, is Dr. Niels von Holst, who was a native of the region and, appropriately, an expert in *baltendeutsche und russlanddeutsche* art history.[73] Holst was a member of what was called the Parity Commission, which negotiated with representatives of the Baltic states and later the Soviet Union. His primary tasks entailed determining what Germanic artworks were located in the Baltic region, where they were housed, and how they could be attached. He combined his expertise as a curator and scholar (prior to the war Holst had worked for the Berlin State Museums) and his skills as an administrator (he had also been employed by Bernhard Rust's Education Ministry as a consultant).[74] Himmler lured Holst away from Rust in early 1940, as indicated by a letter Himmler sent to his subordinate Wolfram Sievers: "I ask you to direct a petition to the Education Ministry so that Director von Holst can arrange absolutely nothing without instructions from the Reichskommissar [Himmler]."[75] He also used his funds as Reichskommissar to pay Holst.[76] As a result, Himmler claimed authority over the artworks that Holst and his colleagues managed to obtain. On 13 December 1940 Himmler instructed Sievers that the objects from Latvia that Holst had secured should "be brought to my Central Place for Secured German Artworks in Poznan. I myself retain the right to further decisions over the final resting point for all cultural goods."[77]

Niels von Holst and his colleagues did not obtain many artworks prior to the German occupation of the Baltic region in June 1941, which came as a result of the initial success of Operation Barbarossa (the attack on the Soviet Union). The explanation for this is quite simple: intransigence – first on the part of the Baltic leaders and later from the Soviets. Historian Jürgen von Hehn has described the difficult and protracted negotiations that took place from October 1939 until June 1941, where the Germans tried to conclude legal agreements to obtain artworks (for example, from German

churches and provincial museums), archives, and other cultural objects.[78] The Baltic leaders, when they possessed relative autonomy prior to mid-1940, wanted compensation in return for the release of the cultural objects. For example, the Latvian president Karlis Ulmanis demanded that the Germans relinquish an archive from Kurland, which he claimed had been lost to his nation in 1919 as part of the Treaty of Versailles.[79] After the Soviets incorporated Latvia and Estonia into their sphere of influence in the summer of 1940, the negotiators made progress. The Soviets attempted to generate goodwill on the part of the Germans and moved the talks ahead, first by encouraging the new Baltic leaders to adopt a more cooperative stance and then by taking over the negotiations themselves.[80] The Soviets' cooperative mood began to dissipate toward the end of 1940, however, and long, difficult talks ensued that lasted until the two nations went to war.[81]

The diplomatic discussions between the Germans and the Soviets, which addressed cultural issues, involved officials at the highest level. Ultimately Ambassador F. W. von der Schulenburg and Foreign Minister Vyacheslav Molotov represented their respective nations. Holst traveled with the German delegation to Moscow on a number of occasions in 1940 and 1941; but, as noted above, agreement proved difficult, and recesses without tangible accomplishments were the norm.[82] In spring 1941 the Germans and the Soviets eventually seemed to make progress. Holst wrote to Sievers (and hence Himmler) on 6 May 1941 that "Molotov had hastened to assure that the Russian government was fundamentally prepared to arrive at a decision to the questions regarding German interests."[83] At this point Holst also received permission, thanks to the intervention of Molotov, to visit museums in Leningrad (St. Petersburg) and Moscow in order to inspect cultural objects of German origin.[84] Holst and his superiors talked of purchasing artworks from the Soviets, with Dr. Posse to be consulted in those cases involving unusually expensive pieces.[85] Plans were drawn up for a program whereby German museum administrators would be consulted about finding works to trade to the Soviets in exchange for desirable Germanic works.[86] On the diplomatic front, German-Soviet discussions about exchanging artworks were scheduled to resume at the end of June 1941. As late as 18 June, Sievers wrote to Holst, remarking that Holst's last letter about the positive prospects for the upcoming negotiations caused him *Freude.*[87] Despite such optimism, this round of talks, of course, never took place. Shortly thereafter Holst found himself engaged in the pursuit of art even farther eastward – in the Soviet Union.[88] But in 1940–41 the Germans appeared sufficiently moderate in their behavior that many Baltic partisan groups initially joined in the fight against the Red Army.[89]

Niels von Holst, working with a small staff, continued to follow Himm-

ler's orders during the invasion, but acquiring and not just identifying and locating the art became the focus of his efforts. The savage war with the Soviet Union induced the Germans to do away with many of their previously restrained policies with respect to the Baltic region. Holst's group was quickly joined by rival agencies such as the Einsatzstab Reichsleiter Rosenberg and the Sonderkommando Ribbentrop. The entire Baltic region, as part of Rosenberg's Ostministerium, was subjected to the harsh measures of the New Order. As Rosenberg wrote in a policy paper concerning the region in May 1941, "The suitable elements among the populations must be assimilated and the undesirable elements exterminated. The Baltic Sea must become an inland German lake, under the protection of Greater Germany."[90] Still, because the Baltic states were to be incorporated into the Reich—as compared with an occupied foreign land—the measures imposed there were marginally less brutal than those in many of the other territories in the east.[91] "German rule between 1941 and 1944 was . . . less harsh than the periods of Soviet rule which preceded and followed it, and less brutal than the treatment meted out by Germany to the other subject nationalities of eastern Europe."[92]

However, the severity of the German occupation should not be underestimated. Conditions were still nightmarish for the region's inhabitants during the war as the *Einsatzgruppen* and SS committed atrocities and arbitrary rule was the norm. Regarding artworks and cultural property, an article published on 13 October 1941 in the *Deutsche Allgemeine Zeitung* ("the official organ of the Reichskommissar") and commented on by Joseph Vizulis conveys a sense of the perils: "At the commencement of the German-Soviet War on 22 June 1941, private property did not exist in the countries under Soviet rule, so nobody could claim to be a legal proprietor. By sacrificing the blood of German soldiers all these countries had been liberated. The German Reich therefore became the legal heir to the 'Soviet inheritance.' All state and private property in the Baltic countries became the property of the German Reich."[93] Most artworks of Baltic-German origin were removed from the region by the Nazis during the war, and the works were stored in depots in the Wartheland (a section of Poland incorporated into the Reich) and West Prussia.[94] The aims of the Nazis in the Baltic states, which formerly appeared limited (in terms of both means and ends), underwent a dramatic transformation amid the unrestrained war of conquest. In 1939 they were concerned with consolidation—claiming both people and objects that they classified as German. By 1941 they pursued a more aggressive policy of expansion and expropriation. The inhabitants of the Baltic lands fared better than those in most other regions in the occupied east, but they still suffered miserably under Nazi rule.

An operation comparable to the Nazis' efforts to secure art in the Baltic states occurred in the South Tyrol. The timing of both actions was similar (1939 and 1940 emerged as the critical years in episodes that were both protracted), and Himmler, as RKFdV, again played a crucial role in the transfer of populations as well as art in that he oversaw not only the "practical" arrangements but also the diplomatic preparations.[95] In both cases the Germans dealt with governments with which they had established a modus vivendi. However, the breakdown of German-Soviet relations and the ensuing war left the Baltic people in a more hazardous situation. Hitler not only made concessions to Mussolini regarding the fate of the South Tyrol for larger geostrategic reasons (as he had initially done with Stalin regarding eastern Europe); he stood longer by these sacrifices for the sake of the Axis alliance.[96] This more enduring relationship, as well as the Nazis' more favorable opinion of the racial qualities of the non-German population in the South Tyrol (as compared to the non-German Balts), led to a less severe experience for the Alpine people.

Hitler charged Himmler with negotiating the South Tyrol border agreements with the Italians, whereby most of the region's 220,000 ethnic Germans, their property, and the objects comprising their cultural legacy were to be brought into the Reich.[97] The Reichsführer-SS had previously made two successful visits to Rome in 1936 and 1937 and had established a rapport with certain members of the Fascist government (in particular with Propaganda Minister Dino Alfieri and Director of the Police Arturo Bocchini).[98] Gerald Reitlinger in this connection has written that Hitler regarded Himmler as a "diplomatist" and "as particularly acceptable to the Italians."[99] The rather unlikely emissary therefore met first with Mussolini to establish the ground rules for subsequent negotiations and then, in order to arrange the details of the agreement, with Italian representatives including Police Director Bocchini and the prefect of the Bolzano province, Giuseppe Mastromattei. The crucial pact, entitled Rules for the Repatriation of German Citizens and for the Emigration of German-Speaking Inhabitants of the Alto Adige to Germany, came on 21 October 1939, after Himmler, Bocchini, and Mastromattei had met earlier in the month for three days of talks in Tremezzo. The agreement stipulated that German "citizens" were obliged to be repatriated, that German-speaking "inhabitants" would have to make a choice between the two nations by 31 December 1939; and that those who opted for German citizenship would move to Germany before 31 December 1942.[100] Himmler and his compatriots initially advocated a plan of forced migration but compromised with

Himmler and Mussolini at excavation of ancient ruins in Italy, 1938, with Goebbels and Hitler among the dignitaries in attendance (BAK)

the Italians and allowed the inhabitants the option of choosing their destiny.[101] Provisions allowing art of German origin to be transferred to the Reich (as long as Italian export laws were not violated) and works of Italian or Roman character to remain in South Tyrol had been agreed upon earlier in the summer of 1939.[102]

Despite the initial efforts to arrive at a clear-cut and amicable arrangement about the fate of the cultural goods in the region, the two sides found no easy solutions. The Germans' interpretation of the various agreements is aptly expressed by Kajetan Mühlmann in his letter to Wolfram Sievers, as he wrote, "A personal meeting took place between the Duce and the Reichsführer-SS, which concerned art objects from German cultural circles that were created in the South Tyrol: these objects, whether they belong to the state or church or are private property, will be returned to the Reich, while art objects from the Roman cultural milieu will remain in Italy."[103] The Germans defined the term *cultural goods* broadly, applying it to almost the entirety of the migrating populations' property. They pointed to Article 27 of the 21 October 1939 pact that allowed for the removal of "'objects forming part of interior furnishings, even fixtures which have artistic or sentimental value (for example, wall cupboards, antique wall coverings, tiled stoves, etc.),' personal vehicles, fifty percent of livestock, private collections, and archives concerning German culture, and tombstones."[104] It

was these latter categories – specifically, the private collections and archives concerning German culture – that precipitated the central disputes between the two delegations and soured the implementation of the South Tyrol agreement. The Italians sought a narrower definition of the term *cultural goods* and opposed all attempts by the Germans to claim the church's property.

The Nazi agency responsible for the reclaiming of *deutsches Kulturgut* (German cultural objects), called the Kulturkommission, was headed by Wolfram Sievers, the Ahnenerbe's business manager and coordinator of the GTO. Created by Himmler on 2 January 1940, the Kulturkommission was charged with registering, securing, and transporting the objects in question to Germany.[105] According to one of the commission members, Friedrich Hielscher, they initially hoped to secure and transport the cultural goods prior to the actual migration.[106] Yet they encountered constant opposition from the Italians, whether it entailed deciding what actually was a *deutsches Kulturgut* or how certain objects were to be treated. A subdivision of the Kulturkommission was formed that was charged directly with dealing with the artworks in question. Called the Abteilung Kunst der Kulturkommission and led by Josef Ringler, the group began work in the region in July 1940.[107] The Abteilung Kunst made inventories of private property and surveyed the holdings of the region's seven major museums (located in Bolzano, Merano, Bressanone, Brunico, Vipiteno / Sterzing, and Clauzetto). On 1 August 1940 they sat down with their Italian counterparts to negotiate the division of the artworks.[108] As noted above, the discussions yielded few easy solutions. One key example emerged in the case of the great artist Michael Pacher, whose altars merited world renown. Dr. Josef Ringler and his associates argued that Pacher was German and his work should go to the Reich. The Italian delegation, led by an engineer, Dr. Antonio Rusconi, argued that Pacher was of alpine (*alpinländisch*) origin and defied easy classification.[109]

In light of these difficulties, by July 1941 the Abteilung Kunst of the Kulturkommission had accomplished "almost nothing."[110] In April 1941 Sievers and Führermuseum Director Hans Posse, who had been ordered by Hitler to keep an eye on the region in case important works came to light, both agreed "that further dealings with the Italians based on the current understandings were pointless."[111] The Abteilung Kunst still managed to form a number of four-man work groups, and using Bolzano as their headquarters, they set out to claim all artworks that they could tie to Germans or Germany.[112] During the first year of their existence (prior to July 1941) the work groups confined their activities to surveying the art objects of the region, and they produced photographic records. The behavior of the Itali-

ans at this time entailed not only opposition to the removal of artworks but also a concerted effort to purchase objects at low prices from those who were choosing to emigrate. Representatives of the Uffizi Gallery were even reported to have exploited this opportunity.[113]

This competitive posture induced the Germans to adopt an even more aggressive stance. They began to allocate funds to the experts in the work groups so that they could also buy desired pieces. Sievers, for example, provided RM 20,000 for acquisitions in November 1940, although he recommended that expenditures should not exceed RM 5,000 per month.[114] Local art and antiquities dealers were also placed in the service of the Kulturkommission. The Nazis reasoned that these agents not only knew the terrain well but would acquire objects at lower prices than outsiders.[115] As the meager sum of Sievers's allocation suggests, the Germans were not especially interested in purchasing artworks. This was a tactic of last resort and primarily the domain of Posse, who had a separate purchasing budget for the Sonderauftrag Linz.[116] Posse participated in the South Tyrol project primarily in an advisory capacity, as he made numerous trips to the region in 1940 and 1941 when was policy was being formulated. Posse met with Sievers, Mühlmann, and others, and they agreed that while Posse might buy certain exceptional pieces, the members of the Kulturkommission should strive to "reclaim" the majority of the artworks without financial transactions.

The conflicting interpretations of the clauses pertaining to cultural goods in the agreement that transferred the South Tyrol to the Italians continued unabated through the summer of 1941 and, indeed, strained the Pact of Steel, which had been signed in May 1939. Himmler and the members of the Kulturkommission maintained their stance that all Germanic art should be brought *heim ins Reich,* and the Italians stubbornly resisted this interpretation. The Italians raised new objections to the division of museums, arguing that museums and their contents were often communal (and not private) property and, as such, should remain in place. With respect to art found in churches, the Italians contended that this was a matter that the Germans had to take up directly with the Vatican. Lower-level negotiations between the two nations failed to resolve these issues. In September 1940 Wolfram Sievers therefore suggested to the German diplomatic representative (the Deutsche Generalkonsul, who was part of a board called the Amtliche Ein- und Rückwandererstelle) that "we therefore must request the involvement of higher authorities in Berlin, complemented by an official German step in Rome."[117] Yet even though Himmler was very much involved in the project, Hitler never intervened, despite being kept apprised of the Italians' intransigence.[118] The members of the Kultur-

kommission were therefore frustrated by the diplomatic stalemate, so much so, that the specialists (*Fachleute*), beginning in late summer 1941, asked to be given a more rewarding area of operation.[119] Himmler obliged, and in October 1941 he empowered the Kulturkommission to secure *Kultur-güter* belonging to ethnic Germans in Gottschee and in the Unterkrain (the regions bordering the Adriatic in present-day Slovenia).[120]

In the first years of the war the Nazis did not obtain artworks in the South Tyrol on the scale of the Polish, Baltic, or even French enterprises. While they came to agreement with the Italians on certain objects and simply absconded with others, their hesitation about antagonizing their Axis partner put the brakes on Sievers and the other agents. After September 1943, however, when the Germans, in response to the Badoglio government's armistice with the Allies, invaded the region and established two military operation zones (Adriatic Seaboard and Sub-Alpine), their behavior became more brazen and self-interested. The newly created zones were placed under the command of two brutal administrators. Franz Hofer, the Gauleiter of the Tyrol, took over the Sub-Alpine zone, and Friedrich Rainer, the Gauleiter of Carinthia, oversaw the Adriatic zone.[121] These two organized an accelerated process of Germanization, which entailed a more undisguised policy of expropriating cultural objects. The Ahnenerbe again played a central role here.[122] Yet even during this "tragic phase" from 1943 to 1945, a phrase commonly used to describe this period of the South Tyrol's history, the Nazis' persecution and criminality never matched that in Poland and the Baltic states.[123] Hitler's desire to sustain cooperation with Mussolini and the generally more civilized nature of war and occupation in the west helped to limit the Nazis' plundering activities.[124]

A graphic depiction of the difference between art looting in eastern Europe and that in the South Tyrol can be obtained by focusing on Kajetan Mühlmann. This plunderer, who had created a reputation for himself in Vienna and Poland, was called in to evaluate the situation in the South Tyrol in the spring of 1940. In his reports, which he sent to Sievers, Himmler, and others, Mühlmann advocated forceful, aggressive action. Germanic art had to be reclaimed, he argued, whether it belonged to churches or museums.[125] Sievers and Mühlmann were working together at this time in Poland but arranged to meet on several occasions in the South Tyrol to assess the local situation. Mühlmann expressed his eagerness to participate in the Kulturkommission's project and even directed this request to the Foreign Office.[126] However, he made his involvement contingent on being named Leiter der Kulturkommission–a step that Sievers considered carefully as he consulted his colleagues.[127] But Mühlmann's appointment was not to be, because, as Sievers noted on 30 July 1940, there were "objections

Wolfram Sievers, business manager of the Ahnenerbe and employee in the GTO (BDC)

of the gentlemen in the Art Group (*Kunstgruppe*) of the Kulturkommission who know Dr. Mühlmann extremely well."[128] The implications of Sievers's note, and the lesson to be drawn from this episode, is that Mühlmann's heavy-handed methods were deemed unsuitable for the more delicate situation in the South Tyrol.[129] Mühlmann played virtually no role in the Kulturkommission's South Tyrol project.[130]

As Mühlmann's experience in the South Tyrol suggests, these agents in Himmler's employ–at least those concerned with securing artworks–knew one another and maintained contact throughout the war. Himmler's bureaucratic empire, based as it was on the ideological precepts of loyalty to others in the SS and the furthering of the interests of the nation and the *Volk*, not surprisingly generated a network of cooperative fanatics. More specifically, Wolfram Sievers and his colleagues in the Ahnenerbe placed a premium on contact between these various individuals and groups. They often played the role of coordinators in the SS's own cultural bureaucracy, and Himmler envisioned them as a focal point for all forms of cultural activity. Himmler even ordered that the Ahnenerbe hold a conference once every three months as a means of promoting contact and "coordinating worldviews."[131] A sense of the SS's cultural activities can be gained by examining these meetings. At one gathering in April 1941, for example, Sievers provided a detailed report of the South Tyrol operation.[132] Himmler,

to be sure, discouraged too much cooperation among subordinates. For example, he thwarted a plan by Oswald Pohl (chief of the SS economic and administrative department) to create a board with representatives of the various SS branches because he feared that his underlings "might get together to oppose him."[133] As a typical Nazi administrator, Himmler desired just enough cooperation among his subordinates to ensure the functioning of his bureaucratic machine.

The vastness of Himmler's bureaucratic empire also deserves special emphasis. In geographical terms his forces dominated eastern, southeastern, and southern Europe. Administratively the Reichsführer-SS lorded over a dizzying array of offices. Foremost among them were the SS, the Waffen-SS, the SD/RSHA complex (which included the Gestapo), the RKFdV, the VoMI, and as of August 1943 the RMdI. In September 1943 Himmler also organized a *Kunstschutz* unit to cover the Italian peninsula occupied by the Germans. Headed first by Bernhard von Tieschowitz and later by Professor Hans Gerhard Evers and SS-Sturmbannführer Alexander Langsdorff, the unit removed a number of artworks to the north in an effort to "safeguard" them from the advancing Allies.[134] The size and variety of the forces in his bureaucracy afforded Himmler considerable flexibility. He seemingly used all of these organizations at some point to pursue cultural treasures. For example, the Gestapo secured a collection of 25,000 *Votivebilder* and 10,000 prints in Laibach (Ljubljana), and a cable from the RSHA office in the Steiermark (Styria) to the Reichsführer-SS's personal staff in December 1942 reported that one of their Wachkommandos (watch commandos) had been placed over a local *Schloß* Feistriz near Krieglach and that the contents (including artworks) had been sequestered.[135] Himmler was not the only NS leader with operatives in these regions, but his considerable and diverse resources made him the most capable plunderer in eastern and southeastern Europe.

The Reichsführer-SS proved so adroit at securing artworks that he elicited a strongly worded warning from Martin Bormann in December 1944, in which the latter reiterated the Führer's prerogative over such objects. Bormann's letter included the accusation, "In recent months, the Sicherheitsdienst, especially in Styria, has confiscated various collections and immediately disposed of them."[136] The letter, which had a sense of urgency to it – having been marked *persönlich!* and sent to Himmler at his field headquarters – detailed the Führer's own plans for a museum complex (Sonderauftrag Linz) and contained the request that Himmler communicate to his operatives that Hitler's art staff was to have precedence in all cases.[137] Himmler obeyed Bormann's orders, as he directed the information to Ernst Kaltenbrunner (then head of the RSHA/SD) and other SS

leaders in January 1945.[138] Himmler, an ideologue dedicated to Hitler, the Reich, and the German *Volk,* carried out his plundering operations not so much for selfish reasons but in an attempt to realize his misguided ideals.

A COMPARISON OF THE THREE CASES

A comparison of the Nazis' behavior with regard to Poland, the Baltic states, and the South Tyrol presents special difficulties because of the opaqueness of their intentions. Their plans for Poland appear most clear, as they unswervingly pursued a program of subjugation and destruction. The territory and resources that fell into their hands met with either expropriation or elimination – in short, a fairly straightforward policy. Their plans for the Baltic and South Tyrol regions, however, are more difficult to fathom. The Nazis' policies for both areas suggest numerous parallels. Both were seemingly written off by Hitler and his cohorts in 1939, sacrificed to cynical foreign leaders in exchange for their tacit support of objectives deemed more important. Both regions were later attached by the Germans, and their inhabitants were exposed to cruel programs of Germanization and resettlement. It is difficult to determine, however, whether Hitler used the Baltic states and the South Tyrol as pawns in larger geopolitical gambits, consciously intending to reclaim the ceded territories as soon as other gains had been consolidated, or whether he improvised his strategy and became emboldened by his military successes in Poland and western Europe. Hitler was in all likelihood prepared to transfer the South Tyrol to the Italians, whom he regarded as true allies, as long as the ethnic Germans (needed for the armed forces and industry) and their cultural goods came *heim ins Reich.* The reclaiming of the territory in the South Tyrol stemmed more from the disastrous military fortunes of the Italians than from a predetermined plan. On the other hand, the Nazis' long-standing goal of seeking *Lebensraum* in the east encompassed the eventual annexation of the Baltic states, making it more probable that Hitler's concessions to Stalin represented an intentionally duplicitous policy.

Despite differences in the policies of the NS leaders concerning these regions, certain common features emerged in all three cases. The first was the identification and preservation of all that was deemed German – whether human or inanimate. Himmler in particular oversaw the so-called experts who were charged with this sorting process. Himmler, of course, also oversaw a program whereby many non-German elements were to be destroyed. It is a testament to the inhumanity of the Reichsführer-SS and his subordinates that they made little distinction between people and ma-

terial objects in pursuing this process of Germanization. In addition to this effort to categorize, the second overriding concept in all three cases was boundless imagination, or a sense that anything was possible. The Nazis did not shy away from radical, ahistorical, or even preposterous solutions. Their attempt to exterminate the Jews and the Gypsies constitutes one and, indeed, the most important manifestation of this quality. Yet Himmler's contemplation of a plan to resettle the *Volksdeutsche* of the South Tyrol to Burgundy–tombstones, altarpieces, and all–represents a continuation of this mode of thinking.[139] The overriding goal of the Nazis in these three cases was to care for ethnic Germans and their cultural artifacts–or what was often called the *germanische Erbe* (Germanic heritage).[140] While this ambition in itself was not inherently opprobrious, it led to measures that caused suffering of immense proportions.

5 OCCUPATION AND EXPLOITATION, 1940–1943

Despite the bountiful haul of artistic and cultural treasures taken from Czecho-Slovakia, Poland, the Baltic states, and the South Tyrol, the real prizes for the Nazis – or the most fertile ground for reaping the harvest of artistic booty – lay in western Europe, and above all, in France. The western portion of the continent offered the Nazis artworks that appealed to their largely traditional aesthetic sensibilities and provided them the opportunity to exorcise certain feelings of cultural inferiority. They sought to control Europe's magnificent artistic legacy (both German and otherwise) by possessing its material expression – the artworks. Hegemony over the European continent, for the Nazis, had an inseparable cultural component. Hitler, Göring, and a number of other leaders gradually came to view the acquisition of artworks as an important symbol of their expanding empire.

The plundering of western Europe proved consistent with other aspects of the ideology of the National Socialists. Most notably, their attack on European Jewry included stealing their victims' art as one part of the process of persecution, dehumanization, and eventual annihilation. The Nazis

justified their confiscations of the property of western European Jews on the grounds that no armistice or peace treaty was ever concluded with the Jewish people (as viewed distinctly from the French, Belgian, or Dutch governments).[1] The non-Jewish population of western Europe, while burdened with hardships and clearly not exempt from acts of cruelty on the part of the occupying forces, nonetheless could turn to the negotiated occupation statutes to help restrain the Nazis. This also applied to determining the ownership of artworks, as the Waffenstillstand (cease-fire) Kommission in Wiesbaden considered, among numerous issues, the fate of disputed artworks.[2] The Jews, however, who lacked any legal recourse with which to stem the onslaught, had no way of saving their collections. Also, because many western European Jews felt that their governments would keep them relatively safe from Nazi persecution, many did not evacuate their art collections prior to the 1940 invasion, as compared to their counterparts in Czecho-Slovakia a few years earlier.[3]

As with the attachment of Jewish property, the second major component of the National Socialists' plundering during the war, arranging the "return" of Germanic art, was also planned in advance of hostilities. The Nazis conceived the term *Germanic art* to mean both artworks created by Germans and those that were once owned by their compatriots. They believed in a nation's right to control its cultural heritage: hence Himmler's projects in eastern and southeastern Europe where he oversaw the immigration of the *Volksdeutsche* population along with their artistic possessions, as well as the widespread sympathy among Nazi officials to requests by other countries (especially allies) to have certain meaningful artworks repatriated.[4] The legislative activity of the Nazis in the late 1930s, which aimed at preventing the export of German art (see Chapter 2), also conveys their thoughts on this issue. The impulse to repatriate their cultural heritage developed in the mid-1930s, while the actual methods of realizing this goal came about as a result of their experiences in 1939 and 1940.

THE FRUITLESS ENDEAVORS OF GOEBBELS AS AN ART PLUNDERER

It was not until August 1940, seven weeks after the cease-fire signed at Compiègne, that Goebbels took the first concrete steps to repatriate Germanic artworks from the conquered western nations. Acting with Hitler's authorization, he had taken over from Education Minister Bernard Rust a project to reclaim German art now in the west.[5] Referred to as the Rückforderung von Kulturgütern von Feindstaaten (reclamation of cultural goods from enemy states), this plan, in Goebbels's mind, would place him

at the center of efforts to acquire art during the war. His first move was to commission a team of accomplished art historians, led by the General-direktor of the Berlin State Museums, Otto Kümmel, to compile a list of all art objects that had been in German hands since the sixteenth century but were now located abroad.[6] To complement the art historians' work, Goebbels sent out to the thirty-five RPL bureaus, the Education Ministry, the RMdI, the Foreign Office, and the Gaue branches of the RkdbK a request for lists of artworks that might fall into this category.[7] This initial stage of the Rückforderung project supposedly entailed only research. On signing the various armistice agreements and establishing the terms of the occupation, the Germans had pledged not to remove artworks owned by the defeated western nations until after the conclusion of a proper peace treaty. Goebbels's commission from Hitler on 13 August 1940 read, "For various reasons it is necessary to determine all artworks and historically important objects, which, over the course of time, have found their way into the hands of our present enemy. Furthermore it is necessary to study whether in the conclusion of the upcoming treaties, all the conditions of a lawful change of ownership are feasible. The Führer charges Reichsminister Dr. Goebbels with the central leadership of this survey."[8] Goebbels developed plans that went beyond mere research, however, and as he communicated to Kümmel, he envisioned three stages: (1) the seizure of works taken by the French in the Napoleonic Wars, (2) the securing of art of Germanic origin, and (3) the pursuit of objects on the grounds that they had what he called "Germanic character."[9]

In the months after garnering the commission, Goebbels and his associates confined themselves to researching the subject. There were those, of course, who called for a more aggressive policy. Friedrich Christian Prinz zu Schaumburg-Lippe (an RMVP employee) recommended to the minister that the Germans also return art to the Italians and the Spanish that had been taken by Napoleon and now sat in the Louvre. This, he argued, would elicit the "greatest applause" from these countries.[10] One year later, when Goebbels's group (called the Rückforderung Kommission) had still not made practical arrangements to seize the works on the lists, Reinhard Heydrich urgently noted that "the last moment has now come when it [the return of the Germanic objects] can still be done."[11] Goebbels himself had no aversion to taking action. As a man inclined toward radical measures, the propaganda minister had written to Hans Lammers on 30 August 1940, expressing his preparedness to commence the *Rückführung* (repatriation) action in October, pending the approval of the Führer.[12] As Heydrich's plea one year later indicates, Hitler's endorsement was not forthcoming.

While Goebbels entertained ideas of dominating the plundering bu-

Otto Kümmel, Generaldirektor of the Berlin State Museums and chief researcher for Rückforderung program, 1940 (BAK)

reaucracy in the west, these aspirations did not yield results, as other NS leaders also advanced schemes of their own. The propaganda minister, to speak metaphorically, became entangled in the bureaucratic jungle that took hold in this fertile territory. By autumn 1940 the following ministers were vying with Goebbels for control of Jewish-owned and Germanic artworks in the occupied western regions: Alfred Rosenberg, who headed what became probably the most effective art plundering agency the world has ever witnessed – the ERR; Martin Bormann, who was Rosenberg's superior in the Party and hence the ERR and also controlled the Sonderauftrag Linz agents; Hermann Göring, who also possessed some authority over the ERR (by way of an alliance with Rosenberg) and used his various offices, such as the Devisenschutzkommando (foreign currency protection commando) within the Four-Year Plan office, as well as his small army of private agents to collect artworks; Foreign Minister Joachim von Ribbentrop, who received orders directly from Hitler to confiscate art in France and used his staff in the Paris embassy for this purpose; Heinrich Himmler and Reinhard Heydrich, the masters of the polycephalic police apparatus that permeated all occupation zones; Franz Graf Wolff Metternich, who headed the Oberkommando des Heeres' (army's) *Kunstschutz* unit, which made an effort to actually safeguard artworks; and Arthur Seyss-Inquart, who as Reich commissioner for the occupied Netherlands hired Kajetan Mühlmann to steal and purchase artworks wherever he found them.

Goebbels made a concerted effort to win out over these rivals: after so-

liciting the 12 August 1940 decree from Hitler to start the Rückforderung project, he attempted to broaden his base of support by convening an advisory board comprised of representatives of the various branches of government.[13] The board's first session, which Goebbels chaired, met on 22 August 1939 in the RMVP's building on the Wilhelmstraße. Those present included Robert Scholz, who acted on Rosenberg's behalf, and Hans Posse, the head of the Linz Project, as well subordinates representing Göring, Speer, Ribbentrop, Rust, and Frick.[14] This attempt to muster broad-based support, which was reminiscent of the way Goebbels had created the *entartete Kunst* Disposal Commission, did not lead to success. One can only speculate as to why Goebbels failed to triumph in the plundering bureaucracy. He still suffered in 1940 from falling out of favor with Hitler in the wake of the Baarova affair and therefore did not have the Führer's ear. He incurred disadvantages vis-à-vis his rivals by not spending much time physically present in the occupied west (for example, Rosenberg had ERR offices in Paris, and Göring made frequent excursions in order supervise the Luftwaffe in the Battle of Britain). Also, Goebbels's preexisting dominance over the cultural sphere of the Nazi government made Hitler, with his divide and rule philosophy, wary of investing him with more power. All these factors, combined with his relative alienation from the military (he not only lacked a military appointment but also had never experienced combat as a result of his physical disability), worked against Goebbels. While a fast starter in the race to control the plundering of art, he soon faded from contention.[15]

ROSENBERG AND THE ART PLUNDERING BUREAUCRACY IN FRANCE

The victor in this competition to administer the artistic booty emerged in the fall of 1940. The indefatigable Alfred Rosenberg, though repeatedly discredited by past failures, nonetheless managed to rebound and enjoy his greatest success within the cultural bureaucracy. To be sure, he had a legitimate claim to oversee the disposition of the newly acquired artworks, having been one of the Nazi authorities on painting and sculpture. Yet his commission as head of the ERR came about primarily as an extension of his position as the Party ideologue. Whereas he once concentrated on theorizing about the opponents of National Socialism – Jews, Freemasons, and Communists – he now played an active role in destroying them. This shift from theory to praxis centered around his Hohe Schule project, the planned network of ten institutions that were to serve as the loci of higher education for NS studies. Rosenberg, who received the commission for the

Hohe Schule from Hitler on 29 January 1940, did not initially market them as a vehicle for plundering; rather, he stressed their importance in propagating the Nazi ideology and proving its validity.[16] This goal is discernible in the names of the branch institutes themselves: for example, the Institute for Jewish Research in Frankfurt, which focused on the Jews (with the Nazis' biases of course), and the Institute for Biology and Racial Studies (*Rassenkunde*) in Stuttgart, which aimed to legitimate the Nazi racialistic worldview. Rosenberg's Hohe Schule only became a part of the plundering bureaucracy on 5 July 1940, when, through a *Führerbefehl*, he received authorization to collect the archives and libraries of the declared enemies of National Socialism.[17] This commission did not apply to artworks. In fact, shortly thereafter, on 15 July 1940, the OKH issued an order that strictly prohibited the movement of art without written permission from the Militärbefehlshaber (regional military commander).[18]

Rosenberg and his colleagues quickly organized a staff to locate the archives and books that they had been commissioned to secure. By reshuffling personnel within the DBFU and bringing in a few new "specialists," they created the ERR. Gerhard Utikal, an employee in the DBFU who emerged gradually during the war as Rosenberg's right-hand man, obtained the position of administrative chief of the ERR (Leiter des Zentralamtes).[19] From their Berlin headquarters Utikal and his staff in the Zentralamt began to spin the absurdly complex web of staffs, special commandos, and work groups that eventually came to comprise the ERR. The various branches of the ERR that came into existence in the summer of 1940, including the notorious Dienststelle Westen (Western Office) of Kurt von Behr, initially confined their activities to written materials. However, they were far from inactive: for example, on 26 August 1940, an Organization Todt transport of eleven train cars (1,224 cases) left France for the Sonthofen Ordensburg (one of a series of ideological training centers) via Frankfurt am Main.[20] The contents of this transport came from various archives and libraries, the most notable targets being the Polish, Turgenev, Jewish, and Rothschild libraries in Paris.[21]

The radicalization of the Nazis' plans for art in the occupied west continued, despite the ERR's restricted scope of authority and despite the efforts of the OKH to safeguard France's artistic treasures. In addition to the 15 July order limiting the ERR and other rapacious agencies, the army utilized a *Kunstschutz* unit organized in June 1940 under Graf Wolff Metternich, which endeavored quite earnestly to protect the artworks and monuments threatened by battle. The drift toward radicalization continued unabated, however, as the uncertain commands stemming from above provided the more malignant types room for maneuvering. As early as 30 June

Hitler had assented to a verbal order that called for the expropriation of Jewish-owned artworks.[22] This order and hence the first organized plundering of art in France went through the Foreign Office, with the chain of command stretching from Hitler to Ribbentrop to Otto Abetz (the German ambassador to occupied France). Abetz in turn charged three embassy employees, Dr. Karl Epting, Carl-Theodor Zeitschel, and Eberhard Freiherr von Künsberg (the latter two also being field police agents), with the specific task of securing and transporting to the Louvre artworks belonging to French Jews that had been removed by the French to chateaus in the Loire.[23] Plans were developed to catalog the works that would be assembled at the Louvre and then send the suitable pieces to Germany.[24] This scheme elicited frequent protests from both the army's *Kunstschutz* chief Wolff Metternich and his superiors (General Karl Heinrich von Stülpnagel, General Walther von Brauchitsch, and others are also on record for their complaints).[25] An army report from 1941 also did not shy away from the damning facts. For example, one passage in the report revealed that in the summer of 1940 Abetz had "allowed a series of collections from Jewish possessions to be brought to a house neighboring the German embassy on the Rue de Lille," and that "he has the intention of examining the list of artworks himself, and from it, selecting approximately twenty to twenty-five outstanding pieces."[26] Indeed, by August 1940 the commandos led by Künsberg had placed some 1,500 Jewish-owned paintings in the embassy depot, and a curator from the Berlin state museums named Dr. Maier had begun to make an inventory of the plunder.[27] But neither the protests nor the reports with specific allegations proved sufficient to stem the onslaught of the plunderers.

While Joachim von Ribbentrop had Hitler's permission to pursue Jewish-owned artworks in France, he, for inexplicable reasons, failed to secure a written and circulated order.[28] This quite understandably contributed to the confusion and allowed Metternich and his *Kunstschutz* staff, backed by their superiors in the army, to oppose Ribbentrop and Abetz's program. Metternich's battle with the various plunderers is well known – even if he did embellish the story in postwar accounts. He indeed refused to surrender artworks in his unit's care, challenged efforts to remove the seized artworks to Germany, resigned his commission as a Hauptsturmführer (lieutenant captain) in the SS, and was eventually fired in 1942 – reportedly on Hitler's express orders – as a result of his intransigence.[29] Throughout his stint as head of the *Kunstschutz*, Wolff Metternich insisted that the other occupiers respect the 15 July 1940 order of the army prohibiting the movement of artworks. However, Abetz, like Rosenberg later on, instructed his agents to ignore these objections. He told them that they had directives of

their own to follow and argued that they, in fact, were taking steps that would best protect the artworks in that the treasures would be much safer in Germany.[30] Amid the quarrel between Metternich and Abetz, Rosenberg reasserted himself and won the crucial commission for the ERR to secure artworks in France.

Rosenberg's coup came in the form of an order on 17 September 1940 from Field Marshal Keitel, head of the OKW to General von Brauchitsch, the head of the Military Administration in France; the decision, however, according to a Military Administration report, came *vom Führer persönlich*.[31] The ERR was empowered to secure all ownerless (*herrenlos*) cultural property, including those objects given to the French state by the enemies of the National Socialists since the outbreak of war on 1 September 1939. This order struck Rosenberg's rivals like a lightning bolt in that it reversed a trend that had been developing: the limiting of the ERR's jurisdiction by the various authorities in the occupied regions. For example, on 28 August 1940 representatives of the ERR and the Military Administration had met to delineate their respective spheres of authority. The results of the conference left the ERR with little independence apart from the Military Administration and allowed them to deal only with "the protection of archives."[32] Prior to that meeting, the OKH had, on 3 August 1940, issued guidelines to the ERR that the Military Administration report had characterized as having a "clearly restrictive tendency."[33] Until the 17 September order the fight to control the fate of the artistic booty in France appeared to center around the Foreign Office and the army. Rosenberg's agency, the Himmler/Heydrich police apparatus, and Göring's Devisenschutzkommandos were ostensibly secondary or auxiliary forces.

Clearly Hitler allowed a chaotic and redundant bureaucracy for art plunder to develop in France as well in as Belgium and Holland. The situation mirrored the governing process of the Third Reich in general. The "polyocracy," to use Martin Broszat's expression, entailed numerous advantages for Hitler and emerged as a result of a more or less conscious policy. Placing ministers in competition with one another elicited energetic and industrious behavior and actualized his Social Darwinist worldview. As illustrated by Goebbels's, Rosenberg's, and Ribbentrop's appeals to Hitler, where they requested authorization to organize looting campaigns, Nazi subleaders exhibited tremendous initiative. Aside from establishing a dynamic or motor force to drive the plundering bureaucracy, this overlapping succession of offices assured Hitler the position as arbiter, and the stakes of this game were not solely political power, but the control of the much-desired artworks. Obsessed as Hitler was with amassing his mammoth art collection, it was of paramount importance to him that he alone deter-

mine the fate of the looted art. By making his underlings insecure and be-holden to him, he assured himself this pivotal role. So essential was this polycratic arrangement to Hitler's power that at no point during the war did one minister or agency have sole jurisdiction over the plunder.

The rationale behind Hitler's decision to invest Rosenberg with this im-portant commission is not entirely clear. There was a certain logic in giving this task to the leader of the ideological war. Rosenberg's demonstrated ability during the summer of 1940 to assemble operation units quickly within the ERR also made him an attractive choice. Rosenberg's indis-putable enthusiasm for the project also played a role in Hitler's decision, as the Party philosopher repeatedly approached Hitler about the matter and displayed no hesitancy about dealing with the occupation officials in France.[34] Additionally, the ERR, while pursuing archives and books, also acquired artworks; or as the Military Administration report noted, "the Einsatzstab, while investigating archival materials also stumbled upon artis-tic treasure."[35] Lastly, Hitler knew Rosenberg to be one of the more sub-servient and malleable Nazi subleaders. The important position of oversee-ing the collection of precious art objects – the sinecure made all the more valuable because so many of the elite also sought the assignment – was not to be entrusted to one of his more independent-minded colleagues.[36]

With the 17 September 1940 order in hand, Rosenberg set out in earnest to pursue Jewish-owned artworks. He did so very quickly. The French gov-ernment after the war estimated that three-fourths of the ERR's plunder was confiscated prior to mid-1941.[37] Key works taken by the ERR included Vermeer's *The Astronomer*, Frans Hals, *Lady with a Rose*, Fragonard's *Young Girl with Chinese Figure*, Chardin's *Portrait of a Young Girl*, and Boucher's *Portrait of Madame Pompadour*. All five of these works came from the Roths-childs and were amongst the 3,978 objects lost by the various branches of the family.[38] Other noteworthy collections confiscated by the ERR be-longed to the Kanns, the Seligmanns, the Wildensteins, the David-Weils, the Levys, and the Cassels. The most important of Rosenberg's subordi-nates in the initial confiscations was Kurt von Behr, a fanatical Nazi who had worked for the German Red Cross and who continued to wear the uni-form as he plundered art in France (as compared with to the brown uni-forms with swastikas that were worn by the other members of the ERR).[39] Heading the ERR's main working group, which he expanded into a division called the Dienststelle Westen, Behr established his headquarters in Paris, first in the Louvre, then in the Jeu de Paume. He coordinated the activities of a variety of workers, from art historians who identified and cataloged the artworks to soldiers who accompanied the commandos. Behr had one key rival: Robert Scholz, Rosenberg's longtime expert on art. Scholz continued

Rosenberg arriving at the Jeu de Paume to inspect the work of his Einsatzstab, 1940 (Librarie Plon)

with many of his prewar activities (including editing *Kunst im Deutschen Reich*) while overseeing the Sonderstab Bildende Kunst, which also collected artworks in France. Scholz maintained his office in Berlin, making only occasional trips to the west. Behr therefore was the crucial on-the-spot authority for the ERR. The geographic separation of the two functionaries did not prevent a power struggle from gradually developing. It came to a climax in 1943 and nearly precipitated a collapse of the agency.[40]

The ERR, despite having Hitler's backing, still encountered serious difficulties in executing their commission in the early fall of 1940. The first of these problems stemmed from a lack of funding, a seemingly perpetual concern for Rosenberg. Turning to his previous source of assistance, Party Treasurer F. X. Schwarz (the ERR was a Party agency), he tried to gain financial support with the promise of great returns on the investment. For example, in an 18 September 1940 letter Rosenberg recounted the acquisition of the Rothschild treasures and noted that the ERR was "on the trail of valuable materials in Belgium and Holland."[41] The appeal here appeared more financial than ideological. Yet it eventually worked, as the Party sent

the first RM 100,000 grant in November and effectively solved the ERR's funding dilemma.[42]

The other major difficulties faced by the fledgling ERR can be divided into two categories: transportation and the continued opposition from other German offices. Rosenberg solved both these problems by joining forces with Hermann Göring. Rosenberg was in contact with the Reichsmarschall almost immediately after gaining his commission to pursue artworks. In a letter dated 21 September 1940 Rosenberg tentatively explored the possibilities of a cooperative approach to the confiscation of Jewish artistic property.[43] Göring, who hoped to derive personal advantage from such a relationship, responded affirmatively to Rosenberg's inquiry, and among other things, he offered to place the Luftwaffe's trains and guard staff at the ERR's disposal (a useful service considering the army's reluctance to assist the plunderers). Rosenberg knew full well that this provided the shrewd Reichsmarschall with a means of involving himself in the looting operation. But previously the ERR had suffered frustrating problems with the Organization Todt's overextended transportation network. The first shipment of archives and books destined for the Sonthofen Ordensburg had been lost (albeit temporarily), and the ERR was developing a backlog of materials to be shipped.[44] Rosenberg's approach to Göring came with the realization that securing a reliable means of transport back to the Reich was essential for the ERR to fend off its rivals.

Rosenberg also agreed to an alliance with the powerful Reichsmarschall due to *Realpolitik* considerations. He knew that he lacked the stature and resources to hold off the competing German agencies, and at this point he had yet to secure funding from the Party. Rosenberg also had learned through Reinhard Heydrich that Göring himself intended to oversee an art plundering operation by way of his offices, utilizing both the Four-Year Plan agency (specifically the Devisenschutzkommando, which had offices in Paris, Brussels, and Amsterdam) and the Luftwaffe.[45] On 14 August 1940 the Devisenschutzkommando, whose task was to oversee mints and detect currency violations in the occupied territories, garnered the right to search bank vaults in the course of conducting investigations.[46] Rosenberg's letter to Göring on 21 September therefore had a nervous, threatened undertone to it. While not an explicit invitation for an alliance – Rosenberg merely said that he wished to avoid conflict and felt confident that arrangements could be worked out – the letter led to their collaboration. Rosenberg's fear of Göring developing a rival organization, when added to the threat posed by Ribbentrop/Abetz and Goebbels, as well as the opposition of the army and its *Kunstschutz* unit induced him to sacrifice some of his agency's autonomy in return for assistance.

Rosenberg and Göring together proved an unbeatable combination – at least early in the war, before the Luftwaffe chief was discredited. Examples of their cooperation included the Devisenschutzkommando assisting the ERR units in their plundering forays, the sharing of intelligence garnered through bribes (large sums were spent in this manner), and the intermingling of two leaders' staffs (Göring would loan personnel, such as the art historian Dr. Bruno Lohse, who helped catalog plundered collections in the Jeu de Paume, while many ERR employees developed a primary allegiance to the Reichsmarschall).[47] So extensive was their mutual assistance that Göring's agency voluntarily relinquished artworks to the ERR. A Devisenschutzkommando chief wrote in May 1941, "According to the decision of the Reichsmarschall, all of the art objects have been taken over by the ERR."[48] Göring also explicitly stated his willingness to use his influence to smooth over any difficulties that Rosenberg's agency encountered and to approach the Führer when the need arose.[49]

Göring himself, in a letter to Rosenberg in late November 1940, took credit for vanquishing Ribbentrop and Abetz, as he expressed his satisfaction at having induced the Führer to rescind the authority to secure artworks that had initially been given to the foreign minister.[50] Indeed, the losers turned over most of the artworks stored in the Rue de Lille warehouse to the ERR, as they maintained possession of only those works that Ribbentrop had managed to commandeer for his personal collection as well as a number of undesirable modern pieces.[51] The conclusive defeat occurred in October 1940, and accordingly Abetz wrote to the Military Administration on 28 October: "Due to the changed political situation, the confiscation of artworks by my representatives must now fundamentally cease and should be carried out solely by the Military Administration or according to a written *Führerbefehl* [meaning the commission given to the ERR]."[52] It is curious that Ribbentrop and Abetz retained custody of certain modern works (pieces they derisively referred to as the products of *Wilden*, or savages), but they harbored designs to trade these pieces for more acceptable traditional works. Even this unseemly venture brought out the Nazis' competitive instincts, as Ribbentrop and Abetz worried that the ERR might first sell its modernist booty and flood the market.[53] In their forays through occupied France the ERR had, of course, turned up artworks that did not conform to Hitler's stylistic dictates. Behr, Scholz, and the other leaders who made ERR policy attempted to dispose of such art in the fashion mentioned above by Abetz: bartering and selling the pieces at a discount to art dealers in France and Switzerland. With their low regard for such art, they made highly disadvantageous trades, with exchanges of modern art for traditional works not

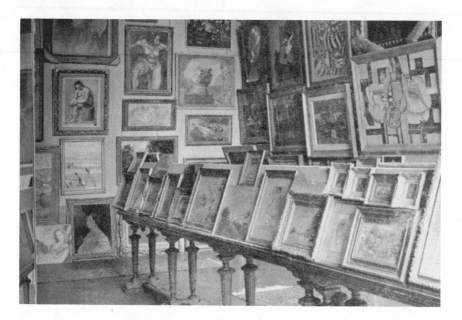

Separate room in ERR's Jeu de Paume storage facility for "degenerate" modern works, 1942 (Librarie Plon)

uncommonly occurring at a 25-to-1 ratio.[54] Furthermore, when forced to retreat eastward from France in mid-1944, they failed to take many modern works with them for fear of "contaminating" the Reich (the pragmatic looters did ship degenerate art to the Slovakian protectorate).[55] Yet an order from Hitler (through Bormann) noted in an ERR report of 15 April 1943 had explicitly prohibited the import of modern art into the Reich.[56]

In exchange for his assistance to the ERR, Göring obtained considerable influence over the agency. The postwar French government report termed the period dating from November 1940 to July 1942 *la période de l'hégémonie Göring*.[57] During this period the Reichsmarschall acquired approximately 600 artworks from the ERR, including a Boucher painting, *Diana*; a prized Watteau, *Galante Scène*; and Velásquez's *Portrait of the Infanta Margareta-Teresa*.[58] In establishing the various areas of cooperation with the ERR, Göring reserved for himself a favorable position in the hierarchy of precedence for the secured works of art. According to his famous order of 5 November 1940 the right to select artworks from the booty proceeded as follows: Hitler had first choice, followed by Göring, Rosenberg's Hohe Schulen, appropriate German museums, and finally, French art dealers, who would be engaged to auction off the remaining pieces, with the proceeds going to widows and children of deceased French soldiers.[59] Göring

claimed that he planned to pay for the works he took–"corresponding compensation," as it was called–and accordingly employed an art expert named Professor Jacques Beltrand to determine the "estimated price."[60] But the Reichsmarschall never forwarded any payment to the ERR or to the Party for the art that he received.[61] What was important to the Reichsmarschall was the appearance of legality. He even claimed to have opened bank accounts for such purposes (again, no transfer of funds is discernible).[62]

Göring visited the Jeu de Paume to inspect and select from the ERR's plunder. He made twenty such visits prior to November 1942, beginning with a session on 5 November 1940 when he dictated the above-noted order. On this first visit alone he earmarked for his own collection an estimated RM 1 million worth of art. Fourteen works from the fifteenth and sixteenth centuries that stemmed from the Seligmann brothers' collection pleased him the most.[63] Kurt von Behr oversaw these Jeu de Paume "exhibitions" for the Reichsmarschall, assisted by art historians Bruno Lohse, Hermann Bunjes, and Günther Schiedlausky. These four were so devoted to Göring that Robert Scholz accused them–and Behr in particular–of being more loyal to the Reichsmarschall than to their ostensible chief, Alfred Rosenberg.[64] Scholz also claimed that the ERR's top administrator, Gerhard Utikal, was overly attentive to Göring. He wrote to Rosenberg in a December 1942 report that "this approach of Behr [to Göring] was concealed and supported by Staff Leader Utikal."[65] While Behr and Utikal were perhaps just being cynically realistic, acknowledging the true source of their protection, other members of the ERR were in the actual service of Göring. Bruno Lohse and Hermann Bunjes both became members of the Luftwaffe and had to answer directly to the Reichsmarschall.[66] Lohse repeatedly tried to extricate himself from his post as assistant to Behr, finding the job unsavory. Protestations aside, he played a key role in helping Göring establish *la période de l'hégémonie,* and after the war the French extradited and imprisoned him for his deeds.[67]

The ERR employee who exhibited the greatest loyalty to Rosenberg, Robert Scholz, became frustrated by Göring's nefarious cooptation of the agency, both because of his personal loyalty to his longtime chief and because of his more selfless approach to National Socialism (the plundering action he conducted was, in his mind, not for personal gain). His protests about Göring's arrangement varied in tone. In trying to resist the Reichsmarschall's incursions, he initially tried to be calm and factual, as illustrated by the memorandum to the files noted above, where he explained the views of Behr and Utikal. In this document he also remarked that de-

Rosenberg and Kurt von Behr inspect looted objects in Paris, 1940 (Librarie Plon)

spite Göring's declared willingness to pay for the objects transferred to his care, he could not "designate as correct the business ways of Herr von Behr, who bears ultimate responsibility for this affair."[68] Scholz later became dramatic in his remonstrations. On more than one occasion he threatened to quit Rosenberg's employ (and evidently serve at the front) if the corruption provoked by Göring did not cease.[69] Rosenberg was never pleased about Göring's cooptation of his agency, but he was outmaneuvered by his higher-ranking colleague. Göring's craftiness especially irked him, as works were selected and on view in Carinhall before Rosenberg realized what had happened. Göring utilized various ploys to conceal his expropriations. Typically he himself would serve as a sort of middleman between the ERR and Hitler and in the process would create enough confusion to abscond with desired works.[70] Göring's selections were so poorly documented by the ERR that earlier, in March 1941, Rosenberg had taken the step of sending Scholz to Paris to determine what objects had found their way to the Reichsmarschall's collection.[71] Rosenberg's decision to transfer Behr to another branch of the plundering operation, the *M-Aktion*, which did not specifically involve artworks, undoubtedly alienated Göring, as Behr was the Reichsmarschall's key ally within the ERR. It should not be surprising that Behr's departure from the art plundering scene corresponds with the end of Göring's period of hegemony over the ERR.

The German civil administration in France made a concerted effort to revive the nation's–or at least the capital's–cultural life after the armistice in June 1940. In addition to opening nightclubs, theaters, and cinemas, they permitted art exhibitions. Most of these exhibitions were projects undertaken by the French that featured indigenous artists. Arno Breker was the only German to have an exhibition in wartime France. The retrospective of his sculpture that took place in the Orangerie gallery of the Louvre from 15 March to 31 May 1942 was an extraordinary event, as French artists, including Aristide Maillol, André Derain, Jean Cocteau, and Charles Despiau mingled with both the French and the German political and military elite. Abel Bonnard, the Vichy minister of education, arranged a reception for artists from both nations at the Hotel Ritz, and Robert Brasillach delivered a lecture on Breker at the Théâtre Hébertot.[72] Breker's patron and friend Albert Speer had arranged the funding and logistics for the exhibition. Despite Speer's inability to attend the opening (he came later), the enterprise proved a tremendous propaganda success for the Germans as they flaunted the collaboration in the press (including the showcase magazine *Signal*) and in newsreels.[73]

The Germans also managed to arrange a limited number of exhibitions in France that conveyed their ideological agenda. As in nearly all of the territories they occupied, the local population and the German armed forces were exposed to a range of propagandistic shows. While the Poles had *Warsaw Accuses* and various cities in the West hosted the sardonic exhibition *The Soviet Paradise*, the French endured *The Jew and France*, which was housed at the Berlitz Palace, and *Free Masonry Unveiled*, which had the Petit Palais as its venue.[74] The Germans also encouraged the French to stage a number of ideologically suitable exhibitions. The General Commissariat for the Family, for example, organized shows that, in the historian Matila Simon's words, "would do honor to Vichy's slogan, 'Country, Family, Work' (which had replaced 'Liberty, Equality, Fraternity')."[75] The productions of the General Commissariat stressed pronatalist and profamily messages.

There were a number of other events concerning the visual arts that had a propagandistic raison d'être. A group of celebrated French artists toured Germany in November 1941, where they visited the ateliers of their German colleagues. André Derain, Maurice Vlaminck, and others participated in this program, and they were filmed for the newsreels inspecting Speer's architectural models, visiting Breker's atelier, attending a reception hosted by Ziegler, and touring German museums.[76] The French artists had been induced into this fiasco with the promise that between 200 and 250 French

prisoners of war would be released for each participating artist. In fact, no prisoners were released as a result of the trip. The Germans also organized an exhibition of the art of French prisoners of war in the Galliera Museum in mid-1941. Featuring amateur artworks, the show was part of the Germans' effort to generate goodwill. A committee of liberated French prisoners participated in the planning, and visitors to the show could purchase a special postcard to send to those still incarcerated, whose correspondence was normally restricted.[77]

The German occupiers hoped to use cultural events to calm the French population and restore a sense of normality to everyday life. They encouraged the French to stage the 154th Salon d'Automne – which they did at the Museum of Modern Art in 1941. Art journals, such as the *Revue des Beaux Arts de France*, the official organ of the Ministry of National Education and the secretary general of the Fine Arts, appeared beginning in October 1942.[78] The French were also induced to bring some of the safeguarded treasures back from the provinces. The Louvre opened sections of the museum, including the Greek sculpture gallery, at the end of September 1940. A photo of Feldmarschall von Rundstedt and one of the museum's curators before a classical statue was distributed to the press.[79] The Germans even loaned works by Claude Monet from collections in Berlin and Bremen for a Monet-Rodin retrospective organized by the Musée Nationaux in late 1940.[80] Still, the harsh cultural policies of the occupation – which included not only the expropriation of Jewish property and the forced exile of many artistic luminaries but also the smelting down of statues – undermined this halfhearted pacification program.[81]

SECURING ART IN THE NETHERLANDS AND BELGIUM

Rosenberg's ERR, while an efficient force in the plundering of France, did not prove as effective in the other areas where branches were established. Various factors contributed to the curtailment of Rosenberg's confiscation plans. But put simply, the ERR in the Netherlands, Belgium, and in the Occupied Eastern Territories lost out to competing agencies. Rosenberg failed to exert his influence in these regions, both in the narrow sense of obtaining the right to capture art and more generally as a respected figure in the occupation administrations. Hence, for example, despite holding the title minister for the Occupied Eastern Territories (appointed by Hitler on 17 July 1941), he lacked real power. The usurpers in the east alone ranged from Himmler and Heydrich to the Reichskommissars and Generalkommissars whom he supposedly oversaw (Hinrich Lohse,

Erich Koch, and Wilhelm Kube).[82] In the Netherlands the ERR lost out to the Dienststelle Mühlmann and the Feindvermögensverwaltung (Enemy Property Administration), agencies that both fell under the jurisdiction of Reichskommissar Arthur Seyss-Inquart.[83] The two organizations worked together to the exclusion of the ERR, although the scope of their seizures never matched those of Rosenberg's forces in France.

The ERR did possess a mandate to conduct a campaign against the "enemies of National Socialism" in the Netherlands and Belgium. Rosenberg's guidelines, however, stipulated that the methods here were to be more restrained. As the Nazis perceived the Netherlands as a country inhabited by racial types similar to the Aryan and having a history and language with clear German connections, their occupation policies were less harsh and lawless than in the other European countries. The Netherlands was in fact slated to be administratively linked to the Reich.[84] The ERR's work group in the Netherlands, which was headed initially by a bureaucrat named Albert Schmidt-Staehler, therefore proceeded in a more cautious manner. Schmidt-Staehler had a modest staff of about eight workers.[85] They determined that Dutch Jews did not have art collections comparable to those of the Jews in France and decided to focus their limited resources on the securing of archives and libraries as well as Masonic lodges.[86] Additionally, the anti-Jewish measures were not implemented immediately upon the advent of the occupation. Not until 1941 did the full force of the Nazis' genocidal program go into effect.[87] Ultimately some art did find its way into the ERR's storage facilities, but this did not constitute a significant yield.[88] For the most part the ERR played a minor role in the Low Countries, as Rosenberg remained marginalized and without viable allies.

Those significant Jewish art collections that did fall into Nazis' hands usually went to the Dienststelle Mühlmann. The agency's accounts ledger listed 1,114 paintings as passing through their hands, and this did not cover their entire operation.[89] By enjoying the support of Reichskommissar Seyss-Inquart the Dienststelle had a great advantage, as their protector had a virtually unassailable position in the country's occupation administration (answering only to Hitler).[90] Mühlmann, fresh from his brutally successful enterprise in Poland, was recruited to the Netherlands by his friend Seyss-Inquart, and he initially viewed this next undertaking with the same malevolent intentions. In his postwar report the Dutch intelligence officer Jean Vlug conveyed the plunderer's eagerness, noting dramatically, "Rotterdam was still burning when Kajetan Mühlmann in his SS-uniform arrived in Holland to take up his task of the Dienststelle."[91] However, Seyss-Inquart restrained Mühlmann, making it clear that this project involved a different set of rules. True, the plunderers had an anti-Jewish ordinance to facilitate

their expropriations. *Verordnung* no. 58/1942, issued by Seyss-Inquart, required Jews to take their valuables, including jewels, precious metals, and artworks, to the Bankhaus Lippmann, Rosenthal, and Company – an Aryanized Jewish bank in Amsterdam.[92] This property was then handed over to the Feindvermögensverwaltung of the Reichskommissariat, under the direction of the economic chief, Dr. Hans Fischböck. The Feindvermögensverwaltung informed the Dienststelle Mühlmann of those valuable Jewish-owned artworks that came into the Bankhaus and then effected their transfer. There were at least seventy-five instances when this occurred.[93]

The Dienststelle Mühlmann did not normally resort to using commando tactics, although they cooperated extensively with the Gestapo and the Devisenschutzkommando – the two agencies that responded most often when Jews did not voluntarily turn over their valuables. The Dienststelle functioned like an art dealership or a clearinghouse for artworks uncovered by the other occupation agencies. The Dienststelle usually sold the works in its care, charging a commission of 15 percent above the *Schatzpreis*. Most of the major works went to Hitler and Göring, and in this arrangement money usually changed hands. There were instances when no payment was rendered for Jewish collections, as with the art belonging to Alphonse Jaffe and Fritz Lugt.[94] In all cases Hitler and the Linz agents were exempt from the commission. But in general the Dienststelle operated more like a business than any other branch of the NS plundering bureaucracy. Other Nazi elite also bought pieces from the Dienststelle. Among Mühlmann's customers were Heinrich Himmler, Baldur von Schirach, Hans Frank, Erich Koch, Julius Schaub, Heinrich Hoffmann, and Fritz Todt.[95] Nonetheless, Posse, Voss, and the Linz agents were the Dienststelle's most important clients.[96]

The staff of the Dienststelle Mühlmann included Mühlmann's chief assistant, art historian Eduard Plietzsch; two Viennese art historians, Franz Kieslinger and Bernhard Degenhart (the latter specializing in sculpture); Mühlmann's half-brother, Josef, who had established a reputation as an efficient plunderer in his own right; and a chief administrator, Josef Ernst.[97] Eduard Plietzsch, a specialist in Dutch art who had penned a book on Vermeer, had volunteered for the position, anticipating that it would be lucrative. He was not disappointed, as he reportedly commanded a salary of RM 10,000 per month plus expenses as well as a commission on the sales that he engineered.[98] The Dienststelle Mühlmann was a self-supporting operation; the commercial inclinations of its staff found expression not only in the sales to other Nazi leaders but also in the auctioning of artworks in the Reich, as prestigious firms such as the Dorotheum in Vienna, Adolf

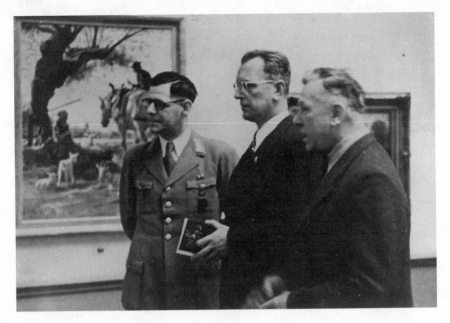

Seyss-Inquart (center) visits exhibition in Düsseldorf, 1942 (BAK)

Weinmüller in Munich and Vienna, and Hans Lange in Berlin sold off the plunder on their behalf.[99] With minimal costs and a sizable clientele, they were assured of a lucrative enterprise.

The Linz directors Hans Posse and Hermann Voss, while not plundering in the literal sense of pillaging or stealing, were so aggressive and exploitative in their behavior that they deserve to be considered part of the Nazi plundering bureaucracy. They also had official clout in the Netherlands. Posse was not only a museum director in Dresden and Linz (both state positions) but also the Referent für Sonderfragen (officer for special questions) in the Reichskommissariat. Posse set up an office at Seyss-Inquart's headquarters in The Hague (the former American embassy), where he could better oversee the three *Sonderkontos* that the Reichskommissar had established for Führermuseum purchases.[100] Even the art dealers working for the Linz Project–Alois Miedl and Erhard Goepel were the most important in the Low Countries–had official appointments issued from Bormann's Party chancellery. Armed with these directives, these dealers could issue very effective threats to reluctant sellers. However, one did not require an official position in order to intimidate or coerce, as indicated by the behavior of other dealers working for the Nazi leaders. Sepp Angerer, for example, who had worked on behalf of Göring to dispose of degenerate art abroad, but who held no state or Party post, was nonetheless known to raise the specter of the Gestapo in the course of difficult negotiations.[101]

Indeed, despite the respectable outward appearance of the Linz agents, their behavior was so sordid that the American OSS officers recommended in 1945 that "Sonderauftrag Linz be declared a criminal organization" and that the agents stand trial.[102]

Posse was very competitive and territorial regarding the art market in the Netherlands. He first approached Bormann in mid-June 1940 to request an ordinance restricting the art trade, whether this be denying other dealers travel passes or imposing regulations on imports to the Reich.[103] No such exclusive privileges were granted, although Bormann initially appeared sympathetic to the idea. Scores of German dealers continued to make their way westward to scour the Dutch market. Earlier, Göring's chief agent, Walter Andreas Hofer, had found his way to Holland, arriving five days after the capitulation, and he devoted much of his time to this market.[104] This mounting competition infuriated Posse, who sent a second unsuccessful proposal for restrictions to Bormann in February 1941. In this letter he argued for the radical measure whereby "private German purchases . . . should be prohibited, or the sale prices should be limited to approximately 1,000–2,000 guilder per item."[105] Yet Posse could have expected little else but a crowded market in light of the decision to link the economy of the Netherlands to the Reich. The currencies of both countries became directly convertible in April 1941, obviating the need for *Devisen* (foreign currency), which was normally very difficult to obtain.[106] In this relatively unregulated environment the Dutch art market experienced a boom and an inflation of prices from 1940 to 1944 that was unparalleled in the history of the country.[107] Göring even claimed that he and his staff of art agents could not come close to evaluating all of the works offered to them for purchase. Posse was forced to work extremely assiduously–to the extent that he continued to exert himself right up until his death from cancer in December 1942. His successor Hermann Voss, who bought even more artworks than Posse, also purchased frenetically. Being ever-diligent predators, they utilized auctions, private tips, renowned galleries, and of course the Dienststelle Mühlmann.[108] Between June 1940 and mid-1944 the Linz agents spent approximately RM 20 million on artworks in the Netherlands and contributed directly to the economic exploitation of the country.[109]

Posse and Voss fared well in the Netherlands not only because they had virtually unlimited resources at their disposal and could therefore outbid the competition but because they were closely allied with Seyss-Inquart. As the post of Reichskommissar was a political appointment–as compared with that of military governor that existed in France and Belgium–greater dedication to NS principles and to Hitler himself could be expected. This was true of Seyss-Inquart, a convinced Nazi of Austrian origin who re-

mained loyal to Hitler until the end (he was appointed foreign minister in the last cabinet of the Third Reich).[110] Furthermore, Seyss-Inquart did not shy away from illegal actions in order to accomplish his objectives. He would regularly intervene in the Linz agents' negotiations and apply pressure to the extent that he thought necessary, as he did with regard to the Mannheimer collection. In this case he threatened to push for the confiscation of the massive collection of Vermeers, Rembrandts, and other old masters, which had belonged to the deceased Jewish banker, unless the trustees of the estate consented to sell the works at far below the market rate.[111] Moreover, Seyss-Inquart apparently used his influence to discourage other German buyers from pursuing Mannheimer's art (this was as close as Posse came to his cherished monopoly).[112] The forced sale therefore allowed Hitler to purchase the key works for Linz (which included Rembrandt's *Jewish Doctors*) through the Dienststelle Mühlmann in 1941 for 5.5 million guilders–2 million guilders below the asking price. Lest one believe that Seyss-Inquart was entirely self-effacing in his devotion to Hitler and National Socialism, there have been reliable reports that he personally made a substantial sum on the deal (a figure in the millions of guilders).[113]

It was typical of the NS state that the Darwinist struggles between functionaries spawned a network of ententes and even friendships. These relationships developed at all levels, with the Göring-Rosenberg working relationship representing an alliance of two high-ranking leaders, and the Seyss-Inquart–Mühlmann partnership standing as an example of a subleader establishing a long-term collaboration with a functionary. Seyss-Inquart and Mühlmann, of course, worked together in Austria, Poland, and the Netherlands. Alliances below the elite level also formed within the Nazi state. Subordinates would establish contacts and working relationships with their counterparts in different offices. Within the Dienststelle Mühlmann, Dr. Franz Kieslinger handled all business with the Reichskommissariat's Feindvermögensverwaltung.[114] Inducing one agency to turn over artworks to another was rarely easy during the Third Reich. Yet Kieslinger and his counterpart in the Feindvermögensverwaltung, Dr. Gutjahr, developed a relatively frictionless arrangement.[115] Mühlmann and his colleagues in the Dienststelle, who never numbered more than a dozen, also maintained close ties with the SD, the Gestapo, and the SS. Owing to the small size of his agency, Mühlmann thought it important to make use of the German police forces in the Netherlands, and he went so far as to allow Peter Gern, the head of the SD in Holland, to share his house in The Hague.[116] Throughout western Europe Himmler's agents played a largely supporting role in confiscating artworks by assisting with the seizures and lending their transportation network to various agencies. They handled

Aktion Berta, for example, where eighteen railway cars filled with art were sent to the salt mine repository at Alt Aussee in March 1944.[117] While the SS rarely retained control of the objects confiscated in the west, Himmler's seemingly ubiquitous forces were so effective as collaborators that they, in a sense, comprised the oil that lubricated the plundering machinery.

PLUNDERING ON THE EASTERN FRONT

On the Eastern Front the bitter, unrestrained military conflict was underscored by even greater organizational chaos. While Himmler's forces took the lead, a number of rivals operated simultaneously but with relative autonomy (although significantly there was no *Kunstschutz* in the east). The various German forces inflicted immeasurable suffering on the local populations. In the realm of art plundering, the key organizations mirrored those existing at the more general administrative level. The task of securing art was divided between the SS and the SD, the Wehrmacht, and Rosenberg's RMBO. Added to this mix was the Sonderkommando Ribbentrop, which was something of an anomaly because the organization had no other administrative incarnation. It existed only to plunder. The lawless brutality that prevailed in the east obscured both jurisdictional spheres and the fate of the captured artworks. No orderly cataloging or transport process comparable to that developed by the ERR in France or the Dienststelle Mühlmann in the Low Countries ever existed; hence the complete disappearance of treasures such as the Amber Room – the amber- and jewel-encrusted chamber formerly in the Czarist summer palace at Zarskoje Selo (now called Pushkin).[118]

The ERR once again played a central role in the pursuit of cultural objects. While Rosenberg's organization began operation in the east on 1 September 1941 (with their headquarters in Smolensk), they were repeatedly denied the authority to coordinate art looting operations until they secured a specific Führer decree on 1 March 1942.[119] Previously Rosenberg had submitted numerous plans for a full-scale confiscation program, especially in autumn 1941 when the prospects for a successful campaign appeared the greatest.[120] Bormann, who helped implement Hitler's "divide and rule" theory cf government, did not want to invest too much authority in Rosenberg.[121] Bormann therefore arranged for the ERR to achieve the "goal of securing material for the spiritual fighting of opponents" but kept this assignment very general, not allowing Rosenberg to institute a program specifically aimed at artworks.[122] As in the west, some time elapsed before Rosenberg's staff expanded the range of their targets from libraries

and archives to artworks. Such a hiatus provided the basis for the postwar testimony of some of the perpetrators that they had not plundered art. Gerhard Utikal, the head of the ERR's Central Office, for example, stated that "the task [of the ERR in the east] did not extend to art treasures."[123] Utikal, like many of his associates, lied in his postwar statements and was convicted of war crimes.[124]

The March 1942 commission unleashed the ERR-Ost units in the pursuit of artworks. Significantly, many of the ERR art experts in France were listed as part of the agency operating on the Russian front. Even the overtaxed Robert Scholz was listed in the ERR-Ost records as heading the Abteilung Kunst in Rosenberg's RMBO.[125] Niels von Holst, who earlier answered to Rust and Himmler when he oversaw the repatriation of Germanic artworks in the Baltic region, had received a transfer to the ERR-Ost in October 1941. Holst continued to be in contact with Hans Posse, serving as the latter's chief agent in the east, as he looked for highly valued works.[126] The scope of the undertaking on the Eastern Front was daunting, and the ERR was somewhat overwhelmed by the task of securing art up and down the 1,300-mile front from the Baltic Sea to the Black Sea. Yet they engaged units throughout the east. For example, the ERR's Main Work Group Ukraine, with the help of Himmler's forces, removed paintings and other valuable objects from the municipal museum in Taganrog in the spring of 1942 and then struck the picture galleries in Kharkov and Pleskau, shipping back to the Reich forty wagons filled with "cultural goods" in October 1942.[127] The ERR agents emerged as the chief transport coordinators from the Eastern Front to the Reich, often overcoming the stubborn resistance of the local authorities, such as Generalkommissar for White Russia Wilhelm Kube, who battled to retain control of the art in the territory under his administration.[128] The history of the ERR in the east is still being written, as large archival repositories in the Central State Archives in Kiev, for example, have recently been opened. Scholars have even found evidence of considerable destructiveness on the part of the Soviets' Red Army in Kiev and other historic cities, as they implemented a "scorched earth" policy in their initial retreat in 1941.[129]

One must avoid viewing the ERR-Ost operatives as overly solicitous about conservation measures, although they themselves often claimed that they were merely engaged in safeguarding the art.[130] In fact, their behavior frequently reflected the brutal ideological warfare that marked this conflict. There were numerous cases of wanton destruction attributable to the ERR-Ost, including transforming the Tschaikovsky Museum in Klin into a motorcycle garage (with manuscripts and scores used as fuel for the stove) and burning out the Ekaterinsky palace in Pushkin after denuding it

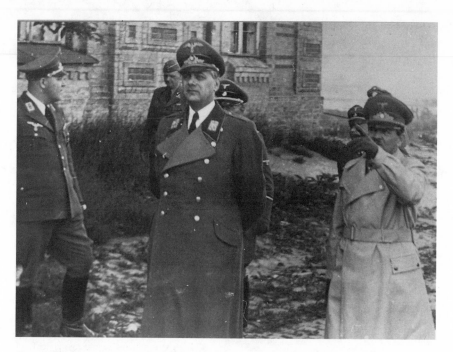

Rosenberg (center) and Koch (right) inspect cloister at Lawra in Kiev, 1942 (BAK)

of all of its treasures.[131] The ERR-Ost, which made use of the logistical advantages provided by the RMBO, was efficient in moving the artworks westward, but their program was not confined to protecting (or even to stealing) cultural treasures.

The ERR also engaged units in southeastern Europe and the Balkans, although deployment in these areas usually occurred later in the war and did not entail massive plundering operations. The ERR arrived in Yugoslavia in early 1943, but as the Jews of the region had earlier managed to evacuate most of their valuables, the haul was limited. The "highlight" came when 350 "artistically valuable paintings" from Belgrade were sent north to the monastery at Buxheim near Memmingen.[132] Bulgaria, Rumania, and Hungary were by and large spared from *Kunstraub* because they had joined the Axis alliance. Hungary lost this exemption in March 1944 when Admiral Horthy refused his country's military cooperation. The ERR then went in and sent back to the Reich a considerable quantity of art belonging to Hungarian aristocrats and Jews. The Museum of Fine Arts in Budapest was one of the state collections that fell into the Nazis' hands. Among the works they lost were a Lenbach portrait of Bismarck, which Hitler ordered directed to the Linz collection, and two Italian landscapes that Göring was rumored to have commandeered.[133] An ERR unit in Greece specialized in antiquities, but their activities were confined largely to carrying out excava-

Eberhard Freiherr von Künsberg, art plunderer in France and the Soviet Union
(BDC)

tions, and they left alone nearly all of the national treasures.[134] The ERR-Ost did most of its damage in the Soviet Union. Artworks in the southeast and south were a secondary consideration for them.

More enigmatic than the ERR, and arguably more effective as an art plundering organization in the east, was an agency known by its popular name, the Sonderkommando Ribbentrop.[135] Although overseen by the foreign minister and possessing a headquarters on the Hermann Göring Straße in Berlin, the critical figure was the aforementioned SS officer and major in the Geheime Feldpolizei, Eberhard von Künsberg, who accompanied his men to the front (and proved so important that his own squad was often referred to as the Sonderkommando Künsberg).[136] The Sonderkommando Ribbentrop organization consisted of three battalions that followed the invading army groups, an organizational scheme resembling that used by the murdering squads, the *Einsatzgruppen*; a fourth unit was deployed in North Africa.[137] The Sonderkommando Ribbentrop was comprised primarily of SS forces attached to Ribbentrop's Foreign Ministry.[138] Initially totaling 80 to 100 men, it later grew after the addition of 300 to 400 reserves.[139] A number of the original troops, like Freiherr von Künsberg, had been active plunderers the preceding summer in France. As Alfred Rosenberg had secured a veritable monopoly on the French booty, these forces were freed to move eastward and accompany the invading armies.

PETRODVORETS. Photograph of 1946

The Great Palace near St. Petersburg, 1946 and today (Aurora Art Publishers)

According to testimony given at the Nuremberg trials, the foreign minister issued verbal orders to the commandos' leaders on 5 August 1941 that placed the battalions in active service on the Eastern Front.[140] Previously, the groundwork for the Sonderkommandos had been established when, on 11 June 1941 (prior to the attack on the USSR), General Franz Halder issued a directive – classified as a *Geheim Kommandosache*, or a secret commando concern – that ordered all army personnel to support Ribbentrop's operatives.[141] It is undeniable that on the Eastern Front, "the Wehrmacht actively engaged in art theft and the conscienceless depredation of irreplaceable cultural objects."[142]

The most effective of the Sonderkommando Ribbentrop forces followed closely behind General Feldmarschall Wilhelm von Leeb's Army Group North in the advance through the Baltic states into northern Russia during the late summer and autumn of 1941. The Sonderkommando's more noteworthy targets included palaces formerly belonging to the czars and their relations. Peter the Great's estate Montplasir at Peterhof, the Pavlovsky palace in Pavlovsk, and the magnificent residence referred to in German documents as *Schloß* Marly were all ransacked.[143] Like the ERR endeavors, their activities combined destruction with theft. The palaces noted above were left charred remains, as were other cultural landmarks such as Pushkin's and Tolstoy's homes. The Soviet prosecutor at Nuremberg estimated that 34,000 objects alone were taken from the castles Marly, Montplasir, and Pavlovsky, and the famed Amber Room, which had been a gift of Friedrich Wilhelm I to Peter the Great in 1716, was packed up and shipped westward.[144] As books were also a prime target of Ribbentrop's commando, it is difficult to assess the raw numbers reported at the International Military Tribunal.[145] Perhaps more vivid is the estimate that forty to fifty freight cars per month of looted valuables were sent westward by the vari-

ous branches of the Sonderkommando.[146] Many of these objects were stored in a depot on the Hardenbergstraße in Berlin, although a number of pieces, including the disassembled Amber Room, went to warehouses in Kaliningrad (Königsberg).[147] The Soviets took steps to evacuate eastward artistic objects in order to keep them from the Germans. For example, none of the 2.5 million artworks in the Hermitage Museum's collection at the time was lost to the enemy.[148] Nonetheless, more artworks could have been saved from the Germans had the Soviet NKVD agents initially not equated evacuation measures with defeatism and hindered museum staffs in their work.[149]

The Sonderkommando Ribbentrop had no organized cataloging system; more than anything else, they were a part of the machinery of destruction ordered by Hitler.[150] In the summer of 1941 Hitler issued a supplement to *Führererlaß* no. 33, in which he argued that his forces would be able to secure large areas only "by striking such terror into the population that it loses all will to resist."[151] In another revealing directive, Feldmarschall von Leeb and the Sonderkommando Ribbentrop were informed in late September 1941 that "the Führer is determined to remove the city of St. Petersburg from the face of the earth."[152] As indicated above, the Sonderkommando acted in accordance with these guidelines by annihilating numerous cultural landmarks. Hitler believed it essential to undermine the culture of the Slavic people. In his *Table Talk* he pontificated, "Education will give the more intelligent among them an opportunity to study history, to acquire a historical sense, and hence to develop political ideas which cannot but be harmful to our interests."[153] The Nazis' program of cultural impoverishment therefore applied to the visual arts: destroying the artistic legacy of the eastern peoples was integral to their policy of subjugation. The Soviets claimed after the war that 427 of the 992 museums that fell into German hands were completely destroyed.[154] Even prior to their arrival the Nazi leaders held the view that the cultureless Slavs would at best have only remnants of the treasures once possessed by the royal family, and even these objects would be mostly of foreign origin (like the Amber Room).[155] After the ideological war of conquest commenced in June 1941, it was terror, more than acquisition, that formed the basis of the wartime policies in the east.

6 THE CONTRACTION OF THE CULTURAL BUREAUCRACY, 1943–1945

As the war progressed unsatisfactorily for the Germans, two members of the NS hierarchy emerged as particularly powerful and capable leaders. Martin Bormann and Joseph Goebbels continued their ministerial battles with inordinate energy and shrewdness, such that they, more than any other of the elite, directed the reorganization of the government and society during the nation's mobilization for total war. Heinrich Himmler and Albert Speer also enhanced their authority during the final stages of the Third Reich; but Bormann, as master of the Führer's antechamber, and Goebbels, who replaced Hitler as the regime's most visible public representative, were the ultimate victors in the twelve-year-long struggle for ministerial hegemony. Conversely, Hermann Göring and Alfred Rosenberg, the two Nazi chieftains who had fared so well at the start of the war, suffered an ignominious loss of stature and power as the Nazis struggled for their existence.[1] The fate of the two victors and the two who were vanquished lies at the heart of the final realignment within the NS government.

Joseph Goebbels's fortunes as a government minister progressed inversely to those of the nation as a whole throughout the course of the war. During the early stages, marked by military success, he was eclipsed by his rivals. Subsequently, the tenacious *alter Kämpfer* (who had been chosen by Hitler seventeen years earlier to head the Nazi organization in *rote Berlin* for this very quality) recovered amid the more general setbacks of the post-1943 period. Goebbels's most important bureaucratic instrument, the RMVP, had expanded during the Reichsminister's difficult years in the early 1940s, growing from 956 employees in April 1939 to 1,902 by March 1941.[2] But this increase was merely a part of the initial military measures – most of the thousand new workers were there in *Kriegseinsatz* (war duty) and would be released after hostilities had ended – and did not reflect a substantial increase in terms of his own power vis-à-vis the other Nazi leaders. Goebbels's exertions early in the war did not yield to him increased influence over policy making or, in particular, allow him a voice in determining military strategy.[3]

Goebbels's energetic but unavailing attempt to expand his authority through the Rückforderung project marked the nadir of his career as a Reichsminister. He had expended considerable political capital attempting to secure the commission to repatriate Germanic art. This ranged from convening a committee composed of representatives from the relevant government and military offices to writing to Hitler personally. Yet Hitler, for the complex reasons discussed earlier – which included not wanting to invest too much power in one subordinate as well as being swayed by the Göring-Rosenberg alliance – chose not to endorse Goebbels's proposal. In the wake of this setback, Goebbels responded in a revealing manner. He persisted in his quest to administer the booty, but he did so not by continued appeals to the Führer but by intraministerial machinations. Turning to the same tactics employed by Göring, the propaganda minister attempted to coopt Rosenberg's employees. He hoped first to collaborate with members of the ERR and then eventually win them over to his own offices.

Goebbels repeatedly approached key members of the ERR staff, but he had only limited success. This attempt to poach within the Party philosopher's domain extended back prior to the outbreak of war. Goebbels's efforts in the summer of 1939 to lure Robert Scholz away from the DBFU to head the Visual Arts Department within the RMVP stand out as a prime example.[4] Rosenberg had firmly but politely rejected Scholz's transfer to the RMVP. Goebbels had more success approaching Herbert Gerigk, a music expert within the DBFU, who headed the Sonderstab Musik of the ERR.

Gerigk was engaged in searching occupied France for valuable old instruments, manuscripts, and other treasures relating to music. Goebbels provided Gerigk with funding – RM 20,000 on one occasion – and offered to wield his political influence on the latter's behalf. He concluded one letter to Gerigk by thanking him "with special sincerity for the already accomplished work, and repeat that I will personally intervene at any time with any sort of difficulties."[5] Rosenberg allowed Gerigk to cooperate with Goebbels at this point for two reasons. First, in the autumn of 1940 it was not clear that the ERR would have a monopoly on plundering in France. He wanted to keep open the possibilities of an alliance as well as gather useful information (and Goebbels's operatives often had valuable knowledge about artworks during the early stages of the war).[6] Second, Rosenberg had always faced funding difficulties. He therefore allowed Gerigk, who headed a low-priority division, to accept the RMVP's money, so long as Gerigk's primary loyalty remained unchanged. This turned out to be the case, as Gerigk remained in Rosenberg's employ until the end of the war. Once Rosenberg secured his exclusive commission in France, and once he had made arrangements for funding with Party Treasurer Schwarz, Goebbels was rendered redundant. His advances to the ERR staff thus came to naught.[7]

Goebbels sought to improve his position within the NS cultural bureaucracy not only through the cooptation of underlings but by means of alliances with other leaders. Again, these efforts amounted to little in the early years of the war. His most feasible and potentially most fruitful attempt at collaboration centered around Robert Ley, the head of the DAF. Ley and Goebbels, who were both experiencing difficulties in realizing their goals, proposed to Hitler that the KdF program, which was the cultural and recreational program of the DAF, be incorporated as the seventh chamber in Goebbels's RKK complex. According to their vision, Ley would become the president of this new chamber, which they would call either the Volkskulturpflege Kammer (the Chamber for the Nurturing of Popular Culture) or Die Kammer für Sozial-Kulturel Volksbetreuung (the Chamber for Social-Cultural People's Supervision).[8] Goebbels and Ley advanced this idea with great enthusiasm in mid-1941, exchanging proposals that were almost nostalgic about earlier instances of cooperation (they noted the RMVP had helped the KdF with its cultural programs on numerous occasions in the 1930s).[9] For Goebbels, bringing the massive KdF under his jurisdiction would have been a great coup. He would not only gain control over associations such as local choirs, art appreciation groups, and dance societies, but more important, millions more people would be part of his organization.

Goebbels and Ley encountered opposition from other ministers, most notably Rosenberg and Bormann, who resisted others' efforts to enhance their power on principle and who in this case, hoped that some Party agency would take over the supervision of popular culture.[10] Their shared opinion of the Goebbels-Ley merger constituted an important source of agreement between the two, and this cooperation helped shape the relatively frictionless relationship between Bormann and Rosenberg during the early war years.[11] In debating the merits of an expanded RKK, these four actors produced a flurry of proposals, complaints, and threats in 1941. Only Hitler's decision, which came in November of that year, ended the *Papierkrieg*.[12] The verdict, which was not in Goebbels's favor, was graciously phrased: the merger was opposed on the grounds that such bureaucratic reform should be postponed until after the war. While Goebbels was far from devastated by the outcome of this dispute – he had never invested too much energy or ego in the plan – the setback was part of a series of defeats that he suffered prior to 1943.[13] The aborted plan for a seventh chamber, when considered in light of his lost battle with Baldur von Schirach for supervision of Vienna's cultural institutions, with his failure to dislodge Reich Press Chief Otto Dietrich from his cherished position next to Hitler, and with his unsuccessful struggle with Ribbentrop for control over foreign propaganda, reflected the difficulties that Goebbels encountered in this period.[14]

Goebbels's response to the repeated setbacks he suffered from 1939 to 1943 consisted of initiating new projects. Rudolf Semmler, a journalist who worked in the RMVP, noted that "if Goebbels did not go out of his way to find extra work, his routine tasks in the ministry, he says, 'would fill only four or five hours a day.'"[15] Although this statement seems quite remarkable in light of the fact that Goebbels conducted his daily 11:00 A.M. sessions to direct the press, oversaw the sole newsreel production company (he had consolidated the three prewar establishments into one unit), and still handled a variety of tasks in the RMVP, the RPL, and the Berlin Gau office, the propaganda minister still found time for new projects.[16] Most important, his writing and speaking endeavors kept him in the public spotlight and provided the basis for the revival of his career. He wrote a regular column for the fashionable weekly *Das Reich*, which was an attempt "to make Nazism intellectually respectable by collecting the best journalistic talent remaining in Germany."[17] As the newspaper's circulation rose to 1.5 million copies per issue, second only to the NSDAP's *Völkischer Beobachter*, the column helped Goebbels maintain a high public profile. Goebbels published at least three different volumes of collected essays and speeches during the war, and while these tomes did not reach as wide an audience, they were a

part of his own personal publicity campaign and helped lend him an air of intellectual respectability.[18] Public speaking was also an important component of Goebbels's job. Appearances at public rallies, such as his famous total war speech at the Berlin Sportpalast in the wake of the Sixth Army's defeat at Stalingrad on 18 February 1943, enhanced his position as a national leader. By making use of the new *Deutsche Kleinempfänger*, the inexpensive radio that greatly increased the number of listeners in the Reich (the total war speech, for example, was broadcast live to the nation), Goebbels reached out to the German people in an unprecedented manner.[19] "The great personalities on the air were Goebbels and [the RMVP's head of radio broadcasting, Hans] Fritzsche–apart, that is, from Hitler, whose voice was heard less and less often as the war progressed and his public appearances diminished almost to vanishing point."[20] By utilizing the various media largely under his control, Goebbels established himself as the regime's most crucial link to the German people.

Despite his tireless efforts to maintain public morale, Goebbels continued to have his bureaucratic designs thwarted through early 1943. Although the propaganda minister came to be associated with the total war measures that were implemented to mobilize the nation further, he did not gain a position on the Committee of Three that Hitler created to oversee the post-Stalingrad reforms. To his "bitter disappointment," to use Rudolf Semmler's words, Goebbels was relegated to an advisory role as Lammers, Bormann, and Keitel (the head of the armed forces) received the coveted appointments.[21] In August 1943 Goebbels's aspirations to direct the home front were again dashed when Himmler was named Wilhelm Frick's successor as minister of interior. Not until July 1944, in the wake of the failed attempt to assassinate Hitler, did Goebbels complete this reversal of fortune, when he was named general plenipotentiary for total war and finally assumed the responsibilities that he had long sought.[22]

Ironically, Goebbels's bureaucratic success in 1944 did not entail the expansion of his offices. Rather, as plenipotentiary for total war he oversaw the dismantling of many Party and state agencies. Power within the bureaucracy during the last years of the war meant the ability not so much to expand one's scope of authority as to maintain that which had previously been created. With manpower at a premium, only those offices that could be justified as essential to the war effort were allowed to continue to function. Goebbels therefore fared quite well during this final phase of contraction. Not only were his own offices left largely intact, albeit with staff reductions as the Unruh Commission pared down all branches of the state bureaucracy, but he also oversaw these total war measures.[23]

The propaganda minister, to be sure, tried to lead by example, but the

Speer, Ley, and Goebbels – bureaucratic allies during the war – together at Berlin Sportpalast, June 1943 (BAK)

cutbacks in his own sphere were largely a part of his public relations and self-promoting schemes. Robert Herzstein writes, "Goebbels was ostentatious about his austerity long before the proclamation of total war in 1943. In 1941, Goebbels made his old Party comrades bring their own bread and meat ration cards to the 15th anniversary celebration of his accession to the Gauleitership of Berlin."[24] Goebbels also paraded in front of his peers the fact that the RKK reduced its personnel by 75 percent.[25] Yet the RMVP, the RPL, and the Berlin Gau office continued in most of their functions. Goebbels used this image as an austere, committed, and fanatical fighter to muster support from among his peers. Beginning in the spring of 1943 he led the Wednesday Group, which consisted of other leaders who styled themselves in a similar fashion. It is significant that Goebbels also referred to this informal assembly, which included Speer; Walther Funk, the economics minister; Ley; Fritz Sauckel, Gauleiter of Thuringia and Reich commissioner of labor; and Wilhelm Stuckart, Staatssekretär in the RMdI, as the "radical group."[26] In assuming a leading role in implementing the total war cutbacks, Goebbels first did so unofficially and then, in 1944, from a recognized bureaucratic position. Despite having formed the radical group to counter the influence of the Committee of Three, Goebbels developed a working arrangement with Bormann; the two shared an enthusiasm for drastic reforms.

An example of Goebbels wielding his authority to institute cutbacks in the cultural realm of the bureaucracy can be found in his dispute with Bernhard Rust about the closing of art and music *Hochschulen.* The long-standing struggle between the two men to oversee these schools (Rust had managed here to preserve his ministry's traditional jurisdiction) resurfaced when Goebbels issued orders to close them down. Goebbels anticipated little resistance from Rust, who by this point had lost the respect of his peers because of a drinking problem and the widespread perception of his general incompetence. For example, Rust's speech to a 1943 rectors' conference in Salzburg was "delivered in a state of acute inebriation [which] was seen as a public admission of his impotency."[27] Rust, however, vigorously and stridently opposed Goebbels's orders for the art school closures, appealing to Bormann, and hence Hitler, to keep them open.[28] To a limited degree, Rust's pleas found acceptance as Hitler decided that an architectural *Hochschule* in Weimar could be left open because of its "special importance in the training of skilled builders and engineers."[29] Bormann, however, as with most total war measures, sided with Goebbels and favored the *Stillegung* (shutting down) of the schools.[30] Goebbels's and Bormann's improved relations in the last years of the war, as with Bormann's and Rosenberg's falling out, were crucial to the changing ministerial dynamic and hence the distribution of power.

Goebbels did not always need to take matters into his own hands to implement the cutbacks that he desired. Rivalries between other Nazi ministers and the contracting boundaries of the *Großdeutsches Reich* sometimes did this work for him. The most visible of such cases was the evaporation of Alfred Rosenberg's sea of offices. As the Party philosopher had revived his career in the early war years by heading organizations that functioned in the conquered territories, the turning of the military tide eliminated much of the work that he was charged with carrying out. This, however, did not entail an immediate cutback in his staff. In October 1944 Semmler reported Goebbels's complaint that "it is fantastic to think there should be a Minister for Eastern Territories with a staff over a thousand now that we have for all practical purposes lost them. . . . [Goebbels] cannot imagine what they do in Rosenberg's ministry. . . . Rosenberg, he says sarcastically, reminds him of the many European monarchs without countries or subjects."[31] In Rosenberg's case Bormann also did much to scale back his authority. This struggle, discussed below, was part of the trend whereby the eventual survivors of the leadership rivalry—Bormann, Goebbels, Himmler, and Speer—jointly subdued their less successful peers. Goebbels, who for a long time appeared to be among the losers, reversed his fortunes by means of initiative and cunning and finished his career not only as

Bormann, Hitler, Eigruber, and an unidentified individual on inspection tour, 1942 (BHSA)

the overseer of total war measures but as the last chancellor of the Third Reich.

BORMANN AND ROSENBERG: TWO DIFFERENT FORTUNES

Martin Bormann also maintained his position at the end as he was appointed by Hitler in his "Political Testament" to head the Nazi Party. Yet he had managed to wield almost this much power while the Führer was alive, as he had acted as head of the Party Chancellery from May 1941 and as Hitler's official secretary from May 1943. This latter position provided him with the authority to issue orders on Hitler's behalf to the Reichsministers and not only to the Reichsleiters and Gauleiters, as had formerly been the case.[32] His assemblage of formidable titles, his ability to control the flow of information to (and to a lesser degree from) the Führer, and his scheming, conniving ways made him the most effective combatant in the (metaphorical) battle among the Nazi ministers. Goebbels, who felt culturally and intellectually superior to the vulgar Bormann but nonetheless feared him, worked hard to find common cause.[33] As already seen, they did so quite late in the war in a joint effort to mobilize the country and reform the government in the most radical way. Not all Nazi leaders managed to appease

the vitriolic Reichsminister; those whose positions stemmed from the Party side of the "dual state," such as Alfred Rosenberg, were more vulnerable to Bormann's machinations.[34] Yet other leaders, most notably Göring but also Speer, Ley, Rust, and Lammers, were also subject to attack.[35]

Bormann struck at both Rosenberg and Göring in early 1943 by moving to close down the ERR (a Party agency) as well as many offices within the DBFU. This came about to a great extent because he had learned of Göring's cooptation of the agency. Bormann opposed Göring's rapacious arrangement because he thought the Reichsmarschall undeserving of such riches and because it constituted a threat to the Führermuseum collection that he was overseeing (he was specifically in charge of allocation of funds but in fact had broader powers). Bormann hoped that the Sonderauftrag Linz staff, which had expanded gradually throughout the war to thirty, could take over the ERR's responsibilities, which by now mostly entailed sorting, transporting, and sheltering the stolen art. The Linz employees viewed the ERR as a compromised agency and charged Rosenberg's operatives with inefficiency and incompetence, especially with respect to the cataloging process.[36] They eventually induced Bormann to issue a series of orders to Rosenberg in January, February, and April 1943, which entailed shutting down the ERR and transferring the plunder to the Linz staff for further processing (*Bearbeitung*).[37] The order of 21 April 1943 was vintage Bormann as he attacked his rival's position through Hitler's authority: "The Führer wishes that the art objects seized through the Einsatzstab be given over to the specialists of the Führer for further processing."[38] This series of letters jeopardized Rosenberg's position as head of the ERR and keeper of the plunder in Paris and at the castles Neuschwanstein and Herren-chiemsee in southern Bavaria.

Rosenberg responded with a six-page letter on 4 May 1943 that had panicky undertones.[39] He volunteered to close a number of his offices so that the personnel could be released to the military, but he argued that because of "war necessity" the ERR be kept in action.[40] Rosenberg's most compelling reason for keeping control of the ERR was that the agency's work was still in progress and to transfer authority would delay the cataloging and safeguarding process. Furthermore, he stressed, the French were sure to make claims on these artworks, and only an accurate inventory would allow the Germans to put the issue to rest. Rosenberg tried to impress Hitler with his staff's work. On the Führer's birthday in April 1943 he presented Hitler with an updated report on the ERR (called the *Zwischenbericht*, or intermediary report) and three leather-bound volumes of photographs that detailed the prize booty collected by his agency (he added that another twenty volumes were almost ready).[41] Rosenberg also stressed the accom-

plishments of Robert Scholz, the author of the *Zwischenbericht*. Scholz, who was widely recognized (by Hitler and Bormann, among others) as a remarkable cultural bureaucrat, was allowed to continue many of his projects, including editing the regime's extravagant art journal, *Kunst im Deutschen Reich*, which Hitler insisted be kept in production until the destruction of the printing facilities in Munich in the autumn of 1944.[42] Scholz also helped determine the locations and nature of the *Bergungsorte* (safe repositories), or the castles and salt mines used by the Nazis to store their treasures. The task of hiding the art had import for the bureaucratic struggle: in one of many letters to Bormann, Rosenberg claimed that his organization safeguarded over 80,000 artworks—an exaggerated figure meant to impress Hitler and to discourage a transfer operation.[43]

Rosenberg ultimately retained control of the ERR by agreeing to cut Göring off completely from the agency's booty. Rosenberg had written a letter to the Reichsmarschall on 18 June 1942 wherein he attempted to end their special relationship. Göring waited out this rebuff. But five months later, on 24 November 1942, he made his last visit to the Jeu de Paume to select pieces for his collection.[44] Göring tried in vain to maintain his arrangement with the ERR, promising that he would pay for the 700 works that he had commandeered (there was no point in continuing the deception now that Scholz had made an inventory of the works taken by Göring from the ERR) and insisting that Carinhall would one day become a foundation (the Göring Stiftung) "to the German people."[45] Bormann and Rosenberg discussed the matter on the telephone, and Bormann made it clear that he would not allow the slippery Reichsmarschall any latitude here.[46] Rosenberg recognized his only course of action, reiterated the no-access rule to Göring in a letter of 3 June 1943, and issued new orders to the ERR staffers affirming anew the *Führer Vorbehalt*.[47] As a further sign that Göring's exploitation of his agency was a thing of the past, Rosenberg transferred the pro-Göring ERR employee Kurt von Behr to pursue furniture in the *M-Aktion*. This tactic of distancing himself from Göring worked quite well for Rosenberg, as he fended off Bormann's attacks better than could be expected.

Despite the continued existence of the ERR, Bormann and Rosenberg still found themselves at odds over the issue of safeguarding the valuable objects—the main task left to the looting organization. A settlement was finally reached when they made it a joint enterprise. The safeguarding plans advocated by Bormann and his adjutant Helmut von Hummel, which relied on salt mines as storage sites for the bulk of the treasure, were approved by Hitler, despite Robert Scholz's objections that such an environment constituted an unsuitable climate.[48] Scholz incorrectly argued that

the combination of cold temperatures and moisture would damage the artworks; the two dangerous combinations were either moisture and heat or cold and dryness. Hitler therefore sided with Bormann, Hummel, and the conservation experts in a dispute that was both protracted and passionate.[49] The decision to store the Führermuseum collection at Alt Aussee, establishing what was code-named Depot Dora, came in December 1943. Scholz raised further objections, arguing that the movement of artistic treasures during the winter would be too hazardous, as the mine was located atop a mountain in rural Austria and the road was treacherous. Nonetheless, objects earmarked for Linz began to arrive in January 1944, and by spring Scholz's objections, like the snow, had melted.[50] Rosenberg did not want to lose control of his cache at Neuschwanstein and Herrenchiemsee, and he continually opposed the demands of Director Voss and the Linz staff to move the more than 21,000 objects taken there from France by the ERR. With the Allies' successful invasion of the continent, however, Rosenberg yielded a bit and allowed seven convoys of Neuschwanstein booty to be transported to the mines.[51] In another compromise Rosenberg agreed that the guards who manned the storage facilities at Neuschwanstein could include SS men and Bormann's representatives, so long as ERR staff members also remained with the plunder. Bruno Lohse, later joined by Robert Scholz, stayed until the Americans arrived. Bormann's agents seemingly had the upper hand at the Alt Aussee site. Just days prior to the final collapse, Hummel traveled to the depot and removed millions of Reichsmarks' worth of gold coins and art.[52] But the ERR remained in existence until the end of the Third Reich and participated in the safeguarding of the major portion of their handiwork.

Bormann proved more effective in stifling Rosenberg's activities in other areas. As mentioned earlier, the Party philosopher in particular suffered from the contracting borders of the Nazi empire, losing the territory of his RMBO by the spring of 1944 and his foothold in France the following summer. Bormann did more than his share to pare Rosenberg's offices and limit his former ally's power. He did this by using a variety of tactics; most important, he cut off Rosenberg from Hitler, going so far as to release Rosenberg's liaison officer from the *Führerhauptquartier*.[53] Rosenberg, who wrote repeatedly to Hitler requesting direct access – that is, trying to circumvent Bormann – reportedly complained late in the war that he had not been able to speak alone with the Führer since late 1941.[54] This was an exaggeration, as there was at least one meeting in the interim on 16 November 1943.[55] Still, this visit was not enough to regain the dictator's confidence or revive his career.

In seizing control of the Party apparatus, Bormann also arranged for his

office, the Party Chancellery, to take over responsibilities that had previously been others'. Bormann's motivation for undermining Rosenberg were twofold. On the one hand, he thought little of the Party philosopher, and on the other, he was highly ambitious and sought to maximize his own power.[56] Therefore, in the post-1942 period he tried to pursue both goals simultaneously and personally assume the authority that was once Rosenberg's. One example (among many) concerned overseeing the indoctrination of Wehrmacht troops. While Rosenberg had previously negotiated an arrangement with Feldmarschall Keitel to carry out this project, Bormann eventually prevailed by assuming authority over the indoctrinating corps, the NS-Führungsoffiziere, who, after the battle of Stalingrad, were attached to all fighting units.[57] Rosenberg's DBFU also had most of its divisions closed down. This task was facilitated by the destruction of their Berlin offices by Allied bombs in November 1943. Toward the end of the war, the reduced staff worked from *Schloß* Kogl near Vöcklabruck, located in rural western Austria. "Of the manifold ideological projects previously handled by Rosenberg's office, only anti-Semitic and anti-Bolshevist research remained."[58] "Almost Rosenberg" (the name Goebbels had given him), who had ridden on others' coattails into a leading position at the start of the Second World War, was ultimately isolated and hence rendered quite powerless.

BORMANN AND GÖRING: TWO DIFFERENT FORTUNES, PART 2

Contemporaneous to his triumph over Rosenberg, but considerably more impressive, was the campaign Bormann led against Göring. The Reichsmarschall himself did much to contribute to his own downfall. The failure of the Luftwaffe, which not only lost the Battle of Britain but also proved unable to live up to expectations on the Eastern Front and in the skies over Germany, as well as Göring's increasingly isolated and sybaritic lifestyle led to a decline in his prestige. Others besides Bormann also worked to diminish the Reichsmarschall's influence, especially Albert Speer.[59] Bormann, however, did more than any other rival leader to bring about Göring's demise.[60]

The Göring-Bormann contest manifested itself in a variety of ways. Göring's joining Goebbels's radical group in the spring of 1943, motivated by his desire to counter Bormann's Committee of Three, is but one example. The struggle to control confiscated artworks constitutes another. As Göring focused so much attention on art during the war and as he invested so much of his ego in the development of his personal collection, Bormann

naturally used the issue of who possessed the plunder to attack his rival's position. One of the most striking examples of Bormann using art to humble the Reichsmarschall involved the Lanckoronski collection, a remarkable assemblage of art housed in Vienna that belonged to the aristocratic Austro-Polish family. Their treasures, which in Vienna alone were appraised by the Nazis at RM 8 million (and included 1,695 artworks), had been confiscated in October 1939 by the Gestapo because the owner, Anton Lanckoronski, had taken on Polish citizenship and fought against the Germans in the opening campaign of World War II.[61] The Lanckoronskis' Austrian property was placed under the care of a businessman in the lumber trade named Waldemar Polleter. As the state administrator, he was deemed capable of keeping track of the family's art as well as their rural estates. Polleter had no real power; the struggle to control the magnificent collection featured Göring, claiming this right for his HTO—which administered confiscated Polish property and supposedly credited the seized assets against the Polish war debt—against Bormann. Reichsminister Lammers and a host of officials in Vienna, the foremost being Reichsstatthalter Baldur von Schirach, also became involved in this case. Yet the contest, culminating in late 1943, quickly boiled down to one between Göring and Bormann.

The Reichsmarschall assumed the role of aggressor in trying to arrange a division of the collection, which remained housed in the Lanckoronski's Viennese palace until well into 1943 due to the general shortage of storage space. In February Göring had his aide, Dr. Reetz of the HTO, contact Bormann's Sonderauftrag Linz staff and inform them that some progress needed to be made in this matter as both the Reichspost and the Kriegsmarine (Navy) needed the palace for office space.[62] The following week Göring's representative articulated a more detailed plan for dividing the plunder: Göring's HTO; the Sonderauftrag Linz staff; Albert Forster, a Gauleiter whose territory encompassed much of the annexed Polish territory and who had some unspecified claim on the Lanckoronskis' property; and various Austrian museums would all receive portions of the collection. Göring proposed auctioning off any remaining pieces at the Dorotheum in Vienna, with the proceeds going toward Polish war reparations.[63]

Prior to the acceptance of any plan by Bormann (and hence Hitler), Göring arranged for at least three paintings in the Lanckoronski palace to be picked up by his agents and delivered to him (although Polleter reported that eight paintings as well as oriental rugs were removed).[64] These paintings included one attributed to Botticelli (*Madonna with Child and Angel*) and a Rudolf von Alt landscape. The former was accepted by Göring as a birthday gift from his staff. His office paid the highly favorable price of

RM 25,000 to the Institut für Denkmalpflege, the agency that generally administered confiscated collections in former Austria. Göring gave the Alt piece to Hitler on the latter's birthday in April 1943.[65] The Reichsmarschall tried to be generous in dividing up the plunder, earmarking another Rudolf von Alt work for Gauleiter Forster and inviting other authorities to take pieces. Despite a concerted effort to buy off his colleagues as well as Hitler, and despite his limited objectives to obtain but one piece to augment his collection of Renaissance art, Göring encountered strong opposition. The officials at the Institut für Denkmalpflege were incensed that Göring had spirited away the three works. Göring's agents were supposedly at the palace merely to inspect the collection. Furthermore, Bormann was unprepared to share the wealth with any of the other elite. Bormann repeatedly rejected the redistribution plans: "The Führer wishes that you notify Herr Reichsmarschall Göring, the Reichsstatthalter von Schirach, and the HTO directly and inform them once again that the collection stands at the Führer's exclusive disposal."[66]

During early 1943 Bormann and Göring continued to fight over the disposition of the Lanckoronski collection with their characteristic bluster and deception. Bormann refused to let any further artworks leave the custody of the Institut für Denkmalpflege and demanded that Göring return those pieces that he had managed to obtain.[67] The Reichsmarschall responded to Bormann's stern orders with a variety of promises. He said that he would talk to the Führer personally about the matter and that he intended to make a special presentation to Hitler of some 100 "especially valuable objects."[68] It is not clear whether Göring took the matter to Hitler.[69] He was usually too intimidated by Hitler to approach him about such potentially embarrassing affairs. Bringing up this awkward incident might also threaten the collection he had already amassed; he did not want his manipulation of the ERR, his ties to Kajetan Mühlmann (who had been his key informant about the Lanckoronski collection), or his egregious abuse of official funds to become a topic of discussion. The dispute moved toward a resolution in July 1943, when Bormann and Lammers came to recognize that Göring had not taken the most valuable treasures of the Lanckoronskis. The Reichsmarschall not only left the three Rembrandts, but the Botticelli painting was described (by Lammers) as *ein Art des Botticellis* (literally, a type of Botticelli); and the Rudolf von Alt was determined to be a watercolor, and hence of limited value.[70]

Bormann allowed Göring to keep two paintings, content in knowing that the Reichsmarschall had lost face by not being able to manipulate the situation to his advantage as in earlier days. Of the three paintings taken from the palace by Göring's representatives, two were paid for (in addition to the

RM 25,000 for the Renaissance piece, Göring provided RM 4,000 for the Alt), and one went to Hitler as a present.[71] Bormann therefore reserved the bulk of the Lanckoronski collection for his own purposes, the Sonderauftrag Linz, and the provincial museums of the Ostmark.[72] This victory over Göring was one of a number that Bormann engineered in the final years of the war. Another symbolic triumph came in May 1944, when Bormann arranged for Reichsminister Lammers to receive an eighty-acre estate adjoining Carinhall as a gift for the latter's sixty-fifth birthday.[73] Lammers had requested an "inflation-proof" token of esteem, although RM 600,000 also reportedly accompanied the land. Göring had always treated the property surrounding his "baronial residence" as his own; he frequently allowed his hunting parties to stray across the technical boundaries. Bormann, in providing for the award in Hitler's name, challenged Göring's sense of superiority and demonstrated the changed balance of power.[74]

Bormann's ambition knew virtually no limits, as he sought to achieve the "partification" of Germany's state and society.[75] Yet Bormann lacked a persona suitable for the nation's leader. In Hitler's political testament Bormann was not part of the order of succession as head of state (though as mentioned earlier, he was invested with considerable power). It is nonetheless apparent that Bormann, as with many of the Nazi leaders, perceived himself as a qualified supervisor of cultural policy – as a viable successor to Goebbels, Rosenberg, and Rust. He cultivated this image both publicly and within government circles. Publicly Bormann marketed himself as a populist, as part of the *völkisch* faction within the Nazi Party. In the *Verordnungsblatt der Reichsleitung der NSDAP* of January 1943 Bormann pontificated on culture as he envisioned it: "Culture is not a mere affair for fine people and one certainly does not need a doctorate in order to pursue a National Socialist cultural policy in one's township."[76] Bormann imagined the social and cultural life of the future Germany as grounded in village life. Stressing *gemeinschaftlich* values, his *Blut und Boden* vision harkened back to his roots in rural Mecklenburg and was clearly in opposition to modern, urban society. His antimodern vision was of the variety peculiar to National Socialism. While he warned of the dangers of jazz music, he nonetheless took pride in German technical accomplishments such as the *Autobahnen*.[77] Bormann, who worked in an isolated and bizarre world next to Hitler during the last years of the war, developed a number of eccentric and unrealistic views: his advocacy of polygamy for men and his extremist position on religious issues stand as just two examples.

Within the governmental sphere, Bormann pursued his goal of determining cultural policy by advancing the idea of a new office, the Haupt-

kulturamt der NSDAP (Chief Cultural Office of the NSDAP). He made plans to expand the Party Chancellery, and they became known to his colleagues at a remarkably late date in the spring of 1944. Bormann's earlier attacks on Rosenberg, which became evident at the beginning of 1943, suggest, however, that he had harbored this ambition for some time. Rosenberg and his subordinates gained knowledge of the plans for the Hauptkulturamt in May 1944. In a DBFU internal memorandum marked *Geheim!*, it was reported that Bormann had approached the Führer with a plan for the Party to take a more active role in regulating culture; this was meant to include the supervision of film, radio, and "other areas."[78] Hitler, in one of the rare instances where he did not follow Bormann's recommendations, decided that the time was not right for the creation of a new office. Bormann therefore was stymied in his efforts to gain a legitimate, recognized office for the control of culture. His ambitions unabated, he nonetheless continued to exert a strong influence in this sphere by means of the Party Chancellery. Bormann's liaison to Goebbels' RPL headquarters, Walter Tiessler, offered an effective means of communicating his opinions. Robert Herzstein, who described Bormann's 1943 article in the *Verordnungsblatt* (mentioned above) as "a challenge to Goebbels, who viewed such affairs as entirely within the scope of his own competence," observed that "towards the middle of the war, Bormann and the Party Chancellery became more active in propaganda work."[79] Despite his limited education, his crude mannerisms, and his unexceptional oratorical skills, Bormann perceived himself as qualified to shape the cultural life of the nation. Indeed, he wielded great influence in the last years of the Third Reich as he added to the particularly poisonous atmosphere that hung over the nation–a situation so dangerous that even Adolf Ziegler, the long-serving president of the RkdbK, was imprisoned by the Gestapo in the summer of 1943 for "subversive behavior" because of his relationship with Arnold Rechberg, an academic who formulated a plan to make peace with the western Allies.[80] While Ziegler spent a short time in a concentration camp, Hitler, according to the architect Leonhard Gall, remarked that "Ziegler should be happy that he has not been shot."[81]

SPEER AND HIMMLER: CULTURAL AMBITIONS REALIZED?

Aside from Bormann and Goebbels, two other leaders enhanced their positions within the government during the latter half of the war and hence wielded significant power within the regime's cultural bureaucracy: court architect and Reichsminister for armaments Albert Speer and

Reichsführer-SS Heinrich Himmler. Both men concerned themselves primarily with noncultural matters during this period, but in fact, prestige in the nonartistic realm could be, and was, translated into influence within the cultural bureaucracy—a situation that reflected the nature of the state apparatus. That both Speer and Himmler viewed their wartime duties as just that—the fulfillment of obligations to the nation and to the NS cause—and that the two leaders articulated plans for the postwar era that involved artistic endeavors attests to the pervasive cultural ambitions of the Nazi elite.

Albert Speer, prior to his assumption of Fritz Todt's responsibilities as minister of armaments in February 1942, had become an increasingly important figure in the cultural bureaucracy of the NS state. His influence stemmed from three sources: his close personal relationship with Hitler; his post as the GBI, where he oversaw all state-sponsored building projects in the capital; and his status as the preeminent architect of the Third Reich (and hence the first among equals within the artistic community).[82] Speer, from early 1942 on, devoted minimal time to cultural matters. Not only were his new duties very demanding, but the Nazis' halted their ambitious building projects once their hopes for a quick victory were dashed. Still, Speer managed to find time for his artistic concerns. He continued to edit the architectural section in *Kunst im Deutschen Reich*; exhibitions of his models and designs toured occupied and neutral European countries (he often attended the openings); he continued to use the enormous resources at his disposal to purchase paintings and commission sculptures; and he maintained friendships with artists such as Arno Breker and Wilhelm Kreis, with both becoming, in part thanks to Speer's sponsorship, officers of the RkdbK in 1943.[83] Indeed, both publicly and privately Speer continued to define himself as an artist. In a January 1942 article in *Das Reich*, which appeared one month before his appointment as Reichsminister for armaments, he insisted that the war had interrupted but not put an end to his artistic endeavors.[84] In a move calculated to bolster his image as a man without political aspirations, Speer wrote a letter to Hitler in January 1944 wherein he reaffirmed his desire to work only as an architect and interior designer after the conclusion of hostilities.[85]

Speer used his persona as an artist to great advantage: to appear apolitical, to suggest that he had no governmental ambitions, and to indicate that his actions were different from the unsavory maneuvers of the political and military leaders. The myth that Speer nurtured so successfully after the war, that of a naive but complicitous leader, had it roots much earlier, even though it bore little resemblance to reality. Speer was a shrewd, amoral self-promoter, and this is confirmed by a more focused analysis of his comport-

ment within the cultural bureaucracy.[86] Prior to the outbreak of the war, Speer had replaced Heinrich Hoffmann as the colleague with whom Hitler felt most inclined to discuss aesthetic matters. The underground passageway that linked the Speer-designed New Reich Chancellery (and hence Hitler's office) to Speer's studio on the Pariserplatz symbolized this close relationship.[87] Hitler took pleasure in the notion of this easy access to his architect and imagined spontaneous visits when the muses so moved him. Hitler relied on Speer to help implement many aspects of his cultural program, including the brutal and unlawful expropriation of artworks belonging to neighboring countries. As noted in Chapter 4, Speer worked in 1940 to bring about the removal of "confiscated church objects" from Poland – including the Veit Stoß altar and treasures from Pelpin – and in the process opposed, among other leaders, the local Gauleiters Forster and Greiser who wished to keep the objects in their territories.[88] In the spring and summer of 1940 Speer helped denude the Rothschild residence in Vienna of its interior decor as he cooperated with the SD, among other agencies, in stripping the palace bare.[89] Hitler also confided his art collecting plans to Speer. The architect on several occasions served as a link to Hans Posse and assisted with logistical arrangements.[90]

Speer's post as GBI provided him with an extraordinary base of operations within the cultural bureaucracy. Speer noted in his memoirs that he alone among the Nazi ministers could obtain Führer decrees directly from Hitler and circumvent Lammers and the rest of the government. Because of the GBI's bureaucratic expansion and the enormity of the office's financial resources, Speer had departments that dealt with all aspects of the city's management and growth.[91] Within his organization, Speer created a department called the Referat Kunst, headed by Klaus Böcker, that focused on artistic matters. The Referat Kunst hired artists to execute sketches, watercolors, and models of prospective projects.[92] Despite the building freeze necessitated by the war, these artists continued to design the Third Reich's architecture on paper. The Referat Kunst also purchased numerous artworks. These pieces were to adorn the new structures, although Speer often gave them to other Nazi leaders as gifts. Hundreds if not thousands of paintings were purchased by Speer's organization. For example, the lists of acquisitions for the period extending from December 1943 until 29 March 1945 (the date of the last receipt) comprise three thick folders in the Bundesarchiv.[93] The GBI bought the work of living artists, making Speer all the more important as a patron of the visual arts. He lavishly sponsored the sculptors Arno Breker and Josef Thorak, even prior to the creation of the GBI in 1937. Speer also oversaw many of the shelters where the artworks were safeguarded from Allied bombing.[94] He, in fact,

Speer and Thorak in the latter's atelier at Baldham in Bavaria (BAK)

designed the two huge and virtually indestructible flak towers at Friedrichshain and *am Zoo* in Berlin that were key repositories for the city's artworks.[95] While the construction and administration of these storage shelters did not in itself make Speer a cultural leader, this responsibility was a point of contention among the NS officials and a symbol of Speer's influence in the cultural realm.

Though Speer was a powerful and manipulative actor within the Nazi state, his exertions were benign when compared with those of Himmler, Bormann, and the more radically doctrinaire leaders.[96] A balanced assessment of his behavior would note that on occasion he even had a positive influence on the nation's cultural producers. Speer was indeed a friend to many artists, and he intervened in a number of cases to aid the persecuted. For example, Speer helped Josef Thorak extricate himself from political difficulties in 1943 caused by remarks that were critical of the regime.[97] Later, in November 1944, Speer wrote to Himmler on behalf of two artist friends of Arno Breker who were in the Gestapo's custody.[98] Arguing for lenient treatment of one of the prisoners, a painter named Bretz, Speer made the interesting observation that the artist had "always been against decadent representations in art–also prior to the seizure of power." Whether this antimodernist sentiment was sincere on Speer's part is difficult to ascertain because of his ambivalent comments on the subject. But Speer's attempt to induce Himmler to intervene reflects his concern for

many of the nation's artists.[99] As both an administrator and a practitioner, Speer was undoubtedly a key figure in the cultural realm.

Heinrich Himmler, another Nazi leader who managed to expand his power during the course of the war, also positioned himself as one of the key arbiters of culture. Like Bormann, Himmler was drawn to cultural matters by the prestige and power associated with managing this sphere. The Reichsführer-SS, despite being an unlikely candidate to take the lead in such affairs, afforded cultural considerations a prominent place in his racialistic worldview. A combination of megalomania and ideology inspired Himmler to expand the scope of his authority. Certain developments helped whet his appetite for power in the cultural arena, such as assuming the post of minister of interior in August 1943 – a position that held the potential for a tremendous broadening of influence.[100] More importantly, however, Himmler expanded the SS so as to include a wide range of enterprises, many of which touched upon cultural matters. As Alfred Rosenberg complained after the war, "Whether it concerned publishing houses, art events, medical periodicals, social questions, porcelain manufacturing, concentration camps, cultivating plants, producing synthetic rubber, or finally, the creation of the Waffen-SS, it was all, as I later said, just a collection of points."[101] The SS, sometimes described as a "state within a state," therefore included a cultural bureaucracy of its own.

The SS cultural bureaucracy, in mirroring the organization as a whole in its breadth and complexity, featured a number of different components. The most important of these with respect to culture came under the purview of the Persönlicher Stab des Reichsführer-SS, the administrative branch of Himmler's empire that oversaw many of his favored projects, including the Ahnenerbe and the Lebensborn program. The cultural activities of the Ahnenerbe, as discussed previously, entailed overseeing the disposition of artworks and cultural artifacts among the migrating populations in eastern and southern Europe, the undertaking of supposedly scholarly research, the administering of museums and collections, and the publishing of books and pamphlets. Yet the Persönlicher Stab of the Reichsführer-SS also coordinated other enterprises or, as they called them, economic undertakings (*wirtschaftliche Unternehmungen*).[102] There were more than forty SS-sponsored enterprises situated at more than 150 factories and offices.[103] While these projects were sometimes profitable, they often existed because they offered Himmler a means of furthering his own cultural and ideological interests. Many of the *Unternehmungen* under the purview of the Persönlicher Stab des Reichsführer-SS "stemmed as a whole more or less from the personal initiative of Himmler, who, with their establishment, pursued specific ideological goals or personally favored notions."[104]

Those *wirtschaftliche Unternehmungen* with cultural significance can be divided into four different spheres: publishing houses and the press, art institutes and museums, archaeological and historical enterprises, and the porcelain and ceramic factories. The publishing ventures of the SS were particularly significant because they directly concerned Himmler's efforts to project his social and cultural views. Himmler, who prided himself on being one of the oracles of Nazi ideology, had a number of forums that articulated his cherished ideas. *Das Schwarze Korps*, the official newspaper of the SS, had long served this purpose. Editorials on *entartete Kunst*, the mystical and quasi-divine German landscape, and even reviews of the *GDK* appeared throughout the twelve-year Reich. The SS publishing house, the Nordland Verlag, published over 200 titles during its eleven-year existence. *Blut und Boden* literature and tracts that were antichurch and anti-Semitic predominated. The Nordland Verlag, which was headed by SS-Hauptsturmführer (captain) Dr. Alfred Mischke, was large, profitable, and influential. In 1942 it had sales of RM 7.3 million and earned a profit of RM 1 million, a figure that made it "in terms of gross revenue already the largest German publishing house at this time."[105] Although the Nordland Verlag continued to grow throughout the war, publishing more books and periodicals (sometimes in different languages so as to meet the needs of the multilingual New Order), the Picture Department (Bilderabteilung) became divorced from the house in 1942, re-forming under the name Völkischer Kunstverlag.[106] Alfred Mischke continued to head both the Nordland Verlag and the Völkischer Kunstverlag. Through this second enterprise he guided the plans for an art journal that would reflect Himmler's views on culture, namely, German-centered, aesthetically conservative, and tied in to various sorts of anthropology and "pre-history."[107] The total war measures and bombing raids, however, prevented the appearance of this journal. The Völkischer Kunstverlag therefore confined its activities to the reproduction of portraits of Hitler, Himmler, and the other Nazi leaders as well as prints of famous artworks.[108]

Himmler also arranged for the SS to take control of a number of institutions concerned with art. Some of these organizations simply fell into Himmler's hands, such as the collection of paintings and the library in Darmstadt of Frau Mathilde Merck, who bequeathed her deceased husband's collection to the SS after her own death.[109] Himmler inaugurated plans for SS-managed museums, including the distressingly ironic galleries dedicated to the traditions of the "culturally meretricious" Jews and Freemasons – groups he intended to render historic phenomena.[110] Adolf Eichmann, a key figure in the implementation of the Final Solution, began his SS career in 1934 as part of the staff that created the museum for Free-

masonry.[111] In many cases Himmler and the SS assisted preexisting institutions with funding and political protection.[112] An example of this latter variety, the Deutsches Kunsthistorisches Forschungs Institut in Paris, was headed by SS-Obersturmführer (first lieutenant) Professor Dr. Hermann Bunjes.[113] The most important project undertaken at the institute, and one that illustrates the ideological thrust of the scholars' work, concerned the Bayeux tapestry. Bunjes arranged for photographers to take precise photos of the medieval Norman tapestry so that its "Germanic roots" could be better understood. Himmler ordered the institute to confiscate the tapestry (it had been returned to the French authorities) upon the Allies' landing in France in June 1944, an episode that reveals the difficult position of the professional staff under SS oversight. Still, employees of the Paris institute, while unambiguously Nazified, for the most part refrained from confiscations or other sorts of blatantly illegal conduct. Himmler never obtained the famed tapestry.[114]

The third type of cultural enterprise that concerned the SS focused on historic and archaeological sites. The Gesellschaft zur Förderung und Pflege Deutscher Kulturdenkmäler e.V., which was formed in 1936 as a suboffice of the Persönlicher Stab des Reichsführer-SS, discovered and cared for sites that Himmler deemed culturally significant. By 1945 this office supervised sites throughout the Reich and the occupied territories, including the castle at Wewelsburg near Paderborn, the excavation project at Haithabu near Schleswig, the Glandor House in Lübeck, and Burg Busau in Moravia.[115] The Gesellschaft had substantial funds at its disposal; one of their accounts in the Dresdener Bank had RM 13 million as of 1943.[116] With such resources Himmler could indulge his interest in Teutonic cultural history. He therefore sponsored the search for significant objects, such as runic carvings in stones and decorative spears, and bought such items on the open market.[117] Furthermore, Himmler financed the rebuilding of castles and historic structures. This was one of the tasks assigned to SS-Standartenführer (lieutenant colonel) Hermann Bartels, the *persönliche Architekt Himmlers*.[118] Engaging Bartels, who also worked to transform the Wewelsburg castle into an SS school and meeting place for the leadership corps, was but one element in Himmler's cultural program. Similarly, the Reichsführer-SS had an art agent in his employ, SS-Sturmbannführer (captain) Wilhelm Vahrenkamp, who occupied a top post within the Entwurf und Kunstüberwachungsbüro, or Design and Art Supervision Office.[119] Bartels and Vahrenkamp had regular contact with Himmler. They dedicated themselves to the cultural endeavors of the Reichsführer-SS and were among the many artists and intellectuals who lent their skills to the most heinous of the Nazi leaders.

The Allach Porzellan Manufaktur, which was founded in 1935 as a private concern and which came under the auspices of the SS in 1936, was supervised by yet another unconscionable cultural figure: an artist named Professor Karl Diebitsch, who oversaw the Abteilung für Kulturelle Forschung (Department for Cultural Research) within the Persönlicher Stab des RF-SS, and later served, among various wartime assignments, as commander of the 11th SS-Totenkopfstandarte.[120] Although there are few extant records concerning Diebitsch or the activities of his Kulturelle Abteilung, he was concerned with "all artistic and architectural questions which were of interest to the Reichsführer-SS," and this included activities ranging from the drafting of the Ahnenerbe logo to the design of an eagle that Himmler wanted placed in the Quedlinburg cathedral.[121] Diebitsch's primary responsibility lay in overseeing the Allach porcelain factory, which expanded in 1937 with the opening of a second plant at Dachau (prisoners from the SS-run concentration camp located nearby were employed at the outset of the war).[122] The crafts produced at Allach and Dachau were available to the general public in the Reich and many of the occupied territories. The flagship store was on the Hermann Göringstraße in Berlin, although most items were intended for the SS.[123] Himmler remarked in 1941 that he wanted "art in every German home, but first of all, in the houses of my SS-men."[124] Approximately half of the objects produced by the Allach concern were allocated according to Himmler's specific orders, as he commissioned objects as gifts and awards: for example, the *Jul-Leuchtern* (the candlestick holders for the pagan *Julfest* that Himmler proposed as a replacement for Christmas) and the *Geburtsleuchtern* (birth candlesticks), which went to SS men upon the birth of the fourth child.[125] Himmler, who received a 40 percent discount from the Allach Manufaktur, not only sought to induce his followers to commemorate events in his own NS fashion but also hoped that the porcelain enterprise would set the style for the Third Reich. Himmler feared the *Verkitschung* (degeneration into kitsch) of the arts and crafts industry.[126] He therefore charged Allach with making *künstlerisch wertvolle* (artistically valuable) pieces and to this end employed as a designer not only Professor Diebitsch but also the highly esteemed Nazi sculptor Professor Josef Thorak. Furthermore, Himmler had Allach designs inspected by the director of the famed Staatliche Porzellan Galerie in Dresden, Professor Dr. Paul Fichtner. Himmler described the Allach enterprise as "one of the few things which is positive" and viewed the production of ceramics as a means for him to influence the culture of the Third Reich.[127]

Himmler, concerned as he was with the inculcation of Nazi ideology, sought Rosenberg's and not Goebbels's area of jurisdiction. He wanted to

Karl Diebitsch, painter and artistic adviser to Himmler (BDC)

Karl Diebitsch's design of a vase for Himmler to be produced by the SS porcelain manufacturer at Allach (BDC)

control ideological training, education, and culture in the broad sense and did not aspire to manage the artists' associations or control the budgets for museums.[128] His remark to his masseur Felix Kersten, cited earlier, where he contemplated combining his position as head of the SS with the Kultusministerium (culture/education ministry) and his plans for a *weltanschauliche Schule* (to complement the SS academies), convey a sense of his aspirations. The cultural component of his vision of Aryan domination, although rather idiosyncratic because of its emphasis on early German history and the inclusion of an arcane mysticism, was nonetheless an integral part of his own worldview.

THE NATIONAL SOCIALIST ELITE AND CULTURE

The Nazi elite concerned themselves with the visual arts for three main reasons: First, their ideology aimed to be totalistic—that is, a worldview that shaped every aspect of the adherent's outlook—and this entailed an elaborate conception of the nation's culture. Second, Hitler viewed himself a visionary in this realm, and the Führer's interest in the arts induced his followers to adopt similar concerns. Third, propaganda proved to be an enterprise where the Nazi regime attained considerable success. The leaders had the resources for patronage at their disposal as well as the means to issue the orders that shaped the government's *Kulturpolitik*; they therefore involved themselves in this highly visible project to alter the consciousness and taste of the German people. Whether one conceives this enterprise as a transformation of subjective and not objective reality (or a change in perceptions but not in the structures of society), or as "the war that Hitler won," the Nazi leaders managed to manipulate the nation's media and arts to their advantage.[129]

The Nazi ministers' twelve-year-long battle for primacy within the cultural bureaucracy reveals incredible arrogance and self-delusion as well as an avariciousness that was consistent with their aggressive posture toward the outside world. That nearly all of the elite, including the uncouth and poorly educated Bormann as well as Himmler, the eccentric architect of genocide, viewed themselves as capable arbiters of culture attests to their generous assessments of their own abilities. The widespread rivalries in the cultural realm suggest that the elite had virtually no sense of their own limitations. They all, for example, delivered public addresses, even if they, like Alfred Rosenberg, were notoriously boring and unintelligible speakers. Similarly, they almost invariably felt the need to publish books with their own ideas and reflections. Even the cynical *Realpolitiker* Göring issued ideo-

logical tracts.[130] Like sharks who need to move in order to survive, the Nazi elite unceasingly churned forward, asserting themselves as a type of reflex action. The rapaciousness and self-importance that characterized the Nazi elite's conduct within the cultural bureaucracy is significant because it accurately portrays their behavior in a more general sense.

COLLECTING ART

THE
CERTIFICATION
OF AN
ELITE

7

AN OVERVIEW
OF THE LEADERS'
COLLECTIONS
AND METHODS
OF ACQUISITION

This chapter aims to provide an account of the Nazi elite's collecting of art and is organized by individual leader. They are as follows: Adolf Hitler, Hermann Göring, Joseph Goebbels, Joachim von Ribbentrop, Heinrich Himmler, Baldur von Schirach, Hans Frank, Robert Ley, Albert Speer, Martin Bormann, Arthur Seyss-Inquart, and Josef Bürckel. Chapters 8, 9, and 10, which are more interpretive and analytical, refer back to this overview. The sections in Chapter 7 also provide a summary of the wealth and lifestyles of the leaders. As a point of reference, note that the average industrial wage in the Third Reich amounted to RM 150 per month.[1]

THE WESTERN ART MARKET IN THE INTERWAR PERIOD

The art market in Europe during the 1930s and early 1940s fluctuated widely. A deflationary trend existed during the early years of the depression, where certain genres, such as the English eighteenth-century school,

suffered a tremendous drop in prices (for example, Romney's *Miss Anne Warren* sold for $28,014 in 1928 but fetched only $3,767 in 1934). Yet the prices for old masters tended to hold relatively steady or even gain slightly (Rembrandt's *Portrait of an Old Man* went for $91,770 in 1930; the Melbourne National Gallery bought Rembrandt's *Self-Portrait* for $98,900 in 1936).[2] During the 1930s, works from the Renaissance and those by exceptional artists such as Vermeer (who produced fewer than forty known works) garnered the highest prices. The Hermitage Museum sold Raphael's *Alba Madonna* for $1.104 million and Botticelli's *Adoration* for $795,800 in the mid-1930s in order for Stalin to generate foreign currency.[3] In 1939 Hitler bought Vermeer's *An Artist in His Studio* (the Czernin Vermeer) at the highly favorable price of RM 1.65 million ($640,000); four years earlier American collector Andrew Mellon had reportedly offered a million dollars for the painting but was blocked by the Austrian government citing national export laws.[4] The prices of modern art decreased in the 1930s, in part due to the depression and in part from the Nazis' propaganda campaign and their selling such works from the German state collections. Figures for Matisse, for example, show a discernible drop in price, with, for example, *The Red Atelier* selling for $3,680 in London in 1927 and *Village Stream* bringing $1,256 in 1937. Granted, these works, as with others compared here, varied in quality, but they serve to illustrate the trend.[5] The market for the art of Picasso and Braque as well as Monet and a number of the Impressionists was also relatively poor.[6]

German old masters, like most other traditional art, rose in price in the mid- to late 1930s. Works by Hans Memling, the fifteenth-century master, sold for impressive sums, such as $29,900 for *Holy Family* in 1938 and $78,798 for the larger and more significant triptych *Descent from the Cross* in 1939.[7] Nineteenth-century German art also increased in price within Germany. Hitler's love for this art arguably contributed to the trend, with prices for works by Carl Spitzweg (one of his favorite painters) increasing approximately 500 percent from 1938 to 1944.[8] This figure is slightly artificial, as the sums fetched by all artworks rose considerably during the war. This occurred in the markets throughout western Europe. In the Netherlands and France inflation of 100 to 200 percent was not uncommon between 1940 and 1943. The buying and selling frenzy in Paris was so great that one of the leaders of the resistance, Jean Moulin, concealed himself in the capital by masquerading as an art dealer.[9] The Hôtel Drouot and other Parisian establishments had several record years during the occupation.[10] The market in Germany proved even more uncontrollable. The reports of the SD chronicled this inflation, as people sought safe investments in durable goods.[11] As previously discussed, the Nazi leaders contemplated regulating

the market early in the war but then decided against it when they realized that they had virtually unlimited financial resources and therefore could outbid the competition. The Germans also enjoyed a highly advantageous rate of exchange in the countries they occupied. An OSS officer, for example, described the art market in France: "German buyers came to Paris in hundreds. There was nothing to hold them back. Armed with their paper money, the *Reichskassenscheine* (invasion marks), which cost their country nothing, they had a twenty-to-one advantage over the franc and the reassuring knowledge that no matter what they paid in France, they could usually make a 100 percent profit at home."[12] In short, the art market flourished in western Europe throughout most of World War II, as the economic situation compelled the Germans to buy immoderately.

ADOLF HITLER

Hitler's favorite art was the Austro-Bavarian genre painting stemming predominantly from the nineteenth century.[13] It was this art, specifically the work of Carl Spitzweg and Eduard Grützner, that Hitler first collected. Aesthetically conservative, the Führer expanded his holdings during the Third Reich so as to include old masters and a limited quantity of contemporary "Nazi art." Using both personal and governmental funds and empowering his agents to select pieces from the war booty, Hitler amassed art at the most rapid pace in history.[14] A May 1945 inventory of the Sonderauftrag Linz repositories compiled by the MFA and A officers listed 6,755 paintings, of which 5,350 were identified as old masters.[15] Subsequent estimates of the size of the collection have been more modest. Certain scholars now place the number of paintings earmarked for Linz at 4,800 to 5,000.[16] Still, the Führermuseum, which would have featured massive galleries, could have exhibited roughly four times more works than the Louvre at that time.[17]

Hitler, like the other top Nazi leaders, blurred the distinction between official and private property. Hitler allocated enormous sums of governmental resources to build his collection and claimed in his personal will that he had collected on behalf of the state.[18] Yet he so identified with the state and so often treated the artworks assembled as part of the Linz Project as his own (placing pictures such as Watteau's *Landscape with Figures* and Vermeer's *An Artist in His Studio* in his home at the Berghof), that it is justifiable to use the term "Hitler's art collection."[19] Heinrich Hoffmann testified after the war that "after [the late 1930s] Hitler gave up all ideas of a private collection."[20] The manner in which Hitler shuffled the artworks to his

various headquarters and residences affirmed his personal control of these objects.[21]

Though Hitler had long been interested in art–his twice unsuccessful application to the Viennese Akademie der Bildenden Künste in 1907–8 is an oft-told story–financial limitations prevented him from buying art until the late 1920s.[22] Contemporaries have reported that the first noteworthy work Hitler purchased was a painting by Spitzweg. The title of the piece is never specified, but the work appeared in the second floor of Hitler's Prinzregentenstraße apartment in Munich in 1929.[23] Heinrich Hoffmann, who acted as an unofficial art adviser prior to the war, claimed, however, that the first purchase by Hitler of which he was aware was a sketch by Arnold Böcklin, the nineteenth-century Romantic artist whose work had mystical overtones.[24] Hoffmann played an important role in Hitler's early collecting activities, that is, in the pre–Linz Project period when Hitler made a sharper distinction between personal and state holdings. The two men shared a love for the Austro-Bavarian genre paintings. As they each had large sums of money at their disposal–Hoffmann's coming mainly from his monopoly on photographs of Hitler and postcard sales at the Haus der Deutschen Kunst–they would receive the myriad dealers and inspect the seemingly unending offerings.

Hitler's purchases alone supported a number of German art dealers, especially the Munich clique that included Maria Almas Dietrich, an amateurish vender who nonetheless sold more paintings to Hitler than anyone else.[25] Karl Haberstock, who directed over a hundred works to Hitler and the Linz agents, was preeminent among the Berliners.[26] A host of lesser figures–there are at least forty-eight dealers who are mentioned in the extant records concerning the Führermuseum–sustained their businesses by turning to the Führer. The most significant include Hans Lange in Berlin, Gersternberger in Chemnitz, Theodor Abel in Cologne, and Hildebrand Gurlitt in Hamburg.[27] Through these establishments Hitler exerted a considerable influence on the art market. As mentioned earlier, paintings by Spitzweg, Defregger, Thoma, and others in the Austro-Bavarian genre steadily escalated in price. This was both due to his zealous buying habits (thus increasing demand) and because of his influence as a tastemaker. Hitler sought to keep afloat the non-Jewish art dealers in Germany, thereby keeping open his conduit of artworks.

Much of Hitler's collecting took place in Munich, the city designated as the art capital of the Reich (hence the situation there of the showcase museum, the Haus der Deutschen Kunst).[28] There are a number of reasons why Hitler associated Munich with art. It had been one of the sites of his days as an artist prior to the First World War, when he worked as a painter

and maker of postcards. Even after the war, he enjoyed the artistic ambience of the Schwabing district. Hoffmann, his confidant in artistic matters, based his photographic business in Munich. In postwar interviews Hoffmann described accompanying Hitler to the Führerbau to meet with dealers and select paintings.[29] A large building belonging to the Nazi Party, the Führerbau was located on the Arcisstraße in the center of the city and offered storage facilities that were used to house artworks until May 1945.[30] Munich also proved a suitable place to center collecting activities because it had a thriving art market. There were not only a score of dealers eager to do business but a number of important auction houses, including Adolf Weinmüller (Odeonsplatz), Julius Böhler (Briennerstraße), the Brüschwiller brothers (Lenbachplatz), and Karl und Faber (Briennerstraße), as well as the Münchener Kunsthandelgesellschaft (Lenbachplatz).[31] Prior to the war Hitler typically visited Munich every few weeks, and he rarely passed up the opportunity to visit the dealers to inspect their offerings.[32] Later he became accustomed to making decisions based on photographs. Heinrich Hoffmann estimated that Hitler ultimately inspected in person only one-third of the works destined for Linz.[33]

Hitler also purchased a remarkable quantity of Nazi art – that is, art produced under his regime. He acquired Nazi art both from museums and the artists themselves. As an example of the former, his patronage of the annual *GDK* from 1937 to 1944 in the Haus der Deutschen Kunst deserves emphasis. Hitler would typically purchase 200 to 300 pieces from the *GDK* (out of 880 to 1,400 works exhibited). He would also usually make more than one buying foray per show. Nineteen thirty-eight is a representative year as Hitler made five trips to the Haus der Deutschen Kunst, buying 202 pieces and spending a total of RM 582,185.[34] While solicitations from artists also proved extremely common, Hitler and his staff did not buy in bulk in such instances and therefore acquired fewer works in this way. The artists themselves often wrote to Hitler, usually through the Reich Chancellery, offering their creations.[35] As Hitler wanted to nurture a new type of art that represented the Third Reich and as the Nazi government undertook unprecedented building projects that used art for decorative purposes, Hitler's generous patronage does not defy explanation. It is extraordinary, however, that Hitler himself made most of the buying decisions, leaving the Reich Chancellery staff – in particular Hans Lammers and the latter's immediate subordinate, Wilhelm Kritzinger – to negotiate the price and arrange payment. Hitler placed most of the Nazi art in his offices and various public or semipublic spaces. For example, Breker's sculptures adorned the New Reich Chancellery and Ziegler's triptych, *The Four Elements*, was placed in a salon of the Munich Führerbau. His private residences rarely had con-

temporary pieces. At the Berghof, for example, among the 534 pictures located there in 1945, only a couple can be classified as Nazi art, and these invariably had special sentimental value (a portrait of Troost, for example).[36]

A serious collector such as Hitler could not ignore opportunities in Berlin, and he naturally established contact with the city's important dealers. He had learned of Karl Haberstock because the dealer had developed a clientele in the 1920s within right-wing anti-Semitic circles. Haberstock, a shrewd businessman and sincere Nazi, catered to those who disliked doing business with Jews (although he received his training in the firm of Paul Cassirer).[37] He sold his first picture to Hitler in 1936 at a time when Hitler was accelerating the pace of his purchases.[38] Haberstock's peak years of influence came in the early 1940s. He counted Hans Posse as an ally and fared particularly well prior to the Linz director's death in December 1942. Both Haberstock and Posse competed with Heinrich Hoffmann for influence with Hitler. The rivalry grew quite bitter. Posse and Haberstock rightly thought Hitler's photographer ignorant of art (and frequently ridiculed him, for example, claiming that he pronounced the name of the Austrian painter Hans Makart like the Cafe Maquart in Berlin).[39] Hoffmann, conversely, accused Haberstock of profiteering, a claim that also had much substance. Haberstock prevailed in this contest while Posse lived. Yet even subsequently he fared better than Hoffmann, who was marginalized further because he was held in poor regard by Bormann and Hermann Voss. Haberstock had developed extensive foreign contacts. His own dealership included a branch in London until the onset of hostilities, and he worked with a number of influential collaborators in Paris, Lucerne (he was a friend of the *entartete Kunst* auctioneer Theodor Fischer), and other European cities.[40] His numerous contacts kept him in business until the end of the war.

Although the OSS investigators recommended that the Sonderauftrag Linz be declared a criminal organization, much of their collecting came about through purchases.[41] Hitler "spent more on art than anybody in the history of the world"–RM 163,975,000.[42] The agents in Hitler's employ tended to have territories where they specialized. Hans Posse, for example, though the director of the Linz Project, rarely traveled to Paris. He concentrated on the Netherlands and Italy and left France to Haberstock and others. In the Low Countries Posse's most effective representative was a German dealer named Alois Miedl, who obtained the famed Goudstikker collection, among many important finds.[43] In Italy Posse engaged Philipp Prinz von Hessen, who provided the advantage of being married to Princess Mafalda, the second daughter of King Vittorio Emanuele III. Prinz Philipp was well acquainted with many of Italy's leading families, thus help-

ing induce many of them to sell their art. He also had good relations with Mussolini, which proved particularly useful to Hitler because he was able to circumvent the Italian export laws that were made increasingly strict starting in the 1930s.[44] Hermann Voss used a somewhat different corps of agents, but the effect was the same.[45] In fact, Voss purchased more artworks than Posse, while continuing to mine largely the same quarries in the Netherlands and Italy.[46]

Hitler's art collecting activities depended on funding. While collecting privately, prior to the *Machtergreifung* and in the early years of the Third Reich, Hitler relied primarily on the revenue generated from the sales of *Mein Kampf* and on donations made to the Nazi Party. Book royalties amounted to substantial sums: the Eher Verlag paid Hitler royalties of RM 1.5 to 2 million per year between 1934 and 1944.[47] Income from investments, including the real estate holdings managed by Bormann and the various financial windfalls, such as the Adolf Hitler Spende, which was financed by major industrialists such as Gustav Krupp von Bohlen und Halbach, provided Hitler with supplemental income.[48] In 1937 Hitler developed the scheme for the *Kulturfonds*. The *Sonderbriefmarken* or special postage stamps, where buyers made a contribution above and beyond the postal rate, generated sizable revenues.[49] A report from Reichspostminister Ohnesorge to Hitler in February 1942 noted that the program had generated RM 20,387,046 to date, of which RM 19,990,000 had been allocated to *Kulturfonds*.[50] While archival records indicate that the annual revenue produced by the *Sonderbriefmarken* ranged from RM 3 to 6 million per year, one document, dated March 1945, suggests that over RM 52 million were eventually raised by way of the stamp program (an average of RM 6.5 million per year).[51] A bank account reserved for Sonderauftrag Linz purchases, called *Sonderfonds L*, was replenished with the *Kulturfonds*. The *Sonderfonds L* were administered by Reich Chancellery chief Lammers.

While Hitler paid for most of the art destined for the Führermuseum, he was not averse to illegal means of acquisition. Within the Reich Hitler allowed his agents to procure art through forced sales. The Czernin Vermeer, *An Artist in His Studio*, which was acquired only after the intervention of Bormann, Seyss-Inquart, Bürckel, and Baldur von Schirach, was a sufficiently unpleasant experience for the Czernin family that after the war members initiated proceedings challenging the legality of the transaction. In negotiating for the Vermeer Hitler's surrogates undertook investigations into the aristocratic Austrian family's tax obligations and made veiled threats via remarks about their patriotism. As mentioned earlier, Hitler obtained the picture for the favorable price of RM 1.65 million.[52] Hitler's recourse to illegal means of acquiring art also included the enhancement of

his collection with art confiscated from Jews within the Reich. One finds at least 324 pictures in the inventory of the Führermuseum that stemmed from Viennese Jews. Hans Posse exploited the Aryanization process, as shown earlier where he selected paintings for the Führermuseum in Munich in the wake of the November 1938 confiscations.[53] Later, when the ERR became active in France, one of the first treasures to be apprehended and earmarked for the Führermuseum was Vermeer's *The Astronomer*, which was owned by Baron Edouard de Rothschild.[54]

Hitler believed it his right as conqueror to claim artworks as the spoils of victory; even after nonmilitary successes, such as the dismemberment of Czecho-Slovakia, Hitler took artworks for his own collections. Thus, for example, Hitler removed tapestries from the Hradcany castle in Prague in March 1939 after his two-day visit and had them taken to Berlin. Later he had Breughel's *The Hay Harvest* taken from the National Museum, earmarking it for Linz.[55] The plundering in Poland also yielded works for the Führermuseum. Hans Posse visited Mühlmann in Poland in late 1939 and selected pieces for Sonderauftrag Linz, including works by Raphael, Leonardo, and Rembrandt.[56] The ERR collected over 21,000 works that had once belonged to French Jews as well as many artworks from Belgian, Dutch, and Eastern European Jews. The finest of the stolen works were to be part of Hitler's collection. Fifty-three of the best paintings confiscated by the ERR in France were not placed in the Neuschwanstein or Herrenchiemsee repositories but were among the artworks destined for Linz discovered in the Munich Führerbau.[57] In Vienna Hans Posse personally visited the Rothschild villa on the Theresianeumgasse in order to expropriate the leather wall hangings for Linz.[58]

Besides plunder and purchase, Hitler had one other means of acquiring art: gifts. An elaborate culture of gift-giving developed among the Nazi elite, and Hitler received hundreds of artworks as tribute. These gifts came from a variety of sources, but foremost from subordinates within the Party. To take but a few examples, on Hitler's birthday in 1936 Goebbels presented him with a Lenbach painting, and in 1939 he gave Becchi's *Leda and the Swan*, while Gauleiter Fritz Sauckel that year sent Lucas Cranach the Elder's *Naked Venus*.[59] Gifts also stemmed from foreign leaders. Mussolini gave Hitler Hans Makart's *Plague in Florence*, remembering the Führer's praise of the piece during the 1938 trip to Italy.[60] Finally, gifts were often presented by those who sought to curry favor with the dictator. The industrialist Alfried Krupp von Bohlen und Halbach, for example, journeyed to Obersalzberg in 1940 to give Hitler an ornate table made from Krupp steel, carved by the sculptor Erich Kuhn with various Nazi insignia and laudatory inscriptions.[61] This practice of giving art became standardized and even rit-

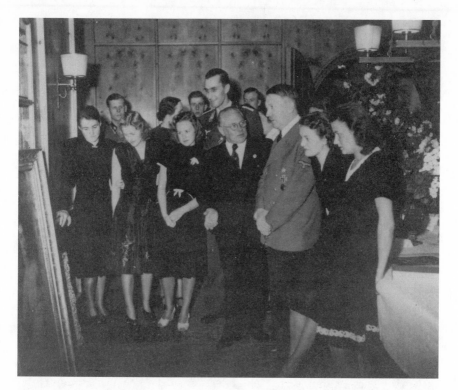

Hitler receives a painting in the company of friends at the Berghof on his birthday in 1943 (Getty Center, Resource Collections, Stefan Lorant Papers)

ualized, with Hitler and others fully cognizant of the symbolic import of the gesture.

HERMANN GÖRING

The number two man in the Third Reich had the second largest art collection in the country. Although Göring claimed that he eventually planned to turn his collection over to the state and make Carinhall a museum on his sixty-fifth birthday (which would have been 12 January 1958), he was also known to boast that he possessed the largest art collection in Europe owned by a private individual.[62] The emphasis of the collection, as illustrated by the instructions of the Direktor der Kunstsammlung des Reichsmarschalls, Walter Andreas Hofer, to the subordinate agents, lay in German old masters (the Cranachs, Dürer, and Grünewald), Italian Renaissance painting and sculpture, Dutch and Flemish old masters and tapestries, and the art favored by the French court in the eighteenth century

(Boucher and Fragonard, for example).[63] In 1945 OSS officers calculated that Göring's collection consisted of 1,375 paintings, 250 sculptures, and 168 tapestries.[64] By 1943 he already possessed 5 works by Rembrandt and 73 works attributed to the two Cranachs.[65] Walter Hofer estimated in postwar testimony that Göring spent over RM 100 million on art.[66]

Among the many sides of Göring's multifaceted personality two stand out: "the beer hall adventurer of 1923 and the lion of society of 1932."[67] Priding himself as something of an aristocrat from an early point, Göring unabashedly pursued the trappings of the nobility. After World War I, as a deactivated air force officer of bourgeois origins—his father had been a judge and colonial administrator—Göring had the desire but not the resources to acquire luxury items such as art. He married Swedish aristocrat Carin von Fock in February 1923.[68] Even then the moderate sums of money that Göring and his wife possessed in the early 1920s often went to the Nazi Party, which Göring had joined in 1922. Forced to flee Germany in the wake of the unsuccessful beer hall putsch of November 1923, the couple remained in exile until the Weimar government granted an amnesty in 1927. Göring was obliged to work during his years in Sweden, and their lifestyle was not extravagant by any means. When the Görings returned to Germany, Carin's terminal illness left them in difficult straits.[69]

Göring began to amass his art collection in the late 1920s, after Hitler had charged him with wooing German society over to the Nazis' cause. He became a Reichstag delegate in 1928 and started to receive significant sums of money as bribes from industrialists. Erhard Milch claims that Lufthansa alone gave Göring RM 1,000 per month.[70] In 1929 the Görings moved into their first luxurious residence in the Schöneberg section of Berlin. The "steel magnate Fritz Thyssen donated to him the decor and furnishings of the new apartment."[71] After Carin's death in late 1931, Göring closed the Schöneberg apartment and moved into a suite in the Kaiserhof hotel, a center of operations for Hitler. Göring, then the "respectable" Nazi, had become accustomed to the fruits of the Party's success. By 1933 he had moved back to more luxurious accommodations, an apartment on the Kaiserdamm that was sufficiently sumptuous to serve as a site for parties whose guests included Prinz August-Wilhelm, Philipp Prinz von Hessen, and Fritz Thyssen.[72]

Once in power Göring had an official residence provided for him as minister president of Prussia. By 1934 he had acquired land on the Schorfheide (sixty miles northeast of Berlin). While Göring used official funds for his building projects—Carinhall cost the German taxpayers RM 15 million that came from the budgets of both the Prussian Ministry and the new Air Ministry—he also continued to solicit funds from industrialists and others

The main hall at Göring's Carinhall estate (NAW)

with wealth. The "systemized bribery" included replenishing an account specifically called the *Göring Kunstfond*.[73] Even the employees in his various organizations had money withheld from their paychecks in order to pay for presents.[74] Using this combination of government funds, bribes, "contributions," and his salary, Göring financed a number of lavish residences. Besides Carinhall he had a castle called Veldenstein near Bayreuth; his hunting lodge, Romintern, in eastern Prussia; a Berlin villa on the Leipzigerstraße, which he had transformed into a Renaissance palazzo; a castle at Mautendorf near Salzburg; a chalet at Berchtesgaden near. Hitler's Berghof; a model farm called Gollin near Berlin; and Ringenwalde, an eighteenth-century manse also near Berlin.[75] Göring filled all of his homes with artworks, though Carinhall, a huge, Norse-style structure, was his show-piece and therefore the repository of his most valuable pieces. By mid-1944 a visitor would enter the great atrium of Carinhall and witness a stunning array of artworks, with the center of the room dominated by four huge canvasses: two Hans Memling portrayals of the Madonna and child, a Madonna and child by Lochner, and Han van Meergeren's *Christ and the Adulteress*, the last being an infamous fake Vermeer that duped Göring and his experts.[76]

Occupied as he was with his many official responsibilities, Göring came to rely on Walter Andreas Hofer to coordinate his purchases of artworks and a secretary named Gisela Limberger to compile an inventory and keep the records. Hofer succeeded an art historian and dealer named Binder in the mid-1930s as Göring's chief counsel on art. He in turn utilized a host of

others to help the Reichsmarschall build his collection.[77] The OSS report on Göring's pursuit of art listed eight individuals aside from Hofer as "purchasing agents": Sepp Angerer, the rug and art merchant discussed earlier who helped trade pieces of degenerate art abroad; Walter Bornheim, an art dealer based in Munich; Kajetan Mühlmann, the plundering specialist who searched Poland and the Netherlands, much to Göring's benefit; Bruno Lohse, a Berlin art dealer who was drafted into the Luftwaffe and sent as a liaison to the ERR in Paris; Alois Miedl, a crafty dealer based in the Netherlands who sold artworks to both Hitler and Göring and then escaped to Spain at the end of the war with many valuable paintings by old masters; Gottlieb Reber, a German living in Lausanne, Switzerland, who also proved an effective buyer in Italy; Hermann Bunjes, the ERR operative based in Paris during the war; and Kurt von Behr, the leader of the main ERR commando in France and arguably Göring's chief link to the plundering agency.[78] To the OSS list of those who played a key role in aiding Göring in the collection of artworks, one could add Theodor Fischer in Lucerne; Hans Wendland, another German dealer based in Switzerland, who also engaged in large-scale trades with the Reichsmarschall; and Gustav Rochlitz, a German living in France, who played a key role in bartering confiscated modern paintings for the more traditional types of art favored by Göring.[79]

Göring employed a hands-on method of collecting – even when the items involved were tainted by their having been obtained by force. His twenty visits to the Jeu de Paume between November 1940 and November 1942, where he inspected the booty taken in by the ERR and removed at least 594 pieces for his own collection, are a prime example of him not shying away from potentially embarrassing situations.[80] As mentioned earlier, the OSS investigators determined that Göring never paid for these pieces, though in his correspondence with Rosenberg and other leaders of the agency he expressed his willingness to do so. His failure to deliver payment stemmed from the administrative confusion that prevailed at the time: Göring claimed not to know who should receive the payments (NSDAP Treasurer F. X. Schwarz was the most likely candidate, as the ERR was a Party agency).[81] Göring did succeed in keeping careful records at other times, however, as when he profited by selling to other leaders or admirers (among other deals, he sold four Canalettos and a Jan van Goyen to Reichskommissar Erich Koch and two Jan Steens and a Jan Ruysdael landscape to the tobacco magnate Philipp Reemstma).[82] He was sufficiently deft to arrange complicated trades of modern works to Switzerland, even when the modern works had been seized by the ERR. Göring, Hofer, and staff arranged trades of modern artworks to Swiss dealers on eighteen occa-

Carinhall gallery (Getty Center, Resource Collections, Stefan Lorant Papers)

Göring's study in Carinhall, featuring a Franz von Lenbach portrait of Bismarck (NAW)

Jean-Honoré Fragonard's Young Girl with Chinese Figure, *which was acquired by Göring after it was looted from the Rothschilds by the ERR* (CDJC)

sions.[83] The Reichsmarschall's endeavors in the artistic sphere do not suggest any lack of organization but reveal an undeniable ability to manipulate the market. Göring's bartering arrangements were not confined to his disposing of unwanted modernist pieces. The most notable cases were perhaps the trades he carried out with the Louvre in 1943–44, where he acquired works such as a statue called *La Belle Allemande* in exchange for old masters and Dutch landscapes.[84] Göring "had a collector's passion for possession and an art merchant's aptitude for buying cheaply."[85] He "would have made a good dealer."[86]

Göring normally strived for legally binding and outwardly proper deals when acquiring art. There are indeed a number of cases where he shied away from transactions because they were potentially incriminating: for example, the Schloss affair in France. The Vichy government, led by Abel Bonnard and Louis Darquier de Pellepoix, joined forces with the Nazis to appropriate 332 paintings in the unoccupied zone and then transferred them to Paris for liquidation. The two governments engineered a forced sale whereby the Linz agents obtained 262 works, the Louvre took 49 pieces (of a higher quality), and a Vichy-appointed agent named Lefranc disposed of the rest of the collection. Göring, though initially involved in the matter, kept away from the affair because of "malodorous rumours."[87] Another incident occurred later in the war, in January 1944, when the Hermann Göring Division of the SS delivered sixteen crates of magnificent artworks to its namesake at Carinhall (including two Titians and Breughel the Elder's famous work *The Blind Leading the Blind*). Göring, upon learning

Pater's Joyous Outing, *which Göring acquired through the ERR, an example of eighteenth-century French art favored by many Nazi leaders (Librarie Plon)*

Göring visiting art dealers in Amsterdam in June 1940 (NAW)

that this art had been evacuated by the Italians from Monte Cassino, thought it best to consult Hitler. The Führer advised him to remove the artworks from his private residence, and Göring took them off "temporary" display at Carinhall, placing them in the flak bunker at Kurfürst on the outskirts of Berlin.[88]

Although Göring's art collecting activities were a part of his effort to project himself as an aristocrat and as a man of culture–he was known to boast, "*Nun mal bin ich ein Renaissancetyp* (after all, I'm really a Renaissance type)"–there were a number of incidents involving art that were incontrovertibly sordid.[89] In late 1941 an Englishman named Don Wilkinson wrote to the Reichsmarschall reminding him of a visit to his Quai d'Orsay home one year earlier, when Göring had admired a portrait of William of Orange's mother hanging in the living room. By late 1941 Wilkinson's wife had been interned by the Germans. The two men agreed to her release in exchange for the portrait being given to Göring.[90] Art dealers who did business with Göring sometimes encountered threats, either explicit or veiled. Gustav Rochlitz, a German dealer with a sullied reputation who was based in Paris as of 1933, told OSS interrogators that when negotiating the sale of Titian's *Portrait of a Man* and Jan Weenix's *Still Life*, Göring communicated to him through his representative, Bruno Lohse, that his asking price was *trop chère* and that he would "have to take the consequences" of not entering into the transaction according to the stated terms.[91] On a number of occasions Göring did business with Jews in the occupied west. While one might argue that he offered them protection, he also exploited the situation for his own profit.[92]

Unlike most of the other Nazi leaders, Göring had little interest in the contemporary art of the Third Reich. He was often absent from the *GDK* openings and was not a beneficent patron of the country's artists. The exceptions to this were his sponsorship of the tapestry factory created by the Nazis, his position as *Protektor* of the Prussian Akademie der Künste, and his patronage of an art school in Kronenburg called the Hermann Göring Meisterschule für Malerei (though he did not buy the products of the students).[93] Göring's sponsorship of the tapestry works was part of his effort at self-definition. He sought the association with these objects that were so expensive to produce and that were linked with the lives of the nobility. Nazi art, which was in theory a product of the *Volk* and which was more widely accessible in terms of price and popular appreciation, did not appeal to the neo-aristocratic Reichsmarschall.

Göring's art collecting thus stemmed from his desire to demonstrate his own exalted position and his cynical predilection to plunder. Indeed, his collection blossomed during the war, when at least a thousand pieces were

added by way of purchase and theft. The Reichsmarschall was almost schizophrenic, as his dual personas switched back and forth between the noble Renaissance type and the ruthless barbarian (not that the two were mutually exclusive among condottiere). He would at times claim that all of his collection had been legally acquired–he told the Americans after the war that he had lived respectably (*anständig*) for twelve years–but then boast unabashedly about his unassailable power.[94] He stated to a 1942 conference of Reichskommissars for the Occupied Territories, "It seemed to me to be a relatively simple matter in former days. It used to be called plundering. It was up to the party in question to carry off what had been conquered. But today things have become more humane. In spite of that, I intend to plunder and to do it thoroughly."[95] By means of his numerous offices and plentiful resources, Göring assembled the second largest art collection in the Third Reich. His artworks were indeed his passion, and it comes as no surprise that he spent his last days in power evacuating them to the relative safety of Obersalzberg, where they were housed in trains kept in secret, sheltered tunnels.

JOSEPH GOEBBELS

As the minister most responsible for the art produced in the Third Reich, Goebbels played a highly visible role not only as a theorist and critic but also as a collector of Nazi art. Goebbels noted in 1940 journal entry, "Examined my picture collection. We have now already collected a wonderful treasure. Gradually the Ministry will be a great art collection. So it must be, because yes, art is administered here."[96] As he had written his dissertation on romantic literature, published a novel, and always kept himself informed about the visual arts, Goebbels viewed himself as an arbiter of culture.[97] Upon coming to power in the spring of 1933, Goebbels immediately sought the accoutrements of his new position. He commandeered a palatial official residence from the minister of nutrition and began filling it with artworks, some of which were borrowed from the state museums and some of which were purchased.[98] Goebbels continued to collect art throughout his twelve-year tenure as head of the RMVP, though his more independent and sophisticated taste in art, which characterized his buying prior to 1936, gradually gave way to the conservative aesthetic line advocated by Hitler, Göring, and his peers. Goebbels was a man of contradictions. He emerged from the left-wing faction of the NSDAP and always had a popular, frugal streak (he was the chief proponent of the *Eintopf*–or one-pot meal–and the food in his home was notoriously austere). Yet he had a

massive wardrobe with some 500 suits as well as three residences within the environs of Berlin. Art was another area where Goebbels allowed himself to indulge. While he did not devote himself to collecting with the passion of Göring or the resources of Hitler, the self-styled "Czar of Nazi Culture" nonetheless used this activity to help shape his personal and professional persona.

Goebbels's openness to modern art, in particular, German Expressionism, early in his career is perhaps best illustrated by an incident noted earlier: Albert Speer's redecoration of the propaganda minister's official residence in May 1933, where he placed watercolors by Nolde in the living room.[99] These pictures depicting flowers in a moderately abstracted and expressionistic manner had been borrowed from the Berlin National-galerie, and they, in Speer's words, "delighted" Goebbels and his wife. Goebbels's liking of many types of modern art, which included having a Barlach sculpture in his Wilhelmplatz office, having his portrait painted by the Impressionist artist Leo von König, and sitting on the Committee of Honor for an exhibition of Italian Futurist paintings of airplanes, did not extend to the work of left-wing modernists such as George Grosz and Otto Dix. This was due to both political and aesthetic reasons. Specifically, he objected to these artists' products because of their cynical, critical, and often grotesque depictions—a sensitive point, seemingly, for the physically imperfect Reichsminister.[100] German Expressionism, which often had an idealistic element—and this would include Nolde's work where he sought to amplify the natural beauty of a flower or a landscape—was in Goebbels's mind both aesthetically pleasing and intellectually defensible.[101]

The evolution of Goebbels's antimodernist stance on aesthetic issues came about as a result of Hitler's gradually hardening line against the use of abstracted images. By 1936 Goebbels's tastes had narrowed to encompass only traditional styles and the folksy genre painting that comprised so much of Nazi art. As explained earlier, the reasons for this were largely political. This was a clear expression of the *Führerprinzip*, with Hitler adjudicating a strident debate. The proscription of modern art therefore became one of Goebbels's tasks. He was responsible for implementing the official *Kulturpolitik* and for fostering the art that would reflect and represent the "new Germany."

One of the key mechanisms for shaping the national culture came in the form of the patronage of artists, and for this purpose Goebbels had official funds at his disposal. The Mittel zur Förderung Künstlerische Zwecke (Fund for the Promotion of Artistic Goals) was an integral part of the RMVP's budget, and even with the outbreak of the war, Goebbels refused to economize in this area.[102] Goebbels especially enjoyed visiting the *GDK* before the

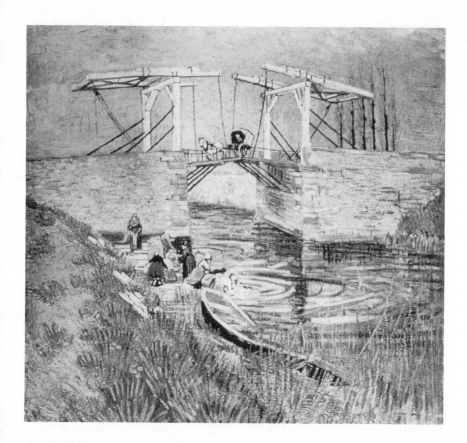

Van Gogh's The Bridge of Langlois at Arles, *a painting acquired by Göring that reveals his appreciation of certain modern works* (CDJC)

exhibition was open to the public and spending large sums of money on artworks. These went either to his ministry, to the various regional offices under his jurisdiction, or to his homes. In 1937, prior to the opening of the first annual *GDK,* he noted in his journal, "An art fund has been secured for me. I will have RM 200,000 at my disposal."[103] The following year, before the 1938 show, he wrote, "Just in Munich for the great exhibition. A series of pictures purchased. The level of the show is hit and miss. The sculpture is very good. Some pictures are outstanding, some rather kitschy. I picked the best ones out for myself."[104] The buying spree at the Haus der Deutschen Kunst became an annual event for the propaganda minister. Even if the visit, as in June 1941, was only a fleeting stopover between engagements in other cities, Goebbels nonetheless found time to buy numerous works (thirty-four in this case).[105]

Goebbels's support for artists working in the Third Reich extended beyond purchasing from the major exhibitions, as he supported artists di-

Hitler and Magda and Joseph Goebbels listen to Putzi Hanfstaengl play the piano in the Goebbels's Schwanenwerder home (Getty Center, Resource Collections, Stefan Lorant Papers)

rectly. He would personally visit the ateliers of luminaries such as Professor Arno Breker and Professor Fritz Klimsch and either extend commissions or buy existing pieces.[106] Goebbels arranged for a specific section of the RMVP, the Visual Arts Department, to be responsible for the patronage of living artists, although one internal memorandum dated 13 January 1936 noted that the bureaucrats were not to act too independently: "The Minister has the final decision on the purchase of all artworks by the Ministry. . . . Pictures, sculptures, and the products of German craftsmanship should be placed before the Minister *before* they are bought."[107] Buying art, therefore, was an activity that Goebbels did not delegate to others. His subordinates were primarily there to assist in the correspondence and the transferral of payment.

The art funds at Goebbels's disposal were by no means limited to the purchasing of contemporary Nazi art. The Reichsminister used his governmental budget to buy old masters, Dutch landscape paintings, and a variety of other artworks. Goebbels acquired two works by Rembrandt in the autumn of 1941, *Portrait of the Father* and *Portrait of the Mother*, for RM 100,000 from Max Winkler, the Bürgermeister of Graudenz in Danzig-Western Prussia who held a high-ranking positions in the Reich Film Chamber and the HTO.[108] These pieces ended up in Goebbels's Lanke home, although officially, as he explained to Winkler, they were on permanent loan to

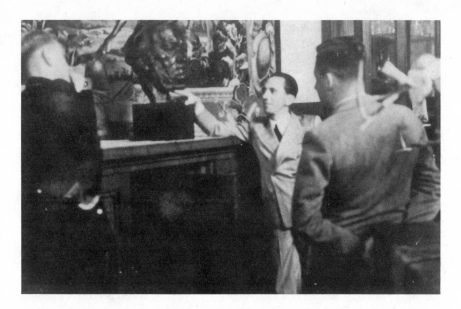

Goebbels and Schirach discuss Breker's bust of Wagner in the Berghof (Fabritius)

him.[109] Goebbels bought art from many of the prominent art dealers of the time. He purchased works from Theodor Fischer in Lucerne and from Bernhard Boehmer (also one of the degenerate-art dealers), as well as an art historian, Frau Dr. Rosso-Koska, who served as one of his key agents in occupied France.[110] Purchasing old masters required substantial sums: a Van Dyck painting, *The Holy Family*, which Goebbels bought with the help of both Fischer and Boehmer, cost 150,000 Sf–far more than most pieces of Nazi art.[111] Yet the Mittel zur Förderung Künstlerischer Zwecke consisted of the significant sum of RM 2 million per year by 1941, and half of that sum existed as Goebbels's "discretionary fund" and could be spent directly on artworks.[112] As the RMVP received funding not only from the Finanzministerium but also had the means of generating its own revenue, and as Goebbels had the means of generating a large private income (each article published in *Das Reich* brought him RM 2,000), he was able to purchase quality art.[113] Goebbels even gloated about his financial resources, as he wrote in early 1940, "I have a ton of money for cultural purposes at my disposal."[114]

Although Goebbels lost his bid to oversee the art plundering apparatus in the west and though he did not manage to coopt an agency, as Göring had done with the ERR, the propaganda minister was not completely excluded from the race for art in the western territories. The art dealers mentioned above did most of his bidding, and Goebbels in exchange provided them with travel papers and protection. Goebbels, for example, wrote to

the Fremdpolizei (Foreign Police) office in Berlin in order to obtain a pass for Theodor Fischer and added that governmental funds in the amount of RM 60,000 had been put at his disposal for the purchase of art in Paris.[115] Goebbels also journeyed to Paris on several occasions, where, in the capital of the wartime art market, he made purchases himself. His colorful diary entries in October 1940, for example, describe shopping sprees with Göring.[116] In most cases, however, he used agents to represent him. Frau Dr. Rosso-Koska, who sometimes worked under the code name "Schmall" (slim), had large sums of money transferred to her via the Reichskreditkasse in Paris (the institution that handled the procurement of *Devisen* in France), allowing her to pay for her purchases in cash. This is illustrated in a 13 April 1944 document where Goebbels provided her, under the name "Schmall," with RM 250,000 "for the purchase of art objects."[117] The French art dealers who did business with Goebbels's representatives knew the identity of the real customer. One receipt from dealer Theo Hermsen, who had a gallery on the Rue de la Grange-Batelière in Paris, listed the RMVP Visual Arts Department as the recipient. This bill (for a total of 5,315,200 ffr) listed the artworks acquired by the RMVP, including a Gobelin tapestry; landscape paintings by Jan van Goyen, Cornelis Decker, and Jan Lingelbach; and a picture attributed to Hubert Robert.[118]

Goebbels used agents in France to buy artworks and antiques that were to be considered his own private property, and the distinction between official and personal acquisition became only increasingly muddled as the war progressed. One RMVP document listed objects under the heading, "bought by Herr Brandl in Paris and taken over by the Propaganda Ministry."[119] It numbered some forty-eight objects and, in a column entitled "remarks," detailed the locations of the objects. They were invariably placed in one of Goebbels's three homes (Lanke, Schwanenwerder, or the urban palace on the Hermann Göring Straße in Berlin). The list included over 2.3 million ffr worth of antiques, porcelain, tapestries, and objets d'art. Another document in this Bundesarchiv file noted a separate set of bills incurred for objects that went into Goebbels's Hermann Göringstraße home. Among the creditors mentioned were art dealers, including the well-known Berlin auction house Hans Lange.[120]

Goebbels spent extraordinary sums of the government's money on homes and luxury items that he and his family alone enjoyed. While he usually acknowledged that this wealth was not entirely his own – his Lanke home, which cost RM 2.7 million, was declared in 1939 to be "the property of the German film industry" (which Goebbels headed) – it is nonetheless unlikely that he would have ever relinquished any of the objects that he acquired as propaganda minister.[121] There are a number of reasons for this

cynical assessment of Goebbels's intentions. His peers were, for the most part, also corrupt, taking bribes and honorariums and exploiting their positions of power. Goebbels, an egotist who thought himself superior to most of his colleagues, would also have thought such perquisites his due. Additionally, he actively engaged in giving artworks as gifts to other leaders. This entailed the use of ministerial funds to buy objects that would be considered private property by their recipients and further calls into question Goebbels's views toward the artworks and luxuries in his own homes.[122] The propaganda minister also invested considerable time and effort in designing his homes and acquiring his art. They were personal expressions of himself (and of Magda, who loved to buy antiques and spend time decorating).[123] While Goebbels occasionally complained in his diaries about the building process, this is perhaps understandable, considering that he had three homes being either constructed or remodeled at one point in 1939.[124] Goebbels thought of himself as a collector, as a shaper of an assemblage of objects by means of his own creative gifts. He therefore had a personal attachment to his dwellings and artworks.

Goebbels's taste in art came to be centered around old masters (especially Dutch masters), nineteenth-century genre painting (including the Austro-Bavarian variety favored by Hitler), and NS art. Goebbels was also particularly interested in self-portraits. He extended official commissions to many artists, including Leo von König (1935), Conrad Hommel (1938), Wilhelm Otto Pitthan (1938), H. J. Pagels (1940), Arno Breker (1942), and Rudolf Zill (1943).[125] The common theme that ties together these different fields of collecting is egotism. Whether he was the subject or whether these works represented the Nazi art with which he so closely identified because of his official position, Goebbels viewed the works as reflections of himself. Even collecting old masters involved self-promotion, as he attempted to act as one of the sovereigns of Europe's cultural legacy. Goebbels was a cynical parvenu who sought to use art to enhance his fame and sense of nobility. This generalization applies to many of the other Nazi leaders, but it is perhaps more striking and intriguing here in light of his quasi-socialist roots.

JOACHIM VON RIBBENTROP

The Reich foreign minister's art collecting activities appear quite consistent with Goebbels's accusation that Ribbentrop bought the "von" in his name, married for his fortune, and intrigued for his position.[126] Ribbentrop, who did in fact purchase his title from a distantly related "aunt" in 1925 and who married the extremely wealthy Annelies Henkell, the daugh-

Annelies Ribbentrop before a painting by André Derain in the Ribbentrops' Dahlem home (BAK)

ter of Germany's largest wine vendor, collected art because it conformed to the persona that he affected: that of cultured and cosmopolitan royalist cum militant Nazi.[127] Ribbentrop, who only joined the NSDAP in 1932 and by all accounts was an anti-Bolshevik royalist prior to 1930, never identified with the popular or socialist element in Nazism.[128] Prior to the seizure of

Ribbentrop villa in Dahlem in postwar condition (BAK)

power, he assisted Hitler and "the movement" by means of his contacts, by offering his Dahlem villa for important negotiations and receptions, and by giving advice on foreign policy issues. Ribbentrop, as most of his contemporaries recognized (notably excepting Hitler), was more show than substance. He nonetheless worked hard to project the fabricated image.

Ribbentrop's marriage to Annelies Henkell in July 1920 was the most important development in his life prior to the Nazis' seizure of power. It was the crucial determinant in his decision to sell wine and liquor for a living (his father-in-law was key here), and it established his social milieu. Annelies brought to the marriage the money for their first home – a house (that would later, after repeated reconstruction projects, qualify as a villa) in the increasingly fashionable Berlin suburb of Dahlem. Annelies also possessed a number of artworks; she not only came from a wealthy background but had studied art history in Munich.[129] By some accounts Annelies was fond of art, while Ribbentrop himself had more of an interest in music (during the war he purchased a Stradivarius violin in Paris).[130] Yet the two of them, who were both socially and politically ambitious, worked hand in hand to establish his career, their fortune, and of course, their collection.

A survey of the Ribbentrops' art collecting activities offers insights into various aspects of their personalities. For one, they acquired a number of works that suggest that they were orthodox Nazis. They had many Austro-Bavarian genre paintings as well as some contemporary works from the

Oath–Taking of the Leibstandarte-SS *by Diebitsch* (BAK)

Third Reich.[131] In public life, and especially where cultural matters were concerned, Ribbentrop played the role expected of him: that of an interested, supportive, and cultured leader, but one who followed, and did not make, aesthetic policy. The foreign minister therefore belonged to a number of the patron groups in vogue at the time, including the Nordische Gesellschaft (mentioned earlier in connection with its leader Alfred Rosenberg), the Kameradschaft der deutschen Künstler, and the Vereinigung der Freunde der bildenden Kunst. These were officially sanctioned organizations, and Ribbentrop's participation was mostly symbolic, as he would attend functions and make donations.[132] Because Ribbentrop was the recipient of artworks on numerous occasions, from both fellow Nazis and foreign colleagues, it was inevitable that he would have many officially acceptable pieces. Thus, for example, in 1937, to complement Ribbentrop's appointment as an honorary SS lieutenant general (Obergruppenführer), Himmler gave him a large canvas by the former's art expert, Karl Diebitsch, entitled *Oath-Taking of the Leibstandarte*. Himmler's gift, which portrays SS men marching with torchlights past the Feldherrnhalle in Munich – a quasi-

Courbet's Baigneuse, *owned by the Ribbentrops* (BAK)

Gustave Moreau's Water Nymph in Grotto, *a painting owned by the Ribbentrops* (BAK)

Monet's Water Lilies, *a work in the Ribbentrops' collection* (BAK)

sacred site in Nazi lore – remained in the Ribbentrops' inventory of artworks until the end of the war.[133] Similarly, the foreign minister received a pair of Lenbach portraits of Bismarck. One that he especially valued was from Hitler; the other was from Hungarian prime minister Lazlo Bardóssy.[134]

The Ribbentrops nonetheless assembled a rather diverse collection of art, especially by Nazi standards. The foreign minister did not think himself constrained by the official aesthetic policies conceived by his colleagues. He and his wife collected according to personal taste and thus acquired a significant number of modern French pieces, including paintings by Gustave Courbet, Camille Corot, Gustave Moreau, Claude Monet, and André Derain.[135] Derain was a particular favorite of the couple and was invited to travel to Germany during the war to paint family portraits, although he declined.[136] After the conquest of France, the foreign minister reportedly commandeered a number of works, "including works by Utrillo, Monet, Degas, Bonnard, and Braque."[137] Ribbentrop thought himself a sophisticated cosmopolitan who need not limit himself to German cultural products. He perceived himself as a modern European aristocrat, a polyglot able to appreciate the finest of the continent's high culture. He also knew that he was powerful enough to weather most storms caused by a deviation from the Nazi aesthetic norm.[138] Indeed, the Ribbentrops' worldly taste drew some attention. One friend of the family, Maria May, noted after the war, "These pictures really pleased me because at that time one collected official art like that of Spitzweg, Defregger, and Grützner; only in this house could one see modern and classic French painting."[139] Ribbentrop felt more refined than his peers as a result of this slightly more modern sensibility, even though his taste in art never extended to the more controversial German modern art once embraced by Goebbels and others.

Ribbentrop, like many of the Nazi elite, enhanced his sense of nobility

Winterhalter's Portrait of a Lady, *from the Ribbentrops' collection* (BAK)

Watteau de Lille's The Bird's Nest, *owned by the Ribbentrops* (BAK)

through his art collecting. He was a "passionate" collector of tapestries and fine rugs (traditional accoutrements of the aristocracy), and Hitler remarked during the war that he had never before seen such beautiful and expensive weavings as in the home of the foreign minister.[140] The family also had a number of works by F. X. Winterhalter and J. H. Fragonard – artists favored by members of Europe's courts in earlier epochs. Yet the Ribbentrops took greatest pride in a Fra Angelico Madonna that was indeed a truly remarkable work. The Fra Angelico piece, which was placed on the list of Germany's national treasures from the list's inception in 1919, was especially valued because it was inherited. Annelies had received half a share of the painting from a deceased uncle in 1932.[141] Although a half-share of the masterpiece belonged to Annelies's sister, the Ribbentrops took possession of it. They even brought it along with them to London and placed it in the German Embassy there, apparently hoping that it would project a certain impression to English society.

Closer examination of Ribbentrop's comportment as German ambassador to Great Britain, specifically with reference to his use of art and interior design during this unsuccessful mission, reveals the degree to which he sought to impress others. Ribbentrop transported a small museum to London in 1936 when he took up his appointment: sixty-seven works, valued then at over RM 350,000, were borrowed from state museums throughout Germany, including the Kunsthalle Hamburg, the Wallraf-Richartz Museum in Cologne, the Staatsgemäldesammlung in Dresden, and the National-galerie in Berlin.[142] While it had long been the norm for public officials to have access to some of the less valuable artworks owned by the state ("for representative purposes"), Ribbentrop overstepped the bounds of this perquisite, taking works such as Lucas Cranach's renowned *Suicide of Lucretia Borgia* and Arnold Böcklin's *A Spring Day*.[143] Ribbentrop's abuse of this privilege induced Prussian minister president Göring and the others who had authority over state collections to henceforth curtail public officials' access to the artworks.[144] Ribbentrop, who had special funds placed at his disposal by Hitler (Sonderfonds des Führers), also ordered the remodeling and enlargement of the embassy, Carlton House Terrace, and brought in Albert Speer as a consultant.[145] RM 5 million was reportedly spent on the renovations, and much of the work was to help effect an "extension of cultural relations." A hall for concerts and lectures was built, and space was created for the exhibition of artworks.[146] As was often the case with Ribbentrop, he tried too hard to make this transformation to the regal ambassador and ended up alienating more people than he impressed. The "Cliveden set" that he thought he had won over would make token gestures, such as the Marquess Londonderry (they were on a first-name basis)

extending invitations for weekend visits. But inevitably Ribbentrop would find some way to offend. Wallace Simpson and others, for example, had a very unfavorable reaction to the large detachment of SS guards that Ribbentrop had deployed.[147] Even his colleagues thought Ribbentrop's pretensions were too much. They snickered at the rebuilt embassy and called it the "Frankfurter Hauptbahnhof."[148] Ribbentrop, obsessed as he was with remodeling plans and bringing in Horcher's gourmet fare from Berlin, was hardly conscious of his poor performance. His stint as ambassador ended, after all, with a promotion, when he was appointed foreign minister in February 1938. Yet one English observer at the time noted, "He relied for the success of his mission not on the simple truth of his cause, which was bad, but on its gorgeous trappings."[149]

As foreign minister, Ribbentrop acted with even greater conceit and arrogance, as his increasingly baroque lifestyle complemented his haughty personality. He was able to affect the trappings of the aristocracy in part because of the power and resources that his new position afforded him and in part because of his private wealth, which continued to grow as his wine business (Firma Impegroma) generated a substantial income.[150] Hitler supported his indulgences: Ribbentrop, like many of the Nazi elite, received cash gifts, or *Dotationen*. He awarded the foreign minister at least two "one-time," tax-free grants of RM 500,000 (one in 1939 and one in 1943), and some of this money went to the purchase of artworks.[151] In addition to the financial gifts, Ribbentrop obtained exclusive permission to use residences that had been taken over by the state. This applied most noticeably to *Schloß* Fuschl near Salzburg, where Ribbentrop often stayed when Hitler was at Obersalzberg.[152] While the official correspondence regarding *Schloß* Fuschl makes it clear that this was not Ribbentrop's private property, the foreign minister sometimes gave another impression. On the occasion of a Hitler-Mussolini meeting there in May 1942, an official communiqué noted that Ribbentrop was the host of the meeting "in his father's castle."[153] This claim, which was either an example of Nazi propaganda or a testament to Ribbentrop's self-delusions, reveals his desire to project an aristocratic image. Ribbentrop's conspicuous consumption later warranted charges at the Nuremberg trials that he possessed six residences. *Schloß* Fuschl was incorrectly listed as Ribbentrop's property, as was a hunting lodge called Pustepole in the Sudetenland.[154] Despite his exclusive rights, both properties belonged to the state. Still, his Dahlem villa, his lavish 750-acre "farm" (or *Gut*) at Sonnenburg near Berlin that he purchased in 1937, the house at Tanneck bei Düren near Aachen that he used for horse-breeding, and his chalet near Kitzbühel afforded him a grand lifestyle. He also took the formal presidential palace in Berlin as an official residence when he became

Ribbentrop at one of his many residences, his estate (Gut) at Sonnenburg, 1938 (BAK)

Ribbentrop at a reception in his Dahlem home (BAK)

foreign minister and again engaged Speer to oversee the extensive renovations.[155] The English prosecutor at Nuremberg, Sir David Maxwell-Fyfe, was justifiably curious as to how Ribbentrop could afford to lead such a life on his official salary.[156]

While Ribbentrop as an art collector did not pose a serious threat to his peers, he was a good customer for both German and foreign dealers (possessing sufficiently close contacts to help arrange trades of art confiscated by the ERR in France to dealers in Switzerland).[157] In addition to the above-noted income, he had discretionary funds due to his position as foreign minister, which he not only spent at galleries but also used to patronize artists. Georg Kolbe, Fritz Klimsch, Franz Lenk, and other well-known Nazi artists were among those who sold him their works.[158] Ribbentrop also used his ministerial funds to buy works that were rather surprising considering their official character. One note to his financial manager Bernd Gottfriedsen in 1941 requested payments for two Courbet paintings, *Village in the Valley of Ornans* (RM 8,750) and *Model in Green* (RM 16,250), giving instructions that the payment for the works by the leftist French artist should come from the "account for the decoration of the Wilhelmstraße 73 house [the foreign minister's official residence]."[159] Ribbentrop asked Gottfriedsen si-

multaneously to make the payment for two Austro-Bavarian genre paintings. In this instance he took care not to appear too cavalier in his purchasing habits. The inventory of paintings compiled by the Ribbentrops for insurance purposes, that is, those they considered private property, was numbered sequentially to 265. Officially sanctioned styles balanced out the more daring selections.[160]

Ribbentrop was an outsider who constantly strove to be accepted. The two milieus to which he sought entrance – the world of high society and that of the Nazi *Bonzen* – both valued art and its collecting. For the nobility and for the Nazis, art was a symbol of larger and more substantive issues: wealth, quality of life, power, and erudition, to name a few. Ribbentrop, the poseur, attempted to deceive with his art and pretentious lifestyle. Many were not taken in. The English frequently mocked him as "Ribbensnob," while his Nazi colleagues never warmed to him and rarely addressed him with the "von."[161] After the outbreak of war in 1939, many of Ribbentrop's colleagues expressed a sense of disappointment and betrayal. Göring, for example, remarked, "He sure took us in with his 'contacts.' When we got a closer look at his French counts and British lords they all turned out to have made their fortunes in champagne, whiskey, and cognac."[162] Göring also added that "Ribbentrop has made only one friend here [Hitler], otherwise nothing but enemies."[163] Herein lies the real significance of Ribbentrop's art collecting and neo-aristocratic life: he deceived Hitler into believing him a cultured, cosmopolitan, and well-connected man. As this guise was combined with a pliable nature, he seemed exactly what Hitler wanted from his foreign minister.

HEINRICH HIMMLER

In the evolution of his persona over the course of the Third Reich, Himmler adopted aristocratic affectations but more specifically relied on feudal motifs and models.[164] As head of the cultist SS, he consciously alluded to the mythic Teutonic knightly order that he thought served as an antecedent. Himmler became involved in the pursuit of artworks within this context. The Reichsführer-SS appeared somewhat less concerned with amassing a personal fortune than Göring, Ribbentrop, and the others and instead focused on his position as leader of what he considered the warrior elite. Himmler's feudal persona, which has been recognized by a number of historians, was nonetheless multifaceted. Equally important were the changes in character that took place after 1939, as Himmler became more concerned with assuming the role of a warlord. Artworks figured promi-

nently in Himmler's endeavors to create and indoctrinate a cohesive fighting elite.

The hub of the neofeudal empire envisioned by Himmler was the castle Wewelsburg in Westphalia. Himmler conceived of the castle in part as a shrine to König Heinrich I (Henry the Fowler) and spent millions of Reichsmarks to restore and refurbish the structure, justifying the expenditure on the grounds that it would also serve as a special meeting place for the leaders of the SS. It is not surprising that Himmler should have had such high regard for Germany's royal leaders. This was not only consistent with his notions of a German racial elite but also in line with his upbringing, as his father had worked as a tutor for Prinz Heinrich at the Wittelsbach court in Bavaria (Prinz Heinrich was Himmler's namesake and godfather).[165] Wewelsburg's interior design emphasized the feudal aspects of the SS. Just as Himmler's subleaders, or vassals, all had rooms reserved for them as well as special personalized chairs at an Arthurian table and their coats of arms displayed in the main conference chamber, so too were rooms named after Germanic kings, such as Otto the Great, Friedrich Hohenstauffen, and Philipp of Swabia.[166] One of the purposes of Wewelsburg was to make the SS elite feel powerful and noble, and to this end Himmler surrounded them with artworks and other luxuries. "Each room was furnished with genuine period pieces and often personal items such as garments, armor, or shields that belonged to the hero for whom the room was named. A fortune in SS funds was spent by Himmler's aides as they scoured museums and private collections all over Europe for appropriate items."[167] The reports of the British art experts who first came across the remnants of the burned fortress in May 1945 include not only inventories of the paintings, objets d'art, and furniture in the fortress but also receipts of purchases. According to one receipt from Holland, RM 206,000 was spent on antiquities and objets d'art.[168]

Some of the objects that Himmler collected and used to decorate the castle were of "prehistorical" origin and hence were more palaeological artifacts than they were works of art. They were, however, museum-quality pieces. Antique handcrafted armor and ceremonial spears with runic inscriptions were collected in a spirit that was similar to that associated with actual artworks and therefore deserve mention here. In pursuing these pieces for himself and for Wewelsburg, Himmler exploited the other agencies in his empire—most notably, the Ahnenerbe, which specialized in *vor- und frühgeschichtliche Forschung* (pre- and early historical research) and which had a number of museums and excavation sites under its control. In one case, for example, Himmler personally ordered the Ahnenerbe to transfer an Etruscan bronze helmet and three spears to Wewelsburg.[169]

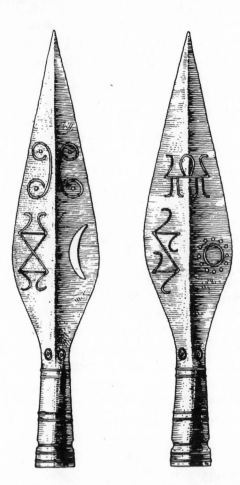

Himmler's appreciation for these sorts of objects extended back quite far. In 1933, for example, he had *vorgeschichtlicher Töpferkunst* (prehistoric bowls) removed from a museum in Halle and placed in his office.[170] Throughout the Nazi period he continued to entertain solicitations from dealers, museums, and private parties. One interesting offer came from Prince Juritzky in Paris, who wrote Himmler in late 1941 concerning "art objects" from what he called "the era of the Germanic tribes' invasions." A jewel-encrusted belt buckle and a gold garment-clasp were typical of the objects mentioned.[171] Himmler, in this case, let Wolfram Sievers and the experts at the Ahnenerbe handle the verification of the objects and the purchase.[172] Himmler's appreciation of these cultural relics was so pronounced that others commonly gave him pieces as gifts. The employees at the Ahnenerbe as well as other NS leaders, such as Minister of Interior Frick, who gave Himmler a carved spearhead, contributed significantly to Himmler's collection.[173]

Himmler by no means limited his interests to anthropological objects, as he acquired a range of artworks both privately and for the Wewelsburg fortress. One favorite means of decorating his surroundings came through the granting of commissions. Himmler particularly enjoyed this, as it allowed him some input into the artwork's creation. In his commission of a statue for Wewelsburg by sculptor Anton Grauel (Himmler saw a piece by him in a Danish magazine and asked the artist to re-create it–with the chin of the figure slightly altered) and his supervision of the project to erect a monument to Reinhard Heydrich in the Berlin War Veterans' Cemetery, it is evident that the Reichsführer-SS actively involved himself in a number of artistic projects.[174] Himmler attempted to establish ties to artists and was enthusiastic about extending portrait commissions. Pictures of the Reichsführer-SS were among those of Nazi leaders that appeared regularly in the GDK.[175]

Himmler also had substantial contact with art dealers, to the extent that he consented to allow one to act as his personal agent. SS-Sturmbannführer (captain) Wilhelm Vahrenkamp wrote Himmler in August 1942 asking permission to represent him in the search for artworks.[176] As Himmler was constantly approached by dealers offering him both Nazi art and old masters, he approved the idea of having someone coordinate this sphere of his life. Himmler, however, limited the scope of Vahrenkamp's authority. As was the custom among the Nazi leaders, Vahrenkamp could not buy without his superior's explicit consent.[177] Through Vahrenkamp and other German dealers, such as Günther Koch, Himmler bought a considerable number of artworks, including an etching by Dürer and ninety-six "views of cities" (Städtebilder).[178] He also thought it necessary to consult a wide range of experts regarding his purchases. Besides his art adviser, Professor Diebitsch, Himmler directed inquiries to Heinrich Hoffmann (most notably concerning a Breughel painting that had been offered to him for RM 200,000), to the painter Wilhelm Peterson, and to Hans Posse.[179] Records indicate that he usually followed their counsel. Himmler was thrifty in his buying and frequently rejected offers because of the price. Vahrenkamp also convinced Himmler that he served a useful purpose because he saved him money. In one letter Vahrenkamp added–with some exaggeration–that art prices in the Reich had increased eightfold between 1939 and 1942 and that he could assist Himmler in taking advantage of the better values in the Occupied Western Territories.[180]

Himmler continued to be a visible patron of the arts during the war despite his many responsibilities and the inflation in the art market. He made regular annual visits to the GDK in Munich, typically purchasing a dozen pieces per show. On 28 August 1942, for example, toward the end of the

GDK's run that summer, Himmler toured the exhibition and bought twenty pieces. His selection included a wide range of objects – from sculptures to woodcuts to paintings of the Führer.[181] His support of official artists extended to the acquisition of drawings by Arno Breker, as he bought fourteen in 1943 from the Berlin dealer W. B. Schwan.[182] Himmler also appeared at many cultural events, including exhibition openings. He was especially keen on participating in events that involved Hitler, such as the *GDK* openings (he would also review the parade that was the other highlight of the *Tag der deutschen Kunst*). Of course, he played a highly visible role at events organized by offices under his jurisdiction – the Ahnenerbe's exhibitions, for example. Furthermore, Himmler lent his own artworks for shows. One example occurred in 1939, when he provided works by a Romantic painter named Friedrich Stahl for an exhibition in Rome.[183]

Himmler engaged in an elaborate system of bestowing and receiving gifts, with artworks figuring prominently as commonly presented objects. The presents served as a means of communication for the Nazi elite, helping them reveal bonds, convey praise, and demonstrate the power and wealth at their disposal. Himmler focused his gift-giving on two different groups. The first encompassed the other Nazi leaders, including Hitler; the second was comprised of those within the SS. In both cases Himmler sought to define a relationship through the giving of artworks. With the first group, the objects tended to be either expensive or highly personal. Hitler received a valuable Adolph von Menzel painting, *Frederick the Great on a Trip*, from Himmler on the Führer's forty-ninth birthday in April 1938 as well as another painting with an undeterminable title during the elaborate celebrations for his fiftieth birthday the following year.[184] Himmler later gave Göring a *schönen Homespun* (a beautiful knit garment) for Christmas in 1942.[185] Within the SS he created a more ritualized sort of gift-giving, as underlings were honored on selected occasions (most notably birthdays, *Julfest*, and when having children), with porcelain, candlestick holders, books, and drawings. The SS leadership doled out a veritable fortune in such cultural objects not only to the SS men but also to their wives and children (especially if they were Himmler's godchildren).[186] Just as Wewelsburg housed treasures to be shared collectively by the SS elite, these objects, which invariably had an ideological bent, were supposed to help cement the bonds between the giver and the recipients.

Himmler increasingly came to view himself as a warlord – that is, not solely as a political leader and police official (his earlier self-conception) but as a wielder of military force. The growth of the Waffen-SS from an armed paramilitary group of 165,000 men in 1941 to a full-fledged army of 800,000 in 1945 is one manifestation of this transformation.[187] Himmler's

Himmler, in SS dress attire, with Spanish fascists, 1940 (BAK)

Meeting of SS leaders Huber, Nebe, Himmler, Heydrich, and Müller amid artworks (BAK)

power increased as the war went on. Despite this, many historians have maintained that he remained a scrupulously honest man with respect to financial matters and reportedly went to Martin Bormann on one occasion to borrow RM 80,000.[188] An analysis of Himmler's own financial arrangements makes this loan difficult to understand, except that he kept his budget for his two families (his wife and daughter on the one hand and his mistress and her two children on the other) largely separate from his official funds. Himmler himself lived a life almost completely covered by official sources. This applied to his housing, food, uniforms, transportation, health treatments, and other necessities. Generally, however, he had enormous sums of money at his disposal. Artworks and other gifts were usually paid out of a fund called the *Sonderkonto R*, which Himmler could replenish from a variety of sources. These included the group Freundeskreis des Reichsführers-SS; the SS "economic enterprises" that were quite profitable (see Chapter 6); the gold from the teeth of the victims in the extermination camps that was stored in the Reichsbank alongside artworks; the millions of Reichsmarks delivered to Himmler toward the end of the war in exchange for saving specific numbers of Jews; and the plunder that the SS liquidated (for example, through the Vugesta).[189] Himmler actually spent recklessly and indulgently at times. Wewelsburg is one example already mentioned, and projects such as brothels for foreign workers and Tibetan expeditions undertaken by Ahnenerbe researchers demonstrate that Himmler had remarkable discretionary funds at his disposal.

While it is unclear whether Himmler amassed a huge personal fortune, he undoubtedly led a luxurious life. Whether it was his opulent Prinz Albrechtstraße headquarters (the palace had previously been an art college); his more temporary centers for operations, such as Zhitomir in the Ukraine (which had among other features, lovely grounds and a tennis court); his personal train named *Heinrich* (lavishly decorated in a faux antique style); his "splendid villa" in Dahlem; or his farm at Gmund, near the Tegernsee, which was large enough to contain a collection of armor and a number of paintings, Himmler arranged for a mise-en-scène appropriate to a man of his stature.[190] His special diets, attentive masseur, and elaborate uniforms are further evidence of the pampering in which he indulged. The point is that while Himmler may have kept his two families in a fairly modest style, he himself, as the head of a neofeudal order, let a privileged life.

Himmler also did not shy away from looted artworks, which, among the Nazi elite, were recognized as trophies. As Himmler lorded over a large plundering bureaucracy, he needed only ask his agents to direct pieces to the desired location and the request was carried out. SS-Oberführer

Kajetan Mühlmann, who answered to Himmler while operating in post-*Anschluß* Austria as well as in Poland and the Netherlands, sent works back to his commanding officer. There was considerable contact between the Dienststelle Mühlmann and higher SS officials, whereby tapestries and paintings were shipped back to the Reich (but most evidently paid for).[191] Himmler's Höhere Polizei- und SS-Führer in The Hague, Hanns Rauter, went to the storehouse of Jewish valuables, the bank Lippmann, Rosenthal, and Co., and bought art at bargain prices for the Reichsführer-SS on "some 140 occasions."[192] In the Netherlands, other high-ranking SS leaders were also able to turn to Mühlmann to purchase artworks as presents. Gestapo Chief Ernst Kaltenbrunner, for example, bought Himmler a painting listed as *Horseman* by Sebastian Vranxs in the autumn of 1943.[193] Other property of dubious origin that found its way into Himmler's hands included Russian paintings housed at his farm at Gmund and sixty-nine Dutch landscapes and old masters that were stored in a shelter in Berlin.[194] As the SS was charged with safeguarding much of the plunder taken by the Nazis—this ranged from overseeing the confiscated Jewish property in the late 1930s and caring for the Veit Stoß altarpiece taken from Poland in 1939, to administering the depots of evacuated Italian art—it should come as little surprise that Himmler personally controlled some of the artworks.[195] Himmler also received objects such as a green marble desk that was produced by inmates working in the Buchenwald prisoners' sculpture shop. Nonetheless, he convinced many that he was an honest and ascetic type, simply serving Hitler and National Socialism.[196]

While it is understandable how Himmler, a sadistic chieftain, comported himself in this manner, it is ironic that he could so warmly embrace the trappings of culture. His involvement with the arts ran contrary to the prevailing, if naive, belief that culture was humanizing and associated with the more benign elements in society. Himmler was no doubt aware of the paradox of being both a violent police/military leader and a lover of the arts. He was perhaps also aware of the sinister implications of this union, deliberately attempting to be radical and to undermine this traditional view of culture. Himmler meant to impress and to intimidate those around him and was consciously "a mixture of criminal and ideologue."[197] He was not the meek middle-class bureaucrat as some have depicted him.[198] He instead tried to create quasi-feudal hierarchies around him. Fixated on the nobility, Himmler considered himself part of that caste. While this veteran of the Nazi movement also had a populist side to him and occasionally projected himself as an educated peasant or a tiller of the soil who was content with a modest, traditional life, he outgrew this persona as it proved incompatible with the relentless quest to increase his power. The Reichsführer-

SS, who was simultaneously the minister of interior, commander of the Waffen-SS, and head of the Reserve Army, grew into the role of feudal lord. It was appropriate, then, that Himmler inhabited Wewelsburg – the fortress first built by a twelfth-century robber baron.[199]

BALDUR VON SCHIRACH

The longtime head of the Hitler Jugend and, as of 1940, the Gauleiter and Reichsstatthalter in Vienna also had aristocratic pretensions and a penchant for high living. Yet Schirach is particularly interesting because he represents a common type within the Nazi government: the quasi-autonomous chieftain of a particular territory. Replacing the dual leadership of Arthur Seyss-Inquart and Josef Bürckel in Vienna, Schirach treated the Austrian capital and its outlying areas as his own from 1940 to 1945. This provides another element to the feudal metaphor. Not only were there reciprocal ties binding the subleaders to Hitler (and to a lesser extent each other), but certain subleaders, such as Schirach, were charged with ruling specific geographic areas. That the thirty-five Gauleiters usually abused their relative autonomy is no revelation. Schirach, however, offers a striking case of a subleader obtaining authority from Hitler and then exploiting this position for personal gain.

Schirach was in many ways comparable to his brutal associates, such as Gauleiter/Reichskommissar Erich Koch of East Prussia and the Ukraine, Gauleiter/Reichskommissar Josef Bürckel of the Westmark (the territory encompassing the Saar, Palatinate, and Lorraine), and Gauleiter Albert Forster of Danzig, in that he viewed himself as the prince of his territory (he was, however, less brutal and less anti-Semitic). Upon moving to Vienna he inhabited a lavish villa in the Hohe Warte neighborhood, a residence previously used by Bürckel. He immediately enhanced its furnishings by "borrowing" rugs and tapestries from the Schwarzenberg palace, a sequestered property located in the center of the city.[200] Schirach had become accustomed to living in style. Upon his appointment as Reichsjugendführer in 1933, he had moved into a luxurious lakeside abode on the Kleine Wannsee in Berlin, and the following year he and his wife acquired a retreat in the Bavarian mountains.[201] Schirach's residential arrangements in Vienna are telling. They convey a sense of his own self-importance and a willingness to break laws for personal benefit. His concern for style and interior design also reflects the emphasis on culture that marked his rule in Vienna. He was transferred to Vienna with explicit orders to organize and rehabilitate the city's flagging cultural life, although not to the point where it

Schirach (left) and Gauleiter Rainer of Salzburg (far right) visit exhibition in Vienna (BAK)

would rival that in Berlin.[202] Hitler created a special arrangement whereby Schirach, not Goebbels, would be responsible for the arts in that region (the RMVP, however, continued to provide funding).[203] Schirach not only controlled the budget of the city's cultural institutions but was given funds (including sizable *Dotationen*) with which to patronize and entertain. Artists were frequently guests at his dinner table and at diplomatic functions.[204]

Schirach projected himself as an artist from the outset of his career with the Nazis. Howard Becker, in describing Schirach's early years wrote, "In Munich . . . he was studying art history and Germanic lore in 1924. By 1925, Hitler was referring to him as a 'true follower' and a 'dependable lad,' and a close friendship seems to have been formed, partly on the basis of their common interest in art. . . . His poems met with Hitler's approval, and before long Schirach was the poet laureate, so to speak, of the Nazi movement."[205] Furthermore, Schirach came from a privileged and cultured background. His father had been the head of the Weimar Hoftheater (royal theater) and held the titles Rittmeister, Gardekürassier, Kammerherr, and Generalintendent.[206] Young Baldur had not only grown up in the royal *Schloß* but, interestingly enough, had been exposed to a fairly progressive brand of theater. Productions staged by his father included Ibsen's *The Wild Duck*.[207] Hitler therefore chose Schirach for the Vienna post in

1940 because he wanted a more sophisticated and cosmopolitan man to bring the problematic city into line.

Schirach, however, did not consistently toe the Party line regarding aesthetic policy.[208] The reasons for this are several. He considered himself an aristocrat who could indulge in a more refined and independent understanding of culture. His roots within the movement stretched back to his participation in the more rebellious and freethinking student groups, such as the NSD-Studentenbund, whose Berlin chapter led the fight to reconcile modern art with National Socialism. In addition, Schirach had a more international background. His mother was a U.S. citizen, and his father had American relatives. He had grown up speaking English often and had been exposed to more than provincial or exclusively Germanic culture.[209] Schirach's cultural policies as Reichsjugendführer were moderate but not decisively promodern. Despite a clear antipathy for the *völkisch* art advocated by Rosenberg (he had mocked ideologues such as Wolfgang Willrich), he had refrained from assuming an aggressive posture in the debate over Expressionism.[210] There were early indications of his later iconoclasm, but it took the independence and power of his position in Vienna to transform him into a cultural maverick.

Schirach's promodernist thinking manifested itself both in his cultural policies and in his art collecting. Certainly his behavior in the public realm attracted more attention and caused him more difficulty than did his private efforts to acquire art. For example, Schirach generated controversy during the war by arranging for Richard Strauss and Gerhart Hauptmann, two cultural giants who had fallen out of favor with the regime, to have public celebrations on landmark birthdays, and to have modernist artist Leo von König receive an honorary membership from the Viennese Academy of the Visual Arts (despite the opposition of the Education Ministry).[211] The clamor caused by these acts paled in comparison with that caused by his sympathy for Emil Nolde (with whom he discussed the possibility of offering a studio, financial assistance, and protection). Robert Scholz, for example, wrote memorandums to Rosenberg and helped mobilize the opposition to Schirach.[212] Scholz claimed to count Arno Breker and Albert Speer as like-minded allies in this instance. Because Schirach quickly backed away from the embattled Nolde, the consequences of the episode were not especially dire. The same cannot be said of his sponsorship of the exhibition *Junge Kunst im Deutschen Reich*, which contained works with abstracted images and "unnatural" colors. The February 1943 exhibition so infuriated Hitler that he called Schirach to Obersalzberg, scolded him in a ferocious manner (accusing him of "sabotage" and of "leading the cultural opposition to him"), and then ordered the show closed.[213] Schi-

rach had not only appointed the organizer of the show, Wilhelm Rüdiger, and helped publicize it but had also purchased six paintings totaling RM 26,500.[214] Toward the end of the Third Reich, Schirach clearly suffered from Hitler's lack of support (and the increasing enmity of Bormann and Goebbels). Both contemporary observers and historians have linked the *Junge Kunst* debacle with Schirach's post-1943 decline: "He remained in Vienna until 1945, although after a stormy meeting at the Berghof at Easter 1943, he had forfeited Hitler's trust and friendship on account of his 'un-German' cultural policies and 'liberal' attitudes toward Jews."[215]

Baldur von Schirach's personal collecting of modernistic artworks caused him fewer problems. Other leaders treated the acquisition of such artworks as a private matter – at least as his prerogative as the ruler of Vienna. Thus, whether it concerned the landscape painting by Renoir that he bought from the Wels Gallery in Salzburg, the two Rodin sculptures that he kept in his bedroom, or the Van Gogh picture, *Poppies in the Field*, that he purchased in Holland with the help of the Dienststelle Mühlmann and the director of the Kröller-Müller Museum, Dr. van Deventer, Schirach incurred little discernible criticism.[216] The problem-free act of privately acquiring the Van Gogh can be compared with a public gesture: a speech delivered on the 250th anniversary of the Viennese Akademie der bildenden Künste in the autumn of 1942, where Schirach dared to mention Van Gogh in the same breath with Rembrandt and Beethoven. He categorized the products of all three men as among the "greatest achievements in art" and in doing so precipitated widespread criticism (Robert Scholz in the DBFU again was particularly upset).[217] Similarly, Scholz complained when Schirach arranged for the Wiener Galerie, a public institution, to buy a piece by Vienna's own Gustav Klimt as well as a portrait by Lovis Corinth. Scholz noted that the Corinth picture had been removed from the Berlin Kronprinzenpalais during the *entartete Kunst* "cleansing" and that, furthermore, both works had been purchased from the *halbjüdischer* Berlin art dealer Hildebrand Gurlitt.[218] Schirach's penchant for moderately abstract works – he had no interest in Wassily Kandinsky, Paul Klee, or the radically modern artists – caused problems for him only when his activities entered the public realm. Indeed, in private conversations with Hitler prior to the falling out in 1943, Schirach felt sufficiently secure in his views to defend the work of Franz Marc.[219]

While Schirach espoused more enlightened views toward art, he was nonetheless an agent of Nazi oppression and corruption. In the realm of art collecting this manifested in his sponsorship of the Gestapo's Vugesta agency in Vienna, which liquidated artworks confiscated from Jews. While the Vugesta dates back to the immediate post-*Anschluß* period, and hence

prior to Schirach's presence in Vienna, he not only allowed the agency to continue to operate but turned to it to purchase a number of works for his own collection. After the war, OSS agents approached Schirach with incriminating documents, showing, for example, that he bought a picture by Lucas Cranach, *Madonna with Child* (once possessed by the Gomperz family), from the Vugesta.[220] Another document reveals that Schirach spent RM 42,092 for other unidentified works from the Vugesta between December 1942 and June 1943.[221] Schirach also acquired Pieter Breughel's *Wolf Overtaking Deer*, which had been confiscated from the Austrian Jew Ernst Pollock, after he received approval from Hitler and Hans Posse.[222] Schirach's ingenuous response after the war to the accusations was to claim, "I possess a great collection of paintings and I am convinced that none are from Jewish property."[223] The transparency of Schirach's lies becomes increasingly clear upon scrutiny of the surviving documents. A June 1943 letter from the Gestapo chief in Vienna, Dr. Karl Ebner to Dr. Siebert, a government official from Bohemia, noted, "Schirach has been informed of the confiscation of the picture collection and has personally inspected it; he has ordered that personnel from the Kunsthistorisches Museum in Vienna take photographs."[224] Ebner went on to report of Schirach's consultation with Hitler about the allocation of the artworks. The agents from Linz took their pick, and the remaining artworks were set for distribution among Austrian museums.

Schirach engaged in a number of other unsavory activities in his efforts to amass an art collection. He bought regularly from the Dienststelle Mühlmann in the Netherlands, having earlier befriended Kajetan Mühlmann. Henrietta von Schirach tells in her memoirs of an improbable occurrence in 1943: As the Schirachs were leaving The Hague, a man identified as "M" (presumably either Mühlmann or the art dealer Alois Miedl, with whom they were also acquainted) handed the couple two wrapped packages. After boarding the train and opening the parcels, they found that they had been given an early Italian Renaissance painting featuring Tobias with an angel, which they placed in their Vienna residence.[225] Schirach's father-in-law, Heinrich Hoffmann, also procured pictures for the couple (as well as Hitler and other leaders), frequently obtaining the works while in the Netherlands. He had good business connections there and could benefit more generally from the Germans' occupation of the country. Hoffmann helped Schirach obtain works from the Goudstikker collection, which was acquired by Miedl at a highly favorable price and then sold at great profit.[226] In the final days of the war Schirach allegedly ordered valuable works removed from the mines at Alt Aussee, arranging for the removal of a Rembrandt self-portrait and an unidentified Rubens. Schirach

hoped to make use of these valuables during his escape. He was captured in the South Tyrol in June 1945, and his suitcase containing paintings as well as rare first edition books was found in a nearby farmhouse.[227] This incident also reveals that the Reichsstatthalter of Vienna had some authority over the nearby storage facilities.

Although Schirach ruled in a relatively independent and cavalier manner in Vienna, his power stemmed from Hitler and his place at the Führer's court. To this end he made sure to keep the political constellation in his favor – at least until 1943. For starters, Schirach helped Hitler procure art. His efforts included assisting in the negotiations with the Czernin family for Vermeer's *Artist in His Studio*, obtaining for Linz a Rubens picture entitled *Ganymede* by way of a forced exchange for the Bloch-Bauer porcelain collection, and working with Hoffmann to acquire works for the Führermuseum from the Netherlands and Italy, including a valuable Rubens, *Venus and Cupid*.[228] Schirach's exertions on behalf of Hitler earned him goodwill and helped consolidate his position in Vienna. The added benefits, such as the right to the Gomperz Cranach mentioned above after the Linz agents had selected works by Breughel, Spitzweg, and others, were nice extras.[229] In other instances of Schirach cultivating useful alliances by helping peers acquire art, he gave a painting by Rudolf Eisenmenger to Party treasurer F. X. Schwarz in 1943 and arranged for Göring to acquire the missing pieces of a multipaneled Gothic altarpiece.[230] Most of the panels were housed in Carinhall, but two remained in the Viennese Akademie der Bildenden Künste.[231] Schirach helped the Reichsmarschall by engineering a trade. As the exchange also constituted the city's birthday present to the Reichsmarschall, who was celebrating his fiftieth birthday in January 1943, the generosity of the deal cannot be in doubt.

Baldur von Schirach exercised tremendous power in his post atop the Nazi administration of Vienna. To take the case noted above as an example, it is instructive that Göring had long tried to purchase the two panels from the Akademie der Bildenden Künste, but without success. Only the intervention of Schirach, the local authority, enabled the transfer. Schirach was both energetic and territorial in his management of the city's cultural life. He boasted to American interrogators after the war, "From the time I took over there was no art property being lent out from Vienna."[232] Schirach's cultural attaché, Walter Thomas, commented about Vienna's museums in his memoirs, "After the long years of stagnation and inactive conservation and protection, there occurred a not altogether healthy, but nonetheless hectic and hasty flurry of purchases, whereby next to some valuable works, also some of the second rank came into the public state collections for a great deal of money."[233] During the war Schirach traveled to the Nether-

lands with Fritz Dworschak, the Nazi who had been appointed to head the Kunsthistorisches Museum after the *Anschluß*, in order to obtain Vermeer's *Man with a Tall Hat*.[234] This purchase on behalf of the city reflected the civic allegiance felt by Schirach (although he of course also used the occasion to buy for private purposes, favoring the Amsterdam dealer de Boer).[235] He perceived Vienna as his own domain and believed that a flourishing cultural life would contribute to his reputation. Schirach therefore patronized the arts on a grand scale and fought a continuous battle with the powers in Berlin to keep the confiscated cultural objects the property of the local Gau.[236] Schirach's ostentatious concern for culture was one of the reasons that he elicited the sobriquet "pompadour of Vienna."[237]

HANS FRANK

Hans Frank, the Nazi legal expert who became the potentate of the vestige of Poland, the General Government, is comparable to Schirach and many of the Gauleiters in terms of independent authority and exclusive accountability to Hitler, but because he administered an occupied (and not annexed) territory, his circumstances were somewhat different. Frank exhibited such cruelty in stifling the Jewish and Slavic cultures in his domain that he more aptly fits in with the malevolent Reichskommissars of the east. A conservative lawyer and jurist who had raised objections to the murder of Röhm and other Party members in 1934, he was at first not entirely comfortable with the harsh and unlawful methods used to subdue the neighboring lands after the military defeat.[238] Himmler and the SS leaders were indeed more radical in their ideas and actions than the governor general. Yet Frank became a satrap as he created an exalted, quasi-regal existence in Poland, which eventually led Hitler to refer to him as "König Stanislaus V."[239]

More concerned with the trappings of power than the collection of artworks, Frank nonetheless managed to assemble an impressive collection of pictures. To a considerable extent Frank turned to confiscated works to fill his four main residences: the old royal castle known as the "Wawel" in Cracow; the Potocki castle at Krzeszowice, which one historian described as his *privater Herrensitz*; the Belvedere Palace in Warsaw; and his retreat on the Schliersee in Upper Bavaria.[240] As he had followed in the wake of Göring and Himmler in decreeing the confiscation of all state, church, and valuable private property in former Poland – the main difference between their edicts being that Frank wanted the General Government and not the Reich to administer the property – he had little difficulty obtaining art-

works.[241] Kajetan Mühlmann was most concerned with keeping in the good graces of Göring and preferred to have Frank select from the *Wahl II* objects.[242] But Frank's sense of self-importance meant that he was not satisfied with second-class works. He therefore also commandeered some of the nation's most outstanding museum pieces. American MFA and A officer Thomas Howe described coming across Frank's plunder after the war: "The paintings looted from Warsaw were the *pièces de résistance* . . . especially the nine great canvasses by Belotto, the eighteenth century Venetian master. Governor Frank had ruthlessly removed the pictures from their stretchers and rolled them up for shipment. . . . When we examined the pictures, they were spread out on the floor. They filled two rooms, forty feet square."[243] Another notable artwork plundered in Poland that found its way into Frank's possession was Leonardo da Vinci's *Lady with an Ermine* (also known as *Portrait of Cecilia Galleriani*). According to one report, this work, which came from the Czartoryski Gallery in Cracow, had first been sent to Berlin and shown to Hitler and Posse, as well as to Göring. Along with Raphael's *Portrait of a Young Man* and Rembrandt's *Breaking Storm*, the three pieces mysteriously found their way back to the General Government, and the works by Leonardo and the Rembrandt soon adorned the walls of Frank's office in the Cracow castle (there are conflicting reports about the Raphael also ending up in Frank's Cracow abode).[244] There is no disputing that the Leonardo was found at the end of the war in Frank's Bavarian residence, as Frank and his chief curator (Mühlmann's successor) Wilhelm Ernst de Palezieux fled to the Schliersee sanctuary in January 1945. The Raphael has never been recovered.[245]

Frank also had huge financial resources at his disposal, and he used these funds to purchase artworks. Mühlmann testified to OSS agents after the war that "Frank had a great discretionary fund. Frank personally bought art through me in Paris, and had the various objects brought to his Munich home."[246] The Generalgouverneur siphoned off funds from his occupation administration and established accounts for Mühlmann in the west, including one in the Netherlands.[247] Jean Vlug's report for the Art Looting Investigative Unit contains seven pages of lists chronicling Frank's purchases; over 100 paintings can be found in this report, including Breughel's *Landscape with Wood*, a landscape by the Dutch master Leegenhoek, three still-life works by an artist named von Bolen, and Hubert Robert's *Landscape with Deer and Castle*.[248] Despite these purchases Frank's art collecting was more closely tied to plundering and his exploitation of the Poles.

In overseeing the Nazi cultural program in the General Government, Frank, along with his colleagues, sought to eradicate the Polish national

culture and remove the traditional elite. Regarding the former, Frank's famed entrance into the Warsaw Royal Castle—a structure that the Germans eventually went to great lengths to destroy—where he approached the magnificent throne and tore off the embroidered silver eagles, the emblem of Poland, set the tone of his administration.[249] The second project, the displacement of the traditional elite in Poland by the Nazi rulers, found symbolic expression in his decision to occupy the castle of the illustrious Potocki family. In employing two German architects—men named Rötggen and Horstmann—to refurbish the war-damaged structure, Frank utilized artworks that Mühlmann and his experts had confiscated, from among others, members of the Polish nobility.[250] Frank visited the central collecting point in the Jagellonian Library in Cracow on a number of occasions to select works from the collections of the Tarnowskis, the Skorzewskis, and the Bninskis, among others.[251] Frank profited personally from the expropriation of works belonging to the leading families as well as the national museums. As the Polish Ministry of Information wrote in 1944, "Nothing remains, either, of the Baracz branch of the [national] museum, the contents of which have been used to furnish the Potocki residence in Krzeszowice. This has been confiscated and bestowed by Hitler personally on the Governor General, so that presumably, the furnishings are also considered Frank's private property."[252] Poland had "a rich collection of objets d'art, tapestries, bronzes, coins, armor, porcelain, antique furniture, manuscripts[, and] antiquarian books," and accordingly, much of the cultural booty acquired by Frank did not involve paintings.[253] These other objects, however, nonetheless contributed to an opulent lifestyle.

Frank's acquisition of artistic objects reflected the nature of the occupying regime. The governor general sought plundered artworks as a display of his own despotic power. When the flow of Mühlmann's plunder abated in 1943, Frank fired him. Mühlmann testified after the war that this was because Frank "wanted valuable pictures to enter his possession."[254] Frank had witnessed Mühlmann directing works to Göring, including Antoine Watteau's *The Pretty Polish Girl*, and he therefore sought a plundering agent who would more responsive to him personally. Mühlmann's successors, Ernst Wilhelm de Palezieux and Dr. Werner Kudlich, continued to search for and catalog artworks in the General Government.[255] An even greater irritation developed gradually when Himmler and the Höhere-SS und Polizei leaders became more assertive. Himmler's appointment as minister of the interior in August 1943 made his SS operatives increasingly bold.[256] While the general governor had at one time managed some accommodation with the rival Nazi organization, as symbolized by the Gestapo presenting him in 1940 with Rembrandt's *Portrait of Martin Soolmans* from the

Lazienski collection, cooperation between Frank and Himmler soon came to an end, and the two clashed repeatedly.[257] Frank became alienated and frustrated and reportedly submitted his resignation to Hitler on fourteen occasions.[258] Despite these persistent efforts, he was compelled to stay on and to tolerate the competing authority of the SS.

Hans Frank did not play the role of despot easily or convincingly. His peers within the Nazi elite had little regard for him. Hitler received him on only three occasions during the war and then stripped him of his position as Reichsleiter in 1942, following four controversial public speeches.[259] While the SS and Party zealots thought him a weak and unimpressive man, most officers in the Wehrmacht perceived him as an undeserving beneficiary of an important sinecure. Frank also had personal problems. He was an upper middle-class lawyer, and the life of a potentate was not consistent with his background.[260] Even his wife objected to the airs that he affected. Kajetan Mühlmann testified after the war how she grew uncomfortable with both his brutal policies and his lavish lifestyle, noting that she did not like playing the role of *die große Dame*.[261] Ultimately, Mühlmann said, "a great alienation developed between Frank and his wife."[262]

Despite the eventual failure of Frank's marriage and career, his fate during the Third Reich could have been much worse. One of his subordinates, Dr. Karl Lasch, was convicted of plundering art for personal gain and was executed without a trial in June 1942 in Wroclaw (Breslau).[263] Frank himself foiled an investigation into his personal corruption during the war, and Himmler raised the possibility of bringing Frank up on charges of treason on several occasions in 1943–44.[264] Frank's ideas concerning the role of the police (that they should be subordinated to a policy-making executive) and the marginally less harsh cultural policy that emerged within the General Government in the wake of the battle of Stalingrad (Frank himself opened the Chopin museum in Cracow) angered the increasingly influential radical cadre surrounding Hitler.[265] Still, he was an *alter Kämpfer*–part of the brotherhood fashioned by Hitler and the Nazi elite, and in which they invested great importance. This constituted a sort of insurance policy for Frank, and Röhm's experience aside, he knew that, contingent on continued loyalty and subservience to Hitler, his life would not be placed in danger.[266] Frank, despite his controversial speeches, made sure to appease Hitler. To this end Posse had first choice from the confiscations in the General Government, and Frank took partial credit for the leather-bound volumes of photographs of the Polish artistic booty that Mühlmann presented to Hitler. With sufficient deference to the *Führerprinzip*, Frank was left free to abuse his power and lead his imperious life.

Ley receives a picture painted by a DAF employee, 1938 (BAK)

ROBERT LEY

The head of the DAF, Gauleiter of the lower Rhineland, and the Reich organization leader – and hence one of the most powerful officials in the Third Reich – has long been an enigmatic and overlooked figure.[267] Ley was not only a tremendously influential member of the elite but also highly typical in both his public and private behavior. His conduct in the official sphere expressed the unrelenting impulse to expand and increase his personal power. Thus, a history of the DAF appears much like that of the SS, as this mass organization for workers grew to encompass a dizzying array of enterprises. The cultural wing of the DAF, the KdF, which counted 10,000 employees by 1937, has been discussed in Part I; its branches for coordinating exhibitions, publications, and other leisure activities made Ley a genuine force in the cultural sphere.[268] In his private life Ley also appears very much the Nazi potentate, creating a lifestyle reminiscent of Göring.

Ley amassed a personal fortune that rivaled the wealth accumulated by the other top leaders. In his case charges of embezzlement and mismanagement of funds extend far back into the *Kampfzeit*.[269] Later, in 1938, Party court judge Walter Buch went to Hitler with a dossier detailing Ley's out-

landish thievery. Hitler ignored the well-documented complaint and reportedly went to tea at the Leys' home that same afternoon.[270] In terms of income, his secretary, Hildegard Brueninghoff, testified after the war that Ley had a monthly income of RM 7,100; this came from RM 4,000 as head of the DAF, RM 2,000 as Reichsorganisationsleiter, RM 700 as a Reichstag deputy, and RM 400 as a Prussian Staatsrat.[271] In terms of Ley's total earnings, "this was just the tip of the iceberg."[272] Royalties from publications (for example, a reported RM 150,000 over a three-year period from his paper *Der Angriff*) and his abuse of funds confiscated from the trade unions that had been incorporated into the DAF made him fabulously wealthy.

Robert Ley's art collection can be understood only within the context of his other expenditures. Historian Ronald Smelser has addressed the topic of Ley's homes, which were central to his grand lifestyle:

> He owned a number of villas throughout Germany, all of them in exclusive neighborhoods, and staffed . . . lavishly. In Berlin, his main seat of residence, the villa was located in fashionable Grunewald (Herthastraße 13/15). . . . His home in a wealthy Munich suburb (Geiselgasteig 6) housed another housekeeper and two maids. And there was yet another home in the east at Saarow/Mark (Kronprinzendamm 27). A fourth home – in Bonn (Blücher Straße) – he had turned over to his divorced wife and daughter. Up to 1938, the DAF paid for these homes. The real tangible symbol, though, of Ley's corruption and gigantomania, his aspirations to achieve social status, and his attempt to overcome childhood familial disaster and establish a place of permanent security was his landed estate, Rottland.[273]

This estate, located near his hometown in the Rhineland, was where Ley invested the most energy and which best serves as a reflection of his personality.

Located near the town of Waldbröhl, Rottland was a landed estate – declared by Ley to be an *Erbhof* (or hereditary property protected by Nazi law from foreclosure or subdivision) – that included a manor house and a working farm. Purchased in December 1935 for RM 150,000, the estate was sumptuously refurbished during the next few years. Ley employed architect Professor Clemens Klotz, best known for designing *Ordensburgen* (order castles), to realize this personal vision. Smelser's description of Rottland is again vivid and useful:

> All of the buildings, some of them quite venerable half-timbered ones, were to be demolished. . . . Up went a new set of buildings in a horseshoe-shaped design, with a long drive leading up to the manor house.

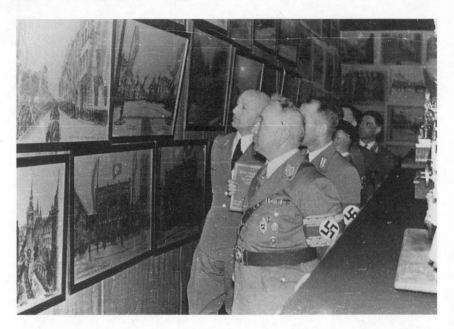

Ley visits KdF exhibition (BAK)

Flanking the entrance stood two huge statues mounted in cement, one of a stormtrooper holding a swastika flag, the other a peasant sowing seed. Inside the house was finished lavishly. On its walls hung valuable paintings including a Kaulbach, a Corinth, two Menzel sketches, and Pesne's portrait of Frederick the Great.[274]

Ley continued to expand and renovate Rottland throughout the war. He even had a coat of arms designed that incorporated the DAF's insignia – a swastika encircled by a gear – to help him convey his lofty status as lord of the manor, which he sometime referred to as "Leyhof."[275]

It is clear that the grandiose residences of the Nazi leaders invariably contained impressive collections of artworks, and as indicated above, Ley and his dwellings proved no exception to this rule. Because so many of the DAF's records were destroyed during the war – including most of Ley's personal papers – one can manage only an impressionistic account of his collecting. But documents exist that convey a sense of his activities. For example, he brought old masters from Maria Almas Dietrich. Another document, a receipt for four works by Francesco Guardi, conveys the scale of his purchases.[276] He also patronized the Cologne art dealership of Theodor Abel and the Chemnitz-based Gersternberger gallery and employed an architect-agent named Nadolle to search out suitable works.[277] In 1938 he bought Lucas Cranach the Elder's *Lucretia* in Amsterdam from dealer

Walter Paech. He later gave this work to Göring as a birthday present.[278] In 1942 the Haus der Deutschen Kunst in Munich assembled an album of Ley's purchases from that year's *GDK*. He bought forty-six works in all on this expedition; several were quite expensive. Wilhelm Dachauer's *The Morning* and his *The Spring Moves Over the Land* cost RM 20,000 each, and Claus Bergen's depiction of a U-boat called *In the Atlantic* went for RM 25,000.[279] The wholesale purchasing that occurred on this trip to the *GDK*, and the "gigantomania" – to borrow a term favored by Smelser – that one finds in his domestic life, make it clear that Robert Ley possessed an extremely large and valuable art collection.

ALBERT SPEER

Albert Speer defined himself as an artist and as a patron of the arts who, with the progression of his career, became increasingly comfortable with privilege and luxury. While Speer's wife pressured him to retain some distance from the other leaders and therefore reject a prominent lifestyle in favor of a more family-based existence, Speer himself had tremendous ambition. It is not surprising that he followed in the footsteps of his peers and repeatedly looked to improve the quality of his dwellings. The starting point for Speer was a home that he described as "of modest dimensions" in the Berlin neighborhood of Schlachtensee. He paid RM 70,000 for it in June 1935 and claimed in his memoirs that he needed the assistance of his father to finance it, in part because "in an idealistic spirit which seemed to accord with the temper of the time, I had renounced any architect's fees for all my official buildings."[280] Speer's outlook changed over the next years. He amassed a personal fortune, which by his own account was worth RM 2.5 million in 1945.[281] He conceivably had much more. Toward the end of the Third Reich, with his thoughts on the postwar period, Speer made an intriguing offer, as he noted in his memoirs: "On February 14, [1945] I sent a letter to the Finance Minister offering to turn over 'the entire sizable increase of my property since the year 1933 for the benefit of the Reich.' This action was intended to help stabilize the Reichsmark."[282] Speer evidently believed that his own resources could affect the national economy. Perhaps he thought that the absence of personal wealth would improve his fortunes with the Allies. In any case Speer's offer was pure show as he kept his private property until apprehended by the Americans.

In between the spells of real or feigned generosity at the beginning and end of the Third Reich, Speer did very well financially. As with other leaders, the war years marked a transformation in lifestyle. Speer moved his

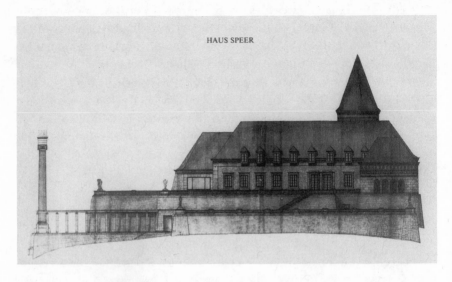

HAUS SPEER

Albert Speer's design for his own home, to be called "Alt Ranft" (Archives d'Architecture Moderne)

family into a *Dienstwohnung* (official residence) in Berlin in 1941: a large and beautifully appointed house on the Lichtensteinallee.[283] Speer spent enormous sums to expand and redecorate the structure, although it was destroyed by an air raid in 1943. In 1942 Speer acquired an estate in the Oder region, approximately half an hour from Berlin. For this property he designed a villa that he called "Alt Ranft." Architectural historian Leon Krier has described the dwelling as "commanding a splendid view of the Oderbruch [lake] . . . [with plans for it] to be crowned by the workshops and villas of the Reich's most eminent artists."[284] Speer's ambitions were reflected in the designs for this residence, as it took the guise of an imposing manor house. The rather strange but prepossessing structure combined historic features such as conical medieval towers and Hellenic columns along with fortresslike walls (expensive materials such as imported pentelic marble from Greece were also specified). Although it was never built – as with many of Speer's designs – this veritable castle suggests a great deal about the owner and architect.

Speer was also an avid collector of art. During the early stages of the war he had time to attend auctions. At Hans Lange's in Berlin, for example, he bought two unspecified paintings in December 1940, when the firm liquidated the remainder of the Goudstikker collection from the Netherlands.[285] In Paris during the occupation Speer availed himself of his advantageous position and purchased a great deal; in one instance he shipped

back to Germany twenty-five cases of unidentified "objets."[286] In his memoirs Speer referred to other collecting activities: "Later I grew accustomed to Hitler's taste in art, though I myself still went on collecting early romantic landscapes by such painters as Rottmann, Fries, or Kobell."[287] He maintained something of an independent spirit with respect to art, reporting, for example, that he kept an etching by Käthe Kollwitz in his room until at least early 1945. Entitled *La Carmagnole*, it depicted a revolutionary mob dancing around a guillotine.[288] In his memoirs Speer expressed a deep attachment to this artwork; he claimed to feel sympathy for a weeping woman in the image who was off to the side in a cowering position. This Kollwitz etching aside, most of the art in his collection was within the prevailing guidelines. Speer even had a watercolor painted by Hitler. The picture of a Gothic church, a gift from the Führer in the mid-1930s, had been painted in 1909 while Hitler was in Vienna.[289]

Speer made most of his purchases, however, in some official capacity. As GBI he bought hundreds of works to decorate the buildings he designed. The New Reich Chancellery budget alone allowed him to acquire 185 paintings at a cost of RM 366,230.[290] He purchased these works from a wide variety of sources, ranging from the Haus der Deutschen Kunst to the Vereinigung Bildender Künstler in Vienna. As his ministerial empire expanded and the funds at his disposal increased, he and his staff bought even more. The funds for *Künstlerischer Zwecke* were not reduced from peacetime levels.[291] A balance sheet on GBI expenditures on art for the years 1943 to 1945 shows Speer's office spending RM 37,600 in 1943, RM 757,995 in 1944, and RM 147,345 in the truncated year of 1945.[292] Speer's generous patronage of leading artists, as discussed earlier, where he paid the sculptors Arno Breker and Josef Thorak millions of Reichsmarks for their creations, reveals further that he conceived buying art to be part of his official duties. The amount Speer directed to these artistic stars was often extraordinary: for example, the GBI paid Breker the "astronomical sum of RM 27,396,000" prior to the end of the war.[293] These payments undoubtedly were meant to cover the materials and the large staff (Breker employed over 100 workers at his atelier, Jackelsbrüch).[294] Of additional interest is Speer's inclusion of supplementary funds, such as RM 60,000 to Breker during the war as a "gift of Reichsminister Speer."[295] Speer's position as an important patron in the Third Reich, especially for those artists whom he befriended, is beyond doubt.[296] His ability to acquire important works also stands out, as he, for example, obtained Herbert Lanzinger's portrait of Hitler as a knight, *The Standard Bearer* (called by one art historian the most famous Nazi artwork), and placed it in his Berlin office.[297]

Speer gave a great number of paintings to colleagues as gifts: for ex-

ample, a Karl Rottmann sketch to Hitler in 1933, Breker's bust of Richard
Wagner to Göring for the Reichsmarschall's birthday in 1943, A. Holst's
Glazer Bergland to Admiral Dönitz in 1943, a painting by Erik Richter to
Hans Lammers as a sixty-fifth birthday present in 1944, and another work by
Richter to a subordinate referred to as Colonel Schaede in 1944.[298] In an-
other representative document, Speer wrote to Posse in May 1941 inform-
ing him of an offer from Freiherr Arnold Rieder von Riedenau that in-
volved *gute Arbeiten*. Speer not only passed along information here but
noted that "I myself am interested in the picture 46/327 [an inventory
number], and perhaps I will have the opportunity to give it to the Führer as
a gift."[299] While Speer patronized galleries in Berlin, Vienna, Salzburg, and
other cities, he also had special sources for artworks.[300] He noted in his
memoirs, "If I myself wanted to give paintings to associates, I chose them
from among the excluded pictures stored in the cellars of the House of
German art. Nowadays, when I see these paintings here and there in the
homes of acquaintances, I am struck by the fact that they can scarcely be
distinguished from the pictures that were actually shown at the time."[301]
This passage underscores Speer's connections to the Haus der Deutschen
Kunst and its director Karl Kolb, but also his ability to use his special posi-
tion to move beyond the officially sanctioned realm to that gray area of ac-
ceptability.[302] Yet Speer was not so much a maverick as an exceptionally
powerful member of the Nazi cultural bureaucracy. His patronage of artists

contributed to his own self-definition as a cultural arbiter and provided him a means of bonding with Hitler as well as with many of his colleagues.

MARTIN BORMANN

Martin Bormann, while described by General Heinz Guderian as a "thick-set, heavy jointed, disagreeable, conceited and bad-mannered *eminènce grise* of the Third Reich," nonetheless envisioned himself as one of the aristocrats of the "new Germany."[303] He and his wife, Gerda, like many of the Nazi elite, harbored the dream of retiring to an East Elbian estate where they would live like the *Junkers* of old.[304] As he wrote her in July 1943, "Of course, I hope that I'll safely survive the war and that, when its all over, the Führer will give me Krumbeck or another estate in Mecklenburg as an endowment and entailed family seat."[305] Bormann fantasized about the Krumbeck estate in part because he thought that Hitler might retire to the nearby *Schloß* Stolpe, and herein lies the crucial motivating factor in Bormann's behavior: his unflagging devotion to Hitler.

More important than self-aggrandizement was his place next to his idol. Bormann himself was relatively honest when it came to personal finances. He had established himself in the NSDAP early by scrupulously managing the Party's Relief Fund – an account that, prior to his arrival, had been reportedly ravaged by Goebbels and Göring.[306] Hitler considered Bormann so trustworthy that he placed the entire Obersalzberg complex in the latter's name. He also entrusted Bormann with the purse strings to a number of crucial bank accounts – including those reserved for Sonderauftrag Linz. Bormann therefore played a central role in the purchase of artworks for Hitler. The initial guidelines for Posse required him to clear all deals in excess of RM 10,000 with Bormann, and while Posse gradually gained greater independence of action, his successor, Hermann Voss, later had similar constraints placed upon him. Because Bormann had such hands-on control of the Sonderauftrag Linz bureaucracy, he in a sense was a surrogate collector for Hitler. It is rather difficult to know what to make of the claim in S. L. Faison's OSS report that Bormann purchased twenty works from the Munich dealer Maria Almas Dietrich, as they might very well have been acquired for Hitler.[307] Bormann sometimes bought artworks with his own funds and then presented them to Hitler as a gift. For example, he purchased a forest landscape by Jacob van Ruisdael for RM 35,000 in April 1939 and gave it to Hitler for his birthday.[308]

Bormann, however, did not completely abjure personal ambition. He owned four homes: one in the Nazi elite's colony in Pullach Bavaria, a

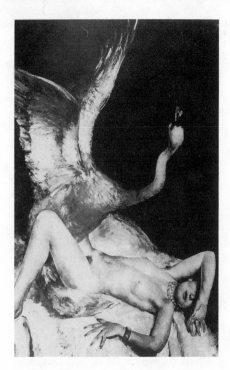

Paul Mathias Padua's
Leda and the Swan,
purchased by Martin Bormann
from the 1937 GDK
(Bildarchiv Heinrich Hoffmann)

chalet on the Obersalzberg, the estate in Mecklenburg, and the fourth, ac-
quired during the war, a Black Forest chalet on the Schluchsee, which had
been confiscated Jewish property.[309] Bormann's standard of living was suf-
ficiently immodest to induce Albert Speer to compare him to Göring.
Speer claimed that they "were always trying to outdo one another with
splendid showpiece homes."[310] Bormann's personal wealth was more than
adequate to enable him to purchase artworks on his own. In the spring of
1945 a mob reportedly looted his Berchtesgaden chalet and absconded with
"his collection of more than a thousand watercolors and drawings by
Rudolf Alt."[311] The seriousness with which Bormann pursued certain art-
works is suggested in another case described by Heinrich Hoffmann, where
Bormann attempted to acquire the sexually explicit picture by Paul Ma-
thias Padua, *Leda and the Swan.* The controversial painting hung in the first
GDK of 1937 on the specific orders of Hitler. Hoffmann wrote that despite
the furor, "there were just as many patrons who were so enthusiastic [about
the painting] that they wished to acquire it. But Martin Bormann beat
them all to it."[312] This incident, beyond demonstrating that Bormann had
the resources with which to collect artworks, illustrates his competitive na-
ture.[313] While he never achieved any profound understanding of the visual
arts, Bormann nonetheless became involved with such matters because it
interested both Hitler and his associates. Bormann, "like Hitler, would oc-

casionally invite artists" to his house at Pullach.[314] While such behavior may seem out of character for this thuggish man, it is entirely explainable in light of his relationship to Hitler and the prevailing ethos that existed amid, to use Jochen von Lang's term, the "Nazi Bonzocracy."[315]

ARTHUR SEYSS-INQUART

Arthur Seyss-Inquart controlled a series of *Sonderkonto* while acting as Reichskommissar in the Netherlands.[316] While these accounts were established to facilitate purchases for Sonderauftrag Linz, they helped form a complicated financial system that Seyss-Inquart exploited for his own advantage. During the war Seyss-Inquart used "money belonging to the Reichskommissariat to finance his stockmarket operations, which were bringing him a fortune."[317] He sold dollar bonds to the Deutsche Golddiskontobank for "enormous profit," and the "first official objections from Berlin did not come until the middle of 1944."[318] Because of Seyss-Inquart's role in the liquidation of the Mannheimer collection, he reportedly "pocketed five million Guilder (or $3.4 million) from the forced sale."[319] While this claim is unsubstantiated, Seyss-Inquart undoubtedly became a rich man. In 1945 American troops found a cache of foreign currency in excess of RM 5 million that he had stashed near Nuremberg.[320]

Previously Seyss-Inquart had directed some of this wealth toward artworks. For example, he owned a Breughel picture called *The Party* as well as Dutch genre paintings by J. van Cleve and B. Cuyp and a number of tapestries.[321] In the report written by Dutch Captain Jean Vlug, the Reichskommissar merited the observation that "in comparison with the purchases of Göring, those of Seyss-Inquart were moderate."[322] Yet this comment should not impugn the quality of his collection. One might also note that Seyss was an honorary member of the SS and that he too participated in the reciprocal gift-giving of the order. Himmler's gifts to him included not only various porcelain objects from Allach (for example, a chess set and a *Julleuchter*) but also an oil painting entitled *Attack at Verdun* for his birthday in 1942, while Seyss-Inquart sent his family coat of arms to Wewelsburg for placement in the chamber with the round table.[323]

JOSEF BÜRCKEL

Josef Bürckel underwent a transformation that proved very common among the regional leaders. He came from a modest background, as he

was a schoolteacher when he joined the Nazi Party in 1921. His political career took off in the later 1920s and early 1930s, and he established his reputation after becoming a Reichstag delegate in 1930 and the Reichskommissar overseeing the incorporation of the Saarland in 1935. Known as a shrewd negotiator and a tough administrator who also had a sense of propriety (by Nazi standards), Bürckel replaced Odilo Globocnik in Vienna in 1938 after the latter was indicted for profiteering from illegal foreign currency transactions. Yet Bürckel became increasingly autocratic and extravagant in his lifestyle, so much so that he earned "the displeasure of the National Socialist hierarchy."[324] Bürckel's opulent home in the Hohe Warte section of Vienna and his retreat outside the city were noted earlier. His use of confiscated Jewish property as a source of furnishings and decorative materials took place on a massive scale.[325]

When transferred to the Westmark in 1940, he again commandeered a villa for his own private purposes. Bürckel had no direct control over any branch of the plundering bureaucracy during the war. He did, however, manage to obtain a few pieces from the Ahnenerbe, which was actively collecting cultural objects in Lorraine (Bürckel's SS membership—he held the rank of Obergruppenführer—helped in this respect).[326] Bürckel endeavored to "reclaim" cultural objects for Lorraine that had found their way to France and the Low Countries.[327] As Reichskommissar in the Westmark he had considerable autonomy, which included the opportunity to allocate official funds for private purposes. He purchased from exhibitions, for example, buying "several works" from the show *Zwischen Westwall und Maginotlinie* in Saarbrücken in 1941.[328] Indeed, all the Reichskommissars lived in a grand manner.[329] Their behavior was even sanctioned in Berlin, as the Reich Devisen office processed enormous amounts of foreign currency to enable them to purchase art and furniture. One extant receipt from June 1943 represents the accepted application from Bürckel to have RM 120,000 in French francs for paintings, porcelain, and furniture; another from 1941 shows Bürckel obtaining RM 150,000 for paintings alone.[330] He clearly reveled in his power and fame. Bürckel was a leader of national stature, although he elicits only limited attention today.[331] Just as his ability to access *Devisen* in 1943 communicated his status to other government and Party officials, the inclusion of a portrait bust by the Munich artist Emil Krieger in the 1944 *GDK* constituted an act of public recognition.[332] Bürckel was a fanatical Nazi, and like other regional chiefs, he bore responsibility for, among other crimes, the deportation of Jews. He committed suicide on 28 September 1944 as the western Allies advanced into his territory. The implication that his behavior had been too atrocious to face the consequences is not without foundation.[333]

8

ART COLLECTING AS A REFLECTION OF THE NATIONAL SOCIALIST LEADERS' WORLDVIEWS

Because Hitler acted as the ultimate arbiter of ideological issues and governmental decisions, this chapter first focuses on him and then encompasses the other members of the Nazi elite. His views must be considered as the core of the NS Weltanschauung. While there were clearly permutations in thought from one subleader to the next, from a standpoint of a history of ideas, Hitler's views constituted the foundation of the entire Nazi ideological edifice.[1] For Hitler, two projects surpassed all others in importance. The first, which might be characterized as domestic and personal, concerned his self-promotion. Hitler, a "pathological egotist," sought to overawe the nation by realizing projects of unprecedented scale. These include the buildings for Party congresses in Nuremberg, the remodeling of Berlin, the mammoth suspension bridge planned for Hamburg, and, of course, his Sonderauftrag Linz.[2] All these projects were conceived not only to elicit a sense of pride in the population but also to demonstrate the Führer's vision and his ability to transform such dreams

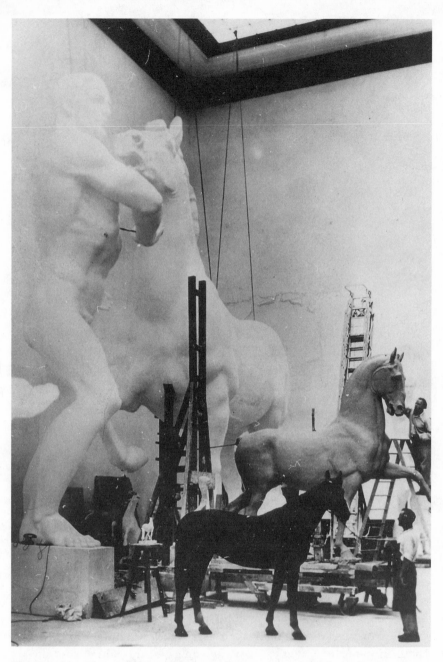

Thorak in his atelier, working on monumental figures as part of grandiose official projects
(BAK)

into reality. They were to be testaments to the NS revolution in a general sense and, more specifically, symbols of his bold dictatorship.

Hitler's second great ideological project, which tied in more closely with his foreign policies, concerned the triumph of German-Aryan culture. Hitler posited an ineradicable link between the racially conceived nation and its cultural manifestations. His ambition therefore surfaced not only in military terms but also in a cultural sense. As Norman Rich has argued, "It was with undoubted sincerity that Hitler, the frustrated artist, paid homage to the German ideal of *Kultur* and made it the foundation of his entire ideological system. . . . Because the Germans were the only true creators of culture, because they were universal in a cultural sense, it followed that they had the moral right to be universal in a territorial sense as well; in other words, that they had a moral right to world territorial dominion."[3] In undertaking the creation of the largest art museum in the history of mankind, and in the process dictating a new hierarchy of values for the artworks, in which the "Germanic" occupied an exalted position, Hitler attempted to realize his culturally based ideology. He did not conceal his conception from the world, as he exclaimed at the Nuremberg Party congress in 1937, "This [nation] is not intended to be a power without culture, a force without beauty. For the armament of a nation is only morally justified insofar as the shield and sword are used for a higher purpose . . . as [a] supporter and guardian of a higher culture!"[4] Furthermore, the relatively early date of this proclamation – prior to his conception of the Linz Project, which came the following year – reveals a consistency in Hitler's thinking about culture.[5]

Hitler's use of art to glorify his rule dates back to his first year in power. On 15 October 1933, in a public ceremony that was communicated to the nation by means of both radio and newsreel coverage, he laid the groundstone for the Haus der Deutschen Kunst in Munich – "a temple for art," as he said, but also a monument to himself. This project, which combined his two greatest cultural passions, architecture and the visual arts (with the former being arguably the more important), was the first large-scale building project undertaken by the Nazi regime.[6] That Hitler commissioned his favorite architect – and one might also use the term personal architect – Paul Ludwig Troost, to design the structure; that he publicized his own contributions to its conception; and that he played a crucial role in the completion of the museum after Troost's death in January 1934 made the Haus der Deutschen Kunst all the more his own personal project. Hitler's special and well-publicized relationship with Albert Speer, who succeeded Troost, served the same purpose: it allowed the Führer to identify more closely with the architectural creations that epitomized his regime.[7] The monumentality of these representative buildings as well as their substantial

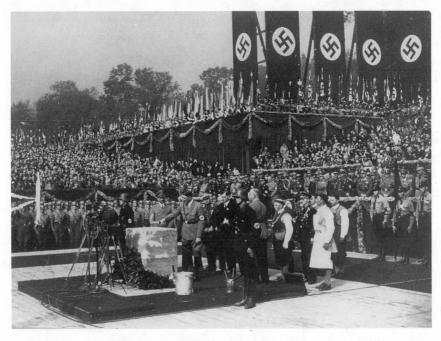

Hitler strikes a block of granite at the groundbreaking ceremony for the Haus der Deutschen Kunst in Munich, 15 October 1933 (BAK)

cost (note the exorbitant price of the stone, especially in light of the nation's economic circumstances) conveyed to all the authority he possessed.[8] Furthermore, that Hitler proceeded so quickly with his building plans – as a counterpoint, two years of competitions and haggling had followed the immolation of the Glaspalast (the precursor to the Haus der Deutschen Kunst) – accented the decisive character of his rule.

In his first years in power, Hitler institutionalized his annual cultural speech at the Nuremberg Party congress, thereby signaling his intent to serve as the arbiter of the aesthetic disputes that raged in the period prior to 1936. He commissioned Speer to design a building specifically for these speeches, the Kulturhalle, which further indicates the importance he assigned to his engagement with culture.[9] Although Hitler refrained from imposing his antimodernist views on the country for some time and only gradually adopted a more interventionist approach to aesthetic policy, he had long believed that the artistic creations of the Third Reich embodied the creativity of the Aryan race and that they served as a reflection of his rule. The sentiments he expressed about his building projects applied also to the visual arts: "It is not merely the aesthetic feeling of our veneration that is stirred by the sight of those great cathedrals; they also force us to bow in ad-

miration before the generations of men who conceived such vast ideas and brought them to realization. . . . The greatness of the present will be measured by the immortal quality of the works it leaves to posterity."[10]

Hitler not only sought this self-promotion through high-quality, inspired art but also endorsed the production of glorified portraits of himself. Heinrich Hoffmann, who became the head of the *GDK* and the jury for the submitted works, recalled that "every year we could have filled a complete room with 'portraits to the Führer'–there were normally up to 150 of them."[11] Hoffmann claimed, however, that Hitler feared overexposure and therefore decreed that only one portrait of him per year could hang in the *GDK*.[12] A more accurate count determined that there were 31 portraits of Hitler between 1937 and 1943 in the annual *GDK* in Munich, an average of over four per year.[13] These pictures offered varied representations òf Hitler: from Teutonic *Ritter* (knight) to aristocratic Herr with walking stick to ascetic leader of "the movement." This art, as with most other pieces in the *GDK,* had an overtly propagandistic purpose. Hitler personally had mixed feelings about using art to sway the opinions of the German people. While he realized its usefulness as a means of indoctrination and social control, this violated his more idealistic principles–those that had germinated in his bohemian days prior to World War I. He also realized that officially commissioned art suffered certain liabilities; this perhaps explains his gradually increased interest in collecting traditional art.[14]

Sonderauftrag Linz, the cultural complex planned for Hitler's childhood hometown that had the Führermuseum as its center, expressed Hitler's megalomania and style of self-promotion. Everything about the project was to set new records for size and grandeur–from the number of works in the galleries to the sculptural frieze that he planned for the central gallery, which at 660 feet in length would be the largest in Europe, if not the world.[15] Yet the Linz Project, which Hitler launched in 1938 when he was securely in power, was not intended to glorify the Führer only at that historical moment but also to constitute a lasting and transcendent monument to his rule. Just as he and Speer discussed the "ruin-value" of the representative buildings–where they would age and crumble with the grandeur of those constructed by the Greeks and Romans–the Führermuseum was conceived with posterity in mind.[16] With its auspicious natural landscape that would allow for the placement of the cultural complex atop a hillside with a breathtaking view of the Danube–thus magnifying the effect of the monumental architecture–Hitler's Sonderauftrag Linz was to be a tribute to the beneficence of his rule.[17] He even planned to locate his tomb nearby.[18] Still, he kept these plans private and usually discussed them only in late-night sessions with his inner circle. Director Posse's initial commis-

sion came with the provision that it be kept under *höchsten Geheimhaltung* (highest secrecy).[19] Although there were occasional leaks about the project – it was mentioned in the December 1942 obituaries written for Hans Posse – the museum was not broadly advertised until April 1943, when Heinrich Hoffmann published an article in the art journal *Kunst dem Volk*.[20] This general announcement of the grandiose Linz Project and the account of the already impressive accomplishments implied an eventual victory for the Reich. Significantly, it came in the wake of the Germans' crushing defeat at Stalingrad.[21] In attempting to bolster the spirits of the people, Hitler abandoned his earlier plans to conceal the undertaking. Delaying the announcement of projects until they had neared completion was a tactic he favored not only in artistic matters but also in political and military endeavors.[22] The presentation of a fait accompli to the world enhanced the effect of the accomplishment and gave Hitler greater freedom of action. It also increased his power as he alone knew of all the variables.

Art collecting not only allowed for the glorification of his rule but also provided Hitler with a context in which he could articulate and emphasize his own vision of western culture. Within this larger project for Linz, he proposed to substantiate the triumph of the Aryan race. To do this, he first sought to rearrange the hierarchy of value attached to the different artistic styles, such that Austro-Bavarian genre painting gained the recognition he thought it deserved. This was largely a personal mission: Speer, for example, was initially "stunned . . . at what met with Hitler's approval," while Hans Posse quite simply disagreed with the positive assessment of this art.[23] The first Linz director, who had in part been hired because of his vast knowledge and expertise in artworks traditionally recognized as masterpieces (for example, Italian Renaissance and Dutch old masters), tolerated these objects of Hitler's passion and collected them only because of his chief's explicit orders.[24] Posse hoped that the abundance of other treasures would displace the Austro-Bavarian works once the galleries were assembled. Yet Hitler had other plans. He believed this art undervalued because it had been created too recently, and he compared it to the art of Rembrandt and Vermeer, insisting that the passage of time would ensure its proper appreciation.

In fact, Hitler himself drafted the layout of the galleries of the Führermuseum as well as the furniture, the shape and styles of the windows, and much more.[25] The design was based on his sketches for a national gallery that he had made in 1925, attesting to the durability of his dreams.[26] In presenting these plans to Roderich Fick, Albert Speer, and Hermann Giesler, the architects nominally in charge of the project, he explained the ratio-

nale: the rooms housing the old masters would lead directly to those holding the Austro-Bavarian works.[27] The sequence conveyed a line of art history that valorized the accomplishment of the Germans. French art of the nineteenth century, for example, was almost entirely overlooked in Hitler's revisionist schema. This juxtaposition of old masters and nineteenth- and twentieth-century German art could also be found in the pages of *Kunst im Deutschen Reich* and other official journals, with the same intentions underlying the layout.[28] Additionally, one should note that the Austro-Bavarian art corresponded to the work Hitler produced during his youth, thus perhaps providing a more personal element to this predilection. The most significant difference between the Austro-Bavarian art and Hitler's own work lay in the latter's inability to paint or draw human figures, the stated reason he was denied admission to the Akademie der Bildenden Künste in Vienna.[29] Hitler called his rejected application to art school the greatest disappointment in his life.[30] Given his obsessive personality, one could only expect him to transform this long-standing opinion into a personal crusade.

Hitler's love for this particularly German art derived in part from his cultural nationalism. Providing his own interpretation of theories of art developed during the Romantic period, he postulated that all art was national.[31] Hitler believed that race formed the basis of both nationhood and culture and therefore linked the three concepts in an inseparable manner. Amid the larger project of promoting the cultural manifestations of the nation and race, Hitler engaged in a crusade to gain control over the entire cultural heritage of the German people. Just as he aspired to unify the German *Volk* in Europe, he sought to bring together all of the artworks that constituted the nation's artistic legacy. Others around him clearly understood this artistic irredentism. Goebbels organized the Rückforderung action of 1940, discussed in Chapter 5, whereby professional art historians were enlisted to ascertain what artworks had been removed from Germany since the year 1500, and various branches of the government bureaucracy were mobilized to pursue the return of these works. Even Mussolini acknowledged this principle of national sovereignty over one's artistic heritage. The works of art he presented to Hitler and the Nazi leaders were frequently German. He gave Hitler Hans Makart's *Plague of Florence*, a masterpiece by the Austrian painter, whom Hitler of course considered German, and presented Göring with the exquisitely crafted Sterzing (or Vipiteno) Altar by Hans Multscher, a German artist from the South Tyrol.[32] National pride was invariably an issue in the fascist leaders' deliberations about art.

Sonderauftrag Linz, however, represented more than an effort to control the artistic products of the German nation; it constituted the clear expression of Hitler's plans to dominate Europe. The creation of the largest museum in the world would serve as a symbol of Germany's cultural hegemony. Filling it not only with Germanic treasures but also with those of France, Italy, Spain, and other western European nations allowed Hitler to demonstrate the Third Reich's primacy on the continent. While collecting eighteenth-century aristocratic art from France or Baroque religious paintings from Italy seemed incongruous with the Nazi ideology (in light of the antiaristocratic and antichurch tenets), the possession of such works nonetheless conveyed Germany's newly dominant role in this pan-European New Order.[33] The means of acquisition also had symbolic significance. Whether taken by force (a sign of the Reich's military might) or obtained by sale in occupied western European nations whose economies had been manipulated to the Germans' advantage, the strength of the revitalized Reich found tangible expression. There was a sense that the flow of artworks into Germany marked a reversal of an earlier state of weakness, as when Göring order Mühlmann to engineer a trade with the Kröller-Müller Museum in Holland for works by Hans Baldung Grien, Barthel Bruyn, and Lucas Cranach. Göring exclaimed, according to an OSS officer, that the exchange was "a matter of national prestige" and that "these paintings had been bought in Germany just after the last war during the inflation period and that the purchases were therefore made under adverse and unfair conditions for the Germans."[34] One might also point out a couple of the specific acts of the NS leaders that in themselves were especially communicative of their nation's reacquired power, including the incident mentioned earlier, where Hans Frank tore the silver Balduchin eagles from the Polish throne (nearly all royal insignia were destroyed by the Germans), and Foreign Minister Ribbentrop claimed Metternich's globe for himself, snatching it out of the Viennese Hofburg just after the *Anschluß*.[35] Artworks and cultural objects provided the means with which to flaunt Germany's resurgent power.

The Nazi leaders also articulated their cultural imperialism with their various plans to exhibit German art in all reaches of the New Order. This entailed the construction of museums devoted to Germanic culture. Examples include Joseph Goebbels wishing to transform the Wildenstein Gallery in Paris – an Aryanized art dealership – into a venue for German art; the establishment of a Museum für Vor-geschichte in Kharkov; and the

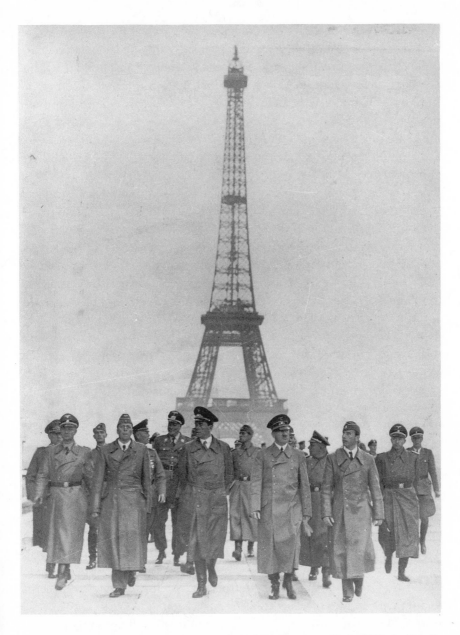

"Art trip" in Paris, June 1940. From left: Karl Wolff, Hermann Giesler, Wilhelm Keitel, Wihelm Brückner, Speer, Hitler, Bormann, Arno Breker, and Otto Dietrich. (BAK)

short-lived picture gallery that the Germans provided for their troops in Kiev.[36] These museums were transparently ideological. The Kharkov museum for prehistory, for example, exhibited archaeological evidence of the Germans' presence in the region in earlier times and hence attempted to support their present-day claim. There were also temporary exhibitions that aimed to display German artistic accomplishment. Examples include the Cracow exhibition opened by Hans Frank in 1942, *Deutsche Künstler sehen das Generalgouvernement*; Arno Breker's one-man show in the Orangerie in Paris; and the exhibition *Deutsche Größe*, which was organized by Alfred Rosenberg's agency and traveled to Brussels and other western European cities.[37] The Germans also sponsored negative ideological exhibitions in the occupied territories. These shows, such as *Warsaw Accuses*, *The Jew and France*, and *The Soviet Paradise*, were not so much concerned with the greatness of German culture as with the defamation of other nations and races.[38] Still, they offer examples of artworks providing a forum for ideological representations.

Hitler expressed other aspects of his worldview in the manner by which he assembled his art collection. The ERR's confiscations in France, as with the various commandos that operated on the Eastern Front, constituted but one aspect of the war against the Jews. As mentioned earlier, the Nazis contended that no armistice had ever been concluded with the Jews and hence justified their plundering activities on this principle. Hitler and many of his subordinates also believed that Jews had long dominated the business of dealing art in Europe and viewed the war as an opportunity to alter the Jews' "stranglehold" over this business. Karl Haberstock, a Christian dealer, had played upon this sentiment before the outbreak of war and attracted customers by way of this racist principle. Granted, Hitler always maintained a general aversion to art dealers, believing them avaricious and unscrupulous.[39] Hitler wished, therefore, to take art out of the hands of Jews in particular and art dealers in a broader sense. As noted in Part I, works produced by Slavs, like those produced by Jews, were also subject to defamation and in many cases destruction. No Russian or Slavic pieces found their way into the Linz collection, although, in line with Hitler's desire to exhibit Germany's mastery of the continent, he did plan special museums to showcase this meretricious culture. In one of the "secret conversations" recorded by Bormann, Hitler said, "I must do something for Königsberg with the money Funk [the minister of economics] has given me. I shall build a museum in which we shall assemble all we've found in Russia."[40] Similarly, as noted earlier, Himmler, the overseer of the Final Solution, commissioned the creation of museums for the culture of Jews

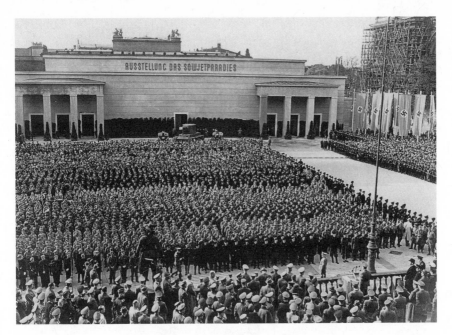

Exhibition Das Sowjet Paradies, *Vienna, 1942, one of many propagandistic shows orga-nized by the regime (Österreichisches Institut für Zeitgeschichte, Vienna)*

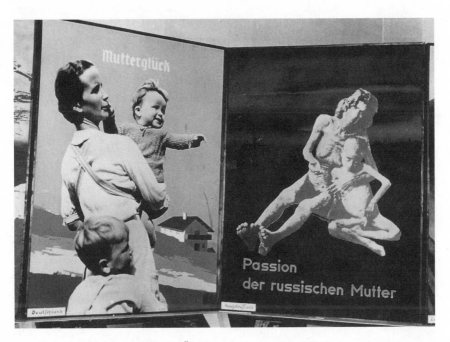

Exhibit from Das Sowjet Paradies *(Österreichisches Institut für Zeitgeschichte, Vienna)*

and for that of Freemasons. The Nazis sought to render the culture of these groups to posterity. These "historic" exhibits would be presented in a manner consistent with the Nazis' worldview, with the culture of these people shown to be parasitic or a threat to the valued Aryan culture.[41] One tragic manifestation of these symbolic plans was that the Jewish experts who assisted with the curatorial preparations for the museum on Judaic culture slated for Prague were killed when it became evident that the war would prevent the completion of the project.[42]

The Nazi leaders' gradually escalating war against the Catholic church also found expression in the disposition of the cultural objects in their possession. The concordat between the Nazi regime and the Vatican in July 1933 did not prove especially durable, as the state gradually encroached upon the domains claimed by the church (such as education). The state-instigated legal proceedings against clerics began in 1935 and are significant not only for the anti-Catholic sentiment but also because they focused on the issue of property (currency violations were a common charge).[43] The war in Poland undoubtedly exacerbated antichurch sentiment among the Nazi leaders. Recognizing the mutually enforcing relationship between Polish nationalism and Catholicism, the Nazis attacked churches as part of their program to dismember the country. After establishing this precedent of confiscating church property, the regime then turned to religious institutions inside the Reich. Among the numerous churches and monasteries (*Stifte*) that had their artistic and religious works seized, the most notable were the Stifte Klosterneuberg, Göttweig, Kremsmünster, Lembach, St. Florian, Schlägel, Wilhering, St. Peter, Admont, St. Lambrecht, Vorau, St. Paul, and the cloister at Korneuberg.[44] Within the leadership there was a range of opinion as to how the Catholic churches should be treated, with Bormann representing the most radical policy of outright destruction and Himmler taking the more common view that the process must be gradual and devoid of ostentation in order to be successful.[45] Hitler, a Catholic who never officially left the church, shared Himmler's views. All Nazi leaders subscribed to the idea that no challenge to the regime would be brooked, and the priests in particular, whom they viewed as power-hungry rivals, warranted immediate action.[46] The demise of the church would be reflected in the loss of its property – artworks included – to the benefit of the German state.

Between the polar extremes of the "sublime" Aryan achievements and the valueless expressions of the *Untermenschen*, Hitler and his colleagues posited the existence of a Nordic culture that emanated from the Germanic people of northern Europe – most notably the Dutch and Scandi-

navians. Hitler reasoned that these people, who were of basically sound racial stock, had the potential for great culture but that these impulses required nurturing and guidance. Hitler could justify his acquisitions of Dutch old masters in a manner similar to his rationalizing the purchase of eighteenth-century French art: namely, that earlier impulses toward cultural achievement had been lost over time due to changes in the societies and governments of these nations. The Dutch, unlike the French, still had considerable promise according to Hitler's warped thinking. To this end he charged Himmler in August 1942 with overseeing a "Teutonization program" that would bring out the positive, Germanic elements in the people of modern-day Holland as well as in Luxembourg, Denmark, Norway, and sections of Belgium (especially those areas inhabited by the Flemish).[47] More specifically, the program involved "reviving Germanic ways of life in the conquered areas as a means of preparing the way for a reunification with the Reich."[48] As Himmler wrote Seyss-Inquart during the war, "Nine million Germanic-Lower German (*niederdeutsche*) people have been alienated from Germandom for centuries; with a firm but nonetheless very soft hand we will bring them back and integrate them again into a Germanic community."[49] While the full implications of this plan for Teutonization were never articulated, its cultural manifestations in the Netherlands and Luxembourg included the eradication of modern, degenerate art and the establishment of corporatist cultural organs akin to the RKK–steps that supposedly would induce the growth of a "healthy" Germanic culture.[50]

The Linz Project, which represented the mature form of Hitler's cultural ideology, therefore rested on two key principles. The first was the pursuit of Germany's cultural hegemony over the continent in a material sense, whereby Hitler arranged for the nation to possess the bulk of Europe's artistic heritage. Hitler in fact said, "For the Linz museum I can think of only one motto: to the German people, that which belongs to them."[51] Second, Linz represented Hitler's attempt to recast the hierarchy of artistic accomplishment, to induce the world to recognize the supreme accomplishment of Aryan culture. Hitler had noted in a 1938 speech that "the understanding of contemporaries when faced with great creative works does not as a rule keep pace with the appearance of these works. Often centuries may pass before the greatness of an age . . . is comprehended."[52] Hitler envisioned that his actions would be most appreciated in the future. He viewed his wars of conquest as well as the outlay of unprecedented sums of money for the purchase of artworks as necessary short-term sacrifices in the pursuit of larger goals that were central to his ideology.

Hitler romanticized the Linz Project and clung to his dreams of a cultural mecca and Führermuseum until a shockingly late date. On 26 January 1945, in the wake of the failed Ardennes offensive, he ordered Bormann to compile an inventory of all of his art. Bormann in turn transmitted this order to Himmler.[53] A more vivid expression of Hitler's hopes for the future can be seen in his penchant for spending hours at a time in the Berlin Führerbunker room devoted to the models for Linz, a habit that became more pronounced toward the end of the Third Reich.[54] Hitler was a man motivated and sustained by his dreams, and the Linz Project constituted an integral part of his fantasies. Hitler's fondness for the model room in the bunker provided a metaphor that rivals Nero's mythic fiddling: a symbol of an escape from reality, of divorcing oneself from the terrible events going on outside the sanctuary.[55] Yet his behavior here also reflected his culturally based worldview, of perceiving this largely military situation by focusing on an artistic consideration. An earlier example can be found in his selecting Liszt's *Les Préludes* as a victory fanfare just prior to his invasion of the Soviet Union, and his prediction that the German people would hear it often.[56] Finally, the episodes in the bunker represented Hitler's extraordinary faith in all enterprises that he undertook.

While Hitler's confidence in a reversal of momentum in the war continued until a very late date – even Roosevelt's death on 12 April 1945 was interpreted as a providential sign – he eventually abandoned hope and turned viciously on the German people, calling them unworthy of victory and ordering the implementation of a "scorched earth" policy. Contemporaneous with this destructive impulse was the hope, embraced by a number of the Nazi elite, that a Fourth Reich could someday be engineered – a new movement that would rise from the ashes of the present catastrophe. Both the impulse toward destruction and the hope for a future revival can be discerned in the Nazi leaders' actions with respect to their art collections at the end of the war. Regarding the former, the destruction of the artworks, it is certain that in April 1945, orders came from high-ranking sources to make preparations for the ruination of the salt mines that held the works for Linz. August Eigruber, the fanatical Gauleiter of the Oberdonau (Upper Danube) region, ordered six unexploded American bombs placed in the tunnel leading to the Alt Aussee storage chambers. The courageous actions of the local resistance, the eventual collusion of Gestapo Chief Ernst Kaltenbrunner in circumventing Eigruber's orders, and Hitler's growing ambivalence about the destruction of the artworks eventually prevented a

disaster.[57] Hitler himself apparently first ordered that the entrance to the mine be closed by the bombs. Upon learning that an explosion of a significant magnitude could easily collapse the tunnels or provoke a flood, Hitler had second thoughts. His indecisiveness – though he did state explicitly that the artworks were not to be destroyed – nonetheless enabled those with malevolent intentions, such as Eigruber, to threaten the existence of the artworks.

Against this backdrop, where the artworks in Alt Aussee were clearly in jeopardy, a number of high-ranking leaders took steps to use the artworks for their own plans. For example, in the last days of the war Bormann sent his adjutant Helmut von Hummel to pick up the gold coins collected for Linz.[58] Baldur von Schirach charged his aide Fritz Wieshofer as well as his cultural adviser (Generalkulturreferent) Hermann Stuppäck with the task of securing at least four valuable paintings – including a Breughel and a Rembrandt – and removing them to the relative safety of the South Tyrol.[59] Both Bormann and Schirach, who hoped to escape from the Allies and reconstitute the Nazi movement in some other form, believed that the valuables accumulated for Linz could be useful in the future. Certain historians, who are less than reliable, maintain that the Nazis actually managed to remove significant quantities of art to South America and Spain with the very purpose of sustaining the movement.[60]

The claims about the art evacuated abroad are much like the reports that Nazi leaders prepared to destroy the works in the repositories. In both cases it is difficult to distinguish legend from fact. Historian Matila Simon reported that Robert Scholz, who was overseeing ERR repositories in Bavaria, received orders from Bormann, via Hummel, to destroy all artworks in the shelters (the implication being that Bormann would not have acted without Hitler's authority).[61] While her research is generally quite good, Simon does not provide any documentation in this case. She also claims that Himmler gave orders to blow up Neuschwanstein, the *Schloß* that housed the 21,000 objects taken by the ERR. In this instance her account seems better substantiated, as she cites eyewitnesses to document the episode (and Himmler did destroy Wewelsburg).[62] Because Gauleiter Eigruber was a fanatical Nazi – he supported Otto Skorzeny and his detachment of 3,000 SS men who moved to the Alps to resist the Allies by any means, including sabotage – the specter of wanton destruction loomed over the artworks at the end of the war.[63] It is nonetheless quite difficult to fathom the intentions of the individual subleaders. More certain is the unlikelihood that any radical actions would have occurred without Hitler's consent. He had played such an active role in the collecting and plunder-

Ruins of Carinhall, which Göring refused to allow to fall into Soviet hands and ordered Wehrmacht engineers to destroy in the spring of 1945 (BAK)

ing that no subleader would have taken the initiative without his approval. Two documents provide evidence that, to a limited degree, exonerate Hitler on the charges of plans to destroy the artworks. One is his personal will, dictated shortly before his suicide at the end of April 1945. Hitler noted here that he collected on behalf of the German nation and that he hoped that the Linz museum would be realized after his death (thus suggesting the survival of the artworks).[64] The other document, dated 1 May 1945, stems from Bormann's aide Helmut von Hummel. It states that the artworks are not to fall into the Soviets' hands but that they should also not be destroyed.[65] Hitler therefore evidently contemplated the destruction of the collection but was ultimately not prepared to do so. In any case, Hitler did not prove himself a strong dictator with respect to this issue. Mine workers felt it necessary to seal the entrance to the Alt Aussee repository to preserve the works and did so by setting off small detonations on 5 May.[66] Indeed, his behavior contrasts with that of Göring, who took great precautions to protect his artworks, traveling with them by train to the relative safety of the Austrian Alps.[67]

Nearly all of the Nazi elite followed Hitler's lead in expressing a concern for the arts and, more specifically, in collecting artworks. In casting themselves not only as lovers of the arts but also, in many cases, as artists or individuals with artistic sensibilities, these subleaders not only conformed to Hitler's vision of the true Aryan (as a promoter of culture) but also reflected the *Führerprinzip*: that which concerned the Führer invariably concerned them. While nearly all of the NS leaders transformed themselves so that they amplified the artistic element within their personae, this transfiguration did not always come easily. The artificial quality of certain leaders' interest in the arts suggests that political and psychological reasons motivated their concern.

While the Nazi elite often had artistic aspirations, their professed interest in culture was sometimes feigned and not an accurate reflection of their minds or their intellectual abilities. Albert Speer told a revealing anecdote about the performance of Wagner's opera *Die Meistersinger* at the Nuremberg Opera House, an event held annually during the Party congresses.[68] Speer recalled how the special performance for privileged Party members in 1933 was woefully underattended, despite the fact that the famed conductor Wilhelm Furtwängler was leading the Berlin State Opera. Speer related that the "next year Hitler explicitly ordered the Party chiefs to attend the festival performance. They showed their boredom; many were visibly overpowered by sleep. . . . From 1935 on, therefore, the indifferent Party audience was replaced by members of the public who had to buy their tickets for hard cash. Only then was the 'atmosphere' as encouraging and the applause as hearty as Hitler required."[69] While a love of Wagnerian opera is not a requisite for cultural refinement, Speer's anecdote illustrates the sense in which a certain type of conduct was encouraged among the subleaders and that Hitler played a crucial role in inculcating a concern for culture. Indeed, it is significant that the episode described by Speer transpired in 1933, at a point when many of the Nazi chieftains had not participated in many cultural events or been sufficiently educated (or conditioned) to appreciate such matters. By the late 1930s the Nazi elite had attended enough functions – including exhibition openings, artists' receptions, and cultural speeches by Hitler – to guarantee at least a superficial savvy about such matters. Nonetheless, their interest in the arts, as with art collecting, stemmed foremost from their relationship to Hitler and from their desire to perceive and project themselves as members of a cultured and privileged elite.

Hitler delivers speech on art at the Haus der Deutschen Kunst, 1939. Audience, from left: Hess, Finck, Wagner, Neurath, Troost, and Attolico. (BAK)

Document listing seating protocol for Hitler's speech in the Haus der Deutschen Kunst, 1939 (BHSA)

Sitzordnung bei der Eröffnungsfeier im Haus
der Deutschen Kunst am 16.7.1939.

1.Reihe links	2. Reihe links	1. und 2.Reihe rechte
1. Wagner	1. Brückner	Frau Wagner, mit
2. Führer	2. Schaub	Neurath mit den Diplo-
3. Finckh	3. Dr.Ley	maten.
4. Hess	4. Frau Ley	
5. Frau Hess	5. Ministerpräsident	
6. Dr.Goebbels	6. Frau Siebert	
7. Frau Goebbels	7. v. Epp	
8. Alfieri	8. Schwarz	
9. Bottai	9. Frau Schwarz	
10. v.Ribbentrop	10. Fiehler	
11. Frau v.Ribbentrop	11. Frau Fiehler	

Rosenbergs Heimat
mit Rosenbergs Augen
Unbekannte Werke einer künstlerischen Jugend

Stadtmauer mit Türmen und Olai-Kirche

Aufnahme: v. Kaull

Motiv aus Võsu (Estland)

Birkenwald in Estland

Die alte Poststraße, Motiv aus Reval

Blick auf den Langen Hermann, das Ordensschloß in Reval

Rosenberg's homeland, as depicted in his own paintings from Die Braune Post, *13 October 1935* (BAK)

A brief synopsis of the Nazi leaders' cultural aspirations suggests the prevalence of artistic personae. Goebbels, for example, fancied himself a novelist and critic and, in Albert Speer's words, had "the conceited academic's literary ambitions."[70] Alfred Rosenberg, though known as a writer, had been trained as an architect in Riga, where he had also dabbled as a painter. His early efforts on canvas were even published in the NS press.[71] Göring, who described himself as a Renaissance type, believed that he had a special understanding of the arts. Besides being the patron of the Prussian State Theater and having honorary positions overseeing art schools, he delivered cultural speeches and published books of his collected essays.[72] In this way he attempted to prove himself more than a political leader. Baldur von Schirach wrote poetry and, like the other leaders, delivered speeches on art and culture. Reinhard Heydrich, the brutal head of the SD, was an accomplished violinist, who, as deputy Reichsprotektor of Bohemia and Moravia, delivered speeches on art, including a highly ideological one that stressed *Blut und Heimat* at the reopening of the Rudolfinum museum in Prague on 16 October 1941.[73] Julius Streicher painted in his spare time and, at war's end, attempted to conceal himself as a humble, provincial artist (*Heimatkünstler*).[74] Ribbentrop was passionate about music, writing while imprisoned at Nuremberg, "My violin went with me everywhere, throughout my life. It never let me down, as so many people did."[75] Albert Speer, of course, had legitimate artistic talent and always conceived of himself first as a *Künstler*.[76]

The Nazi elite believed Hitler's theories that Aryans were the culture-carrying inheritors of the earth. For them, as for Hitler, their cultural mission helped legitimize brutal and bellicose policies. According to the then much-vaunted principles of Social Darwinism, the dominant position of the Nazi leaders within the Reich represented the natural ascendancy of the best and the fittest, and Hitler convinced them that a love of culture was a sign of this superiority. The Social Darwinism that was so pervasive in the NS ideology also found other cultural outlets. Within Germany, artists themselves were expected to compete, with those deemed most fit being the ones to survive and flourish. In 1938 there were 170 competitions organized for those concerned with the *bildende Künste* (painters, sculptors, and architects), with RM 1.5 million in prizes awarded.[77] The number of official awards for the arts increased at such a rapid rate that Goebbels deemed it necessary to impose a freeze on new awards once the war began, lest the leaders become bogged down serving on committees.[78] Of course, the cultural imperialism discussed above – the leaders' drive to amass collections by dominating the neighboring lands – provides an obvious manifestation of the Social Darwinist impulses.

The cultural policies of the Nazi leaders – and art collecting is subsumed under this larger rubric – did not only justify and provide symbolic expression of their oppressive and militaristic worldview; these policies were in themselves part of the motivation for the ensuing hegemonic behavior. This raises the central question regarding the Nazis' views about culture: Were their actions exclusively symbolic, or did cultural considerations actually incite and animate the leaders? Clearly the NS elite used these policies instrumentally in an attempt to articulate their larger concerns. Albert Speer described this in his memoirs when he wrote, "Hitler openly aimed his intention to pervert the very meaning of the concept of culture by mobilizing it for his own power."[79] Speer also noted that "these monuments were an assertion of his claim to world dominion long before he dared to voice any such intention even to his closest associates."[80] Behavior in the cultural arena therefore prefigured and expressed designs on a more grand scale. Yet the Nazis' preoccupation with culture was so great that it became an element in itself in the motivations behind their behavior. So intense was their desire to propagate Germanic art across the continent and to control Europe's artistic legacy that these considerations, along with the biologically centered drive for *Lebensraum* (living space), the political mission to eradicate Communism, and the *Realpolitik* notion of military superiority, powered the expansionist machine.

ART COLLECTING AND INTERPERSONAL RELATIONS AMONG THE NATIONAL SOCIALIST ELITE

Art collecting proved important to the relations between the Nazi leaders in three key respects: first, the artworks served as the primary medium in the elaborate culture of gift-giving that evolved during the Third Reich; second, the pursuit of these treasures constituted a symbolic and yet tangible source of rivalry; and third, the collection of art afforded the display of wealth, which in Nazi Germany, as in many other societies, indicated the possession of power. Art collecting for the Nazi elite was highly symbolic and communicative, as it provided a kind of language that, although often imperfect and inaccurate, became familiar to the entire governing hierarchy. The artworks were a part of the material culture that all societies imbue with expressive potential; this applies also to clothing (which also had symbolic import in the Third Reich), houses, or any of a variety of objects possessed by subjects under consideration.[1]

While anthropologists have tended to focus on nonwestern and nonurban cultures because their values and rituals are assumed to be more static and cohesive, the Nazi elite also lend themselves to an interpretation of

their conscious and unconscious symbolic gestures. The Nazi leaders, by way of their many years of association – the most veteran of the *alte Kämpfer* began their mission thirteen years prior to their seizure of power – developed a group identity that can be compared to a tribal ethos. The ruling clique shared not only certain key values and goals but also many semiotic assumptions.[2] This in part explains their obsession with ritual acts, totemic objects, and insignia. Myth, which also builds upon shared suppositions, also flourished during the Third Reich.[3] Certainly subgroups, such as the SS, existed alongside the ruling clique, but these other associations did not negate the sense of solidarity among the Nazi leaders.

The disposition of artworks facilitated the articulation of myriad ideas about the NS regime. For example, among the Nazi elite the privilege of borrowing state-owned works for representative purposes has already been mentioned. Göring, as minister president of Prussia, had final say over the province's loans and wielded this authority in a political fashion.[4] Granting foreign museums the right to borrow artworks from German collections had implications for international affairs. A voluminous correspondence would often develop as a result of a loan request from abroad, as with the Italians' attempt to borrow artworks for a 1939 exhibition concerning the Medicis. The correspondence entailed letters from Ambassador Attolico, Marshal Badoglio, Ribbentrop, and Hitler.[5] Indeed, the Germans' reluctance to lend old masters and other national treasures after 1937, a shift that corresponded to a more aggressive foreign policy, was observed by both the political or artistic cognoscente.[6] Similarly, the decision to participate in world expositions or international exhibitions, such as the Venice Biennale, also conveyed messages that did not go unnoticed. Giving, loaning, and exhibiting art, therefore, comprised a vital component of the extensive symbolic communication that took place within the Nazi elite and between German and foreign leaders. The symbolic language employed among the Nazi elite, and their understanding of that language, differed somewhat from that used in foreign relations. For example, Rudolf Hess became fixated on the fact that a portrait of General Blücher that he wished to present to General Werner von Blomberg in 1937 had once belonged to a Freemasons' lodge.[7] While Hess fretted about the implications of the picture's provenance, it is unlikely that such considerations would have come into play in dealings with foreigners (the sale of *entartete Kunst* abroad might offer a suitable parallel). Certain signs and gestures had import only within the group, which in itself is not extraordinary.[8] The Nazis' use of artworks represents a facet of social interaction that can be explained within the context of their highly developed group ethos, their shared ideology, and their penchant for ritualized and symbolic activities.

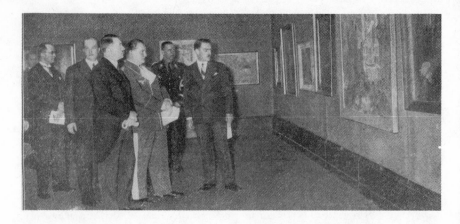

Hitler and Göring, with Polish ambassador Josef Lipski (behind Hitler), visit exhibition of Polish art in Berlin, 1934 (BHSA)

THE CULTURE OF GIFT-GIVING

Artworks only gradually became symbolic objects for the NS elite. The giving of art, for example, did not take place on a significant scale prior to 1933. During the *Kampfzeit* the Nazis affirmed their ties to one another and articulated hierarchical distinctions by other means. The Party congresses, for example, which took place in the city of Weimar prior to being established as an annual event in Nuremberg in 1927, served as one noteworthy means of expressing group bonds and loyalties and affirming the status of the leaders. The keynote addresses, the processions (which sometimes incorporated symbolic objects such as the Blood Flag from the 1923 putsch attempt), and the special, restricted meetings of the elite behind closed doors all contributed to the formation of the Nazis' group dynamic. Giving artworks at this time was impractical due to the financial woes of the Party and was antithetical to the populist and quasi-socialistic philosophy that prevailed. Only Göring and Hitler received artworks as presents prior to 1933, and these gifts came about as a result of the contacts these two men had with the commercial elite of Germany. As described in Chapter 7, Fritz Thyssen not only made large financial contributions as part of his "insurance policy"–he donated money to a number of political parties in an effort to foster good relations with whatever group came to power–but more specifically, he helped Göring decorate his Berlin apartment and provided Hitler with the means to live in style in Munich.[9] While Thyssen provided funds for these two top leaders to acquire the artworks and trappings considered necessary to impress other elites in Germany, he did not give the Nazis actual artworks. He merely hoped to make the street-fighting radicals

more presentable to the upper reaches of society. Among the Nazis themselves, the custom of giving gifts of any sort had yet to evolve to a significant degree.[10]

While one might categorize the bestowal of artworks in the Third Reich in a variety of ways, two distinct types of giving stand out: that involving Hitler, where the issues of tribute and favoritism appeared paramount, and the other that occurred among the subleaders, where alliances and friendship found expression. The distinction between the two types of giving is advanced here for reasons other than organization. The issue of reciprocity, which anthropologists including Marcel Mauss have stressed in their studies of gifts, is more valid for the exchanges that took place among the subleaders. Hitler, the arbitrary dictator, responded to the tributary gifts by extending protection and support rather than by regularly bestowing tangible objects. Marcel Mauss described the responsibilities normally incumbent in the exchanges of gifts: "Although prestations and counterprestations take place under a voluntary guise they are in essence strictly obligatory."[11] Hitler's supreme position entailed bonds with his underlings, but he enjoyed the freedom to articulate such ties in ways other than gifts.

For Hitler, because of his lofty, unparalleled status, all gifts – even those from longtime colleagues – were a form of tribute. Hitler had some notion of the distinction between private or personal gifts, and those that were presented to him as the German leader. However, this division between personal and official became blurred early, and no clear-cut categories could be strictly maintained. Administratively, official gifts were, in principle, handled by the Presidential Chancellery (headed by Otto Meissner), while private gestures were directed to either the Reich Chancellery (Hans Lammers) or the Party Chancellery (Hess and Bormann). Those objects that Hitler chose not to place immediately in one of his residences or offices were sent into storage at either the Braunhaus or the Führerbau in Munich. The distinction between private and official therefore was often lost after the reception of the gift due to the relatively centralized storage facilities.

Despite this overlap of the official and the personal, one can identify a primarily private and personal type of gift to Hitler. First, those objects that came from his closest collaborators often fit into this category. Artworks would frequently be presented to Hitler in person. Judging from Goebbels's journal entries, the reaction of Hitler had a profound impression on the giver. In Goebbels's case, he felt closer to Hitler, writing on 22 April 1936, "Führer's birthday: we are all so happy! Magda, Maria and the children there. He is very touched and takes great joy in my Lenbach."[12] Göring, too, often managed to create the impression of a personal gift. He

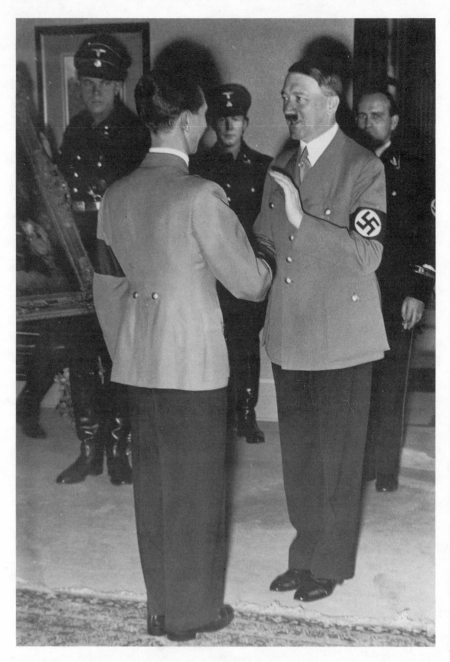

Goebbels gives Hitler a painting, date unknown.
*(*Rijksinstituut voor Oorlogsdocumentatie*)*

Watercolor by Hitler from World War I given to Hermann Göring as a gift (Librarie Plon)

had direct access to Hitler and would usually be present when the artwork was bestowed. He also chose objects that he knew would please the Führer, making the gesture seem more thoughtful and intimate. The reinforcement of personal ties through gifts is axiomatic, but there was something distinctive about certain gifts and the way that they were presented that distinguished them from the other forms of tribute.[13] Hitler, inclined toward sentimentality as he was, would also be touched by modest gifts, perceiving certain self-made items as personal mementos: a poem or drawing, such as an illuminated Schirach panegyric, could also be classified as a private gift.[14] Hitler sometimes attempted to reciprocate with a personal gift, and the object of choice was one of his own artworks from the pre–World War I era. Göring, Bormann, Speer, and Heinrich Hoffmann, for example, were all recipients of a Hitler drawing or watercolor.[15] Hitler acknowledged the unexceptional quality of these pieces and took steps to keep most out of public view.[16] Yet his embarrassment concerning his art made the gifts all the more personal, almost as if he were confiding in the recipients or sharing a vulnerability.

Although gifts might enhance the personal ties between individuals, the honorific messages were never absent. Göring and Goebbels presented so

many artworks to Hitler that the giving became ritualized to a considerable extent. The Reichsmarschall gave Hitler the following artworks: a Lenbach portrait, *Bismarck in Cuirassier Uniform*, bought at Lange's auction house in Berlin for RM 75,000; two paintings by Pannini that depicted St. Peter's cathedral; Rembrandt's *Democritus and Heraclitus*; twenty-eight drawings by Dürer, which Mühlmann had taken from Lvov; and a seventeenth-century Italian work, *View of the Roman Forum.*[17] The Schirachs gave, among other items, a Spitzweg painting in an official capacity in 1936, which Hitler placed in a guest room at the Berghof with the plaque reading "gift of the Hitler Jugend."[18] Ribbentrop bureaucratized the search for Hitler's presents, as he, for example, employed a consul in Paris to buy a present for the Führer's birthday in 1944 (he came up with a statuette of Frederick the Great).[19] Gifts that stemmed from a city, such as the bust of Frederick the Great by Josef Thorak, given to Hitler by the city of Munich in 1939, or those that came from a Gau, as with the painting *Summer Walk in the Woods* by Professor Carl Bantzer, presented by the Gau Kurhessen in 1939, also had an honorific character.[20] These presents were symbols of tribute; they helped the underlings acknowledge Hitler's leadership. Julius Streicher sending Hitler a ceremonial sword from the Italian Renaissance that was part of the collection of the Germanisches Museum in Nuremberg, with congratulations on his "victory" over Austria in 1938, might also be understood in this way.[21]

Certain gifts were not for Hitler personally but were presentations to him as the head of the German state. This proved especially true with plundered and repatriated art. Subleaders would secure artworks that they knew Hitler wanted in German hands and present them to him. These objects were not intended to be private property, even though they were offered to Hitler personally. Examples of this phenomenon include Gauleiter August Eigruber presenting the Hohenfurth Altarpiece to Hitler on 20 April 1939 (the piece was removed from the monastery near Prague after the Germans' occupation); Gauleiter Forster's taking credit for the return of the Veit Stoß altar from Cracow; and museum director Ernst Buchner's successful hunt through Belgium and France for the Van Eyck altar, *The Mystic Lamb*. The numerous albums of plunder presented to Hitler, whether from Mühlmann in Poland or Rosenberg in France, were also intended as gifts to Hitler as the head of state. Alfred Rosenberg, according to an anecdote reported by Heinrich Hoffmann, at one point tried to give Hitler two paintings from the ERR's confiscations. Hitler, who was reportedly "anything but pleased," responded, "Tell Rosenberg that I am not in the habit of accepting presents such as these. The proper place for these paintings is in an art gallery."[22] While this story may be propaganda – Hitler

Painting given as a gift to Ribbentrop by Hungarian minister president Bardóssy (BAK)

Makart painting presented as a gift to Ribbentrop from Bardóssy (BAK)

was not above taking stolen objects for himself (for example, the Dürer drawings from Lvov handed over by Göring that were kept in the Führerhauptquartier) – there were certainly instances where he received gifts that were in fact bequests to the nation.

Gifts stemming from foreign leaders also straddled the line between official and personal. Emil Hácha, president of "rump-state" Czecho-

Ribbentrop in his office with Rumanian foreign minister Grigore Gafencu, in front of a Lenbach painting from Bardóssy (BHSA)

Slovakia, for example, presented Hitler with a Spitzweg painting of a *Zoll-wachtmann* (customs guard) as a birthday present in 1939. This constituted a personal act because Spitzweg was one of the Führer's favorite artists and because Hitler's father had been a customs official. Still, Hácha's gift also represented the repatriation of the Germans' cultural heritage and was intended as an official act.[23] The same can be said of Hungarian minister President Bardossy's gifts to Ribbentrop of a Lenbach portrait of Bismarck and Makart's *Putto with the Weapons of Aries* (in April and October 1941, respectively). They contained symbolic messages that were quite personal, yet the gifts were made to Ribbentrop in his capacity as representative of the Reich.[24]

Mussolini and Hitler repeatedly exchanged presents after 1936, the year their two countries established a defensive alliance. With this series of gifts, as with those of other heads of state, Hitler bestowed objects of lesser value than the ones he received, thus implying a certain asymmetry in the relative balance of power. This inequality provided another element in the communicative function of the gifts. Hitler and his cohorts used the exchange of artworks and other cultural objects in an attempt to give material expression to German superiority. To return to the specific case of the Italians, even prior to the outbreak of war, before military events had humbled Mussolini and his countrymen, the exchange of gifts favored the Germans–although the disparity initially was not great. When Mussolini visited Germany in 1937, Hitler presented him with an inscribed book–a modest present customary for such an occasion.[25] During Hitler's first important state visit to Rome in 1938 the gifts he received were rather more generous. With respect to those concerning art–in all, more than twenty gifts were reported in Hitler's files–Mussolini gave Hitler a landscape entitled *Ruin* by Giovanni Pannini; the Italian Fascist Party presented a fourth-century B.C. "Etruscan" vase and a silver replica of the Capitoline wolf (a symbol of Rome); King Vittorio Emanuele III gave a watercolor called *Via Sacra* by an anonymous Roman artist; and Princess Maria of Savoy offered two small etchings.[26] Mussolini, prior to 1939, also received a number of officially sanctioned, if modest, presents from the Germans, including a Hanoverian horse from the mayor of the eponymous city.[27] Additionally, Hitler paid tribute to him by renaming both Adolf Hitler Platz in Berlin and a train station (in planning) after the Italian leader.[28]

With the auspicious start to the war, the two leaders turned to more generous exchanges, thus magnifying the effect. As mentioned earlier, Mussolini arranged for Hans Makart's triptych painting, *The Plague of Florence*, which belonged to the Landau-Finaly near Florence, to be given to Hitler in 1940, thus fulfilling a long-standing wish of Hitler's.[29] On Göring's birth-

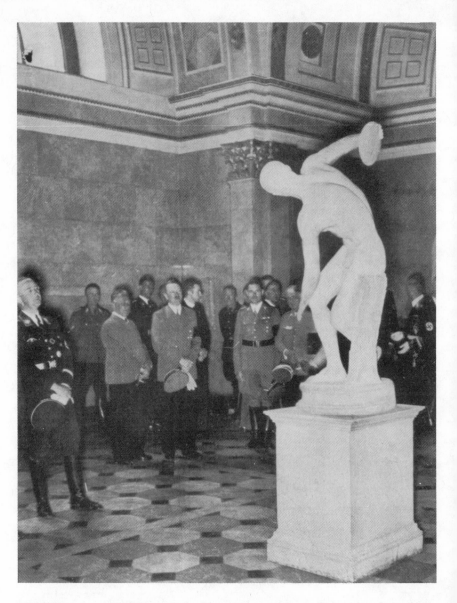

Hitler, Himmler, and others admire the discus thrower of Myron, obtained from Italy after Mussolini granted an export waiver, 1938 (BHSA)

day in January 1942, Mussolini had the Italian ambassador in Berlin Dino Alfieri present the Reichsmarschall with a gift from Il Duce: the precious eight-paneled Sterzing (or Vipiteno) altar by Hans Multscher, for which the Italian government had paid the Church 9 million lire (RM 1.2 million). Mussolini's gesture was undoubtedly an attempt "to ingratiate himself with the Germans."[30] Hitler responded on behalf of his nation by giv-

ing his counterpart a marble *Führerbüste* (a bust of Hitler) sculpted by the highly regarded Josef Thorak.[31] Mussolini's willingness to suspend Italian export restrictions for Hitler (and Göring) might also be viewed as a type of gift. The Germans' recalcitrance with similar export waivers, which contrasted with the Italians' position, indeed reflected the nature of relations between the two nations.[32] Hitler, while loyal to his fascist counterpart, soon grew disenchanted with the Italians' contribution to the Axis war effort. Hitler therefore vetoed Hans Frank's proposal that Leonardo da Vinci's *Picture of a Woman* be repatriated to Italy as a gift to the country's leader.[33] As this decision took place in March 1943, just four months prior to Mussolini's downfall, Hitler's judgment in this case appeared rather sound.

While the exchange of gifts between Hitler and Mussolini reflected, in a general way, both the relative power of their nations and the relative avariciousness of their regimes, these acts were more symbolic and communicative than influential or deterministic. The nature of the two countries' relations did not change as a result of these exchanges. Rather, the gifts served to express the existing state of affairs and the relative balance of power – as an examination of the gift-giving with other heads of state shows. General Francisco Franco of Spain, for example, sent presents to the German leaders to express his gratitude for assistance rendered during the Spanish Civil War. Franco gave Hitler three paintings by the Spanish painter I. Zuloaga in 1939; he presented Göring with a valuable antique sword of Toledo, thus honoring the titular head of the Condor Legion; and he awarded an inscribed golden box to Baldur von Schirach.[34] Yet despite this apparent generosity, Franco stubbornly resisted all pleas for Spanish cooperation with the Axis in the Second World War. Of course, the "Spanish masterpieces" presented to Franco by the head of the Vichy government Marshal Pétain in December 1940, including an extraordinary Murillo, might have been a counterweight, but the fact remains that gifts between national leaders have long been an institutionalized part of diplomatic relations, and most governments developed guidelines and bureaucracies for dealing with this practice.[35] As noted above, Hitler, from an early point in his rule, had entrusted the Presidential Chancellery with overseeing gifts and related gestures. During the Third Reich this responsibility expanded in scope because Hitler received a steadily increasing number of presents and telegrams on special occasions, such as his birthday. In 1937 he received 5,478 letters and telegrams, an increase of 1,228 from the previous year, along with over 130 presents. Some of these acknowledgments were of domestic origin, while many came from abroad.[36] The steady increase in gifts in the mid- to late 1930s and the decline after the midpoint of the war suggest that

Himmler presents Hitler with a painting by Menzel, 20 April 1939. Sepp Dietrich and Karl Wolff look on (BAK)

a correlation existed between these gifts and Germany's fortunes in international affairs. Still, these official gifts, while often imbued with symbolic meaning, were customary among heads of state and diplomats. In themselves, they did not entail firm commitments on the part of the givers or receivers.

. Because giving a gift to Hitler constituted a symbolic act and thus had communicative potential, Hitler moved to control this means of expression (as he did all others). Gifts, especially extravagant ones, could undermine the "Führer myth" that he and Goebbels had so carefully constructed. A key component of this myth involved the selfless and ascetic nature of the

Hitler presents Göring and Rosenberg with presents – Makart's The Falconer *and a bust of Dietrich Eckart, respectively – as shown in the* Thüringer Gauzeitung, *13 January 1938* (BAK)

leader.[37] Hitler therefore limited the flow of information so as to conceal the enormous wealth that he quickly amassed once in power. He allowed certain gifts to be reported in the press, but he kept most of these gestures private and hidden. An analysis of the Party press with respect to disclosures about artworks received as presents confirms this inconsistent policy. Francisco Franco's gifts, Himmler presenting Hitler with Adolf von Menzel's *Frederick the Great on a Ride* on the Führer's fiftieth birthday in 1939, and a Reichsbank-sponsored Titian, *Venus before the Mirror*, which Walther Funk presented to Hitler on his fiftieth birthday, were among the gifts announced to the public.[38] Publicity decisions were usually made according to the dictates of the moment. For example, Hitler was feted and honored with great fanfare for his birthday in 1939 at a time of tension due to international events.[39] He hoped that the symbolic tribute here would enhance his popular support. Hitler became accustomed to managing the flow of information in Germany, and as important as appearing sufficiently selfless and ascetic was the Führer's concern that he maintain control over the process of disclosure.

Gifts, while imbued with communicative potential, could also convey false or unwanted messages. Hitler learned this only gradually. Whereas early in the Third Reich there were no specific guidelines regarding the publicizing of gifts, this had changed by 1938, when Hitler issued a *Führerbefehl* prohibiting public revelation without his specific consent. The precipitating incident was, in fact, a gift from Hitler to one of his subordinates, Foreign Minister Konstantin von Neurath, on the latter's sixty-fifth birthday on 2 February 1938. Hitler had been particularly generous with his underlings at this point. Three weeks earlier he had given Göring a stunning Makart painting of a falconer, and Rosenberg a bust of the early Nazi philosopher Dietrich Eckart, both in public ceremonies on their common

Lenbach portrait of Bismarck given to Ribbentrop by Hitler as a gesture to recognize diplomatic skill (BAK)

12 January birthday. Indeed, the two presents were reported in great detail in the press.[40] Hitler's gift to Neurath was also made public, though the exact title or artist was not stated in the official releases (one writer later described it as a "superb piece of medieval art").[41] Extravagant words of praise from the dictator accompanied the gesture.[42] Two days later Hitler arranged a massive restructuring of the top echelons of both the army and the Foreign Ministry, replacing Neurath with Ribbentrop. Hitler then realized the misleading signal he had sent and ordered measures that assured him complete control over future episodes. By order of the Führer's Chancellery, gifts to and from Hitler could not be reported without official permission "either in picture or text."[43]

Hitler's gifts to his underlings continued to possess symbolic meaning, but after 1938 his messages were meant to be either private or for a small group. Hitler's communication by the conferment of artworks occurred in a variety of ways. The artwork itself often conveyed a message. Hitler liked to pun or make personal references in this fashion. Hitler gave Wilhelm Ohnesorge, the Reich post minister, a painting by Paul Hey called *The Old Post Coach*; Reich Minister of Transport Dorpmüller received on his seventieth birthday a Spitzweg landscape depicting a train; Admiral Erich Raeder was given Wilhelm van der Velde's *A Naval Battle*; and Robert Ley, the reportedly alcoholic chief of the DAF, garnered Hans Grützner's *The Carousing Monk*.[44] Such personalized gifts were important to the political dynamic that Hitler had created in the Third Reich, where power and recognition stemmed foremost from the Führer.

Hitler, with time, grew increasingly concerned that his ministers remain dependent on him for their authority and ego gratification. While this progression is reflected by his wartime orders prohibiting ministers from congregating in his absence, Hitler's gift-giving habits also revealed this bald "divide and rule" policy.[45] Turning to the time-honored German tradition of financial rewards to successful military leaders, he extended the cash awards, or *Dotationen*, to both political and military figures. While simultaneous awards of art and money were very rare – one example was Fritz Todt receiving a painting by Eduard Thöny entitled *West-Wall Worker* along with RM 100,000 for his fiftieth birthday in September 1941 – Hitler bestowed increasingly fewer artworks during the war. Instead, he gave ever-larger (and tax-free) *Dotationen*. Such *Dotationen* bestowed by *Führerbefehl* were numerous: RM 250,000 for Reichspostminister Ohnesorge on his seventieth birthday in 1942; RM 50,000 for the former inspector of the concentration camps Theodor Eicke in 1942; RM 250,000 to Generalfeldmarschall Hans Günther von Kluge in 1942; a confiscated estate (Rittergut Hünern) for Generaloberst (later Generalfeldmarschall) Ewald von Kleist, who wanted land and not money; RM 250,000 to Minister of the Interior Wilhelm Frick for his sixty-fifth birthday in 1942; RM 250,000 to Alfred Rosenberg for his fiftieth birthday in 1943; RM 1 million to Robert Ley in 1941; RM 250,000 to Reichsprotektor von Neurath in 1943; RM 500,000 to Foreign Minister Ribbentrop in 1943 (the second *Dotation* for that amount); RM 100,000 to art adviser Gerdy Troost; and RM 250,000 to Arno Breker.[46] These examples of extravagant gifts by Hitler reveal the extent to which he attempted to make his subordinates beholden to him. Albert Speer reflected while in Spandau prison: "Today I sometimes think that Hitler consciously tolerated or even promoted the corruption. It tied the corrupt men to him – doesn't every potentate attempt to consolidate his rule by gestures of favoritism? Besides, corruption corresponded to his notion of the right of those wielding power to take possession of material goods. Authority, he thought, also needed outward show; the common man was impressed only by display. He liked his satraps to live in castles and palaces; he definitely wanted them to be ostentatious."[47] The *Dotationen* offered a means of establishing these ties. They ultimately became so common that Lammers notified Finance Minister Schwerin von Krosigk in late 1942 that awards which did not exceed RM 50,000 would not be reported to his office.[48] Because Hitler had his own sources of funding – whether they were the postage stamp mechanism for generating the *Kulturfonds* or the Bormann-managed Adolf Hitler Fund (which came from contributions and various other means) – he considered it his "highest personal right" to determine expenditures in his own arbitrary fashion.[49]

While Hitler indulged in capricious and discretionary behavior, he simultaneously placed certain limitations on his subleaders in an attempt to induce them to act in a more restrained and obedient fashion. The Führer's order against using confiscated Jewish artworks to decorate offices or residences, first issued in 1938, offers one such example, although the subleaders complied with this regulation with great inconsistency.[50] For Hitler there was a constant tension between his wish to control his underlings and his expectation that they exercise power and exhibit initiative. Indeed, there were instances where he expected his deputies to act boldly and independently. As anthropologist Hugh Duncan noted, "A social order defines itself through disorder as well as order. Improprieties set limits. . . . Without such limits, a role cannot take form."[51] Nonetheless, Hitler placed limitations on his subleaders, which admittedly varied according to the individual and the environment (both time and geography). Among the subleaders in the Nazi state there existed a dichotomy between the controlled and often ritualized behavior, and lawless autonomy.

GIFTS AMONG THE SUBLEADERS

The NS subleaders' relations with one another reflected the above dichotomy, as they were at once expected to act cooperatively and supportively and induced to compete in a Social Darwinian manner. With respect to the former, Hitler encouraged public displays of Nazi unity and loyalty. The ritualized productions held annually at Nuremberg (the Party congresses) and in Munich (to commemorate the failed 9 November 1923 putsch) constituted two such displays.[52] The semi-institutionalized custom of gift-giving provided a more private expression of this group unity. The subleaders made budgetary allowances for the purchase of gifts and employed staff members to oversee their procurement. Thus, for example, Robert Scholz wrote Rosenberg in the fall of 1941, notifying him that the Nazi publisher Max Amann would soon be celebrating a birthday. If Rosenberg was considering an artwork as a gift, Scholz would like to be informed so that he could supervise the acquisition.[53] Goebbels, as discussed earlier, had special *Kulturfonds* that he used to buy artworks as gifts. While the propaganda minister's film expert Fritz Hippler could claim after the war that "Goebbels had no friends," the minister nonetheless showered his associates with presents.[54] Goebbels often viewed the bestowal of gifts as a necessary burden – a *große Sorge* (great trouble), as he noted in his journal prior to one Christmas.[55] Yet among his efforts in this department one finds

a "small bronze Venetian statue" for Fritz Sauckel for the latter's fiftieth birthday in October 1944; a painting depicting a hospital by Barberini for Julius Streicher's sixtieth birthday on 12 February 1945; two paintings for Robert Ley (*Seaside* by Plessier and *Landscape* by Schelfhout) as birthday presents in February 1945; a picture called *Schloß Friesack* by Brunner for Reichsarbeitsführer Konstantin Hierl on his birthday on 24 February 1945; and the painting *Boat in a Storm* by Düringer von Steckborn for Otto Meissner, the chief of the Presidential Chancellery, on his sixty-fifth birthday in March 1945.[56] Goebbels maintained a stockpile of artworks in a Hermann-Göringstraße depot. As the gifts noted above are listed in a single document and pertain to a limited time frame, it is possible to infer that the propaganda minister presented artworks to his associates at a torrid pace.

The gifts exchanged by the Nazi subleaders could be pro forma, but they could also suggest more specific messages, such as alliances or indebtedness. An example of the former, the ritualized gift-giving with nonspecific messages, can be found in the 1942 birthday of Wilhelm Frick, the minister of the interior. A poorly regarded leader who had failed to realize his vision for the civil service and who in fact lost his post the following year to Himmler, Frick nonetheless received eighty-six official gifts on his sixty-fifth birthday. A document entitled "Gifts Received by the Minister's Office" includes a Gobelin tapestry from Gauleiter Konrad Henlein, a painting of the Starnberger See from the Oberbürgermeister of Munich, Karl Fiehler, a painting and a collection of letters from Goethe and Schiller from Gauleiter Fritz Sauckel, and Hans Makart's *Landscape* from the Salzburg Gauleiter Gustav Scheel.[57] The gifts received from his superiors were less consistently flattering. Himmler gave four photographs (two of *Ordensburgen*), Rosenberg offered a "*schwarz/gold*" vase, and Göring sent an inscribed picture of himself. In all, one-third of the gifts were pictures (approximately twenty-five), while the other objects were usually books, porcelain objects, tapestries, or historic documents.

The most ritualized presentation of gifts took place within the SS, where Himmler used objects to solidify bonds and to propagate his own ideological conceptions. Himmler employed staff members within his Persönlicher Stab to oversee this activity, and they kept detailed records of the gifts presented for three main occasions: for the *Julfeier* (the Nazis' secularized Christmas), for birthdays, and for the acknowledgment of births, a concern that was prominent in the agenda of the Reichsführer-SS. While Himmler used devices other than gifts to establish his elitist order, including awarding the title of *Ehrenführer*, or the honorary SS positions that Himmler be-

Himmler gives a birthday present to Hans Lammers, 1939 (BAK)

stowed on other members of the Nazi elite, his use of symbolic objects pro-
vided a tangible expression of the bonds that existed within the SS.[58] To
take one example, Arthur Seyss-Inquart, an *Ehrenführer* as of 1938, who had
the rank of Obergruppenführer (lieutenant general) received *Julfeier* gifts
in 1938, 1941, and 1942, with a typical present being five porcelain riding-
figures from the SS manufacturer at Allach. Seyss-Inquart also merited

birthday gifts each year, with an oil painting entitled *Attack on Verdun* standing out as the most noteworthy.[59] The bonds between Himmler and his corps were reciprocal, as Himmler also received many presents. Ernst Kaltenbrunner, for example, the sadistic successor to Heydrich as chief of the Reich Main Security Office, bought a painting in the occupied west with the assistance of the Dienststelle Mühlmann in autumn 1943 and presented it to Himmler.[60] The leaders of the Ahnenerbe devoted great thought to their birthday presents to their protector. Wolfram Sievers and his colleagues showed considerable creativity in finding an array of gifts ranging from Langobard jewelry and Viking swords to fifteenth-century shields.[61] Himmler, as one of the leaders with the greatest appreciation of rituals and symbols, therefore developed and sustained this elaborate culture of gift-giving within his bureaucratic empire. However, he was not unique in expecting his subordinates to pay homage by way of gifts.[62]

The giving of art could also reflect more short-term developments and changes of interministerial relations. In the case of Hermann Göring and Alfred Rosenberg, for example, two leaders who throughout the prewar period had refrained from exchanging presents, the onset of giving art in 1941 suggested a closer working arrangement.[63] The two leaders, who collaborated in leading the ERR's operations in France, continued to exchange artworks through 1944, even though their working relationship had failed to endure. In January 1943 Rosenberg presented Göring with a Dutch seascape by Jacob Adrian Bellevois, "as a small memento for your museum [Carinhall]."[64] The following year, in January 1944, Göring gave Rosenberg a painting for the latter's birthday – an unspecified work that Gauleiter Alfred Meyer of North Westphalia bestowed on his behalf.[65] Significantly, there is no evidence that Rosenberg reciprocated subsequently – an understandable development considering that Göring had been cut off from the ERR stockpile and discredited in the eyes of his colleagues. In a contemporaneous incident, Goebbels became incensed when Göring selected a Van Dyck painting that cost RM 250,000 as his gift from the city of Berlin in January 1944. Rudolf Semmler elaborated, "All day long Goebbels has been excited about this affair. He wants to make a protest to Hitler."[66] Goebbels argued that Göring's gift cost ten times too much, thus reflecting not only the total war frugality that prevailed at this point but also his estimation of Göring.[67]

During the Third Reich, gifts offered the Nazi elite an important means of communication. The NS leaders were highly sensitive to signs and gestures, and the presentation of artworks was only one aspect of their dialogue through symbols. From the text of birthday greetings, for example, they extracted subtle assessments of relative status. Even their salutations

warranted consideration. Alfred Rosenberg, for example, crossed out the respectful *Ihr* in a draft of a birthday greeting to Goebbels when they were feuding with one another in 1934.[68] Similarly, whether Hitler presented a hand-signed photograph or a reproduced signature also hinted at the current standing of the recipient. Gifts, and artworks in particular, were fraught with many meaningful subtexts.

THE COMPETITION TO COLLECT

While artworks were exploited by the Nazi leaders as a means of expressing admiration and articulating group bonds, the competitive search for desirable pieces also led to rivalries. Infighting permeated the circle of Nazi leaders from the outset of the Party's existence—a condition observed by both contemporaries and historians of the period.[69] Such rivalries could involve gifts. Gauleiter Fritz Sauckel, for example, became upset with one of Bormann's assistants, Walter Hanssen, when the latter purchased a painting by Otto Runge that the Thuringian Party chief had intended to give to Hitler.[70] The competition for artworks, however, usually concerned works that were earmarked for their own collections. As nearly all the ruling elite collected artworks, a forum developed that expressed their competitive feelings. Jean Cassou, a curator at the Louvre, vividly described this situation as "a network of intrigues and dirty deals in which the most redoubtable leaders of National Socialism squabbled and defied each other in a sordid, stubborn struggle for the possessions of famous paintings or valuable pieces of sculpture."[71]

The Nazi leaders' competition for artworks nonetheless conceded a submissiveness to Hitler. With the exception of Hermann Göring, no other member of the Party elite challenged the Führer or his agents.[72] While even Göring was cowed by Hitler and often relinquished artworks on command (he openly granted priority for eighteenth- and nineteenth-century works), there were a number of noteworthy occasions when the number two figure in the Reich asserted his own interests.[73] The most important incident involved Göring's defense of his 5 November 1940 order regarding the selection hierarchy for the artworks confiscated by the ERR in France, whereby the Reichsmarschall had second choice after Hitler.[74] In fact Göring in this instance fought to maintain his ability to expropriate pieces for his own collection from the ERR, and hence the Führermuseum. Competition between the two leaders' staffs of agents also occurred, most notably in Holland and Italy. Hans Posse, for one, was highly conscious of his rivals. He wrote Bormann on 14 October 1940, just prior to a buying trip to

Belgium and the Netherlands, "I wish to arrive earlier than certain other people, and catch them napping."[75] As noted in Chapter 5, Posse tried to induce Hitler to issue orders that would legally limit other German buyers, although no such restrictions were ever implemented. Kajetan Mühlmann also reported the dilemma presented by answering to both Hitler and Göring. He noted after the war, "The competition between Hitler and Göring caused a pressure from which one could not escape. . . . I personally was in a very difficult position."[76] When Mühlmann assisted Göring in the trade of a number of modern French paintings for the Kröller-Müller museum's *Venus* by Hans Baldung, Posse became deeply upset.[77] Göring's occasional victories induced him to act the braggart, and he once remarked to Mühlmann, "As collectors, we are, the Führer and I, private persons: first come, first serve."[78] Yet this bluster was confined to his interactions with underlings. In nearly all situations that entailed direct competition with Hitler, Göring acceded to his superior.[79] Göring would on occasion take steps to avoid even the appearance of challenging his Führer. In 1939 he sent a series of telegrams to Bürckel and other leaders denying any intention of acquiring the Czernin Vermeer because of Hitler's interest in the painting.[80] When Hitler commented that Carinhall was too dark, Göring commissioned Speer "to do the whole thing over in the light and bare style favored by the Führer"; after the war he admitted to becoming sick to his stomach whenever he tried to confront Hitler.[81]

The competition for artworks among the subleaders was considerably more unrestrained and open. The Nazi elite were, of course, conscious of hierarchies and spheres of influence. Therefore, few wanted to antagonize Himmler, and most recognized the legitimacy of Goebbels's patronage of contemporary artists. Yet the leaders openly pursued the necessarily limited number of artworks that were to their liking. Auctions occurred where either the leaders or their representatives bid against one another. One illustrative sale took place at Lange's auction house in Berlin in December 1940, when the remainder of the Goudstikker collection (Hitler and Göring having first selected the most precious works) was offered to the public. Albert Speer acquired two Dutch landscapes, and both Goebbels and Ribbentrop evidently sent agents.[82] Even the rush to purchase artworks from the *GDK* constituted a form of open competition. Hitler had the right to select first, but Goebbels, Himmler, and other leaders also bought from these very commercial exhibitions before they were opened to the public.[83]

During the twelve years of the Third Reich a variety of incidents took place that involved leaders' competing for precious objects. Such episodes sowed discord and intensified already existing antagonisms. Hence, for example, Ribbentrop's successful bid to claim Metternich's globe from the

Austrian Foreign Ministry in 1938 upset Göring greatly, as the Reichs-marschall had supposedly been promised the historic piece by Guido Schmidt, the official charged with liquidating this branch of the state bu-reaucracy.[84] Kajetan Mühlmann told of another incident involving Göring, where the Reichsmarschall and Generalgouverneur Hans Frank vied for da Vinci's *Lady with an Ermine* from the Czartoryski collection in Cracow. Answerable to both leaders, Mühlmann carted the treasure "at least twice" back and forth between Cracow and Berlin (Göring lost this contest as well, as the picture went to Frank and was found at the end of the war in his Bavarian retreat).[85]

Amid this struggle to commandeer artworks, a key principle stands out as the underpinning of many of the leaders' actions: the Nazi chief-tains, whether they were Reichsministers, Reichskommissars, or Gauleiters, wanted control of those artworks that they perceived as falling within their bailiwick. The ability to retain treasures reflected their personal power and their mastery of the domain in their charge. This was true especially for the Gauleiters and Reichskommissars, where their territorial jurisdic-tion was clearly defined and independence of action a key goal.[86] The most clear-cut effort of a local ruler fighting to resist the encroachment of other leaders took place in Vienna directly after the *Anschluß*, as Gauleiter/ Reichskommissar Josef Bürckel fought to keep the confiscated Jewish art-works stored in the Hofburg palace (see Chapter 3). He conducted a veri-table *Papierkrieg* with the Reich Chancellery over this issue, stymying Hitler's first art agent (Haberstock) but eventually succumbing to the efforts of his successor, Hans Posse, who took the exceptional pieces for the Führer-museum and arranged for the rest to be distributed throughout Austria (though nearly all of the art ended up stored in salt mines and castles and was divided up only on paper). Hans Frank operated according to this same principle in the General Government; hence the reason for his suc-cessful retention of the Leonardo, despite Göring's exertions. In certain cases the Gauleiters and Reichskommissars voluntarily directed pieces to Berlin, but these actions served as gestures of tribute and demonstrations of their willingness to administer their territories in the harsh and unsenti-mental manner ordered by Hitler. Gauleiter August Eigruber's forwarding of the Hohenfurth Altar to the Reich after the dismemberment of Czecho-Slovakia offers an apt example.[87] Still, such gestures did not negate the sub-leaders' wish to retain control over the bulk of the local treasure.

A subleader who managed to effect the relocation of an important art-work into his territory could score a major symbolic victory – one that did not go unnoticed by his peers. Undoubtedly the most adroit territorial chief in this respect was Wilhelm Liebel, the mayor of Nuremberg. His

most noteworthy coups involved moving the Holy Roman treasures from Vienna to Nuremberg and arranging for the Veit Stoß altar to be brought to his city from Cracow. With the latter, Hans Frank opposed him, but as Josef Mühlmann (Kajetan's half-brother, who was also a plunderer) noted, "Liebel had too influential friends" [*sic*].[88] Liebel personally traveled to Cracow for the altarpiece. With a *Führerauftrag* (Führer commission) in hand, he confronted Frank but was still thwarted in his initial efforts. Only an appeal to Bormann, who communicated to Frank that Hitler was "enraged" by his uncooperative behavior, induced Frank to relinquish the piece.[89] Liebel could justify his demands on the grounds that Nuremberg was the site of the Germanisches Nationalmuseum (that is, the national museum deserved such national treasures) and that a curator there was the preeminent expert on Veit Stoß.[90] Previously he had argued for transferring the imperial treasures for historic reasons, claiming that they had been removed from his city to Vienna in the 1790s due to the threat of a French invasion.[91] The clever and well-connected Liebel held his post as Oberbürgermeister until the capitulation in 1945.[92]

THE EXHIBITION VALUE OF ART

The collecting of art offered the Nazi leaders the means to demonstrate both their political puissance and their private prosperity – the two concepts of course often being interlinked. Göring again provides the most extreme example of using art collecting and wealth to communicate power. Speer noted, "Göring loved to revel in his illicit riches and it was a ritual with him to show his guests through his cellars, where some of the world's most priceless art treasures were stored."[93] The Reichsmarschall's attempt to realize the communicative potential of artworks included placing glass vitrines in Carinhall that displayed some of the gifts he had received from other political figures. The sheer scope of his collections was enough to intimidate (and in certain cases repulse) visitors.[94] Yet as the German market experienced a steady and marked inflation during the war, the artworks became more potent symbols of power. Because the domestic art market gradually became exhausted, the possession of prized works soon came to denote power that extended to foreign lands, the regions that emerged as the best sources of art.

Because the stringent currency controls imposed by the government made purchases abroad quite difficult, only the best-connected leaders and dealers were able to procure the needed *Devisen*. The availability of foreign currency gradually dwindled, such that by 1944 only Hitler and Göring – the

latter possessing tremendous clout in the economic realm due to his Four-Year Plan Office – could buy abroad on a regular basis.[95] Prior to this point a broader range of top officials could procure *Devisen*. Yet even during the early years of the war, considerable influence was still needed in order to arrange purchases abroad. Goebbels, for example, experienced difficulties when his star was low prior to 1942.[96] The records of approval and rejection that exist in the Reich Economics Ministry and in the clearing offices – such as the Reich Office (Reichsstelle) for Wood and Paper – reveal the competitive nature associated with foreign purchases.[97] Gauleiters frequently failed to get the needed approval. The rejected application of the Party chief of Salzburg, Gustav Scheel, in his attempt to buy art, rugs, and furniture in France in June 1942 is but one example.[98] The hierarchical Nazi elite had numerous ways of expressing the omnipresent distinctions. Access to foreign currency was another symbol of power and status in the Third Reich.

The Nazi elite, while surely a competitive, back-stabbing group, nonetheless shared a common semiotic vocabulary – or a way of interpreting signs, symbols, and behavior. Artistic treasures offered them a particularly expressive means of communication: as tribute to the dictator, as ritualized gift-giving to help convey the appearance of group solidarity, or as representations of rank. The import of these symbolic expressions was that Hitler was dominant and virtually incontestable, while Göring was successful, but often by means of his bluster and amoral guile. The remainder of the Nazi elite occupied various positions within the hierarchy. Their ability to elicit gifts and their proficiency in collecting art roughly corresponded to their rank. Artworks, which emerged as a lingua franca for the Nazi elite, therefore served as evocative symbols. These symbols were manipulated or used instrumentally by the Nazi elite. While some communication was unconscious, much involved careful consideration and planning. Walter Benjamin's concept of the aestheticization of politics found expression here in a way perhaps unintended by the author as the NS leaders worked creatively to exploit the expressive power of this medium.[99]

10 ART COLLECTING, LUXURY, AND THE NATIONAL SOCIALIST ELITE'S CONCEPTION OF STATUS

This study examines a group of Nazi leaders who constituted a distinct and self-conscious elite within the Third Reich. The concluding chapter focuses on the social position of the NS elite and, more specifically, the leaders' evolving views toward the aristocracy – the traditional elite. While the Nazi leaders' opinions regarding the historic nobility varied greatly during the years prior to the seizure of power, and while no complete agreement on this issue was ever reached, a trend in their thinking can be discerned from the pre-1933 period to the years of total war. The Nazis began with highly ambivalent views about the nobility, in which socialistic and populist sentiments conflicted with ultranationalist and even monarchical impulses. There then followed a period of greater respect for the traditional aristocracy. The Nazis moderated their views in an attempt to coopt them as wealthy backers and parlay their support into greater legitimacy. The seizure of power marked the start of the Nazi leaders' serious efforts at emulation and assimilation; in promulgating a new, more meritocratic basis for elite status, they hoped for a merging of the old and new

[287]

Invitation to a breakfast hosted by
Bürgermeister Fiehler of Munich to cele-
brate the anniversary of the Haus der
Deutschen Kunst, 1938 (BHSA)

"nobility." During the mid- to late 1930s their attempts to join forces with the aristocracy gradually shifted to efforts to displace them – to deprive the non-Nazi nobility elite status. In this effort to reach the pinnacle of German society, the Nazi leaders used art and objects of luxury as symbols of their ascent. Yet for the Nazi leaders, artworks and other treasures were more than mere symbols. The Nazis used these objects instrumentally to help define their social position and to shape their interactions with other elevated classes and groups.

THE SOCIAL BACKGROUNDS OF THE NAZI LEADERS

The Nazi leaders came from backgrounds that were not as humble or marginal as many contemporaries and historians have believed. While the early postwar scholarship on the social origins of the Nazi leaders suggested that they were "marginal men," to use Daniel Lerner's famous phrase from his 1951 study, or "plebeians," as other scholars have labeled them, more rigorous investigations have largely discredited this view.[1] Michael Kater, for example, in his study on the Nazi Party, has asserted that "the relative

proportion of elite elements was higher among the leaders than in the party at large or in the Reich population," that "the elite proportion tended to increase with rank," that there were no workers among the Reichsleiters, and that 70 percent of the Reichsleiters came from what he called the "elite."[2] Although the leaders adopted certain lower middle-class values, most did not come from either disadvantaged or marginal backgrounds.

The Nazi leaders were raised to appreciate and promote the high European culture that flourished throughout Europe prior to 1914.[3] As youths they had extensive exposure to the culture and the lifestyle of the traditional elite. Hitler frequented the opera in both Linz and Vienna. Göring had childhood vacations at *Schloß* Veldenstein (owned by his "godfather" Baron Epenstein) and was later sent to the prestigious Lichterfelde Akademie. Himmler's father tutored a Wittelsbach Prince and always maintained ties to the Bavarian royal house. Schirach came from impoverished nobility but was raised in castles because his father oversaw the royal theaters in Weimar and Vienna. Rudolf Hess's family "maintain[ed] a luxurious Egyptian villa and a German summer home."[4] Goebbels attended the finest Germany universities (eight in all) and obtained his doctorate from Heidelberg. "Hitler's ministers like Papen's tended to be university graduates, doctors, high civil servants,"[5] and "among the seventeen Reichsleiters who were members of the elite, all but three or four were so well established socially that they would certainly have succeeded in their chosen occupations."[6] The Nazi elite were ambitious men. They stemmed from milieus that provided them career advantages and instilled in them a respect for both high culture and the traditional social order.

CONCEPTIONS OF SOCIETY BEFORE AND AFTER
THE SEIZURE OF POWER

World War I provided the formative experience for most of the Nazi elite. Nearly all emerged espousing a form of *Frontsozialismus.* Some of the leaders, including Hitler and Göring, managed to simultaneously accommodate traditional views such as a belief in social hierarchies and loyalty to the monarchy.[7] Herein lay the roots of a conflict that was to riddle the NSDAP until, depending on one's interpretation, either the Röhm purge in 1934 or the end of the Third Reich. This conflict centered around the extent to which the NSDAP was revolutionary and socialist. The period prior to the attempted putsch in Munich in 1923 marked the high point of the leftist impulses within the NSDAP. Points 13 through 18 of the Party Program called for the nationalization of large industrial enterprises, an end

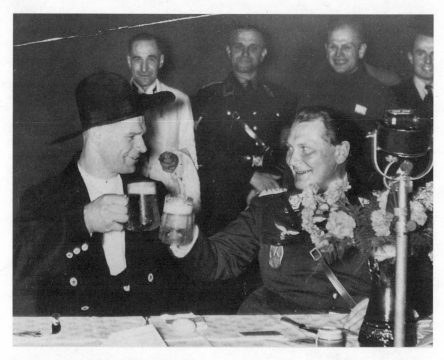

Göring as a "common man" (BHSA)

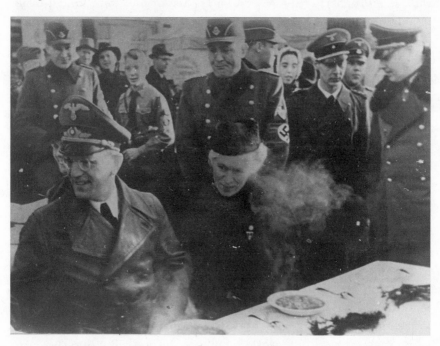

Reichskommissar Seyss-Inquart at an Eintopf *(one-pot) meal, demonstrating wartime frugality* (BAK)

Goebbels and Hitler eat Eintopf, *1933 (Getty Center, Resource Collections, Stefan Lorant Papers)*

to real estate speculation, and an expansion of old age pensions. Additionally, the soldierly ethos was naturally more prevalent due to the temporal proximity to the war.[8] Socialist and revolutionary elements continued to be a part of the Party's platform throughout the *Kampfzeit*–especially in the north, where radical leaders such as the Strassers and Goebbels diverged from the more conservative and promonarchist Bavarian faction. At the crucial 1926 Party meeting in Bamberg, where Hitler effectively dealt with the growing disenchantment and disaffection of the Strasser camp, one of the crucial issues he addressed concerned the NSDAP's policy toward the royal family's property. Hitler unified the Party at this meeting, but he did so while issuing policy statements that offered assurances to the Hohenzollern and the old elite. The north-south factionalism at play in this debate foreshadowed the division that later arose over modern art. The Berlin leaders, most notably Goebbels, clashed with the conservative Bavarian wing and eventually lost out when Hitler cast his decisive vote.[9]

Socialism, for the Nazis, therefore came to entail a spirit of camaraderie combined with a basic welfare program for those deemed part of the *Volksgemeinschaft*. While some anticapitalist rhetoric persisted, the Nazis did not continue to threaten seriously the nobility or the business elite.[10] Hitler in 1928 even chose to "elucidate" points 13 through 18 of the immutable Party Program so as to clarify his position on the expropriation of property:

only Jewish speculators, he stated, deserved such treatment.[11] The Nazis gradually established inroads into circles with wealth and status. In the pre-1923 period they had gained some sympathy from these quarters because of their alliance with General Erich Ludendorff, who, although of bourgeois origin, had considerable support among the upper classes.[12] During the *Kampfzeit*, most East Elbian Junkers continued to look down upon the Nazis as a south German, Catholic, and plebeian political phenomenon.[13] Yet the Nazis attracted the support of a number of the provincial elite: aristocrats on the periphery who "hoped to create a truly national ruling class for Germany."[14]

In spearheading the Nazis' quest for funds and legitimacy, Hitler endeavored to gain support from prominent circles within Germany. While he enjoyed only moderate success, he exploited those connections he established. Having earlier learned to utilize the social ties of his colleagues (for example, Harvard-educated Putzi Hanfstaengl had introduced him to the Bechsteins of piano fame), Hitler turned to Göring and others for similar service. Prinz Viktor and Prinzessin Marie Elisabeth zu Wied tried "to get their whole circle of friends interested in the Hitler movement."[15] Himmler also proved very proficient at recruiting aristocrats into the SS. Prinz Waldeck-Pyrmont (nephew of the queen of the Netherlands) and Curt von Ulrich were two early examples.[16] Even the SA contained a few aristocrats, such as Wolf Heinrich Graf von Helldorf, who was a *Gruppenführer* (lieutenant general) and later head of the Berlin police. Hitler took a pragmatic approach in courting elite backers. Besides altering his rhetoric to better fit his audience, he accepted clandestine support, if that was what the backer insisted on. The Hohenzollern Prinz August-Wilhelm ("Auwi") evidently offered private support beginning in 1929 and did not publicly declare for the Nazis until 1932.[17] Thyssen, like most of the handful of other industrialists who contributed to the NSDAP, also initially sought to keep his support secret. While the Nazis did not gain the undivided support of the elite, Hitler did come to terms with many of them.[18] Some members of the elite Herrenklub in Berlin may have had reservations about Hitler, but one of its members, Franz von Papen, convinced another Junker, President Paul von Hindenburg und Beneckendorff, to abandon the aristocratic General Kurt von Schleicher in January 1933.

Prior to the seizure of power, the Nazi elite, to be sure, were the social inferiors of both the aristocracy and the haute bourgeoisie whom they courted. Hitler and his colleagues indeed harbored resentment against the old elite. Yet such antagonistic views were usually confined to private remarks or else were touched on tangentially and unspecifically in ideological speeches (that is, as part of the antiestablishment message). In fact,

Hitler and friends in formal wear at the Berghof, New Year's 1943. Guests include Heinrich Hoffmann (far left), Speer, Philipp Bouhler, and Bormann (far right). (Getty Center, Resource Collections, Stefan Lorant Papers)

Hitler and the top leaders embarked on a successful program of stroking the egos of the old elite to gradually gain their acceptance. Society hostess Bella Fromm noted in her diary entry of 30 March 1933, "Hitler's eagerness to obtain the good graces of the princes present was the subject of much comment. He bowed and clicked and all but knelt in his zeal to please oversized, ugly Princess Louise von Sachsen Meiningen, her brother, hereditary Prince George, and their sister, Grand Duchess of Sachsen Weimar. . . . Prince Ratibor-Corvey . . . is one of the best paying members of the party. [His daughters] the young princesses reacted with a proper show of pleasure to his hand kissing and his piercing glance."[19] Hitler and Göring, in building on their social alliances, eventually achieved significant support from the traditional elite. Even President Hindenburg with time softened his views toward Hitler. He appreciated Hitler's deferential manner and was heartened to learn that the "Bohemian Corporal" was not actually from Bohemia.[20] Hitler, the *Volkskanzler*, proved willing to wear a dinner jacket and tails (an outfit that Goebbels and other left-leaning Nazis once considered an act of betrayal to the workers).[21] Despite a propensity for faux pas on the part of the Nazi leaders – Robert Ley, for example, at one party unveiled a portrait of his wife naked from the waist up – they were, for the most part, not the uncouth ruffians that many envisioned.[22]

Göring entertaining French ambassador François-Poncet and Generals Vuillemin and Milch in Carinhall (BHSA)

THE "NEW MEN"

While most of the Nazi elite lived in a fairly comfortable style during the *Kampfzeit*, they took advantage of the seizure of power in early 1933 to transform their lives. Never before in modern German history had incoming governing officials embarked on a rebuilding and remodeling program that could approach that of the Nazis. Hitler, not surprisingly, led the way by ordering the extension and redecoration of the chancellor's residence.[23] As described earlier, the other ministers quickly followed suit. Goebbels housed his RMVP in the elegant old Wilhelmplatz palace and commandeered an impressive ministerial residence (ordering a complete overhaul of both structures). Himmler moved his security service into the opulent Prinz Albrechtstraße Palace the following year. Göring occupied the Prussian minister president's mansion (which Speer renovated) and by 1934 had begun construction of Carinhall with Prussian state funds. Virtually every member of the Nazi elite improved his pre-1933 standard of living. Some, including Göring, Goebbels, Himmler, Ley, Bormann, and Ribbentrop, among others, had multiple residences, while others, such as Julius Streicher, Erich Koch, and many of the Gauleiters, preferred huge estates. The new power elite had few compunctions about taking advantage of their

A garden party with servants in livery at Carinhall. SS General Sepp Dietrich lights a cigar. (Getty Center, Resource Collections, Stefan Lorant Papers)

positions. Still, many of their acquisitions came midway through the decade and hence reflected an evolution in their social aspirations. This evolution entailed greater boldness, such that it was not unusual to inhabit property seized from Jews and other "enemies of the people."[24] Yet this transformation, which was part of the radicalization of the late 1930s discussed in Chapters 3 and 4, rested on the leaders' earlier efforts to feel secure in new positions.

During the early years of the Third Reich the Nazi elite's efforts to gain social acceptance entailed the emulation of the superior classes. Art, like luxurious dwellings, provided a means of expressing their newfound status. Whether it was Goebbels's penchant for having his portraits done by the "right" artists (he favored, for example, the aristocratic Impressionist Leo von König) or Ribbentrop displaying the Fra Angelico painting that his wife had inherited (he therefore regarded it as a symbol of his "old" money), artworks provided the Nazis with a vehicle for communicating their social aims.[25] Even the practice of gift-giving can be interpreted as imitative of the aristocracy, as this custom is common among elites throughout the world.[26] Hitler and his associates had extensive exposure to fine homes

and art collections as they rose to power. Hitler particularly admired the collection of Fritz Thyssen, and his behavior later confirmed his belief in the connection between status and the possession of art.[27] Still, the Nazi leaders had formed their notions of upper-class style long before they courted the old elite. For example, Hitler developed an appreciation for the extravagant works of Hans Makart as a youth because the artist "had been the symbol of unattainable social status and of a degree of comfort [that he] could not afford."[28] Like Hitler, Göring was raised with a tremendous respect for symbols of luxury. When he gained power, he exploited these objects to exhibit his new station. Göring used artworks and objects of luxury almost as stage props. With his gold plates and tapestries ("the royal form of painting"—Louis XIV had founded the Gobelin factory in France), he outshined most of the traditional elite.[29]

Göring, of course, was an extreme case. While most of the other Nazi elite upgraded their lifestyle in accordance with their party's success, their transformations were less dramatic. Ernst Hanfstaengl used the phrase "early Pullman taste" to describe the favored style of the Nazis (he argued for the formative effect of hotel life on the leaders).[30] This term, while capturing the traditional nature of the Nazis' interior design, nonetheless fails to convey their efforts to project grandeur and power. The spacious offices they constructed (Goebbels tried to make sure that his office "was three times bigger than that of any minister in the former [Weimar] Republic"), their penchant for massive furniture, and the use of leather as their favorite material, with red as the preferred backdrop (for curtains, rugs, and other accessories), were the constants of the Nazi style.[31] Noteworthy examples included the Party headquarters in Munich, the Braunhaus, and the New Reich Chancellery.[32] The Nazis projected somewhat varied images of themselves to different groups. While the masses and the Party faithful saw mostly uniforms and sleek Mercedes, the social elite gained more exclusive exposure to dinner jackets and mansions.

Hitler's decision to purge the NSDAP of revolutionary and socialist elements in June 1934 constituted an act of accommodation with the old elite and signaled the conservative tack of the surviving Party leaders. Granted, the Röhm purge did entail the killing of General Kurt von Schleicher and the further political debilitation of Papen, who was, in principle, Hitler's governing partner. While consolidating their power, however, the Nazis used this occasion to come to terms with the army—which was still dominated by the nobility—and to assure the civilian elite that there would be no "second revolution." The Röhm purge, while primarily a political act, continued the social trend of the Nazis and helped them find accommodation with the traditional elite. Hitler also established good relations with big

Hitler, in formal attire, with Winifred Wagner, Bayreuth, 1939 (BHSA)

business once in power. The industrialist association led by Gustav Krupp von Bohlen und Halbach agreed to surrender political power in exchange for government-sponsored economic success. Fittingly, Krupp served as chairman of the Adolf Hitler Spende für Industrie, whereby business leaders provided Hitler with discretionary funds, some of which went toward the purchase of artworks.[33]

The Nazi elite pursued a policy of accommodation and integration with the existing powers through the mid-1930s. High society at this point in the Third Reich was less exclusive and more meritocratic than before. Parties might typically bring together aristocrats, movie stars, and Nazi chieftains. One dinner sponsored by the Goebbels's at the RMVP on 29 October 1937 included the following guests: Veit Harlan, Lida Baarova, and Annie Ondra, all from the film world; boxer Max Schmeling (Ondra's husband); and RMVP state secretaries Leopold Gutterer and Karl Hanke, Reichsleiter Philipp Bouhler, and the Speers.[34] In his diaries Goebbels wrote of evenings with Leni Riefenstahl, Philipp Prinz von Hessen, and Hitler.[35] The Ribbentrops threw numerous parties at their Dahlem villa that encouraged the mixing of these various groups in the new ruling order. One event held on 11 August 1936 had a spectacular guest list, where one found, for example, a table with Prinz Auwi, Max Beckmann, and Gustaf Gründgens's wife. Himmler, another guest that evening, scribbled on his program (the

Sehr harmonisch u. schön

11. AUGUST 1936

v. Ribbentrop

Berlin-Dahlem, Lentze-Allee 9

Himmler's program from Ribbentrop's party during the 1936 Olympic games: "very harmonious and nice." (BAK)

N a m e	Zelt	Tisch
Ministerialrat **Hasenöhrl**	A	34
Frau **Hasenöhrl**	A	8
Dr. **Haushofer**	C	
Hausfrau	A	12
Hausherr	A	32
Geheimrat Prof. Dr. **Heide**	A	5
Frau **Heide**	A	23
Reg.-Bürgermeister **Heider**	A	18
Staatsrat **Helfferich**	A	25
Polizeipräsident Graf v. **Helldorf**	A	39
Gräfin v. **Helldorf**	A	20
Herr Karl **Henkell**	A	41
Frau Karl **Henkell**	A	16
Frau Otto **Henkell**	A	27
Herr Stefan Karl **Henkell**	C	
Reichsminister **Heß**	A	3
Frau **Heß**	A	32
S. Kgl. Hoheit Philipp Prinz von **Hessen** …	A	41
I. Kgl. Hoheit Prinzessin Philipp v. **Hessen**	A	17
Herr **Hetzler**	C	
Herr van der **Heyden à Hauzeur**	A	21
Frau van der **Heyden à Hauzeur**	A	42
SS-Gruppenführer **Heydrich**	A	17
Frau **Heydrich**	A	36
Reichsarbeitsführer **Hierl**	A	14
Frau **Hierl**	A	44
Reichsamtsleiter **Hilgenfeldt**	A	37
Frau **Hilgenfeldt**	A	24
Reichsführer SS **Himmler**	A	26
Frau **Himmler**	A	31
Staatskommissar **Hinkel**	A	15
Frau **Hinkel**	A	14
Herr **Hyranyma**	A	17
Herr Heinrich **Hoffmann**	A	24
Frau **Hoffmann**	A	43
Fürstin von **Hohenzollern-Sigmaringen**	A	34
The Right Hon. Lord **Hollenden**	A	1
Lady **Hollenden**	A	21
Konsul **Hommel**	B	
Frau **Hommel**	A	33
Oberstleutnant **Hoßbach**	A	21
Frau **Hoßbach**	A	25
Korpsführer **Hühnlein**	A	43
Frau **Hühnlein**	A	24

8

Page of program from the Ribbentrop party featuring "high society" of Third Reich (BAK)

names of the invited thus being made known to all) his thoughts about the evening: "*sehr harmonisch und schön.*"[36] To be sure, the Nazi leaders did not win over all of the old guard. The Ribbentrops might earn Bella Fromm's praise for "excellent manners" and setting "one of the best tables in Berlin," but they were still considered parvenus by the old guard.[37] The Ribbentrops, in fact, present a special case: by trying overzealously to attain social status, even their Nazi peers ridiculed and spurned them (it did not go unnoticed that Magda Goebbels and Emmy Göring tried to shut out Annelies Ribbentrop).[38] In the mid-1930s, then, the Nazi leaders did not win over all the traditional elite, but they nonetheless brought around a sufficient number so as to feel that they were merging with the aristocracy and forming a new ruling order.

The Nazi elite had an insatiable desire to control and dominate, whether it was in international relations or in the domestic social arena. They were not content merely to coexist. The phase in which they attempted to emulate the old elite and achieve integration into that caste therefore gave way to efforts to surpass them. No clear-cut periodization is possible. The Nazis had long sought not only to gain the acceptance of the old elite but also to exploit them. While Hitler, Göring, Himmler, Ley, and others had solicited their financial support, Ribbentrop, through his foreign policy bureau (a Party office), had employed sympathetic aristocrats for "society spying."[39] Goebbels had long derived satisfaction from having aristocrats as subordinates; employing Friedrich Christian Prinz zu Schaumburg-Lippe as his adjutant and valet perhaps most aptly conveys his desire to humble the old guard. Still, just as 1938 marked a turning point toward a more aggressive foreign policy and a greater willingness to use violence to achieve domestic goals, there occurred at this time a shift in their views toward the old elite.

DISPLACING THE OLD GUARD

The Nazis' project to denigrate the old elite and replace them atop the social order became discernible in 1938, and this trend became even more pronounced in the early years of the war. The onslaught in 1938 began with the replacement of Foreign Minister Konstantin Freiherr von Neurath, a legitimate representative of the nobility, by Party man Ribbentrop.[40] This move coincided with a purge of the army, whereby a number of the truly aristocratic leaders such as Field Marshal Werner von Blomberg and General Werner Freiherr von Fritsch were replaced by Party stalwarts such as Wilhelm Keitel.[41] Hitler's moves in 1938 were not solely due to social considerations but constituted a further attempt to consolidate the Nazi Party's

power. In his mind these two concerns were not unconnected. As the Catholics might have divided loyalties because they looked to their bishops or to Rome, aristocrats were suspected of class allegiances that conflicted with the Nazis' ideological goals.[42] Yet, as mentioned above, the deterioration of the old guard's position occurred gradually after 1938. Historian David Schoenbaum argues that in 1939 "objective" social reality had not undergone a decisive change as "the East Elbian estates continued to be run by the gentry, the civil service by doctors, and the army by generals whose names began with 'von'."[43]

The war provided Hitler the opportunity to pursue his ideologically determined social program, part of which entailed undermining the status of the old elite. In 1940 Prinz Wilhelm, the Kaiser's fifth son, died while fighting. The resultant military funeral, which ostentatiously glorified the Hohenzollern casualty, prompted Hitler to forbid members of the royal family from engaging in combat.[44] Hitler refused to tolerate heroes from these quarters, a sentiment that grew so strong that he decreed on 19 May 1943 that "internationally connected men"—a term that applied to most nobles—were not to hold state, Party, or Wehrmacht appointments.[45] Later that year he issued explicit orders for all princes in the German officer corps to resign their commissions—and this in 1943, at a time when manpower had emerged as a crucial issue.[46]

Another means of debasing the old guard presented itself when the Nazis embarked on their plundering program. They commonly employed aristocrats who were knowledgeable about art both to seek out and to catalog the booty. Rosenberg charged Kurt von Behr, a noble from Mecklenburg, with leading an ERR commando in France. When Behr was transferred to pursue furniture and head the M-Aktion, he was replaced by Hermann Ritter (literally, a knight) von Ingram, an Austrian aristocrat. Eberhard Freiherr von Künsberg worked under Ribbentrop's auspices in both France and the Soviet Union, while the successor to Mühlmann as chief of art plundering operations in Poland, Wilhelm Ernst de Palezieux, also possessed a distinguished lineage (he grew up at the court of the Großherzog von Sachsen).[47] Many of Göring's regional Luftwaffe commanders—who were required to assist the Reichsmarschall in his often sordid business—were of the nobility: General Ritter von Pohl in Italy and Captain von Glasow in Amsterdam are two examples.[48] Inducing or even encouraging such supposedly honorable men to commit criminal acts comprised, either consciously or unconsciously, part of their class's degradation. Kurt von Behr and his wife expressed this shame at the end of the war when they took their lives in a traditional, aristocratic style: they consumed vintage champagne (1918) and poison at midnight in Schloß Banz near Bamberg.[49]

Graf Wolff-Metternich and his aristocratic successor as head of the army's art protection agency in France, Dr. Bernhard von Tieschowitz, offered limited but futile resistance to the ERR until they were displaced in June 1942. In the realm of art theft the old nobility not only proved incapable of standing up to the Nazi leaders but were complicitous agents.[50]

Employing aristocrats to steal art was an extension of the principle of using them to procure art. In the late 1930s an observable phenomenon arose whereby nobles were hired by Hitler, Göring, Ribbentrop, and others to arrange opportunities to purchase art. Philipp Prinz von Hessen, a longtime Nazi Party member, became the Linz Project's chief agent in Italy around this time. His wife was Princess Mafalda of Savoy, the daughter of the king of Italy, and they had numerous contacts within the upper reaches of Italian society.[51] Karl Haberstock developed a network of subordinate art agents and contacts to help him buy for Linz: a number in his circle, such as Karl Freiherr von Pöllnitz, were of noble birth. Yet another symbolic act involved the Nazi elite's purchase of artworks owned by the aristocracy. These occasions were not uncommon, as evidenced by the earlier description of the Czernin family's sale in November 1940 of Jan Vermeer's *An Artist in His Studio*. A survey of the lists of purchases of the Nazi leaders reveals a host of aristocratic sellers, especially during the war. This includes Göring purchasing da Vinci's *Leda* from Prinz zu Wied and Himmler buying archaeological objects from Prince Juritzky in Paris.[52] In 1942 Hitler acquired Watteau's *The Dance* from the crown prince of Prussia, a work that had been handed down through generations of Hohenzollern since Frederick the Great first acquired it.[53] Kaiser Wilhelm II had taken the painting with him to Doorn, Holland; it was sold only after his death in 1941. For Hitler the sensation might have been akin to Goebbels having Prinz Schaumburg-Lippe fetch him his overcoat. Hitler reportedly allowed the crown prince to receive payment (RM 900,000) in the form of a land grant – an ironic twist as the royal obtained property previously owned by his family from the new ruler.[54] Other notables who sold works to Hitler included Johann-Georg Prinz von Sachsen, Freiherr von Frankenstein, the Herzog von Oldenburg, and Prinz Schaumburg-Lippe.[55] Such acts constituted a symbolic triumph for the new men.

While the old elite were gradually forced into inferior and more humble positions during the early stages of the war, their situation deteriorated further with the Germans' military misfortunes. The Nazi elite increasingly made them scapegoats for the nation's failures, calling them degenerate, indulgent, inept, and racially inferior. Goebbels, for example, commented on aristocrats in his journal entry of 30 September 1942: "As a result of the ancient nobility of their lineage they are practically unable to read and

write."[56] Goebbels, like his colleagues, largely confined his attacks on the nobility to the rhetorical realm prior to 1944. As the plenipotentiary for total war (as of February 1943), he advocated publicly spartan living and a unified *Volksgemeinschaft*. Reprimanding the nobility as indulgent and aloof thus offered him a useful propaganda tool (akin to his campaign to close down Horcher's, the gourmet restaurant in Berlin). The displacement of the old elite that did occur during the first half of the war often came about by the steadily creeping influence of the Party. Richard Grunberger, for example, recounted how Party functionaries supplanted aristocrats as the organizers of traditional festivals on the East Elbian estates.[57] Still, the rhetorical bombast and the growing influence of the Party were but an omen of the later developments.

Attacks in earnest against the old elite gained momentum after the failure of the 20 July 1944 attempt to assassinate Hitler and remove the most radical Nazis from power. The conspiracy, led by Claus Schenk Graf von Stauffenberg, involved a wide range of aristocrats – most notably in the army and in the Kreisau circle. It provoked a violent reaction from the Nazi leaders.[58] Robert Ley made the most inflammatory remarks. In a speech to Siemens workers two days after the failed coup – portions were printed in *Der Angriff* newspaper the following day – he raged that "blue-blooded swine" were exclusively to blame for the plot: "Degenerate to their very bones, blue-blooded to the point of idiocy, nauseatingly corrupt, and cowardly like all nasty creatures – such is the aristocratic clique which the Jew has sicked on National Socialism. . . . We must exterminate this filth, extirpate it root and branch."[59] Many Nazi faithful had been gradually conditioned by the wartime rhetoric to despise the nobility. As noted above, there occurred a gradual buildup in this antinoble agitation. In the summer of 1943, for example, Philipp Prinz von Hessen and Princess Mafalda were made the scapegoats for the overthrow of Mussolini's government. The Prinz was deposed as Oberpräsident of Hessen-Nassu as a result of the 19 May 1943 "Decree of the Führer Concerning Internationally Connected Men," and after Mussolini's fall, they were sent by Hitler to the Flossenbürg and Buchenwald concentration camps, respectively.[60] Mafalda was killed in an Allied air raid while living in the Buchenwald camp brothel, while Philipp spent one and a half years in the camp under the name "Wildhof" and barely survived the war.[61] Yet the July 1944 bomb plot ushered in a genuine period of crisis for the German nobility. Although Hitler moved to issue orders prohibiting lynch-mob attacks, not wanting public mayhem and disorder, the Nazi leaders employed their own brand of justice and took revenge on the aristocracy as a whole.[62] Historians such as John Wheeler-Bennett have estimated that as many as 5,000 people were killed in the

Ley and the Duke and Duchess of Windsor, 1937 (BAK)

Philipp Prinz von Hessen, art dealer for Hitler (BHSA)

aftermath of the failed assassination attempt.[63] While the exact percentage of aristocrats in this figure was not calculated, it was undoubtedly considerable – especially in light of the execution of 2,000 army officers that figured into Wheeler-Bennett's calculation. The Nazis' "kith and kin" policy of pursuing the families of the accused, as well as the fact that, in the words of John McCloy II, "Most of these [killed] had nothing to do with its planning," suggests that an element of class warfare and not merely justice was on Hitler's mind when he set loose Ernst Kaltenbrunner and his 400-man squad especially created for the task.[64] The position of the German nobility continued to deteriorate in the post-1944 period (and this trend continued into the postwar period with the Soviet Military Administration and the establishment of the German Democratic Republic, whereby the East Elbian estates were seized and the land redistributed).[65] As the war progressed, the Nazi elite became increasingly eager to replace the aristocracy as the dominant element in German society.

Hitler and his long-standing group of cohorts perceived themselves as a distinct elite. This assertion, however, does not have universal support among historians. Michael Kater, for example, argues that they did not qualify as a "counterelite" because, "coming after and aping in various respects their austere Prussian precursors, they retained far too many epigonal characteristics to be considered a new species."[66] While Kater is undoubtedly correct to acknowledge the many similarities between the traditional and the Nazi elite – this is consistent with the argument made here about emulation preceding displacement – one must consider the fact that the Nazi leaders believed themselves to be a separate ruling group. Beyond perceiving themselves as part of a distinct hierarchy within the Party, and aside from their penchant for physical proximity – they shared exclusive compounds at Obersalzberg and Pullach and gravitated to specific neighborhoods, such as Dahlem-Grünewald in Berlin – they developed elaborate theories about their caste. Himmler propagated the idea of the Nazi *Herrentyp* (noble type), while Rosenberg subscribed to a similar concept of *Orden* (orders) that would govern the Reich.[67] The Nazi leaders sincerely believed themselves to be a new, Nietzschean brand of superior rulers.

Beyond subscribing to a general theory of a new and distinct elite, the Nazi leaders developed self-images whereby each thought himself to have special and unique abilities. Their personae, while admittedly multifaceted, can be summarized as follows: Hitler saw himself as a leader who stood above all German society. Göring fancied himself as a prince, subordinate to the reigning monarch but first in the line of succession. Himmler, with his feudal notions, became a knight – a military chief in the service of his leader. Goebbels thought himself worthy of his lofty station by virtue of his

Luncheon honoring Ley (seated, center left) during his visit to the SS at Dachau, 1936. Note the contrast between the public image of the Dachau camp and this scene. (BAK)

Speer (left) and Feldmarschall Milch (far right) at luncheon in Paris, 1942 (BAK)

Nazi grandeur: Hitler and Göring in the Neue Reichskanzlei. (BHSA)

intelligence and skill (a conviction that would also apply to Speer, the technocrat par excellence). Rosenberg believed himself to be an incarnation of the mythic Aryan type about whom he had spent so much time theorizing. Ribbentrop fused a belief that he was an aristocrat with the notion of the modern man (someone who energetically shaped the world himself). Baldur von Schirach perceived himself as a representative of that part of the old nobility that had carried over to the new elite. Hans Frank thought himself worthy of his fiefdom in the General Government by virtue of his long service to the Party–his was the triumph of the *alte Kämpfer*. Of course, the stereotypes were far more complicated than these short synopses (the artistic personae described at the end of Chapter 8, for example, need to be factored in). Yet the point remains that the Nazi leaders viewed themselves as an identifiable and legitimate elite. They stood apart from other Party members and thus had special privileges. Göring testified at the Nuremberg trials that it was their philosophy that the "chauffeurs of Gauleiter must be prevented from enriching themselves."[68] Indeed, corruption occurred more often among the elite, and this helped set them apart from the lower echelons.[69] Transgressions by lower-ranking officials in the Third Reich sometimes elicited harsh punishment, as illustrated by the previously

mentioned case of Karl Lasch, who was executed for embezzlement in the General Government.[70]

Art and objects of luxury were symbols that the Nazi leaders manipulated to convey a sense of their status. The progression described in this chapter began prior to the seizure of power, when they sought to use these symbols to show that they were not parvenus or marginal types, although this impression was conveyed not to the German public as a whole but to the existing elite who were potential supporters. Once in power, the Nazi leaders began acting like the traditional elite, living in palaces and hanging impressive paintings on their walls. They did not stop here however, as their megalomaniacal nature found expression in their style of living. Habits that began in the late 1930s continued and in most cases became exaggerated during the war. Goebbels, for example, beyond his multiple mansions in the environs of Berlin, continued to use precious watermarked paper until the final capitulation.[71] The Ribbentrops wallpapered their Dahlem home four different times during 1942, never being satisfied with the effect.[72] Berthold Hinz described the linkage between lifestyle and the nature of their rule: "As the National Socialist elites drew away from the people and entrusted control of the people to their more anonymous henchmen . . . they gave themselves up to luxury and pleasure on a feudal scale."[73] Albert Speer himself admitted in his memoirs, "This love for vast proportions was not only tied up with the totalitarian cast of Hitler's regime. Such tendencies, and the urge to demonstrate one's strength on all occasions, are characteristic of quickly acquired wealth."[74] The Nazi leaders used art, like architecture, to articulate not only their broader ideological goals but also their own personal aspirations.

CONCLUSION

The NS elite followed Hitler's lead in expressing a concern for the visual arts. The rationale behind this interest had two main components: one was ideological and political, the other more personal and private. With respect to the former, the Nazi leaders sought to shape the artistic production of their citizens and amass unprecedented collections of artworks in an effort to glorify the German *Volk*. Their racial nationalism and their lust for power therefore found clear expression in their attitudes toward art. In the private or personal sphere, the ambitious Nazi leaders sought self-enrichment. Being corrupt and identifying themselves with the state, they showed little compunction about using their official funds and their political power to further their material well-being. Artworks were high on the list of desired objects. The two components of their rationale for pursuing artworks were interlinked to a significant extent.[1] The exercise and abuse of power was a key element in the Nazi system of government: "Always preferring many small potentates to a few big ones, Hitler even wanted the Gauleiters to have wealth of their own. He felt that there was no danger that this would turn them into independent sovereigns, since they could be deposed at any time."[2]

Hitler controlled the determination of visual arts policy just as he did most aspects of the state in the Third Reich. In fact, Hitler exercised more direct control over art than he did over most other spheres of government. One historian postulated about Hitler, "The singular ability to remember ships and librettos is significant in that it indicates what interested him: power-war and art-music. . . . It is precisely these interests which dominate Hitler's role as government head."[3] The *Führerprinzip* therefore found vivid expression with respect to art in the Third Reich. Hitler intervened as arbiter of the debate over modernism – the crucial issue in the arts policy during the NS epoch. He also asserted himself once the wide-ranging plundering campaigns were under way: the *Führer Vorbehalt* assured him that he would obtain the finest pieces of the booty. In exercising his supreme power in these instances, Hitler enhanced his position as he demonstrated to all his unique prerogatives. Furthermore, he was able to justify these actions by way of the NS ideology. Joseph Nyomarkay posited these two features as crucial to "charismatic legitimacy": acting the role of the leader and instilling in subordinates the belief in some higher power or ultimate ideal.[4] Hitler's art collection, tied as it was to the project of creating the German cultural mecca in Linz, underscored both his sense of mission and his supreme, unassailable position.

The fate of the visual arts in Nazi Germany was not determined by Hitler alone but also by his subleaders, who exhibited tremendous initiative in trying to formulate and carry out policies that would elicit their leader's approbation. Goebbels's efforts beginning in 1935 to carry out the *Entjudung* of the RKK, Himmler's endeavors to reshuffle populations (and sort out their artworks at the same time), and Schirach's exertions to revive the supposedly listless cultural life of Vienna offer three examples among many. Even enterprises that appeared motivated by personal interest often stemmed from the desire to please Hitler. Himmler patronized the Ahnenerbe in their search for a great lost Teutonic culture with the intention of winning Hitler over to this project, although he never successfully did so.[5] The various Nazi ministers all seemed bent on winning Hitler's approval through their concern for the visual arts. This led to a very crowded cultural bureaucracy. While other scholars have described the bureaucratic overlap in a number of spheres, this study has demonstrated that redundancy, or to use Hannah Arendt's term, the "multiplication of offices," occurred in the arts administration.[6]

The wide-ranging interest and involvement of the Nazi subleaders in managing the arts is one of the truly extraordinary aspects of this epoch. Hitler's involvement in such enterprises was presaged by Kaiser Wilhelm II, as the last emperor attempted to impose his aesthetic conceptions on the nation. The degree of their respective intervention varied greatly, however, as did the malignancy of their policies.[7] This parallel aside, there is no precedent in modern history for an entire leadership corps concerning itself with aesthetic matters. It is all the more striking in light of the Nazi elite's other interests and projects, which ran diametrically contrary to the ethos typically associated with the arts (creativity, personal expression, and a concern for morality). This paradox relates to larger issues in German (and world) history, what Robert Cecil summarized as "the vexed problem [of] how the people of thinkers and poets (*Dichter und Denker*) had temporarily become transformed into the people of judges and executioners (*Richter und Henker*)."[8]

The issue of the uniqueness of the NS leaders as conquerors concerned with culture also merits a final observation. It is a subject that has attracted the attention of numerous scholars, as many have been inclined to compare the Nazis to the Romans, the Napoleonic armies, and the Soviets, among others.[9] The Soviets' trophy brigades, which removed more than 2 million art objects from Germany, indeed point to issues of comparability that echo those raised during the *Historikerstreit* in the mid-1980s.[10] Yet despite the temporary rapaciousness of Stalin's forces, and even the Soviet dictator's contemplation of a "supermuseum" in Moscow that would showcase

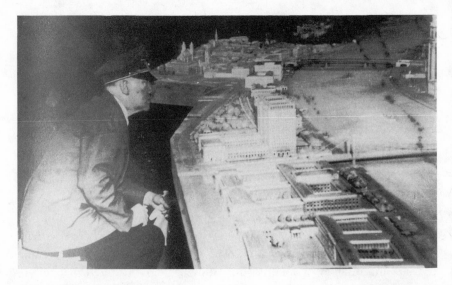

Hitler viewing plans for the cultural complex at Linz in the model room within the Berlin bunker complex, February 1945 (NAW)

much of the war booty, the exceptional qualities of the Nazis must be affirmed.[11] The Soviets did return most of the plunder that they seized – 1.5 million objects (including the Pergamon altar) went to the German Democratic Republic as a result of a 1957 diplomatic agreement. The National Socialists planned for a thousand-year empire, and while one can imagine them relinquishing certain artworks, say, those taken from Italy after the fall of Mussolini in mid-1943, the majority of the works they acquired were to remain in German hands as long as the Third Reich survived. While there is something paradigmatic about both the regime and its cultural policies, the historian must ultimately recognize the Nazis' exceptional qualities. In particular, the scale of their thievery and destructiveness remains unique in the annals of history.

The Nazi leaders used art as a means of expressing power – to convey what they perceived as personal, factional, national, and racial preeminence. Moreover, they used their *Kulturpolitik* as a means of creating the illusion of change – of a transformed Germany. Historians have shown that this fabricated image often deviated greatly from the reality.[12] The Nazi leaders were indeed skilled at this theater politics. In their own way they were masters of gestures and symbols. They communicated their ideas and fantasies by way of a coordinated propaganda campaign, which they themselves also came to believe. One is left with the haunting image of Hitler sitting for hours on end in the model room of his bunker during the last days of the

war, dreaming of the museum, concert halls, and monuments of the new Linz. He himself had been taken in completely by the project. His remark to his Gestapo chief in March 1945 reveals the extent of his departure from reality: "My dear Kaltenbrunner, if both of us were not convinced that after the victorious conclusion of the war we would build this new Linz together, I would shoot myself today."[13] While he adorned his cement bunker with artworks – including a portrait of Frederick the Great (for inspiration, as the Prussian monarch had been saved by providential developments in the Seven Years' War) – the gloomy setting was not especially conducive to the contemplation of greatness. That Hitler's plans for Linz and the picture of a king could sustain him at this hopeless point serves as a testament to his capacity to be captivated by dreams and symbols. It is an extraordinary aspect of the Third Reich that the world articulated in this way was, for many years, in fact the reality.

APPENDIX:

ORGANIZATIONAL CHARTS AND
GLOSSARY OF KEY FIGURES

The National Socialist Fine Arts Bureaucracy, ca. 1937

The National Socialist Art Plundering Bureaucracy, ca. 1941

GLOSSARY OF KEY FIGURES

Otto Abetz (1903–1958).
Ambassador to occupied France;
assisted Ribbentrop in expropri-
ation of Jewish art collections.
Trained as art teacher. Formerly
employee of Dienststelle
Ribbentrop (1935–39).

Klaus Graf von Baudissin (1891–
1961). Director of Folkwang
Museum in Essen (1934). Head
of Amt Volksbildung in RMWEV.
Member of Ziegler's committee
to purge modern art (1937).
SS-Oberführer.

Kurt Freiherr von Behr
(1890–1945). Art plunderer.
Head of the Dienststelle Westen
in the ERR. Overseer of *M-
Aktion.* Strong allegiance to
Göring. Had worked for NSDAP
Auslands Organisation in Italy
during 1930s.

Martin Bormann (1900–1945?).
Reichsminister. Head of the
Party Chancellery (1941) and pri-
vate secretary of Hitler (1943).
Financial overseer of Sonder-
auftrag Linz and Hitler's per-
sonal finances.

Arno Breker (1899–1991).
Prominent NS sculptor; patron-
ized by Hitler, Speer, Göring,
and others. Professor at State
Technical School for Visual Arts
in Berlin (1938–45). Also mem-
ber of Prussian Academy of Arts
and multiple prize winner (e.g.,

Olympic silver medal). Vice-
president of the RkdbK (1945).

Hermann Bunjes (1911–1945).
Employee of the *Kunstschutz* unit
in France and later the ERR.
Director of SS Kunsthistorisches
Institut in Paris (1942–44).
Docent in art history at Bonn
University. SS-Untersturmführer.

Josef Bürckel (1894–1944).
Gauleiter and Reichsstatthalter
of Ostmark (Austria) and later
the Westmark (Saarland Lor-
raine). Previously plenipoten-
tiary for the Saar Palatinate
(1935). SS-Gruppenführer.

Karl Cerff (1907–?). Head of press,
propaganda, and schooling in
Hitler Jugend (1933–39). SS-
Brigadierführer and head of fes-
tival organization in personal
staff of Reichsführer-SS (1939–
41). Head of Hauptamtkultur
in RPL (1941–45).

Richard-Walther Darré
(1895–1953). Reich food minister
(1933–42) and Reich farmers'
leader (1934–42). Also chief of
SS Race and Settlement Office
(1931–38). Propagator of "blood
and soil" (*völkisch*) ideology.

Karl Diebitsch (1889–?). Munich
painter and adviser to Himmler
on visual arts. Head of SS porce-
lain manufacturer Allach. Mem-
ber of RKS (1937). Professor
(1939). SS-Oberführer, comman-

der of 11th Totenkopfstandarte and SS-Standarte "Germania."

Maria Almas Dietrich (1892–?). Munich art dealer and leading vender to Führermuseum.

August Eigruber (1907–1946). Gauleiter of Oberdonau, region in which Linz is located. Also had jurisdictional claims on salt mine safeguarding depots. SS-Brigadierführer.

Karl Fiehler (1895–1969). Mayor of Munich (1933–45). Reichsleiter. Co-organizer of Day of German Art held annually. SS-Obergruppenführer.

Hans Frank (1900–1946). Leading jurist of NSDAP. Reichsminister without portfolio. Bavarian minister of justice. Reichsleiter and general governor of Poland. Also Reichstag deputy and president of the Academy of German Law.

Wilhelm Frick (1877–1946). Reich minister of interior (1933–43), and then Reichsprotektor of Bohemia and Moravia (1943). Previously minister of interior and culture in Thuringia (1930), and Reichstag deputy.

Hermann Giesler (1898–?). Architect commissioned to work with Roderich Fick on redesign of Linz. Member of Prussian Academy of the Arts, and professor (1938). Reichstag deputy (1943).

Joseph Goebbels (1897–1945). Reichsminister of RMVP. Gauleiter of Berlin. President of RKK. Chief of Party Propaganda Office (Reichs Propagandaleitung). Plenipotentiary for Total War. Also editor (e.g., *Der Angriff*), president of RKS, and novelist.

Hermann Göring (1893–1946). Reichsmarschall. Chief of Luftwaffe. Head of Four-Year Plan. Minister president of Prussia. Chair of Reich Defense Committee. Reich hunting master. Reichstag president. Also overseer of Prussian State Theater as well as Hermann Göring School for Painting.

Karl Haberstock (1878–1956). Berlin art dealer. Member of degenerate-art Disposal Commission. Adviser to regime on Linz Project and the disposition of Jewish property confiscated in Austria.

Reinhard Heydrich (1904–1942). Head of Reich Main Security Office, which included the criminal police, SD, and Gestapo. Deputy Reich protector of Bohemia and Moravia (1941). Oversaw both plundering and genocidal programs.

Heinrich Himmler (1900–1945). Reichsführer-SS and head of German police (including the SD and Gestapo) and Waffen-SS. Minister of Interior (1943). Also patron of das Ahnenerbe, among myriad organizations within the SS.

Hans Hinkel (1901–1960). General secretary of RKK. Overseer of troop entertainment (1942).

Reich film director (1944). Formerly leading member of KfdK and Berlin editor of *Völkischer Beobachter* (1930–32).

Walter Andreas Hofer (1893–?). Director of art collection of Göring, and independent art dealer.

Heinrich Hoffmann (1885–1957). Hitler's photographer and an unofficial artistic adviser. Professor (1938). Chief of jury selecting works for the *GDK*. Publisher of *Kunst dem Volk*. Also Reichstag deputy (1940), and father-in-law of Schirach.

Niels von Holst (1907–1981). Art historian and plunderer specializing in Baltic and eastern European works in employ of the RMWEV and, later, the ERR.

Erich Koch (1896–1986). Gauleiter and Oberpräsident of East Prussia and Reichskommissar of Ukraine (1941–44). Honorary SS-Gruppenführer.

Wilhem Kreis (1873–1955). Architect. Member of Prussian Academy of the Arts (1937). Professor (1938). Commissioner of the Formation of War Cemeteries (1940). President of the RkdbK (1943). Supervisor of NSDAP memorials (1944).

Otto Kümmel (1874–1952). Director of Berlin Staatlichen Museen (1933). Special commissar for securing foreign museums and German cultural objects (1940).

Eberhard Graf von Künsberg (1909–1945). Legationsrat in Foreign Ministry. Art plunderer in France and Soviet Union. Head of Sonderkommando Ribbentrop (1941–43). Commander of Waffen-SS battalion (1943–45).

Robert Ley (1890–1945). Leader of DAF, including the KdF free-time organization. Reich organization leader. Gauleiter of Rhineland. Overseer of *Ordensburgen* (NS academies).

Wilhelm Liebel (1897–1945). Mayor of Nuremberg (1933–45). Very effective in arranging return of cultural objects, including Holy Roman jewels, to city. Reichstag Deputy. SA Obergruppenführer.

Kajetan Mühlmann (1898–1958). Leading art plunderer in Austria, Poland, and the Netherlands (Dienststelle Mühlmann). State Secretary in Austria (1938). Previously an organizer of Salzburg festival. SS-Oberführer.

Konstantin Freiherr von Neurath (1873–1956). Foreign minister (1932–38), then Reich protector of Bohemia and Moravia (1939).

Philipp Prinz von Hessen (1896–1980). Art dealer for Sonderauftrag Linz and son-in-law of King Vittorio Emanuele III of Italy. Appointed liaison between Hitler and Mussolini (1936). SA-Obergruppenführer (1938).

Eduard Plietzsch (1886–1961). Art historian and art dealer in service of Dienststelle Mühlmann.

Hans Posse (1879–1942). Director of Sonderauftrag Linz (1938)

and Dresden Staatliche Gemälde Galerie (1913). Adviser to Hitler on plan to distribute confiscated Jewish art to museums in Reich (1939).

Joachim von Ribbentrop (1893–1946). Reich minister for foreign affairs (1938). Previously ambassador to Great Britain and head of Dienststelle Ribbentrop within the NSDAP.

Alfred Rosenberg (1893–1946). Party philosopher who headed the DBFU (Amt Rosenberg), the ERR, the planned network of Hohe Schule, and the RMBO. Also editor of *Völkischer Beobachter, Kunst im Dritten/ Deutschen Reich*; author of *Mythos des 20. Jahrhunderts* and numerous ideological tracts.

Bernhard Rust (1883–1945). Reich minister of science, education, and popular culture (1934–45). Prussian minister of science, art, and education (1933–45). Gauleiter of Hanover-Brunswick.

Baldur von Schirach (1907–1974). Head of Hitler Jugend (1929–40), then Gauleiter and Reichsstatthalter of Vienna (1940–45). Also poet and author (e.g., *Revolution der Erziehung* in 1939).

Robert Scholz (1902–1981). Artistic adviser to Rosenberg; Division Chief in DBFU, coeditor of *Kunst im Deutschen Reich,* and operative in ERR. Director of Staatliche Galerie Moritzburg in Halle (1939–45) and protector of na-tional symbol (1941). Also art critic for *Völkischer Beobachter,* among other publications.

Franz Xaver Schwarz (1875–1947). NSDAP treasurer or Reichs-schatzmeister (1931–45). Also Reichstag delegate (1933) and Reichsleiter (1933).

Arthur Seyss-Inquart (1892–1946). Reichsstatthalter in Austria, Reichsminister (1939), and then Reichskommissar in Occupied Netherlands (1940). Also tenure as Austrian minister of interior (1938) and deputy governor general in Poland (1939). SS-Obergruppenführer.

Otto Andreas Schreiber (1907–?). Leader of Berlin chapter of NSD-Studentenbund, promod-ernist activist, head of cultural office within KdF. Journalist/ author (e.g., *Der Arbeiter in der bildenden Kunst* of 1938).

Wolfram Sievers (1905–1948). Business manager of das Ahnenerbe. Deputy chief of the HTO. Also a key official in the Kulturkommission in the South Tyrol. Previously worked as book vendor. SS-Oberführer.

Albert Speer (1905–1981). Architect. GBI (1937). Reich minister for armaments and war production (1942–45). Super-visor of party celebrations (1934). Professor (1937). Head of Amt Schönheit der Arbeit within the KdF program (1934). Prussian state councillor (1938). Member of Prussian Academy of Art.

Editor of architectural supplement to *Kunst im Dritten/Deutschen Reich.*

Julius Streicher (1885–1946). Gauleiter of Franconia (1925–40). Reichstag deputy. Publisher/editor of *Der Stürmer.*

Josef Thorak (1889–1952). Sculptor. Professor of Academy of Visual Arts in Munich (1937). Recipient of commissions for sculptures to adorn *Autobahnen,* the Nuremberg Party Grounds, and the Reich Sports Field, among other sites.

Gerhard Utikal (1912–?). Chief of staff for Rosenberg in DBFU and ERR. Previously leading figure in KfdK.

Hermann Voss (1884–1969). Second director of Sonderauftrag Linz as well as director of Dresden Staatliche Gemälde Galerie (1943–45). Previously director of Wiesbaden Museum (1935), after having lost position as director of Berlin Kaiser-Friedrich Museum (1933).

Adolf Wagner (1890–1944). Gauleiter of Munich–Upper Bavaria (1929). Staatskommissar for Bavaria. Bavarian minister of interior (1933) as well as education and culture (1936). Suffered stroke in 1942 that effectively ended career.

Wolfgang Willrich (1897–1948). Artist. Antimodern polemicist. Author of *Säuberung des Kunsttempels* (1937). Member of Ziegler's purging commission for modern art. SS-Obersturmbannführer.

Franz Graf Wolff-Metternich (1893–1978). Provincial curator of Rhineland-Westphalia. Head of Army's *Kunstschutz* unit (1940–42) who tried to who limit confiscations by ERR.

Adolf Ziegler (1892–1959). President of the RkdbK (1936–43). Professor at Munich Academy of Visual Arts as of 1933. Head of commission that purged modern art from state collections (1937–38). Temporarily imprisoned by Gestapo in 1943 on grounds of subversive behavior.

NOTES

ABBREVIATIONS

AdR	Archiv der Republik (in the ÖSta)		Contemporary History), Munich
BAK	Bundesarchiv Koblenz (German Federal Archives)	IMT	International Military Tribunal
BDC	Berlin Document Center	NAW	National Archives, Washington, D.C.
BHSA	Bayerisches Hauptstaatsarchiv (Bavarian Central State Archive), Munich	OFD	Oberfinanzdirektion (Main Tax Office), Munich
Bl.	Blatt/Blätter (leaf/leaves)	OMGUS	Office of the Military Governor of the United States
BMfU	Bayerisches Ministerium für Unterricht (Bavarian Ministry for Education)	ÖSta	Österreichisches Staatsarchiv (Austrian Federal Archives), Vienna
CDJC	Centre Documentation Juive Contemporaine, Paris	PrGSta	Preußisches Geheimes Staatsarchiv (Prussian Privy State Archives), Berlin-Dahlem
CIR	Consolidated Interrogation Report		
DIR	Detailed Interrogation Report	RFM	Reichsfinanzministerium (Finance Ministry)
IfZG	Institut für Zeitgeschichte (Institute for		

INTRODUCTION

1. Schumann, "Beim dritten Schlag zersprang der Hammer," 18.

2. Howe, *Salt Mines and Castles*, 251. Also Haase, *Kunstraub und Kunstschutz*, 171–74.

3. Goebbels, *Tagebücher*, 4:369.

4. Cone, *Artists under Vichy*, 9. Also Goebbels, *Tagebücher*, 4:365, 15 October 1940.

5. Goebbels, *Tagebücher*, 4:369.

6. Kurz, *Kunstraub in Europa*, 155, and Haase, *Kunstraub und Kunstschutz*, 89–90. Note that General Hanesse would also on occasion handle the money during Göring's shopping excursions in Paris.

7. BAK, R55/423, Bl. 48–51, bill of 2,322,200 ffr (RM 116,110 for the antiques and other artworks purchased by Goebbels in Paris, 24 February 1942).

8. Goebbels, *Tagebücher*, 4:369, 19 October 1940.

9. Speer, *Inside the Third Reich*, 234, and Overesch, *Das III. Reich*, 96.

10. Quotation from Anthony Bannon, in Licata, "Burchfield and Friends," 62.

11. Adorno, *Ästhetische Theorie*, 201. See also George Steiner's query, "Why did humanistic traditions and models of conduct prove so fragile a barrier against political bestiality?" Steiner, *In Bluebeard's Castle*, 30.

12. Hinz, *Art in the Third Reich*, 159.

13. Fest, *Face of the Third Reich*.

14. BAK, R43II/1062c, Bl. 69–78, correspondence between the Reichskanzlei and the Direktor der Staatlichen Schlössern und Gärten, August–September 1934.

15. Painter Karl Leipold, for example, has been described as a protégé of Hess's. Nicholas, *Rape of Europa*, 14.

16. Lerner, *Nazi Elite*, where he utilizes the 1934 *Führerlexikon* as a guide and hence concerns himself with approximately 1,600 Nazi leaders. Michael Kater's study, *The Nazi Party*, focuses on a smaller group, but his "leadership cadres" still number over 500.

17. Orlow, *History of the Nazi Party, 1933–1945*, 7. Also Smelser, *Robert Ley*, 308.

18. Roxan and Wanstall, *Rape of Art*, 23, and Howe, *Salt Mines and Castles*, 162.

19. Rousseau, "CIR No. 2," 157.

20. BAK, R55/698, Bl. 88, Hanke to Ott and Keudell, 13 January 1936, and BAK, NS19/3055, Brandt to Vahrenkamp, 14 August 1942, for Himmler and his art dealer SS-Sturmbannführer (captain) Wilhelm Vahrenkamp.

21. James Sheehan writes, "The culture of the baroque court was shaped by the assumption that political power and social hierarchy could not be taken for granted but had to be expressed over and over again, with ceremonies and symbols, architectural monuments and festive display." Sheehan, *Germany*, 150.

22. Schönberger, *Die Neue Reichskanzlei von Albert Speer*, 104–49.

23. Thies, "Hitler," 190. Also Speer, *Inside the Third Reich*, 151.

24. Speer, *Inside the Third Reich*, 164, and Sonja Günther, *Design der Macht*.

25. Schönberger, "Die Neue Reichskanzlei in Berlin," 169. Schönberger also says that these portraits constitute "a gallery of spiritual ancestors."

26. Schönberger, *Die Neue Reichskanzlei von Albert Speer*, 109.

27. Schönberger, "Die Neue Reichskanzlei in Berlin," 170–71.

28. Note that Hitler took an active role in decorating other rooms and that these can also be analyzed. The Berghof at Obersalzberg, the Führerbau in Munich, and the Reich chancellor's palace in Berlin offer three apt examples. See Schaffing et al., *Der Obersalzberg*; Dresler, *Das Braune Haus*; and, for the Reich Chancellor's palace, the archives of the Vereinigten Werkstätten für Kunst im Handwerk in Munich. For more on interior design, see Speer, *Inside the Third Reich*, 59–61, 81, 135–36, 168–70.

29. Orlow, *History of the Nazi Party, 1919–1933*, 8.

30. Broszat, *Hitler State*, xi.

31. Caplan, "Bureaucracy, Politics, and the National Socialist State," 251.

32. Broszat, *Hitler State*, 194.

33. Speer, *Spandau*, 346.

34. Hitler, *Mein Kampf,* 17, 34–35; Speer, *Inside the Third Reich,* 73; Fest, *Hitler,* 526–27. See also Grosshans, *Hitler and the Artists,* 11. Grosshans also quotes Hitler declaring on 21 July 1941, "My dearest wish would be to wander about Italy as an unknown painter."

35. Speer writes that Hitler "frequently asserted that his political, artistic and military ideas formed a unity which he had developed in detail between the ages of twenty and thirty." Hitler continued to execute architectural sketches during the 1930s and early war years. Speer collected 125; a quarter of them concern the cultural complex at Linz–which Speer noted "was closest to Hitler's heart." Speer, *Inside the Third Reich,* 172, 200.

36. See, for example, Backes, *Hitler und die bildende Künste,* and Grosshans, *Hitler and the Artists.*

37. Merker, *Die bildenden Künste,* 136, and Barlach's description of 1937 as *das schlimme Jahr* (the bad year) in Groves, *Ernst Barlach,* 10.

38. Broszat, *Hitler State,* 294, 308.

39. Of the 249,683 objects that were cataloged at the Central Collecting Point, 135,681 were Austrian, 545 were Belgian, 19,110 were Czecho-Slovakian, 30,207 were French, 1 was Greek, 2,554 were Hungarian, 1,123 were Italian, 7 were Yugoslav, 1 was from Luxembourg, 6,891 were from Holland, 4,075 were Polish, and 49,488 were Russian. See Haase, *Kunstraub und Kunstschutz,* 243. This figure does not encompass all the plunder. For example, the Soviets took control of other depots. A precise number is difficult to obtain. Matila Simon, for example, claims that 400,000 artworks were returned to "non-German countries" by September 1948. Simon, *Battle of the Louvre,* 194.

40. A number of artworks in German care were nonetheless destroyed in the war (as one would expect in light of the Allied bombing campaign and extensive combat on German soil). See Adams, *Lost Museum,* and Schade, *Berliner Museuminsel.*

41. Hitler, like Göring and many of the other elite, tried to maintain the appearance of propriety in collecting art. Albert Speer, for example, maintained that "Hitler did not use his authority for his private ends. He did not keep in his own possession a single one of the paintings acquired or confiscated in the occupied territories." Speer, *Inside the Third Reich,* 244. While Hitler did not put looted works in the Berghof, he did earmark them for the Führermuseum. The OSS report written after the war included the observation, "Confiscation played a basic role as a method of acquisition." Faison, "CIR No. 4," 26.

42. Speer, *Inside the Third Reich,* 81.

43. Ibid., 135–36, and Schaffing et al., *Der Obersalzberg.* Also Schütz, *München,* 394–98.

44. Note that Hitler evinced particular admiration for the nineteenth-century art. He was known to label certain works by Grünewald as ugly because of the elongated features and disconcerting facial expressions. The other leaders, however, proved less critical of this early German painting. Grosshans, *Hitler and the Artists,* 84.

45. Speer, *Inside the Third Reich,* 243.

46. Kubin, *Sonderauftrag Linz,* 68.

47. Kurz, *Kunstraub in Europa*, 395. For more on the return of artworks at the end of the war, see Smyth, *Repatriation of Art.*

48. Hinz, *Art in the Third Reich*, 162.

49. Fest, *Face of the Third Reich*, 255.

50. Himmler visited Auschwitz on two occasions. See the documentary series, *The World at War*, episode, "The Final Solution, Part III." For Streicher's capture, see Rapport and Northwood, *Rendez-Vous with Destiny*, 744.

CHAPTER ONE

1. Balfour, *Propaganda in War*, 45.

2. See Dünkel, "Die Liquidierung der Kunst," 44–53; Hochman, *Architects of Fortune.*

3. Brenner, "Art in the Political Power Struggle," 403.

4. For Rust's praise of Nolde, whom he once called "the greatest living German painter," see ibid, 403–4. Rust's persecution of Schardt is discussed in Janda, *Das Schicksal einer Sammlung*, 64–67.

5. For the July 1933 exhibition, see Brenner, "Art in the Political Power Struggle," 404–8, and Germer, "Kunst der Nation," 22–24.

6. Balfour, *Propaganda in War*, 12. Later, on 9 August 1932, Goebbels again mapped out the future RMVP. Goebbels, *Tagebücher*, 2:218. See also the description of the dinner party prior to the "seizure of power," where Hitler and Goebbels made plans for the administration of culture, in Wagener, *Hitler*, 308–11.

7. For a detailed history of the RPL, see Paul, *Aufstand der Bilder.*

8. Balfour, *Propaganda in War*, 14, and Zemon, *Nazi Propaganda*, 40.

9. Balfour, *Propaganda in War*, 12. *Ministerialrat* is a position below state secretary within a ministry. A major reason for this antipathy stemmed from Goebbels's vitriolic attacks against Hindenburg in the 1932 presidential elections (a favorite slogan was "Is he still alive?"). See Friedrich, *Before the Deluge*, 284.

10. Balfour, *Propaganda in War*, 14–15.

11. Lerner, *Nazi Elite*, 11, and Herzstein, *War That Hitler Won*, 120.

12. Balfour, *Propaganda in War*, 15.

13. Bramsted, *Goebbels and National Socialist Propaganda*, 29–30.

14. Balfour, *Propaganda in War*, 51.

15. Brenner, "Art in the Political Power Struggle," 410–11, and Thomae, *Die Propaganda-Maschinerie*, 389, 511.

16. Balfour, *Propaganda in War*, 16.

17. Hardy, *Hitler's Secret Weapon*, 28.

18. See, above all, Brenner, *Die Kunstpolitik des Nationalsozialismus*, and her article, "Art in the Political Power Struggle."

19. For the text of Hitler's cultural speech of 5 September 1934, see the *Völkischer Beobachter*, 6 September 1934.

20. Merker, *Die bildenden Künste*, 132–34.

21. Germer, "Kunst der Nation," 21–40.

22. The June 1935 edition of *Die Kunstkammer*, for example, featured the abstract sculpture of two young artists named Waldemar and Rämisch. Lehmann-Haupt, *Art under a Dictatorship*, 73.

23. Merker, *Die bildenden Künste*, 135, for Robert Scholz's review in the *Völkischer Beobachter*, where he described the art as "decadent, sectarian, and meaningless."

24. Brenner, "Art in the Political Power Struggle," 419.

25. Rudloff, *Kulturpolitik im "3. Reich" am Beispiel Emil Nolde*, 10.

26. Fest, *Face of the Third Reich*, 83–97.

27. Speer, *Inside the Third Reich*, 58.

28. Brock, Kunst auf Befehl?, 18. Note that Kollwitz, after an initial period of toleration, was silenced by the NS regime.

29. Backes, "Adolf Hitlers Einfluß," 103.

30. Lang, *Der Hitler-Junge*, 199.

31. Ibid., 103, and BAK, R55/92, Bl. 212. König's portrait of Goebbels is reproduced in Kroll, *Leo von König*.

32. Bramsted, *Goebbels and National Socialist Propaganda*, 189, and Orlow, *History of the Nazi Party, 1919–1933*, 8.

33. See, more generally, Hunt, "Joseph Goebbels."

34. Merker, *Die bildenden Künste*, 133.

35. Lane, *Architecture and Politics*, 152.

36. For a history of the RKK bureaucracy, see Schöndienst, "Kulturelle Angelegenheiten," 988–98. Also Steinweis, *Art, Ideology, and Economics*.

37. Merker, *Die bildenden Künste*, 131.

38. Ibid. Goebbels also hoped to lure Thomas Mann and Marlene Dietrich back from exile and mentioned Emil Nolde as a candidate to head one of the state art schools. Flavell, *George Grosz, 183*.

39. This warning came from Hans Hinkel in his article in the *Völkischer Beobachter* on 16 July 1933. Brenner, "Art in the Political Power Struggle," 406.

40. Brenner, "Art in the Political Power Struggle," 406. For more on this ambivalent speech by Hitler in September 1933, see Lane, *Architecture and Politics*, 180.

41. Lane, *Architecture and Politics*, 183.

42. Ibid., 149 (and in particular n. 10), 174.

43. Bramsted, *Goebbels and National Socialist Propaganda*, 76–87.

44. Backes, "Adolf Hitlers Einfluß," 110.

45. Sington, *Goebbels Experiment*, 110.

46. Rothfeder, "Alfred Rosenberg's Organization," 50.

47. Bramsted, *Goebbels and National Socialist Propaganda*, 76–87.

48. Ibid.

49. Lehmann-Haupt, *Art under a Dictatorship*, 68, and Adam, *Art of the Third Reich*, 53.

50. Dahm, "Die Reichskulturkammer als Instrument kulturpolitischer Steuerung," 53–84.

51. Lane, *Architecture and Politics*, 149.

52. Merker, *Die bildenden Künste*, 82.

53. Ibid., 131.

54. CDJC, CXLV-618, *Gründungs-Protokoll*, 4 January 1928.

55. Rothfeder, "Alfred Rosenberg's Organization," 28.

56. Broszat, *Hitler State*, xvii.

57. Lane, *Architecture and Politics*, 149.

58. Himmler also joined the organization early. See the protocol in CDJC, CXLV-618. Also Steinweis, "Weimar Culture and the Rise of National Socialism," 402–23, and Bollmus, *Das Amt Rosenberg*, 27–54.

59. Lane, *Architecture and Politics*, 150. In n. 14 she lists a number of academics involved with the KfdK.

60. Lane, *Architecture and Politics*, 150.

61. Ibid., 158.

62. Ibid., 152–61.

63. Ibid., 151.

64. Brenner, "Art in the Political Power Struggle," 405.

65. Wistrich, *Who's Who in Nazi Germany*, 210.

66. Merker, *Die bildenden Künste*, 133.

67. BAK, NS15/252, *Lebenslauf* (or curriculum vitae) of Robert Scholz. Scholz, an Austrian who became a German citizen in 1934, was a member of the NSDAP prior to the putsch attempt in 1923. Scholz also wrote for the *Steglitzer Anzeiger* and the *Deutsche Tageszeitung*.

68. Wilhelm Arntz Papers, box 26, Getty Center. See also Grote, "Museen und Ausstellungen," 999–1000. Other museum officials were released later in the year. Janda, "Fight for Modern Art," 107, and Haase, *Kunstraub und Kunstschutz*, 42. The dismissal of Reichskunstwart (Reich Art Warden) Edwin Redslob in March 1933 also constituted a victory for the conservatives. See Heffen, *Der Reichskunstwart*. For the firing of faculty at the art academies, see the chapter "Entlassungen von Professoren an den Kunstakademien" in Wirth, *Verbotene Kunst*.

69. For more on the *Schandausstellungen*, see Zuschlag, "'Educational Exhibition,'" 83–104.

70. Ibid., 98.

71. Barr, "Art in the Third Reich," 211–30.

72. Merker, *Die bildenden Künste*, 123.

73. Rothfeder, "Alfred Rosenberg's Organization," 51–52.

74. Balfour, *Propaganda in War*, 43.

75. Cecil, *Myth of the Master Race*, 175–78, and Snyder, *Hitler's Elite*, 151–52.

76. Zemon, *Nazi Propaganda*, 137.

77. Rothfeder, "Alfred Rosenberg's Organization," 43.

78. Ibid., 40.

79. Ibid., 53. Also Cecil, *Myth of the Master Race*, 113. Cecil notes that Rosenberg wrote to Hitler on 1 December 1933 informing him that if matters continued to deteriorate, "there would then be a compelling need for me to withdraw from the entire cultural activity of the NSDAP."

80. Lane, *Architecture and Politics*, 182, where Hans Hinkel is reported to have announced this merger on 17 December 1933.

81. Craig, *Germany*, 646.

82. Ibid., 595.

83. Broszat, *Hitler State*, xiii.

84. Hitler, *Mein Kampf*, 258–63, and Janda, *Das Schicksal einer Sammlung*, 62.

85. Broszat, *Hitler State*, 200.

86. Note that the DBFU was divided into subsections, with offices for *Kunstpflege* (the care or cultivation of art), *Vor- und Frühgeschichte* (pre- and early history), *Schrifttumspflege* (the care of writing), *Schulung* (schooling), and *Feierabend* (festivals).

87. BAK, NS15/169, 27 November 1935.

88. Rothfeder, "Alfred Rosenberg's Organization," 77.

89. Ibid., 82.

90. Hüneke, *Die Faschistische Aktion*, 8–9.

91. Rothfeder, "Alfred Rosenberg's Organization," 79.

92. Rosenberg to Rust, 14 April 1934, NAW, T-454, roll 74, frame 316.

93. Rosenberg to Schwarz, 14 April 1934, NAW, T-454, roll 77, frame 1234.

94. Rothfeder, "Alfred Rosenberg's Organization," 80.

95. Ibid., 21.

96. BAK, NS15/252.

97. Goebbels's 11 April 1934 "internal circular," as quoted in Broszat, *Hitler State*, 246.

98. Grunberger, *Twelve-Year Reich*, 58.

99. Ronald Smelser provides a sense of the scope of the KdF: "In 1938, 9.2 million used its vacation and travel facilities; 8.1 million went to theater performances and concerts . . . ; and 54 million [participated] in some aspect of the full panoply of amusements and diversions. By 1939 a German worker could take part in a different activity every night of the week without doing the same thing twice." Smelser, *Robert Ley*, 216–17.

100. Rothfeder, "Alfred Rosenberg's Organization," 73.

101. Merker, *Die bildenden Künste*, 136. Note that Ley was known to favor modern architecture. Brock, "Kunst auf Befehl?," 18.

102. Edward Peterson, *Limits of Hitler's Power*, 19.

103. Rothfeder, "Alfred Rosenberg's Organization," 75.

104. Ibid., 73.

105. Ibid., 94.

106. Ibid., 71. Also Brenner, "Art in the Political Power Struggle," 427.

107. Ley to Stang, 17 December 1934, NAW, T-454, roll 53, frame 477.

108. Rothfeder, "Alfred Rosenberg's Organization," 94–95, and Bollmus, *Das Amt Rosenberg*, 71–72.

109. Rothfeder, "Alfred Rosenberg's Organization," 96.

110. Ibid., 97.

111. Broszat, *Hitler State*, 246–47.

112. Giles, *Students and National Socialism*, 159.

113. Broszat, *Hitler State*, 246–47; also Zentner and Bedürftig, *Encyclopedia of the Third Reich*, 823.

114. Zentner and Bedürftig, *Encyclopedia of the Third Reich*, 823, and Edward Peterson, *Limits of Hitler's Power*, 53–54.

115. BAK, R2/4868, Bl. 33–35, unsigned *Vermerk* from the RFM, May 1934.

116. Ibid.

117. Ibid.

118. Ibid., Bl. 61–65, the protocol of the 19 June 1934 *Chefbesprechung*.

119. Ibid., Bl. 105, *Vermerk* from the RFM, 29 November 1934.

120. Ibid.

121. BAK, R21/203, Bl. 11–12, Zschintzsch to Rust, 24 June 1936.

122. Lehmann-Haupt, *Art under a Dictatorship*, 71.

123. BAK, R21/203, Bl. 11–12, Zschintzsch to Rust, 24 June 1936.

124. BAK, R2/4868, Bl. 199–201, Goebbels to Lammers, 20 February 1937.

125. Goebbels, *Tagebücher*, 2:368.

126. Wulf, *Die bildenden Künste*, 14.

127. Lehmann-Haupt, *Art under a Dictatorship*, 71, and Shirer, *Rise and Fall of the Third Reich*, 309.

128. Merker, *Die bildenden Künste*, 137, and Lang, *Der Hitler-Junge*, 202. Schirach's sympathy for a more liberal *Kulturpolitik* is also in evident in his correspondence with Rosenberg, BAK, NS8/165 and NS8/212.

129. BAK, NS8/171, Bl. 157–59, Rosenberg to Goebbels, 19 February 1936, where he discusses his appeal to the Gestapo to confiscate the periodical *Kunst der Nation*.

130. Backes, "Adolf Hitlers Einfluß," 112.

131. Merker, *Die bildenden Künste*, 133. Other modern artists, including Emil Nolde, Max Pechstein, and Erich Heckel, also petitioned Nazi leaders in the hope of finding official acceptance. Reuth, *Goebbels*, 368. See also their personal files, BDC.

132. Merker, *Die bildenden Künste*, 135.

133. BAK, R43II/1237, Bl. 38, Goebbels (represented by Keudell) to the Reich Chancellery, 6 August 1935. See also the Barlach file, BDC, Bernhard Boehmer to Goebbels, 5 August 1935.

134. BAK, R43II/1237, Bl. 38, Goebbels (represented by Keudell) to the Reich Chancellery, 6 August 1935.

135. BAK, NS8/171, Bl. 209–14, Goebbels to Rosenberg, 25 September 1934.

136. Zweig, *World of Yesterday*, 271–93. Prior to the interception of the "seditious" letters, Goebbels had repeatedly defended Strauss against Rosenberg's attacks; see BAK, NS8/171, for their exchange of letters.

137. Grunberger, *Twelve-Year Reich*, 407.

138. Balfour, *Propaganda in War*, 44; Grunberger, *Twelve-Year Reich*, 111–12; Steinweis, *Art, Ideology, and Economics*, 56–58; Cuomo, "Hanns Johst und die Reichsschrifttumskammer," 120, 130; and Ritchie, *German Literature*, 99.

139. Balfour, *Propaganda in War*, 43.

140. BAK, NS15/169, a *Völkischer Beobachter* clipping, 5 March 1935.

141. BAK, NS1/553, Bl. 18–19, Rosenberg to Schwarz, 15 December 1938.

142. Lane, *Architecture and Politics*, 182.

143. Domarus, *Hitler: Speeches and Proclamations*, 2:695.

144. Balfour, *Propaganda in War*, 44.

145. Welch, *Propaganda and the German Cinema*, 16.

146. Goebbels, *Tagebücher*, 2:554.

147. Fest, *Face of the Third Reich*, 83–97.

148. Bramsted, *Goebbels and National Socialist Propaganda*, 197.

149. That Goebbels was inclined to think of these three as allies is reflected in his diaries; see, for example, the 21 August 1935 entry, where he accused them of "*kultischer Unfug*" (cultish mischief). Goebbels, *Tagebücher*, 2:504.

150. Ibid., 533.

151. Ibid., 544.

152. Ibid., 526.

153. Ibid., 733–34, 22 November 1936.

154. Balfour, *Propaganda in War*, 44, and Bramsted, *Goebbels and National Socialist Propaganda*, 84–85.

155. For evidence that the senate did hold meetings, see Goebbels's journal entry for 17 November 1935, Goebbels *Tagebücher*, 2:541. See also the list of eighty-three participants in BAK, R55/165, Bl. 85–90, 1938 (undated), and BAK, R18/297, a meeting at the Deutsches Opernhaus in December 1941. By this time the RKS functioned as an executive committee of the RKK.

156. BAK, NS8/171, Bl. 173, Goebbels quoting Rosenberg's *Rundschreiben* in a 7 November 1935 letter to Rosenberg.

157. Ibid.

158. Goebbels, *Tagebücher*, 2:537, 9 November 1935.

159. Balfour, *Propaganda in War*, 44.

160. Goebbels, *Tagebücher*, 2:541.

161. Ibid.

162. Ibid.

CHAPTER TWO

1. Merker, *Die bildenden Künste*, 136.

2. Broszat, *Hitler State*, 294.

3. Arntz, "Bildersturm in Deutschland," part 2 (May 1962), "Die Verhöhnung der Bilder," 45.

4. Bramsted, *Goebbels and National Socialist Propaganda*, 194.

5. Zuschlag, "'Educational Exhibition,'" 100–101.

6. Exhibition themes included folk art, Frederick the Great, and "Sport in Hellenic Times." Hart-Davis, *Hitler's Games*, 130, 148.

7. Ziegler file, BDC, for an exchange of letters. For Darré's considerable influence prior to 1938, see Broszat, *Hitler State*, 301.

8. Hitler paid Ziegler RM 5,000, even though the artist only asked for RM 1,000. Amtsgericht Munich, Spruchkammer file, H/10451/53, brief of Bandorf and Baumann, 24 March 1953.

9. Cultural editors were also required to be thirty years of age. *Mitteilungsblatt der RkdbK*, December 1936.

10. Backes, "Adolf Hitlers Einfluß," 373.

11. Ibid., 375.

12. Dünkel in "Die Liquidierung der Kunst," 48. The themes of the nine rooms are summarized by the exhibition catalog, *Führer durch die Ausstellung Entartete Kunst*, which was produced in the late autumn of 1937. The organizational schema was as follows: (1) "demoralization of form and color" (i.e., abstraction); (2) mockery of religion; (3) political subversion (with anarchy being the main focus); (4) more politically offensive themes (esp. Marxism and pacifism); (5) immorality (e.g., "the whore as idol"); (6) examples of art that destroyed racial consciousness; (7) "idiots and cretins"; (8) Jews; (9) art that they asserted had come from the insane.

13. Hansen, *Judenkunst in Deutschland*. The link between antimodernism and racial anti-Semitism extends beyond Hansen's work and can be found, for example, in H. F. K. Günther, *Rasse und Stil*, and Schultze-Naumburg, *Kunst und Rasse*. See also Gilman, "Mad Man as Artist," 589–92.

14. Goebbels, *Tagebücher*, 2:521, 554, 4 October and 15 December 1935.

15. A twenty-four-year-old Austrian named Hartmut Pistauer was the chief organizer of the exhibition. Zuschlag, "'Educational Exhibition,'" 90. The famous 30 June 1937 decree from Goebbels is reprinted in Diether Schmidt, *In letzter Stunde*, 217.

16. Hüneke, "On the Trail," 123. See also Goebbels, *Tagebücher*, 3:166.

17. von Lüttichau, "'Deutsche Kunst' und 'entartete Kunst,'" 96–103.

18. Janda, "Fight for Modern Art," 112. Regarding their character and tactics, Willrich was so aggressive that Himmler advised him to ease his attacks, while Hansen was known as one of the most strident cultural ideologues. Doster and Salchow, *Gottfried Benn*, 241–45, and von Lüttichau, "'Deutsche Kunst' und 'entartete Kunst,'" 96–97. For Willrich's art, see Just, *Nordisches Blutserbe*.

19. Janda, "Fight for Modern Art," 113.

20. See Willrich's discussion of difficulties in his letter to Darré, 30 April 1937, cited in Wulf, *Die bildenden Künste*, 313–16; see also Hüneke, "On the Trail," 123.

21. Janda, "Fight for Modern Art," 113. Also Janda, *Das Schicksal einer Sammlung*; Hentzen, *Die Berliner Nationalgalerie im Bildersturm*; and Rave, *Die Geschichte der Nationalgalerie Berlin*.

22. von Lüttichau, "'Entartete Kunst,'" 96; Hinz, *Art in the Third Reich*, 39; and Zweite, "Franz Hofmann und die Städtische Galerie," 262–68.

23. von Lüttichau, "'Deutsche Kunst' und 'entartete Kunst,'" 96.

24. Goebbels, *Tagebücher*, 3:274, 22 September 1937. Also Dünkel, "Die Liquidierung der Kunst," 51.

25. Brenner, *Die Kunstpolitik des Nationalsozialismus*, 109.

26. Lott, "Münchens Neue Staatsgalerie," 292.

27. Ziegler speech, 19 July 1937, reprinted in Peter-Klaus Schuster, *Nationalsozialismus und "Entartete Kunst,"* 217.

28. Baudissin had begun calling for the confiscation of modern art in private

collections during the previous year. "Der Kampf gegen 'entartete Kunst,' " in the *Frankfurter Zeitung* 497, 28 September 1936.

29. Hinz, *Art in the Third Reich*, 39–40.

30. von Lüttichau, " 'Deutsche Kunst' und 'entartete Kunst,' " 97.

31. Arntz, "Bildersturm in Deutschland," part 2 (May 1962), "Die Verhöhnung der Bilder," 46. There were other cases where confusion and indecision reigned: for example, the sculptor Rudolf Belling had works simultaneously in both the *Entartete Kunst* and *GDK* exhibitions. John Dornberg, "Munich," 39. Arno Breker, who became a much lauded figure in the Third Reich, also had one of his early works confiscated. Hüneke, "On the Trail," 124, and Wirth, *Verbotene Kunst*, 257.

32. Zuschlag, " 'Educational Exhibition,' " 102–3.

33. Dünkel, "Die Liquidierung der Kunst," and Dünkel, "Die Verzögerte Heimkehr der Verfemten," 65–69.

34. Goebbels, *Tagebücher*, 3:251.

35. Bussmann, "Degenerate Art," 113–24, and Städtische Kunsthalle, Mannheim, *Entartete Kunst.*

36. For the annual attendance figures of the *GDK*, which are taken from the *Mitteilungsblatt der RkdbK*, see Thomae, *Die Propaganda-Maschinerie*, 41.

37. Heinrich Hoffmann, *Hitler Was My Friend*, 170.

38. Steele, "Die Verwaltung der bildenden Künste," 201.

39. Note that Hitler issued two decrees of empowerment to Ziegler, on 14 July and 4 August 1937. Goebbels, *Tagebücher*, 3:202–3, 226, 15 July and 5 August.

40. BAK, R43II/1646, Bl. 133, Göring to Rust, 28 July 1937.

41. Hüneke, "On the Trail," 124.

42. Wulf, *Die bildenden Künste*, 350.

43. BAK, R43II/1646, Bl. 133, Göring to Rust, 28 July 1937.

44. Ibid., Bl. 134, Göring to Rust, 28 July 1937.

45. Goebbels, *Tagebücher*, 3:214.

46. Ibid., 224–25.

47. Nicolaus, "Als Hitlers Kunst-Schergen Kamen," 79–85, and Dünkel, "Die Liquidierung der Kunst."

48. Hüneke, "On the Trail," 124.

49. BAK, R2/Anhang/26.

50. Herzstein, *War That Hitler Won*, 129.

51. BAK, R2/12947, Goebbels's *Rundschreiben*, 21 December 1938.

52. Ibid., an RMWEV *Rundschreiben* by Zschintzsch on behalf of Rust, 5 January 1939, and Frick's *Rundschreiben*, 5 January 1939.

53. Ibid., Frick's *Rundschreiben*, 5 January 1939.

54. Ibid., *Vermerk* from the RFM, 10 January 1939.

55. Ibid., notes of the 21 February 1939 *Kommissarische Besprechung*. On 21 March a revised protocol (*Niederschrift*) was signed concerning the "Protection of German Cultural Goods": the RMVP had authority over *lebende Kunst*; the RMdI oversaw archival materials, while the RMWEV supervised all other art.

56. Gulick, *Europe's Classical Balance of Power*, 30.

57. BAK, NS8/171, Bl. 117–18, Rosenberg to Goebbels, 31 March 1936.

58. CDJC, CXXIXA-105, Himmler to Rosenberg, 8 April 1936.

59. Rothfeder, "Alfred Rosenberg's Organization," 97–98.

60. Ibid., 100.

61. BAK, NS10/63, Bl. 133–34, Hess to Ley, 7 January 1937. See also Rothfeder, "Alfred Rosenberg's Organization," 101.

62. Rothfeder, "Alfred Rosenberg's Organization," 102.

63. Ibid.

64. Balfour, *Propaganda in War*, 51, 106–9.

65. Kater, *Nazi Party*, 196.

66. BAK, R43II/477a, Bl. 54, announcement from the Zentralverlag der NSDAP, 7 February 1938.

67. Rosenberg yielded to Wilhelm Weiss as editor of the *Völkischer Beobachter* in January 1938 but stayed on as publisher.

68. CDJC, CXLIII-363, Bormann to Rosenberg, 29 June 1939. Also Rothfeder, "Alfred Rosenberg's Organization," 222, and BAK, NS10/25, Bl. 141–52.

69. Even Goebbels called the magazine "an outstanding periodical." BAK, R55/119, Bl. 51, Goebbels to Meissner, 28 June 1939.

70. Rothfeder, "Alfred Rosenberg's Organization," 102–7.

71. BAK, R55/119. Note that in 1933 Scholz had penned the influential memorandum "Reform der staatlichen Kunstpflege" (which demanded a purge of museums). Wulf, *Die bildenden Künste*, 449. For a list of a number of Scholz's art reviews, see Hüneke, "On the Trail," 132.

72. BAK, R55/1000, Bl. 2 and 9, for letters of recommendation from Speer and Troost, 30 May and 17 August 1939.

73. Ibid., Bl. 2–57, for the files concerning Scholz and others being considered as the head of the RMVP's Abteilung Bildende Kunst in 1939.

74. BAK, NS8/255, Bl. 40, Scholz to Philo von Trotha, 6 October 1935.

75. See, for example, the cordial correspondence between Rosenberg and Himmler (via their adjutants) in CDJC, CXXIXA-99, Koeppen to Wolff, 22 December 1936.

76. Goebbels, *Tagebücher*, 2:676, 10 and 11 September 1936, for his critical comments about Rosenberg's oratorical skills.

77. BAK, NS8/253, Bl. 22, Programm der Reichstagung der NS-KG, June 1936.

78. CDJC, CXXIXA-84, Rosenberg to Himmler, 7 March 1938.

79. BAK, NS8/253, Bl. 94, Rosenberg to Stang, 7 January 1936.

80. BAK, NS8/253, for the extensive correspondence concerning the reciprocal exhibitions.

81. Ibid., Bl. 30, Mahlo (of the RMVP) to Rosenberg, 5 December 1938, and BAK, NS8/253, Bl. 122–60.

82. Balfour, *Propaganda in War*, 44.

83. Matthias Schmidt, *Albert Speer*, and Lane, "Architects in the Service of Power." See also Gable, *Albert Speer*.

84. Speer, *Inside the Third Reich*, 54–63.

85. See Speer file, BDC. Speer held the position of Abteilungsleiter in the

RMVP. Speer, *Inside the Third Reich*, 94. For Goebbels introducing Speer to Hitler, see Matthias Schmidt, *Albert Speer*, 43.

86. Rabinbach, "Beauty of Labour," 43–74.

87. Goebbels, *Tagebücher*, 2:659, 11 August 1936. Also Karetnikova and Golomstock, "Totalitarian Culture," 42–45, and Düsseldorf Städtische Kunsthalle, *"Die Axt hat geblüht."*

88. Goebbels, *Tagebücher*, 3:123, 25 April 1937.

89. Ibid., 166, 5 June 1937.

90. Matthias Schmidt, *Albert Speer*, 46.

91. Speer, *Inside the Third Reich*, 203–5.

92. BAK, R2/26722, Bl. 5–6.

93. BAK, R2/26723, Bl. 98, a RFM *Erlaß*, 5 April 1938.

94. BAK, R3/1735, Bl. 77–78, for the *Speerchronik*, a journal compiled by Rudolph Wolters, a close friend of Speer, who acted as the GBI's commissioner for the *Exhibition of New German Architecture*. BAK, R3/1598, for Speer's correspondence with Franco and other Spanish officials.

95. BAK, R120/125, Bl. 12–14.

96. BAK, R3/1580, Bl. 31.

97. BAK, R120/1479.

98. PrGSta, Rep. 151/13467, Rust to the president of the Preußische Akademie der Künste (unnamed), 10 February 1937.

99. Ibid.

100. PrGSta, R151/13468. After a temporary relocation on the Schadowstraße, the Akademie moved into the "cleansed" Kronprinzenpalais on Unter den Linden. Speer, *Inside the Third Reich*, 119.

101. BAK, R3/1735, Bl. 28, for Göring's effusive remarks in April 1941, as quoted by Wolters in the *Speerchronik*.

102. Matthias Schmidt, *Albert Speer*, 49.

103. Ibid. 50–52. See also the contributions in Reif, *Albert Speer*.

104. Kwiet, "'Material Incentives,'" 245–46.

105. Grasskamp, "De-Nazification of Nazi Art," 232. The stone adorning the Congress Hall in Nuremberg, for example, came from Flossenbürg. Speer, *Inside the Third Reich*, 201–2, and Dülffer et al., *Hitlers Städte*, 242–43.

106. BAK, NS8/167, Bl. 75–77, Rosenberg to Speer, 22 June 1940. The museum was to have ties to Rosenberg's network of Hohe Schulen, which also were based on racist conceptions.

CHAPTER THREE

1. Merker, *Die bildenden Künste*, 157–58; Brenner, *Ende einer bürgerlichen Kunst-Institution*; and Hochman, *Architects of Fortune*, 127–44.

2. BAK, R2/4868, Bl. 245–60.

3. Hüneke, "On the Trail," 124–25, and Goergen, "'X' heißt Vernichtung," 47–52.

4. Hüneke, "On the Trail," 124.

5. Zweite, "Franz Hofmann und die Städtische Galerie," 283.

6. BAK, R55/76, Bl. 118, an inhouse memorandum from Ministerialrat Otto, and BAK, R2/4868, Bl. 215, RMVP to RFM, 14 October 1937. Also Goebbels, *Tagebücher*, 3:399–400, 13 January 1938.

7. Goebbels, *Tagebücher*, 3:401–3, 14 January 1938. Also, BAK, R55/698, Bl. 54, 15 April 1942, an RMVP memorandum from the Abteilung Bildende Kunst to Dr. Lucerna. Also Goergen, "'X' heißt Vernichtung," 50.

8. There were, however, recent precedents for this government disposal action. Arntz, "Bildersturm in Deutschland," part 3 (July 1962), "Das Schicksal der Bilder," 28–29.

9. Goebbels, *Tagebücher*, 3:445, 494, 18 May and 29 July 1938.

10. Scholz, *Architektur und bildende Kunst*, 45.

11. BAK, R55/76, Bl. 115–16, Ziegler to Goebbels, 3 June 1938, for the eagerness of many dealers. Hüneke, "On the Trail," 125–27, and "Dubiose Händler," 104. The Colnaghi offer is communicated in a letter to Hitler, 19 October 1938, cited in Strauss, "Dokumente zur entarteten Kunst," 226.

12. For art dealers in Nazi Germany, see Arntz's series "Bildersturm in Deutschland"; Hüneke, "On the Trail," and "Dubiose Händler"; and Zweite, "Franz Hofmann und die Städtische Galerie."

13. BAK, NS10/339, Bl. 95, Haberstock to Wilhelm Brückner (Hitler's adjutant), 20 May 1938.

14. Goebbels personally announced the law on 31 May 1938; it was published under his and Hitler's names in the *Reichsgesetzblatt* of 2 June 1938. Goebbels also organized the drafting of the law. BAK, R2/4868, Bl. 245–48.

15. BAK, R2/4868, Bl. 249, Rust's *Rundschreiben*, 24 March 1938, and Bl. 223, RMWEV to the RMVP, 27 December 1937. Also BAK, R21/209, Bl. 136, a *Vermerk* by Staatssekretär Zschintzsch, 11 May 1938.

16. BAK, R21/209, Rust to Goebbels, 27 December 1937, and BAK, R2/4868, Bl. 225, a memorandum by Funk, 10 December 1937.

17. BAK, R43II/1235b, Bl. 72, a letter from the RMVP (anonymous) to Lammers. For proof that Rust and the RMWEV received compensation from the RMVP, see PrGSta, Rep. 151, 10/689, Hermann (of the RMWEV) to the Generaldirektor der Staatlichen Museen für die Nationalgalerie, 3 June 1941. Also Lott, "Münchens Neue Staatsgalerie," 297.

18. BAK, R55/76, Bl. 115–16, Ziegler to the RMVP, 3 June 1938. The paintings that were transferred to Göring were Paul Cezanne's *The Quarry*; Vincent Van Gogh's *Corn Field*, *The Garden of the Daubignys*, *Loving Couple*, and *Portrait of Dr. Gachet*; Franz Marc's *Tower of the Blue Horses*, *Deer*, and *Three Doe*; Edvard Munch's *The Embrace*, *Snow Storm*, *Melancholy*, and *Meeting at Sea*; and Paul Signac's *Harbor*. Note that the paintings taken by Göring have an average value far higher than those auctioned publicly in Lucerne. *Portrait of Dr. Gachet*, for example, was auctioned for $82.5 million on 15 May 1990, making it to date the most expensive artwork ever sold. Nickerson, "West Irked by Paid-In-Japan Art," 2a.

19. Certain scholars have claimed that Göring stored degenerate artworks in Carinhall. Lehmann-Haupt, *Art under a Dictatorship*, 82, and Marquis, *Alfred Barr*, 177.

20. PrGSta, Rep. 90, *Akte* 2464. Bl. 1–2, a Preußisches Staatsministerium *Vermerk*, 5 May 1938.

21. Ibid., Bl. 34–44. Also NAW, RG 260/438, MFA and A interrogation of Angerer, 20 May 1947.

22. PrGSta, Rep. 90, *Akte* 2464, Preußisches Staatsministerium *Vermerk*, 5 May 1938. *Sperrmarks* came about in the mid-1930s when the German government blocked the export of currency owned by foreigners; such funds could still be used to purchase goods within the Reich, as in this case.

23. Ibid., Bl. 34, 57.

24. Ibid., Bl. 58–61, 17 December 1939.

25. Ibid., Bl. 13, 23 June 1938.

26. William Shirer, in an interview conducted by the author at Shirer's home in Lennox, Massachussetts, on 27 October 1989, reported the Kokoschka affair. He claimed that Göring offered him the Kokoschka as a favor because Shirer had helped the Nazi leader secure a contract with the Hearst Newspaper Syndicate.

27. PrGSta, Rep. 90, *Akte* 2464, Bl. 34.

28. Ibid., *Akte* 90, Bl. 3, Göring to Funk, May 1938 (undated).

29. Ibid., *Akte* 2464, Bl. 58–61, Göring to the Preußisches Staatsministerium, 17 December 1939.

30. Ibid., Bl. 63–65, letters dating from February 1940. Some scholars have maintained that Göring did not indemnify the museums. Arntz, "Bildersturm in Deutschland," part 3 (June 1962), "Das Schicksal der Bilder," 33.

31. Arntz, "Bildersturm in Deutschland," part 3 (July 1962), "Das Schicksal der Bilder," 26.

32. BAK, NS10/116, Bl. 33, a *Vermerk*, 19 November 1938.

33. Arntz, "Bildersturm in Deutschland," part 3 (June 1962), "Das Schicksal der Bilder," 31.

34. For revenues from the sales going to the war machine, see the anonymous article, "Fischer Auktion in Lucerne" in *Die Weltwoche* (16 July 1987), *Kultur* section, 1. Also Janda, "Fight for Modern Art," 114; Nicholas, *Rape of Europa*, 3–5; and, for the reports on the meetings of the Disposal Commission, Diether Schmidt, *In letzter Stunde*, 233–38.

35. BAK, NS10/116, Bl. 33, Hofmann to Bormann, 19 November 1938. Also BAK, NS10/339, Bl. 84, Haberstock to Julius Schaub, 26 November 1938.

36. Zweite, "Franz Hofmann und die Städtische Galerie," 284, and Barron, "Galerie Fischer Auction," 137.

37. BAK, NS10/116, Bl. 33, Hofmann to Bormann, 19 November 1938.

38. See the London *Times*, 17 May 1939, 13b. An auction catalog was also published and distributed; see Fischer, *Gemälde und Plastiken moderner Meister*.

39. London *Times*, 4 July 1939, 14b. Also Kreis, "Entartete Kunst in Basel," 163–89.

40. London *Times*, 4 July 1939, 14b.

41. Ibid. The London *Times* article noted that it was "surprising" that there were no buyers for the latter work, as it had been a showpiece of the Hamburger Kunsthalle. Barron, "Galerie Fischer Auction," 144.

42. Arntz, "Bildersturm in Deutschland," part 3 (June 1962), "Das Schicksal der Bilder," 31.

43. After this second sale, eleven works remained in Fischer's care. These were sold en bloc to another Swiss art dealer in 1942 for 4,000 Sf. Ibid., 32.

44. Fischer, "My Point of View," as quoted in Barron, "Galerie Fischer Auction," 139.

45. Ibid., 140.

46. On 22 February 1939 Goebbels endorsed Hofmann's suggestion to burn those works considered unsellable. See Roh, *"Entartete" Kunst*, 53.

47. Hüneke, "On the Trail," 128, and Zweite, "Franz Hofmann und die Städtische Galerie," 284.

48. Hüneke, "On the Trail," 128, and Goergen, "'X' heißt Vernichtung," 50.

49. Zweite, "Franz Hofmann und die Städtische Galerie," 284.

50. The immolation in March 1939 only became public knowledge after the war, as first revealed by Paul Rave in *Kunstdiktatur*, 53. Wilhelm Arntz initiated a debate in 1962 with his series of articles in *Das Schönste*. Arntz argued that the number of paintings claimed to have been destroyed by the RMVP was greatly exaggerated to impress Hitler. This revisionism, however, has deservedly not found wide acceptance among scholars and museum experts. Bussman, "Degenerate Art," 113–24. Even less is known about the fires in the Tuileries in Paris on 27 May 1941 and 23 July 1943, where among old frames and storage containers a number of modernist artworks may have been burned. See the exhibition *Faszination und Gewalt*, Zepplin-tribüne, Nuremberg, and Rose Valland, "Bildersturm in Frankreich," in *Das Schönste* (February 1963), 68–69.

51. BAK, R55/698, Bl. 57, Hofmann to Arnold, 11 January 1940.

52. For Goebbels's report of 4 July 1941, see Backes, "Adolf Hitlers Einfluß," 391–92.

53. For a list of works acquired by dealers at scandalous prices, see Nicholas, *Rape of Europa*, 24–25.

54. Arntz, "Bildersturm in Deutschland," part 3 (June 1962), "Das Schicksal der Bilder," 34, and Hüneke, "On the Trail," 129.

55. BAK, R2/4868, Bl. 244–46, for the opinions of Frick and Hess on the *entartete Kunst* law.

56. BAK, R55/698, Bl. 54, RMVP memorandum, 15 April 1942.

57. Ibid., Bl. 55, Lucerna to Rust, 29 April 1942.

58. Lott, "Münchens Neue Staatsgalerie," 297. For the Baarova affair, see Heiber, *Goebbels*, 240–51.

59. For more on the *Modell Wien*, see Aly and Heim, *Vordenker der Vernichtung*, 33–42. Ninety percent of Austria's Jewish population lived in Vienna. There were approximately 170,000 Jews in the capital just prior to annexation. Pauley, *From Prejudice to Persecution*, 209, 284.

60. Hofmann, "Up and Down Somebody Else's Stairs," 385–86.

61. There have been claims that Louis de Rothschild's art collection entailed 400,000 objects. Roxan and Wanstall, *Rape of Art*, 26–27. Also Kurz, *Kunstraub in Europa*, 18–20.

62. Kurz, *Kunstraub in Europa*, 41, and Hofmann, *The Viennese*, 277–78.

63. Kubin, *Sonderauftrag Linz*, 21–23. More typical is George Leitmann's report that his family lost artworks, including a painting by Jan Steen, as part of the *Kristallnacht* riots (9 November 1938). See Decker, "Legacy of Shame," 56.

64. The "Verordnung über die Anmeldung des Vermögens der Jüden," signed by Göring and Frick, in *Reichsgesetzblatt* (I, 1938), 414.

65. For a concise overview of anti-Jewish measures for the period dating from the Nuremberg Laws of 1935 to those decrees of January 1939, see Dawidowicz, *War against the Jews*, 95–106, and the IMT proceedings in Nuremberg, doc. 3450-PS.

66. Dawidowicz, *War against the Jews*, 58, and Majer et al., *Recht, Verwaltung, und Justiz*, 269.

67. Rathkolb, "Nationalsozialistische (Un-) Kulturpolitik in Wien," 260–65.

68. BAK, R43II/1269a, Bl. 157–60, a Lammers' *Vermerk*, 30 January 1939, in which he reports on a 23 January 1939 letter from Himmler. Also Luza, *Austro-German Relations*, 279–80.

69. BAK, R43II/1269a, Bl. 5, Lammers to Himmler, 18 June 1938.

70. Ibid., Bl. 27, Himmler to Lammers, and Bl. 31, Lammers to Himmler, 13 August 1938, for Hitler's negative response.

71. Nicholas, *Rape of Europa*, 41.

72. Wulf, *Die bildenden Künste*, 337.

73. BAK, R43II/1269a, Bl. 53–54, Lammers's *Vermerk*, 7 November 1942.

74. Edward Peterson, *Limits of Hitler's Power*, 39.

75. Kurz, *Kunstraub in Europa*, 36.

76. BAK, R43II/1269a, Bl. 166–67, a *Vermerk* from the Reich Chancellery, 25 February 1939.

77. Ibid., Bl. 174, Heydrich to Lammers, 26 April 1939, and BAK, R43II/1269g, Bl. 8–30.

78. BAK, R43II/1269a, Bl. 167–68, Lammers to Himmler, 30 March 1939; Bl. 177, Lammers to Seyss-Inquart, 4 May 1939; and Bl. 171, Kritzinger to Haberstock, 6 April 1939.

79. Bormann to Posse, 16 May 1940, attachment 4 of Faison, "Supplement to CIR No. 4."

80. Rathkolb, "Nationalsozialistische (Un-) Kulturpolitik in Wien," 262–65.

81. BAK, R43II/1269a, Bl. 191–200, Haberstock to the Reich Chancellery, 6 June 1939.

82. Ibid., Bl. 176, Reich Chancellery *Vermerk*, 4 May 1939.

83. Ibid., Bl. 186–87, 200–213, June 1939 (undated).

84. ÖSta, AdR, Bürckel Material, No. 2429, Bürckel to Bormann, 25 May 1939.

85. BAK, R43II/1269a, Bl. 166–67, a Reich Chancellery *Vermerk*, 25 February 1939. Also BAK, NL180 (*Nachlaß* Seyss-Inquart)/61, Seyss-Inquart to Hitler, 4 May 1939.

86. Seydewitz and Seydewitz, *Das Dresdener Galeriebuch*, 130, and Roxan and Wanstall, *Rape of Art*, 18.

87. Roxan and Wanstall, *Rape of Art*, 18, and Kubin, *Sonderauftrag Linz*, 14–18.

88. The main architects for Linz were Hermann Giesler and Roderich Fick,

although Speer was awarded the plum projects of the art gallery and the stadium. Hitler provided Speer with sketches of his ideas. Speer, *Inside the Third Reich*, 147.

89. BAK, R43II/1269d, Bl. 55, Gottfried Reimer to Lammers, 7 February 1944.

90. BAK, R43II/1269a, Bl. 200–210, Friedrich Plattner to Lammers, 26 September 1939.

91. Kubin, *Sonderauftrag Linz*, 24, and Faison, "CIR No. 4," attachment 72. Pieces noted here include Cranach the Younger's *Melanchthon*, Rembrandt's *Portrait of Anthonis Coopal*, and two Frans Hals portraits. Ultimately Posse took 327 works from the Austrian depot for Linz. Kurz, *Kunstraub in Europa*, 62.

92. For Posse's initial proposal, 20 October 1939, see Faison, "Supplement to CIR No. 4," attachment 72.

93. The Posse-Seiberl correspondence from 1940–43 is in the OFD, folder IV.

94. BAK, R43II/1269a, Bl. 212, Lammers to Bürckel, 1 November 1939.

95. Kurz, *Kunstraub in Europa*, 22–23, and Roxan and Wanstall, *Rape of Art*, 31. BAK, NL180/3, the Seyss-Inquart and Koch correspondence.

96. Kurz, *Kunstraub in Europa*, 23, 46, and BAK, R43II/1269a, Bl. 188–200, Ott of the RMVP to Lammers, May 1939 (undated).

97. Vlug, *Report on Objects Removed to Germany*, 32, 103–4, and the OMGUS report on Schirach, OMGUS, 5/347–3/3. See also ÖSta, Verwaltungsarchiv file on the Vugesta. More generally, see Rosenkranz, *Verfolgung und Selbstbehauptung*, 229–43.

98. ÖSta, AdR, NS Parteistellen, Karton 40, Gauschatzmeister Wien to Reichsschatzmeister, 7 April 1941.

99. OFD, *Akte* 200, Bürckel to Mühlmann, 23 June 1939, and BAK, NL180/3, the correspondence between Seyss-Inquart and Bürckel, beginning in June 1939.

100. Rathkolb, "Nationalsozialistische (Un-) Kulturpolitik in Wien," 263. Some scholars have asserted that Hitler personally ordered Mühlmann's dismissal due to differing views of the redistribution plan. Nicholas, *Rape of Europa*, 41, 66.

101. Mühlmann was a well-known figure in Austria prior to the *Anschluß*. He had previously worked as the Propagandaleiter of the Salzburg festival and accompanied Schuschnigg to Berchtesgaden on 12 February 1938, when Hitler and the Austrian chancellor had their famous meeting. Because Seyss-Inquart appointed him Staatssekretär after his forty-eight-hour tenure as chancellor, many, including Bürckel, did not recognize the title. The contentious correspondence is reprinted in Roser, *Deutsche Gemeinschaft*, 340–65.

102. BAK, NL180/3, for Göring's and Himmler's intervention; also Seyss-Inquart file, BDC, and Kurz, *Kunstraub in Europa*, 39–40.

103. Bürckel and Seyss-Inquart continued to feud even after the latter's departure from the city. Seyss-Inquart file, BDC, Kaltenbrunner to Himmler, 22 December 1939.

104. Barkai, "Arisierung," 84–87, as well as *From Boycott to Annihilation*. Lucy Dawidowicz noted that the pace of Aryanization picked up in the Reich after September 1938. Prior to this point about fifty Jewish businesses per month

were transferred to Aryan owners. Starting in the autumn of 1938, this number increased to 235 (a pace comparable to that in Austria). Dawidowicz, *War against the Jews*, 97.

105. BAK, R43II/1238c, Bl. 17, and R43II/1269d, Bl. 15, *Anordnung* published in report of the Deutsches Nachrichtenbüro, 27 May 1941.

106. Majer et al., *Recht, Verwaltung, und Justiz*, 266.

107. Barkai, *From Boycott to Annihilation*, 136–37.

108. OMGUS, 5/347–1/9, report of 23 January 1946. More generally, Selig, "Judenverfolgung in München," 398–415.

109. BAK, R2/31098, Munich Oberfinanzpräsident Wiesensee to Staatssekretär Reinhardt (RFM), 2 March 1942.

110. Ibid. Also Schütz, *München*, 402–17.

111. BAK, R2/31098, Wiesensee to RFM Krosigk, 9 March 1942.

112. Ibid.

113. Ibid., Wagner to Reinhardt, 25 February 1942.

114. Ibid. Wagner notes that the galleries paid the *Kaufpreis* (purchase price) to the Gestapo, as determined by an unspecified commission. He also notes that Hitler gave permission to the museums to buy the seized art on 7 November 1940.

115. BHSA, MK 51498, Bayerisches Nationalmuseum to the Bayerisches Staatsministerium für Unterricht und Kultus, 16 August 1948.

116. BAK, R2/31098, "Verzeichnis der Juden, bei denen Kunstgut sichergestellt würde," undated.

117. BAK, R2/31098, Robert Scherer to Professor Rauch, 23 December 1941. For the hunt for the *Mystic Lamb* altar, see Plaut, "DIR No. 2: Ernst Buchner." Buchner also advised in the safeguarding of stolen artworks from French Jews in Neuschwanstein. See IfZG, MA-1452, 0154693, Buchner to Bormann, 30 January 1941.

118. BAK, R2/31098, "Verzeichnis der Juden, bei denen Kunstgut sichergestellt würde," 8.

119. Bradley, *Emil Nolde*, 175–78.

120. Grosshans, *Hitler and the Artists*, 76, and Lehmann-Haupt, *Art under a Dictatorship*, 126. Himmler's office also published an annual blacklist for literature. This list has been recently reprinted: Himmler, *Liste des schädlichen und unerwünschten Schrifttums*.

121. BAK, NS15/69, Bl. 18, Amt für Kunstpflege to Gestapo, 8 August 1935. The letter concerns the political reliability of sculptor Edwin Scharf.

122. Lehmann-Haupt, *Art under a Dictatorship*, 144.

123. Ibid., 158, and Manvell and Fraenkel, *Himmler*, 50. More generally, see Kater, "Das Ahnenerbe."

124. Manvell and Fraenkel, *Himmler*, 50.

125. Karl Wolff also played an important role in soliciting donations. Lang, *Der Adjutant*, 54–58. Also, Vogelsang, *Der Freundeskreis Himmler*.

126. There were forty-six officially sanctioned projects, which were organized into "research institutes." Friemuth, *Die geraubte Kunst*, 17.

127. Padfield, *Himmler*, 170.

128. BAK, NS21/227.

129. BAK, NS21/228, Sievers to Cerff, 27 July 1943.

130. Bunjes file, BDC, letter of rejection from the scholarship committee, June 1938.

131. This appointment came via a *Führererlaß*, 7 October 1939. Manvell and Fraenkel, *Himmler*, 85, and Wistrich, *Who's Who in Nazi Germany*, 140. Also Koehl, *RKFDV*.

132. Kater, "Das Ahnenerbe," 423 (n. 6).

133. Ibid., 2. Grosshans, *Hitler and the Artists*, 84.

134. Flavell, *George Grosz*, 177. For the Willrich-Himmler correspondence, see Chapter 2, note 18, above.

135. Kersten, *Totenkopf und Treue*, 188.

136. BAK, NS19/3356, Himmler to Pohl, 26 February 1944.

CHAPTER FOUR

1. Kurz, *Kunstraub in Europa*, 69–70.

2. Ibid., 70, and Mastny, *Czechs under Nazi Rule*.

3. Roxan and Wanstall, *Rape of Art*, 37. BAK, R43II/1272a, Bl. 12–13, for Bormann conveying Hitler's orders to Heydrich to remove six paintings from *Schloß* Raudnitz in March 1942 because it was Jewish property. Also Faison, "Supplement to CIR No. 4," attachments 68 and 82, and Haase, *Kunstraub und Kunstschutz*, 161–62.

4. Schellenberg, *Labyrinth*, 70.

5. Rings, *Life with the Enemy*, 26.

6. Ibid., 26. Also Piotrowski, *Hans Frank's Diary*, 43–45. A 4 November 1939 meeting between Hitler and Frank also entailed orders to destroy the royal castle in Warsaw and to leave the city in ruins. Präg and Jacobmeyer, *Das Diensttagebuch des deutschen Generalgouverneurs*, 59.

7. Brenner, *Die Kunstpolitik des Nationalsozialismus*, 131.

8. BAK, R43II/1341a, Bl. 59, and Vlug, *Report on Objects Removed to Germany*, 150–60.

9. Koehl, "Feudal Aspects of National Socialism." Also Kershaw, *Nazi Dictatorship*, 61–81.

10. Dawidowicz, *War against the Jews*, 115.

11. Kater, "Das Ahnenerbe," 134.

12. BAK, R43II/1269f, Bl. 58–60, undated, and NS21/240, "Bericht über die Tätigkeit des Generaltreuhänders," 28 March 1941.

13. Interviews of Peter Paulsen by Michael Kater on 27 September and 30 October 1968, in Sammlung Kater, IfZG, ZS A25, 1:242–55.

14. Brenner, *Die Kunstpolitik des Nationalsozialismus*, 266, and Kurz, *Kunstraub in Europa*, 77.

15. BAK, R43II/1269f, Bl. 2–60, for the SD plundering activities in Poland. These documents concern taking church treasures from Pelpin.

16. Ministerstwo Informacji Poland, *Nazi Kultur in Poland*, 100. Also Kurz, *Kunstraub in Europa*, 84, 91.

17. Sammlung Kater, IfZG, ZS A25, 1:242–55.

18. Ministerstwo Informacji Poland, *Nazi Kultur in Poland*, 99–105.

19. Kurz, *Kunstraub in Europa*, 86.

20. IfZG, IMT, doc. 369, Hans Schleif to Sievers, 6 January 1940. Also doc. 367, memorandum to files from Sievers, 20 May 1940. The reasons for Paulsen's limited success, including his disagreements with Harmjanz and other German operatives in the region, are discussed here.

21. BAK, R43II/1341a, Bl. 63, identity papers signed by Gritzbach, Göring's adjutant, 9 October 1939, and Bl. 43–100, "Die Gesamttätigkeit des Sonderbeauftragten für die Erfassung der Kunst- und Kulturschätze im Generalgouvernement," undated report (presumably from 1943) with a cover letter from Dr. Gramsch, a Vierjahresplan Agency official. Kater, "Das Ahnenerbe," 135.

22. Kurz, *Kunstraub in Europa*, 90.

23. BAK, R43II/1341a, Bl. 47, for the decrees noted above: the 15 November 1939 Verordnung über die Beschlagnahme des Vermögens des früheren Polnischen Staates innerhalb des Generalgouvernements and the 16 December 1939 Verordnung des Generalgouvernements für die Beschlagnahme des gesamten öffentlichen Kunstbesitzes.

24. Ibid., Bl. 54–60.

25. IMT, *Nazi Conspiracy*, 4:211–14, 1709-PS. Also Arendt, *Eichmann in Jerusalem*, 48. She includes a quotation from Eichmann, where he apologizes to the interviewers, saying, "Officialese (*Amtssprache*) is my only language."

26. IMT, *Trial of the Major War Criminals*, 3042-PS, 31:512–13, Eidliche Erklärung of Mühlmann, 19 November 1945.

27. BAK, R43II/1341a, Bl. 54–57.

28. Mühlmann file, BDC, Scheel to Bormann, 12 November 1942. For more on Mühlmann, see Petropoulos, "Importance of the Second Rank."

29. Ibid. Also Pauley, *Hitler and the Forgotten Nazis*, 197; Vlug, *Report on Objects Removed to Germany*, 12; and Venema, *Kunsthandel in Nederland*, 90–103.

30. Padfield, *Himmler*, 270–71.

31. Ministerstwo Informacji Poland, *Nazi Kultur in Poland*, 100.

32. Kurz, *Kunstraub in Europa*, 106–7.

33. Estreicher, *Cultural Losses of Poland*, and Ministerstwo Informacji Poland, *Nazi Kultur in Poland*.

34. Roxan and Wanstall, *Rape of Art*, 49, and Kurz, *Kunstraub in Europa*, 89, 112.

35. Kurz, *Kunstraub in Europa*, 112–13.

36. BAK, R43II/1341a, Bl. 62, which notes that works from *Wahl I*, including those by Rubens, Breughel, and Dirk Bouts, are in the *Safe der Deutschen Bank* in Berlin.

37. Ibid., Bl. 60.

38. Kurz, *Kunstraub in Europa*, 102, where he cites IMT doc. 3832-PS; Keneally, *Schindler's List*, 49.

39. Wistrich, *Who's Who in Nazi Germany*, 95.

40. Kurz, *Kunstraub in Europa*, 98.

41. Kater, "Das Ahnenerbe," 135.

42. Präg and Jacobmeyer, *Das Diensttagebuch des deutschen Generalgouverneurs*, 147.

43. Sammlung Kater, IfZG, ZS A25, 1:219–24, an interview with Dr. Alfred Kraut on 24 April 1963. Kraut, who worked with Sievers in various capacities, noted the Treuhandstelle Ost's need for scholars and the scholars' collaboration because most did not want to fight on the Eastern Front.

44. BAK, NS21/240, *Bericht über die Tätigkeit des Generaltreuhänders*, 28 March 1941.

45. Ibid.

46. Ibid.

47. Ibid.

48. Roxan and Wanstall, *Rape of Art*, 52.

49. IMT, *Nazi Conspiracy*, 4:130–32, 1600-PS, Posse to Bormann, 14 December 1939.

50. Nicholas, *Rape of Europa*, 59.

51. Ibid., 70.

52. Flanner, *Men and Monuments*, 238–39, and Kurz, *Kunstraub in Europa*, 85–86.

53. BAK, R43II/1236a, Bl. 95, Liebel to Lammers, 5 December 1939. Speer also assisted with the transport of church treasures out of Poland, working with Gauleiters Forster of Danzig and Greiser of the Warthegau. BAK, R3/1588, Bl. 7–8, Speer to Lammers, 12 and 16 November 1940.

54. BAK, R43II/1236a, Bl. 93, Liebel to Lammers, 16 November 1939. Also Kurz, *Kunstraub in Europa*, 86.

55. BAK, R43II/1236a, Bl. 96, Speer to Lammers, 8 January 1940, and Bl. 101–3 concern Goebbels's exhibition plans. The Kaiser Friedrich Museum in Berlin exhibited these photos in the autumn of 1940. Ministerstwo Informacji Poland, *Nazi Kultur in Poland*, 104, and Friemuth, *Die geraubte Kunst*, 18.

56. Nicholas, *Rape of Europa*, 70.

57. Examples of atrocities include Polish paintings being cut from their frames so that the canvasses could be used as blackout curtains, and bonfires being made from "precious Polish manuscripts" and archival materials. Flanner, *Men and Monuments*, 238–39.

58. Reitlinger, *The SS*, 124.

59. Ibid., 126.

60. BAK, NS21/240, Sievers to Willrich in the SD Hauptamt, 10 October 1940. Also Dettenberg file, BDC, Kraut to SD, 29 May 1941.

61. BAK, NS21/240, Sievers to the Persönlicher Stab of the Reichsführer-SS, 3 August 1942.

62. Dettenberg file, BDC, unidentified SS-Obersturmführer to Dettenberg, 25 June 1942.

63. Rings, *Life with the Enemy*, 41. These figures, including Jews and Christians, represent the highest percentage losses of any country in the war.

64. IMT, *Nazi Conspiracy*, 8:677–90. Also Vizulis, *Nations under Duress*, 92.

65. Hiden and Salmon, *Baltic Nations and Europe*, 105–6. Also Hoover, "Baltic Resettlement of 1939," 79–89.

66. Hehn, *Die Umsiedlung der baltischen Deutschen*, 160.

67. Misiunas and Taagepera, *Baltic States*, 72, 276. Also Hiden and Salmon, *Baltic Nations and Europe*, 109.

68. The RuSHA originated as the SS marriage office; it evolved into a resettlement and deportation agency. The VoMI, which was previously concerned with German-speaking people abroad, became engaged in the repatriation of ethnic Germans.

69. Hiden and Salmon, *Baltic Nations and Europe*, 115.

70. Reitlinger, *The SS*, 130. Also Hiden and Salmon, *Baltic Nations and Europe*, 115.

71. Reitlinger, *The SS*, 131.

72. Hehn, *Die Umsiedlung der baltischen Deutschen*, 155.

73. Holst file, BDC, Holst to Himmler, 24 June 1941. Also Holst's report of 23 May 1941.

74. Holst file, BDC, Holst to the Reichsschrifttumskammer, 18 March 1935. Also ÖSta, AdR, 15 Kunstwesen, 3636–41, and Hehn, *Die Umsiedlung der baltischen Deutschen*, 148.

75. Holst file, BDC, Himmler to Sievers, 1 February 1940, and Sievers to Rust, 7 February 1940.

76. Ibid., Sievers to Himmler, 2 March 1940.

77. Ibid., Himmler (written *im Auftrag* by Dr. Walters) to Sievers, 13 December 1940.

78. Hehn, *Die Umsiedlung der baltischen Deutschen*, 150–51.

79. Ibid., 144–45.

80. Ibid., 150, 157.

81. ÖSta, AdR, Kunstwesen 15, 3636–41, Holst's report, 23 May 1941.

82. Kaslas, *Baltic Nations*, 246–64, and Hehn, *Die Umsiedlung der baltischen Deutschen*, 158.

83. Holst file, BDC, Holst to Sievers, report concerning *Kulturgut-Verhandlungen*, 6 May 1941.

84. ÖSta, AdR, Kunstwesen 15, 3636–41, Holst's report, 23 May 1941.

85. Holst file, BDC, Holst to Himmler, 24 June 1941.

86. ÖSta, AdR, Kunstwesen 15, 3636–41, Holst's report, 23 May 1941.

87. Holst file, BDC, Sievers to Holst, 18 June 1941.

88. Ibid., Sievers's *Aktenvermerk*, 29 October 1941.

89. Vizulis, *Nations under Duress*, 77–78.

90. Arad, *Ghetto in Flames*, 37–38.

91. Hiden and Salmon, *Baltic Nations and Europe*, 116.

92. Ibid., 119.

93. Vizulis, *Nations under Duress*, 81.

94. Hehn, *Die Umsiedlung der baltischen Deutschen*, 162.

95. Himmler was officially charged by Hitler to oversee the "resettlement" on 16 June 1939, before his appointment as RKFdV. Steurer, *Südtirol*, 345.

96. Toscano, *Alto Adige – South Tyrol*, 27.

97. Of the 220,000 ethnic Germans in the Südtirol, 80,000 migrated to the Reich. Stuhlpfarrer, *Umsiedlung Südtirol*, 26.

98. BAK, NS21/225. Also Rees, *Biographical Dictionary of the Extreme Right*, 6, and Steurer, *Südtirol*, 355.

99. Reitlinger, *The SS*, 112, and Manvell and Fraenkel, *Himmler*, 73.

100. Toscano, *Alto Adige – South Tyrol*, 46, and Steurer, *Südtirol*, 357.

101. Toscano, *Alto Adige-South Tyrol*, 47–49, 261.

102. Stuhlpfarrer, *Umsiedlung Südtirol*, 392–93.

103. Mühlmann file, BDC, Mühlmann to Sievers, 3 May 1940.

104. Toscano, *Alto Adige – South Tyrol*, 47.

105. Himmler to Bormann, 28 February 1940, in Faison, "CIR No. 4," 64.

106. Sammlung Kater, IfZG, ZS A25, 1:134, an interview with Friedrich Hielscher, 27 July 1962.

107. Stuhlpfarrer, *Umsiedlung Südtirol*, 408.

108. Ibid., 409.

109. BAK, NS21/433, protocol of meeting, 28 August 1940. Rusconi stressed the Italian influences on Pacher, prompting Ringler to respond, "Dürer also cannot be considered Italian because he painted the Strahoven Madonna under the influence of Bellini in Venice."

110. Kater, "Das Ahnenerbe," 140.

111. Ibid., 140, and Stuhlpfarrer, *Umsiedlung Südtirol*, 396.

112. BAK, NS21/212, Frodl to Sievers, 15 September 1941. Also, BAK, NS21/229, Sievers's speech at a conference sponsored by the Ahnenerbe, 23/24 April 1941.

113. BAK, NS21/210, Sievers to Hofer, 7 November 1940, and a *Vermerk* by Helm, 26 March 1941.

114. Ibid., Sievers's circular to the members of the Kulturkommission's Abteilung Bildende Kunst, 28 November 1940. Stuhlpfarrer, *Umsiedlung Südtirol*, 401. The scope of Himmler's projects as Reichskommissar are also conveyed by his request to the Reichskanzlei for RM 10 million for his resettlement activities in late 1939. BAK, R43 II/1412, Lammers to RFM Krosigk, 28 September 1939.

115. BAK, NS21/210, *Vermerk* by Helm, 26 March 1941.

116. Posse and Mühlmann files, BDC, for the many documents concerning Posse's visits.

117. BAK, NS21/210, Sievers to an unnamed Deutsche Generalkonsul, 2 September 1940.

118. Himmler to Bormann, 28 February 1940, in Faison, "Supplement to CIR No. 4," attachment 18. There are numerous documents that refer to briefings of Hitler: e.g., BAK, NS21/210, Sievers to Himmler, 10 October 1940, and Ringler to Bene, May 1941.

119. Kater, "Das Ahnenerbe," 142.

120. Ibid. Note that the Ahnenerbe, apart from the Kulturkommission, also engaged in similar collecting activities in other regions, e.g., in the Crimea and Alsace. BAK, NS19/3052, Sievers to Himmler, 17 November 1942, and Simon, *Battle of the Louvre*, 72–73.

121. Höffkes, *Hitlers Politische Generale*, 144, 260.

122. Lehmann-Haupt, "Cultural Looting of the 'Ahnenerbe.'"

123. Toscano, *Alto Adige–South Tyrol*, 55.

124. Jaeger, *Linz File*, 121. Also OMGUS, 5/347–1123, for the Americans' interrogation of Göring's art agent Walter Hofer, 15 September 1945.

125. Mühlmann file, BDC, report, 3 May 1940.

126. Ibid. Stuhlpfarrer, *Umsiedlung Südtirol*, 396–97.

127. Mühlmann file, BDC, Sievers to Posse, 22 May 1940.

128. Ibid., Sievers's *Vermerk*, 30 July 1940.

129. The members of the German Kulturkommission later also insisted that their work was scholarly and not ideological (or, to use the term of one veteran, Herbert Jeschke, "*weltanschaulich einwandfrei*"). Sammlung Kater, Jeschke interview, 28 July 1962, IfZG, ZS A25, 1:191. This representation is also maintained by Oswald Trapp in his memoirs, *Die Kunstdenkmäler Tirols in Not und Gefahr*.

130. Stuhlpfarrer, *Umsiedlung Südtirol*, 397.

131. BAK, NS21/229, Himmler (*im Auftrag* Brandt) to Wüst, 4 July 1941.

132. Ibid., a report on the conference of 23/24 April 1941.

133. Reitlinger, *The SS*, 219.

134. Cooper and De Wald, "German Kunstschutz in Italy"; Siviero, *L'Arte e il Nazismo*; and Haase, *Kunstraub und Kunstschutz*, 179–83.

135. BAK, NS21/160, an unnamed professor to Trapp of the South Tyrol Kulturkommission, 4 July 1942. BAK, NS19/3165, RSHA (Steiermark) to the Persönlicher Stab of the Reichsführer-SS, 30 December 1942.

136. BAK, NS19/1418, Bormann to Himmler, 31 December 1944.

137. Ibid.

138. Ibid., Himmler to Kaltenbrunner, 18 January 1945.

139. Ackermann, *Heinrich Himmler als Ideologe*, 192, 225.

140. Stuhlfpfarrer, *Umsiedlung Südtirol*, 391.

CHAPTER FIVE

1. CDJC, XIII-34, Utikal to Pellepoix, 3 November 1941.

2. CDJC, XII-36, Werner Best (chief of civil administration in Paris) to the Waffenstillstand Kommission, 28 February 1942; XIII-31, an ERR memorandum (undated from 1942) discussing the protests of the French; and XIII-32 and XIII-33, Rosenberg to General Hermann Reinecke, 12 October and 3 November 1941. Also Simon, *Battle of the Louvre*, 49–60.

3. Kurz, *Kunstraub in Europa*, 69.

4. PrGSta, Rep.90/2402, Bl. 353–54, for Hitler (upon Rust's recommendation) returning a fourteenth-century picture of the "Kaiser Saga" to the Japanese in 1935. The picture, which the Germans had possessed since 1907 when it was brought back by a scholar, was considered sacred by the Japanese.

5. Brenner, *Die Kunstpolitik des Nationalsozialismus*, 142, 266.

6. BAK, R55/1476, Bl. 23–25, Biebrach to Goebbels, 12 August 1940. Kümmel and his associates continued a project begun in 1939 by art historians Rudolf

Brandts and Karl Wilkes entitled "Denkschrift und Listen über den Kunstraub der Franzosen im Rheinland seit 1794." Kümmel's team compiled three thick volumes (over a thousand pages total): BAK, R55/1200, 1201, and 1203. The items listed range from the somewhat credible claims on objects taken by the French 135 years earlier to the outlandish: e.g., "In the Tower of London, a 'Prunkannisch' gift of Kaiser Maximillian to King Henry VIII, delivered by Konrad Seusenhofer." See also NAW, RG 239/81, Phillips and Sutton, "Preliminary Interrogation of Alfred Hentzen," 1.

7. BAK, R55/1476, Bl. 10–17, Goebbels's circular, 19 August 1940.

8. Ibid., Bl. 18, Lammers to Goebbels, 13 August 1940.

9. Kurz, *Kunstraub in Europa*, 121. Also Bouresh, "Sammeln Sie Also Kräftig!," 59–75.

10. BAK, R55/1476, Bl. 38, Schaumburg-Lippe to Goebbels, 14 August 1940.

11. Heydrich quoted in BAK, R21/330, Bl. 63, Hermann to Rust, 31 July 1941.

12. BAK, R55/1476, Bl. 66–67, Goebbels to Lammers, 30 August 1940.

13. Ibid., Bl. 22–23, Ernst Biebrach (head of the Abteilung Bildende Kunst in the RMVP) to Goebbels, 12 August 1940.

14. Ibid., Bl. 51–52.

15. Note that in November 1941 Goebbels continued to express optimism about the *Rückführung* project. This was highly unrealistic in light of other developments. Ibid., Bl. 117–18, Biebrach to Goebbels, 4 November 1941.

16. BAK, NS8/264, Bl. 1, for an overview of the Hohe Schule complex. Rosenberg was forced to put on hold many of his plans for the Hohe Schulen until after the war. BAK, NS8/163, Bl. 58, Rosenberg to Bormann, 21 October 1941. Also Bollmus, "Zum Projekt einer nationalsozialistischen Alternativuniversität," 125–52.

17. BAK, R55/1476, Bl. 70, or NS30/14, Bl. 2, Keitel, head of the OKW to Bockelberg 5 July 1940. For a copy of the order, see the "Verordnungsblatt des Militärbefehlshaber des Heeres," no. 3, 49. For an outstanding overview of the measures concerning the expropriation of artistic property in France, see Treue, "Bargatzky-Bericht."

18. The 15 July order, signed by Bockelberg of the OKH, "Zur Sicherung gegen Beschädigung oder Entwendung [of art]" was primarily an effort to limit the transgressions of the occupying German troops. Cassou, *Le Pillage par les Allemands*, doc. 4, 80–81. Note that all art objects valued at over 100,000 ffr were to be reported to the Feldkommandantur by 15 August. IMT, *Trial of the Major War Criminals*, 8:68.

19. IfZG, ZS 793, Utikal interrogation, 2 April 1947.

20. BAK, NS8/259, Bl. 7, Ebert (Rosenberg's Stabsführer) to Koeppen (Rosenberg's adjutant), 27 September 1940.

21. Brenner, *Die Kunstpolitik des Nationalsozialismus*, 147. BAK, NS30/14, a report within the Militärverwaltung in France, "Bericht über die Wegnahme französischer Kunstschätze durch die deutsche Botschaft und den ERR in Frankreich," undated, 15.

22. CDJC, LXXI-104, Rudolph Schleier to the German embassy in Paris, 31 July 1942. Also Ribbentrop to Göring, 3 August 1940, in Cassou, *Le Pillage par les Allemands*, doc. 5, 82–83, and Kurz, *Kunstraub in Europa*, 134.

23. CDJC, LXXI-88, a Foreign Office report (undated).

24. BAK, NS30/14, 3.

25. Kurz, *Kunstraub in Europa*, 138–42, 150–51, 188–89, 197, and Friemuth, *Die geraubte Kunst*, 17.

26. BAK, NS30/14, 6, 8.

27. Kurz, *Kunstraub in Europa*, 136–38.

28. CDJC, LXXI-104, Schleier to the German embassy in Paris, 31 July 1942.

29. NAW, RG 239/79, Metternich, "Concerning My Activities." Report translated and reprinted in Cassou, *Le Pillage par les Allemands*, 149–78. See also Metternich file, BDC.

30. BAK, NS30/14, 15.

31. Cassou, *Le Pillage par les Allemands*, doc. 6, 84, or Brenner, *Die Kunstpolitik des Nationalsozialismus*, 221. BAK, NS30/14, Military Administration report, 19.

32. BAK, NS30/14, 15.

33. Ibid., 17.

34. Ibid., 14–15, 20.

35. Ibid., 18.

36. Rosenberg, in writing to the Military Administration's Dr. Best with his hopes of caring for and transporting the secured artworks, explicitly acknowledged the *Führer Vorbehalt* over the artworks. Ibid.

37. CDJC, XIII-51, "Exposé du Ministre Public: Le Pillage des Oeuvres d'Art," January 1946, 22.

38. Rorimer, *Survival*, 262; Howe, *Salt Mines and Castles*, 193; Kubin, *Sonderauftrag Linz*, 69; and Flanner, *Men and Monuments*, 223. Also Robert Scholz's report, 15 July 1944, in Cassou, *Le Pillage par les Allemands*, doc. 20, 122–26.

39. Behr file, BDC. Simon, *Battle of the Louvre*, 39.

40. Yahil, "Einsatzstab Reichsleiter Rosenberg," 439–41, and IMT, *Trial of the Major War Criminals*, 7:64.

41. CDJC, CXLIII-275, Rosenberg to Schwarz, 18 September 1940.

42. Rosenberg to Schwarz, 14 November 1940, in Cassou, *Le Pillage par les Allemands*, doc. 13, 103–4.

43. BAK, NS8/167, Bl. 61–62, Rosenberg to Göring, 21 September 1940.

44. BAK, NS8/259, Bl. 7–11, and Bl. 25–27, Göring's circular, 5 November 1940.

45. BAK, NS8/167, Bl. 61–62, Rosenberg to Göring, 21 September 1940. Also, Rousseau, "CIR No. 2," 26.

46. CDJC, CCXXXI-27, Hartmann (a Devisenschutzkommando officer) to Weil-Piccard, 29 October 1940.

47. CDJC, CCXXXI-25, Devisenschutzkommando Frankreich to the Militärbefehlshaber Frankreich, 5 May 1941. Also, Plaut, "DIR No. 6."

48. CDJC, CCXXXI-25, Devisenschutzkommando Frankreich to the Militärbefehlshaber Frankreich, 5 May 1941.

49. Göring to Rosenberg, 21 November 1940, in Cassou, *Le Pillage par les Allemands*, doc. 14, 105–7. The 5 November 1940 order issued by Göring concluded with the promise to consult Hitler about the ERR's project. BAK, NS8/259, Bl. 25–27.

50. Göring to Rosenberg, 21 November 1940 in Cassou, *Le Pillage par les Allemands*, doc. 14, 105–7.

51. Kurz, *Kunstraub in Europa*, 143, citing Secret Protocol of the Foreign Office, IMT doc. NG-3763. CDJC, LXXI-88, report from German Embassy in Paris (undated), and CDJC, LXXI-59, Schwarzmann to Abetz, 21 May 1941. Also Brenner, *Die Kunstpolitik des Nationalsozialismus*, 150.

52. BAK, NS30/14, 10.

53. Zeitschel to Abetz, 11 August 1941, in Cassou, *Le Pillage par les Allemands*, doc. 33, 145.

54. Plaut, "DIR No. 4"; Wittman and Taper, "DIR of Hans Wendland"; and Rousseau, "DIR No. 9." Also OMGUS, 5/347–1/31.

55. Assouline, *An Artful Life*, 295.

56. Exhibit RF-1316, for the order prohibiting the import of modern art. IMT, *Trial of the Major War Criminals*, 7:60.

57. CDJC, XIII-51, "L'Exposé du Ministre Public."

58. Ibid., 53. Rousseau, "CIR No. 2," 24. Also Howe, *Salt Mines and Castles*, 161; Irving, *Göring*, 302; Cassou, *Le Pillage par les Allemands*, photographs after 240.

59. For Göring's order of 5 November 1940, see BAK, NS8/259, Bl. 25–27. Note that the last category was created primarily for propaganda purposes. Little of value was left after those higher up the ladder had made their selections. Note also that the 5 November order was provisional upon Hitler's approval. Göring met with Hitler on 14 November and secured this assent.

60. CDJC, CXLIV-397, Scholz's *Aktenvermerk*, 3 December 1942.

61. IMT, *Trial of the Major War Criminals*, 27:564.

62. CDJC, XIII-38, Rosenberg to Göring, 18 June 1942.

63. CDJC, XIII-51, "L'Exposé du Ministre Public," and Kurz, *Kunstraub in Europa*, 156.

64. CDJC, CXLIV-397, Scholz's *Aktenvermerk*, 3 December 1942. Also Infield, *Secrets of the SS*, 120.

65. CDJC, CXLIV-397, Scholz's *Aktenvermerk*, 3 December 1942.

66. Plaut, "DIR No. 6."

67. OMGUS, 5/345–3/2, an MFA and A report on the ERR, 30 March 1945.

68. CDJC, CXLIV-397, Scholz's *Aktenvermerk*, 3 December 1942. Besides memoranda to files, Scholz kept Rosenberg informed of ERR affairs by face-to-face meetings, often as frequently as once per week. BAK, NS8/243.

69. CDJC, CXLIV-398, Scholz to Rosenberg, 30 November 1942.

70. Kurz, *Kunstraub in Europa*, 161–63, 183.

71. Ibid., 161, 183.

72. Wilson, "Collaboration in the Fine Arts," 119. Breker, *Paris, Hitler et Moi*, 95–105.

73. Wilson, "Collaboration in the Fine Arts," 106. Thomae, *Die Propaganda-Maschinerie*, 92. Breker had numerous connections among French artists. He had previously studied in France, and during the war he was given a residence: the home of cosmetics manufacturer Helena Rubenstein on the Ile St. Louis that was expropriated because she was Jewish. CDJC LXXI-98, Zeitschel to Ribbentrop, 3 June 1942.

74. Jaeger, *Linz File*, 115; Cone, *Artists under Vichy*, 155, 235; and Wilson, "Collaboration in the Fine Arts," 110. Note that *The Soviet Paradise*, which opened at the Lustgarten in Berlin in May 1942, was the target of a resistance group who ignited fires at different points in the exhibition. This, however, did not destroy all of the exhibits, and the RMVP sent those that survived on a tour of the west. Merson, *Communist Resistance in Nazi Germany*, 240–43, and Bussmann, *Kunst im dritten Reich*, 213.

75. Simon, *Battle of the Louvre*, 100.

76. Ibid., 98–99, and Cone, *Artists under Vichy*, 154–57.

77. Simon, *Battle of the Louvre*, 95.

78. Wilson, "Collaboration in the Fine Arts," 108.

79. Perrault and Azema, *Paris under the Occupation*, 70; Thomae, *Die Propaganda-Maschinerie*, 109; and Simon, *Battle of the Louvre*, 177–78.

80. Wilson, "Collaboration in the Fine Arts," 110.

81. Ibid., 103. Note that some Jewish artists who remained in France, such as Otto Freundlich, were deported and killed in the death camps in Poland. Matila Simon reports that 1,096 bronze statues were taken by the Germans from France, although how many were destroyed is not given. Simon, *Battle of the Louvre*, 196.

82. Goebbels called Rosenberg's RMBO the "Ministry of Chaos." Freeman, *Atlas of Nazi Germany*, 162.

83. Lindner, *Das Reichskommissariat für die Behandlung feindlichen Vermögens*.

84. Hirschfeld, *Nazi Rule and Dutch Collaboration*, 27.

85. BAK, NS8/138, Bl. 161, an OKW memorandum (undated).

86. Van der Leeuw, *Dienststelle Mühlmann*, 4. He notes that there were not even half a dozen first-rate collections. Also Kurz, *Kunstraub in Europa*, 295–96.

87. Haase, *Kunstraub und Kunstschutz*, 115.

88. OMGUS, 5/345–3/2, an MFA and A report on the ERR, 30 March 1945. The ERR's largest confiscations came from their raids on the antique stores owned by Jews. BAK, NS30/15. Rorimer includes a photograph of a Rubens portrait "from the collection of Graf Moltke" that was looted by the ERR in Brussels. Rorimer, *Survival*, 120.

89. Van der Leeuw, *Dienststelle Mühlmann*, 5.

90. Hirschfeld, *Nazi Rule and Dutch Collaboration*, 20, and van der Leeuw, *Dienststelle Mühlmann*, 9.

91. Vlug, *Report on Objects Removed to Germany*, 5. Mühlmann actually arrived in Holland on 15 May 1940. Plaut, "Hitler's Capital," 76.

92. Kurz, *Kunstraub in Europa*, 256.

93. Ibid., 294.

94. Faison, "CIR No. 4," 7, 28, and Vlug, *Report on Objects Removed to Germany*, 8.

95. Vlug, *Report on Objects Removed to Germany*, 49–148, and van der Leeuw, *Dienststelle Mühlmann*, 2.

96. Faison, "Supplement to CIR No. 4," attachment 58. The eighty-four works listed here include paintings by Rubens, van Goyen, ter Borch, and the Breughels.

97. Van der Leeuw, *Dienststelle Mühlmann*, 2. Also Rousseau, "CIR No. 2," 90–92.

98. Vlug, *Report on Objects Removed to Germany*, 7, 14.

99. Faison, "CIR No. 4," 45.

100. BAK, R43II/1653a, for the creation and management of these accounts. BAK, R43II/677a, for the correspondence between Posse and Seyss-Inquart.

101. Flanner, *Men and Monuments*, 247.

102. Faison, "CIR No. 4," 86.

103. Kurz, *Kunstraub in Europa*, 259.

104. Flanner, *Men and Monuments*, 248.

105. Posse to Bormann, 1 February 1941, in Faison, "CIR No. 4," attachment 37. BAK, NS18/291, for an extensive correspondence regarding placing controls on the art market, including Bormann's ideas and Ziegler's "Anordnung über Versteigerung und Verkauf von Kunstwerken," 15 December 1941.

106. BAK, R43II/1653a, Bl. 39, for the *Berliner Borsen-Zeitung*, 2 April 1941, 1. The new statute stipulated that while Germany and the Netherlands were to ease currency restrictions, no individual could take more than RM 5,000 per month in currency or goods from the Netherlands without government approval.

107. Venema, *Kunsthandel in Nederland*, and Haase, *Kunstraub und Kunstschutz*, 115–26.

108. Plaut, "Hitler's Capital," 75.

109. BAK, R43II/1653a, and OFD, *Akte XXXVI*, Bl. 386, an account ledger, 23 October 1944.

110. Seward, *Napoleon and Hitler*, 233.

111. Infield, *Secrets of the SS*, 120–21, and Kurz, *Kunstraub in Europa*, 282–86.

112. Faison, "CIR No. 4," 9, 36–38.

113. Flanner, *Men and Monuments*, 227.

114. Ibid., 21.

115. Ibid., 25–26.

116. Ibid., 24.

117. Faison, "CIR No. 4," 61. The Schloss Affair, whereby a huge collection was transferred from unoccupied France to Paris in spring 1943, also involved an SS transport. Ibid., attachment 26, statement of Bruno Lohse.

118. Enke, *Der Bernsteinzimmer-Report*.

119. Flanner, *Men and Monuments*, 240, and Kurz, *Kunstraub in Europa*, 320.

120. CDJC, CXII-234, Rosenberg to Bormann, 21 October 1941, and BAK, NS8/259, Bl. 113, Rosenberg to Koch, 3 October 1941.

121. IfZG, ZS 793, Utikal interrogation, 4 April 1947.

122. Ibid.

123. Ibid.

124. Note, for example, that the French imprisoned Robert Scholz for five years after the war. Haase, *Kunstraub und Kunstschutz*, 59.

125. IfZG, ZS 793, Utikal interrogation, 4 April 1947. Also Plaut, "DIR No. 3."

126. Akinsha and Kozlov, "Spoils of War," 133. Also Kurz, *Kunstraub in Europa*, 302.

127. BAK, NS30/52, and BAK, NS30/20, Bl. 3745.

128. Kube to Rosenberg, 29 September 1941, in Wulf, *Die bildenden Künste*, 425, and Kurz, *Kunstraub in Europa*, 304–6.

129. Grimsted, "Fate of Ukrainian Cultural Treasures." For more on the activities of the ERR in the Ukraine, see the microfilmed documents in the Holocaust Memorial Museum, RG-31, reel 8.

130. OMGUS, 5/345–3/2, an MFA and A report on the ERR.

131. Flanner, *Men and Monuments*, 241–42.

132. Kurz, *Kunstraub in Europa*, 331.

133. Ibid., 334–35.

134. Ibid., 332.

135. Seydewitz and Seydewitz, *Die Dame mit dem Hermelin*, 27.

136. IMT, *Trial of the Major War Criminals*, 8:69–70.

137. A fourth battalion accompanied the Afrikakorps. Kurz, *Kunstraub in Europa*, 302.

138. Research file SS-HO 780–867, BDC, Krüger to Himmler, 12 February 1942. For other documents pertaining to the commando, see the Künsberg file, BDC.

139. IMT, *Trial of the Major War Criminals*, 10:441.

140. Ibid., 442.

141. Seydewitz and Seydewitz, *Die Dame mit dem Hermelin*, 27.

142. Kurz, *Kunstraub in Europa*, 301.

143. Seydewitz and Seydewitz, *Der Raub der Mona Lisa*, 89; Flanner, *Men and Monuments*, 241; and Varshavsky and Rest, *Saved for Humanity*, ills. 50–53.

144. IMT, *Trial of the Major War Criminals*, 8:78, 88–89.

145. Haase, *Kunstraub und Kunstschutz*, 156.

146. Roxan and Wanstall, *Rape of Art*, 115.

147. Kurz, *Kunstraub in Europa*, 312–16.

148. Varshavsky and Rest, *Saved for Humanity*, 19; Barker, "Russo-German Art Pact," 12; and Nicholas, *Rape of Europa*, 188–96.

149. Akinsha and Kozlov, "Spoils of War," 132.

150. IMT, *Trials of the Major War Criminals*, 10:442.

151. Seward, *Napoleon and Hitler*, 209.

152. Varshavsky and Rest, *Saved for Humanity*, 271.

153. *Hitler's Table Talk*, 69, 424–25. More glibly, Hitler noted, "At the most, one must let them learn not more than the meaning of road signs. Instruction in geography can be restricted to one single sentence: the capital of the Reich is Berlin, a city which everyone should try to visit once in his lifetime."

154. IMT, *Trials of the Major War Criminals*, 7:100. Also Kurz in *Kunstraub in Europa*, 322.

155. Note that among the Nazi leaders, there existed some difference of opinion about the cultural *niveau* of the Slavs. Rosenberg, himself from the east (Reval), was among the most positive. Cecil, *Myth of the Master Race*, 164.

CHAPTER SIX

1. Orlow, *History of the Nazi Party, 1933–1945*, 417, and Broszat, *Hitler State*, 313.
2. BAK, R55/9, Bl. 148, Leiter der Personalabteilung, RMVP to Goebbels, 27 March 1941.
3. Manvell and Fraenkel, *Doctor Goebbels*, 198.
4. BAK, R55/1000, Bl. 2–57.
5. BAK, NS8/243, Bl. 17–18, Goebbels to Gerigk, 3 October 1940. For more on Gerigk, see de Vries, *Sonderstab Musik*.
6. For RMVP intelligence about artworks, ibid., Bl. 10–16, September and October 1940. Kurz, *Kunstraub in Europa*, 306.
7. BAK, NS8/243, correspondence between Goebbels and Gerigk and Scholz, which ceased in late 1940.
8. BAK, NS18/530, for Goebbels's and Ley's correspondence as well as Bormann's and Rosenberg's objections. Also Smelser, *Robert Ley*, 111.
9. Sington, *Goebbels Experiment*, 110–12.
10. Smelser, *Robert Ley*, 106, 287.
11. BAK, NS18/530, Rosenberg to Bormann, 30 July 1941, and Rosenberg's follow-up, 2 August 1941.
12. Ibid., Gutterer to Tiessler, 21 November 1941.
13. Goebbels, *Tagebücher*, 4:497, 9 February 1941.
14. Balfour, *Propaganda in War*, 103–10, and Manvell and Fraenkel, *Doctor Goebbels*, 196–97.
15. Semmler, *Goebbels*, 74, 13 March 1943.
16. Welch, "Goebbels, Götterdämmerung, and the Deutsche Wochenschau," 80–99.
17. Balfour, *Propaganda in War*, 114.
18. Goebbels, *Die Zeit ohne Beispiel* (1941), *Das eherne Herz* (1943), and *Der Steile Aufstieg* (1943). Also Manvell and Fraenkel, *Doctor Goebbels*, 189.
19. Grunberger, *Twelve-Year Reich*, 401.
20. Manvell and Fraenkel, *Doctor Goebbels*, 188. Also Moltmann, "Goebbels' Speech on Total War," 298–342.
21. Semmler, *Goebbels*, 66, 18 January 1943.
22. Manvell and Fraenkel, *Doctor Goebbels*, 257. Balfour, *Propaganda in War*, 120.
23. The commission, headed by General Walter von Unruh, aimed at recruiting the maximum number of troops. Hancock, *National Socialist Leadership and Total War*, 59.
24. Herzstein, *War That Hitler Won*, 127.
25. BAK, R43II/666b, Goebbels's report, 30 July 1944.

26. Semmler, *Goebbels*, 79, 125, 20 March 1943 and 2 June 1944. Also Manvell and Fraenkel, *Doctor Goebbels*, 232–33, and Reuth, *Goebbels*, 582.

27. Giles, *Students and National Socialism*, 320–21.

28. BAK, R43II/942c, Bl. 38–44, Rust to Bormann, September 1944.

29. Ibid., Bl. 59–61, Bormann to Rust, 5 October 1944.

30. Ibid., Bl. 80–90, correspondence between Bormann, Goebbels, and Rust, November 1944.

31. Semmler, *Goebbels*, 155–56, 6 October 1944.

32. Orlow, *History of the Nazi Party, 1933–1945*, 422.

33. Semmler, *Goebbels*, 106–7, 20 November 1943.

34. Orlow, *History of the Nazi Party, 1933–1945*, 424.

35. Ibid., 420, 422, 432, 434, 457, 468, for other NS leaders who incurred Bormann's opposition, including Speer, Ley, Rust, and Lammers.

36. Kurz, *Kunstraub in Europa*, 232.

37. BAK, NS8/242, Bl. 162–64, Bormann to Rosenberg, 26 January 1943. More specific orders followed, including those in letters of 4 February and 21 April 1943. Brenner, *Die Kunstpolitik des Nationalsozialismus*, 232.

38. Bormann to Rosenberg, 21 April 1943, in Kurz, *Kunstraub in Europa*, 232.

39. Ibid., 232.

40. BAK, NS8/139, Bl. 177–78, and BAK, NS8/260, Bl. 54–61, for the numerous requests for active military service and the generally nonconfrontational correspondence between the Unruh Commission and Rosenberg's offices.

41. Cassou, *Le Pillage par les Allemands*, 117–21.

42. BAK, NS8/243, Bl. 157, Koeppen to Scholz, 1 September 1944.

43. BAK, NS8/188, Bl. 142–43, Rosenberg to Bormann (no date – an *Abschrift* or copy).

44. Kurz, *Kunstraub in Europa*, 219.

45. Ibid., 243.

46. BAK, NS8/167, Bl. 9–10, Rosenberg to Göring, 3 June 1943 (letter is also in CDJC, XIXa-16).

47. Ibid.

48. BAK, NS8/262, Bl. 12–14, Scholz to Rosenberg, 29 April 1944. Note that while the artworks placed in the salt mines were not adversely affected by the climate, armor and other metal objects did suffer from the moisture. Howe, *Salt Mines and Castles*, 141, and Pöchmüller, *Weltkunstschätze in Gefahr*, 17, 24.

49. BAK, NS8/262, Bl. 17–23, Scholz to Rosenberg, 17 February 1944, and BAK, NS6/481, for the extensive debate among the Nazi leaders about using the salt mines for the storage of artworks. Also Kurz, *Kunstraub in Europa*, 363.

50. Kurz, *Kunstraub in Europa*, 366.

51. BAK, NS8/243, Bl. 145, Scholz to Rosenberg, 1 July 1944.

52. Faison, "CIR No. 4," 20–23.

53. Lang, *Bormann*, 171.

54. Ibid., 171. BAK, NS8/167, Bl. 9–10, Rosenberg to Göring, 3 June 1943. See also Rosenberg to Hitler, 16 April 1943, in Cassou, *Le Pillage par les Allemands*, 116.

55. Kurz, *Kunstraub in Europa*, 240.

56. Lang, *Bormann*, 170.

57. For Bormann taking over the NS-Führungsoffiziere (whom Orlow compares to the Soviet army's political commissars), see Orlow, *History of the Nazi Party, 1933–1945*, 436, 460.

58. Ibid., 466.

59. Ibid., 377.

60. Lang, *Bormann*, 162.

61. BAK, R43II/1270a, Bl. 4–5, a Reich chancellery *Vermerk*, 14 February 1940, and Bl. 6, Plattner to Lammers, 12 March 1940. Kurz, *Kunstraub in Europa*, 53–4, and Luza, *Austro-German Relations*, 280.

62. BAK, R43II/1270a, Bl. 48, Reetz (of the HTO) to Reimer (of Sonderauftrag Linz), 16 February 1943.

63. Ibid., Bl. 53, Reetz to Lammers, 19 February 1943, and bl. 58, HTO/Sonderabteilung Altreich (anonymous) to Lammers, 27 February 1943.

64. Ibid., Bl. 86–100, complaints of Pelleter against Reetz, 15 May 1943.

65. Ibid., Bl. 62, a Reich chancellery *Vermerk*, 17 March 1943.

66. Ibid., Bl. 66, Bormann to Lammers, 19 March 1943.

67. Ibid., Bl. 119, Reimer to Reetz, 1 July 1943.

68. Ibid., Bl. 120–21, Lammers's *Vermerk*, 14 July 1943, where Göring's response is noted.

69. Kurz, *Kunstraub in Europa*, 57.

70. BAK, R43II/1270a, Bl. 120–21, 14 July 1943.

71. Ibid., Bl. 126–33, Reetz to Pelleter, 5 July 1943.

72. The most valuable pieces were safely stored, but much of the Lanckoronskis' less exceptional property, including antiques and rugs, perished in a bomb attack in late 1944. Ibid., Bl. 144, a Reich Chancellery *Vermerk*, 22 November 1944.

73. Lang, *Bormann*, 237.

74. Ibid.; Speer, "Interview," 84.

75. Orlow, *History of the Nazi Party, 1933–1945*, 13–14.

76. Herzstein, *War That Hitler Won*, 153–55.

77. Bormann wrote to his wife, Gerda, on 5 February 1945: "A victory for Bolshevism and Americanism would mean not only the extermination of our race, but also of everything that its culture and civilization has created. Instead of the '*Meistersinger*' we should see Jazz triumphant, and the '*Kätchen von Heilbronn*' would have to yield pride of place to the pornographic skit!" Bormann, *Bormann Letters*, 172–73.

78. BAK, NS8/243, Bl. 64, *Aktennotiz*, 24 May 1944.

79. Herzstein, *War That Hitler Won*, 148, 155.

80. Ziegler file, BDC, Bayerisches Staatsministerium für Unterricht und Kunst to Rust, 28 April 1944. Also, Amtsgericht Munich, Spruchkammer file, H/10451/53, brief on behalf of Ziegler by Robert Bandorf and Hanns Baumann, 11 September 1953. Ziegler had also jeopardized his position in 1943 by supporting the artist Constantin Gerhardinger, who had refused to deliver works to the

1943 *GDK* because he believed them endangered by bombs. Hitler was infuriated by this act, which he viewed as defeatist.

81. Amtsgericht Munich, Spruchkammer file, H/10451/53, statement of Gall, 30 October 1948.

82. Giesler, *Ein anderer Hitler*, 352.

83. BAK, R3/1598, Bl. 86–95, and BAK, R120/1082, Bl. 3–153, for the architectural exhibitions. Also, Breker, *Paris, Hitler et Moi*, 148–55, and Thomae, *Die Propaganda-Maschinerie*, 424–25. The presidents of the RkdbK after Ziegler were Kreis, Leonhard Gall, and Paul Junghanns.

84. Jürgen Peterson, "Der Krieg hat diese äusseren Arbeiten unterbrochen."

85. BAK, R3/1614, Bl. 15, Speer to Hitler, 25 January 1944.

86. Matthias Schmidt, *Albert Speer*.

87. Speer, *Inside the Third Reich*, 119.

88. BAK, R3/1588, Bl. 7, Speer to Lammers, 16 November 1940. Also BAK, R43II/1269f, Bl. 2–60, and BAK, R43II/1236a.

89. BAK, R43II/1269g, Bl. 8–30, April–August 1940. Also Kwiet, "'Material Incentives,'" 245.

90. BAK, R3/1594, Bl. 143–44, Speer to Posse, 27 and 29 May 1941.

91. BAK, R3/*Anhang*/33, for the bureaucratic structure of the GBI's agency.

92. The *Speerchronik* notes that twelve engravers worked for the Referat Kunst in 1942. BAK, R3/1736, Bl. 6.

93. BAK, R120/1634, 1635, and 1636.

94. BAK, R3/1594, Speer to Popitz, 2 August 1941, and BAK, R18/297, Goebbels and Speer correspondence, 1942.

95. Nicholas, *Rape of Europa*, 310.

96. Hancock, *National Socialist Leadership and Total War*, 64.

97. BAK, NS18/551, Frauenfeld to Tiessler, 4 February 1943.

98. BAK, R3/1583, Bl. 126, Speer to Himmler, 14 November 1944.

99. Speer's ambivalent remarks regarding modern art are reflected in Goebbels's journal. Goebbels, *Tagebücher*, 3:166, 172, 5 and 12 June 1937. In his memoirs, Speer praises modernist architects, including Peter Behrens, but admits, "It is plain that at the age of twenty-eight I did not understand the Bauhaus." Speer, *Inside the Third Reich*, 202, and Speer, *Spandau*, 302.

100. Heiber, *Goebbels*, 279, and Lang, *Bormann*, 287.

101. Rosenberg, *Letzte Aufzeichnungen*, 202.

102. Georg, *Wirtschaftliche Unternehmungen*, 30–31.

103. Ibid., 10.

104. Ibid., 14.

105. Ibid., 16.

106. The journals published by Nordland included one on behalf of the Ahnenerbe, called *Germania*, as well as *Nordland* and *Der Brunnen* (*The Fountain*). The pamphlet *Der Untermensch*, which Georg called a "*Hetzbroschüre*" (inflammatory pamphlet) was published in 1942/1943 by Nordland in fifteen languages. Ibid., 15.

107. BAK, NS3/1451 and 1452.

108. Georg, *Wirtschaftliche Unternehmungen*, 16.

109. BAK, NS21/229, Sievers to the Mayor of Darmstadt, July 1940.

110. Kersten, *Totenkopf und Treue*, 20–34.

111. Arendt, *Eichmann in Jerusalem*, 37.

112. See also the example of the ethnographic museum in Berlin, which was taken *in Hände* in 1944. BAK, NS19/3053, Brandt to Fitzner, 1 May 1944.

113. Bunjes file, BDC. See Chapter 3 above.

114. Simon, *Battle of the Louvre*, 61; Kurz, *Kunstraub in Europa*, 297–98; and Lapièrre and Collins, *Is Paris Burning?*, 208. Also BAK, NS21/*Vorl.* 807 and NS21/*Vorl.* 290.

115. Georg, *Wirtschaftliche Unternehmungen*, 21.

116. Ibid., 22.

117. BAK, NS19/3052, Sievers to Himmler, 17 November 1942.

118. Georg, *Wirtschaftliche Unternehmungen*, 22.

119. Vahrenkamp file, BDC. Vahrenkamp answered to Diebitsch within the Persönlicher Stab des RF-SS.

120. Ibid., 16, n. 21. Also Diebitsch file, BDC, Himmler *Aktenvermerk*, 9 November 1940.

121. Vahrenkamp file, BDC, 16. Also Diebitsch file, BDC, Sievers to Fischer, 10 June 1939.

122. Huber, "Porzellan-Manufaktur Allach," 58.

123. Ibid., 55.

124. Ibid.

125. Georg, *Wirtschaftliche Unternehmungen*, 16–18.

126. "Kitsch," in Zentner and Bedürftig, *Encyclopedia of the Third Reich*, 498–500.

127. Huber, "Porzellan-Manufaktur Allach," 55.

128. Kater, "Das Ahnenerbe," 21.

129. Schoenbaum, *Hitler's Social Revolution*, 285–86, and Herzstein, *War That Hitler Won*.

130. See, for example, Hermann Göring, *Der Geist des neuen Staates* (1933), *Aufbau einer Nation* (1934), and *Reden und Aufsätze* (1938). For more on the extraordinary array of publications by NS leaders, see Ulbricht, "Völkische Publizistik in München."

CHAPTER SEVEN

1. Spielvogel, *Hitler and Nazi Germany*, 183.

2. Reitlinger, *Economics of Taste*, 211, 215–16. The prices he cites are all in English pounds Sterling, which he calculates as being the equivalent of $3.48 US; RM 2.5 equaled $1 US.

3. Ibid., 216–17.

4. ÖSta, AdR, 15 Kunstwesen, *Karton* 133, and Grosshans, *Hitler and the Artists*, 91.

5. Reitlinger, *Economics of Taste*, 382.

6. Assouline, *An Artful Life*, 218–69, and Reitlinger, *Economics of Taste*, 410–11.

7. Reitlinger, *Economics of Taste*, 386.

8. Thomae, *Die Propaganda-Maschinerie*, 177–82.

9. This claim is made in the exhibit on the French Resistance in the Musée d'Invalides, Paris.

10. Nicholas, *Rape of Europa*, 153, 306.

11. BAK, R58/157, an SD *Meldung* (report), 20 February 1941.

12. Rousseau, "CIR No. 2," 33.

13. The preeminent artists of the Austro-Bavarian genre include Carl Spitzweg, Franz von Defregger, Hans Grützner, Ferdinand Waldmüller, Hans Thoma, Wilhelm Leibl, and Rudolf von Alt.

14. Simon, *Battle of the Louvre*, 77, and Kurz, *Kunstraub in Europa*, 18, 361.

15. Faison, "CIR No. 4," 78.

16. Flanner, *Men and Monuments*, 234, and Kubin, *Sonderauftrag Linz*, 68.

17. Note that in terms of total holdings, the Führermuseum would not equal the Louvre, the Hermitage, or other preeminent national museums, which commonly have between 1 million and 3 million objects in their inventories.

18. Maser, *Hitler's Letters and Notes*, 205. Faison, "Supplement to CIR No. 4," 7. Hitler issued an order of 30 September 1942 designating the Upper Austrian Gau as the owner of the works in the Führermuseum. Kubin, *Sonderauftrag Linz*, 11.

19. ÖSta, AdR, 15 Kunstwesen, *Karton* 133. In the file, an article from *Life* magazine (24 October 1949) is also cited in which the author places the Vermeer in Hitler's retreat.

20. Rousseau, "DIR No. 1."

21. Faison, "CIR No. 4," 78.

22. Jenks, *Vienna and the Young Hitler*, and Jaeger, *Linz File*, 9–21.

23. Schwarzwäller, *Hitlers Geld*, 145–46. Wolfgang Schuster, "Hitler in München–privat?," 125–30.

24. Rousseau, "DIR No. 1."

25. Faison, "CIR No. 4," 48.

26. Ibid., 47.

27. Haase, *Kunstraub und Kunstschutz*, 53.

28. Backes, "Adolf Hitlers Einfluß," 243–44.

29. Rousseau, "DIR No. 1."

30. An unidentified newspaper article in the archives of the Munich Oberfinanzdirektion, 3 March 1950, reported that "not fewer than 650 first-rate paintings were stolen from the well-secured bunker of the former Führerbau in the chaos at the end in April und early May 1945 [by] . . . plundering masses." OFD, *Akte* 184. Kubin, *Sonderauftrag Linz*, 68.

31. *Kunstpreis-Verzeichnis*. Also Faison, "CIR No. 4," attachment 54.

32. Speer, *Inside the Third Reich*, 72–73.

33. Kurz, *Kunstraub in Europa*, 29.

34. Thomae, *Die Propaganda-Maschinerie*, 42–43, and Steele, "Die Verwaltung der bildenden Künste," 201–2. BAK, R43II/1646c, receipts for Hitler's *GDK* purchases.

35. BAK, R43II/1064a, for generic correspondence about solicitations.

36. Adam, *Art of the Third Reich*, 119.

37. Nicholas, *Rape of Europa*, 24.

38. Faison, "CIR No. 4," 48.

39. Ibid., 3.

40. Faison lists seventy-five individuals in France alone who collaborated with Haberstock. Ibid., 48.

41. Kubin, *Sonderauftrag Linz*, 86.

42. Simon, *Battle of the Louvre*, 77, and Faison, "CIR No. 4," 18.

43. Faison, "CIR No. 4," 62–63 and attachments 44 and 59.

44. Ibid., 10, for a subsequent law prohibiting the export of national treasures, 9 May 1942.

45. BAK, R43II/1653a, Bl. 137, Voss to Bormann, undated report for the period 1 April 1943 to 3 March 1944. The key agents were Hildebrand Gurlitt, Erhard Göpel, and Dr. Hans Herbst (the latter was on staff at the Dorotheum auction house in Vienna). Also Faison, "CIR No. 4," 18, 44–58, and Venema, *Kunsthandel in Nederland*, 72–119.

46. Voss, as head of the Linz Project's visual arts department, did not head the entire project as had Posse. Rather, other experts had more autonomy in overseeing their own collections as follows: for coins, Fritz Dworschak; for armor, Leopold Ruprecht; and for books, Friedrich Wolffhardt. Faison, "CIR No. 4," 17–22, 71–74.

47. Schwarzwäller, *Hitlers Geld*, 174, and Grunberger, *Twelve-Year Reich*, 361.

48. Wistrich, *Who's Who in Nazi Germany*, 181.

49. BAK, R43II/1108, Bl. 93, a Reich Chancellery memo for the inception of the *Sonderbriefmarken*. Faison, "CIR No. 4," 41; Kubin, *Sonderauftrag Linz*, 65; and Thomae, *Die Propaganda-Maschinerie*, 164.

50. BAK, R43II/1108, Bl. 77, Ohnesorge to Hitler, 14 February 1942.

51. Ibid., Bl. 7, report dated 2 October 1942, for a year-by-year breakdown of the *Sonderbriefmarken* revenue. Also Kubin, *Sonderauftrag Linz*, 66.

52. Faison, "Supplement to CIR No. 4."

53. Kubin, *Sonderauftrag Linz*, 70. BAK, R2/31098, Wagner to Reinhardt, 25 February 1942.

54. Flanner, *Men and Monuments*, 223.

55. Roxan and Wanstall, *Rape of Art*, 37–40.

56. Faison, "CIR No. 4," attachment 5, Posse to Bormann, 14 December 1939.

57. Ibid., 59–60, attachment 56b, Bormann to Posse, 31 December 1940, whereby Bormann claims that Hitler himself ordered certain ERR-France pieces to be directed to his collection in Munich. Ibid., attachment 9, Posse to Bormann, 20 April 1941, with the request to inspect the art in Neuschwanstein "with a view to the needs of the Führermuseum in Linz." Also Cassou, *Le Pillage par les Allemands*, 116, Rosenberg to Hitler, 16 April 1943.

58. Kurz, *Kunstraub in Europa*, 57.

59. Goebbels, *Tagebücher*, 2:603, 22 April 1936. For the 1939 painting, for which Goebbels paid RM 98,000, see Thomae *Die Propaganda-Maschinerie*, 164. Haase, *Kunstraub und Kunstschutz*, 61.

60. OFD, XXIVA, 120–130, and Faison, "CIR No. 4," 28–29.

61. Wulf, *Die bildenden Künste*, 229.

62. IMT, *Trial of the Major War Criminals*, 8:63. Also, Göring to Rosenberg, 21 November 1940, in Wulf, *Die bildenden Künste*, 439–41.

63. Göring to Rosenberg, 21 November 1940, in Cassou, *Le Pillage par les Allemands*, 105–7. See also the extensive collection of Hofer's correspondence in the Douglas Cooper Papers, box 39, Getty Center.

64. CDJC, XIII-51, *Exposé du Ministre Public*, 52. Also Rousseau, "CIR No. 2," 174.

65. Kurz, *Kunstraub in Europa*, 226.

66. Simon, *Battle of the Louvre*, 63.

67. Irving, *Göring*, 106. Note that the work of this historian has been very controversial. While many of his opinions are patently wrong (e.g., denying the existence of gas chambers), he nonetheless has been very successful in obtaining new archival materials. In short, I have approached the work of this historian with caution.

68. Ibid., 25–27, 46.

69. Ibid., 90, 102.

70. Ibid., 95.

71. Ibid.

72. Ibid., 120.

73. Ibid., 136–37, 167–68. PrGSta, Rep. 151/85, for receipts covered by the Prussian Finance Ministry. Also Rousseau, "CIR No. 2," 162–63, and Haase, *Kunstraub und Kunstschutz*, 88.

74. Speer, *Inside the Third Reich*, 417–18.

75. Flanner, *Men and Monuments*, 243–44.

76. Kurz, *Kunstraub in Europa*, 290; Flanner, *Men and Monuments*, 262; and Werness, "Hans van Meegeren *fecit*," 1–57.

77. Rousseau, "CIR No. 2," 3.

78. Ibid., 9–20.

79. Plaut, "DIR No. 4," and Wittmann and Taper, "DIR of Hans Wendland."

80. CDJC, XIII-51 (Nuremberg Trial Document 1015-PS), report of Robert Scholz, 14 July 1944; CDJC, XIII-42, Scholz's report, 15 April 1943 (Nuremberg Trial Document 172-PS); and CDJC, XIII-51, *L'Exposé du Ministre Public*.

81. David Irving, interview with the author in Cambridge, Mass., 23 October 1989. For Beltrand's estimates, see Cooper, *Looted Works of Art in Switzerland*, in Douglas Cooper Papers, box 39, Getty Center. Also Rousseau, "CIR No. 2," 157.

82. Rousseau, "CIR No. 2," 149–56. Janet Flanner noted that Göring would sometimes trade artworks presented to him as gifts—in short, that he was not overly sentimental. Flanner, *Men and Monuments*, 247.

83. Haase, *Kunstraub und Kunstschutz*, 87–88, 136–40.

84. Rousseau, "CIR No. 2," 141–42.

85. Flanner, *Men and Monuments*, 242, and Telford Taylor, *Anatomy of the Nuremberg Trials*, 305.

86. Rousseau, "CIR No. 2," 149.

87. Faison, "CIR No. 4," 30–33.

88. Speer, *Inside the Third Reich*, 244–45, and Kurz, *Kunstraub in Europa*,

353–54. Kurz claims that Titian's *Danae* was placed in Göring's bedroom.

89. Mosley, *Reich Marshal,* 267.

90. Irving, *Göring,* 303.

91. Plaut, "DIR No. 4," and Kurz, *Kunstraub in Europa,* 274.

92. Two cases involve Professor Max Friedländer and the collector Nathan Katz—both of whom survived, in part, due to Göring's intervention. Kurz, *Kunstraub in Europa,* 291–92, and Haase, *Kunstraub und Kunstschutz,* 95, 116.

93. Wulf, *Die bildenden Künste,* 350, and PrGSta, Rep. 151/82. Göring was also the honorary head of the Deutsches Jagdmuseum (the German Hunting Museum), which he helped found in Munich's Prinz Leopold Palais. BAK, R43II/1235, Bl. 60–63.

94. Haase, *Kunstraub und Kunstschutz,* 87.

95. Harris, *Tyranny on Trial,* 389, and IMT, *Trial of the Major War Criminals,* 9:633–34.

96. Goebbels, *Tagebücher,* 4:688, 13 June 1941.

97. Goebbels, *Michael.*

98. BAK, R55/68, Bl. 13–14, "Leihvertrag zwischen dem Direktor der Staatlichen Schlösser und Garten zu Berlin und dem RMVP," 11 November 1933. Approximately twenty works, mostly from the schools of old masters, were borrowed. For other loans, BAK, R43II/1062c.

99. Speer, *Inside the Third Reich,* 58–59.

100. Brock, "Kunst auf Befehl?," 18.

101. Brenner, "Art in the Political Power Struggle," 402.

102. For Goebbels's refusal to reduce the *Mittel* in 1940, see BAK, R2/4868, Bl. 321–24, *Vermerk* of Dr. Hofmann, 8 January 1940.

103. Goebbels, *Tagebücher,* 3:114, 17 April 1937. BAK, R43II/1237, Bl. 38, Keudell to the Reich Chancellery.

104. Goebbels, *Tagebücher,* 3:476, 9 July 1938.

105. Ibid., 4:725, 30 June 1941. Also see the albums of photographs documenting the propaganda minister's *GDK* acquisitions, the volumes for 1939 and 1941 in the Third Reich Collection, Library of Congress, Rare Books Division. The 1939 photo catalog contains forty-three illustrations and the titles of five subsequent works that he bought.

106. BAK, R55/698, Bl. 90, Hofmann to Goebbels, 16 October 1941; BAK, R55/869, Bl. 13, Ott to Hofmann; and Goebbels, *Tagebücher,* 4:421.

107. BAK, R55/698, Bl. 18, Hanke to Ott and Keudell, 13 January 1936.

108. Ibid., Bl. 90–92, 16 October 1941, and Bl. 100, 4 November 1941. For more on Winkler, see Lindner, *Das Reichskommissariat für die Behandlung feindlichen Vermögens,* 153–55, and Zentner and Bedürftig, *Encyclopedia of the Third Reich,* 1050.

109. BAK, R55/698, Bl. 100, Goebbels to Frowein, 4 November 1941.

110. BAK, R55/667, Bl. 27, Hopf to Draga of the Fremdpolizei, 8 July 1942.

111. Ibid., Bl. 30, Biebrach to Goebbels, 10 April 1942.

112. BAK, R55/698, Bl. 89, Lucerna to Biebrach, 2 August 1941. Also Bl. 97, "Leiter H" to Goebbels, 4 February 1942. Note that this sum of RM 2 million in 1941 entailed an increase from earlier budgetary allotments for patronage. The

1934 RMVP budget provided for RM 500,000 for *Künstlerische Zwecke*. Ibid., Bl. 79, an anonymous RMVP memorandum, 9 December 1934. Also Steele, "Die Verwaltung der bildenden Künste," 201.

113. Balfour, *Propaganda in War*, 114–15.

114. Goebbels, *Tagebücher*, 4:3, 3 January 1940.

115. BAK, R55/667, Bl. 27, Hopf memorandum (undated).

116. Goebbels, *Tagebücher*, 4:369, 19 October 1940.

117. BAK, R55/667, Bl. 6, Hopf to the Leiter der Reichskreditkasse in Paris, 13 April 1944.

118. Ibid., Bl. 12, receipt from Hermsen, 22 April 1944.

119. BAK, R55/423, Bl. 48–50.

120. Ibid., Bl. 51. List of charges for RM 34,093, 24 February 1942.

121. Heiber, *Goebbels*, 228.

122. BAK, R55/1392, Bl. 70–73, an RMVP Abteilung Bildende Kunst list, August 1944, which reports that Goebbels gave art to Sauckel, Streicher, Hierl, Meissner, and Ley.

123. Jürgen and Roos, "Magda," 17.

124. Goebbels, *Tagebücher*, 3:571, 10 February 1939.

125. Thomae, *Die Propaganda-Maschinerie*, 285, 348, 387, 524.

126. Fest, *Face of the Third Reich*, 179.

127. Weitz, *Hitler's Diplomat*, 8–9, and Schwarz, *This Man Ribbentrop*, 62–63. BAK, NL163/12, for Ribbentrop's documents relating to his title.

128. Schwarz, *This Man Ribbentrop*, 65.

129. BAK, R170/1457, Bl. 104, statement of Olaf Gulbransson, professor at the Bayerische Akademie der Kunst (undated).

130. Ibid., Bl. 95–96, statement by a former governess, E. E. Pettifer, 9 July 1952. Note that there were doubts about the violin's authenticity. Weitz, *Hitler's Diplomat*, 6–7.

131. Works by Defregger, Waldmüller, and Nazi artists such as Lenk and Peiner were part of their collection. BAK, NL163/8, and BAK, R170/1457, Bl. 109–19, 126–27.

132. Ribbentrop also belonged to the SS-Lebensborn program. See BAK, NL163/6, for his organizational affiliations.

133. BAK, NL163/8. Among other presents received by the Ribbentrops that were in line with the official government policy are a number of works by the Nazi painter Werner Peiner, which came from Göring, and a painting called *Landscape* by the contemporary artist E. Rotterkin, an April 1940 present from Gauleiter Alfred Meyer. Also, Ribbentrop file, BDC, Himmler to Ribbentrop, 21 July 1942, for the gift of another picture entitled *Storenfried*.

134. BAK, NL163/8. Hitler gave Ribbentrop the Bismarck portrait on 30 April 1941. Bardóssy, who presented the foreign minister with Hans Makart's *Putto with the Weapons of Aries* in October 1941, also provided Ribbentrop with the second Lenbach portrait in January 1942, while the foreign minister was making a state visit to Budapest.

135. BAK, R170/1457, a list of artworks designated as having belonged to the Ribbentrop family. It includes Gustave Courbet's *Bridge over a Stream in a Moun-*

tain Landscape, Camille Corot's *Landscape on the Neimsee,* Gustave Moreau's *Water Nymph,* Claude Monet's *Landscape with Train,* and André Derain's *Portrait of a Young Girl.*

136. Simon, *Battle of the Louvre,* 98.

137. Nicholas, *Rape of Europa,* 125. Also CDJC, LXXI-45 and LXXI-59.

138. Weitz, *Hitler's Diplomat,* 173.

139. BAK, R170/1457, Bl. 107, statement of Maria May (undated).

140. Kurz, *Kunstraub in Europa,* 142–43. Simon, *Battle of the Louvre,* 57.

141. BAK, NL163/7, for many documents pertaining to the Fra Angelico.

142. BAK, R2/*Anhang, Akte* no. 25.

143. Weitz, *Hitler's Diplomat,* 130, and BAK, R2/*Anhang, Akte* no. 25.

144. PrGSta, Rep. 90/2403, Bl. 8, Göring memorandum, 27 May 1937, and Bl. 36, Kümmel to Rust, 9 November 1937.

145. Schwarz, *This Man Ribbentrop,* 193. Speer, "Die Deutsche Botschaft in London," 345–56.

146. Erich Kordt, Ribbentrop's assistant, set the remodeling costs at RM 5 million. Kordt, *Nicht aus den Akten,* 154.

147. Schwarz, *This Man Ribbentrop,* 199, 204.

148. Weitz, *Hitler's Diplomat,* 123.

149. Schwarz, *This Man Ribbentrop,* 220.

150. BAK, NL163/9, report of Otto Bredt, 14 March 1943; also Weitz, *Hitler's Diplomat,* 145.

151. BAK, NL163/13, Lammers's *Vermerk,* 5 April 1939, and Ribbentrop to Michael, 25 June 1943, notes the second award on 30 April 1943. BAK, NL163/4, reveals that the *Dotationen* were placed in an account in the Deutsche Bank in Berlin. From this account there were numerous withdrawals to pay for artworks: e.g., on 2 February 1944, RM 34,500 went toward a *"Gemälde Defregger,"* and on 25 February 1944, RM 53,000 was spent on a picture by Franz Lenk.

152. The former owner of *Schloß* Fuschl, Baron Gustav von Remitz, who was a prominent anti-Nazi, was placed in a KZ-Lager after the *Anschluß*; the *Schloß* became government property, allocated to the Foreign Ministry. BAK, R2/*Anhang*/25. BAK, NL163/9, report of Bredt, 14 March 1943.

153. Schwarz, *This Man Ribbentrop,* 237.

154. IMT, *Trial of the Major War Criminals,* 10:208–14.

155. Weitz, *Hitler's Diplomat,* 201.

156. IMT, *Trial of the Major War Criminals,* 10:208.

157. Wittmann and Taper, "DIR of Hans Wendland," 13. For contacts with Hans Lange and other dealers, see BAK, R2/12920. The Ribbentrops also were acquainted with dealer Ferdinand Möller. See Möller to Annelies Ribbentrop, 9 November 1938, in Hüneke, "On the Trail," 127.

158. BAK, NL163/8; BAK, NL163/12, Bl. 8–10, for an inventory from May 1943 entitled "Aufstellung der nach Dahlem, Haus Lentze-Alle 7/9 gelieferten Gegenstände"; and BAK, R2/1290, Burmeister to Referenten Baccarich, 10 July 1943, as well as BAK, R170/1457, Bl. 97–99, the testimony of Oskar Möhring, 27 October 1951, and Jacob Wilhelm Fehrle, 28 July 1952.

159. BAK, NL163/2, Ribbentrop to Gottfriedsen, 28 July 1941.

160. BAK, NL163/8, for lists and photographs.

161. Speer, in *Inside the Third Reich*, never affixes the aristocratic prefix to Ribbentrop's name, whereas he does so with others.

162. Irving, *Göring*, 250.

163. Ibid., 250.

164. Koehl, "Feudal Aspects of National Socialism."

165. Manvell and Fraenkel, *Himmler*, 1.

166. Koehl, "Feudal Aspects of National Socialism," 155.

167. Infield, *Secrets of the SS*, 135. Also Frischauer, *Himmler*, 67–69; Manvell and Fraenkel, *Himmler*, 49; and Hüser, *Wewelsburg*, 309–10, 399.

168. NAW, RG 239/69, Report of S. F. Markham, 20 May 1945, and the attached documents, including "Aufstellung von Antiquitäten für die Wewelsburg, ausgesucht durch SS-Sturmführer Bartels."

169. BAK, NS21/228, Himmler to Sievers, 20 November 1942.

170. Himmler to Hahne, 24 October 1933, in Heiber, *Reichsführer!*, letter 5.

171. BAK, NS21/227, Juritzky to Himmler, 15 December 1941 and 23 March 1942.

172. Ibid.

173. BAK, NS21/290, for the Ahnenerbe's gifts to Himmler, including a Viking sword (Christmas 1937), a fifteenth-century shield from Konstanz (Christmas 1938), Langobard jewelry (birthday 1943), a drawing entitled *Germanische Führerpersönlichkeiten* (Leading Germanic personalities) (birthday 1944), and an etching depicting the *Nordisch-Germanische Volkskräfte* in the South Tyrol (presented in early 1945). BAK, NS21/225, for Frick's gift, the *Speerspitze von Kowel.*

174. BAK, NS19/3086, documents from 3 July 1944 to 9 March 1945. Specifically, Brandt to Berger, 23 August 1944, notes, "The Reichsführer-SS asks you to issue a commission to the sculptor Grauel to finish the sculpture *The Loving One* (*Liebende*). He wishes, however, that the protruding chin of the man be slightly altered." For Himmler's commission to Wilhelm Kreis in 1943, see Thomae, *Die Propaganda-Maschinerie*, 423–24.

175. *Kunst im Dritten Reich* (1938, vol. 1) showed and discussed a bust of Himmler (along with Hess, Göring, Frick, and others). Also BAK, NS19/3165, Radke to Brandt, 30 July 1942, for approval to five different artists for either busts or portraits.

176. BAK, NS19/3055, Vahrenkamp to Himmler, 5 August 1942.

177. Ibid., Brandt to Vahrenkamp, 14 August 1942.

178. Ibid., Brandt to Koch, 22 March 1940 and 6 January 1944.

179. BAK, NS19/1351, Hoffmann to Himmler, 14 June 1943. BAK, NS19/3055, for an example of Himmler consulting Posse, and for Peterson's advice.

180. BAK, NS19/3055, Vahrenkamp to Himmler, 5 August 1942.

181. BAK, NS19/3165, Brandt to "Erika," 29 August 1942.

182. BAK, NS19/632, Schwann to Brandt, 1943 (undated).

183. BAK, NS8/242, Bl. 44–45, an anonymous report about the Friedrich Stahl exhibition in Rome, February 1939.

184. Lang, *Der Adjutant*, photograph and caption following 160. Lang claims

that the Menzel was paid for by the Freundeskreis des Reichsführer-SS. For the title of the work, Backes, "Adolf Hitlers Einfluß," 356. Also Thomae, *Die Propaganda-Maschinerie*, 163, and Roxan and Wanstall, *Rape of Art*, 99.

185. BAK, NS19/2748, Himmler to Pohl, 20 September 1942.

186. BAK, NS19/2044 and NS21/290, for a representative sample of books, porcelain busts, pictures of König Heinrich I, etc.; BAK, NS19/3535, for Himmler giving Gerda Bormann a silver bowl; and BAK, NS19/3672, gift records for Himmler's godchildren.

187. Freeman, *Atlas of Nazi Germany*, 150.

188. Manvell and Fraenkel, *Himmler*, 166, and Schellenberg, *Labyrinth*, 358.

189. Hüser, *Wewelsburg*, 455, and Vogelsang, *Der Freundeskreis Himmler*. The gold from the murdered Jews was placed in the Reichsbank Berlin, and the SS had a special account there called "Max Heiliger." Manvell and Fraenkel, *Himmler*, 134, 198. Michael Freeman notes that "the SS slave empire . . . grew to yield an annual turnover in excess of fifty million Reichsmarks." Freeman, *Atlas of Nazi Germany*, 72.

190. Rürup, *Topographie des Terrors*. For more on Zhitomir, see Manvell and Fraenkel, *Himmler*, 151, 211; for the other residences, Padfield, *Himmler*, 248.

191. Mühlmann file, BDC, notes that he joined the SS on 12 March 1938 and was promoted six times prior to attaining the rank of Oberführer in April 1943. Also Vlug, *Report on Objects Removed to Germany*, 106, 112–20.

192. Kurz, *Kunstraub in Europa*, 294, and Bouresh, "Sammeln Sie Also Kräftig!," 60–65.

193. Vlug, *Report on Objects Removed to Germany*, 106.

194. The full title of the list reads, "Ölgemälde aus Beständen Reichsführer-SS gelagert bei der Firma Hess & Rohm Leipziger Straße in den Tresor Burgstraße 26 überführt am 23. November 1943." BAK, NS19/3666, for the three-page list, 26 February 1944. Jaeger, *Linz File*, 139–40. For more on Himmler and plunder, BAK, NS19/400, the unidentified head of a Waffen-SS depot to Himmler's Persönlicher Stab, 23 December 1942, and Richard Teichler to the Gestapo, 17 February 1943.

195. Cooper and De Wald, "German Kunstschutz in Italy," 7. Also Kurz, *Kunstraub in Europa*, 352–55.

196. Manvell and Fraenkel, *Himmler*, 88.

197. IfZG, ZS 25/1 (Sammlung Kater), 274, Kater interview with J. O. Plassmann, 19 May 1963.

198. Manvell and Fraenkel, *Himmler*, 187. They describe him as "a small, middle-class man, a petty-bourgeois figure whose appearance made men laugh."

199. Graber, *History of the SS*, 87.

200. OMGUS, 5/347–3/3, interrogation by General Charles Gailey, 30 September 1946. Henrietta von Schirach, *Der Preis der Herrlichkeit*, 237, 243.

201. Lang, *Der Hitler-Junge*, 147–50.

202. Rathkolb, "Nationalsozialistische (Un-) Kulturpolitik in Wien," 265–76, and Tabor, "Die Gaben der Ostmark," 283–87.

203. Baldur von Schirach, *Ich glaubte an Hitler*, 264–66, 285.

204. Ibid., 271, 274. BAK, R43II/1250a, for Schirach getting Reich funds for patronage.

205. Becker, *German Youth*, 170.

206. Henrietta von Schirach, *Der Preis der Herrlichkeit*, 190, and Lang, *Der Hitler-Junge*, 13.

207. Baldur von Schirach, *Ich glaubte an Hitler*, 7.

208. Henrietta von Schirach, *Der Preis der Herrlichkeit*, 80, 92.

209. Stachura, *Nazi Youth in the Weimar Republic*, 245–46.

210. Lang, *Der Hitler-Junge*, 198–202.

211. Grunberger, *Twelve-Year Reich*, 69–70, and Baldur von Schirach, *Ich glaubte an Hitler*, 287–88. Also Nierhaus, "Adoration und Selbstverherrlichung," 111–12.

212. BAK, NS8/243, Bl. 96–97, Scholz to Rosenberg, 16 November 1942, and Bl. 110–13, Scholz to Rosenberg, 24 March 1943, for the *Junge Kunst* exhibition. Also Thomas, *Bis der Vorhang Fiel*, 145.

213. Baldur von Schirach, *Ich Glaubte an Hitler*, 288, and IMT, *Trial of the Major War Criminals*, 14:427. Also, Tabor, "Die Gaben der Ostmark," 293–94.

214. ÖSta, AdR, BMfU, 1789–1943, no. U71, memorandum, 8 March 1943. The artists whose works Schirach bought are Karl Albiker, Theo Champion, Franz Gebhardt, Ludwig Kasper, C. O. Müller, and Hans Wimmer. Schirach promoted the exhibition in the journal of the Hitler Jugend, *Wille und Macht*. Lang, *Der Hitler-Junge*, 330–32.

215. Stachura, *Nazi Youth in the Weimar Republic*, 245, and IMT, *Trial of the Major War Criminals*, 14:428–29.

216. OMGUS, 5/347–3/3, John Allen, the chief of the Restitution Branch Office for OMGUS, reported the purchase. Also Vlug, *Report on Objects Removed to Germany*, 42, and Henrietta von Schirach, *Der Preis der Herrlichkeit*, 234.

217. BAK, NS8/243, Bl. 96–97, Scholz to Rosenberg, 16 November 1942.

218. Ibid.

219. Henrietta von Schirach, *Der Preis der Herrlichkeit*, 35–36.

220. OMGUS, 5/347–3/3. Gailey cites other purchases of confiscated Jewish property by Schirach, including antique Grecian jewelry.

221. OFD, XA, 128, Schirach to Huber, 24 June 1943.

222. Kurz, *Kunstraub in Europa*, 62.

223. OMGUS, 5/347–3/3.

224. OFD, *Akte* XA, 128, Ebner to Siebert, 29 June 1943.

225. Henrietta von Schirach, *Der Preis der Herrlichkeit*, 218–21.

226. Vlug, *Report on Objects Removed to Germany*, 32–33, 42, 103–4.

227. OMGUS, 5/347–3/3, and *Süddeutsche Zeitung* 16, 18/19 January 1958, 8.

228. Faison, "CIR No. 4," 20, and attachment 25, Bormann to Posse, 11 February 1941, for the forced exchange for the Rubens. BAK, R43II/1649a, Bl. 52–64, for his efforts with Hoffmann. Also Kubin, *Sonderauftrag Linz*, 53–57. Schirach also assisted with Hitler's acquisition of Rembrandt's *Portrait of Hendrickje Stoffels*. ÖSta, AdR, 15 Kunstwesen, 2196/43.

229. OFD, *Akte* XA, 126, Schirach to Reimer, 16 October 1943, where he notes the purchase of the two works "with the approval of the Führer."

230. For the gift to Schwarz, see ÖSta, AdR, NS Parteistellen, Karton 40, Voggeser to Schulze, 29 January 1943.

231. BAK, R2/12913, and Henrietta von Schirach, *Der Preis der Herrlichkeit*, 181, 230.

232. OMGUS, 5/347–3/3.

233. Thomas, *Bis der Vorhang fiel*, 140.

234. Faison, "CIR No. 4," 20. Note that Schirach also bought artworks for his private collection during this trip, including eighteen paintings in one day from the Amsterdam dealer de Boer. For a trip to the Netherlands to purchase a Vermeer, *Picture of a Reading Man*, ÖSta, AdR, BMfU, 3304–1941 and GZ 1883/41. Also Thomas, *Bis der Vorhang fiel*, 142–44.

235. For Schirach purchasing eighteen works for 127,000 Dutch florins at de Boer, see Vlug, *Report on Objects Removed to Germany*, 103–4.

236. Schirach's hands-on management of the patronage of local artists is conveyed in Libiger, *Schirach*. Also, ÖSta, AdR, Inneres RSt. III, box 7691; BMfU, Kunstangelegenheiten, 1789–1943; BMfU, Kunstangelegenheiten, GZ 983/41 and GZ 1229/41; and AdR, 15B, Kunstwesen, Karton 71, Kunstankäufe. For a budget of RM 1 million for cultural expenditures, see ÖSta, AdR, Kunstwesen 15B1, 584–41, a 1941 Reichsstatthalterei memorandum, November 1941.

237. Rathkolb, "Nationalsozialistische (Un-) Kulturpolitik in Wien," 270.

238. Wistrich, *Who's Who in Nazi Germany*, 78.

239. Vlug, *Report on Objects Removed to Germany*, 44.

240. Kurz, *Kunstraub in Europa*, 95–96, and Nicholas, *Rape of Europa*, 76.

241. Dr. Wächter and other subordinates also gave pieces to Frank. Vlug, *Report on Objects Removed to Germany*, Mühlmann interrogation, 247–53, in OFD, *Akte* no. 200.

242. Kurz, *Kunstraub in Europa*, 95–96.

243. Howe, *Salt Mines and Castles*, 251; Jaeger, *Linz File*, 61; and Flanner, *Men and Monuments*, 239.

244. Kurz, *Kunstraub in Europa*, 100–101. Also Kowalski, *Liquidation*, 27–30 and illustration 14.

245. Ibid., 327–28. Haase, *Kunstraub und Kunstschutz*, 173–74; Nicholas, *Rape of Europa*, 77–79; and Jaeger, *Linz File*, 60–63.

246. Vlug, *Report on Objects Removed to Germany*, Mühlmann interrogation, 247–53, in OFD, *Akte* no. 200.

247. Nicholas, *Rape of Europa*, 76.

248. Vlug, *Report on Objects Removed to Germany*, 142–49.

249. Jaeger, *Linz File*, 59.

250. Vlug, *Report on Objects Removed to Germany*, 45.

251. Ministerstwo Informacji Poland, *Nazi Kultur in Poland*, 96–98.

252. Ibid., 105.

253. Jaeger, *Linz File*, 61.

254. Vlug, *Report on Objects Removed to Germany*, Mühlmann interrogation, 100, 247–53, in OFD, *Akte* no. 200.

255. Haase, *Kunstraub und Kunstschutz*, 171.

256. Reitlinger, *The SS*, 148–49.

257. Jaeger, *Linz File*, 61. The Rembrandt painting was mentioned in the *Völkischer Beobachter*, 6 December 1940. Piotrowski, *Hans Frank's Diary*, 125.

258. IMT, *Trial of the Major War Criminals*, 18:161 and 12:87, 133.

259. Ibid., 12:18. Also Zentner and Bedürftig, *Encyclopedia of the Third Reich*, 290.

260. For an account of Frank's prewar lifestyle, see the chapter on his son Niklas in Posner, *Hitler's Children*, 10–42. Mühlmann, who knew Frank well, pointed out that he was a *"Jurist, Mathematiker, und ausgezeichneter Musiker,"* skills not normally expected of someone who became a tyrant. Vlug, *Report on Objects Removed to Germany*, Mühlmann interrogation, 247–53, in OFD, *Akte* no. 200.

261. Posner, *Hitler's Children*.

262. Ibid.

263. Reitlinger, *The SS*, 225.

264. Posner, *Hitler's Children*, 22, 29.

265. Piotrowski, *Hans Frank's Diary*, 116. IMT, *Trial of the Major War Criminals*, 12:132.

266. IMT, *Trial of the Major War Criminals*, 12:41. Frank also suffered some sort of nervous collapse in 1943–44 and took a sick leave. Ibid., 12:132.

267. Note, for example, that Ley is not included in Fest, *Face of the Third Reich*.

268. Smelser, *Robert Ley*, 211.

269. Ibid., 52, 54–55.

270. Ibid., 110, and Lang, *Bormann*, 122.

271. Smelser, *Robert Ley*, 108–9.

272. Ibid., 67, 108–9.

273. Ibid., 108–109, 114–15.

274. Ibid., 114–15.

275. BAK, NS22/689.

276. BAK, R8/XIV/5, Dietrich to the Reichsstelle für Papiere (undated).

277. BAK, R8/XIV/II, Bl. 237–52 (documents from 1942–44), and Roxan and Wanstall, *Rape of Art*, 95.

278. Haase, *Kunstraub und Kunstschutz*, 126.

279. Library of Congress, Rare Books Division, Third Reich Collection.

280. Speer, *Inside the Third Reich*, 102. Pictures of the structure can be found in Krier, *Albert Speer*, 197.

281. Speer, *Inside the Third Reich*, 103. Speer notes that he had RM 1.5 million and was owed RM 1 million for his work as an architect.

282. Ibid., 543.

283. BAK, R120/1622, Bl. 12–24, for funds spent by Speer on the Lichtensteinallee property. Expenditures of RM 1,673,631 are noted for the structure's *Umbau* (reconstruction), but the total costs were considerably greater.

284. Krier, *Albert Speer*, 203–5.

285. OMGUS, 5/347–3/3, report of John Allen, 14 January 1948.

286. Nicholas, *Rape of Europa*, 155.

287. Speer, *Inside the Third Reich*, 78.

288. Ibid., 535.

289. Ibid., 166.

290. BAK, R43II/1062b, Bl. 92–95, for the "Verzeichnis der auf veranlassen des GBI für die Reichshauptstadt für die Reichskanzlei erworbenen Bilder." The dates of the purchases range from February 1936 until December 1940, with two purchases added from 1942.

291. BAK, R2/4868, Bl. 321–24, a GBI *Vermerk*, January 1940 (undated).

292. BAK, R3/*Anhang*/175, for a postwar account of the ministry's purchases. The document includes a thirty-two-page list that details specific artworks.

293. Bushart, "überraschende Begegnung mit alten Bekannten," 35. Also, BAK, R120/3460a, Bl. 13, a list of payments to Breker through March 1945 totaling RM 9,077,000.

294. Cone, *Artists under Vichy*, 160.

295. BAK, R120/3460a, Bl. 13. Also BAK, R43II/986, Bl. 51, for Bormann giving Breker a RM 250,000 tax-free *Dotation* in April 1942 based on Speer's recommendation.

296. Speer, *Inside the Third Reich*, 203, and Speer, *Spandau*, 134.

297. Golomstock, *Totalitarian Art*, 227. The quote about the Lanzinger picture is from the curator of the U.S. Army Art Collection, Marylou Gjernes, interview in Washington, D.C., 14 January 1994.

298. Speer, *Spandau*, 261, and Overesch, *Das III. Reich*, 331. BAK, R3/1588, Bl. 43, Speer to Lammers, 26 May 1944; BAK, R120/1635, Bl. 11, Speer to Dönitz, December 1943; and BAK, R3/1599, Bl. 8, Speer to Schaede, 12 May 1944.

299. BAK, R3/1594, Bl. 143, Speer to Posse, 27 May 1941.

300. BAK, R120/1635 and R120/1636.

301. Speer, *Inside the Third Reich*, 87.

302. BAK, R3/1587, for Speer's correspondence with Kolb.

303. Manvell and Fraenkel, *Himmler*, 205.

304. Other Nazi leaders sought estates in the east. See, for example, Darré's plans in IfZG, Nuremberg Trial doc. NG-2746, statement of Max Winkler, 24 September 1945.

305. Bormann to Gerda, 21 July 1943, in Bormann, *Bormann Letters*, 13.

306. Lang, *Bormann*, 56.

307. Faison, "CIR No. 4," 50.

308. Backes, "Adolf Hitlers Einfluß," 358.

309. Lang, *Bormann*, 96, 180.

310. Speer, "Interview," 86.

311. Nicholas, *Rape of Europa*, 320.

312. Heinrich Hoffmann, *Hitler Was My Friend*, 172–73.

313. Roxan and Wanstall, *Rape of Art*, 96. BAK, NS8/242, Bl. 45, Rittich to Rosenberg (undated), for another example of Bormann's collection of art–his loan of works for a Friedrich Stahl exhibition in Rome.

314. Lang, *Bormann*, 274.

315. Ibid., 276.

316. BAK, R43II/6779, Bl. 33.

317. Roxan and Wanstall, *Rape of Art*, 81.

318. Ibid.

319. Flanner, *Men and Monuments*, 227.

320. *Hamburger Nachrichten-Blatt*, 19 June 1945.

321. Vlug, *Report on Objects Removed to Germany*, 108.

322. Ibid., 51.

323. Seyss-Inquart file, BDC, for his extensive correspondence with Himmler; in particular, Himmler to Seyss-Inquart, 10 February 1941. An exchange from April 1939 deals with the *Familienwappen*. Also BAK, NS19/3535, "Geschenkliste."

324. Zentner and Bedürftig, *Encyclopedia of the Third Reich*, 121.

325. Kurz, *Kunstraub in Europa*, 23, 46, 61.

326. Lehmann-Haupt, "Cultural Looting of the 'Ahnenerbe.'"

327. ÖSta, Adr, BMfU, 15 Kunstwesen, 3.785/40, Thomasberger to Schirach, 30 January 1941.

328. Ibid., Kunstangelegenheiten, GZ 2.558/41, anonymous memorandum to Schirach, May 1941 (undated).

329. For the lifestyles of other Reichskommissars, such as Erich Koch residing in *Schloß* Friedrichsberg near Königsberg and his villa in the Ukraine, see Kurz, *Kunstraub in Europa*, 278, and Haase, *Kunstraub und Kunstschutz*, 135.

330. BAK, R8/XI/32, receipts, 7 June 1943 and 27 May 1941.

331. Exceptions are Harrison, *Gauleiter Bürckel and the Bavarian Palatinate*, and the documentary by Inge Plettenberg, *Der Gauleiter: Lebensweg eines Politikers aus der Pfalz* (a production of the Saarländischer Rundfunk).

332. Thomae, *Die Propaganda-Maschinerie*, 161.

333. Höffkes, *Hitlers Politische Generale*, 42.

CHAPTER EIGHT

1. For more on the relationship between Nazism and Hitlerism, see Jäckel, *Hitler's World View*, 13–26. Also Bracher, "Role of Hitler," and Kershaw, *Nazi Dictatorship*, 6–81.

2. Rich, *Hitler's War Aims*, 1:xiii, and Thies, "Hitler's European Building Programme," 423–31.

3. Rich, *Hitler's War Aims*, 1:3–4.

4. Prange, *Hitler's Words*, 154. Quoted from account of Nuremberg speech of 7 September 1937 in the *Völkischer Beobachter*, 8 September 1937.

5. See Speer, *Inside the Third Reich*, Introduction, n. 5, where Speer comments on the unity of Hitler's political, artistic, and military ideas and their early formation.

6. Barbara Lane calls this "the first of Hitler's own buildings." Lane, *Architecture and Politics*, 212. Also Rasp, *Eine Stadt für tausend Jahre*, 28.

7. A well-known photograph of Hitler and Speer contemplating blueprints

was widely circulated at the time (e.g., it was the frontispiece to Rudolf Wolters's book on Albert Speer). In the *GDK* of 1939 there was a large painting portraying Hitler as a sculptor-architect. Robert Taylor, *Word in Stone*, 17.

8. Rasp, *Eine Stadt für tausend Jahre*, 28. Robert Taylor, *Word in Stone*, 45–46, 147–50.

9. Speer, *Inside the Third Reich*, 109.

10. Prange, *Hitler's Words*, 147. Quoted from the 11 September 1935 Nuremberg Rally cultural speech as reprinted in the *Völkischer Beobachter*, 12 September 1935.

11. Heinrich Hoffmann, *Hitler Was My Friend*, 171.

12. Ibid.

13. Thomae, *Die Propaganda-Maschinerie*, 166.

14. Hitler's belief in the independent artist is conveyed by a comment made by Speer: "Hitler had, I knew, much greater confidence in nonofficial architects – his prejudice against bureaucrats colored his views in everything." Speer, *Inside the Third Reich*, 103.

15. Fest, *Hitler*, 526–27.

16. Speer, *Inside the Third Reich*, 92–93.

17. *Hitler's Table Talk*, 445–46, 28 April 1942. Also Bukey, *Hitler's Hometown*, 196–201.

18. Giesler, *Ein anderer Hitler*, 334.

19. Kurz, *Kunstraub in Europa*, 33.

20. For Posse's obituaries, see the *Völkischer Beobachter*, 12 December 1942; the *Frankfurter Zeitung*, 11 December 1942; and the *Deutsche Allgemeine Zeitung*, 9 December 1942. Another announcement of the "Linzer Galerie" is in Robert Oertel, "Ein Hort Europäische Kunst," in *Das Reich*, 31 January 1943.

21. This point is also suggested by the fact that Hoffmann created a special armed forces' edition of this issue. Faison, "CIR No. 4," 83.

22. Speer, *Inside the Third Reich*, 195.

23. Ibid., 78.

24. Kurz, *Kunstraub in Europa*, 33.

25. Brenner, *Die Kunstpolitik des Nationalsozialismus*, 155, and *Hitler's Table Talk*, 245–46.

26. Fest, *Hitler*, 529. The sketchbook is now located in the Bayerisches Hauptstaatsarchiv.

27. Kurz, *Kunstraub in Europa*, 17, 33–34, and Giesler, *Ein anderer Hitler*, 97–104, 213–17.

28. Tabor, ". . . Und Sie folgten Ihm," 403.

29. Price, *Adolf Hitler als Maler und Zeichner*.

30. Heinrich Hoffmann, *Hitler Was My Friend*, 175.

31. In this respect, the ideas of Johann Gottfried von Herder (including that of the *Volksgeist*) were particularly susceptible to distortion. Berlin, *Vico and Herder*, 145–46.

32. Faison, "CIR No. 4," 28–29, and Rousseau, "CIR No. 2," 98–99.

33. Herzstein, *When Nazi Dreams Come True*, 8.

34. Rousseau, "CIR No. 2," 139–40.

35. Weitz, *Hitler's Diplomat*, 158. The fate of Polish royal insignia was reported in Jan Pruszynski, "Losses in Poland" (presentation at "The Spoils of War," symposium, 19 January 1995, New York).

36. Kurz, *Kunstraub in Europa*, 242, 324–25.

37. The Cracow exhibition is "reviewed" in the *Deutsche Allgemeine Zeitung*, 3 November 1942. For reports on *Deutsche Größe*, BAK, NS8/233, Bl. 19–26, reports to Rosenberg, June 1942.

38. For *Warsaw Accuses*, see Jaeger, *Linz File*, 115. *The Jew and France* and other propaganda exhibitions in France are discussed in Chapter 5. Also, Thomae, *Die Propaganda-Maschinerie*, 79–116. For the film version of *The Soviet Paradise*, see Welch, *Propaganda and the German Cinema*, 250.

39. *Hitler's Table Talk*, 109, 19 February 1942.

40. Ibid., 209, 15–16 January 1942. While Hitler formulated plans for the Russian art, he had no interest in these works and refused to inspect them. Roxan and Wanstall, *Rape of Art*, 116.

41. For plans for museums devoted to both Jews and Freemasons, BAK, NS8/167, Bl. 75–77, Rosenberg to Speer, 22 June 1940; PrGSta, Rep. 90/1791, correspondence between Himmler, Heydrich, Göring, and Hans Kerrl concerning a picture of Immanuel Kant (a Freemason) confiscated from a Königsberg Lodge in 1935. Also Kersten, *Totenkopf und Treue*, 20–34.

42. Vivian Mann, "Jewish Private Property and Ceremonial Art" (presentation at "The Spoils of War," symposium, 19 January 1995, New York).

43. Rhodes, *Vatican in the Age of the Dictators*, 198, 207–8.

44. Conway, *Nazi Persecution of the Churches*, appendix 17, 393–97, Protest of the Austrian Bishops to the Minister of the Interior, 1 July 1941.

45. Rhodes, *Vatican in the Age of the Dictators*, 309, and Bormann, *Le National Socialisme et le Christianisme*.

46. Rhodes, *Vatican in the Age of the Dictators*, 168–69.

47. Rich, *Hitler's War Aims*, 2:172.

48. Lang, *Bormann*, 286.

49. Seyss-Inquart file, BDC, Himmler to Seyss-Inquart, 2 January 1941.

50. Rich, *Hitler's War Aims*, 2:159.

51. *Hitler's Table Talk*, 209, 15–16 January 1942.

52. Baynes, *Speeches of Adolf Hitler*, 601, Hitler's remarks in Munich, 22 January 1938.

53. Roxan and Wanstall, *Rape of Art*, 148–49.

54. Galante and Silianoff, *Last Witnesses in the Bunker*, 139.

55. While the Nero metaphor might strike some as unhistorical, the Nazi leaders themselves utilized the Roman emperor as a point of comparison, as exhibited by the 19 March 1945 "Nero Command," which called for the destruction of everything in the territory to be occupied by the enemy. Zentner and Bedürftig, *Encyclopedia of the Third Reich*, 643. See also Albert Speer's references to Nero, whether it be great columns or a discussion of the relative size of the Führer palace and Nero's Golden House. Speer, *Inside the Third Reich*, 108, 216.

56. Speer, *Inside the Third Reich*, 246.

57. Jaeger, *Linz File*, 124–36, and Kubin, *Sonderauftrag Linz*, 211–81. Also Giefer and Giefer, *Die Rattenlinie*, 39–45.

58. Faison, "CIR No. 4," 22.

59. OMGUS, 5/347–3/3, report of Mason Hammond of the MFA and A, 25 July 1945. He notes the four works taken, including a Rembrandt self-portrait and works by Van Goyen and Rubens. Also, ÖSta, AdR/Inneres, zl. 25028–2/47, report on Schirach and Stuppäck, January 1946.

60. Manning, *Martin Bormann*, 207. He writes, "At the end of 1943, Martin Bormann prepared to put into force Operation Tierra del Fuego, which involved transporting large quantities of gold, money, stocks, paintings, and other works of art to Argentina via submarine." An OSS report dated 4 December 194 and marked "Secret" stated, "After D-day, Göring had commissioned [Alois] Miedel [an art dealer in his employ] to convoy 200 paintings to Spain in two cars." OMGUS, 5/345–3/2. Also OMGUS, 15/112–2/1, an OMGUS report on Himmler's plans to evacuate valuables, November 1945.

61. Simon, *Battle of the Louvre*, 184.

62. Ibid., 185.

63. Mühlmann file, IfZG, Vienna, testimony of Alfons Walde, 27 March 1947.

64. Hitler's private will in Maser, *Hitler's Letters and Notes*, 205.

65. Hummel to Karl Sieber, a conservation specialist at the mine, 1 May 1945, in Kubin, *Sonderauftrag Linz*, 102, 115.

66. Nicholas, *Rape of Europa*, 316–17.

67. Note, however, that Göring ordered Wehrmacht engineers to dynamite Carinhall in April 1945 as the Red Army approached. Zentner and Bedürftig, *Encyclopedia of the Third Reich*, 490.

68. Speer, *Inside the Third Reich*, 99.

69. Ibid.

70. Ibid., 80.

71. See *Die Braune Post* from 13 October 1935, 15, which contains five illustrations of Rosenberg's work. They are surprisingly close to the Impressionists' style.

72. See the conclusion to Chapter 6 and, more specifically, his speech at the Göring Meisterschule für Malerei in Kronenburg on 9 June 1938, in BAK, Zsg. 118/8.

73. BAK, R43II/1326, for the text of Heydrich's speech.

74. Rapport and Northwood, *Rendez-Vous with Destiny*, 744.

75. Ribbentrop quoted by Weitz, *Hitler's Diplomat*, 6.

76. BAK, R3/1614, Bl. 15, Speer to Hitler, 25 January 1944.

77. Taylor and van der Will, "Aesthetics and National Socialism," 12.

78. BAK, R55/122, Goebbels's circular that forbids the creation of new awards, 6 February 1943. BAK, R43II/122, Goebbels's regulations for new art prizes.

79. Speer, *Inside the Third Reich*, 98.

80. Ibid., 110.

1. Reynolds and Stott, *Material Anthropology*. In particular, McCracken, "Clothing as Language."

2. Koehl, "Feudal Aspects of National Socialism," 157.

3. Baird, *To Die for Germany*.

4. PrGSta, Rep. 90/2403. The file concerns the approval of loans prior to 1939 to, among others, Walther Funk, Franz von Papen, Bernhard Rust, Ernst von Weizsäcker, and Fritz Todt.

5. BAK, R43II/1236a, Bl. 2–78.

6. Nicholas, *Rape of Europa*, 27–28.

7. BAK, NS8/178, Bl. 116, Hess to Blomberg, 4 April 1937.

8. For a discussion of the "social interactionists," who include Weber, Tönnies, Durkheim, and Malinowski, see Duncan, *Symbols and Social Theory*, 2–158.

9. Irving, *Göring*, 94; Schwarzwäller, *Hitlers Geld*, 150; and Gritschneder, "Hitler in der Münchener Society," 122–25.

10. The few documented cases of gifts prior to 1933 were quite exceptional. For example, Hitler gave Baldur and Henrietta von Schirach a German shepherd as a wedding gift after he served as their witness. Henrietta von Schirach recounted, "Hitler liked to give well-bred dogs as presents." IfZG, ZS 2238, Henrietta von Schirach interview.

11. Mauss, *The Gift*, 3. Note that the word *prestation* has feudal connotations (referring to feudal law where rent or tax is exchanged for a lord's assent), which is relevant to other arguments in this study.

12. Goebbels, *Tagebücher*, 2:603.

13. Hyde, *The Gift*, 56.

14. For numerous examples of modest gifts to Hitler–such as books with inscriptions, poems, or photographs–see the Third Reich Collection in the Library of Congress, where many extant examples are housed. Along these lines, Speer noted the kitschy objects at Obersalzberg ("swastikas on knickknacks and pillows"), and quoted Hitler as saying, "I know these are not beautiful things, but many of them are presents. I shouldn't like to part with them." Speer, *Inside the Third Reich*, 81.

15. On his birthday in 1936 Heinrich Hoffmann received a watercolor from Hitler. It was one of at least four works by Hitler owned by Hoffmann. Davidson, *Kunst in Deutschland*, 2/1:39. Bormann's possession of Hitler's work was evident at a recent auction of twenty paintings by Hitler in Italy. The works were acquired by an art historian, Rudolfo Siviero, from Bormann's wife in Merano in 1947. See the Associated Press article, "Watercolors by Hitler Kept from Neo-Nazis," in the *Boston Globe*, 19 November 1992. Speer's gift is cited in Chapter 7.

16. Hitler charged Bormann with creating a catalogue raisonné of his works and then collecting as many as possible to keep them out of public view. Bormann directed the NSDAP Hauptarchiv in Munich to carry out this project. BAK, NS26/19–33.

17. Faison, "CIR No. 4," 26, 64; Heinrich Hoffmann, *Hitler Was My Friend*, 181; Davidson, *Kunst in Deutschland*, 2/1:39; and BAK, R43II/1341b, a Four-Year Plan Office report.

18. The painting, entitled *Travelling People*, had been bought by the Schirachs from the Galerie Helbing. Henrietta von Schirach, *Der Preis der Herrlichkeit*, 92.

19. BAK, NL163/11, Gottfriedsen receipt, 19 June 1944.

20. Thorak file, BDC. In particular, the June 1939 exchange of letters between Thorak, Bormann, and Speer. BAK, R55/1017, Bl. 117, Goebbels's nomination of Bantzer for the Kunst und Wissenschaft Preis of 1939.

21. Kurz, *Kunstraub in Europa*, 23–24.

22. Heinrich Hoffmann, *Hitler Was My Friend*, 180.

23. BAK, NS10/9, Bl. 1–2, Kiewitz to Brückner, 6 April 1939.

24. BAK, NL163/8.

25. Hitler's inscription read, "Benito Mussolini in the capital of the movement, MCMXXXVII." Thomae, *Die Propaganda-Maschinerie*, 164.

26. BAK, NS10/6, Bl. 41–47, and BAK, NS10/92, for the lists of gifts received by Hitler and his entourage on their May 1938 trip. Also Scobie, *Hitler's State Architecture*, 32–33, and Faison, "CIR No. 4," 26, 64.

27. BAK, R43II/1451a, Bl. 83–85, Haltenhoff *Vermerk*, 8 December 1942, for the gift of the horse in December 1937.

28. BAK, R43II/1450, Bl. 84, Reichskanzlei *Vermerk*, 17 July 1939.

29. Faison, "CIR No. 4," 28.

30. Irving, *Göring*, 304. Also Kurz, *Kunstraub in Europa*, 342–43, and Siviero, *L'Arte e il Nazismo*, 23–24.

31. BAK, R43II/985a, Bl. 2, Reichskanzlei *Vermerk*, 5 December 1941.

32. Kurz, *Kunstraub in Europa*, 342–51. BAK, R43II/1646, Bl. 65–70, for the Italians' unsuccessful efforts to secure artworks from the Germans that they considered part of their national heritage.

33. BAK, R43II/1451a, Bl. 88–92, internal memorandums from the Reich Chancellery and Hitler's adjutants, March 1943.

34. For the gift to Hitler, noted in the *Völkischer Beobachter* on 6 July 1939, see Thomae, *Die Propaganda-Maschinerie*, 164. Also Howe, *Salt Mines and Castles*, 209, and Henrietta von Schirach, *Der Preis der Herrlichkeit*, 79.

35. Nicholas, *Rape of Europa*, 142. See also the June 1994 exhibition on gifts to German Democratic Republic leaders in the Haus der Geschichte der Bundesrepublik Deutschland, Bonn, entitled, *Aus der Wunderkammer der SED.* Also, Hyde, *The Gift*, 71.

36. BAK, R54/88, and BAK, R54/90.

37. Fred Weinstein, *Dynamics of Nazism*, 82; Kershaw, *The "Hitler Myth"*; and Carr, "Hitler Image in the Last Half-Century."

38. Thomae, *Die Propaganda-Maschinerie*, 162–64.

39. Bucher, "Hitlers 50. Geburtstag," 423–46.

40. "Die Geschenke des Führers für Hermann Göring und Alfred Rosenberg," in the *Thüringer Gauzeitung*, 13 January 1938. Note that Göring's present, Makart's *Die Falknerin*, was purchased from Karl Haberstock for RM 13,400. BAK, R43II/1646a, Bl. 36, Schaub to Lammers, 29 January 1938.

41. Weitz, *Hitler's Diplomat*, 150–51.

42. Thomae, *Die Propaganda-Maschinerie*, 163. The *Völkischer Beobachter* gave extensive coverage to Neurath's birthday festivities on 2 and 3 February 1938, noting the *Glückwunsch* telegrams and Hitler's congratulatory speech. Also Heineman, *Hitler's First Foreign Minister*, 168.

43. Thomae, *Die Propaganda-Maschinerie*, 163. There were antecedents regarding public disclosure, such as Hitler's order of 1928 where he prohibited intra-Party feuds from being conducted in the newspapers. Hale, *Captive Press*, 45.

44. Heinrich Hoffmann, *Hitler Was My Friend*, 179–80.

45. Edward Peterson, *Limits of Hitler's Power*, 31–32.

46. BAK, R43II/985, Bl. 103–5, September 1941. For the *Dotationen*, see BAK, R43II/985a, 985c, and 1092b.

47. Speer, *Spandau*, 126.

48. BAK, R43II/985c, Bl. 35–40, correspondence between Lammers and Krosigk, December 1942 to April 1943.

49. Karl Anders calculated that Hitler spent RM 305 million while in power. Lang, *Bormann*, 90, and BAK, R43II/986, a Reichskanzlei *Vermerk*, 9 October 1943.

50. BAK, R43II/1269a, Bl. 5, Lammers to Himmler, 18 June 1938. This order was reiterated on several other occasions: e.g., BAK, R2/31098, Bormann to Lammers, 6 December 1942.

51. Duncan, *Communication and Social Order*, 281.

52. Benz, "Ritual and Stage Management of National Socialism," 72–81.

53. BAK, NS8/242, Bl. 104, Scholz to Rosenberg, 10 November 1941.

54. IfZG, ZS 247, Hippler interview, July 1952.

55. Goebbels, *Tagebücher*, 2:752, 10 December 1936.

56. BAK, R55/1392, Bl. 69–73, for a list of twenty-four artworks given by Goebbels to other ministers.

57. BAK, R18/5109, Bl. 25–33, 10 March 1942. For another opportunity to analyze the birthday gifts received by a Nazi leader, see Julius Streicher's experience in February 1939, in Varga, *Number One Nazi Jew-Baiter*, 39.

58. Reitlinger, *The SS*, 51–52.

59. BAK, NS19/3935, and BAK, NS163/8.

60. Vlug, *Report on Objects Removed to Germany*, 106.

61. BAK, NS21/290, files on the gifts of the Ahnenerbe.

62. Göring carried this practice to the extreme, as he would request specific items. Among the numerous examples, he arranged for the Luftwaffe to present him with a sixteenth-century French painting, *Portrait of a Man with a Hawk*, in 1936 and Cranach's *Fountain Nymph* in 1938. Flanner, *Men and Monuments*, 247; Kurz, *Kunstraub in Europa*, 168; and Haase, *Kunstraub und Kunstschutz*, 100.

63. It is apparent that Göring did not give Rosenberg a present on the latter's forty-sixth birthday in 1939. See the list of *kostbare Geschenke* from other leaders (Darré, Amann, et al.), where there is no mention of Göring. BAK, NS8/7, Bl. 78, memorandum, January 1939.

64. BAK, NS8/167, Bl. 18, Rosenberg to Göring, 11 January 1943.

65. Ibid., Bl. 3, Rosenberg to Göring, 27 January 1944.

66. Semmler, *Goebbels*, 116–17, 5 January 1944.

67. Ibid. See also Goebbels's journal entry for 28 February 1945, where he calls Göring *"ein Sybarit"* and exclaims, "Decoration-clad fools and lazy, perfumed fops do not belong in the war-leadership. Either they change themselves or they must be eliminated." Goebbels, *Tagebücher*, 5:49.

68. BAK, NS8/171, Bl. 224, Rosenberg to Goebbels, October 1934.

69. Speer, *Inside the Third Reich*, 80, and Snyder, *Hitler's Elite*, 155. Speer described this phenomenon in more evocative terms in a 1971 interview: "Hitler's circle was like a Byzantine court, seething with intrigue and jealousy and betrayal." Speer, "Interview," 87.

70. BAK, NS6/447, Bl. 72–73, Hanssen to Bormann, 18 April 1941.

71. Simon, *Battle of the Louvre*, 30.

72. IMT, *Trial of the Major War Criminals*, 9:548.

73. Haase, *Kunstraub und Kunstschutz*, 86.

74. Göring defended his hegemony over the ERR with a 21 November 1940 directive that was a response to Hitler's command of 18 November repudiating the order of priority initially conceived by the Reichsmarschall. Irving, *Göring*, 302.

75. Posse to Bormann, 14 October 1940, in Faison, "CIR No. 4," attachment 60.

76. Vlug, *Report on Objects Removed to Germany*, 52.

77. Faison, "CIR No. 4," 17–18.

78. Ibid., 49.

79. There are several instances where direct competition arose between the two leaders, such as the quest for Leonardo's *Leda and the Swan* from the Spiridon collection in Rome. OMGUS, 5/346–1/40.

80. ÖSta, Bürckel Material, Karton 126, no. 2429, Göring to Bürckel, 30 December 1939.

81. Nicholas, *Rape of Europa*, 35, and Fest, *Face of the Third Reich*, 75.

82. OMGUS, 5/347–3/3; Heinrich Hoffmann, *Hitler Was My Friend*, 181; and BAK, R2/1290, Baumeister to Krosigk, 27 July 1943.

83. Hinz, *Art in the Third Reich*, 10–11.

84. Schwarz, *This Man Ribbentrop*, 235–36. Ribbentrop's behavior with respect to Hitler was markedly different. The sycophantic foreign minister, for example, made a picture by Wilhelm Leibl "immediately available" to Posse in 1942. OFD, *Akte* no. 146, 119, Luther to Posse, 23 February 1942.

85. Mühlmann interrogation, 20 August 1947, in OFD, *Akte* no. 200, 247–53, and Estreicher, *Cultural Losses of Poland*, 41.

86. Edward Peterson, *Limits of Hitler's Power*, 17–18. Also Nyomarkay, *Charisma and Factionalism*, 30.

87. Eigruber to Bormann of 17 April 1941, in Faison, "CIR No. 4," attachment 70.

88. Ibid., 6.

89. Mühlmann interrogation, 20 August 1947, in OFD, *Akte* no. 200, 247–53.

90. For more on the curator Eberhard Lutze, see Nicholas, *Rape of Europa*, 70.

91. BAK, R43II/1236, Bl. 42–54, and BAK, R43II/1236a, Bl. 93–103, correspondence between Liebel and the Reichskanzlei, June 1938. Also Howe, *Salt Mines and Castles*, 252–53.

92. Liebel cultivated relationships with many powerful figures in the Third Reich, including Streicher, the Gauleiter of Franconia (which included Nuremberg). Liebel arranged for the city to give Streicher the Cramer-Klett villa in 1935. Varga, *Number One Nazi Jew-Baiter*, 204.

93. Speer, "Interview," 84.

94. For an instance of a visitor being offended by Carinhall, see Welles, *Time for Decision*, 118–19.

95. By the spring of 1942 the *Devisen* situation was sufficiently grim for Hitler to order that the purchase of art be confined to a few, exceptional cases. BAK, R43II/810b, Lammers to Bormann, 21 May 1942. Also Rousseau, "CIR No. 2," 164.

96. BAK, R55/640, in particular, Hopf to the RWM [Economics Ministry], 16 July 1943. The propaganda minister's rebound is suggested by his ability to procure foreign currency to buy a Frans de Hulst landscape in France in mid-1944. BAK, R8 XIV/19, Hans Lange to the Reichsstelle für Holz und Papiere, 9 August 1944.

97. BAK, R8 XIV, *Akte* 5, 11, 12 (vol. 2), 19, 40, 41, and 87, for *Devisen* applications.

98. BAK, R43II/810b, Bl. 75, Funk to Lammers, 16 June 1942, and Bl. 76–78, for Schirach's attempts to buy art in Hungary, June 1942.

99. Benjamin, "Work of Art in the Age of Mechanical Reproduction," 241.

CHAPTER TEN

1. Lerner, *Nazi Elite*, 3. For examples of other scholars labeling the Nazi leaders "plebeians," see Zapf, *Die Wandlungen der deutschen Elite*, 51–53, and Guerin, *Fascism and Big Business*, 137.

2. Kater, *Nazi Party*, 196, 229, 380–81. Also Schoenbaum, *Hitler's Social Revolution*, 247. Categorizing the social origins of the Nazi elite is subject to interpretation. For example, Wulf Schwarzwäller in *Hitlers Geld* argues for Hitler coming from a prosperous family. While Kater describes Martin Bormann's father as a "lower civil servant," Baldur von Schirach, in an official publication on Nazi leaders, wrote that Bormann was the "son of a civil servant (*Beamten*) and enjoyed a good primary education." Baldur von Schirach, *Die Pioniere des Dritten Reiches*, 23.

3. Mayer, *Persistence of the Old Regime*. See chap. 4, "Official High Cultures and the Avant-Gardes," where Mayer argues for the predominance of the former. Mayer recognizes that the avant-garde flourished primarily in urban centers. The Nazi leaders stemmed largely from provincial backgrounds. See Speer's discussion of the prevalent "provincial mentality" among the leaders, in *Spandau*, 100–101.

4. For Hess, see Posner, *Hitler's Children*, 46.

5. Schoenbaum, *Hitler's Social Revolution*, 282. Schoenbaum also notes, "Nor were the Nazis with doctorates, even the most aggressively egalitarian of them like Ley and Goebbels, inhibited about appearing in public with their titles."

6. Kater, *Nazi Party*, 174.

7. Cecil, *Myth of the Master Race*, 57.

8. Noakes and Pridham, *Documents on Nazism*, 38–41. For *Frontsozialismus*, see Hanfstaengl, *Unheard Witness*, 61.

9. For more on the political implications of modern art, see Joan Weinstein, *End of Expressionism*.

10. Schoenbaum, *Hitler's Social Revolution*, 51–53.

11. Cecil, *Myth of the Master Race*, 58.

12. Brian Peterson, "Regional Elites," 175.

13. Ibid., 177.

14. Ibid., 186. Also Pool and Pool, *Who Financed Hitler?*, 421–26.

15. Carin Göring (born von Fock) quoted in a letter to her mother, February 1930, in Irving, *Göring*, 96. Also Bewley, *Hermann Göring and the Third Reich*, 153, and Hanfstaengl, *Unheard Witness*, 65.

16. Herbert Ziegler, *Nazi Germany's New Aristocracy*.

17. Hanfstaengl, *Unheard Witness*, 154–55, and Hamilton, *Who Voted For Hitler?*, 413. Note that Prince Auwi was not the sole Hohenzollern to back Hitler. Prinz Eitel Friedrich also wore an SA uniform during the *Kampfzeit*. Irving, *Göring*, 96.

18. Hiden and Farquharson, *Explaining Hitler's Germany*, 93.

19. Fromm, *Blood and Banquets*, 97.

20. Hanfstaengl, *Unheard Witness*, 50.

21. Schoenbaum, *Hitler's Social Revolution*, 58.

22. Smelser, *Robert Ley*, 112.

23. Paul Ludwig Troost was commissioned to renovate the chancellor's residence in early 1933. Speer, *Inside the Third Reich*, 60–61.

24. Among those who inhabited confiscated properties were Bürckel (in Vienna), Ribbentrop (*Schloß* Fuschl), Neurath (Prague), Josef Thorak (Zell am See), and the head of the Prussian State Theater, Gustaf Gründgens (in Zeesen, Brandenburg). BAK, R43II/1269g, Bl. 200, memorandum, 14 February 1943. Also Alford, *Spoils of War*, 69, and *The Week in Germany*, 24 January 1992, 7.

25. Thomae, *Die Propaganda-Maschinerie*, 285. Evidence suggests that all members of the Nazi elite commissioned at least one portrait. Berthold Hinz analyzed the numerous portraits of Nazi leaders' wives, noting, "In these paintings, the specific National Socialist typology in the form of a 'BDM' girl . . . 'a guardian of the race' [or] a heroine . . . is never emphasized. The image projected is that of a 'lady.'" Hinz, *Art in the Third Reich*, 162.

26. For gift-giving as a practice among other elites, see, for example, the discussion of gifts among the Japanese aristocracy in Klein, "Letter From Tokyo," 74. He talks of "satisfying social obligations, again including gift-giving, within the kin network of royalty and its circle."

27. Schwarzwäller, *Hitlers Geld*, 148.

28. Hinz, *Art in the Third Reich*, 162.

29. Ibid., 158. Göring's fixation with the aristocracy took innumerable forms. This included his hunting trips, where he and his attendants sported traditional garb and attempted to imitate the landed gentry of old, as well as staying in the Princes' Suite at the Ritz in Paris.

30. Hanfstaengl, *Unheard Witness*, 202–3.

31. Goebbels quoted in Infield, *Leni Riefenstahl*, 53. For more on Nazi design, Heiber, *Goebbels*, 228–31; Irving, *Göring*, 135–37, 155–56, 173–74, 293–94; and Speer, *Inside the Third Reich*, 69–71, 192–93.

32. For analyses of the Braunhaus, see Rasp, *Eine Stadt für tausend Jahre*, 28; Padfield, *Himmler*, 111; and Dresler, *Das Braune Haus*.

33. Krupp also provided Himmler with discretionary funds by giving to the Freundeskreis des Reichsführer-SS. Wistrich, *Who's Who in Nazi Germany*, 181.

34. BAK, NS10/43, Bl. 27, *Tischordnung* for twenty-four guests, 29 October 1937.

35. Goebbels, *Tagebücher*, 2:434, 16 June 1933.

36. This was but one event of the Olympic festival. Goebbels and Göring also hosted extravagant parties that allowed elites to mingle. For Himmler's program, BAK, NL126/20.

37. Fromm, *Blood and Banquets*, 206, and Hassell, *Von Hassell Diaries*, 149.

38. Fromm, *Blood and Banquets*, 221.

39. Smelser, *Robert Ley*, 65–66, and Fromm, *Blood and Banquets*, 207.

40. Regarding the Neurath's social position and its connection to style of living, Speer reported how in 1937 the foreign minister refused Hitler's offer to enlarge the official residence. Speer wrote, "Here for once a member of the old nobility was demonstrating confident modesty and deliberately abstaining from the craving for ostentation on the part of the new masters." He then notes that the Ribbentrops found the foreign minister's residence unacceptable and moved into the former presidential palace. Speer, *Inside the Third Reich*, 157.

41. Craig, *Germany*, 700.

42. The cosmopolitan character of European aristocrats is a common observation. Friemuth, *Die geraubte Kunst*, 63.

43. Schoenbaum, *Hitler's Social Revolution*, 284.

44. Reitlinger, *The SS*, 247–48.

45. See the Sonderakte 4 in the research files, BDC, for the 19 May 1943 "Erlaß des Führers über die Fernhaltung international gebundener Männer in Staat, Partei und Wehrmacht." The file includes a 30 April 1944 list of aristocrats released from service. Also Goebbels, *Goebbels Diaries, 1942–1943*, 284, 27 November 1943.

46. Grunberger, *Twelve-Year Reich*, 142.

47. Haase, *Kunstraub und Kunstschutz*, 171.

48. Rousseau, "CIR No. 2," 22.

49. Jaeger, *Linz File*, 88.

50. Cassou, *Le Pillage par les Allemands*, 147–77.

51. Prinz Philipp, as the principal buyer in Italy for the Führermuseum,

figures prominently in the extant archival records. BAK, R43II/1649b, and OMGUS, 5/346-1/40.

52. Haase, *Kunstraub und Kunstschutz*, 135. The list of aristocratic sellers and facilitators of acquisitions who dealt with Göring is too long to include here. In Italy alone one can count Prince Corsini, Prince del Drago, Count Paolo Labia, Prince Massimo, Princess Emilia Ourousoff, Countess Spiridon, Countess Luisa Traine, and Count Alexander Tatistscheff. Rousseau, "CIR No. 2," 106–9, and BAK, NS21/227, Himmler and Juritzky correspondence, December 1941 to March 1942.

53. Flanner, *Men and Monuments*, 228.

54. The land in question was deemed Reich hunting forest. Ibid. Also Faison, "Supplement to CIR No. 4," 8. Hitler also acquired another painting from the Crown Prince in 1942: T. Dijk's *Italian Port*, for RM 8,500. Faison, "Supplement to CIR No. 4," attachment 76: "Partial List of Purchases For Linz Made in Germany."

55. Faison, "Supplement to CIR No. 4," attachment 76: "Partial List of Purchases For Linz Made in Germany."

56. Goebbels quoted by Heiber, *Goebbels*, 236.

57. Grunberger, *Twelve-Year Reich*, 156.

58. Hans Mommsen writes that "the social structure of the active opposition was comparatively homogeneous. Its members were predominantly upper-class." Mommsen, "Sociology of the Resistance," 59.

59. Smelser, *Robert Ley*, 290–91. For Ley's speech, Semmler, *Goebbels*, 140. It is ironic that Ley should have such antiaristocratic views, as he himself emulated their ways to a considerable degree. As already mentioned, he had an estate, "Leyhof bei Rottland"; a coat of arms that he designed personally; and a professed desire to be known as the duke of the Rhineland.

60. Philipp Prinz von Hessen file, BDC, document deposing Prinz Philipp signed by Hitler and Göring, 25 January 1944, and a Reich Chancellery *Vermerk*, 10 January 1944.

61. IfZG, ZS 918, Philipp Prinz von Hessen interview, 1 March 1948, and Ellinghaus, "Der Prinz." Also Reitlinger, *The SS*, 247.

62. Kramarz, *Stauffenberg*, 20. Hitler had Bormann issue an order on 24 July 1944 that, in Kramarz's words, "warned against any temptation to attack or insult the aristocracy."

63. Wheeler-Bennett, *Nemesis of Power*, 685. This figure, based on the British admiralty report, is on the high end of the varying estimates. For a lower estimate, Peter Hoffmann, *History of the German Resistance*, 529. Historians generally agree that the number arrested as coconspirators stands near 11,000. Weitz, *Hitler's Diplomat*, 311.

64. For more on the principle of *Sippenhaft* (incarceration of relatives), see Wheeler-Bennett, *Nemesis of Power*, 685; McCloy, "Impact of the Resistance Movement," 307; and Manvell and Fraenkel, *Men Who Tried to Kill Hitler*, 179.

65. Dahrendorf, *Society and Democracy in Germany*, 391–96.

66. Kater, *Nazi Party*, 232.

67. Schoenbaum, *Hitler's Social Revolution*, 237–39, and Cecil, *Myth of the Master Race*, 156–57.

68. IMT, *The Trial of the Major War Criminals*, 9:545.

69. Grunberger, *Twelve-Year Reich*, 99.

70. Koehl, *Black Corps*, 176.

71. Goebbels, *Goebbels Diaries, 1942–1943*, xiv.

72. Weitz, *Hitler's Diplomat*, 295.

73. Hinz, *Art in the Third Reich*, 161–62. One could continue with architectural metaphors by citing Hitler's plans for a palace in the heart of Berlin, which was to have 22 million square feet and massive fortified walls to keep the masses at a distance. Speer, *Inside the Third Reich*, 216, and Krier, *Albert Speer*, 85–88.

74. Speer, *Inside the Third Reich*, 109.

CONCLUSION

1. Dietrich Orlow has addressed this issue, noting, "The administrative system of 'bureaucratized romanticism' . . . neither differentiated between the party functionary's role as a private individual and as a public person, nor did it seek to separate decision-makers from decision-administrators." Orlow, *History of the Nazi Party, 1919–1933*, 4–8.

2. Lang, *Bormann*, 248.

3. Edward Peterson, *Limits of Hitler's Power*, 9.

4. Nyomarkay, *Charisma and Factionalism*, 16.

5. Grosshans, *Hitler and the Artists*, 84.

6. Hannah Arendt has described the "multiplication of offices" regarding Jewish policy, students, foreign policy, and legal affairs, among other spheres. Arendt, *Origins of Totalitarianism*, 396–403.

7. Paret, *Berlin Secession*.

8. Cecil, *Myth of the Master Race*, viii.

9. Kurz, *Kunstraub in Europa*, 399–408; Haase, *Kunstraub und Kunstschutz*, 9–29; and Chamberlain, *Loot*.

10. Akinsha and Kozlov, "Spoils of War" and "The Soviets' War Treasures." Also Maier, *Unmasterable Past*.

11. Kurz, *Kunstraub in Europa*, 361. See also the account of Konstantin Akinsha's lecture entitled "The Discovery of Secret Repositories" from the symposium "The Spoils of War," as reported in Blumenthal, "Revelations and Agonizing."

12. Schoenbaum, *Hitler's Social Revolution*, 285–86.

13. Jaeger, *Linz File*, 135.

BIBLIOGRAPHY

ARCHIVAL MATERIALS

Amtsgericht, Hauptkammer Munich
 Spruchkammer file of Adolf Ziegler, H/10451/53
Berlin Document Center (BDC)
 Personal files for the following individuals:
 Otto Abetz
 Ernst Barlach
 Klaus Graf von Baudissin
 Kurt von Behr
 Bernhard Böhmer
 Professor Arno Breker
 Dr. Hermann Bunjes
 Karl Cerff
 Johannes Dettenberg
 Professor Karl Diebitsch
 Maria Alma Dietrich
 Wolfgang Ebert
 August Eigruber
 Dr. Joseph Goebbels
 Erhard Goepel
 Hermann Göring
 Wolfgang Gurlitt
 Karl Haberstock
 Professor Heinrich Harmjanz
 Erich Heckel
 Max Herbst
 Philipp Prinz von Hessen
 Franz Hofmann
 Dr. Niels von Holst
 Helmut von Hummel
 Hermann Ritter von Ingram
 Professor Herbert Jankuhn
 Hermann Knoll
 Professor Wilhelm Kreis
 Eberhard Freiherr von Künsberg
 Dr. Robert Ley
 Dr. Bruno Lohse
 Alois Miedl
 Dr. Kajetan Mühlmann
 Professor Peter Paulson
 Max Pechstein

Professor Werner Peiner
Wilhelm Peterson
Dr. Hans Posse
Dr. Gottfried Reimer
Joachim von Ribbentrop
Alfred Rosenberg
Bernhard Rust
Robert Scholz
Otto Andreas Schreiber
Dr. Arthur Seyß-Inquart
Wolfram Sievers
Professor Albert Speer
Professor Josef Thorak
Dr. Bernhard von Tieschowitz
Gerdy Troost
Gerhard Utikal
Wilhelm Vahrenkamp
Dr. Hermann Voss
Wolfgang Willrich
Dr. Franz Graf von Wolff-Metternich
Professor Adolf Ziegler
Bundesarchiv Koblenz (BAK)
 NS1 Reichsschatzmeister der NSDAP
 NS6 Partei Kanzlei
 NS8 Kanzlei Rosenberg
 NS10 Persönlicher Adjutantur des Führers
 NS15 DBFU
 NS19 Persönlicher Stab Reichsführers-SS
 NS20 Kleine Erwerbungen der NSDAP
 NS21 das Ahnenerbe
 NS22 Reichsorganisationsleiter der NSDAP
 NS26 Hauptarchiv der NSDAP
 NS30 Einsatzstab Reichsleiter Rosenberg
 NS34 SS Personalhauptamt
 R2 Reichsfinanzministerium
 R2 *Anhang* Kriegsberichte von Bundesfinanzministerium
 R3 Reichsministerium für Rustung und Kriegsproduktion
 R3 *Anhang* Der Beauftragte für die Verwaltung der Reichsvermögenswerte
 im frühern Geschäftsbereich Speer
 R6 Reichsministerium für die besetzten Ostgebiete
 R8 X Reichsstelle für Edelmetalle
 R8 XI Reichsstelle für Glas, Keramik und Holzverarbeitung
 R8 XIV Reichsstelle für Papier
 R18 Reichsministerium des Innern
 R21 Reichsministerium für Wissenschaft, Erziehung, und Volksbildung
 R22 Reichsjustizministerium

R26I Beauftragter für den Vierjahresplan
R28 Dienststellen der Deutscher Reichsbank
R43 I Reichskanzlei – alt
R43 II Reichskanzlei – neu
R54 Präsidial Kanzlei
R55 Reichsministerium für Volksaufklärung und Propaganda
R56 I Reichskulturkammer – Zentral
R58 Reichssicherheitshauptamt
R120 Generalbauinspektor für die Reichshauptstadt Berlin
R170 Oberfinanzdirektion Hamburg
NL94 Nachlaß Richard Walther Darré
NL118 Nachlaß Joseph Goebbels
NL126 Nachlaß Heinrich Himmler
NL163 Nachlaß Joachim von Ribbentrop
NL180 Nachlaß Arthur Seyß-Inquart
NL241 Nachlaß Wilhelm Frick
Centre Documentation Juive Contemporaine, Paris (CDJC)
Archival material relating to the pillaging of artworks in France (by the ERR in particular)
Exhibits and documents used by the French prosecutors at the International Military Tribunal, Nuremberg
Getty Center for the History of Art and the Humanities, Los Angeles
Wilhelm Arntz Papers (pertaining to the *entartete Kunst* campaign)
Douglas Cooper Papers (pertaining to art looting)
Ernst Ludwig Kirchner Papers
Stephan Lorant Collection
Ernst Reuti Papers
Institut für Zeitgeschichte, Munich (IfZG)
Sammlung Kater (documents pertaining to das Ahnenerbe)
Zeugnisse Schrifttums (interviews with knowledgeable survivors of the Third Reich)
National Socialist periodicals
Microfilm of Captured German War Records
OMGUS records (especially the OMGUS Report on German Art Personnel during and after World War II: Investigations, Memos, and Correspondence, 5/345-3/2)
Institut für Zeitgeschichte, Vienna
Personal file of Kajetan Mühlmann
Photograph archive
Library of Congress, Washington, D.C.
Papers of Paul Ludwig and Gerdy Troost
Third Reich Collection (includes a collection of National Socialist books, photo albums of Hermann Göring, and albums containing photographs of artworks purchased by Joseph Goebbels and Robert Ley at the *Große Deutsche Kunstausstellungen*, 1939, 1941, 1942)

National Archives, Washington, D.C. (NAW)
Captured German War Records, microfilm rolls examined in T-454 series
American Defense-Harvard Group Lists
Records of the American Commission for the Protection and Salvage of
Historic Monuments in War Areas (RG 239)
Records of the U.S. Occupation Headquarters, World War II
Ardelia Hall Collection
Heinrich Hoffmann photographic archive (RG 260)
Oberfinanzdirektion München, Treuhandverwaltung von Kulturgut
Münchens, Munich (OFD)
Selected photocopies of Bundesarchiv documents that pertain to art
Office of Strategic Services Reports on art looting
Thirty-volume set of albums chronicling paintings acquired for
Sonderauftrag Linz (presented to Hitler by Hans Posse, Kajetan
Mühlmann, and Hermann Voss)
Collection of artworks formerly exhibited at the *Große Deutsche
Kunstausstellungen* in the Haus der Deutschen Kunst
Österreichisches Staatsarchiv, Vienna (ÖSta)
Archiv der Republik (AdR)
Gruppe 01 (Auswärtige Angelegenheiten)
BKA/AA, Abteilung Kultur
BMAA, Neue Politische Akten
Gruppe 02 (Unterricht/Wissenschaft/Kunst)
BMUK, BMWF, Kunstangelegenheiten
BMUK, BMWF, Personalakten
Gruppe 04 (Inneres/Justiz)
Bürckel
Reichsstatthalter Wien
Gau Akten
From the Allgemeines Verwaltungsarchiv
Sammlung 09 (Kunstwesen)
Preußisches Geheimes Staatsarchiv, Berlin-Dahlem (PrGSta)
Preußisches Finanzministerium, Rep. 151
Preußisches Ministerium für Wissenschaft, Kunst und
Volksbildung, Rep. 76
Preußisches Staatsministerium, Rep. 90
Rijksinstituut voor Oorlogsdocumentatie, Amsterdam
Files concerning art looting
Photo archive
University of California, Los Angeles, University Research
Library, Department of Special Collections
Collection No. 338 (Nazi ephemera)
Collection No. 512 (Franz Werfel Papers)
United States Holocaust Memorial Museum Archives, Washington, D.C.
Collection RG-31 (ERR Ukraine files)

Arts Council of Great Britain. *The Arts in Wartime: A Report on the Work of C.E.M.A.* London: Council for the Encouragement of Music and the Arts, 1944.

Boberach, Heinz, ed. *Meldungen aus dem Reich, 1938–1945: Die geheimen Lageberichte des Sicherheitsdienstes der SS.* 17 vols. Nuwied: Herrsching, 1965.

Cooper, Douglas. "Report of Mission to Switzerland." MFA and A report, 10 December 1945.

Cooper, Douglas, and Ernest De Wald. "German Kunstschutz in Italy between 1943 and 1945." MFA and A report, 30 June 1945.

Domarus, Max. *Hitler: Reden und Proklamationen, 1932–1945. Kommentiert von einem deutschen Zeitgenossen.* 2 vols. Würzburg: Privately printed, 1962/1963.

———. *Hitler: Speeches and Proclamations, 1933–1945.* 4 vols. London: I. B. Tauris, 1992.

Faison, S. L. "Consolidated Interrogation Report No. 4: Linz: Hitler's Museum and Library." OSS report, 15 December 1945.

———. "Detailed Interrogation Report No. 12: Hermann Voss." OSS report, 12 September 1945.

———. "Supplement of January 15, 1946 to the Consolidated Interrogation Report No. 4: Linz Hitler's Museum and Library." OSS report, 15 January 1946.

International Military Tribunal (IMT). *Nazi Conspiracy and Aggression, Opinion and Judgment.* Washington, D.C.: U.S. Government Printing Office, 1946.

———. *The Trial of the Major War Criminals.* 42 vols. Nuremberg: International Military Tribunal, 1947.

Lehmann-Haupt, Hellmut. "Cultural Looting of the 'Ahnenerbe.'" OMGUS report, 1 March 1948.

Ministerstwo Informacji Poland. *The Nazi Kultur in Poland.* London: H.M. Stationery Office, 1945.

Phillips, John, and Denys Sutton. "Report on Preliminary Interrogation of P. W. Alfred Hentzen." OSS report, 23 June 1945.

Plaut, James. "Consolidated Interrogation Report No. 1: Activity of the Einsatzstab Reichsleiter Rosenberg in France." OSS report, 15 August 1945.

———. "Detailed Interrogation Report No. 3: Robert Scholz." OSS report, 15 August 1945.

———. "Detailed Interrogation Report No. 4: Gustav Rochlitz." OSS report, 15 August 1945.

———. "Detailed Interrogation Report No. 5: Günther Schiedlausky." OSS report, 15 August 1945.

———. "Detailed Interrogation Report No. 6: Bruno Lohse." OSS report, 15 August 1945.

———. "Detailed Interrogation Report No. 10: Karl Kress." OSS report, 15 August 1945.

Rousseau, Theodore. "Consolidated Interrogation Report No. 2: The Goering Collection." OSS report, 15 September 1945.

———. "Detailed Interrogation Report No. 1: Heinrich Hoffmann." OSS report, 1 July 1945.

———. "Detailed Interrogation Report No. 2: Ernst Buchner." OSS report, 31 July 1945.

———. "Detailed Interrogation Report No. 7: Gisela Limberger." OSS report, 15 September 1945.

———. "Detailed Interrogation Report No. 8: Kajetan Mühlmann." OSS report, 15 September 1945.

———. "Detailed Interrogation Report No. 9: Walter Andreas Hofer." OSS report, 15 September 1945.

———. "Detailed Interrogation Report No. 11: Walter Bornheim." OSS report, 15 September 1945.

———. "Detailed Interrogation Report No. 13: Karl Haberstock." OSS report, 1 May 1946.

van der Leeuw, A. J. *Die Bestimmung der vom deutschen Reich entzogenen und von der Dienststelle Dr. Mühlmann übernommenen Kunstgegenstände.* Amsterdam: Rijksinstituut voor Oorlogsdocumentatie, 1962.

Vlug, Jean. *Report on Objects Removed to Germany from Holland, Belgium, and France during the German Occupation on [sic] the Countries.* Amsterdam: Report of Stichting Nederlands Kunstbesit, 25 December 1945.

Wittmann, Otto, and Bernard Taper. "Detailed Interrogation Report: Hans Wendland." OSS report, 15 September 1946.

Wolff-Metternich, Franz Graf von. "Concerning My Activities, May 1940 to June 1942." Statement for Art Looting Investigative Unit, 1945.

CONTEMPORARY PERIODICALS

Berliner Tageblatt

Deutsche Allgemeine Zeitung

Deutsche Bühnenkorrespondenz, Berlin, NS-KG/DBFU, 1933–37

Frankfurter Zeitung

Germania, Berlin, Das Ahnenerbe, 1938–44

Hamburger Nachrichten-Blatt

Kunst dem Volk, Munich, 1939–44

Kunst im Dritten (Deutschen) Reich, Munich, DBFU, 1937–44

Das Mitteilungsblatt der Reichskammer der bildenden Künste, Berlin, RMVP, 1934–45

Das Reich

Das Reichsgesetzblatt

Das Schwarze Korps

Völkischer Beobachter

Baynes, Norman, ed. *The Speeches of Adolf Hitler, April 1922–August 1939: An English Translation of Representative Passages Arranged under Subjects.* New York: Howard Fertig, 1969.

Bormann, Martin. *The Bormann Letters: The Private Correspondence between Martin Bormann and His Wife from January 1943 to April 1945.* Introduction by Hugh Trevor-Roper. London: Weidenfeld and Nicolson, 1954.

————. *Le National Socialisme et le Christianisme.* N.p., 1942.

Breker, Arno. *Im Strahlungsfeld der Ereignisse: Leben und Wirken eines Künstlers.* Preußisches Oldendorf: Schutz, 1972.

————. *Paris, Hitler et Moi.* Paris: Plon, 1970.

Dietrich, Otto. *12 Jahre mit Hitler.* Munich: Isar, 1955.

Dodd, William E. *Ambassador Dodd's Diary.* New York: Harcourt, Brace, 1941.

Fromm, Bella. *Blood and Banquets: A Berlin Social Diary.* New York: Harper and Brothers, 1942.

Giesler, Hermann. *Ein anderer Hitler: Bericht seines Architekten. Erlebnisse, Gespräche, Reflexionen.* Leoni am Starnberger See: Druffel, 1977.

Goebbels, Joseph. *Final Entries 1945: The Diaries of Joseph Goebbels.* Edited by H. R. Trevor-Roper. New York: 1978.

————. *The Goebbels Diaries, 1939–1941.* Translated and edited by Fred Taylor. London: Putnam's Sons, 1982.

————. *The Goebbels Diaries, 1942–1943.* Edited, translated, and with an introduction by Louis Lochner. Garden City, N.J.: Doubleday, 1948.

————. *Die Tagebücher von Joseph Goebbels: Sämtliche Fragmente, 1923–1940.* 4 vols. Edited by Elke Frölich. Munich: Sauer, 1987.

Göring, Emmy. *My Life with Goering.* London: David Bruce and Watson, 1972.

Göring, Hermann. *Aus Görings Schreibtisch: Ein Dokumentenfund.* Edited by T. R. Emessen. Berlin: Dietz, 1990.

Hanfstaengl, Ernst. *Unheard Witness.* Philadelphia: Lippincott, 1957.

Hassell, Ulrich von. *The Von Hassell Diaries, 1938–1944.* London: Hamish Hamilton, 1948.

Heiber, Helmut, ed. *Reichsführer!: Briefe an und von Himmler.* Stuttgart: Deutsche Verlags-Anstalt, 1968.

Hitler's Table Talk, 1941–1944. Introduction by H. R. Trevor-Roper. London: Weidenfeld and Nicolson, 1953.

Hoffmann, Heinrich. *Hitler Was My Friend.* London: Burke, 1955.

Kersten, Felix. *Totenkopf und Treue: Heinrich Himmler ohne Uniform.* Hamburg: Mölich, 1953.

Kordt, Erich. *Nicht aus den Akten.* Stuttgart: Union Deutsche Verlagsgesellschaft, 1950.

Maser, Werner. *Hitler's Letters and Notes.* New York: Harper and Row, 1973.

Oven, Wilfred von. *Mit Goebbels bis zum Ende.* Buenos Aires: Dürer-Verlag, 1950.

Piotrowski, Stanislaws, ed. *Hans Frank's Diary.* Warsaw: Panstowowe Wydawnictwo Naukowe, 1961.

Pöchmüller, Emmerich. *Weltkunstschätze in Gefahr.* Salzburg: Pallas, 1948.

Präg, Werner, and Wolfgang Jacobmeyer, eds. *Das Diensttagebuch des deutschen Generalgouverneurs in Polen, 1939–1945*. Stuttgart: Deutsche Verlags-Anstalt, 1975.

Prange, Gordon, ed. *Hitler's Words: Two Decades of National Socialism, 1923–1943*. Washington, D.C.: American Council on Public Affairs, 1944.

Ribbentrop, Joachim von. *Zwischen London und Moskau*. Leoni am Starnberger See: Druffel-Verlag, 1953.

Rosenberg, Alfred. *Memoirs of Alfred Rosenberg*. Chicago: Ziff-Davis, 1949.

Schellenberg, Walter. *The Labyrinth: Memoirs*. New York: Harper, 1956.

Schirach, Baldur von. *Ich glaubte an Hitler*. Hamburg: Mosaik, 1967.

Schirach, Henrietta von. *Der Preis der Herrlichkeit*. Wiesbaden: Limes, 1956.

Semmler, Rudolf. *Goebbels, the Man Next to Hitler*. London: Westhouse, 1947.

Speer, Albert. *Inside the Third Reich*. New York: Macmillan, 1969.

———. "Playboy Interview: Albert Speer." *Playboy*, June 1971, 69–203.

———. *The Slave State: Heinrich Himmler's Masterplan for SS Supremacy*. London: Macmillan, 1981.

———. *Spandau: The Secret Diaries*. New York: Macmillan, 1976.

Thomas, Walter (Anderman). *Bis der Vorhang fiel: Berichtet nach Aufzeichnungen aus den Jahren 1940 bis 1945*. Dortmund: Karl Schwalvenberg, 1947.

Thyssen, Fritz. *I Paid Hitler*. New York: Farrar and Rinehart, 1941.

Wagener, Otto. *Hitler: Memoirs of a Confidant*. Edited by Henry A. Turner. New Haven: Yale University Press, 1985.

Welles, Sumner. *The Time for Decision*. New York: Harper, 1944.

Zweig, Stefan. *The World of Yesterday: An Autobiography*. 1943. Reprint, London: Cassell, 1987.

WORKS BY NATIONAL SOCIALIST AUTHORS

Dresler, Adolf. *Das Braune Haus und die Verwaltungsgebäude der Reichsleitung der NSDAP*. Munich: Eher, 1939.

———. *Deutsche Kunst und entartete 'Kunst'–Kunstwerk und Zerrbild aus Spiegel der Weltanschauung*. Munich: Deutscher Volksverlag, 1938.

Feistel-Rohmeder, Bettina, ed. *Im Terror des Kunstbolschewismus: Urkundensammlung des Deutschen Kunstberichtes aus den Jahren 1927–1933*. Karlsruhe: Müller, 1938.

Fischer, Theodor. *Gemälde und Plastiken moderner Meister aus deutschen Museen*. Lucerne: Galerie Fischer, 1939. Auction catalog.

Goebbels, Joseph. *Das eherne Herz: Reden und Aufsätze aus den Jahren 1942–1943*. Munich: Eher, 1943.

———. *Der Steile Aufstieg: Reden und Aufsätze aus den Jahren 1942–1943*. Munich: Eher, 1943.

———. *Michael, a German Fate*. New York: Amok, 1987.

———. *Die Zeit ohne Beispiel: Reden und Aufsätze aus den Jahren 1939–1940*. Munich: Eher, 1941.

Göring, Hermann. *Aufbau einer Nation*. Berlin: Mittler, 1934.

———. *Der Geist des neuen Staates*. Berlin: Steegemann, 1933.

———. *Reden und Aufsätze*. Edited by Erich Gritzbach. Munich: Eher, 1938.

Gritzbach, Erich. *Hermann Goering, the Man and his Work*. London: Hurst and Blackett, 1939.

Günther, Hans F. K. *Rasse und Stil*. . . . Munich: Lehmann, 1926.

Hansen, Walter. *Judenkunst in Deutschland: Quellen und Studien zur Judenfrage auf dem Gebiet der bildenden Kunst, 1900–1933*. Munich: Lehmann, 1942.

Himmler, Heinrich. *Liste der schädlichen und unerwünschten Schrifttums. Stand vom 31. Dezember 1938 zusammen mit den Jahreslisten für die Jahre 1939–1941*. Ruggell, Lichtenstein: Topos, 1979.

Hinkel, Hans, ed. *Handbuch der Reichskulturkammer*. Berlin: Deutscher, 1937.

Hitler, Adolf. *Mein Kampf*. Translated by Ralph Manheim. Boston: Houghton Mifflin, 1971.

———. "Speech Inaugurating the 'Great Exhibition of German Art, 1937.'" In *Theories of Modern Art: A Sourcebook by Artists and Critics*, edited by Herschel B. Chipp, 474–83. Berkeley: University of California Press, 1968.

Just, Oskar. *Nordisches Blutserbe im süddeutschen Bauerntum: Tafeln von Oskar Just und Wolfgang Willrich*. 2 vols. Introduction by R. W. Darré. Munich: Bruckmann, 1938.

Kaiser, Fritz. *Führer durch die Ausstellung Entartete Kunst*. Berlin: Verlag für Kultur und Wirtschaftswerbung, NSDAP, 1937. Facsimile reproduction edition in German and English, Redding, Conn.: Silver Fox Press, 1972.

Libiger, Richard. *Reichsleiter Baldur von Schirach: Tätigkeit als Reichsstatthalter und Gauleiter in Wien, August 1940–November 1942*. Vienna: NSDAP Gauleitung Wien (Gaue Presse Amt), 1942.

Oertel, Robert. "Ein Hort Europäische Kunst." *Das Reich*, 31 January 1943.

Peterson, Jürgen. "Der Krieg hat diese äussern Arbeiten unterbrochen. Aber" *Das Reich*, 11 January 1942.

Rosenberg, Alfred. *Letzte Aufzeichnungen: Ideale und Idole der nationalsozialistischen Revolution*. Göttingen: Plesse Verlag, 1955.

———. *Myth of the Twentieth Century: An Evaluation of the Spiritual-Intellectual Confrontations of Our Age*. Torrance, Calif.: Noontide Press, 1982. First published in German as *Mythos des 20. Jahrhunderts*. Munich: Hoheneichen, 1930.

———. *Revolution in der bildenden Kunst?* Berlin: Eher, 1934.

———. *Selected Writings of Alfred Rosenberg*. Edited by Robert Pois. London: Jonathan Cape, 1970.

Schirach, Baldur von. *Junge Kunst in Deutschland: Veranstaltet vom Reichsstatthalter Baldur von Schirach*. Vienna: Künstlerhaus Wien, 1943.

———. *Die Pioniere des Dritten Reiches*. Essen: Zentralstelle für den deutschen Freiheits Kampf, 1934.

———. *Zwei Reden zur Kunst*. Weimar: Gesellschaft der Bibliophilen, 1941.

Schreiber, Karl Friedrich. *Die Reichskulturkammer: Organisation und Ziele der deutschen Kulturpolitik*. Berlin: Junker und Dünhaupt, 1934.

Schultze-Naumburg, Paul. *Kampf um die Kunst.* Munich: Lehmann, 1932.

———. *Kunst und Rasse.* Munich: Lehmann, 1928.

Speer, Albert. "Die Deutsche Botschaft in London, Architekt Albert Speer."
Moderne Bauformen 37 (July 1938): 345–56.

Willrich, Wolfgang. *Die Säuberung des Kunsttempels: Eine kunstpolitische
Kampfschrift zur Gesundung deutscher Kunst im Geiste nordischer Art.* Munich:
Lehmann, 1937.

Ziegler, Hans Severus. *Entartete Musik: Eine Abrechnung.* Düsseldorf: Völkischer,
1938.

SECONDARY SOURCES

Ackermann, Josef. *Heinrich Himmler als Ideologe.* Göttingen: Musterschmidt,
1970.

Adam, Peter. *Art of the Third Reich.* New York: Abrams, 1992.

Adams, Robert. *The Lost Museum: Glimpses of Vanished Originals.* New York:
Viking, 1980.

Adorno, Theodor. *Ästhetische Theorie, Gesammelte Schriften.* Vol. 7. Edited by Rolf
Tiedemann. Frankfurt a.M.: Suhrkamp, 1970.

Akademie der Künste, Berlin. *Skulptur und Macht: Figurative Plastik im
Deutschland der 30er und 40er Jahre.* Berlin: Akademie der Künste, 1983.

———. *Das war ein Vorspiel nur . . . Bücherverbrennung Deutschland 1933:
Voraussetzungen und Folgen.* Berlin: Medus Verlagsgesellschaft, 1983.
Exhibition catalog.

Akinsha, Konstantin, and Grigorii Kozlov. "The Soviets' War Treasures: A
Growing Controversy." *ARTnews* 90, no. 9 (September 1991): 112–19.

———. "Spoils of War: The Soviet Union's Hidden Art Treasures." *ARTnews*
90, no. 4 (April 1991): 130–41.

Alford, Kenneth. *The Spoils of World War II: The American Military's Role in the
Stealing of Europe's Treasures.* New York: Birch Lane, 1994.

Aly, Götz, and Suzanne Heim. *Vordenker der Vernichtung: Auschwitz und die
deutsche Pläne für eine neue europäische Ordnung.* Hamburg: Hoffmann und
Campe, 1991.

Arad, Yitzhak. *Ghetto in Flames: The Struggle and Destruction of the Jews in Vilna in
the Holocaust.* Jerusalem: Yad Vashem, 1980.

Arendt, Hannah. *Eichmann in Jerusalem: A Report on the Banality of Evil.* New
York: Viking, 1963.

———. *The Origins of Totalitarianism.* 1951. Reprint, San Diego: Harcourt Brace
Jovanovich, 1973.

Arntz, Wilhelm. "Bildersturm in Deutschland." Parts 1–5. *Das Schönste* 8, no. 5
(May 1962): 45–48; no. 6 (June 1962): 30–35; no. 7 (July 1962): 26–29; no. 8
(August 1962): 36–39; no. 9 (September 1962): 42–45.

Assouline, Pierre. *An Artful Life: A Biography of D. H. Kahnweiler, 1884–1979.*
New York: Fromm International, 1990.

Backes, Klaus. "Adolf Hitlers Einfluß auf die Kulturpolitik des Dritten Reiches." Ph.D. dissertation, Ruprecht-Karl Universität, Heidelberg, 1984. Revised as *Hitler und die bildenden Künste*. Cologne: DuMont, 1988.

Baird, Jay. *To Die for Germany: Heroes in the Nazi Pantheon*. Bloomington: Indiana University Press, 1990.

Balfour, Michael. *Propaganda in War, 1939–1945: Organizations, Policies, and Publics in Britain and Germany*. London: Routledge and Kegan Paul, 1979.

Barkai, Avraham. "Arisierung." In *The Encyclopedia of the Holocaust*, edited by Israel Gutman, 1:84–87. New York: Macmillan, 1990.

———. *Vom Boycott zur "Entjudung": Der Wirtschaftliche Existenzkampf im Dritten Reich*. Frankfurt: Fischer, 1988. Published in English as *From Boycott to Annihilation: The Economic Struggle of German Jews, 1933–1943*. Translated by William Templer. Hanover, N.H.: University of New England Press, 1989.

Barker, Godfrey. "The Russo-German Art Pact." *Spectator*, 11 July 1992, 12–13.

Barr, Alfred. "Art in the Third Reich – A Preview." In *Defining Modern Art: Selected Writings of Alfred Barr*, edited by Irving Sandler and Amy Newmann, 163–75. New York: Abrams, 1986.

Barron, Stephanie. "The Galerie Fischer Auction." In *"Degenerate Art": The Fate of the Avant-Garde in Nazi Germany*, edited by Stephanie Barron, 135–70. New York: Abrams, 1991.

———, ed. *"Degenerate Art": The Fate of the Avant-Garde in Nazi Germany*. New York: Abrams, 1991.

Bartetzko, Dieter. *Illusionen in Stein: Stimmungsarchitektur im deutschen Faschismus*. Reinbek: Rowohlt, 1985.

———. *Zwischen Zucht und Ekstase: Zur Theatalik von NS-Architektur*. Berlin: Gebrüder Mann, 1985.

Becker, Howard. *German Youth: Bond or Free*. London: Kegan Paul, Trench, Trubner and Co., 1946.

Behnken, Adolf, and Frank Wagner, eds. *Inszenierung der Macht: ästhätische Faszination im Faschismus*. Berlin: NGBK/Nishen, 1987. Exhibition catalog.

Benjamin, Walter. "The Work of Art in the Age of Mechanical Reproduction," in *Illuminations: Essays and Reflections*, by Walter Benjamin. New York: Schocken Books, 1969.

Benz, Wolfgang. "Der Generalplan Ost: Germanisierungpolitik in den besetzten Ostgebieten." In *Herrschaft und Gesellschaft im nationalsozialistischen Staat*, edited by Wolfgang Benz, 72–81. Frankfurt: Fischer Taschenbuch, 1990.

———. "The Ritual and Stage Management of National Socialism: Techniques of Domination and the Public Sphere." In *The Attractions of Fascism*, edited by John Milfull, 273–88. New York: Berg, 1990.

Berlin, Isiah. *Vico and Herder: Two Studies in the History of Ideas*. New York: Viking, 1976.

Berlinische Galerie. *Stationen der Moderne*. Berlin: Nicolai, 1988. Exhibition catalog.

Bewley, Charles. *Hermann Göring and the Third Reich.* Toronto: Devin-Adair, 1962.

Biget, Hervé. *La Chambre de Culture dans le régime totalitaire du III. Reich.* Paris: Domat-Montchrestien, 1937.

Birn, Ruth Bettina. *Die Höheren SS-Und Polizeiführer.* Düsseldorf: Droste, 1986.

Black, Peter. *Ernst Kaltenbrunner: Ideological Soldier of the Third Reich.* Princeton: Princeton University Press, 1984.

Blumenthal, Ralph. "Revelations and Agonizing on Soviet Seizures of Artwork." *New York Times,* 23 January 1995.

Bollmus, Reinhard. *Das Amt Rosenberg und seine Gegner: Studien zum Machtkampf im nationalsozialistischen Herrschaftssystem.* Stuttgart: Deutsche Verlags-Anstalt, 1970.

———. "Zum Projekt einer nationalsozialistischen Alternativuniversität: Alfred Rosenbergs 'Hohe Schule.'" In *Erziehung und Schulung im Dritten Reich,* edited by Manfred Heinemann, 125–52. Stuttgart: Klett-Cotta, 1980.

Bouresh, Bettina, "Sammeln Sie Also Kräftig!: 'Kunstrückführung' ins Reich – im Auftrag der Rheinischen Provinzialverwaltung, 1940–1945." In *Kunst auf Befehl?,* edited by Bazon Brock and Achim Preiß, 41–58. Munich: Klinkhardt und Biermann, 1990.

Bracher, Karl Dietrich. *The German Dictatorship: The Origin, Structure and Effects of National Socialism.* New York: Oxford University Press, 1978.

———. "The Role of Hitler: Perspectives of Interpretation." In *Fascism: A Reader's Guide,* edited by Walter Laqueur, 199–212. Berkeley: University of California Press, 1976.

Bradley, William. *Emil Nolde and German Expressionism: A Prophet in His Own Land.* Ann Arbor: UMI Research Press, 1986.

Bramsted, Ernest. *Goebbels and National Socialist Propaganda, 1925–1945.* East Lansing: Michigan State University Press, 1965.

Breitman, Richard. *The Architect of Genocide: Himmler and the Final Solution.* New York: Knopf, 1991.

Brenner, Hildegard. "Art in the Political Power Struggle of 1933 and 1934." In *Republic to Reich: The Making of the Nazi Revolution,* edited by Hajo Holborn, 395–434. New York: Random House, 1972.

———. *Ende einer bürgerlichen Kunst-Institution: Die politische Formierung der Preußischen Akademie der Künste ab 1933.* Stuttgart: Deutsche Verlags-Anstalt, 1972.

———. *Die Kunstpolitik des Nationalsozialismus.* Reinbek: Rowohlt, 1963.

Brock, Bazon. "Kunst auf Befehl?: Eine kontrafaktische Behauptung." In *Kunst auf Befehl?: Dreiunddreißig bis Fünfundvierzig,* edited by Bazon Brock and Achim Preiß. Munich: Klinkhardt & Biermann, 1990.

Brock, Bazon, and Achim Preiß, eds. *Kunst auf Befehl?: Dreiunddreißig bis Fünfundvierzig.* Munich: Klinkhardt & Biermann, 1990.

Broszat, Martin. *The Hitler State: The Foundation and Development of the Internal Structure of the Third Reich.* London: Longman, 1981.

Bucher, Peter. "Hitlers 50. Geburtstag: Zur Quellenvielfalt im Bundesarchiv." In *Aus der Arbeit des Bundesarchivs: Beiträge zum Archivwesen zur Quellenkunde*

und Zeitgeschichte, edited by Heinz Boberach and Hans Booms, 423–46. Boppard: Harold Boldt, 1977.

Bukey, Evan Burr. *Hitler's Hometown: Linz, Austria, 1908–1945*. Bloomington: Indiana University Press, 1986.

Bushart, Magdalena. "Überraschende Begegnung mit alten Bekannten: Arno Brekers NS-Plastik in neuer Umgebung." In *NS-Kunst: 50 Jahre danach. Neue Beiträge*, edited by Berthold Hinz, 35–54. Marburg: Jonas, 1989.

Bussmann, Georg. "Degenerate Art: A Look at a Useful Myth." In *German Art of the Twentieth Century*, by Georg Bussmann, 113–22. Munich: Prestel, 1985.

———, ed. *Kunst im Dritten Reich: Dokumente der Unterwerfung*. Frankfurt: Frankfurter Kunstverein, 1974.

Caplan, Jane. "Bureaucracy, Politics, and the National Socialist State." In *The Shaping of the Nazi State*, edited by Peter Stachura, 234–56. New York: Harper and Row, 1978.

Carr, William. "The Hitler Image in the Last Half-Century." In *Aspects of the Third Reich*, edited by Howard Koch, 462–83. New York: St. Martin's, 1985.

Cassou, Jean, ed. *Le Pillage par les Allemands des Oeuvres d'art et des Bibliothèque Appartenant à des Juifs en France*. Paris: CDJC, 1947.

Cecil, Robert. *The Myth of the Master Race: Alfred Rosenberg and Nazi Ideology*. London: Batsford, 1972.

Chamberlain, Russell. *Loot: The Heritage of Plunder*. New York: Facts on File, 1983.

Claus, Jürgen. *Entartete Kunst: Bildersturm vor 25 Jahren*. Munich: Haus der Kunst, 1962.

Cone, Michèle. *Artists under Vichy: A Case of Prejudice and Persecution*. Princeton: Princeton University Press, 1992

Conway, J. S. *The Nazi Persecution of the Churches, 1933–45*. Toronto: Ryerson, 1968.

Corino, Karl. *Intellektuelle im Bann des Nationalsozialismus*. Hamburg: Hoffmann und Campe, 1980.

Craig, Gordon. *Germany, 1866–1945*. London: Oxford University Press, 1978.

Cuomo, Glenn. "Hanns Johst und die Reichsschrifttumskammer: Ihr Einfluß auf die Situation des Schriftstellers im Dritten Reich." In *Leid der Worte: Panorama des literarischen Nationalsozialismus*, edited by Jörg Thunecke, 108–32. Bonn: Bouvier, 1987.

Dahm, Volker. "Die Reichskulturkammer als Instrument kulturpolitischer Steuerung und sozialer Reglementierung." *Vierteljahrshefte für Zeitgeschichte* 34 (January 1986): 53–84.

Dahrendorf, Ralf. *Society and Democracy in Germany*. New York: Doubleday/Anchor, 1969.

Damus, Martin. *Sozialistischer Realismus und Kunst im Nationalsozialismus*. Frankfurt: Fischer Taschenbuch, 1981.

Davidson, Mortimer. *Kunst in Deutschland, 1933–1945: Eine wissenschaftliche Enzyklopädie der Kunst im Dritten Reich*. 3 vols. Tübingen: Grabert, 1988.

Dawidowicz, Lucy. *The War against the Jews*. New York: Holt, Rinehart and Winston, 1975.

Decker, Andrew. "How Things Work in Austria: Stolen Works of Art." *ARTnews* 92, no. 6 (Summer 1993): 198–200.

———. "A Legacy of Shame." *ARTnews* 83, no. 10 (December 1984): 53–76.

———. "A Worldwide Treasure Hunt: The Disclosure That the Soviet Union Has Been Secretly Holding Thousands of Works Seized from the Nazis." *ARTnews* 90, no. 6 (Summer 1991): 130–39.

Delarue, Jacques. *The History of the Gestapo.* London: Macdonald, 1964.

de Vries, Willem. *Einsatzstab Reichsleiter Rosenberg, Sonderstab Musik: The Confiscation of Music in the Occupied Countries of Western Europe during World War II by the Einsatzstab Reichsleiter Rosenberg (ERR).* Amsterdam: University of Amsterdam Press, 1996.

Dilly, Heinrich. *Deutsche Kunsthistoriker, 1933–1945.* Berlin: Deutsche Kunstverlag, 1988.

Dimsdale, Joel, ed. *Survivors, Victims, and Perpetrators: Essays on the Nazi Holocaust.* New York: Hemisphere, 1980.

Dobkowski, Michael, and Isidor Wallimann, eds. *Radical Perspectives on the Rise of Fascism in Germany, 1919–1945.* New York: Monthly Review Press, 1989.

Dornberg, Andrew John. "The Mounting Embarrassment of Germany's Nazi Treasures." *ARTnews* 87, no. 7 (September 1988): 130–41.

Dornberg, John. "Munich: Mounting Embarrassment." *ARTnews* 87, no. 4 (April 1988): 39–42.

Doster, Ute, and Jutta Salchow, eds. *Gottfried Benn: 1886–1956: Eine Ausstellung des Deutschen Literaturarchivs im Schillernationalmuseum.* Marbach am Neckar: Deutsches Literaturarchiv, 1983.

Dülffer, Jost, Jochen Thies, and Josef Henke. *Hitlers Städte: Baupolitik im Dritten Reich. Eine Dokumentation.* Cologne: Böhlau, 1978.

Dümling, Albrecht, and Peter Girth, eds. *Entartete Musik: Zur Düsseldorfer Ausstellung von 1938: Eine kommentierte Rekonstruktion.* Düsseldorf: Landeshauptstadt Düsseldorf, 1988.

Duncan, Hugh D. *Communication and Social Order.* London/New York: Oxford University Press, 1970.

———. *Symbols and Social Theory.* New York: Oxford University Press, 1969.

Dünkel, Günther. "Die Liquidierung der Kunst." *tendenzen* 157 (January–March 1987): 44–53.

———. "Die Verzögerte Heimkehr der Verfemten." *tendenzen* 158 (April–June 1987): 65–69.

Düsseldorf Kunstmuseum, eds. *Düsseldorfer Kunstszene, 1933–1945.* Düsseldorf: Düsseldorfer Museum, 1987. Exhibition catalog.

Düsseldorf Städtische Kunsthalle, eds. *"Die Axt hat geblüht . . . ": Europäische Konflikte der 30er Jahre in Erinnerung an die frühe Avantgarde.* Düsseldorf: Städtische Kunsthalle, 1987.

Ellinghaus, Wilhelm. "Der Prinz, der Hitlers Werkzeug war." *Hannoversche Presse,* 27 March 1948.

Enke, Paul. *Der Bernsteinzimmer-Report.* Berlin: Verlag der Wirtschaft, 1986.

Erhard, Benedikt. *Eine Geschichte Südtirols: Option Heimat Opzioni. Vom Gehen und vom Bleiben.* Bolzano: Österreichischer Bundesverlag, 1989.

Esterow, Milton. *The Art Stealers.* New York: Macmillan, 1966.

Estreicher, Charles [Karol], ed. *Cultural Losses of Poland: Index of Polish Cultural Losses during the German Occupation, 1939–1944.* Manuscript ed. London, 1944.

Fassman, Kurt. "Bildersturm in Frankreich." Parts 1–3. *Das Schönste* 9, no. 12 (December 1962): 75–83; 10, no. 2 (February 1963): 28–29; 10, no. 3 (March 1963): 68–81.

Fest, Joachim. *The Face of the Third Reich.* New York: Random House, 1970.

———. *Hitler.* London: Weidenfeld and Nicolson, 1974.

Fischer-Defoy, Christine. *Kunst, Macht, Politik: Die Nazifizierung der Kunst- und Musikhochschulen in Berlin.* Berlin: Elefanten, 1988.

Flanner, Janet. *Men and Monuments.* New York: Harper and Row, 1957.

Flavell, M. Kay. *George Grosz: A Biography.* New Haven: Yale University Press, 1988.

Freeman, Michael. *The Atlas of Nazi Germany.* New York: Macmillan, 1987.

Friedlaender, Saul. *Reflections on Nazism: An Essay on Kitsch and Death.* New York: Harper and Row, 1984.

Friedrich, Otto. *Before the Deluge: A Portrait of Berlin in the 1920s.* New York: Fromm International, 1986.

Friemuth, Cay. *Die geraubte Kunst: Der dramatische Wettlauf um die Rettung der Kulturschätze nach dem Zweiten Weltkrieg.* Braunschweig: Westermann, 1988.

Frischauer, Willi. *Himmler: The Evil Genius of the Third Reich.* London: Odhams, 1953.

Frommhold, Erhard, ed. *Kunst in Widerstand. Malerei. Graphik. Plastik.* Dresden: Verlag der Kunst, 1968.

Frowein, Cordula. "The Exhibition of Twentieth Century German Art in London 1938 – eine Antwort auf die Ausstellung 'entartete Kunst' in München 1937." In *Exilforschung: Ein Internationales Jahrbuch,* 2:212–37. Munich: Haus der Kunst, 1984.

Gable, Carole. *Albert Speer: Architect of the Third Reich. A Bibliography.* Austin: University of Texas (Vance Bibliographies), 1982.

Galante, Pierre, and Eugene Silianoff. *Last Witnesses in the Bunker.* Translated by Jan Dalley. London: Sidgwick and Jackson, 1989.

———. *Voices from the Bunker.* Translated by Jan Dalley. New York: Putnam, 1989.

Ganglmair, Siegwald, ed. *Wien 1938.* Vienna: Historisches Museum der Stadt Wien, 1988.

Geertz, Clifford. *Negara: The Theatre State in Nineteenth-Century Bali.* Princeton: Princeton University Press, 1980.

Georg, Enno. *Die Wirtschaftliche Unternehmungen der SS.* Stuttgart: Deutsche Verlags-Anstalt, 1963.

Germer, Stefan. "Kunst der Nation: Zu einem Versuch, die Avantgarde zu nationalisieren." In *Kunst auf Befehl?,* edited by Bazon Brock and Achim Preiß, 21–40. Munich: Klinkhardt und Biermann, 1990.

Giefer, Rena, and Thomas Giefer. *Die Rattenlinie: Fluchtwege der Nazis. Eine Dokumentation.* Frankfurt a.M.: Hain, 1991.

Giles, Geoffrey. *Students and National Socialism in Germany.* Princeton: Princeton University Press, 1985.

Gilman, Sander. "The Mad Man as Artist: Medicine, History, and Degenerate Art." *Journal of Contemporary History* 20 (1985): 575–97.

Goergen, Jeanpaul. "'X' heißt Vernichtung: Als die Nazis die moderne Kunst verbrannten." *Zitty* 26 (1986): 42–52.

Goldhagen, Erich. "Albert Speer, Himmler und das Geheimnis der Endlösung." In *Albert Speer,* edited by Adelbert Reif, 383–94. Munich: Bernard und Graefe, 1978.

Goldmann, Klaus, and Günter Wermusch. *Vernichtet, Verschollen, Vermarktet: Kunstschätze im Visier von Politic und Geschäft.* Asendorf: MUT, 1992.

Golomstock, Igor. *Totalitarian Art in the Soviet Union, the Third Reich, Fascist Italy, and the People's Republic of China.* New York: HarperCollins, 1990.

Graber, G. S. *The History of the SS.* New York: McKay, 1978.

Grasskamp, Walter. "The De-Nazification of Nazi Art: Arno Breker and Albert Speer Today." In *The Nazification of Art: Art, Design, Music, Architecture, and Film in the Third Reich,* edited by Brandon Taylor and Wilfried van der Will. Winchester: Winchester Press, 1990.

Grimsted, Patricia Kennedy. "The Fate of Ukrainian Cultural Treasures during World War II: The Plunder of Archives, Libraries, and Museums under the Third Reich." *Jahrbücher für Geschichte Osteuropas* 39, no. 1 (1991): 53–80.

Gritschneder, Otto. "Hitler in der Münchener Society: Salonfähig fürs Reich." In *München: "Hauptstadt der Bewegung,"* edited by Brigitte Schütz. Munich: Münchener Stadtmuseum, 1993.

Grosshans, Henry. *Hitler and the Artists.* New York: Holmes and Meier, 1983.

Grote, Andreas. "Museen und Ausstellungen." In *Deutsche Verwaltungsgeschichte,* edited by Kurt Jeserich, Hans Pohl, and Georg Christoph von Unruh, 4:999–1000. Stuttgart: Deutsche Verlags-Anstalt, 1988.

Groves, Naomi Jackson. *Ernst Barlach: Life in Work.* Munich: Piper, 1972.

Grunberger, Richard. *The Twelve-Year Reich: A Social History of Nazi Germany.* New York: Holt, Rinehart and Winston, 1979.

Guerin, Daniel. *Fascism and Big Business.* New York: Pathfinder, 1973.

Gulick, Edward Vose. *Europe's Classical Balance of Power.* New York: Norton, 1955.

Günther, Sonja. *Design der Macht: Möbel für Repräsentanten des "Dritten Reiches."* Stuttgart: Deutsche Verlags-Anstalt, 1992.

Gutman, Israel, ed. *The Encyclopedia of the Holocaust.* 4 vols. New York: Macmillan, 1990.

Haase, Günther. *Kunstraub und Kunstschutz: Eine Dokumentation.* Hildesheim: Georg Olms, 1991.

Haffner, Sebastian. *The Meaning of Hitler.* Cambridge, Mass.: Harvard University Press, 1979.

Haftmann, Werner. *Banned and Persecuted.* Cologne: DuMont, 1986. German

ed., *Verfemte Kunst: Bildende Künstler der inneren und außern Emigration in der Zeit des Nationalsozialismus*. Cologne: DuMont, 1986. Exhibition catalog.

Haftmann, Werner. *Emil Nolde: Unpainted Pictures*. New York: Präger, 1965. Exhibition catalog.

Hale, Oron. *The Captive Press in the Third Reich*. Princeton: Princeton University Press, 1964.

Hamburger Kunsthalle, eds. *Verfolgt und Verführt: Kunst Unter dem Hakenkreuz in Hamburg*. Marburg: Jonas Verlag für Kunst und Literatur, 1983. Exhibition catalog.

Hamburger Museumpädigogischen Dienst, eds. *Als Hamburg Erwachte, 1933: Alltag im Nationalsozialismus*. Hamburg: Museumspädigogischen Dienst, 1983. Exhibition catalog.

Hamilton, Richard. *Who Voted For Hitler?* Princeton: Princeton University Press, 1982.

Hammer, Katharina. *Glanz im Dunkel: Die Bergung von Kunstschätzen im Salzkammergut am Ende des II. Weltkriegs*. Vienna: Österreichisches Bundesverlag, 1986.

Hancock, Eleanor. *National Socialist Leadership and Total War, 1941–1945*. New York: St. Martin's, 1991.

Hanisch, Ernst. *Nationalsozialistische Herrschaft in der Provinz: Salzburg im Dritten Reich*. Salzburg: Landespressbüro, 1983.

Hardy, Alexander. *Hitler's Secret Weapon: The Managed Press and Propaganda Machine in Nazi Germany*. New York: Vantage, 1967.

Harris, Whitney. *Tyranny on Trial: The Evidence at Nuremberg*. Dallas: Southern Methodist University, 1954.

Harrison, E. D. R. *Gauleiter Bürckel and the Bavarian Palatinate*. Leeds: Leeds Philosophical and Literary Society, 1986.

Hart-Davis, Duff. *Hitler's Games: The 1936 Olympics*. New York: Harper and Row, 1986.

Hartt, Frederick. *Florentine Art under Fire*. Princeton: Princeton University Press, 1949.

Haus der Kunst. *Die Dreißiger Jahre: Schauplatz Deutschland*. Munich: Haus der Kunst e.V., 1977. Exhibition catalog.

Heffen, Annegret. *Der Reichskunstwart: Kunstpolitik in den Jahren 1920–1933*. Essen: Blaue Eule, 1986.

Hehn, Jürgen von. *Die Umsiedlung der baltischen Deutschen: Das Letzte Kapitel Baltisch-Deutscher Geschichte*. Marburg: Marburg Ostforschungen, 1982.

Heiber, Helmut. *Goebbels: A Biography*. Translated by John Dickenson. New York: Hawthorn Books, 1972.

Heineman, John. *Hitler's First Foreign Minister: Constantin Freiherr von Neurath, Diplomat and Statesman*. Berkeley: University of California Press, 1979.

Heller, Reinhold. "The Expressionist Challenge: James Plaut and the Institute of Contemporary Art." In *Dissent: The Issue of Modern Art in Boston*, 17–53. Boston: Northeastern University Press, 1986.

Hentzen, Alfred. *Die Berliner Nationalgalerie im Bildersturm*. Cologne: Grote, 1971.

Herf, Jeffrey. *Reactionary Modernism: Technology, Culture, and Politics in Weimar and the Third Reich.* Cambridge, Mass.: Harvard University Press, 1984.

Hermand, Jost. "Art for the People: The Nazi Concept of a Truly Popular Painting." In *High and Low Cultures: German Attempts at Mediation,* edited by Reinhold Grimm and Jost Hermand, 36–58. Madison: University of Wisconsin Press, 1994.

Herzstein, Robert Edwin. *The War That Hitler Won: The Most Infamous Propaganda Campaign in History.* New York: Putnam, 1978.

————. *When Nazi Dreams Come True: The Third Reich's Internal Struggle over the Future of Europe after a German Victory.* London: Abacus, 1982.

Hiden, John, and John Farquharson. *Explaining Hitler's Germany: Historians and the Third Reich.* Totowa, N.J.: Barnes and Noble, 1983.

Hiden, John, and Patrick Salmon. *The Baltic Nations and Europe: Estonia, Latvia, and Lithuania in the Twentieth Century.* London: Longman, 1991.

Hiepe, Richard, ed. *Widerstand Statt Anpassung: Deutsche Kunst im Widerstand gegen Faschismus, 1933–1945.* Berlin: Elefanten, 1980.

Hinz, Berthold. *Art in the Third Reich.* New York: Random House, 1979.

————. "1933–1945: Ein Kapital Kunstgeschichtlicher Forschung seit 1945." *Kritische Berichte* 14, no. 4 (April 1986): 18–33.

————, ed. *NS-Kunst: 50 Jahre danach. Neue Beiträge.* Marburg: Jonas, 1989.

Hinz, Berthold, and Hans Mittig, eds. *Die Dekoration der Gewalt: Kunst und medien im Faschismus.* Gießen: Anabas, 1979.

Hirschfeld, Gerhard. *Nazi Rule and Dutch Collaboration.* Oxford: Berg, 1988.

Hochman, Elaine. *Architects of Fortune: Mies van der Rohe and the Third Reich.* New York: Weidenfeld and Nicolson, 1989.

Hoelterhoff, Manuela. "Art of the Third Reich: Documents of Oppression." *Artforum* 14 (December 1975): 55–62.

Höffkes, Karl. *Hitlers Politische Generale: Die Gauleiter des Dritten Reiches.* Tübingen: Grabert, 1986.

Hoffmann, Peter. *The History of the German Resistance, 1933–1945.* Cambridge, Mass.: MIT Press, 1977.

Hofmann, Paul. "Up and Down Somebody Else's Stairs." In *Vertreibung der Vernunft: The Cultral Exodus from Austria,* edited by Peter Weibel and Freidrich Stadler. Vienna: Löcker Verlag, 1993.

————. *The Viennese: Splendor, Twilight, and Exile.* New York: Anchor, 1988.

Höhne, Heinz. *Der Orden unter dem Totenkopf: Die Geschichte der SS.* Hamburg: Sigbert Mohn, 1967.

Holborn, Hajo, ed. *Republic to Reich: The Making of the Nazi Revolution.* New York: Pantheon, 1969.

Hoover, Karl. "The Baltic Resettlement of 1939 and National Socialist Racial Policy." *Journal of Baltic Studies* 8 (Spring 1977): 78–89.

Hormats, Bess. "Art of the Götterdämmerung: The United States Army's Strange and Little-Known Collection of Nazi War Art." *ARTnews* 74, no. 1 (January 1975): 68–73.

Howe, Thomas. *Salt Mines and Castles: The Discovery and Restitution of Looted European Art.* Indianapolis: Bobbs-Merrill, 1946.

Huber, Gabriele. "Dackel, Hirsche, Bären mit der doppelten Sigrune: überlegungen zum Programm der Porzellen-Manufaktur Allach-München GmbH." In *NS-Kunst: 50 Jahre danach. Neue Beiträge*, edited by Berthold Hinz, 55–79. Marburg: Jonas, 1989.

Hull, David. *Film in the Third Reich: A Study of the German Cinema, 1933–1945.* Berkeley: University of California Press, 1969.

Hüneke, Andreas. "Dubiose Händler im Dunst der Macht." In *Alfred Flechtheim: Sammler, Kunsthändler, Verleger*, edited by Hans Albert Peters and Stephan von Wiese, 101–5. Düsseldorf: Kunst Museum Düsseldorf, 1987.

———. "On the Trail of the Missing Masterpieces." In *"Degenerate Art": The Fate of the Avant-Garde in Nazi Germany*, edited by Stephanie Barron, 121–33. New York: Abrams, 1991.

———, ed. *Die Faschistische Aktion "Entartete Kunst" 1937 in Halle.* Halle: Staatlichen Galerie Moritzburg, 1987.

Hunt, Richard M. "Joseph Goebbels: A Study of the Formation of his National Socialist Consciousness, 1897–1926." Ph.D. dissertation, Harvard University, 1960.

Hüser, Karl, ed. *Wewelsburg 1933 bis 1945: Kult- und Terrorstätte der SS. Eine Dokumentation.* Paderborn: Verlag Bonifatius, 1982. Exhibition catalog.

Hyde, Lewis. *The Gift: Imagination and the Erotic Life of Property.* New York: Random House, 1983.

Infield, Glenn. *Leni Riefenstahl: The Fallen Film Goddess.* New York: Crowell, 1976.

———. *Secrets of the SS.* New York: Military Heritage Press, 1981.

Irving, David. *Göring, a Biography.* London: Macmillan, 1989.

Jäckel, Eberhard. *Hitler's World View: A Blueprint for Power.* Cambridge, Mass.: Harvard University Press, 1982.

Jackman, Jarrell C., and Carla M. Borden, eds. *The Muses Flee Hitler: Cultural Transfer and Adaptation, 1930–1945.* Washington, D.C.: Smithsonian Institution Press, 1983.

Jacobi, Walter. *Bildersturm in der Provinz: Die NS-Aktion "Entartete Kunst" 1937 in Südbaden.* Freiburg a.B.: Dreisam-Verlag, 1988.

Jacobsen, Hans-Adolf, ed. *July 20, 1944: The German Opposition to Hitler as Viewed by Foreign Historians.* Bonn: Press and Information Office of the Federal Government, 1969.

Jaeger, Charles de. *The Linz File.* Exeter: Webb and Bower, 1981.

Janda, Annegret. "The Fight for Modern Art: The Berlin Nationalgalerie after 1933." In *"Degenerate Art": The Fate of the Avant-Garde in Nazi Germany*, edited by Stephanie Barron, 105–20. New York: Abrams, 1991.

———. *Das Schicksal einer Sammlung: Aufbau und Zerstörung der neuen Abteilung der Nationalgalerie im ehemaligen Kronprinzenpalais.* East Berlin: Nationalgalerie, 1988.

Janßen, Karl-Heinz. "Sonderauftrag Linz." *Die Zeit* 2 (2 January 1987): dossier section.

Jenks, William. *Vienna and the Young Hitler.* New York: Columbia University Press, 1960.

Jeserich, Kurt, Hans Pohl, and Georg-Christoph von Unruh. *Deutsche Verwaltungsgeschichte.* 6 vols. Stuttgart: Deutsche Verlags-Anstalt, 1983–88.

Jones, J. Sydney. *Hitler in Vienna, 1907–1913.* New York: Stein and Day, 1982.

Jürgen, Peter, and Hans Roos. "Magda." *Revue,* 12 March 1952, 16–29.

Justin, Harald. *"Tanz mir den Hitler": Kunstgeschichte und (faschistische) Herrschaft.* Münster: SZD-Verlag, 1982.

Kaes, Anton. *From Hitler to Heimat: The Return of History as Film.* Cambridge, Mass.: Harvard University Press, 1989.

Karetnikova, Inga, and Igor Golomstock. "Totalitarian Culture: The Encounter in Paris." *National Review* 9 (May 1986): 42–45.

Kaslas, Bronis. *The Baltic Nations: The Quest for Regional Integration and Political Liberty.* Pittston, Pa.: Euramerica Press, 1976.

Kater Michael. "Das Ahnenerbe: Die Forschungs und Lehrgemeinschaft in der SS." Ph.D dissertation, Ruprecht-Karl Universität, Heidelberg, 1966. Revised as *Das Ahnenerbe der SS.* Stuttgart: Deutsche Verlagsanstalt, 1974.

———. *Different Drummers: Jazz in the Culture of Nazi Germany.* New York: Oxford University Press, 1992.

———. "Forbidden Fruit?: Jazz in the Third Reich." *American Historical Review* 94, no. 1 (February 1989): 11–43.

———. *The Nazi Party: A Social Profile of Members and Leaders, 1919–1945.* Cambridge. Mass.: Harvard University Press, 1983.

Keneally, Thomas. *Schindler's List.* New York: Simon and Schuster, 1982.

Kerschbaumer, Gert. *Faszination Drittes Reich: Kunst und Alltag der Kulturmetropole Salzburg.* Salzburg: Müller, 1988.

Kershaw, Ian. *The "Hitler Myth": Image and Reality in the Third Reich.* New York: Oxford University Press, 1987.

———. *The Nazi Dictatorship: Problems and Perspectives of Interpretation.* London: Arnold, 1989.

Klein, Edward. "Letter from Tokyo." *Vanity Fair,* June 1993, 70–77.

Koehl, Robert. *The Black Corps: The Structure and Power Struggles of the Nazi SS.* Madison: University of Wisconsin Press, 1983.

———. "Feudal Aspects of National Socialism." In *Nazism and the Third Reich,* edited by Henry Ashby Turner, 151–74. New York: New Viewpoints, 1972.

———. *RKFDV: German Resettlement and Population Policy, 1939–1945.* Cambridge, Mass.: Harvard University Press, 1957.

Kowalski, Wojciech. *Liquidation of the Effects of World War II in the Area of Culture.* Warsaw: Institute of Culture, 1994.

Kramarz, Joachim. *Stauffenberg: The Architect of the Famous July 20th Conspiracy to Assassinate Hitler.* New York: Macmillan, 1967.

Kraus, Wolfgang. *Kultur und Macht: Die Verwandlung der Wünsche.* Vienna: Europa, 1975.

Krausnick, Helmut, Hans Buchheim, Martin Broszat, and Hans-Adolf Jacobsen. *Anatomy of the SS-State.* New York: Walker, 1968.

Kreis, Georg. "Entartete Kunst in Basel: Eine Chronik außerordentlicher

Ankäufe im Jahre 1939." *Die Baseler Zeitschrift für Geschichte und Altertumskunde* 78 (1978): 163–89.

Krier, Leon. *Albert Speer: Architecture, 1932–1942.* Brussels: Archives Architecture Moderne, 1985.

Kroll, Bruno. *Leo von König.* Berlin: Rembrandt, 1941.

Kubin, Ernst. *Sonderauftrag Linz: Die Kunstsammlung Adolf Hitler. Aufbau, Vernichtsungsplan, Rettung. Ein Thriller der Kulturgeschichte.* Vienna: Orac, 1989.

Kühnel-Kunze, Irene. *Bergung–Evakuierung–Rückführung: Die Berliner Museen in den Jahren 1939–1959.* Berlin: Gebrüder Mann, 1984.

Kunstpreis-Verzeichnis. Berlin: Weltkunst-Verlag, 1939–43.

Kurtz, Michael. *Nazi Contraband: American Policy on the Return of European Cultural Treasures, 1945–1955.* New York; Garland, 1985.

Kurz, Jakob. *Kunstraub in Europa, 1938–1945.* Hamburg: Facta Oblita, 1989.

Kuspit, Donald. "Diagnostic Malpractice: The Nazis on Modern Art." *Artforum* 25 (November 1985): 90–98.

Kwiet, Konrad. "'Material Incentives': The Lust for Jewish Property." In *The Attractions of Fascism,* edited by John Milfull, 238–52. New York: Berg, 1990.

Lane, Barbara Miller. *Architecture and Politics in Germany, 1918–1945.* 1968. Reprint, Cambridge, Mass.: Harvard University Press, 1985.

———. "Architects in the Service of Power." In *Art and History: Images and their Meaning,* edited by Robert Rotberg and Theodore Rabb, 283–310. Cambridge: Cambridge University Press, 1988.

Lang, Jochen von. *Der Adjutant. Karl Wolff: Der Mann zwischen Hitler und Himmler.* Munich: Herbig, 1985.

———. *Bormann: The Man who Manipulated Hitler.* London: Weidenfeld and Nicolson, 1979. Published in the United States as *The Secretary: Martin Bormann, the Man Who Manipulated Hitler.* New York: Random House, 1979.

———. *Der Hitler-Junge. Baldur von Schirach: Der Mann, der Deutschlands Jugend erzog.* Hamburg: Rasch und Röhring, 1988.

Langer, Walter. *The Mind of Adolf Hitler.* New York: Basic Books, 1972.

Lapièrre, Dominique, and Larry Collins. *Is Paris Burning?* New York: Simon and Schuster, 1965.

Laqueur, Walter, and George Mosse, eds. *Left-Wing Intellectuals between the Wars, 1919–1939.* New York: Harper and Row, 1966.

Lehmann-Haupt, Hellmut. *Art under a Dictatorship.* London: Oxford University Press, 1954.

Leiser, Erwin. *Nazi Cinema.* New York: Macmillan, 1974.

Lerner, Daniel. *The Nazi Elite.* Stanford: Stanford University Press, 1951.

Licata, Elizabeth. "Burchfield and Friends." *ARTnews* 89, no. 1 (January 1990): 62.

Lindner, Stephan. *Das Reichskommissariat für die Behandlung feindlichen Vermögens im Zweiten Weltkrieg: Eine Studie zur Verwaltungs-, Rechts- und Wirtschaftsgeschichte des nationalsozialistischen Deutschlands.* Stuttgart: Steiner, 1991.

Liska, Pavel. *Nationalsozialistische Kunstpolitik.* Berlin: Neue Gesellschaft für bildende Kunst, 1974.

Lott, Dagmar. "Münchens Neue Staatsgalerie im Dritten Reich." In *Nationalsozialismus und "Entartete Kunst,"* edited by Peter-Klaus Schuster. Munich: Prestel, 1987.

Lukas, Richard. *The Forgotten Holocaust: The Poles under German Occupation, 1939–1944.* Lexington: University Press of Kentucky, 1986.

Lüttichau, Mario-Andreas von. "'Deutsche Kunst' und 'entartete Kunst.'" In *Nationalsozialismus und "Entartete Kunst,"* edited by Peter-Klaus Schuster, 83–118. Munich: Prestel, 1987.

Luza, Radomir. *Austro-German Relations in the Anschluss Era.* Princeton: Princeton University Press, 1975.

———. *The Resistance in Austria, 1938–1945.* Minneapolis: University of Minnesota Press, 1984.

Maass, Walter. *The Netherlands at War, 1940–1945.* London: Abelard-Schumann, 1970.

McCloy, John II. "The Impact of the Resistance Movement on Post-War Germany." In *July 20, 1944: The German Opposition to Hitler as Viewed by Foreign Historians,* edited by Hans-Adolf Jacobsen, 301–14. Bonn: Press and Information Office of the Federal Government, 1969.

McCracken, Grant. "Clothing as Language: An Object Lesson in the Study of Expressive Properties of Material Culture." In *Material Anthropology: Contemporary Approaches to Material Culture,* edited by Barrie Reynolds and Margaret Stott, 103–28. Lanham, Md.: University Press of America, 1987.

Maier, Charles. *The Unmasterable Past: History, Holocaust, and German National Identity.* Cambridge, Mass.: Harvard University Press, 1988.

Majer, Diemut, Martin Hirsche, and Jürgen Meinck, eds. *Recht, Verwaltung, und Justiz im Nationalsozialismus: Ausgewählte Schriften, Gesetze und Gerichtsentscheidungen von 1933 bis 1945.* Cologne: Bund-Verlag, 1984.

Manning, Paul. *Martin Bormann: Nazi in Exile.* Secaucus, N.J.: Stuart, 1981.

Manvell, Roger, and Heinrich Fraenkel. *Doctor Goebbels: His Life and Death.* London: Heinemann, 1960.

———. *Heinrich Himmler.* New York: Putnam, 1965.

———. *Hermann Goering.* London: Heinemann, 1962.

———. *The Men Who Tried to Kill Hitler.* New York: Coward-McCann, 1964.

Marquis, Alice. *Alfred Barr: Missionary for the Modern.* Chicago: Contemporary Books, 1989.

Martens, Stefan. *Hermann Göring: "Erster Paladin des Führers" und "zweiter Mann im Reich."* Paderborn: Schoningh, 1985.

Mastny, Vojtech. *The Czechs under Nazi Rule: The Failure of National Resistance, 1939–1945.* New York: Columbia University Press, 1971.

Mauss, Marcel. *The Gift, Forms, and Function of Exchange in Archaic Societies.* Glencoe, Ill.: Free Press, 1954.

Mayer, Arno. *The Persistence of the Old Regime: Europe to the Great War.* New York: Pantheon, 1981.

Merker, Reinhard. *Die bildenden Künste im Nationalsozialismus: Kulturidiologie, Kulturpolitik, Kulturproduktion.* Colgone: DuMont, 1983.

Merson, Allan. *Communist Resistance in Nazi Germany.* London: Lawrence and Wishart, 1985.

Miesel, Victor, ed. *Voices of German Expressionism.* Englewood Cliffs, N.J.: Prentice Hall, 1970.

Milfull, John, ed. *The Attractions of Fascism.* New York: Berg, 1990.

Misiunas, Romuald J., and Rein Taagepera. *The Baltic States: Years of Dependence, 1940–1980.* Berkeley: University of California Press, 1983.

Mittig, Hans-Ernst. "NS-Bauten als Anschauungsmaterial sind unverzichtbar. . . ." *Zitty* 4 (1988): 14–15.

Moltmann, Günter. "Goebbels' Speech on Total War, February 18, 1943." In *Republic to Reich: The Making of the Nazi Revolution,* edited by Hajo Holborn, 298–342. New York: Random House, 1972.

Mommsen, Hans. "The Sociology of the Resistance." In *The German Resistance to Hitler,* edited by Walter Schmitthenner and Hans Buchheim. London: Batsford, 1970.

Mosley, Leonard. *The Reich Marshal: A Biography of Hermann Goering.* New York: Doubleday, 1974.

Mosse, George. *The Crisis of German Ideology: Intellectual Origins of the Third Reich.* New York: Grosset and Dunlap, 1964.

———. *Nazi Culture: Intellectual, Cultural, and Social Life in the Third Reich.* New York: Schocken Books, 1981.

Müller-Mehlis, Reinhard. *Die Kunst im Dritten Reich.* Munich: Heyner Stilkunde, 1976.

Nicholas, Lynn. *The Rape of Europa: The Fate of Europe's Treasures in the Third Reich and the Second World War.* New York: Knopf, 1994.

Nickerson, Colin. "West Irked by Paid-In-Japan Art." *Boston Globe,* 26 May 1990.

Nicolaus, Frank. "Als Hitlers Kunst-Schergen Kamen." *Art,* October 1987, 79–87.

Nierhaus, Irene. "Adoration und Selbstverherrlichung." In *Im Reich der Kunst: Die Wiener Akademie der bildenden Künste und die faschistische Kunstpolitik,* edited by Hans Seiger, Michael Lunardi, and Peter-Josef Popularum, 65–141. Vienna: Verlag für Gesellschaftskritik, 1990.

Nisbet, Peter. "Degenerate Art." *Art Monthly* 148 (July–August 1991): 7–9.

Noakes, Jeremy, and Geoffrey Pridham, eds. *Documents on Nazism, 1919–1945.* London: Cape, 1974.

Noel, Bernard. *Arno Breker et l'art officiel.* Paris: J. Damase, 1981.

Nordrhein-Westfalen Kunstsammlung, eds. *Museum der Gegenwart: Kunst in öffentlichen Sammlungen bis 1937.* Düsseldorf: Rainer Meyer, 1987. Exhibition catalog.

———. *"Und nicht die leisteste Spur: Einer Vorschrift": Position unabhängiger Kunst in Europa um 1937.* Düsseldorf: Kunstsammlung Nordrhein-Westfalen, 1987.

Nova, Fritz. *Alfred Rosenberg: Nazi Theorist of the Holocaust.* New York: Hippocrene Books, 1986.

Nowojski, Walter, ed. *In dunkler Zeit: Künstlerschicksale zwischen 1933 und 1945.* Berlin: Henschel, 1963.

Nyomarkay, Joseph. *Charisma and Factionalism in the Nazi Party.* Minneapolis: University of Minnesota Press, 1967.

Obermann, Karl. *Exil Paris: Im Kampf gegen Kultur- und Bildungsabbau im faschistischen Deutschland.* Frankfurt: Röderberg, 1984.

Ogan, Bernd, and Wolfgang Weiss, eds. *Faszination und Gewalt: Zur politischen Ästhetik des Nationalsozialismus.* Nuremberg: W. Tümmels, 1992.

Orlow, Dietrich. *The History of the Nazi Party, 1919–1933.* Pittsburgh: University of Pittsburgh Press, 1969.

———. *The History of the Nazi Party, 1933–1945.* Pittsburgh: University of Pittsburgh Press, 1973.

Overesch, Manfred. *Das III. Reich, 1939–1945: Eine Tageschronik der Politik, Wirtschaft, Kultur.* Augsburg: Weltbild, 1991.

Overy, Richard. *Göring: The "Iron Man."* London: Routledge and Kegan Paul, 1984.

Padfield, Peter. *Himmler: Reichsführer-SS.* New York: Holt, 1991.

Paret, Peter. *The Berlin Secession: Modernism and Its Enemies in Imperial Germany.* Cambridge, Mass.: Harvard University Press, 1980.

Paul, Gerhard. *Aufstand der Bilder: Die NS-Propaganda vor 1933.* Bonn: Dietz, 1990.

Pauley, Bruce. *From Prejudice to Persecution: A History of Austrian Anti-Semitism.* Chapel Hill: University of North Carolina Press, 1992.

———. *Hitler and the Forgotten Nazis: A History of Austrian National Socialism.* Chapel Hill: University of North Carolina Press, 1981.

Perrault, Gilles, and Pierre Azema. *Paris under the Occupation.* New York: Vendome, 1989.

Peterson, Brian. "Regional Elites and the Rise of National Socialism." In *Radical Perspectives on the Rise of Fascism in Germany, 1919–1945,* edited by Michael Dobkowski and Isador Wallimann, 172–93. New York: Monthly Review Press, 1989.

Peterson, Edward. *The Limits of Hitler's Power.* Princeton: Princeton University Press, 1969.

Petropoulos, Jonathan. "The Importance of the Second Rank: The Case of the Art Plunderer Kajetan Mühlmann," in Günter Bischof and Anton Pelinka, eds., *Austro-Corporatism: Past, Present and Future. Contemporary Austrian Studies* 4 (1995): 177–221.

Petsch, Joachim. *Kunst im Dritten Reich: Architektur, Plastik, Malerei.* Cologne: Vista Point, 1983.

Piper, Ernst. *Ernst Barlach und die nationalsozialistische Kunstpolitik: Eine dokumentarische Darstellung zur "entarteten Kunst."* Munich: Piper, 1983.

———. *Nationalsozialistische Kunstpolitik: Ernst Barlach und die "entartete Kunst."* Frankfurt: Suhrkamp, 1987.

Plaut, James. "Hitler's Capital: Loot from the Master Race." *Atlantic,* October 1946, 75–80.

Pool, James, and Suzanne Pool. *Who Financed Hitler?: The Secret Funding of Hitler's Rise to Power*. New York: Dial, 1978.

Posner, Gerald. *Hitler's Children*. New York: Berkeley, 1991.

Pott, Gertrud. *Verkannte Grösse: Eine Kulturgeschichte der Ersten Republik, 1918–1938*. Vienna: Kremayr & Scheriau, 1989.

Price, Billy. *Adolf Hitler als Maler und Zeichner: Ein Werkkatalog der Ölgemälde, Aquarelle, Zeichnungen und Architekturskizzen*. Zug, Switzerland: Gallant, 1983.

Proestler, Viktor. *Die Ursprünge der nationalsozialistischen Kunsttheorie*. Munich: Dissertations- und Fotodruck Frank, 1982.

Rabinbach, Anson. "Beauty of Labour: The Aesthetics of Production in the Third Reich." *Journal of Contemporary History* 11 (1976): 43–74.

Rapport, Leonid, and Arthur Northwood. *Rendez-Vous with Destiny: A History of the 101st Airborne Division*. Minneapolis: Madella, 1948.

Rasp, Hans-Peter. *Eine Stadt für tausend Jahre: München, Bauten und Projekte für die Hauptstadt der Bewegung*. Munich: Süddeutscher, 1981.

Rathkolb, Oliver. *Führertreu und Gottbegnadet: Künstlereliten im Dritten Reich*. Vienna: Österreichischer Bundesverlag, 1991.

———. "Nationalsozialistische (Un-) Kulturpolitik in Wien, 1938–1945." In *Im Reich der Kunst: Die Wiener Akademie der bildenden Künste und die faschistische Kunstpolitik*, edited by Hans Seiger, Michael Lunardi, and Peter-Josef Popularum, 247–76. Vienna: Verlag für Gesellschaftskritik, 1990.

Rave, Paul Ortwin. *Die Geschichte der Nationalgalerie Berlin*. Berlin: Nationalgalerie der Staatlichen Museen Preußicher Kulturbesitz, 1968.

———. *Kunstdiktatur im dritten Reich*. Hamburg: Gebrüder Mann, 1949.

Rees, Philip. *Biographical Dictionary of the Extreme Right since 1890*. New York: Harvester Wheatsheaf, 1990.

Reif, Adelbert. *Albert Speer: Kontroversen um ein deutsches Phänomen*. Munich: Bernard and Graefe, 1978.

Reinmann, Viktor. *The Man Who Created Hitler: Joseph Goebbels*. London: Kimber, 1977.

Reitlinger, Gerald. *The Economics of Taste: The Rise and Fall of Picture Prices, 1760–1960*. London: Barrie and Rockliff, 1961.

———. "Last of the War Criminals: Erich Koch." *Commentary* 27, no. 1 (January 1959): 30–42.

———. *The SS: Alibi of a Nation, 1922–1945*. New York: Viking, 1972.

Reuth, Ralf Georg. *Goebbels*. Munich: Piper, 1990.

Reynolds, Barrie, and Margaret Stott, eds. *Material Anthropology: Contemporary Approaches to Material Culture*. Lanham, Md.: University Press of America, 1987.

Rhodes, Anthony. *The Vatican in the Age of the Dictators, 1922–1945*. London: Hodder and Stoughton, 1973.

Rich, Norman. *Hitler's War Aims*. Vol. 1, *Ideology, the Nazi State, and the Course of Expansion*. New York: Norton, 1973.

———. *Hitler's War Aims*. Vol. 2, *The Establishment of the New Order*. New York: Norton, 1974.

Rings, Werner. *Life with the Enemy: Collaboration and Resistance in Hitler's Europe, 1939–1945.* New York: Doubleday, 1982.

Ritchie, J. M. *German Literature under National Socialism.* London: Helm, 1983.

Roh, Franz. *"Entartete" Kunst: Kunstbarbarei im Dritten Reich.* Hanover: Fackelträger-Verlag, 1972. Exhibition catalog.

Romanus, Peter, ed. *Im Kampf um die moderne Kunst: Das Schicksal einer Sammlung in der 1. Hälfte des 20. Jahrhunderts.* Halle: Staatliche Galerie Moritzburg Halle, 1985. Exhibition catalog.

Rorimer, James. *Survival: The Salvage and Protection of Art in War.* New York: Abelard, 1950.

Rosenkranz, Herbert. *Verfolgung und Selbstbehauptung: Die Juden in Österreich, 1938–1945.* Vienna: Herold Druck, 1978.

Roser, Wolfgang. *Deutsche Gemeinschaft: Seyss-Inquart und der Anschluß.* Vienna: Europa, 1971.

Ross, Alan. *Colours of War: War Art, 1939–1945.* London: Cape, 1983.

Roters, Eberhard. *Galerie Ferdinand Möller, 1917–1956: Ein Beitrag zur der Kunst und der Kunstgeschichte im 20. Jahrhunderts.* Berlin: Nicolaische Verlagsbuchhandlung Beuermann, 1987.

Rothfeder, Herbert. "A Study of Alfred Rosenberg's Organization for National Socialist Ideology." Ph.D. dissertation, University of Michigan, 1963.

Roxan, David, and Kenneth Wanstall. *The Rape of Art: Hitler's Plunder of the Great Masterpieces of Europe.* New York: McCann, 1965.

Ruckhaberle, Dieter, ed. *Karl Hofer.* Berlin: Staatliche Kunsthalle, 1978. Exhibition catalog.

Rudloff, Christa. *Materialen zur Kunst- und Kulturpolitik im "3. Reich" am Beispiel Emil Nolde.* Nuremberg: Germanisches Nationalmuseum, 1982.

Rürup, Reinhard. *Topographie des Terrors: Gestapo, SS und Reichssicherheitshauptamt auf dem "Prinz-Albrecht Gelände." Eine Dokumentation.* Berlin: Verlag Willmuth Arenhövel, 1987.

Ryan, Judith. *The Uncompleted Past: Postwar German Novels and the Third Reich.* Detroit: Wayne State University Press, 1983.

Salzburg, Siegfried, ed. *Verboten und Verfolgt: Kunstdiktatur im Dritten Reich.* Duisberg: Lehmbruck Museum. Exhibition catalog.

Sauder, Gerhard. *Die Bücherverbrennung zum 10. Mai 1933.* Munich: Carl Hanser, 1983.

Schade, Günter. *Die Berliner Museuminsel: Zerstörung, Rettung, Wiederaufbau.* Berlin: Henschel, 1986.

Schaffing, Ferdinand, Ernst Baumann, and Heinrich Hoffmann. *Der Obersalzberg: Brennpunkt der Zeitgeschichte.* Munich: Langen Müller, 1985.

Schmidt, Diether. *In letzter Stunde: Künstlerschriften 1933–1945.* Dresden: VEB Verlag der Kunst, 1963.

Schmidt, Matthias. *Albert Speer: The End of a Myth.* New York: Macmillan, 1983.

Schnell, Ralf, ed. *Kunst und Kultur im deutschen Faschismus.* Stuttgart: Metzler, 1978.

Schoenbaum, David. *Hitler's Social Revolution: Class and Status in Nazi Germany,*

1933–1939. New York: Norton, 1966.

Scholz, Robert. *Architektur und bildende Kunst, 1933–1945.* Preußisch Oldendorf: Schütz, 1974.

Schönberger, Angela. "Die Neue Reichskanzlei in Berlin von Albert Speer." In *Die Dekoration der Gewalt: Kunst und Medien im Faschismus,* edited by Berthold Hinz and Hans Mittig, 166–96. Gießen: Anabas, 1979.

———. *Die Neue Reichskanzlei von Albert Speer.* Berlin: Gebrüder Mann, 1981.

Schönberner, Gerhard. *Artists against Hitler: Persecution, Exile, and Resistance.* Bonn: Inter Nationes, 1984.

Schöndienst, Eugen. "Kulturelle Angelegenheiten." In *Deutsche Verwaltungsgeschichte,* edited by Kurt Jeserich, Hans Pohl, and Georg-Christoph von Unruh, 4:988–98. Stuttgart: Deutsche Verlags-Anstalt, 1988.

Schumann, Klaus. "Beim dritten Schlag zersprang der Hammer." *Süddeutsche Zeitung* 238 (15/16 October 1983): 18.

Schürer, Ernst. "Emil Nolde in His Times: 'Degenerate Art' and the Totalitarian State." In *Emil Nolde: Works from American Collections,* edited by Ernst Schürer, 1–12. State College: Pennsylvania State University Press, 1988.

Schuster, Peter-Klaus, ed. *Nationalsozialismus und "Entartete Kunst": Die "Kunststadt" München 1937.* Munich: Prestel, 1987. Exhibition catalog.

Schuster, Peter-Klaus, and Lott-Dagmar, eds. *Dokumentation zum nationalsozialistischen Bilderstrum am Bestand der Staatsgalerie moderner Kunst in München.* Munich: Bayerische Staatsgemäldesammlung, 1988. Supplement to exhibition catalog.

Schuster, Wolfgang. "Hitler in München – privat?" In *München: "Hauptstadt der Bewegung,"* edited by Brigitte Schütz, 125–30. Munich: Münchener Stadtmuseum, 1993.

Schütz, Brigitte, ed. *München: "Hauptstadt der Bewegung."* Munich: Münchener Stadtmuseum, 1993.

Schwarz, Paul. *This Man Ribbentrop.* New York: Messner, 1943.

Schwarzwäller, Wolf. *Hitlers Geld: Bilanz einer persönlichen Bereicherung.* Salzburg: Arthur Möwig, 1986.

Scobie, Alex. *Hitler's State Architecture: The Impact of Classical Antiquity.* State College: Pennsylvania State University Press, 1990.

Seiger, Hans, Michael Lunardi, and Peter-Josef Populorum, eds. *Im Reich der Kunst: Die Wiener Akademie der bildenden Künste und die faschistische Kunstpolitik.* Vienna: Verlag für Gesellschaftskritik, 1990.

Selig, Wolfram. "Judenverfolgung in München 1933 bis 1941." In *München: "Hauptstadt der Bewegung,"* edited by Brigitte Schütz, 398–401. Munich: Münchener Stadtmuseum, 1993.

Seward, Desmond. *Napoleon and Hitler.* New York: Viking, 1989.

Seydewitz, Ruth, and Max Seydewitz. *Die Dame mit dem Hermelin: Der größte Kunstraub aller Zeiten.* East Berlin: Henschelverlag, 1963.

———. *Das Dresdener Galeriebuch: Vierhundert Jahre Dresdener Gemäldegalerie.* Dresden: Verlag der Kunst, 1960.

———. *Der Raub der Mona Lisa.* Moscow: Militärverlag der Ministerium für Verteidigung der UdSSR, 1966.

Sheehan, James, *Germany, 1780–1866.* Oxford: Oxford University Press, 1989.

Shirer, William. *The Rise and Fall of the Third Reich: A History of Nazi Germany.* London: Pan Books, 1960.

Short, K. R. M., and Stephan Dolezel, eds. *Hitler's Fall: The Newsreel Witness.* London: Helm, 1988.

Simon, Matila. *The Battle of the Louvre: The Struggle to Save French Art in World War II.* New York: Hawthorn, 1971.

Sington, Derrick. *The Goebbels Experiment.* New Haven: Yale University Press, 1942.

Siviero, Rodolfo. *L'Arte e il Nazismo: Esodo e ritorno della opere d'arte italiane, 1938–1945.* Florence: Cantini, 1984.

———, ed. *Second National Exhibition of the Works of Art Recovered in Germany.* Florence: Sansoni, 1950.

Smelser, Ronald. *Robert Ley: Hitler's Labor Front Leader.* Oxford: Berg, 1988.

Smyth, Craig Hugh. *Repatriation of Art from the Collecting Point in Munich after World War II.* Montclair, N.J.: Abner Schram, 1988.

Snyder, Louis. *Encyclopedia of the Third Reich.* New York: McGraw-Hill, 1976.

———. *Hitler's Elite.* New York: Hippocrene, 1989.

Spalek, John. *Guide to the Archival Materials of the German Emigration to the United States after 1933.* Charlottesville: University of Virginia, 1978.

Spielvogel, Jackson. *Hitler and Nazi Germany.* Englewood Cliffs, N.J.: Prentice Hall, 1988.

Sprengel Museum, Hanover. *Deutscher Künstlerbund 1936: Verbotene Bilder.* Hanover: Sprengel Museum, 1986. Exhibition catalog.

Stachura, Peter. *Nazi Youth in the Weimar Republic.* Santa Barbara, Calif.: Clio Books, 1975.

Städtische Kunsthalle, Mannheim. *Entartete Kunst–Beschalgnahmeaktionen in der Städtischen Kunsthalle Mannheim 1937: Kunst + Dokumentation 10.* Mannheim: Städtische Kunsthalle, 1987.

Staeck, Klaus. *Nazi Kunst ins Museum?* Göttingen: Steil/Zirk, 1988.

Steele, Frank. "Die Verwaltung der bildenden Künste im 'New Deal' und 'Dritten Reich.'" In *Die Dekoration der Gewalt: Kunst und medien im Faschismus,* edited by Berthold Hinz and Hans Mittig, 198–204. Gießen: Anabas, 1979.

Steiner, George. *In Bluebeard's Castle: Some Notes towards the Redefinition of Culture.* New Haven: Yale University Press, 1971.

Steinweis, Alan. *Art, Ideology, and Economics in Nazi Germany: The Reich Chambers of Music, Theater, and the Visual Arts.* Chapel Hill: University of North Carolina Press, 1993.

———. "Weimar Culture and the Rise of National Socialism: The *Kampfbund für deutsche Kultur.*" *Central European History* 24, no. 4 (1991): 402–23.

Stern, Fritz. *Dreams and Delusions: The Drama of German History.* New York: Knopf, 1984.

———. *The Failure of Illiberalism: Essays on the Political Culture of Modern Germany.* New York: Knopf, 1972.

———. *The Politics of Cultural Despair.* Garden City, N.Y.: Doubleday, 1965.

Steurer, Leopold. *Südtirol: Zwischen Rom und Berlin, 1919–1939.* Vienna: Europaverlag, 1980.

Strauss, Gerhard. "Dokumente zur entarteten Kunst." In *Festgabe an Carl Hofer zum 50. Geburtstag,* 53–60. Potsdam: Verlag von Eduard Stichnote, 1948.

Strothmann, Dietrich. *Nationalsozialistische Literaturpolitik.* Bonn: Bouvier, 1968.

Stuhlpfarrer, Karl. *Umsiedlung Südtirol, 1939–1940.* Vienna: Locker, 1985.

Stuttgart Staatsgalerie, eds. *Bildzyklen: Zeugnisse verfemter Kunst in Deutschland, 1933–1945.* Stuttgart: Staatsgalerie Stuttgart, 1987. Exhibition catalog.

Tabor, Jan. "Die Gaben der Ostmark: Österreichische Kunst und Künstler in der nationalsozialistischen Zeit." In *Im Reich der Kunst: Die Wiener Akademie der bildenden Künste und die faschistische Kunstpolitik,* edited by Hans Seiger, Michael Lunardi, and Peter-Josef Populorum, 277–96. Vienna: Verlag für Gesellschaftskritik, 1990.

———. ". . . Und Sie folgten Ihm: Österreichische Künstler und Architekten nach dem 'Anschluß' 1938. Eine Reportage." In *Wien 1938,* edited by Siegwald Ganglmair, 398–428. Vienna: Historisches Museum der Stadt Wien, 1988.

———, ed. *Kunst und Diktatur: Architektur, Bildhauerei und Malerei in Österreich, Deutschland, Italien und der Sowjetunion, 1922–1956.* 2 vols. Baden: Verlag Grasl, 1994.

Taylor, Brandon, and Wilfried van der Will. "Aesthetics and National Socialism." In *The Nazification of Art: Art, Design, Music, Architecture, and Film in the Third Reich,* edited by Brandon Taylor and Wilfried van der Will, 1–13. Winchester: Winchester Press, 1990.

Taylor, Brandon, and Wilfried van der Will, eds. *The Nazification of Art: Art, Design, Music, and Film in the Third Reich.* Winchester: Winchester Press, 1990.

Taylor, Robert. *The Word in Stone: The Role of Architecture in the National Socialist Ideology.* Berkeley: University of California Press, 1974.

Taylor, Telford. *The Anatomy of the Nuremberg Trials: A Personal Memoir.* New York: Knopf, 1992.

Thies, Jochen. *Architekt der Weltherrschaft: Die Endziele Hitlers.* Düsseldorf: Droste, 1976.

———. "Hitler: 'Architekt der Weltherrschaft.'" In *Faszination und Gewalt: Zur politischen Ästhetik des Nationalsozialismus,* edited by Bernd Ogan and Wolfgang Weiss, 177–96. Nuremberg: W. Tümmels, 1992.

———. "Hitler's European Building Programme." *Journal of Contemporary History* 13 (1978): 423–31.

Thomae, Otto. *Die Propaganda-Maschinerie: Bildende Kunst und öffentlichkeitsarbeit im Dritten Reich.* Berlin: Gebrüder Mann, 1978.

Toscano, Mario. *Alto Adige–South Tyrol: Italy's Frontier with the German World.* Baltimore: Johns Hopkins University Press, 1975.

Trapp, Oswald. *Die Kunstdenkmäler Tirols in Not und Gefahr.* Innsbruck: M. F. Rohre, 1947.

Treue, Wilhelm. *Art Plunder: The Fate of Works of Art in War and Unrest.* New York: John Day, 1960.

————. "Bargatzky-Bericht." *Vierteljahrshefte für Zeitgeschichte* 13, no. 3 (July 1965): 285–337.

Trevor-Roper, Hugh. *The Last Days of Hitler*. New York: Collier, 1962.

Ulbricht, Justus. "Völkische Publizistik in München: Verleger, Verlage und Zeitschriften im Vorfeld des Nationalsozialismus." In *München: "Hauptstadt der Bewegung,"* edited by Brigitte Schütz, 131–36. Munich: Münchener Stadtmuseum, 1993.

Valland, Rose. *Le Front de l'Art*. Paris: Plon, 1961.

————. "Bildersturm in Frankreich." *Das Schönste* (February 1963), 68–69.

Varga, William. *The Number One Nazi Jew-Baiter: A Political Biography of Julius Streicher*. New York: Carlton, 1981.

Varshavsky, Sergei, and Boris Rest. *Saved for Humanity: The Hermitage during the Siege of Leningrad, 1941–1944*. Leningrad: Aurora Art Publishers, 1985.

Venema, Adrian. *Kunsthandel in Nederland, 1940–1945*. Amsterdam: De Arbeiderspers, 1986.

Viereck, Peter. *Metapolitics: From the Romantics to Hitler*. New York: Knopf, 1941.

Vizulis, I. Joseph. *Nations under Duress: The Baltic States*. Port Washington, N.Y.: Associated Faculty Press, 1985.

Vogelsang, Reinhard. *Der Freundeskreis Himmler*. Göttingen: Musterschmidt, 1972.

Warmbrunn, Werner. *The Dutch under German Occupation, 1940–1945*. Palo Alto, Calif.: Stanford University Press, 1963.

Warnke, Martin, ed. *Bildersturm: Die Zerstörung des Kunstwerks*. Munich: Carl Hanser, 1973.

Weber, John Paul. *The German War Artists*. Columbia, S.C.: Cerberus, 1979.

Weimar Kunstsammlung, eds. *Angriff auf die Kunst: Der faschischte Bildersturm vor 50 Jahren*. Weimar: Kunstsammlung zu Weimar, 1988. Exhibition catalog.

Weinstein, Fred. *The Dynamics of Nazism*. New York: Academic Press, 1980.

Weinstein, Joan. *The End of Expressionism: Art and the November Revolution in Germany*. Chicago: University of Chicago Press, 1990.

Weitz, John. *Hitler's Diplomat: The Life and Times of Joachim von Ribbentrop*. New York: Ticknor and Fields, 1992.

Welch, David. "Goebbels, Götterdämmerung, and the Deutsche Wochenschau." In *Hitler's Fall: The Newsreel Witness*, edited by K. R. M. Short and Stephan Dolezel, 80–99. London: Helm, 1988.

————. *Propaganda and the German Cinema, 1933–1945*. New York: Oxford University Press, 1983.

Werness, Hope. "Han von Meegeren *fecit*." In *The Forger's Art: Forgery and the Philosophy of Art*, edited by Denis Dutton, 1–57. Berkeley: University of California Press, 1983.

Wheeler-Bennett, John. *The Nemesis of Power: The German Army in Politics, 1918–1945*. London: Macmillan, 1953.

Whisker, James Biser. *The Social, Political, and Religious Thought of Alfred Rosenberg: An Interpretive Essay*. Washington, D.C.: University Press of America, 1982.

Wilson, Sarah. "Collaboration in the Fine Arts, 1940–1944." In *Collaboration in*

France: Politics and Culture during the Nazi Occupation, edited by Gerhard Hirschfeld and Patrick Marsh, 103–25. Oxford: Berg, 1989.

Wirth, Günther. *Verbotene Kunst, 1933–1945: Verfolgte Künstler im deutschen Südwesten.* Baden: Hatje, 1988.

Wistrich, Robert. *Who's Who in Nazi Germany.* New York: Bonanza Books, 1982.

Wolbert, Klaus. *Die Nackten und die Toten des "dritten Reiches."* Gießen: Anabas-Verlag, 1982.

Wolsdorff, Christian. *Bauhaus Berlin: Auflösung Dessau 1932. Schließung Berlin 1933. Bauhaüsler und Drittes Reich: Eine Dokumentation.* Weingarten: Kunstverlag Weingarten, 1985. Exhibition catalog.

Württemberg Verband Bildender Künstler, eds. *Künstlerschicksale im Dritten Reich in Württemberg und Baden.* Stuttgart: Verband Bildender Künstler Württemberg, 1990.

Wulf, Joseph. *Die bildenden Künste im Dritten Reich: Eine Dokumentation.* Frankfurt: Ullstein, 1963.

———. *Literatur und Dichtung im Dritten Reich: Eine Dokumentation.* Gütersloh: Sigbert Mohn, 1963.

———. *Musik im Dritten Reich: Eine Dokumentation.* Gütersloh: Sigbert Mohn, 1964.

———. *Presse und Rundfunk im Dritten Reich: Eine Dokumentation.* Gütersloh: Sigbert Mohn, 1964.

———. *Theater und Film im Dritten Reich: Eine Dokumentation.* Gütersloh: Sigbert Mohn, 1964.

Yahil, Leni. "Einsatzstab Reichsleiter Rosenberg." In *The Encyclopedia of the Holocaust,* edited by Israel Gutman, 1:439–41. New York: Macmillan, 1990.

Yenne, William, ed. *German War Art, 1939–1945.* New York: Crescent Books, 1983.

Zapf, Wolfgang. *Die Wandlungen der deutschen Elite.* Munich: Piper, 1965.

Zavrel, John. *Arno Breker: His Art and Life.* Amherst, N.Y.: West-Art, 1983.

Zemon, Z. A. B. *Nazi Propaganda.* New York: Oxford University Press, 1964.

Zentner, Christian, and Friedemann Bedürftig, eds. *The Encyclopedia of the Third Reich.* New York: Macmillan, 1991.

Ziegler, Herbert. *Nazi Germany's New Aristocracy: The SS Leadership, 1935–1939.* Princeton: Princeton University Press, 1989.

Zurich Kunsthaus. *Kunst in Deutschland, 1930–1949.* Zurich: Kunsthaus Zurich, 1975. Exhibition catalog.

Zuschlag, Christoph. "An 'Educational Exhibition': The Precursors of Entartete Kunst and Its Individual Venues." In *"Degenerate Art": The Fate of the Avant-Garde in Nazi Germany,* edited by Stephanie Barron, 83–103. New York: Abrams, 1991.

Zweite, Armin, "Franz Hofmann und die Städtische Galerie 1937." In *Nationalsozialismus und "Entartete Kunst": Die "Kunststadt" München 1937,* edited by Peter-Klaus Schuster, 261–88. Munich: Prestel, 1987.

INDEX

179, 195–201, 283; aesthetic poli-
cies, 8, 11, 19–28, 39, 41, 44–65,
67, 69, 76–79, 82–83, 109, 206,
221, 260, 291, 309; relationship to
Hitler, 22, 77, 83, 127, 152, 186,
195–96, 201, 265–68, 274, 281,
291; residences, 24–25, 71, 195–
96, 198, 200–201, 294, 296–97,
307; left-wing roots, 24–26, 195,
201, 291, 293; portraits, 25, 196,
201, 295; *GDK*, 53, 196–97, 283;
plunder, 124–27, 130, 133, 152–
53, 199, 247, 315; as writer, 154–
55, 195, 199, 260; as plenipoten-
tiary for total war, 155–58, 302,
318; gifts, 278–79, 281. *See also*
RKK; RMVP; RPL
Goebbels, Magda, 24, 50, 71, 198,
201, 265, 299
Goepel, Erhard, 142
Goethe, Johann Wolfgang von, 279
Goethe Medal, 73
Gomperz family, 224–25
Göring, Carin von Fock, 188
Göring, Emmy, 50, 299
Göring, Hermann, 20, 22, 48, 64,
67, 84, 92, 97, 144, 151–52, 159,
162–66, 175–76, 208, 212, 230,
237–38, 286, 299–300, 304, 306;
in Paris, 3, 4, 134–37, 160, 190,
192, 194; art collecting, 6, 15,
78–80, 141–43, 160, 162–65, 179,
187–97, 225, 239, 248, 256, 282–
83, 285, 301; aesthetic policy, 9,
20, 60–62, 76–77, 79, 123, 197,
260, 263–64, 289–90, 293, 314,
317–19; residences, 10, 79, 137,
160, 165, 187–89, 191–92, 194,
225, 256, 264, 281, 283, 285, 294,
295–96; gifts, 72, 163–65, 216,
225, 233, 236, 247, 264–65, 267–
69, 271–73, 275–76, 279, 281,
285; plunder, 101–3, 105, 107,
123, 126–27, 130, 133–37, 141,
147, 159–60, 162–65, 190, 192,
194–95, 226–28, 281–82, 284;

funding, 187–89, 285–86. *See also*
Devisenschutzkommando; Four-
Year Plan; HTO; Plunder
Göring (Hermann) Meisterschule
für Malerei, 194, 314, 318
Gosebruch, Ernst, 56
Gotschee, 118
Gottfriedsen, Bernd, 211–12
Goudstikkers, 184, 224, 234, 283
Graudenz, 198
Grauel, Anton, 215
Graz, 88
Great Britain, 4, 34, 81–82, 127, 162,
179, 194, 208, 211–13, 320. *See
also* Battle of Britain; London
Greece, 147, 234, 245
Greiser, Arthur, 168
Grien, Hans Baldung, 248, 283
Grosz, George, 196
Grunberger, Richard, 302
Gründgens, Gustaf, 297
Grunewald, Mathias, 187
Grützner, Eduard, 181, 206, 276
GTO (Generaltreuhänder Ost),
102, 107, 111, 116, 119, 315. *See
also* Göring, Hermann; Plunder;
Sievers, Wolfram
Guardi, Francicso, 232
Guderian, Heinz, 87, 237
Gurlitt, Hildebrand, 78, 82, 182, 223
Gutjahr, M. F. H., 144
Gutterer, Leopold, 27, 297
Gypsies, 122

Haberstock, Karl, 301, 318; modern
art, 76, 78–79, 81; plunder, 87–90,
284; art dealing, 182, 184, 250
Hácha, Emil, 269, 271
Hague, 142, 144, 219, 224
Halder, Franz, 149
Halle, 36, 57, 214, 320
Hals, Frans, 131
Hamburg, 182, 208, 241
Hanfstaengl, Eberhard, 56
Hanfstaengl, Ernst ("Putzi"), 198,
292, 295

Windsor, Duke and Duchess of, 209, 303. *See also* Simpson, Wallace

Winkler, Max, 198

Winterhalter, Franz Xavier, 207–8

Wismann, Heinz, 46

Wittelsbach family, 213, 289

Wolff, Karl, 84, 249, 274

Wolff Metternich, Franz Graf von, 126, 128–30, 301, 321

Wolters, Rudolf, 314

World Exposition (Paris), 71, 263

World War I, 35, 57, 182, 188, 245, 248, 267, 289

Yugoslavia, 147

Zeitschel, Carl Theodor, 129

Ziegler, Adolf, 52–53, 55–57, 60–62, 76–77, 95, 138, 166, 183, 314, 317, 321

Ziegler, Hans Severus, 33

Zill, Rudolf, 201

Zschintzsch, Werner, 43, 314. *See also* RMWEV; Rust, Bernhard

Zuloaga, Ignacio, 273

Zurich, 78, 81. *See also* Switzerland

Zweig, Stefan, 46

Zwischen Westwall und Maginotlinie, 240